Stanley Spencer

STANLEY SPENCER

A BIOGRAPHY

KENNETH POPLE

HarperCollins*Publishers*

HarperCollins*Publishers*
77-85 Fulham Palace Road,
Hammersmith, London W6 8JB

This paperback edition 1996
1 3 5 7 9 8 6 4 2

First published by
William Collins Sons & Co Ltd 1991

ISBN 0 00 255664 2

Set in Linotron Sabon by
Rowland Phototypesetting Ltd
Bury St Edmunds, Suffolk
Printed and bound in Great Britain by
Butler & Tanner Ltd, Frome and London

Contents

List of illustrations viii

Preamble xiii

Part One: The Early Cookham Years 1891–1915

 1 The Coming of the Wise Men 3

 2 The Fairy on the Waterlily Leaf 15

 3 John Donne Arriving in Heaven 23

 4 Apple Gatherers 29

 5 The Nativity 36

 6 Self-Portrait, 1914 43

 7 The Centurion's Servant 55

 8 Cookham, 1914 68

 9 Swan Upping 73

 10 Christ Carrying the Cross 86

Part Two: The Confusions of War 1915–1918

 11 The Burghclere Chapel: The Beaufort panels 95

 12 The Burghclere Chapel: Tweseldown 119

 13 The Burghclere Chapel: The left-wall frieze 126

 14 The Burghclere Chapel: The right-wall frieze 142

 15 The Burghclere Chapel: The 1917 summer panels 149

 16 The Burghclere Chapel: The infantry panels 155

 17 The Sword of the Lord and of Gideon 165

Part Three: The Years of Recovery 1919–1924

18 Christ's Entry into Jerusalem 176

19 Travoys Arriving with Wounded Soldiers at a
 Dressing Station at Smol, Macedonia 182

20 The Last Supper 192

21 The Crucifixion, 1921 199

22 The Betrayal, 1923 211

Part Four: The Great Resurrections 1924–1931

23 The Resurrection in Cookham Churchyard 224

24 Burghclere: The Resurrection of Soldiers 253

Part Five: Return to Cookham 1932–1936

25 The Church of Me 272

26 Portrait of Patricia Preece 289

27 The Dustman, or The Lovers 297

28 Love on the Moor 306

29 St Francis and the Birds 313

30 By the River 324

31 Love Among the Nations 341

32 Bridesmaids at Cana 347

Part Six: The Marital Disasters 1936–1939

33 Self-Portrait with Patricia Preece 356

34 Hilda, Unity and Dolls 367

35 A Village in Heaven 372

36 Adoration of Old Men 378

37 The Beatitudes of Love 383

38 Christ in the Wilderness 396

Contents

Part Seven: Resurgence 1940–1950

39 Village Life, Gloucestershire 404

40 Shipbuilding on the Clyde: Burners 415

41 The Scrapbook Drawings 425

42 The Port Glasgow Resurrections: Reunion 438

43 The Resurrection with the Raising of Jairus' Daughter 453

44 Christ Delivered to the People 463

Part Eight: The Reclaiming of Hilda 1951–1959

45 The Marriage at Cana: Bride and Bridegroom 477

46 The Crucifixion 487

47 Christ Preaching at Cookham Regatta 496

48 Envoi 512

Map of Cookham 523

Family Tree 524

Sources and Acknowledgements 525

Notes and References 533

Paintings and Drawings 555

Photographs 562

Index 563

LIST OF ILLUSTRATIONS

COLOUR (*between page xvi and page 1*)

Apple Gatherers
The Centurion's Servant
Swan Upping
Cookham 1914
The Last Supper
The Resurrection in Cookham Churchyard
The Resurrection of Soldiers
Hilda, Unity and Dolls
The Beatitudes of Love: Contemplation
Christ Delivered to the People
The Sabbath Breakers
Christ Preaching at Cookham Regatta (detail)

BLACK AND WHITE

The Coming of the Wise Men	page 2
Cookham Moor *c.*1900	5
East end of Cookham High Street *c.*1900	5
Belmont and Fernlea *c.* 1880	6
The Spencer family, 1906	7
Will at the piano	9
Annie with toddlers Stanley and Gilbert	11
The Fairy on the Waterlily Leaf	14
Slade group on a summer outing, 1912	16
John Donne Arriving in Heaven	22
Apple Gatherers (detail)	30
Jacques Raverat	34
The Nativity	37
Self-Portrait, 1914	42
Henry Lamb	47
The Centurion's Servant	54
The Betrayal	57

List of Illustrations

Annotation of *The Betrayal*	57
Gilbert Spencer's *The Crucifixion*	59
Pa (William Spencer)	60
Cookham, 1914	69
Swan Upping	74
Harvesting walnuts at Fernlea	78
Ma (Anna Spencer)	79
Stanley with Pa and Sydney on Cookham Bridge	83
Christ Carrying the Cross	87
Ovey's Farm, *c.*1900	88
Burghclere Chapel, *Ablutions*	94
The Beaufort War Hospital	97
Washbasins at the Beaufort War Hospital	98
Ward 4 with 'me'	101
Stanley with Sydney and Percy in uniform	102
Convoy of wounded arriving at Beaufort	106
Desmond Chute	111
Drawing of Jack Witchell	116
Jack Witchell aged 64	117
Burghclere Chapel, *Kit Inspection*	118
Sketch of kit layout	121
Gunner 'Jas' Wood	124
Burghclere Chapel, *The Camp at Kalinova*	127
Map of Salonika front	130
Mountains near Lake Doiran	131
View towards Lake Ardzan	134
View from Cockmarsh Hill	135
Burghclere Chapel, *The Camp at Todorova*	143
Gwen Raverat with Elizabeth, her firstborn	144
Burghclere Chapel, *Convoy of Wounded Men Filling Waterbottles*	148
Captain Henry Lamb	152
Burghclere Chapel, *Stand To*	154
Burghclere Chapel, *Reveille*	163
The Sword of the Lord and of Gideon	166
Christ's Entry into Jerusalem	177
Travoys Arriving at a Dressing Station, Smol	183
The Last Supper	193
Beaufort Hospital, Orderlies at Mess	197
The Crucifixion, 1921	199
Hilda painting	201
Gilbert Spencer painting	202
The Betrayal (second version)	212

Drawing of Hilda with hands bound	213
The Disrobing of Christ	216
Stanley posing with *The Betrayal*	217
The Resurrection in Cookham Churchyard	225
Richard Carline	233
Drawing of Hilda on her honeymoon	234
Four drawings for the image of God	242
Hilda with Shirin	245
Chapel View	250
Burghclere Chapel, *Resurrection of Soldiers*	252
Burghclere Chapel exterior	254
Burghclere Chapel interior	254
Burghclere Chapel, *Scrubbing the Floor*	257
Burghclere Chapel, *Washing Lockers*	258
Bathroom of Ward 5 at Beaufort	259
Burghclere Chapel, *Convoy Arriving at Hospital Gates*	260
Sergeant Sam Vickery	261
Lionel Budden	263
Giotto's *Last Judgement*	266
Drawing of the churchhouse	273
Elsie Munday	275
Dudley Tooth	276
Patricia Preece	278
Stanley with Mrs Behrend	281
Lindworth	282
Portrait of Patricia Preece	288
On a motoring trip	292
Moor Thatch	294
Patricia	296
The Dustman, or *The Lovers*	298
Portrait of Patricia by Hilda	305
Love on the Moor	306
St Francis and the Birds	312
Stanley with his painting, *Parents Resurrecting*	314
The Builders	316
Workmen in the House	317
By the River	325
Dorothy Hepworth	326
Patricia in Switzerland	330
Patricia at Cockmarsh Hill	331
The Meeting	335
Separating Fighting Swans	336

List of Illustrations

Stanley with Unity c.1934	338
Love Among the Nations	342
Bridesmaids at Cana	348
Self-Portrait with Patricia Preece	357
Stanley painting at Cookham	359
Stanley and Patricia marry at Maidenhead Registry Office	363
Hilda, Unity and Dolls	366
A Village in Heaven	372
Adoration of Old Men	379
The Beatitudes of Love: Contemplation	384
The Beatitudes of Love: Knowing	388
Kench in full service uniform	390
Kench with an orderly	390
Christ in the Wilderness	397
Village Life, Gloucestershire	405
Study for the Tiger Rug	408
Daphne	413
Shipbuilding on the Clyde: Burners	416
Stanley sketching in Lithgow's yard	420
Four Scrapbook Drawings	424
Stanley, Hilda, Shirin and Unity at Lynton, 1942	435
Port Glasgow Resurrection: Reunion	440
Graham and Charlotte Murray	442
Cliveden View	447
The Temptation of St Anthony	449
The Psychiatrist	451
The Resurrection with the Raising of Jairus' Daughter	454
Moor Thatch under floodwater	457
Christ Delivered to the People	464
Angels of the Apocalypse	469
The Sabbath Breakers	472
Bride and Bridegroom	476
Silent Prayer	482
The Crucifixion	488
The Deposition and Rolling Away of the Stone	491
Stanley at his 1958 Exhibition	493
Christ Preaching at Cookham Regatta (detail)	497
Stanley with Unity at his Investiture	501
Self-Portrait, 1959	502
Portrait of Shirin	505
Dinner on the Ferry Hotel Lawn	509
Listening from Punts	510

I will make the poems of materials, for I think they are to be
 the most spiritual poems,
And I will make the poems of my body and of mortality,
For I think I shall then supply myself with the poems of my soul
 and of immortality. . . .

Walt Whitman: *Starting from Paumanock*

Preamble

> I often think I would enjoy writing more if it were
> not dependent on thoughts logically following each
> other. But I think this limits the capacity of thought
> and cuts it off from something which in its undis-
> turbed condition it can deal with and perform.
>
> Stanley Spencer[1]

In 1938, some of Spencer's friends and associates urged him to assemble his thoughts into an autobiography. They included his dealer Dudley Tooth, the newly appointed director of the Tate Gallery John Rothenstein, and the publisher Victor Gollancz, whose wife had been, as Ruth Lowy, one of Spencer's fellow-students at the Slade and an early patron.

Their intention was to help him. His personal life was in shreds, his finances in disarray, his time largely devoted to saleable but 'pot-boiling' landscapes, his hallowed visionary work misunderstood and largely rejected. A judicious autobiography in which he could explain his ideas and motives might, it was felt, restore his prestige.

Spencer's first reaction was one of caution. If, he argued, the public already found much of his visionary work 'funny', would they not find his explanations more so? Then suddenly he became enthusiastic. He would indeed write an autobiography. But it would not be assembled in the normal chronological arrangement. It would be a leisurely 'stroll' through his life, with pauses, diversions and retraces as the mood took him, a putting down on paper of the events, thoughts and feelings of his entire life to date. Nothing would be omitted. But neither would anything be stressed. The reader, making the journey with him, would be free to find the clues to his life, thinking and art, as Spencer himself had, often in strange and unexpected places.

The promoters were aghast. Some editing, they urged, must be

accepted: 'You are being offered a chance that you would be absolutely crazy to turn down,'[2] fumed Dudley Tooth. Spencer remained unmoved: 'I would rather a book on myself and my work were a confused heap and mass of matter from which much could be gathered than risk something of myself being left out in the interests of conciseness.'[3] The venture collapsed.

Spencer, despite the travail of his circumstances, was blithely unrepentant. The fact was that, seized by the idea, he had already started on the project in private and was to continue it for the rest of his days. There was no discernible pattern to his writings. He would compose extensive essays in thick notebooks, but equally make random jottings in scrapbooks, on drawings, on scraps of letters, on old envelopes, on anything to hand. He seldom kept letters but would draft replies, often unposted because having sorted out his thoughts in them they became more valuable to him in his own possession than in that of the intended recipient. Others were unsent because on reflection he felt their sentiments were too confessional or, in other moods, too accusatory. By the end of his life the writings totalled millions of words, heaped into several trunks into which he would dip to reread, reannotate, re-paginate, rearrange. 'You can burn those,' he told his brother Percy when he knew his time was measured. But by his death, in December of 1959, the matter had passed from Percy's hands, and in any case Percy did not want the responsibility.

To read them now is a disturbing experience, for they are expressed with an intensity he would normally have denied the public gaze. They have been sieved by scholars for references to his paintings, but, interesting though these are, they offer little in the way of immediate illumination. Spencer knew this. They are written in a code, a language of his own which appears to be the language we also use, but is not. The language was born not of secrecy but from the impossibility all artists face, in whatever medium, of finding in the words or images or symbols they are given to use that universality their imagination perceives. In them his thoughts flow like a stream of consciousness, turning and twisting, so that the reader is soon lost in a tangle of developments and, if he or she can summon the will, must go back again and again to re-chart their course over even a few of the many thousands of pages. The surprise is that to each development there is invariably

a beginning and an end; however many diversions Spencer took on the way, he usually knew both his direction and his destination. His imagery, bizarre and esoteric though it often seems, captures both the exuberance of his associations and the precision with which he externalized it in his art.

In venturing today into this study of Spencer's life and art, boldness is offered; but it is boldness disciplined by the sense of the totality of his experience. An artistic interpretation which ignores Spencer's material existence will remain truncated. Yet a biography which blinds itself to the revelation in his paintings of the facts of his existence can only perpetuate the superficiality which saw him – and sometimes sees him still – as whimsical or innocent or unworldy or even as blasphemer or pornographer. His oddities are, like the highly personal and visionary paintings he undertook, sudden flashes of lightning, often charged over long periods, which momentarily illuminate climaxes in a continuous procession in his mind, an inner pageant. The pageant over-whelmed him. To its service he dedicated both his art and his everyday existence. When he could reconcile them, he knew happiness. When they conflicted, he was torn. The demands of art invariably won, but the cost in material sacrifice could be cruelly high.

It would be a rash interpreter who claimed complete elucidation for so complex a personality. Spencer used his art to explain himself to himself. As with the poetry and prose of his contemporaries Eliot, Pound and Joyce, it is the exactness of personal detail in Spencer's paintings which makes so many incomprehensible or uncomfortable. But the paintings were not intended to prompt discomfort. He lived in hope that the public would catch up with him. His art, perceived through sympathetic understanding of his life, can reveal a transcendent outlook, an intriguing and majestic vision of life which some may dismiss as no more than typical of his time, but which most may joyously recognise as having eternal and universal import.

A work of great art – pictorial, musical or literary – reaches out and touches some profundity in our nature independently of its maker. Awed, we may wish to know more of him or her. The quest is often disappointing. We can know nothing of Homer, little of Dante or Shakespeare. Of later artists, of whom we can search to

know more, we sometimes ask ourselves how such fallible men and women could produce such sublimity. The purpose of this study is not to dissect Spencer and his art. Rather is it to recapture through the medium of his own words that sense of the wondrous and mysterious through which he became someone other than the everyday artist people thought they knew, and entered a heaven of his own which he felt he had to strive, through imagery, to share with us. Thus the narrative pauses at some of the major paintings representative of the main periods and events of Spencer's life and offers suggestions as to their emotional origins. (The majority have been chosen as being available in public galleries. They may not always be on display, but can usually be seen by prior arrangement.)

Throughout this book, Spencer – Sir Stanley Spencer CBE, RA, Hon. D. Litt. – is referred to as 'Stanley', not as a mark of familiarity, but in order to distinguish him from his many brothers, and especially from his artist-brother Gilbert, with whom he was sometimes confused. Textually his writings have been rendered into conventional spelling and punctuation, no easy matter at times when he was in full flight. Occasionally bracketed insertions have been made to catch the sense of his often elided thought.

The obvious starting-point for the search for Stanley's inner pageant must be the Thames-side village of Cookham where, in the cool unsettled summer of 1891, on 30 June, he was born.

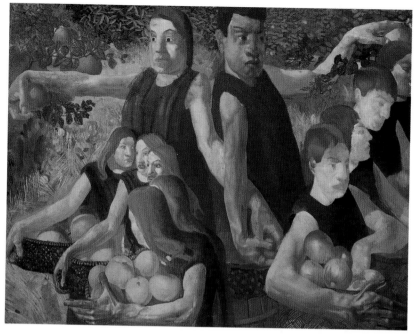

The Apple Gatherers

The Centurion's Servant

Swan Upping

Cookham 1914

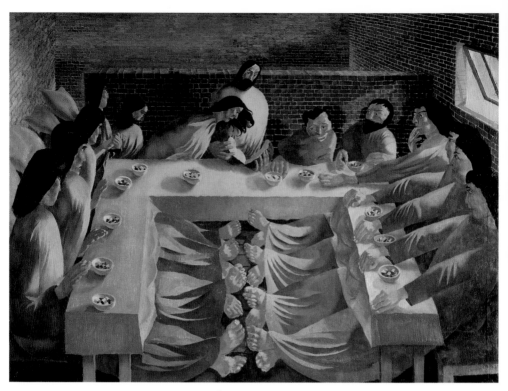

The Last Supper

OPPOSITE: The Resurrection of the Soldiers

The Resurrection in Cookham Churchyard

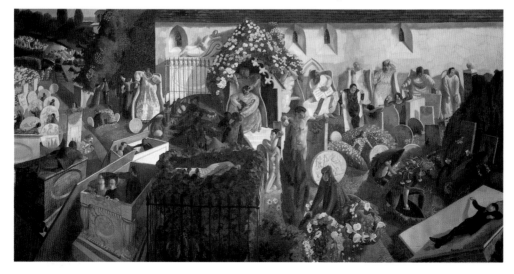

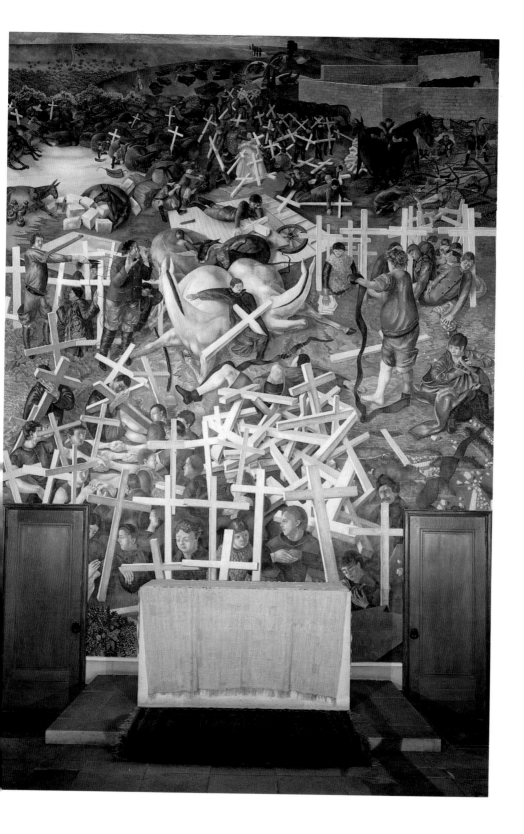

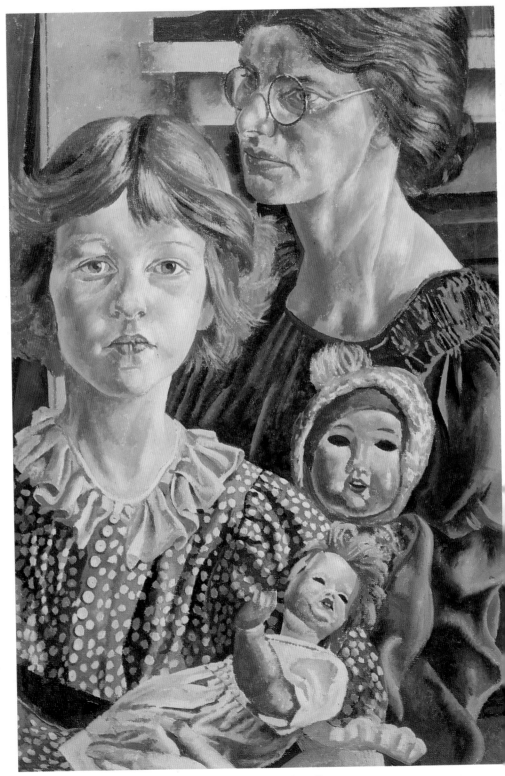

Hilda and Unity with Dolls

The Beatitudes of Love: Contemplation

Christ Delivered to the People

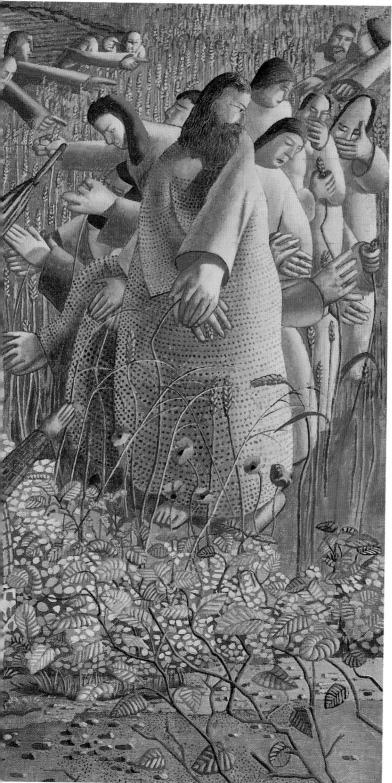

The Sabbath Breakers

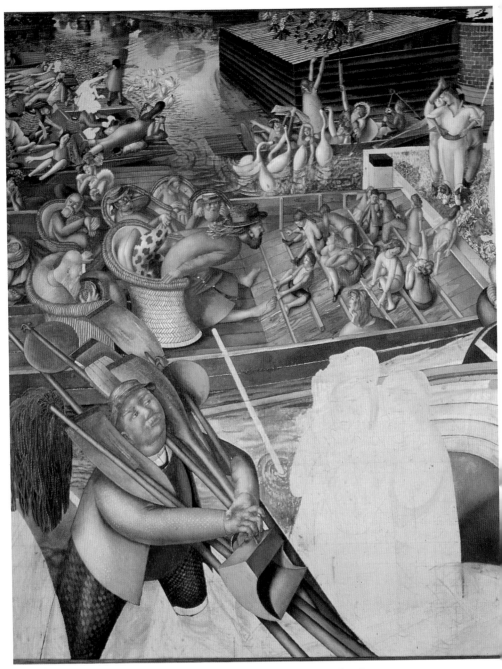

Christ Preaching at Cookham Regatta (*detail*)

PART ONE

The Early
Cookham Years

1891–1915

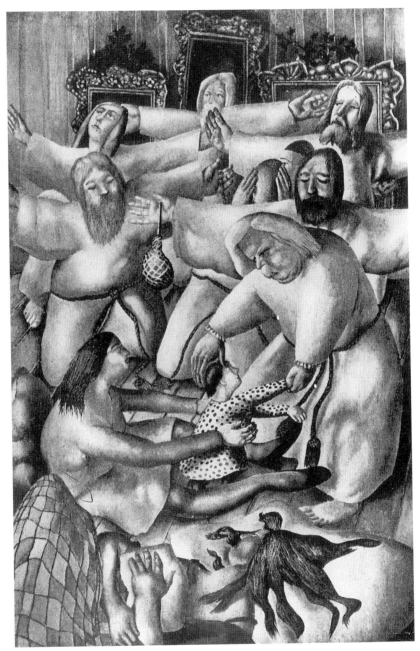

The Coming of the Wise Men

CHAPTER ONE

The Coming of the Wise Men

I am actually old enough to remember the Victorian
Age; and it was almost a complete contrast to all that
is now connoted by that word. It had all the vices that
are now called virtues; religious doubt, intellectual
unrest, a hungry credulity about new things, a com-
plete lack of equilibrium. It also had all the virtues
that are now called vices; a rich sense of romance, a
passionate desire to make the love of man and woman
once more what it was in Eden, a strong sense of the
absolute necessity of some significance in human life.

G. K. Chesterton: *Autobiography*[1]

COOKHAM VILLAGE lies some thirty miles from London along
the favoured stretch of the Thames from Henley, past Marlow and
Cliveden, to Boulter's Lock and Maidenhead Bridge. It rests on the
slightest of rises at a point where the eastward-flowing river makes
an abrupt right-angle bend south against the bluffs of Cliveden
Woods. Lying within the elbow of the bend, the village is in effect
an island, for the river may once have made its course on the other
side of the rise, isolating it today by its low-lying remnants – Marsh
Meadows to the north, Cookham Moor to the west, Widbrook
Common to the south, and Odney Common to the east. These
water-meadows often flooded in Stanley's boyhood, and the winter
rising of the river was anxiously watched, as Stanley's brother
Sydney notes in his diary for January 1912: 'I went up the river
and saw the heron high in the air flying towards Hedsor, dim in
the rain. A peewit and a seagull met, exchanged compliments by
numerous tumblings, then went their several ways. Cattle were
taken off the Moor this morning and pigs from Randall's styes this
evening.'[2] For this reason extension of the village has not been

possible and under protective preservation it remains virtually as Stanley knew it in his boyhood.

A few cosmetic alterations have occurred. The malthouses whose cowls once dominated the village have gone, the blacksmith's forge is now a restaurant, the village shops have become boutiques or tea rooms, Ovey's Farm in the High Street is now a residence, its barns a garage and filling station, and the former Methodist Chapel is now the Stanley Spencer Gallery. But in its structural appearance the village remains much as it was in the early decades of the nineteenth century when Stanley's paternal grandfather arrived from Hertfordshire to help build the superior residences locked inside their high red-brick walls which Victorian genteel wealth and the new commuter railway system from London were imposing on the neighbourhood. A builder by profession but a musician by inclination – he inaugurated a village choir – Grandpa Julius prospered sufficiently to produce two families by two marriages, thus giving Stanley a profusion of 'cousins' in the village. His Spencers were the product of Grandpa Julius' second marriage.

For the two sons of the marriage, Grandpa Julius demolished a row of small cottages in the High Street and replaced them with a pair of semi-detached villas. The elder son, Julius, occupied Belmont, the left-hand villa facing from the road. He had a family of daughters – Stanley's 'girl-cousins' – and was managing clerk to a firm of London solicitors. The younger son, William – 'Pa' to Stanley – occupied the right-hand villa, Fernlea, and was a dedicated musician. The piano and violin being Victorian social accomplishments much in demand, he set up as the local music 'professor', cycling to teach the children of the grand middle-class houses – Rosamond Lehmann remembers a 'gentle old man with a white beard' – and welcoming the humbler in his home.[3] The succession of little girls sitting in the hall awaiting their piano lesson was a long-standing Stanley memory, and he did much of his early painting to the accompaniment of their halting efforts.

Pa supplemented his income by acting as church organist, mainly at St Nicholas, Hedsor, in the advowson of Lord and Lady Boston. Lord Boston had been one of his piano pupils, and in those days of discreet patronage the Bostons did much to help their church organist. They allowed him, for example, to enjoy the study of the

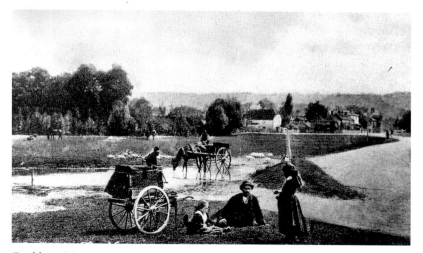

Cookham Moor c.1900. The scene is recognizable today. The River Thames runs from left to right behind the near trees. Cookham High Street (west end) begins on the right. The distant wooded bluffs are those of Cliveden. The view is towards Marsh Meadows.

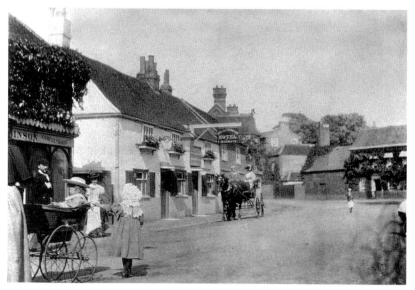

East end of Cookham High Street, about 1900. Bel and the Dragon Hotel on the left. The distant turning left leads to Cookham Church, Cookham Bridge, and Bourne End, while the fork right is the Sutton Road to Maidenhead. The ivy-clad house distant right is Wistaria Cottage.

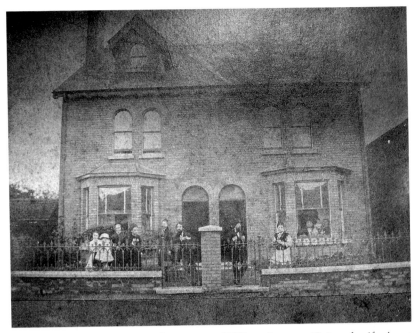

Belmont left, Fernlea right, about 1880. William Spencer (Pa) and wife Anna (Ma) are in the front garden of Fernlea. His brother Julius and wife, with their family of girls, are in the front garden of Belmont. At a later date the front door of Fernlea was walled up to extend the front room and a new entrance made at the side.

stars in their private observatory and on one occasion met his expenses on a cycling holiday along the south coast while his wife, Annie, relaxed at Eastbourne. From his Pa, Stanley asserted, he took his 'sense of wonder', and from Ma his small frame and his sense of the dramatic. Ma was an excellent mimic, a gift which Stanley inherited and could use to social effect.[4]

Ma – Anna Caroline Slack, but Annie always – had been a soprano in old Julius' choir when Pa married her in 1873. Their eldest son, William – 'Will' – was invited at the age of seven to play Beethoven before the Duke of Westminster and his guest the Prince of Wales (later Edward VII) at the nearby mansion of Cliveden. The Prince was so impressed that he presented Will with a piano. At fourteen Will gave a public concert at the prestigious Queen's Hall in London, and under the Duke's patronage studied

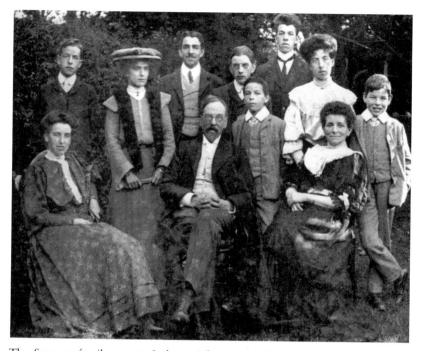

The Spencer family, 1906. Left to right, seated, Florence, Pa, Ma. Standing, Sydney, Natalie (Harold's wife), Horace, Harold, Stanley, Percy, Annie, Gilbert. The photograph was taken for Will who was in Germany preparing for his wedding with Johanna.

and graduated at the Royal College of Music. There he was followed by his brother Harold, a violinist. Today the elder of their two sisters, Anna – Annie always – would have followed them, but the custom of the day decreed that she act as helpmeet to her mother and as a not altogether willing nursemaid to the two youngest sons, Stanley and Gilbert. There were eleven children in all. Florence (Flongy) was the younger sister. The other sons were Horace, who delighted in conjuring and did so professionally; Percy, a keen cellist; and Sydney (Hengy). Stanley was 'Tongly' and Gilbert 'Gibbertry', presumably as derivations of childish attempts at pronouncing their names. A pair of twins died in infancy.

Will was about to be offered a teaching post in Bristol when he suffered a nervous breakdown.[5] In Ma's view it was brought

on by Pa's relentless pressure towards the highest professional standards, a characteristic which all the siblings inherited in their various careers. The collapse necessitated expensive medical treatment at Virginia Water and impoverished the previously thriving household so much that Percy had to give up the prospect of articles with his uncle Julius' law firm and take a job at a neighbouring sawmill; half his meagre pay went to the family. In the crisis Florence took a post as governess, and Sydney, who intended to go into the church, had to restrict his studies to night schools and crammers, later supported by Will. For, having recovered, Will had obtained a post as piano master at Cologne Conservatoire and had there met and wed Johanna, daughter of a prosperous Berlin family.*

In few families can there have been such close identity of interests and passions. There was the devoted and scholarly respect for music which the children shared all their lives. Pianos, violins, violas and cellos were part of their upbringing. So were books, for in all the siblings lay the fierce intent to expand their knowledge and imagination through literature. Will and Sydney kept detailed diaries, lovingly preserved by Florence, who herself had her family recollections typed and bound. Pa's idealistic venture at promoting a village library failed from sheer high-mindedness in the choice of books. All the family were inveterate talkers, for Pa encouraged discussion, especially at mealtimes, on any topic from politics – they were Liberals – to poetry, philosophy, psychology or religion. He worshipped Ruskin. The family were soaked in the language of the King James Bible, for Pa adopted the prevailing custom of family Bible-reading, a habit Stanley was to continue all his life.

The family possessed astonishingly retentive memories both auditory and visual. Will could memorize a page of music or a restaurant menu at one reading, and Stanley could instantly replay a once-heard piano piece which interested him. The acuity of Stanley's visual memory was a cornerstone of much of his painting. Images from a multitude of sources – places, people, gestures, happenings, books, newspapers, paintings, exhibitions – flooded

* Photographs show her as a short, homely, round-faced woman. Gilbert in his autobiography inexplicably gives her surname as Simon, but Will in his diaries and correspondence refers to the name Ohlers. 'Mutter' was Frau Emma and father was respectfully 'The Direktor'. She had a brother Max and sisters Emma and Agnes.

his mind and could be recalled when needed, even years later, with photographic accuracy.

As a family they were encyclopaedic acquirers of information and catholic in their interests. All were immersed in a countryman's instinctive and unsentimental solicitude for nature. Percy, in his

Will at the piano

role of big brother to Sydney, Stanley and Gilbert, took them birdwatching. Sydney's diaries are full of rhapsodies: 'Went up Barley Hill in the dark and gathered poppies and a little corn. I love to see the poppies looking jet-black against the corn. Saw three glow-worms. . . .'[6] Pa's sense of wonder never palled: 'I

crossed London Bridge on Tuesday and could have stood for hours watching the flight of the seagulls – surely the acme of graceful motion. And yet the people passed by without a glance. . . .'[7] Will, translating Heine: 'I discovered that we have no word which quite gives the feeling of *Wehmut*. "Full of sadness" means more than "sadly" but not quite the same as "sorrowful". This brought to my mind a word I had not thought of for years – "tristful". I think the goddess of poetry herself must have helped me to think of it. It more nearly gives the meaning of *Wehmut* than any word we have.'[8] And Stanley: 'The marsh meadows full of flowers left me with an aching longing, and in my art that longing was among the first I sought to satisfy . . . '[9]but, as we shall see, not always in the manner we might conventionally expect.

With these characteristics went an inbuilt instinct for mastery in whatever they undertook. Will, for example, who had been speaking German fluently for years, one day made a slight mistake for which Johanna corrected him.[10] Appalled, he promptly devoted an hour and a half every day to the complete memorization of every detail of German grammar. A similar search for perfection could make Stanley an exhausting companion. As a family they loved charades and games, and were determined solvers of puzzles and problems. Occupied by an erudite question of musical interpretation, Will could divert time to finding the highest score possible at dominoes. Percy's essential function at the substantial London building firm of Holloway and Greenwood, to which he had ascended from his sawmill, was, according to Stanley, 'getting the aforesaid gentlemen out of scrapes'.[11] Gilbert became a considerable bridge player whose skill was in demand at Bloomsbury parties. Horace's aptitude in conjuring was not an unforeseen eccentricity but a deeply rooted family characteristic. Above all they shared a continual search for comprehension and validity in experience.

'Home' had a special meaning for Stanley. His childhood memories would recur time and again in his paintings. Home was where he was 'cosy', tucked up in the safe embrace of those who loved him and shared his values.* At home he was shielded from the

* Stanley's painting of *The Coming of the Wise Men* honours his family and its influence on his creativity. The oval composition hints at the medieval mandorla in which the depicted Christ sits in glory. The subject is emotionally complex and embraces Stanley's private ideas of home and cosiness.

incomprehensible threats which lurked in the world outside; threats quite specific from some of the village boys who were contemptuous of his slight build and tried to bully him – he was to find a defence in the sharpness of his tongue – or from those villagers who had no means of understanding his exaltations and thought him 'funny'.

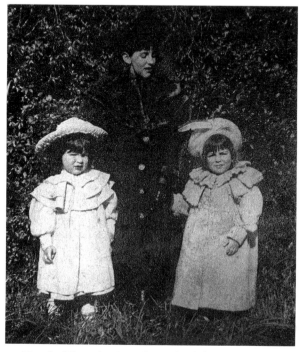

Handholding. Annie with Stanley left, Gilbert right.

Home was where he first experienced the impact of those feelings he came to know as 'happiness'. His happiest feelings, as he frequently emphasized, were those of a baby safe in the known confines of its pram, gazing in wide-eyed wonder at the larger world it saw beyond; except that in Stanley's analogy the larger

The stylized figures can be interpreted as, right to left, Percy, Harold, Sydney (holding head), Horace (indistinct), Will, Pa in the background, Florence, Gilbert, and Annie holding an infant Stanley. Ma, hair awry, lies in the foreground clutching a pillow to ease her bronchial chest. Asked for an explanation of the painting, Stanley offered only the sketchiest of descriptions with strict instructions that he was not to be quoted: a measure of the intimate and personal meaning he always attached to his family and boyhood home.[12]

world was not only physical but, more significantly, metaphysical – what he called 'spiritual'. Home meant handholding, the sanctuary he found as a child when walking with Pa or Annie lest the sensed terror of becoming lost befall him. It represented that peace of mind in which his and mankind's spirit is free to soar untrammelled by emotional bewilderment. All his life Stanley's deepest commitments were to be to those who, like his family in childhood, were willing and able to handhold, to set fire to his imagination and help solve the deep mysteries which beset him.

Stanley's schooling took place at his sisters' dame school, a corrugated iron hut in the next-door garden; Pa was disdainful of the new state product, the village National School. A born educator, Pa had started the school with the help of two local ladies, the Misses George. When they emigrated, his daughters took over. At school, even though taught by his sisters, Stanley became convinced that he was not bright in the scholastic sense. Indeed there were times when he felt himself a 'dunce', for he had no facility in the linear logic so necessary in mathematics or in narrative writing. Composing formal or business letters was a penance to him: 'I have written a letter and hated it, it is so young. I do not mind being young, but it comes out in such an objectionable manner in my letter.'[13] But in school drawing lessons he came into his inheritance and found that he could 'become a boy like any other'. For then his mind functioned as he needed.

Stanley's compulsion to take up art bemused his musical father.* But typically Pa devoted his persistent energy – which Stanley inherited – to winning for his son the best possible training. It began in 1906 – 7 with lessons from Dorothy Bailey, a young local woman who had some leanings as an artist.[15] This was followed by a year at Maidenhead Technical College, mainly drawing plaster casts. Then, initially under the financial patronage of Lady Boston, who had herself studied at the Slade, Stanley was accepted there. He travelled each day by train. For the first few days Pa escorted him. When Stanley felt confident to go by himself, he refused to diverge from the known route unless he were given detailed

* There was no apparent artistic tradition in the family. 'My bedroom is very nice, quite inartistic. Over the washstand are two textboards, old-fashioned ones in frames. One says The Lord Is My Help and contains a picture of bluebells, and the other says Pray Without Ceasing, and contains a picture of daffodils and jonquils. These have been on the walls a good deal longer than I have been alive.'[14]

information beforehand. This unadventurousness was due not so much to timidity as to an innate characteristic which insisted, both in his everyday life and in his art, that he should always know exactly where he was, what he had to do and why, and to a reluctance to take guidance on trust.

To cosmopolitan London thinking, such precision was misinterpreted as parochialism. In the summer of 1911 Henry Tonks, the formidable drawing master at the Slade, decided that Stanley needed his experience of the world widened and arranged for him to stay with a farmer friend at Clayhidon, near Taunton. He might as profitably have sent Stanley to the moon. Sydney, the brother who perhaps most clearly understood Stanley, saw the pointlessness of the exercise: 'I beseeched him by all the love he had for me not to go. But he went.'[16]

Stanley tolerated the event on an everyday level, but the drawings he managed were purely formal. The place meant nothing to him compared with Cookham and its associations. Tonks realized he had made a mistake and did not repeat the error. But in a letter to Florence, Stanley chanced to describe a farmworker he had seen there: 'the old man that I drew, a labourer, was most pathetic. He had knocked off work owing to the heat and looked very ill. His face was beaten and cut with the sword of age. You could divide his face up like a [jigsaw] puzzle.'[17] Yet this vivid comment came from the 'dunce' who at the time could not for the life of him compose a business letter. The quality of Stanley's mind is becoming apparent.

The Fairy on the Waterlily Leaf

CHAPTER TWO

The Fairy on the Waterlily Leaf

All my drawings are self-portraits, and no amount of
'abstract' or what-not will conceal from that.

Stanley Spencer[1]

AT THE SLADE, which Stanley attended from 1908 to 1912, his
talents were quickly recognized. In 1909 he was awarded an
endowed scholarship and became financially, if modestly, indepen-
dent. 'Our genius' became the epithet half enviously, half affection-
ately given to the young Stanley by his fellow-students. It did not
prevent some of them from ragging or playing practical jokes on
him, which he tolerated good-humouredly, except when directed
at his art and its integrity. His dedicated nature had little patience
with the public-school-type humour prevalent among some of the
well-heeled young bloods there. Goaded on one occasion beyond
endurance, he silenced one tormentor by pouring white paint over
his new suit.*

It was the custom for the students, girls included, to be known
only by their surnames. Stanley became not Spencer, but 'Cook-
ham'. Among the star students of his years – Allinson, Gertler,
Nevinson, Currie, Brett, Raverat, Japp, Carrington, Wadsworth,
Roberts, Bomberg and Rosenberg – was Gwen Darwin, grand-
daughter of Charles Darwin, and reared in the academic atmos-
phere of Cambridge. Six years older than Stanley in age but perhaps
a lifetime older in practical experience, Gwen took the young
genius under her wing. He needed sympathetic guidance, a spiritual
handholder.

The Slade students then were in the forefront of the Edwardian
counterblast to Victorian materialism and sentimentality. It was

* The victim was C. R. Nevinson.[2]

15

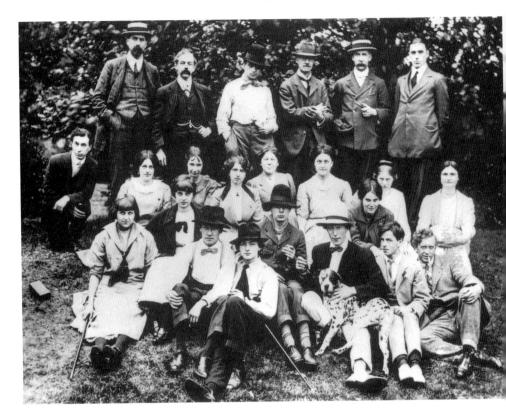

an exciting age in which to be young. In contact at the Slade with lively young minds inevitably fascinated by the new modernism, Stanley encountered moments when his cautious and deliberate absorption of experience was misunderstood. His celebrated reply when asked at the Slade what he thought of Picasso – that he, Stanley, had 'not got beyond Piero della Francesca' – was considered supercilious. But Stanley did not mean to be patronizing. His mind was an instrument which sought connection, and the operation required time. Although he understood the aims of modernism and indeed shared its essential techniques, the fragmentation of its venturing repelled his instinct for totality. Starting from Pa's advocacy of Ruskin and Tonks' enthusiasm for early Renaissance painting, Stanley found in medieval art a serenity which matched his aspirations. Artists then, he argued, were integrated members of a stable culture. They were workmen – stone

The Fairy on the Waterlily Leaf

OPPOSITE: Slade group on a summer outing, 1912. Back row fourth from left is Slade Professor *Frederick Brown* (1851–1941). A noted painter, a strict teacher but a diffident bachelor, he had formed a more than tutorial attachment to *Dora Carrington* (1893–1932), front row extreme left. In the row of women behind her, third from left, is *Dorothy Brett* (1883–1977), an eccentric aristocrat hard of hearing who in 1924 became the sole disciple of D. H. Lawrence and Frieda at their New Mexico commune at Taos; when the venture collapsed she remained there for the rest of her life, painting. On her right, second from left, is *Dorothy Meyer* who became the second wife of Harold Gilman (1876–1919), the first President of the London Group to which many of the progressive Slade students aspired. The central figure on Dorothy Brett's left has been identified as *Ka Cox* (1887–1938), a young lady of independent means and outlook. She was a close friend of Gwen Raverat and an early member of Rupert Brooke's circle at Cambridge. A lover at various times of Jacques Raverat, of Rupert Brooke (by whom she is reported to have had a miscarried child) and of Henry Lamb, she married the painter Will Arnold-Foster in 1918 and settled to happy domesticity in Cornwall. The dark-haired girl beside Carrington might be *Ruth Humphries* or *Barbara Hiles*, both vivacious and unconventional. Carrington, Brett and Hiles formed a long-lasting friendship and were a lively trio known at the Slade as 'the cropheads' from their innovative and then shocking fashion of cutting their hair short. Carrington was deeply loved by both *Mark Gertler* (1892–1939), front row, with walking stick, and *Christopher Nevinson* (1889–1946) sitting beside him. Both were to become noted painters, to whom at the time Carrington offered occasional solace more from affection than passion; there were to be other infatuated devotees in her short life. She married Ralph Partridge, himself devoted to Frances Marshall, but became the companion of the homosexual Lytton Strachey. On his death she committed suicide. The good-looking young man with the dog, front row, is *Adrian Allinson* (1890–1959), representative of the well-heeled element at the Slade. He became a skilled teacher, commercial artist and stage designer. Standing in the back row, second from right, is *Charles Koe Child* (1867–1935), member of staff at the Slade and later Senior Assistant to Tonks when he became Professor in 1918. The young man standing in the back row third from left is *David Bomberg* (1890–1957), a painter whose originality is said to have been largely masked during his lifetime by his success as a teacher, but is now increasingly recognized. The solitary young man kneeling extreme left is *Isaac Rosenberg* (1891–1918). Of refugee parentage and born like the poet Chatterton within sound of the bells of St Mary Redcliffe, Bristol, he was then, like Gertler, living in the East End of London. He was to tell his patron Sydney Schiff that *Stanley Spencer*, front row second from right, was the 'finest of my generation'. The 'finest', caught by the camera in inevitable conversation, this time with the pretty girl behind him, had already that year painted *Apple Gatherers* and was completing *The Nativity*. He was twenty-one.

carvers in the Gothic north, mosaicists and fresco painters in the classical south – whose everyday talents were devoted to the beautifying of the churches, chapels, abbeys and great cathedrals which across Western Europe dedicated political power and economic wealth to the glory of the God who had accomplished them. Ruskin, in his opulent prose, set one such painter in his time:

Giotto, like all the great painters of the period, was merely a travelling decorator of walls, at so much a day, having at Florence a *bottega* or workshop for the production of small tempera pictures. There were no such things as 'studios' in those days. An artist's 'studies' were over by the time he was eighteen; after that he was a *lavatore*, a 'labourer', a man who knew the business and produced certain works of known value for a known price, being troubled with no philosophical abstractions, shutting himself in no wise for the reception of inspiration; receiving indeed a good many as a matter of course, just as he received the sunbeams that came in at his window, the light which he worked by; – in either case without mouthing about it, or merely concerning himself as to the nature of it.

How exactly the sentiments matched Stanley's! First written in the 1850s, they were published in reprint by George Allen in 1900 as *Giotto and his Works at Padua*. Gwen lent Stanley a copy. The glory of the subject was to remain evergreen throughout his life. The apprentice Stanley had no problem with his sunbeams; what he needed was the technique to manifest them. Although Stanley absorbed the excitements of the times, he rebuffed attempts at the Slade to recruit him to partisanship. The function of the place was simply to teach him to draw.

Academically, the Slade emphasized precision in line, a feature which reflected the forceful personality of Tonks. A surgeon by profession, he had long been fascinated by art and was delighted to be enticed into teaching by his friend Ernest Brown, the Slade Professor. A tingling of apprehension would herald his visits to the students working in the lofty hall of the men's Life Class. The college organized a sketch club which held periodic competitions on set subjects, usually biblical. The entries, submitted anonymously, were judged by Tonks, and the prizes were welcome, especially to

the poorer scholarship students. Unfortunately Stanley seldom won,* not because his draughtsmanship was inferior but because his compositions were judged not to illustrate the set theme effectively. Herein lies the first indication of a misunderstanding of the intention of Stanley's art which was to dog him all his life, and which indeed persists in some respects to this day.

Most of Stanley's early drawings – he had not yet seriously ventured into painting – are entries for these competitions. However, *The Fairy on the Waterlily Leaf* was drawn at the request of a Miss White of Bourne End to illustrate a fairy story she had written.[4] She must have been surprised at the result. Stanley's fairy is no elfin figure, but a substantial young lady impossibly posed on two waterlily leaves which in real life would instantly have sunk under her weight. But of course this is not real life, so Stanley portrays the prince who woos her as a Renaissance figure. He was copied from one of Stanley's Slade life-class studies of a male model there called Edmunds.

The fairy too was drawn from life. Her name was Dorothy Wooster (Worster). She and her sister Emily were cousins and had been school pupils with Stanley and Gilbert. But the significant fact about Dorothy was that Stanley was boyishly attracted to her, as was Gilbert to Emily, despite their father, the local butcher, being parentally suspicious of the young Spencers' interest in his daughters.

Stanley's patron had evidently asked for a drawing showing the love of a prince for a fairy. His method of imagining it was to assemble from his own experience images with which he could reproduce the emotion of that theme. The prince was in love with his fairy; he, Stanley, was in love with Dot. So he simply draws her in the situation, buoyant and beautiful because she is loved. The fact that she would sink like a stone was irrelevant: to Stanley the reality of the imagery is subservient to its emotion. However, Stanley admits that the fairy would be small, so he diminishes her by extending the wheat-stalks on the left. There would be water, so what better location than one eventful in his boyhood memory, a little sandy beach by the bank of the Thames where, Florence

* Stanley's record sheet at the Slade shows only two awards, one minor (see Chapter 4) and one major (Chapter 5).[3]

tells us, all the Spencer children loved to play when young. Simple, one might say, almost 'primitive'.

But there is in the drawing a curious detail. In the top left, three flowers or marsh plants are reflected as though on the surface of a pond. In many future paintings we shall find similar detail inserted apparently randomly. Yet its presence can change the entire emphasis of the work. In this case, it suggests that Stanley has turned the smooth surface of the pond from the horizontal to the vertical, so that it becomes a reflecting plate-glass window. The world beyond it is enchanted, its apprehension as intangible as the world Stanley entered when he heard fine music played; the flower reflections have taken the form of musical crochets. The fairy is an emanation from that world, but when the magic ends must return to it. The prince, being of the 'real' world, cannot enter that land. Stanley ruefully confesses in his letters that he never had great success with the village girls – 'buds' to him – and his anticipation at walking and talking with them was invariably disappointed when they failed to match his soaring expectations. Still, he was asked for a drawing of love, and so his love for Dot, which is the love of the prince for the fairy, which is the theme of love in the drawing, becomes a transcendence of the physical into that magic state Stanley cannot yet attain but which he knows to be the spiritual, 'heaven'.

The authoress rejected the drawing. Its heavy, earthy presentation failed to meet the ethereal romanticism she evidently expected. She must have been as puzzled and offended by it as Stanley was puzzled and disappointed at its rejection. The two minds simply did not meet. In July 1919 he gave it as a wedding present to Ruth Lowy, whose family lived near Cookham. She and Stanley often travelled together on the train to London and the Slade, and she had bought some of his early work. Neither Ruth nor her husband, Victor Gollancz, could understand why Stanley had selected it as a gift. They asked him what it meant. Stanley was again disappointed. It did not, he told Gollancz, mean anything: 'I do not know that my picture is called anything. The lady on the waterlily leaf is a fairy if you please, and of course the boy on the bank is Edmunds, but honestly I do not know what the picture is all about. You might give the persons depicted a different name for every day in the week with special names for High days and

Holidays.'[5] 'I was loving something desperately,' he was to say of these years, 'but what this was I had not the least idea. I took the first thing I came to and proceeded to draw it.' His drawing, an honouring of the dawning in his awareness of the miracle of love, derived from deep personal feeling, still unclarified. He meant the figures to be universal. Was this not apparent? Did he really have to spell it out? How could he?

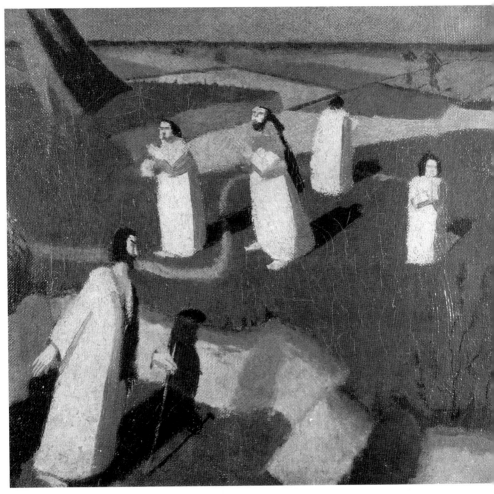

John Donne Arriving in Heaven

John Donne Arriving in Heaven

God will speak unto me, in that voice and in that
way, which I am most delighted with and hearken
most to. If I be covetous, God will tell me that heaven
is a pearl, a treasure. If cheerful and affected with
mirth, that heaven is all joy. If sociable and convers-
able, that it is a communion of saints.

John Donne: *Sermon CXX*, preached at St Paul's.[1]

IT IS NOW 1911. Two Stanleys are emerging. The Stanley in
the tangible world is exploring. His schooling, his reading, his
discussions, particularly with his sisters as teachers and with his
brother Sydney, begin to reveal that world to him at the physical
level. The embryonic world-space of childhood Fernlea extends to
the wider geography of Cookham village. The magic for Stanley
of the one pervades the other. The cowls of the malthouses behind
Fernlea rotate in the wind like the eyes of God. The blacksmith's
anvil rings like the cries of the damned in Dante's *Inferno*. Known
possessions of villagers, once treasured, appear miraculously as
discards on the village rubbish heap. Builders mysteriously carry
ladders to unseen destinations. Swans are caught, carpet-bagged
for their annual marking, and trundled astonishingly down the
High Street in wheelbarrows. Summer steam-launches disgorge
hordes of excursionists on to the riverside lawns of the Ferry Hotel,
beings as remote to Stanley as those who come for the annual
regatta, effete young sprigs in boaters and blazers who lose their
punt poles in the river, or fiercely athletic men who swim and row,
both with elegant women in tow, whose new, less corseted Paris
fashions startle: 'In Cookham the idle rich have been having some
sort of competition for the best bosoms and busts. Ladies patrol
the streets boneless utterly. There is one thing, they keep the dogs
from barking.'[2]

His family-feeling, the reciprocity of home, is tentatively projected outwards to the places and people of Cookham. The places become inwardly, privately, his. But many of the people are too individualistic to be absorbed. Sometimes he achieves response from them, often not. He views them occasionally with passion, frequently only in amusement or sardonically. If they are to be absorbed, they must die for him in their material form and be reborn as emanations from the place-meanings Cookham holds for him.

Places in Cookham mean specific spots – meadows, riverbanks, trackways, copses – in which he finds, or suddenly found, an ecstasy of sensation. He does not know why they bring such ecstasy, he only knows the sensation to be joyous and to spark creativity.

We swim and look at the bank over the rushes. I swim right in the pathway of sunlight. I go home to breakfast thinking as I go of the beautiful wholeness of the day. During the morning I am visited, and walk about being in that visitation. Now everything seems more definite and to put on a new meaning and freshness. In the afternoon I set my work out and begin my picture. I leave off at dusk, fully delighted with the spiritual labour I have done.[3]

Always the drawing came first. When he begins at last to paint – *Two Girls and a Beehive* (1910) is thought to be his first – he sometimes makes a preliminary wash to test the compositional effect. Then he often measures a pencil grid across the drawing with draughtsman's exactitude. He covers the canvas with the equivalent grid scaled up and sketches the outlines of the drawing in their co-ordinated positions on the canvas. Working usually from one side or corner, he almost blocks in the paint to create solidity of form. In early paintings the paint is applied thickly, but later, in the heat of passion, sometimes so thinly that the underlying outline shows through or is reinforced. Oil was his favoured medium. He was virtually self-taught in its use, and later claimed that at the Slade he was given only three or so days' painting tuition, working on a single model: 'three days out of four years!'

After Will's breakdown Ma won the right to promote her values rather than Pa's in the upbringing of the youngest sons. She liked

them to accompany her to Sunday worship in the village Methodist chapel. As the boys grew older, the fundamentalist nature of the chapel worship failed to provide the richer fare they needed. Stanley, on the road to discovering his 'metaphysicals', as Gilbert called them, pleads for help from Gwen:

You must understand that I have had a thorough grounding in Wesleyan Methodism. I have listened to a thousand sermons and would like something to counterbalance this. I would like to read about St Francis and St Thomas Aquinas. I have come out of the Chapel sometimes shaking with emotion. Gil and I used to get so excited that we could not face the prayer-meeting. By the time I had reached the prayer-meeting pitch I felt I was ready to break down. The end of the prayer-meeting was ghastly always, a man would say in a whisper: 'Is there any poor wandering soul here tonight who has not heard the call of Jesus? He is passing by, passing by . . .' A long pause. Of course, I used to feel that I had done wrong in not going up to the stand to acknowledge my conversion, as you are supposed to do. . . . About this there was a wretched clammy atmosphere, and it used to get well hold of you, and it has not gone yet.[4]

Among the books Gwen lent him was a selection of John Donne's *Sermons*. Stanley could not grasp all their meaning, but was excited by a glimpse of spiritual nourishment which seemed to him to exceed the doctrinal exhortation which had been his gruel till then. The earthly joy his Cookham-feelings gave him must, he thought, be equations of the eternal joy which is the Christian celebration of heaven. Those places in Cookham which are associated with such joy must therefore be 'holy'.

Widbrook Common is, Florence tells us, the heaven which John Donne approaches in Stanley's next major painting, *John Donne Arriving in Heaven*. Reading John Donne, Stanley seemed 'to get an impression of a side view of Heaven as I imagined it to be, and from that thought [fell] to imagining how people behaved there. . . . As I was thinking like this I seemed to see four people praying in different directions.'[5] In the painting, heaven becomes an infinity in which the saints are placed in a compositional balance which reflects exactness of feeling.* The Common was a favourite

* Stanley's imaginative and highly personal use of Donne's metaphysic in this painting is striking. The reference is evidently to a passage in Sermon LXVI: 'As my soul shall not go towards heaven, but

picnic spot of the Spencers and well worth the walk there, even on a hot day, as Florence recounts:

Sutton Road [the main road towards Maidenhead from the 'east end' of the village] was an alleyed shadeless desert which must be traversed if one would win through to Widbrook Common, loveliest of commons, and when in the course of time . . . at Cliveden the old Duke of Westminster was succeeded by a gentleman named Waldorf Astor, the pilgrimage to Widbrook on hot summer days became well-nigh intolerable . . . for he stretched a glaring brick wall, of immense height it seemed to us, surmounted by broken glass, along Sutton Road, blotting out the view of Cliveden Woods which had until then helped our journey along. Mr Astor, familiarly known to us as Mr Walled-off Astor, was afraid, we were told, that his son would be kidnapped . . . perfectly preposterous in the familiar Cookham of our hearts.[7]

The wall must still be 'traversed' if one wishes to reach Widbrook Common, now a nature reserve. But the Common has no cliffs. These, Florence tells us, are derived from the same Thames river-bank which appeared in *The Fairy on the Waterlily Leaf*. Since the two are geographically distant, Stanley is not being illustrative. He is not saying, 'I see Widbrook Common as heaven.' Instead he is assembling from his experience places in which he had mysteriously felt the sanctity of ecstasy, and is collaging or conjoining them to convey a feeling or concept of heaven. The places are not intended as symbolic or universal. They have no meaning outside his experience of them. He presumes we all have such places in our memories which evoke similar feelings for us, and that we are able to recognize that those he shows in his painting are but signposts to personal feeling. It is that feeling which he is trying to capture and to universalize.

Stanley presented his painting at the Slade for comment. It did not please Tonks, but it came to the attention of Clive Bell, who was setting up with Roger Fry the second of the two seminal

go by heaven to heaven, to the heaven of heavens, so the true joy in a good soul in this world is the very joy of heaven'.[6] Donne's argument, as in the epigraph of this chapter, that occasions we experience as natural in joy or happiness in this life are moments of heaven by which we fuse into an ultimate heaven, impressed Stanley. It became a cornerstone of much of his outlook, and in commenting on the participants in his final painting, *Christ Preaching at Cookham Regatta*, he will stress the nature of their joy by paraphrasing Donne.

post-impressionist exhibitions of those years in London. The first, in 1910 at the Grafton Galleries, had burst like a bombshell on a largely insular British public, creating a furore and dividing the art establishment into the reactionary and the progressive. Bell selected Stanley's painting for inclusion in the 1912 exhibition also at the Grafton Galleries where in the English section it was hung with works by Wyndham Lewis, Duncan Grant, Vanessa Bell, Henry Lamb and Roger Fry to match the corresponding works of Cézanne, Gauguin, Matisse, Picasso, and Kandinsky in the Octagon. Critics, viewing it, suggested that it indicated Stanley's endorsement of post-impressionism. Some pronounced that he had not got it quite right.[8]

Once again Stanley was flummoxed. Others were defining his work by standards which had no meaning for him. The classifications of critics or art historians were their invention, not his. Stanley could be representative in so far as he took imagery from the real world; visionary in so far as he arranged it on the canvas in unexpected, often subconscious, juxtapositions; expressionist in so far as his aim was to convey personal emotion; symbolist in so far as he cast certain experiences in images which he will repeat as visual shorthand, and imitative in that he sought a visual style of the representational which, whether by instinct or example, came close in his early works to matching the attributes of impressionism. One such invoked the use of colour to replace the normal light and dark of shadow and sunlight, so that at its most exciting impressionist painting appears shadowless, its detail diffused not by light and shade but by luminous colour. In *John Donne Arriving in Heaven* Stanley used diffused colour in this way – except that he also inserted a sunlight which is fiercely low and hard, throwing pronounced shadows. Why? No doubt because he needed a device like the reflected flowers of *The Fairy on the Waterlily Leaf* to point up an emotion in the painting which was of importance to him. The strongest shadow, that of John Donne himself, zigzags to emphasize the verticality of the riverbank. The cliffs could be barriers. John Donne can see heaven beyond them, but he has not yet attained it. He is, writes Stanley, 'walking alongside Heaven'; as, we may assume, was Stanley himself as he quietly read Donne's sermons and poetry.*

* In the collection of Stanley's drawings held in the Tate Archive is a drawing which shows a similar

It is at this point that Stanley departs from post-impressionism. In its perfect forms such painting deliberately avoids kinesis, drama, the sense of the onward march of events. It asks no questions, suggests no answers. It may portray activity, even action, but seldom intent. Each picture is a snapshot of a moment caught with subtlety but without regard for past or future. Respectful though Stanley was of the intensity of its concentration, such stasis could never fully satisfy a young explorer desperate in a sensed world of miracles and mystery to record his moments of discovery and illumination.

John Donne Arriving in Heaven is a totality which celebrates the excitement Stanley feels in journeying towards a concept of joy he knows exists. But in detail he is still a novice struggling through music and literature to master truths which, if they ever come to him on earth, will do so only through time and experience.

scene as a flat promontory with steep cliffs to the right and a figure climbing upwards.[9] The idea of a cliff as a barrier could be derived from Stanley's childhood memories of being lowered by Annie or Florence to play by the Thames, so that he could not climb back up. On being lifted back, the expanse of Bellrope Meadow with its profusion of wildflowers would suddenly come into view; an apparition of 'heaven'.[10] Widbrook Common being another childhood 'heaven' for Stanley, he has simply linked the emotion of the one association to the other. Referring later to the picture, he described it as a 'nowhere picture'.[11] Geographically, the setting is part of Widbrook Common,[12] but in its totality, the emotion is 'nowhere'.

Apple Gatherers

> All my life I have been impressed with the idea of
> emergence – a train coming out of a tunnel, for
> instance.
>
> Stanley Spencer[1]

OUTSIDE COOKHAM – in London, at the Slade, in Taunton –
Stanley was the visitor, observing. But within Cookham he was
emotionally the lover, absorbing: 'I liked to take my thoughts for
a walk and marry them to some place in Cookham,'[2] he was to
say years later of his adolescence. When the place in question
became sufficiently 'holy', Stanley's 'marriage' could be almost
literal, as he confessed in 1912 to Gwen Darwin: 'I never want to
leave Cookham. . . . I have taken some compositions [drawings]
to a little place I know' – it was off Mill Lane – 'and buried them
in the earth there.'[3] Gilbert remembered that Stanley had been
reading Thomas Browne's metaphysical *Urn Burial*. Stanley told
Florence that he put his drawings into a tin 'and while I go up and
down to London, I often think of them. This is sentimental, but it
does not matter. I shall go on being so. This is all very confidential,
mind.' It had to be so because his Slade fellow-students would have
ragged him unmercifully had they known.

Gwen understood. Years later she too was to describe her own
childhood feelings for, of all things, the cobbles of her grandfather
Charles Darwin's patio:

To us children everything at Down was perfect. . . . all the flowers that
grew at Down were beautiful; and different from all other flowers.
Everything was different. And better.

For instance, the path in front of the verandah was made of large round
water-worn pebbles, from some beach. They were not loose, but stuck
down tight in moss and sand, and they were black and shiny, as if they

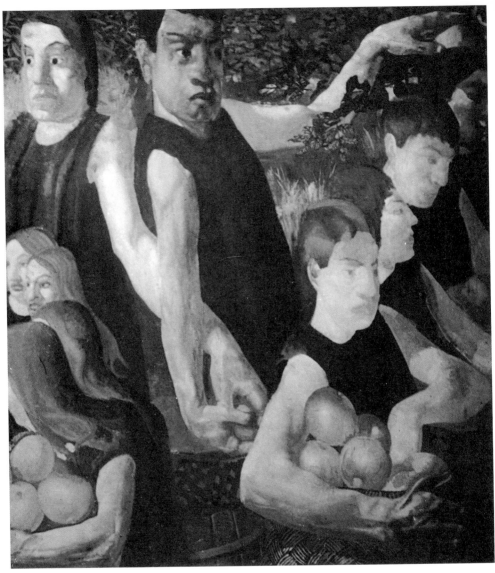

Apple Gatherers (detail; reproduced in full in colour)

had been polished. I adored those pebbles. I mean, literally adored; worshipped. This passion made me feel quite sick sometimes.[4]

At this probationary period in his creativity, Stanley was instinctively circumspect. Perhaps in his day and milieu there was less temptation than today to reject imbibed precepts. In any case, his innate caution would have inhibited rebellion. His mind worked

associatively forward from received experience. Thus in disowning the 'clammy atmosphere' of his Methodist prayer-meeting he was not dismissing the basic assumptions of orthodox Christianity, but trying to reconcile them with some wider concept he was sensing. Such accretion of new experience to old expanded both. So the encompassing instinct implanted in him – the desire to absorb himself into the being of all around him – must be capable of such transcendence, and such was his approach to *Apple Gatherers,* painted during the Christmas – New Year vacation of 1911 – 12.[5]

The title had earlier been set as subject for a Slade Sketch Club competition and Stanley developed the painting from his drawing for the competition.* He began it at Fernlea, but when the house became crowded over Christmas, Gilbert records that he then used the empty Ship Inn, a cottage at the head of Mill Lane, once a tavern. Oddly enough, among the debris there were piles of stored apple trays. Sydney was fascinated to recount Stanley's progress in his diary:

We had a kick or two with the football in Marsh Meadows and then went to Maidenhead to Miss Heybourne's where Stan made purchases for his painting, I paying as his Christmas present. (2 January 1912)

Stan got on very well with his painting. The group seems to be more substantial, more at one with itself than it was. He has covered the neck of the lowest figure with a long curl which has redeemed the head to my fancy. (4 January 1912)

Stan is now engaged on the head of the chief woman figure in the painting. (5 January 1912)

Stan is now on the heads of the four men. He takes his own mouth in the mirror as a copy. Stan's arm for the woman, too. (6 January 1912)

'Stan' was still working on it on 21 January, although by then it was nearing completion. Gilbert later asserted that Stanley painted it over a Resurrection he had done, and subsequent tests have substantiated that this must have been so.[6]

* It was probably this drawing which won Stanley one of his two Slade prizes, a £2 share in the Melville Nettleship Composition Prize of 1911.

With so many of the Slade competitions being set on biblical themes, one might expect that the phrase 'apple gatherers' would bring to Stanley's mind the story of Adam and Eve in the Garden of Eden. But, however associative the topic, Stanley had no wish to be so obvious in his rendering: 'there is no symbolic meaning whatever intended in *The Apple Gatherers*, and I cannot account for the fact that I have divided the sexes in the picture.'[7] No Adam and Eve, no Garden of Eden, no biblical literalness. The Bible was allegory of great truth, but Cookham too was such a book if its pages were read with vision. Adam and Eve, the male and female in Creation, the apple, the seed. If the questioning of God and man's subsequent disobedience led to knowledge of good and evil and a feeling of estrangement from God expressed in prudery, could it not be that the purpose of sexuality was to bring humanity back to God? When all Stanley's Cookham-feelings drove him to that conclusion, how could he use traditional imagery? He would trust his own feelings: were they too not God-given?

From a place in Cookham he would personify his feelings, embody them in visual manifestation: 'I wanted to see the beings that certain places would of their own spiritual essence bring forth. . . . I wanted the persons in the picture to continue without interruption what the place had begun in my mind and for them to be the material outcome of the place.'[8] The place he chose was 'a place on Odney Common where looking towards a grassy bank towards Mill Lane I had the feeling for that picture'. The spot had no orchard, so it 'was not in my picture at all; it was the place I thought about because it seemed to bring the thought of this picture in my mind. It helped me to the frame of mind to produce this idea.'

Stanley simply transferred the place-feeling, as he had done with the river bank and Widbrook Common in *John Donne Arriving in Heaven*, to a known orchard, in this case one which grew in a garden beyond Fernlea, and painted that. Such transferences of associated feelings characterize all Stanley's work. Again it is the emotion which he wished to universalize: 'It is significant to me that in my early religious pictures done at a time when I was innocent I wanted to include in the concept the idea of men and women. I think the *Apple Gatherers* does say something of the fact of men and women, something that does go past and beyond the

usual conceptions to whatever the relationship is.'[9]

The figures in the painting are not merely expressing a discovery of erotic awareness. They are expressing Stanley's nascent comprehension that the purpose of the representation of males and females in his painting would be to come together in 'fusion', and thereby to celebrate the unity which was beginning to mean for Stanley an unfolding of the 'identity' of God. Why God should appear in disparate form as male and female was to Stanley a mystery. He could not accept that any division was connected with concepts of guilt or sin or punishment or banishment or the wrath of God.* To Stanley the miracle was that our instincts impel us to attempt a reconstitution of the original and ultimate unity, the Alpha and Omega. No wonder the figures in his painting are hesitant! They are being born of Creation. They see God.

In a letter of the time to his fellow-student Jacques Raverat, Stanley told him that *Apple Gatherers* was as significant in his thinking as Jacques' own painting *The Dancers* was in his. Jacques Raverat, six years older than Stanley, was the son of a French businessman at Le Havre who combined intellectualism with a worthy propensity for making money. The latter gained him an elegant estate in Burgundy, the Château de Vienne at Prunoy; the former persuaded him to send Jacques for a liberal English education at the progressive Bedales School near Petersfield. First at the Sorbonne and then at Cambridge Jacques read mathematics, became a stalwart of the Rupert Brooke circle, and met Gwen Darwin. Gwen's interest in art led her determinedly to the Slade in 1908 in the same student intake, as we have seen, as Stanley. A recurring illness first manifest in 1907 persuaded Jacques that his true interest also lay in art, and in the spring of 1910 he too joined the Slade. While there he and Gwen married in June 1911. Perhaps Stanley had been a little adoring of Jacques' bride:

C-o-n-g-r-a-t-u-l-a-t-i-o-n-s! As soon as you have more babies than you want, you might give me one. Must have a wife before you can have a

* Stanley came to see the 'essential human being' as 'a gentle, peace-loving, creative, sexual being. Extreme suppression and control cause him to be greedy, inconsiderate and untruthful rather than martyr to some artificial code or rule. Absence of protection from attack causes him to be violent and warlike. But it is not his essential character or nature . . . He is trying to bring about a protected state in which he will not need to fear being disturbed or taken by surprise.'

Jacques Raverat, about 1912

baby. Rotten, I call it. I used to have to eat my bread and butter before I could have my cake. Same thing. I don't think there is any just cause or impediment why you two should not be joined together in holy matrimony, but you might have let me know earlier. My God, if I'd heard the banns . . .![10]

Honeymooning in France, they sent him a 'having-a-marvellous-time-hope-to-see-you-soon' postcard.*[11]

* On a visit to Florence the Raverats met André Gide. They become close friends, Gide often staying with them when he came to London (they had set up home in Croydon).[12] Among his other interests, Gide was a literary editor of the major *Nouvelle Revue Française*. Later he became an advocate for Proust, and was influential in getting much of his work published.

Apple Gatherers

Unlike the free wild creatures of Jacques' *The Dancers*, leaping Matisse-like on some ethereal shore, the figures of Stanley's painting are contemplative, tremulous. Like Stanley himself, the figures stand on the threshold of a wild discovery and are amazed.* When the painting was later exhibited, Stanley was disconcerted to find its theme interpreted as a portrayal of sexual attraction. But to him this was neither its prime intent nor an aspect he wished emphasized. He wanted to 'go past and beyond usual conceptions'. Why then, his critics argued, show the sexes separate? Again Stanley was baffled. He could 'not account for the fact that I have divided the sexes in the picture.' Of course he could not. If he showed them separate, that was because they were posed in the only way he could as yet manage; for in the sublimity to which he aspired he had as yet no experience of the sexual 'fusion' whose meaning he was struggling to understand. If his admirers could not grasp from his painting what he was trying to say, then there was little he could do to help them: 'I feel rather like the young man who when he thinks his girl is admiring his thoughts and ideas and feelings finds that it is the way his hair curls which is the real attraction.'[14]

But to those like the Raverats who genuinely understood, Stanley's joy in his painting was incontestable:

The picture was the first ambitious work, and I have in it wished to say what life was. . . . I felt a need for my religious experience expressed in earlier paintings to include *all* that was a happy experience for me. One can't, I know, make endearing remarks to a canvas before you begin to paint on it, but I felt I could kiss the canvas all over just as I began to paint my apple picture on it.[15]

* Examining himself in 1942 with the intention of "investigating" the meaning behind his paintings, Stanley told himself that "I love the sex feeling (Apple Gatherers), but it must not be allowed to force the pace of this investigation into the matter of what these human beings are".[13]

The Nativity

Study me then you who shall lovers be
At the next world, that is, at the next Spring,
For I am every dead thing
In whom Love wrought new Alchemy.

John Donne: *Poems*[1]

ONCE POSSESSED of an overpowering idea, Stanley would all his life tenaciously worry its development through a succession of paintings. The desperate desire to resolve the paradox of duality became spiritual in *Apple Gatherers*. In *The Nativity*, also painted in 1912, the longing became religious.

If from the title we expect a conventional interpretation, we shall be surprised. Stanley is a will-o'-the-wisp who leads us unsuspectingly into what we think is familiar territory only, Puck-like, magically to change our surroundings, so that we stand bewildered, disturbed, abandoned, even resentful, according to our preconceptions.

What is it in his painting which so suddenly changes terrain we thought we knew? It is his *composition*, the transformation of content into visual presentation, which disorientates us, so that only slowly and perhaps incredulously do we begin to find our bearings. Many, in Stanley's day, never found them, and simply relished the surprise. The message, to his chagrin, was all too often dismissed or devalued.

In his *Nativity*, the three Wise Men have come to visit. They are presented thus in a preliminary drawing. But now two of the Magi have become, surprisingly, the males of two pairs of lovers who meet as the emotional focus of the composition. The third remains a kneeling worshipper. The lovers are absorbed in each other and are oblivious to the presence of the Holy Family. This is not

36

The Nativity

unexpected in view of the fact that Stanley intended the Holy Family to be not a tangible presence in Mill Lane, but visual imagery to convey his awed sense of sanctified discovery. Joseph, the figure on the right of the painting, is portrayed not in the manner of most traditional Nativities as the remarried widower of legend, an old man past sexual capability, but as a virile and romantic young man in a blue Botticelli robe, 'doing something to a chestnut tree'.*

Despite this, the tree is in blossom, not fruit. The imagery is of

* Looking back at the picture in 1942, Stanley wrote: 'The Couple [the main lovers] occupy the centre of the picture. They are in direct contact and direct consciousness with each other, but in the form of Joseph who is on the extreme right doing something to a chestnut tree and Mary who stands by the manger, they appear in their relationship with the elements quality [of the composition], so that to the couple in contact with each other Mary seems like some preponderating element of life, just another big fact of nature such as a tree or waterfall or field or river. Joseph is only related to Mary through some sacramental ordinance and, using the simile of an element, as a quite different element from her.'[2] Stanley's 'Couple' concept is developed in Chapter 37. Andrew Causey sees in Stanley's figure of Joseph 'a reverse image of Botticelli's Mercury in *Primavera*'.[3] Mario Sidoli has compared the figure to that of Joseph picking fruit in Gerard David's *Flight Into Egypt*.[4] Stanley's habit of reversing remembered images persists in his work.

the new life of spring; hardly relevant to a traditional Christmas scene. Precisely what Joseph is doing to the chestnut tree is left to conjecture, but his young thoughts are perhaps linked imaginatively to the erect chestnut candles with which it is girdled. Contrary to orthodox religious interpretations, it is suggested that he has every reason to be suffering sexual frustration. Mary, although a mother and his wife, is still a virgin. God has chosen her over Joseph's head to become the link with the coming of creativity, a prodigious role in which he, Joseph – Stanley – has as yet no part.

Joseph is thus separated from Mary, who stands full in the centre of the painting, large, sombre-robed, almost masculine in appearance. Amy Hatch, another 'cousin' of Stanley's, posed for her. She must, like Dorothy Wooster, have been a sturdy girl. 'Monumental' is Stanley's own adjective for her in the painting, meaning that like a monument in a public place she is unnoticed by those who pass preoccupied. A miracle has been bestowed on her. Its physical form lies in the crib at her feet, added according to Stanley as 'an afterthought'. For of course her concern in Stanley's presentation is not so much with the child as with the wider meaning of creation, that which lies beyond the fence, the world where flesh-and-blood lovers meet in mutual delight. A separation – that of unfulfilment – exists between Mary and her spouse, and there is a division – the fence, the barrier of inaccessibility – between them as spiritual manifestations and the real world. Florence wrote:

neither is it strange that the grandchildren of a builder who was also a fine musician should have been consciously or subconsciously interested in the structural significance of walls and fugues. Cowls, walls and railings have from the first, I think, provided the fugue subjects of many of their works; the cowls, walls and railings which absently focussed our attention as children and about which as children our first thoughts and impressions played.[5]

Like Mary in the painting, Stanley is gazing in wonder and longing at those who are about to enter a comprehension of the renewal of creation as experienced on earth. Indeed, the pairs of lovers may be drawn from Stanley's feelings when Will or Harold or Florence married; the emotional amputation of departing siblings is

a common enough experience in families. Rapt in the adoration of their beloveds, the Wise Men who came to see the birth of God have in that miracle become themselves part of the perennial birth of God, and advance to affirm the universal sacrament of life. Beyond them, in the background field, sheaves of corn seem stooked at harvest. Beyond again are the trees of Cliveden Woods, some of which seem to be turning into autumn brown. Perspective has become a series of compositional waves. Each wave is a season. A fourth dimension has been added to the canvas. Time itself has been compressed.

The secret of the painting stands revealed. It is a hymn to fecundity, to the compulsion and universality of the sexual instinct in its broadest concept, to that miraculousness of the process of creation which humanity has always seen as holy. Mary and Joseph are not simplistically the figures of accepted recognition, nor are the pairs of lovers those of poetic romance. The whole must be God. Mary and Joseph are primal figures dressed in Christian symbolism whose profoundest meanings go back beyond their own time, past the known gods of old, back to our earliest awareness of the sources of our existence and our survival.

The figures in Stanley's paintings are symbols of our primeval consciousness, of the thrust of male fertility and of the protectiveness of female parturition; the duality of fecundity. In his struggle to understand, Stanley is returning to a literal beginning, to the implications of his earlier reading, for example, of *The Golden Bough*, to the 'embryonic fish' of his contemporary Wyndham Lewis, to the understanding which was to obsess another young genius of his generation, D. H. Lawrence, however differently expressed. In the painting, Stanley tells us, Mary and Joseph are 'related in some sacramental ordinance'. It is as yet beyond his comprehension. Stanley is still physically Joseph, virginal, restricted in experience to 'doing something to a chestnut tree'. Yet in some spiritual sense, glimpsed if unrealized, he is also Mary, the mother who is fulfilled in that ultimate act of creation, the birth of God. Stanley's inability to resolve the dichotomy troubles him. He is as yet a child in comprehension, relegated to a crib (an 'afterthought') at the feet of the majesty of creation. 'The painting', wrote Stanley, 'celebrates my marriage to the Cookham wildflowers.'[6]

There were some who glimpsed his meaning, but few who might

have felt the power of what he was trying to say, and fewer still who would have sympathized. To the devout of the day he was toying dangerously with the pagan sources of Christianity. Yet to him the apparent unchangingness of Cookham was becoming revealed as the everlasting rhythm of the mystery of death and rebirth, of the miracle of the emergence of exquisite form from meaningless chaos, of the marvel of that gift given him to fashion into art – into 'compositions' – the random chess or domino or draughts pieces which the world of the senses emptied into his brain. The same forces which compelled Cookham into the renewal of spring were those which moved his hands into creativity and his spirit into ecstasy. He and Cookham were united by that force, 'married', so that creation – birth – emerged from disorder – death – in each.

Spanning the two was the seed. In front of the kneeling Wise Man in *The Nativity* a plant grows, its pattern boldly shadowing him to draw our attention to it. It is apparently a sunflower, that traditional symbol which will appear in future paintings of Stanley's as the promise of seedburst to come. As Stanley wandered enraptured among the wildflowers of the Cookham water-meadows, blossoming then in uncontrolled profusion, he was overcome not only by an aesthetic beauty he would glorify in later landscapes and still-lifes, but by an awe of their greater role as silent witnesses to the compulsion of fecundity. Like a woman adorned for her lover, each flower flaunted its beauty as sexual invitation, honouring its instinctive purpose as the provider of the seed for future life. The seed was in Stanley himself too, as it was in all animate things, in the men, women, girls, babies, trees, flowers, corn, lambs or beehives of his early compositions. As an animate thing it had been nurtured into existence through what scientifically might be called a 'conducive environment', but which to Stanley was the protection, the security, the peace, the 'cosiness' of its 'home'. Thereby it had been brought to its power of fertiliz-ation, the token of an ultimate fulfilment dedicated beyond any urge of immediate satisfaction to the compulsion of rebirth, the cosmic coming-together of male and female elements, the drive of creation. That above all was inevitable and holy, and each of us is a priest in worship. It is surely no coincidence that most of Stanley's early paintings are set in spring or summer, and show meetings,

conjoinings or emergences. The exhortations of John Ruskin have Stanley as firmly in their grip as earlier they had held Proust and Tolstoy.*

Stanley's painting won the Summer Picture Figure Composition Prize of £25 which was shared with a fellow-student. It still hangs today in University College, London.

* 'John Ruskin, although a bore and generally wrong, said some fine things.'[7]

Self-Portrait

Self-Portrait, 1914

All original artists, I am certain, have always worked
without reference to their work's effect on spectators
other than themselves; and they have always assumed
that their work has intrinsic value when they them-
selves have honestly and competently passed it as
exactly the thing which they had set out to do.

R. H. Wilenski: Preface to
The Modern Movement in Art, 1927[1]

I have just bought Cookham's great picture of the *Apple Gatherers*. I
can't bring myself to acquiesce in the false proportions, although in every
other respect I think it's magnificent. I've made great friends with him, I
went down to the place Cookham two Sundays ago and spent the
afternoon in the pullulating bosom of his family. There are too many of
them, six out of nine were there, beside the parent-birds, and they are
very gregarious, so I never got Stanley to myself; but it was an amusing
experience.[2]

THE LETTER-WRITER was Edward Marsh, scholar, wit, man-
about-town, patron of up-coming artists and poets, and at the time
private secretary to Winston Churchill. The letter was to Rupert
Brooke, then (1913) travelling in America and the Pacific:

The father is a remarkable old man still in his early middle age at about
70 – very clever but – I beg his pardon, I mean 'and' – a tremendous
talker, and frightfully pleased with himself, his paternity, his bicycling,
his opinions, his knowledge, his ignorance – due to the limitations of his
fatherhood of nine – his radicalism and everything that is his. . . . Gilbert
is an artist too but only six months since. Stan had only about two things
to show, he does work slowly.

43

Until the 1910 and 1912 London exhibitions of post-impressionist paintings, picture collecting had been largely confined to the purchase of traditional Victorian themes or the resale of Old Masters. But now a fashionable interest was developing among progressive connoisseurs in acquiring the work of young British painters, an interest encouraged by the more enlightened London galleries, by the formation of new groups of artists such as the London Group or the New English Art Club, and by the coming together in loose assemblies of intellectuals and aesthetes. Such an assembly was the celebrated Bloomsbury Group, one venue for which was the Bedford Square home of the startling Lady Ottoline Morrell. The Contemporary Arts Society, formed by Lady Ottoline and Roger Fry in 1910 to acquire the work of up-and-coming artists for national collections, was a product of the new outlook.

Not all the collectors were wealthy enough to indulge their enthusiasm at will. Some, like the 'prodigal collector' Michael Sadler, who had been Steward of Christ Church, Oxford, in the days when the Reverend C. L. Dodgson — Lewis Carroll — had been a tiresome Curator of the Common Room, and who was now Chancellor of Leeds University, had to restrict their collecting to the use of such cash as they could raise extra to their emoluments. Edward Marsh was one of these. Although not at all wealthy, he was the recipient in addition to his salary of a fossil pension which had unexpectedly descended to him from a 'mad aunt' and which was paid periodically on account of a distant forebear, the Prime Minister Spencer Perceval, assassinated in the House of Commons in 1812. This surprising bounty was used by Marsh to buy paintings, originally the conventional old masters, but now from 'all those bloody artists' as Rupert Brooke described them.*

Stanley was encouraged to display *Apple Gatherers* at the Contemporary Arts Society's summer exhibition of 1913 at the Goupil Galleries — the galleries in which the young Vincent van Gogh had once worked as an assistant. The significance of the painting was quickly spotted. Among the visitors was the painter Henry Lamb, then twenty-eight or so, who wrote to congratulate Stanley. The

* 'I hate you lavishing all your mad aunt's money on these bloody artists. Don't forget those woodcuts of Gwen's [Raverat] you were going to buy.'[3] Brooke was probably being facetious. Although he had not yet met Stanley, he had been an early admirer of his work and had already published an appreciation in the *Cambridge Review*.

Gauguinesque influence in the painting appealed to Lamb, whose own work, particularly of Breton fisher-folk, was perhaps similar in style. He was a fringe member of the Bloomsbury Group at the time that Clive Bell was acting as buyer for the Contemporary Arts Society. Lamb and others confidently expected that Bell would agree to the purchase of Stanley's painting for £100, wealth to the young artist. But Bell, obsessed with his art theories, vetoed the purchase.* There was consternation at the decision, and Lamb was so incensed on Stanley's behalf that although by then painting in the west of Ireland he wrote to offer £30. Sydney recounts in his diary the family delight: 'Stan corroborated the happy news that Florence brought me last night. He has had an offer of £30 for his picture the *Apple Gatherers* from a Mr Lamb. I am so glad about this.'⁴

Stanley had not yet met Lamb and knew little of him or the intrigues about the painting. So he not unnaturally assumed that Lamb had offered the £30 because he admired the painting; which he did, but this was not the reason for the offer. Lamb felt that an injustice had been done to a young and worthwhile painter. Although he could ill afford the £30, he ventured on the purchase because he was convinced he could resell the painting at a higher price and thereby blaze abroad the obtuseness of a self-appointed arbiter of taste. In much the same way he had taken up public cudgels the previous year in a battle with French officialdom to support young Jacob Epstein's controversial tomb in Paris of Oscar Wilde.

Stanley delivered the canvas on 3 November to Lamb's London studio at the Vale of Health Hotel, characteristically insisting on precise details of how to get there.⁵ The Vale of Health had been developed in a restful hollow of Hampstead Heath – Leigh Hunt had once lived there and the young Keats wrote poetry there – and the subsequent hotel included artists' studios arranged in pairs each side of a central staircase. Lamb's was on the third floor.

* This despite Lytton Strachey's advice that he should buy it. In the opinion of many of the Bloomsberries – Clive Bell, Roger Fry, Duncan Grant – an original work of art could only *acquire* value. The acquisition of value depended on its ability to evoke emotion in the spectator. The criterion of such ability could only be its form – 'significant form' – because the artist's originating emotion was not normally available to the spectator in making an assessment. This outlook was challenged by Wilenski and others who argued that throughout history the function of art had been to universalize experience, and in that function a work of art had an *intrinsic* value independent of the spectator's immediate assessment.

Outside, lawn terraces overlooked the Heath and a small lake, a scene which forms the view through the window in Lamb's celebrated portrait of Lytton Strachey.[6] However, it was not long before Londoners discovered the hotel's position on the edge of 'Appy 'Ampstead 'Eath and turned it into a holiday pub with a funfair adjacent and drunken fighting at closing time.

None of this troubled the steely and imperturbable Lamb, who reported to friends his first meeting with Stanley with a mixture of amusement and astonishment. As Lamb took Stanley that afternoon round the galleries of London, he who had spent years in France worshipping in the studios of painters he admired, suddenly found himself elevated to the status of a respected guru. They called at the imposing Chelsea home of Darsie Japp, who had overlapped with Stanley at the Slade in 1908 – 9 and who had already bought his *Two Girls and a Beehive*.[7] Stanley was awed by Japp's background, prosperity and *savoir-faire*. To him Japp, like Lamb, 'knew everything'.

A bemused Lamb sent *Apple Gatherers* to Michael Sadler in Leeds, suggesting £60 and assuring Stanley that he would give him the extra. Stanley, who had accepted with equanimity the rejection of the painting, was surprised and gratified, and told the Raverats: 'Lamb has sent the preliminary payment of £30. If he has to sell it – and he thinks he will – any profit he makes by so doing he will give me. He is very good. He said: "What can you expect from these fashion-mongers?" But I do not altogether blame the Society.'[8]

Worried that it was lack of ready cash which was preventing Lamb from being able to retain a painting he admired, Stanley courteously told Lamb in his quaint 'business-letter' style:

I feel crossed [pulled in two directions] about that picture because all the time I am wanting money I am wanting you to keep the picture. You understand I can wait. You see, for another year or so I shall not be having to spend a lot – I seldom do – and if I live as I have been doing until now I shall be able to get through without danger. I tell you that I do not worry about money but I [have to] think about it.[9]

Sadler was prepared to offer only fifty guineas, a sum he had recently received for some extra-mural work. But in the meantime Edward Marsh had come forward as a bidder. At the instigation

of Mark Gertler he had been keen to acquire a Stanley Spencer work. *Apple Gatherers* was in his sights when Stanley and Gertler fell out over their opinions of Cézanne. Marsh felt he could not offend Gertler, whose work he equally admired, and had tactfully

Henry Lamb, 1912

to wait until the tiff exhausted itself. He then invited Stanley to spend a weekend at his apartment in Raymond Buildings, Gray's Inn. Stanley was impressed: 'I spent a weekend with Eddie Marsh. I had Darsie Japp and Gaudier [Brzeska] for dinner one day and

Gertler and a man named Nash* the next. . . . Marsh took me to tea at a Miss Nesbitt's; the elder of the two Miss Nesbitts is very nice. She is an actress and she seems to be so unlike what I imagined an actress to be.'[10] Cathleen Nesbitt was then on the threshold of her long and distinguished stage career. She was deeply in love with Rupert Brooke.

It must have been on that occasion that Marsh ventured to Stanley his wish to purchase *Apple Gatherers*. Like Sadler, he could not offer more than fifty guineas and Stanley would have to wait for payment until the next allocation of the Perceval pension. Stanley reported the offer to Lamb. He let Stanley decide. Stanley chose Marsh.†

The deal was completed in December. Marsh hung the painting in the small guest bedroom of his flat. It joined his embryo collection of contemporary artists – Augustus John, Duncan Grant, Mark Gertler – among his considerable collection of quiet eighteenth- and nineteenth-century works. Seeing them there Paul Nash commented: 'Apparently there has been a recent phase among the English progressives which might be called "The Apotheosis of the Dwarf". Groups of dwarves by Gertler and Spencer seemed to menace me from every wall.'[14] Rupert Brooke, returning from Tahiti in June of 1914 and staying in the guest room, promptly christened the painting 'the Bogeys'. This, thought Marsh, deflated, was 'a disappointing reaction'.[15]

But for Stanley these were halcyon years of both hope and accomplishment. He remained at Fernlea but acquired a 'studio', Wistaria Cottage, a then empty Georgian house at the east end of the High Street in need of structural repair. He rented it from his cousins the Hatches for eighteen pence a week, and liked it for the quiet and for the light from the east-facing rear windows which overlooked the extensive gardens of St George's Lodge as they sweep down to a branch of the Thames at Odney Common, a

* Possibly John Nash. Stanley would have known his elder brother Paul from his Slade days. Also Marsh was promoting the younger brother at that time.

† Sources differ as to whether the sum was fifty pounds or fifty guineas. Stanley told the Raverats that it was fifty pounds.[11] Hassall[12] states that Marsh paid fifty-five pounds (fifty-two guineas), outbidding Sadler by five pounds, but Michael Sadleir in his biography of his father[13] states that Sadler offered fifty guineas, but lost out to Marsh. This author assumes that both bidders offered fifty guineas, but that Stanley favoured Marsh on grounds of acquaintance.

location in which he was to set his *Zacharias and Elizabeth* (1913–14).

The family visited frequently. Will would come over from Cologne in the summer breaks while Johanna joined her family in Berlin. Harold and his wife Natalie – a dancer from Gibraltar – were occupied in light orchestral work, abundant then. Horace's conjuring took him on music-hall engagements at home and overseas. Annie remained reluctantly but dutifully at Fernlea, taking charge of a succession of live-in maids or domestics, for Ma was now confined at times to a bathchair which Stanley would cheerfully push the three miles or so into Maidenhead and back. Florence had married a Cambridge don, J. M. Image, brother to Selwyn Image, Professor of Fine Art at Oxford and an expert on stained glass. Sydney, having worked like a Trojan to matriculate, was overwhelmed by the delights of scholarship, for he had been accepted as a divinity student at Oxford. Percy remained an administrator with his London building firm, and kept a fraternal eye on Gilbert, who was starting his Slade course and, like Sydney, back at Fernlea in vacations.

Stanley's acquaintance with Henry Lamb continued: 'I have seen a lot of Lamb recently when I was having my teeth done a few weeks ago. . . . He had me at his place and he played me – God alone knows what he didn't play me. I went there twice, and he did heaps of Beethoven, the *Diabelli Variations*. I was glad to hear a lot of Mozart[16] [with J. S. Bach, Stanley's favourite composer]. His playing is very good; he gets everything clear.' 'Getting everything clear' – vital to Stanley, in music, in literature, in art, in vision.

Both Gilbert and Stanley were attracting the attention of cognoscenti. Several brought excitement into the lives of Ma and Pa by asking if they could call to see the artists at work. Edward Marsh was followed by Henry Lamb, who during a stay at Marlow walked over to Cookham in March of 1914 and for the first time saw Stanley on his home ground. On 30 May of that long hot summer he was in Cookham again on a ramble with Percy, Gilbert and Stanley, during which Percy took them birdwatching, and 'told the tale of the birds'. During the visit Gilbert showed him his final painting in a trio he called *The Seven Ages of Man*. Lamb was so impressed that he submitted it on Gilbert's behalf to the Contem-

porary Arts Society. It was Lady Ottoline Morrell's turn to act as buyer. To the family's joy she chose it in June for purchase at £100.* Thus Gilbert achieved the success so narrowly denied Stanley. Lamb promptly wrote to Gilbert to warn him that at their next meeting the drinks were on him.

Intrigued to meet the brothers, Ottoline herself came with her husband the Liberal MP, Philip Morrell, by train in July for tea at Fernlea and a walk along the Thames with the family. Stanley had just finished his first oil self-portrait, in which he painted himself in a mirror tilted to see part of the ceiling. The effect is to emphasize the jaw and mouth. Did the Morrells, one wonders, sense that in the set of the face and the quest of the eyes, the owner was beginning to see visions denied to many?†

During the visit there was, according to Sydney, 'keen discussion' of Mozart's music, and 'much fun' over the taking of group photographs, Ottoline being an enthusiastic photographer. The Morrells stunned the Spencers by airily hailing a local taxi for the return journey. A few weeks later Ottoline, having been offered the use of Lady Ripon's box at Covent Garden, reciprocated by inviting the Spencers to a Mozart opera. Evening dress was required. Ma was no problem, and Pa had an aged dress suit. Ottoline arranged for Gilbert to be pinned into one of Philip's, while Stanley disappeared into Edward Marsh's, which he had lent for the purpose. The procession of the party into the opera-house was a spectacle long-remembered with hilarity by the participants.

* In his diary for 1 July 1914, Sydney wrote, 'Gil has sold his picture *The Seven Ages of Man* through the Contemporary Art Club for £100. I learned when I got home that it was the Duke of Portland's sister who had bought the picture.'[17] Gilbert had earlier entered it for the Slade Summer Prize and received a consolation prize of £6. Seeing it at Cookham, Henry Lamb again became an advocate for the Spencers. He asked Gilbert to bring it to his Vale of Health studio to let Ottoline Morrell – 'the Duke of Portland's sister' – view it. The painting was so large that Gilbert and a friend had to carry it to the station like a table top. The painting is now in the Hamilton Art Gallery, Ontario.[18]

† 'How I admire Stan's Self-Portrait now finished! His portrait is to me nothing short of a masterpiece. It glows with warm, but reserved feeling and has the dignity of an old master in it. And he has done the whole of it with penny brushes!'[19] Marsh bought the painting for fifteen guineas – eighteen pounds according to Stanley. Marsh irked Stanley by ingenuously asking him why he had made the head larger than lifesize. Stanley replied with discreet irony that next time he began a portrait he would start with the head of a pin. Less discreetly he complained to the Raverats that 'Marsh is a nice man even if he is a fool.'[20] Marsh asked Stanley to varnish the painting[21] and on 14 July Stanley was in the bathroom of Marsh's flat about to give the painting a preliminary clean by rubbing it down with the cut half of a potato – a recognized if seldom used procedure – when Rupert Brooke is said to have walked in to horrified expostulation that 'poor Cookham' was so hungry that he was reduced to eating raw potato.

Darsie Japp was another welcomed visitor. He had previously visited, and walked 'twenty miles into Buckinghamshire' with Stanley; the Thames at Cookham forms a boundary between Buckinghamshire and Berkshire. On their return to Fernlea they were given boiled eggs for tea by Ma, a simple fare which Japp enjoyed, for, he told Stanley, 'I shall have plovers' eggs tonight.'[22] In August Henry Lamb visited again. Will was there from Germany. Sydney captures in his diary for August the echoes of that last summer before the impact of war: 'Yesterday Henry Lamb came down and spent some hours with us. We walked to Odney, then to Cliveden. . . . Suddenly we all concluded we wanted to bathe. So Gil fetched towels and Guy Lacey came with us. The water was delicious. Coming home, Lamb begged Will to play the Hammer-klavier Sonata.'

Significant though music was to both Henry Lamb and Stanley, it was a mutual recognition of the importance of art which drew together in friendship this otherwise contrasting pair. For all his more worldly literacy, *savoir-faire* and sophistication, Lamb seems to have shared with Stanley those moments of self-doubt, even of despair, which all artists suffer. But whereas Lamb's bouts of despondency would become prolonged, Stanley's natural buoyancy would quickly lift him to the surface. Perhaps Lamb occasionally needed the help of such optimism from his new friend. Eight years older than Stanley, he was a son of Horace Lamb, a distinguished professor of mathematics, later knighted. He had almost completed the medical course intended for him when he suddenly abandoned it, married the notoriously sensual model Nina Forrest, his 'Eu-phemia' – it was said to be a forced marriage – and went to Paris to study art, particularly under Augustus John. There his marriage disintegrated. He returned to England in 1911 to help extricate John from a relationship with Ottoline Morrell which was becoming tiresome. A slim, pale man, according to Lady Ottoline he was as fascinating to women as he was attracted to them. But essentially he was a man of wide cultural, social, musical and artistic sensibilities. He and Stanley shared an honesty of purpose and a clarity of outlook which all their lives resented pretension. When they met it, their reactions differed. Where Stanley would rant or grumble in protest, Lamb would pick up his lance and charge. The jousting blow he delivered to Clive Bell over the *Apple Gatherers* affair was

not mortal, but at least gave him the satisfaction of displaying his contempt. Neither he nor Stanley was greatly interested in material possession, nor in money save as the means to artistic freedom. But both remained in thrall, despite all obstacles, to the 'divine fire'.

Artistically, Stanley's prospects were encouraging. His work was increasingly recognized among connoisseurs, even if not always for the reasons he intended. Materially, it sold. By 1914 he told Gwen: 'I have £52 in the bank and I think I shall take the money I have in the Post Office Savings bank and make a deposit account at the London County & Westminster Bank where I already have a current account. I think you get 4 per cent interest.'[23] He also asks Gwen's advice on whether he should increase his contribution to the family housekeeping; he was paying his mother £1 a month, perhaps £10 a week now. Interesting projects were in the offing. In 1913 Jacques and Gwen Raverat had made moves to get Stanley and Eric Gill involved in illustrating and lettering a version of the four gospels. Gill, however, declined the project as too onerous, and the Raverats, it seems, were modifying it to discussions of an illustrated version of Fitzgerald's *Rubaiyat of Omar Khayyam*, with drawings by Stanley, woodcuts by Gwen, layout by Jacques and lettering by Gill. Rupert Brooke was urging Edward Marsh to promote a theatrical venture with text by himself, scenery by Stanley, and Cathleen Nesbitt as the leading actress.[24] Marsh had already in 1912 published the first of the anthologies of contemporary verse he called *Georgian Poets*. Stanley enjoyed the volume – 'Marsh gave me a book of English poets. I like Rupert Brooke because he knows what teatime is'[25] – and suggested a companion series of 'Georgian painters' to include Gertler, Currie, Nash, the Spencers, Seabrooke, Roberts, Rosenberg, Nevinson, Wadsworth and Gaudier-Brzeska. In addition Stanley was diverting Jacques Raverat's aborted four gospels project towards an associated scheme which was gradually to assume dominance for him in later life: the building of a long gallery – 'chapel' – in which the artists' paintings would illustrate the Life of Christ in terms of their own developing experiences through life.

But all were to come to naught. The times were too troubled. Rupert Brooke, due with Jacques Raverat to join friends on a camping holiday at Helston in Cornwall, sends Stanley ('Dear

Cookham') a letter which sums up the feelings of the perplexed young men:

I wish I knew about painting. I've left Raymond Buildings for months. I don't know when I shall be back. I'm glad I was there when you came. I'm going sailing and walking with Jacques for ten days or so. At least I want to. But this damned war business. . . . If fighting starts I shall have to enlist or go as a correspondent, I don't know. It will be Hell to be out of it; and Hell to be in it. I'm so depressed about the war that I can't talk, think or write coherently. God be with you.[26]

He never made his trip to Cornwall.

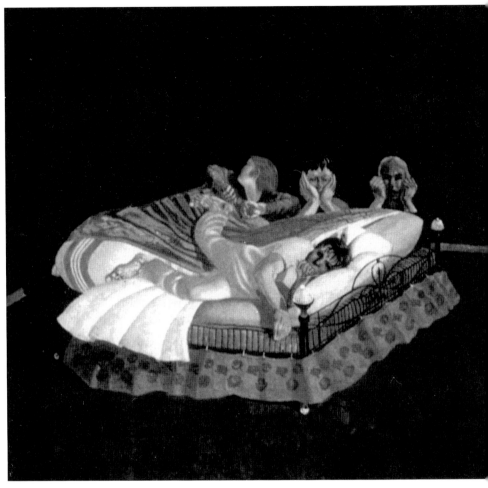

The Centurion's Servant (also reproduced in colour)

The Centurion's Servant

> Here we part with the year 1913 which has had many
> joys for me and few sorrows. What has 1914 got
> locked up in its bosom for me and mine? We shall see
> in time.
>
> Sydney Spencer, 31 December 1913[1]

TUESDAY 4 AUGUST 1914 was Florence's birthday. She had
come to Cookham to enjoy a celebration party at Fernlea. During
the afternoon, Herbert Henry Asquith, long-serving Prime Minister
in the Liberal Government, announced in the House of Commons
the delivery of an ultimatum to Germany demanding the with-
drawal of her troops from Belgium, to whose neutrality Britain
was committed. Florence had cause to remember that day:

On the afternoon of August 4th – my birthday – 1914 I was pacing the
Causeway at Cookham with my brother Percy, gravely discussing with
him the family scene, when he said: 'Of course, I shall have to go.' 'Not
you!' I cried sharply. 'A family of seven sons', he replied, 'could not stand
aside, and if I went, perhaps the younger sons will not have to go.' I
listened dumb-stricken. . . .[2]

The ultimatum expired at midnight. There was, as expected, no
response. On Wednesday the 5th, the recruiting offices opened.

Joining the forces was voluntary. The older married brothers,
pianist Will and violinist Harold, seemed unlikely to be affected,
except that Will now found himself trapped in England, his wife
Johanna in Germany. In the patriotic fervour which swept the
nation, Sydney in Oxford dismayed his parents by joining the
Officers' Training Corps as a cadet. The rolling-stone brother
Horace was trying to get home from West Africa, having suffered

55

a shipwreck from which he escaped with his life only because he was a strong swimmer. Percy stuck to his resolve and joined the Warwickshire Regiment.

Henry Lamb put his medical training to use by becoming a volunteer dresser in a private military hospital in France. Darsie Japp, an excellent horseman, was proposed for a commission in the Royal Artillery; field guns were still pulled by teams of horses. Rupert Brooke joined Churchill's recently formed Naval Division – a forerunner of today's Marine Commandos – as a platoon commander. Gaudier-Brzeska went back to France to join his infantry regiment. Jacques Raverat too crossed over to France and was both chagrined and alarmed to be rejected for military service as medically unfit.

Stanley, like most young men then, had no idea of the meaning of warfare and was attracted to the notion of joining the Royal Berkshires as an infantryman. But it is unlikely that he would have been accepted, on account of his slight stature; he was 5 feet 2 inches tall and weighed 6 stone 12 pounds. In those early days of the war, recruiting followed peacetime standards and the minimum requirements for infantrymen precluded Stanley. However, he and Gilbert compromised by joining the Maidenhead branch of the Civic Guard, an unauthorized but encouraged pre-recruitment training organization, the activities of which consisted mostly of marching and drill. Such team activity required a suppression of self to corporate perfection which appealed to the metaphysical in Stanley, and with the rest of the Cookham contingent he would return at night exhausted but exhilarated. He and Gilbert also joined the Bray brigade of the St John's Ambulance Corps. Provided they could acquire the First Aid Certificate, they would be eligible to join the Royal Army Medical Corps as medical orderlies in the Home Hospital Service, the only basis on which Pa and Ma would consider letting them go.

But if such was their outward behaviour, internally the shock reverberated. It was not so much the danger of going to war which troubled Stanley, for he was seldom concerned for his physical circumstance. Rather it was the spiritual dilemma which disturbed him; the question whether he should offer up his painting, his creative destiny, to the unheeding Behemoth of military service

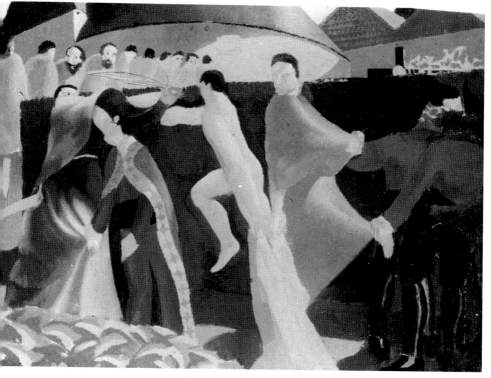

The Betrayal (first version)

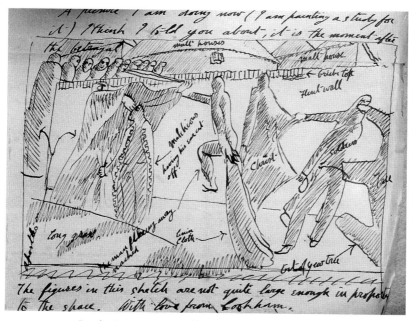

Stanley's annotation of his painting to the Raverats.

which had no need for it. If he joined up, would he, in his words, 'commit a sin against the Holy Ghost'?

It is possible to deduce several hints in Stanley's work during 1914 of the seriousness to him of his perplexity. In *The Betrayal*, painted in that year, Stanley used St Mark's account of the arrest of Christ in which a young man who 'lay hold on Christ' – Stanley shows him holding Christ's hand – is so startled by the violence of the proceedings that he tears himself from Christ's clasp, loses his robe in his haste, and flees from the scene naked. Stanley set the main figures in the back garden of Fernlea against a black wall and makes the young man pale in tone, so that he glows white. So intensely did Stanley feel about the painting that he sent the Raverats an annotated sketch. Even after the painting was finished, he continued to be preoccupied with the theme and made a subsequent pencil-and-wash study in which the wall is rendered lighter in tone. Against it he inserted another of his pronounced shadows; it is that of the young man fleeing, and emphasizes his being torn from the handhold of Christ. That the subject reflects Stanley's disturbed feelings about the war is apparent from the unusual way he has in the study shown Peter drawing his sword to strike off the ear of the High Priest's bailiff. The scabbard has been rotated until it points upwards. He later told a confidante that he based the image on the army drill for unsheathing a bayonet; this was to rotate the scabbard in its belt-holder or 'frog' and withdraw the bayonet downwards, a drill he must have learned from his Civic Guard training and incorporated into the study.

Stanley is surely indicating that he sees himself, like the young companion of Christ in the Bible version, as forced to flee naked from the handholder of his creativity. He is in shock, being compelled to betray his destiny. In a letter to Gwen Raverat he desperately asks her: 'What ought Gilbert and I to do in this war? My conscience is giving me no peace . . . advice from you would greatly relieve me, even if you said I ought to go to the Front. . . . I have been so disturbed that I have not been able to concentrate.'[3] Sydney, at home for the Christmas vacation of 1914, records in his diary the unusual fact that 'Stan made a bad bed companion last night, he kept rolling over and pulling the bedclothes with him.'[4]

In the same vein, Stanley writes to Henry Lamb: 'When you see

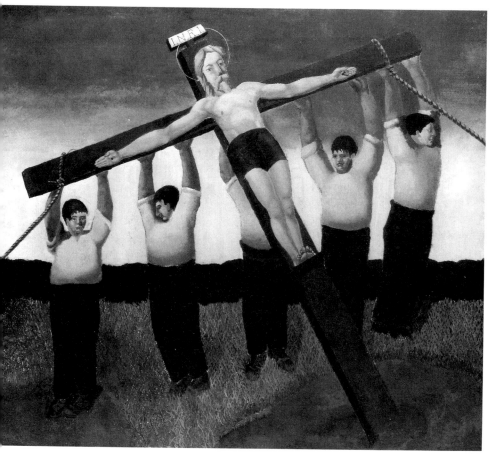

The Crucifixion, by Gilbert Spencer

how Gil's painting is getting on, you will say to yourself "Oh! He must not go to the war!" '[5] Gilbert's painting was *The Crucifixion*. In stark, angular composition it shows the Cross in process of being raised from the horizontal to the vertical. But the figure outstretched on it is Pa, and those hauling him up are five round-faced, dark-haired young men uncannily like the Spencer boys; from which we may suspect that Gilbert is telling of his sympathy for the old man, whose headstrong sons, so anxious to go to war, are emotionally crucifying him. Is then Stanley's *The Centurion's Servant* a comparable allegory, the visual equivalent of a personal nightmare or sleepwalk? Arguably so. Not only is this the first occasion on which Stanley places himself recognizably as the subject of a visionary painting, but even more decisively he stands

59

back to watch himself in his experience by placing himself as the centre onlooker of the kneeling figures, the one who seems to show no emotion but curiosity or contemplation.

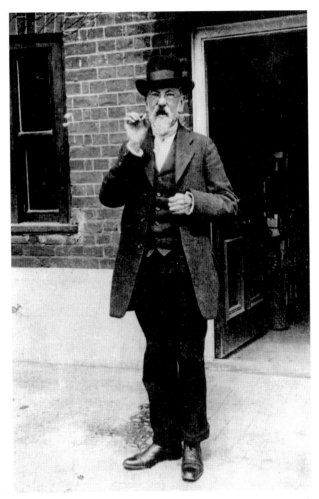

William Spencer, 'Pa'. This photographic image was used extensively by Stanley and Gilbert in their painting.

Stanley had begun to think about the biblical story (Luke 7, Matthew 8) in 1913, conceiving it as a double picture, one section showing the messenger running to Christ, the other Christ's miracle in healing from a distance the centurion's servant or batman. As

with all his paintings to date, he envisaged exterior settings. But 'this seemed beyond me, although in trying to imagine what the scene would be like, I began to find my mind in very outdoor places. I vaguely remember willows and sunlight in certain parts of Cookham.'[6] The imagery, however, would not materialize and 'in that baffled state my mind wandered into some shade, and in doing so I wondered what the scene would be at the house where the servant actually lay, seven miles away. Here I seemed to find better foothold.' The imagery began to take shape. It would be Stanley's first use of an interior, a considerable step in that paced progression which characterized his development. The interior would be a sickroom, a bedroom. So somewhere in his experience he had to cast around for a bedroom which by its association of feeling would recreate for him the sense of the miraculous to which the painting was dedicated.

Why, one might ask, did Stanley not select any bedroom, or indeed invent one? Not merely in Stanley's failure to do so but in his actual inability to do so, we glimpse one essence of his genius. Truth demanded not just a bedroom but the only bedroom possible for the revelation: 'I don't think it struck me then as it does now that the room I selected as being the bedroom in which the servant was to suddenly revive was our own servant's bedroom. I mean [that it was purely coincidence] that they were both servants and both in bedrooms.' Stanley's memory had settled on the servant's attic bedroom at Fernlea not because it classified itself as the bedroom of a servant; still less because the servant was a female. He is more than anxious to disabuse the reader of any connection between the mystery of the event and the possibility that the servants were mysterious to him as female, or that the room was mysterious to him, as some rooms were later to become to him, because he was not allowed to enter them. On the contrary, 'there was never any ban on one going into the attic and I remember that up until shortly after I began to go to the Slade I usually used to sit by the gable window and talk to the servant dressing, and quite innocent [even at] about 19 or 20 years of age' – 'quite innocent' because the maids were usually local girls taking an occupation before hopefully getting married. The reason why Stanley picked the servant's attic bedroom was because:

The attic had a dark recess in which was the big bed, and the china knobs could be seen now and then when the door was open, and when [one day] I passed the door I was impressed to hear her talking to some invisible person, [whom I imagined to be] a sort of angel. This [in fact] was the servant next door. She was talking through the wall, as our own attic and the one next door had only a wall between them. This I did not know till later. When she came down in her afternoon frock from this room I almost expected her face to shine as Moses' did when he came down from the mountains.

Stanley is transferring to the painting that sense of awe he felt on the day he heard the servant talking to her angel, to recreate the holy sense of awe which must have overcome the centurion and his servant on that day two thousand years ago when they knew the joy of salvation from death. He transfers the manner of its arriving to recreate through the medium of art his own joy at finding himself the recipient of a miracle too. He is himself the subject of the painting, as he describes:

The running attitude of the figure on the bed was arrived at through a consideration which did not materialize. I had originally thought of depicting the meeting of Christ and the centurion [as an exterior]. Then, when I was feeling there was too much out-of-doors element in the idea, I considered also including the scene in the servant's bedroom showing his miraculous recovery. I thought I would like to have two pictures in one frame, with a frame between them as division. In the meeting picture, the centurion was to repeat something of the position of the servant lying on the bed which can, I think, be seen to be similar in position to a person walking, only it is lying down. As I lay on my bed one evening in our front bedroom, I realized that I was in such a comfortable position that I would love to take that 'just-me-happy-on-the-front-room-bed' and plant it, with all its fact elements retained, into the other picture. I tried this many times, but it did not come as I wanted and finally I painted the bedroom idea alone. I at this time liked to gaze round the Church when praying and feel the atmosphere I was praying in. In the picture I have remembered my own praying positions in the people praying round the bed, because I knew the state of mind I wanted in the picture was to be peaceful, as mine was in Church, even though the miracle had occurred.

How compressed are Stanley's descriptions of his great paintings! The figure on the bed is 'a person walking only it is lying down'. Visually it is the messenger running to meet Christ of the aborted exterior panel; but spiritually it is the distress of Stanley's dilemma transferred *en bloc* into the bedroom scene. Yet, conversely, the 'state of mind' he wanted to express in the painting was to be 'peaceful', so that 'the miracle had occurred'; so 'peace' is invoked from the terror through his recollected feelings of lying comfortably in bed 'in our front bedroom', but even more from the sensations which overcame him when he gazed around during prayer in Cookham church to catch the 'atmosphere'.

Later he adds: 'The people praying round the bed may have something to do with the fact that in our village, if anyone was very ill, the custom was to pray round the bed, and I thought of all the moments of peace when at such moments the scene might occur . . .' – [7] and there was in Spencer-family recollection an episode in which one of the older boys developed pneumonia. Watched over anxiously by the womenfolk, the stage in the illness was at last reached when young Sydney was sent to run to Pa at Hedsor to tell him that 'the crisis has come'; a message which reached Pa's ears as 'Christ has come.'

The Centurion's Servant, like *The Betrayal*, marks a crisis of its own in Stanley's development. Before it, all his painting had been done in the unfettered joy of creative metaphysical-spiritual discovery. Then, suddenly, the impending war introduced a brutality in existence until then unsuspected. Its darkness broke his arcadia, left him in shock. He had to find a way back to comfort and assurance, and in this endeavour he recognized *The Centurion's Servant* as a watershed in his art. Never again would he be able to recreate exactly the feelings of 'innocence' which pervaded his earlier paintings, a loss he would ever lament. But in the destruction of that innocence the marvel to him was that he was given the means to find reconciliation. We may venture what they were.

In all his visionary pictures, no matter what the titled subject, Stanley is ultimately depicting a cluster of associated experiences, or 'memory-feelings' as he called them. They are chosen so that the feeling he draws from them matches the current feeling he is trying to express in his painting. This happened for him joyously in his earlier paintings when metaphysical revelation could be

visualized from his happy feelings about moments and places in Fernlea and Cookham. But now that he is in shock the match cannot be made directly, for he has no store of shocked memory-feelings. Should he paint reflexively and let his anger show? Such was the response of many painters, especially of the artists of the coming war.

But Stanley's genius is such that he has an added layer to his personality which lifts him above the merely reflexive. Since his distress is greater than can be shown in even the most hurtful experience he can recall, he relates their feeling to a more powerful source, one which will convey the intensity of the required terror: in this present painting, the Bible and one of its happenings. The story he selects describes terror. But its significance is such that in doing so it is able to reveal the possibility of *release* from terror. The centurion is terrified; Christ in healing his servant releases him from his terror. For the centurion a *redemption* has occurred. If Stanley is to find a corresponding release from present terror he too must go back in memory-feelings to a remembered redemption of his own and link its feeling to the power of the biblical event. In composing his picture he will show a moment of personal terror in one part, and then reveal its redemption in another. In this respect an event which happened powerfully in the Bible has already happened for him, even if less emphatically, in Cookham. 'If I had not had that subject, I could not have drawn any of that picture,' he was to say of one religious painting.[8]

What he is doing in *The Centurion's Servant* is that which he will struggle to do for the rest of his life when baffled by the painful. As he grows older he will accumulate memory-feelings sufficiently vivid to match and redeem some bewilderments. But there will also be occasions when his distress will be so agonized that only a return to biblical example will suffice to indicate its intensity. There will even be instances when he is unable to find any forceful match at all between his feelings and the redemption of memory. Then he will be left frustrated, unable to compose his picture, or else forced to use memory-feelings which are 'incompetent' and which in his opinion dilute his intention. But when he can find a match, as in this instance, the ways he finds for expressing it will be a continual surprise and wonder.

The process by which Stanley arrives at his notions is subtle,

perhaps subconscious, perhaps instinctive, but invariably logical in metaphysical terms, and always precise. To convey it, he first states the *fact* of what is taking place. This he depicts so transparently – and in later work with such honest directness – that we should not be tempted into thinking that he intends self-revelation from a desire for self-indulgence. The emotion inherent in the content, even when related to the event he so strikingly depicts, is not used as direct imagery; such use would be sentimentality. Although the imagery of the picture is personal, it is there to transcend the personal. It may be of interest and indeed of help to know that clues to the imagery can lie somewhere in his writings. But detection does not necessarily establish the true notion of the painting; the clues are merely signposts. Once Stanley has found his imagery in the personal, then the associative emotion determines the visual pattern or arrangement in the depiction; the composition. In redemptive work, provided that the imagery to hand was what Stanley called 'man enough to do the job' – there could be no compromise with the 'Holy Ghost' – there will be great, even vital, significance in the painting: a redemption, an emotional movement from one state of awareness to a higher. It is this triumphant discovery which *The Centurion's Servant* records.

In this sense it seems cogent to argue that there was in Stanley's make-up a quality which makes him a dramatic painter. His visionary paintings capture an instant of tension between a before situation and an after situation, like a strip of movie film stopped in the projector. Each painting is that crucial freeze-frame which exactly pinpoints the moment when we become aware that a change is about to happen – *The Nativity* – or is happening – *Apple Gatherers* – or has happened – *The Centurion's Servant*. The freeze-frame is not a random moment. It is the consequence of decision, more particularly of commitment. Its effect is a catharsis, a purging, the moment in drama when the confusion of reality is suddenly dissolved into spiritual comprehension. At that moment, the preceding is clarified and linked to the now inevitable. The past cannot be undone, but it can be apprehended in some awesome synthesis of meaning. A god has come.

Redemption to Stanley was the miraculous means by which he got himself, through his pictures, to where all was 'holy, personal and at peace'; in other words, to his feelings for 'home'. His

pictures are not illustrations of redemptions. They are in themselves a reaching to redemption. It is irrelevant that the past in *The Centurion's Servant* may be a recollection of some serious Spencer family illness or that Stanley has portrayed the future as an expression of 'cosiness' in bed, its valance echoing those of Edwardian prams. Neither the title, nor its allusions, nor its associations are to be taken at face value, and to do so is to limit, even destroy, their meaning. Particularly with this picture Stanley felt that critics might decide its presentation derived from an unpatriotic reluctance to go to the war. The thought of such possibility could never be allowed to interfere with the form of the work. If the content came to him vividly, then it must be valid, demanding expression without dissemblance. Only so could a path be cleared through confusion to meaning. The best precaution he could presently take against misinterpretation was to conceal the painting, even though the clarity he found in its execution convinced him of the truth of his feelings:

My bed picture is an example of how a picture ought to be painted. Everything in that picture, colour particularly, was perfectly clear, and the way to get the colour decided in my mind before I put brush to canvas. The result was that it was done in no time, it was done like clockwork. . . . What pleases me is that I have learned the reason why the picture should be done so as to let me see the idea without having to plough through incompetent [irrelevant] detail that has no fundamental bearing on the idea.[9]*

Stanley's excitement at his achievement is obvious. Some outside force is acting on him, easing his mental suffering into that state of peace through which he can joyfully offer tribute. His picture 'lets him see' his idea in uncluttered clarity. The joy it gave him sprang not from the fact that the picture indicated a *solution* to the perplexity from which it originated; the imperative of physical reality continued to assail. Rather his joy sprang from a discovery that the making of the picture discharged his emotional distress. It

* It is significant that Stanley frequently refers to the painting not by its public title but as his 'Bed Pic'. The feeling of being in bed, cosy, recurs in his work. It is apparent in detail in *The Cookham Resurrection* of 1927, and is evoked in the *Resurrection of Soldiers* at Burghclere and again in his Port Glasgow *Resurrections*.

was a *redemption*. In it, reason became the servant of imagination, imagination of feeling, feeling of revelation, revelation of comprehension, and comprehension the miraculous gift from some exterior power. The process was religious. When in later years an art critic interpreted it as the reaction of children caught in an air-raid, Stanley's contempt was vitriolic.*

For the time being, however, nothing was done with the painting. Stanley stored it in his room at Fernlea while he settled to other work. One such was among the first of what must be called his 'landscapes': the painting of *Cookham, 1914*.

* The critic was Frank Rutter in the *Sunday Times* of 27 February 1927 and in the *Christian Science Monitor* of 21 March 1927. Stanley composed, but did not send a rebuttal.[10] However, his irritation resurfaced in 1938 when he complained to his dealer, Dudley Tooth, of Rutter's continued public misinterpretation of his work. Tooth took the matter up with Rutter, who apologized.[11]

Cookham, 1914

Excuse my muddle-headedness and slowness, when I
see anything I see everything, and when I can't see
one thing I see absolutely nothing.

Stanley Spencer[1]

SUPERFICIALLY *The Nativity* and even *John Donne Arriving in Heaven* can be classified as landscapes. But Stanley would not have regarded them so. For him landscapes, like still-lifes and portraits, captured tangible objects in real time. They can be called his observed paintings. Unlike his visionary or compositional work, observed paintings were invariably painted or sketched *in situ*, where possible in contiguous sessions. In them detail is precise and often continued full into the foreground, a technique which gives such paintings wide-angle clarity of definition and the strong visual impact resulting from great depth of field.* An ancillary of the method, the use of a high-angle viewpoint, occurs in his first major landscape, *Cookham, 1914*, and has been proposed as imaginary,[3] because Stanley often used such viewpoints in subsequent visionary work. But he never did so, we can be sure, in observed paintings. There will exist an exact spot near Cookham which shows the scene precisely as Stanley saw it. It has been identified as near Terry's Lane in Cookham leading up to Winter Hill, a little beyond Rowborough House.[4]

In the most compelling of Stanley's landscapes, we glimpse the

* Florence records that: 'In an interview in the *Daily Mail* in 1932, Stanley is reported as saying that he found it very important to paint what is in the extreme foreground, that he wanted to start a picture with what lay just in front of his feet, something he could reach down and touch . . . "I have always wanted to have everything within my reach, where I can lay my hand on them" . . . That spot seemed to him a sort of taking-off point for the flight of the eye over whatever else was in view. It must be absolutely solid and real . . . It seemed to him all wrong to start at an arbitrary plane say 10 feet distance rather than at the nearest plane in one's line of vision.'[2]

Cookham, 1914 (also reproduced in colour)

power that place had for him: 'My landscape painting has enabled me to keep my bearings. It has been my contact with the world, my soundings taken, my plumb-line dropped.'[5] Meticulousness of detail was not an arbitrarily adopted style. He could paint in no other way, for the precision in his personality was the physical manifestation of his inner search for veracity. *Cookham, 1914* was the forerunner of a magnificent procession of observed paintings, hundreds in all, so decorative and so sought-after that he found himself frequently leaning on them for income. At times he complained of having to churn them out. Sometimes his complaint was justified because he was too rushed and the result mechanical. But in less hurried times he could enjoy the contemplative opportunities they afforded. We should not be deceived by his wail; it reflects only annoyance that he had to give them precedence at periods when he wanted to concentrate on visionary work.

Place, for Stanley, meant objects observed in relation to one another. In a newly observed scene neither the objects nor their relationship would have an immediate impact. Only when he drew some associative inference would the place take meaning. The process needed time. Given time, the place would assume for him an identity from his perception of its components. Change one, and for him the entire identity of the place changed. Thus his more powerful landscapes became connections between himself and the spirit of the landscape which had imposed its identity on him. At the moment of imposition, of connection, the place became an entity, a stasis.

Thus his landscapes in general lack figures. An animate figure, however discreet, would be an intrusion in the stasis of the scene. But stasis does not imply passivity. Each landscape in which place sang for Stanley revealed to him a necessary natural creation which would persist whether or not man interferes. He told Edward Marsh, who bought *Cookham, 1914*,[6] 'I think the true landscape you have of mine has a feeling of leading to something I want in it, I know I was reading *English Ballads* at the time and feeling a new and personal value of the Englishness of England.'[7] It is in the brooding calm of their existence that the power for Stanley of such landscapes rests. They are simply being.

When then is the distinction between such paintings and his visionary work? Why were the latter more significant for him? Essentially it was a question of how fully he could join himself to whatever he was painting. In observed painting, even the most sympathetic, he was not able wholly to amalgamate himself with his subject: 'It is strange that I feel so "lonely" when I draw from nature, but it is because no sort of spiritual activity comes into the business at all – it's this identity business,' he was later to write.[8] Place became ecstatic for him when it became wholly subjective: 'It must be remembered that whatsoever I talk about is the *whole* thing, by which I mean that if I refer to a place, I am talking of a place plus myself plus all associating matters of personal character-istics respecting myself.'[9] He saw it through a filter of personal associations which transfigured it into metaphysical meaning.

But when it came to the visionary paintings this raised a pictorial problem: 'I need people in my pictures as I need them in my life. A place is incomplete without a person. A person is a place's

fulfilment as a place is a person's.'[10] But figures depicted in the same way as he portrayed the detail of merely observed places or objects would destroy the stasis, even when his feelings about the figures made them its fulfilment. They could not be shown in that way, even when they were derived from people he knew and were associated with the place.

Stanley's solution was not to paint the detail in such pictures as it could be observed. The places would be real, but not painted objectively. Nor would figures: they could be real persons but would emerge from his composition in a transfigured form. Both place and people would be reconstructed visually out of his metaphysical relationship with them, after contemplation and invariably in the quiet of a studio. Thus when Stanley paints visionary effusions he is not painting a real place, even though he makes use of one; he is not painting real people, even though he is using them; he is not even painting his feelings about both, though he is making use of them. He is painting a transfiguration of experience.*

This did not mean that he painted such pictures with less meticulousness than he painted his observed scenes. On the contrary, the transfiguration involved him in the most exact choices, for it demanded forms of expression which to the untutored eye can appear to be distorted. If he had to use such distortion of detail, then it had to be in tune with the emotional content of the whole. The balancing act in this process made composition frequently an agony, especially in his novitiate years:

I have [only] as yet been able to see something I want to write or paint in a disarranged state. It is as if I had seen a box of chessmen and had no idea of how or in what order they were to be placed. But I would

* Stanley's *Zacharias and Elizabeth* shows a curious example in reverse of his use of detail to transfigure place. He visualized the scene through the powerful associations raised for him by the garden of St George's Lodge as he saw it from the back of Wistaria Cottage. But in the composition he needed a curved dividing wall. The one there did not have the required associations: 'The high wall seen from the back window of Wistaria, although Cookham and particularly a part that I liked, was not quite personal enough for me.'[11] So in painting the wall, he depicted it in outline but was emotionally quite unable to insert any detail in it. The result was that when the painting was exhibited he found himself exposed to the customary criticism which precipitately seized on the least relevant feature: 'If the buildings and ruins of the Giottesques often lacked architectonic stability, the primitive painters nevertheless did their best to make their walls look like walls. In Mr Spencer's picture the . . . screen-like erection behind the central group looks more like a portion of an enamel bath than a wall.'[12] A less incorruptible painter than Stanley might have eventually crumbled before the continual blasts of such uncomprehending comment.

know if a domino or some draughts got into the box that they had nothing to do with the chess pieces. I know to the last detail what does belong to the game. I only don't know yet the order. It is a big 'only'. I have noted in all my various desires that they have a relationship to each other and that they or many of them, come together to suggest some clue as to what their final form will be. This final something, the thing that ecstasy is about, God alone can give the order and reveal the design.[13]

His own expressed distinction between his observed and visionary paintings was that the observed paintings 'had no memory-feeling'. Memory-feeling was the mainspring of transfiguration. Only when memory-feelings crystallized as moments of metaphysical illumination would people and places merge for Stanley. Then the figures would become personifications, incarnations, of experience through which Stanley strove to approach the meaning by restoring the experience. But the miracle to Stanley was that the attempt to capture the illumination, to approach the meaning, enabled him to compose a work of art based on the sensation of the originating experience but in an imagery which transfigured it and gave him a joy and happiness he could find in no other way. It is a true source of art: certainly of Stanley's art.

CHAPTER NINE

Swan Upping

'What do they mean by religious art? It is an absurdity.
How can you make religious art one day and another
kind the next?'

Picasso[1]

MYSTICISM? EXORCISM? ESCAPISM? SUBLIMATION?
Stanley's astonishing access to the disjointed memory-feelings of
his subconscious, and his creative ability to associate them, in
whatever random or involuntary way they might have come to
him, into patterns of meaning – paintings – which constructed for
him a metaphysical world alternative to the physical world, all
these could fascinate a psychologist: as in fact they were to do in
later life. Through his midwifery of the metaphysical from the
physical, his redemption, Stanley was evolving a unique form of
expression, a language.

Modernism was arriving, its battle-cry 'directness is all'. Direct-
ness was to be achieved by dismembering an object, event or
sensation into its apprehended constituents and then clinically
and unsentimentally reassembling them into a taut form which,
however surprising it might at first appear, was to the artist
more truthful in re-fashioning the essence of the original than
contemporary representational art could offer.

It may seem a far cry to a puzzled young painter cloistered in an
English village. But the link existed. Picasso's exploration of
cubism remained as solidly based on real objects as Stanley's
compositions did on places. Proust's happiness in his cobbles[2] was
echoed in that of Gwen in hers, his mysterious feelings about his
hawthorn blossom by Stanley's for his Cookham wildflowers.*

* 'And then I returned to my hawthorns, and stood before them as one stands before those
masterpieces of painting which, one imagines, one will be better able to 'take in' when one has looked
away, for a moment, at something else; . . . the sentiment which they aroused in me remained obscure
and vague, struggling and failing to free itself, to float across and become one with the flowers.'[3]

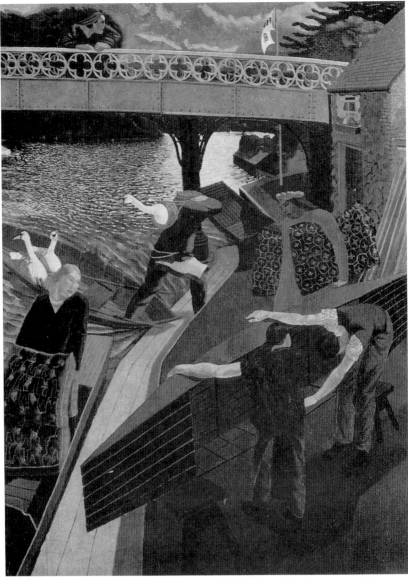

Swan Upping (also reproduced in colour)

James Joyce exactly recalling sensation, even of the cloacal, parallels Stanley sitting seemingly for hours on the outside loo at Fernlea with a worm or newt on his bare thigh to relish its movement against his skin; a habit his family, awaiting their turn, found infuriating. D. H. Lawrence, celebrating sexuality, presages Stanley having an 'interesting discussion' with young Peggy Hatch 'on the relative sizes of our legs just above the knee, but only just above',[4] or tentatively feeling the penis of a boyhood companion and wondering at its softness,* or in the quiet of Wistaria Cottage imagining a girl 'squatting' before him, then feeling a 'warm glow' at the spectacle of the uncovered legs of girls as they played in the straw, or momentarily breathless at the sight of a girl bending to retrieve a ball through railings.[6] For each artist, the minutiae of physical sensation demanded a place in the totality of experience, even if for Stanley their expression in pencil or paint was still hesitantly circumscribed.

The parallels cannot be pushed too far. Modernism was more a state of mind than a specific movement. In the best of it can be found the sense of awe without which no artist can accomplish – Picasso shouting from his studio, 'I am God! I am God!' The disjunctions of Joyce's *Ulysses* or Eliot's *The Waste Land* parallel the many-layered but essentially unified compositions of Stanley's *The Nativity* or of *The Centurion's Servant* or of the many visionary paintings to come. The awe, the impetus to truth, is 'spiritual', 'religious'. It pervades the work of the great modernists, even though many rejected canonical faith; as did Stanley in liturgical literalness. But 'spiritual' and 'religious' it remained for him, and we must continue to use his adjectives in that sense.

If Stanley's interpretation of Christian tradition seems sometimes less than orthodox, he saw no point in divesting his art of its power. When such a magnificent paradigm lay at hand, one with which he was familiar from childhood, why squander its resources in crafting, as did so many of his contemporaries, some less apt device? If Cookham was 'heaven' for Stanley, it was because the Bible was the first text he had known which offered integrated interpretation of the disparate mysteries which were beginning to

* 'I faintly remember when I was about 17 I longed for a youth I knew to put his hands in my trousers and feel my thing. I faintly remember feeling his, which was small. Such a sense of wonder and meaning I felt then.'[5]

possess him. He would not always accept its interpretation literally, but it would remain a yardstick against which he could measure future texts and alternative explanations. For he remained convinced of having been vouchsafed a miracle, that what he saw happening during his adolescence in Cookham had already taken place for him in a deeper sense in the Bible of his Fernlea boyhood. Each Cookham occurrence was for him no more an event in isolation than were the Bible stories Pa had read to him. Each was a drum-roll in his as yet dimly discerned pageant of revelation, and it was his unsolicited destiny to relate the majesty of the one to the other, to take the elements of experience and fuse them into an assembly of spiritual meaning.

Swan Upping demonstrates this particularly well. One of the elements he chose for the composition was the foreground cameo showing two men at work on a punt; a second is that of the two girls carrying cushions to a punt – the sun is in the east, it is morning; the third shows a waterman of the Company of Vintners and Dyers bringing Thames swans ashore for marking. Connecting them, the boardwalk and towpath spike their way towards the lawn of the Ferry Hotel, flag raised to proclaim its services to passing river traffickers. Mr Turk's boathouse is on the right, and beyond it arches Cookham Bridge.*

Each cameo is a little pocket of feeling. Stanley does not directly describe its nature, but its significance can be extracted from allusions in his writing. Part of his Cookham feelings related to his delight in the occupations of the villagers. The purposefulness of their daily activities made them for Stanley participants in some ritual, as though Cookham were a church, its inhabitants communicants, himself a priest. Not all the villagers gave him this feeling, but those that did became part of his abiding joy:

I hear Mr Johnson's little boy call 'Harry, Harry' down below in the street and I hear his scuttling feet across the gravel as he runs past our house. Our back iron gate swings open and hits the ivied wall [of the house] out of which it is built with a bang, and then quick steps up the [side] passage, then the sound of the milk can opening and of the jug drawn off the window cill.[8]

* A wooden bridge was first built in 1839 to replace a former horse-ferry, but became so decrepit that the horse-ferry was brought back into use. The present iron bridge was built in the mid-1860s.[7]

The men tending the foreground punt capture the feeling. Stanley does not tell us who they are but, like the milkman, they are part of his Cookham ritual: men in their physical work, wage-earners, providers of the means to home-making, 'nest-builders', angular in presentation.

The girls behind them share the ritual, but differently. Their function is domestic. The cushions they carry are femininely rounded and patterned, suggesting softness. The girls who actually worked at the boatyard for Mr Turk on busy days have had their identity changed by Stanley.[9] He has, he tells us, substituted for them the Bailey girls. William Bailey was a local builder and also an accomplished artist, and the family was a joyous strand in his Cookham feelings: 'Somehow M. S. or Miss Roberts could never quite give me the significance of Cookham that the Bailey girls did, or any other Cookhamite such as Mr Worcester [Wooster?], Pa, Mrs Croper [Cropper?] or Mr Francis or Mr Pym or Mrs Bailey or Mr Hatch. It's just heaven reciting those names.'[10] It was Dorothy Bailey who gave Stanley his early art training. Her personality caught his imagination, induced his 'love': 'Walking upon the Causeway between white posts placed at the eastern end is Dorothy Bailey. How much, Dorothy, you belong to the Marsh meadows and the old village. I love your curiosity and simplicity, domestic Dorothy.'

Stanley renders unidentifiable the figure bringing ashore the carpet-bagged swans, his elbow lifted, a sack worn for protection against angry beaks and wings. Yet he too is part of the mysterious ritual which makes Cookham holy for Stanley, and which in this painting he has localized along the river because, he says, when in church one day the sounds of river activity filtered in and took on the aura of the religious atmosphere he was experiencing at worship:

My Cookham feelings were really this, that I felt this Ascot-fashion Boulter's-Lock Sunday Bank-holiday terrific physical life could be tremendous seen spiritually, and this desire on my part was intensified by the fact that Cookham had as far as nature aspects were concerned and as far as the different jobs that were done there (boats and boat-building etc) an affinity with the Bible and the Bible atmosphere. So that in a way all the things that happened at Cookham happened in the Bible. . . . Of

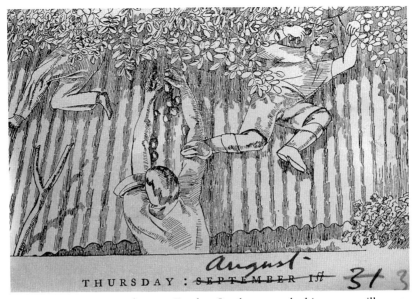

THURSDAY : ~~SEPTEMBER 1st~~ *august* 31

Drawing: Harvesting walnuts at Fernlea. Stanley was asked in 1929 to illustrate a commercial almanac, and in it used several recollections of his boyhood, including this scene. An entry in Sydney's diary for 7 October 1911 describes how 'Stan and I got decidedly punctured by Mr Parsons catching us on his tin sheds and swearing at us, throwing the walnuts at us and steps and all. Went to bed pretty late and talked with Stan about The Egoist.' Stanley used spare copies of the almanac as daybooks in subsequent years.

course in this idealizing of Cookham people it was more just my own idealizing of them, my own feelings of perfection projected on to them . . .'[11]

If interpretation of the painting stops at this point, it may seem a straighforward rendering of an artist's powerful place-feelings; three episodes or transformations of experience chosen from many possible, and assembled visually to define an otherwise intangible totality of meaning. But, Stanley being Stanley, we may guess there must be more. The imagined high-angle viewpoint, the packed composition, the geometrical arrangement of components and the density of colour give a charged intensity of feeling which the pacific cameos so far described do not explain.

The high-angle viewpoint was one with which Stanley had been

Anna Spencer, 'Ma', at the end of the back garden of Fernlea. She is posed beneath the large walnut tree which was a long-standing Stanley-memory. Behind her are 'Mr Parsons' tin sheds' – actually the malthouse stables – on which the Spencer boys would climb to harvest the nuts. Nearer the house was a yew tree.

experimenting in visionary work. Its use in *Swan Upping* was not merely a technical device to shorten perspective and compress into proximity detail normally invisible or discreet when seen from ground level. There was an emotional element. In the back garden

of Fernlea grew a large walnut tree which overhung neighbouring gardens. At harvest the Spencer boys would climb into it to shake down the nuts and, as Sydney described and Stanley later drew, sometimes clambered to do so on to a neighbour's 'tin sheds', much to his fury. Stanley as a boy loved to climb alone into the tree. There was always wonder at the unexpected vistas revealed, and also a feeling of isolation, of remoteness, of godlikeness; very much the feeling in the painting.

The angularity given the towpath has, it has been suggested, affinities with cubism and vorticism.[12] At the time, Stanley's former fellow-students Nevinson, Wadsworth and Bomberg were experimenting with the styles, and Stanley was interested to see their work. However, the towpath actually does zigzag as Stanley shows it, the abrupt changes of direction being caused by the property boundaries of the riverfront cottages. Stanley's artist's eye instinctively registered such minutiae. But, as with all his visionary work, the painting of the scene was not done from actuality. On the contrary, as he stresses in his description, he drew the scene from memory, returning only afterwards to compare his drawing with the reality and to congratulate himself on the accuracy of his observation.

The comment is significant. Stanley is not painting the scene as a landscape. He is deliberately painting it through the filter of 'memory-feeling'. The resulting configuration is subservient to the feeling. Of course, most original artists do this. But where many of his contemporaries developed the distortion to carry their meaning, Stanley reverses the process. He aims to bring the configuration of his memory-feeling into as accurate a parallel with the observed as he can, convinced that the more accurately he can do so, the closer he will draw to the power of the associations inherent in the memory-feelings. He will never expect to match the two exactly. There will always be some distortion. When it increased alarmingly in later years, he felt that he had lost this first and early vision, the 'innocence' in which he was happiest.

If therefore there is cubism or vorticism in Stanley's reconstruction of that part of the scene, it is less because he accepted the tenets of those styles than because the angularity was truthful to the place and could be brought into the picture to convey a directness of feeling which would counterpoint the more rounded

imagery of the figure associations. But an even more striking counterpoint is evident in the upper part of the painting, the bridge section, which is mysteriously different in feeling from the relative calm of the foreground scene. In the bridge section a wind blows, rippling the water, flapping the flag, sending clouds scudding across the sky, streaming the hair of the male figure as he gazes towards Cookham, towards the female figure at the bridge end where the branches of the fir tree seem to extend her feelings to him in sympathy.

Looking back, Florence thought that the male figure on the bridge was the last detail Stanley painted before having to lay the painting aside; he had begun applying the paint from the top. She was evidently hinting that the figure represents Stanley's foreboding at being torn from Cookham by the onrushing winds of war, and the entire top scene can suggest such an emotional dread. But, if so, Stanley was being neither narrative nor illustrative. He was surely doing what he did in *The Centurion's Servant*, striving to transcend the distress of an unavoidable physical necessity by calling this time on the spiritual resources of his Cookham feelings.

That he felt he was succeeding is evident from a later reference to the painting. He began painting it, he said, in Ship Cottage, and at one point army recruits were undergoing field training in the vicinity: 'seeing the manoeuvring of troops going on outside, I felt if only there was not this war, what could I not do?'[13] He conveyed the feeling in a paean to the Raverats: 'I am in a great state of excitement, quite a treat to feel like it. I hear the voice of the acceptable year of the Lord, I want to draw everybody in Cookham, to begin at the top of the village and work downwards.'[14]

What might have been accomplished had Stanley been able to carry out his enthusiasm! *Swan Upping*, like *The Centurion's Servant*, is a hymn of joy to the miracle given him to redeem the apprehension of the unfamiliar through the peace of the known and loved. 'There is', he said in later life, 'greatness in that painting.'[15]

By the time Stanley was composing it, the intricate lines of trenches and barbed wire had been lengthened across Europe from the English Channel to the Swiss frontier. In the Balkans the tragedy of the Dardanelles was about to be played out and Rupert Brooke to die on his way there of a blood infection. On Germany's

eastern frontier, preparations were under way for those Teutonic hammer-blows which were virtually to knock Russia out of the war. At home, volunteers flocked to swell the new Kitchener armies under training. Stanley and Gilbert remained in Cookham, continued their painting and kept up their drill and ambulance training. Stanley read as enthusiastically as ever: 'I am still reading Dante. I have only just finished Hell. I like reading anything like that very slowly. It is wonderful the part where Virgil embraces and carries Dante. . . .'[16] Handholding?

Alas for Stanley, into the creative exaltations of his Cookham feelings, the upheaval of the times kept breaking. He sensed his isolation from his brothers – 'My brother Percy who entered the army as a common private is now a lance-sergeant. My brother Horace who is in Nigeria is guarding prisoners. . . .' – and, even more forcefully, his isolation from village opinion:

In the barber's yesterday a married man who had been in the South African war and was just going to the present talked a lot about how he had done his bit and was waiting for the young men to go, but they did not seem to. He waited for me to stand up . . . and looked me up and down. 'Now, Master Spencer, you ought to be in the army, you know. Here am I, a married man with children, and I am going tomorrow. Yes, tomorrow!' My answer was to stand and look at him like an idiot and a lout, and the fact that the barber had parted my hair made me feel more so. 'Why haven't you joined?' he asked. I tried to become dignified but only became more foolish. 'Well, at any rate,' I said, 'I hope you will believe me that there is some honour in a civilian and when he says he cannot, it is because he cannot'; and with that I strode out, feeling I had made a thorough mess of myself. . . . It is terrible to be a civilian. God says: 'You must go, but I give you the power to obey or disobey this command.' If you do not go, then you feel something has gone from you.[17]

Moreover, as time passed and the wounded – mostly at this early stage of the war regulars, territorials or reservists – came home to convalesce, a further puzzle presented itself: 'It is funny the difference between the wounded soldiers and the ones not yet gone to France. The ones just going look at you and say: "Be a *man*. We're *British*. Will tha join Kitchener's Army?" But the wounded are always quiet and never say a word about our not joining. . . .'[18]

'But the wounded are quiet and never say a word about our not joining up.'
Stanley with Pa and a newly commissioned Sydney on Cookham Bridge.

In May 1915 Stanley sent the Raverats a sympathetic note about
Rupert Brooke. Inflation, virtually unknown within living memory,
was beginning to be an unsettling phenomenon. Jack Hatch was
dropping heavy hints that he would appreciate an increase in the
weekly eighteen-pence rental Stanley paid for use of Wistaria
Cottage. Should he and Gilbert go? Percy had gone. Horace was
on his way home from Africa to join up. Sydney knew that
he would be going, and was snatching for those moments of
remembered joy that many imminently campaigning soldiers
know:

As I came on through Weston [Weston-super-Mare] Woods towards the
Old Pier the sun poured down upon the wet sands of the bay. The woods,
the green grass and dark furze bushes with fringes of fire crept down as
far to the shore as possible. The gulls were lazily crying to each other in
the hazy distance and the whole of creation seemed to speak of peace. . . .
I dawdled and picked flowers. I lived and breathed and exulted for a
dreamy hour in that old land of peace long vanished for me. . . . With

all the grim prospect of the present, how grateful I am to a God who gives respite to his creatures and makes the full enjoyment of such an afternoon still possible.[19]

Back at Fernlea, each of the youngest brothers wished to protect the other, and their parents wanted to shield both. But, by May, Gilbert 'has passed his St John's Ambulance exam. He has got orders to go to Eastleigh.'[20] Eastleigh, near Southampton, was the clearing hospital for the Southern Command group of hospitals which took the brunt of the casualties arriving from France. Rapid expansion of the service demanded more medical orderlies. At the last moment Gilbert's orders were changed. He was to proceed to Bristol and there enlist in the Home Hospital Service of the Royal Army Medical Corps for duty in a newly created hospital, the Beaufort War Hospital, on the outskirts of the city.

Back in Cookham the family eagerly awaited Gilbert's news. Pa consoled himself with the thought that 'the discipline will do him good', for Gilbert was regarded as the wilder of the two youngest brothers. When his letters came, their message was disconcerting: 'Gil says that they intend to kill him if they possibly can. He works from 5 a.m. to 8 p.m. . . . the way he is living is unhealthy . . . the men are horrible . . . they have not inoculated him and yet there is enteric in the next ward. He wrote his letter to us in bed, he gets no rest. . . .'[21] Gilbert stressed that Stanley should not follow him, at least not to the Beaufort. The work would be too heavy, and he should aim for a convalescent home.

To no avail. Stanley too had now passed his St John's examination – 'which was a farce as only about three questions were asked and I don't remember being asked or answering any of them'[22] – and was at last able to persuade his parents to let him volunteer. On 23 July he sent postcards to his friends. To the Raverats he wrote: 'Am going to Bristol. Ma seems very well about my going away. Sydney now has a commission and is a 2nd Lieutenant in the Norfolks.'[23]

Stanley put on his straw hat and Burberry raincoat – it threatened thunder – and, carrying a gladstone bag, made his way out of Cookham by a roundabout route along Sutton Road. He had slipped quietly from home to avoid emotional farewells, and taken an unusual direction to minimize lingering memories of the village.

On the way the thunder-shower broke and his straw hat was ruined. When he reached Maidenhead Station, he was embarrassed to find that his father had cycled in to see him off and was the only fond parent there. The little party of volunteers presented their Civic Guard instructor with a stick with a horse's head handle and then, as the train moved out, Pa compounded his son's embarrassment by calling out to the orderly in charge of the party to take care of him as he was 'valuable'.

How could they know that he was to become one of the century's most celebrated artists? Who would tell the 'rather superior but nice young man' from the Maidenhead branch of W. H. Smith's that the eager, talkative, wiry and boyish young man sitting opposite him was someone whose paintings were already attracting attention? To the others in the party he was just another recruit, good at drawing and something of an artist. But, like Stanley, they knew that as the train drubbed westwards they were being carried away from the familiar and, in Stanley's case, the beloved. The agony of that day was to infuse one of Stanley's most remarkable paintings, his *Christ Carrying the Cross*.

Christ Carrying the Cross

Painting with me was the crowning of an already
elected king.

Stanley Spencer[1]

ACADEMIC CATALOGUING stresses the chronological dating of
an artist's work. In Stanley's case, the exact date of painting may
bear little relation to the emotions of its genesis. He could, as in
The Centurion's Servant, be attracted (1913) to a theme for one
reason, fail to find any suitable visual association, let the project
gestate and then (October 1914) discover that his current emotional
circumstance provided just the trigger he needed. In subsequent
paintings the gap could extend over many years. On the other hand
he could happily paint a picture, keep it unseen for years, then
suddenly produce it out of current context. So too he could produce
what seemed to be a new work but one which proved to be
essentially a reworking of themes in earlier works. Stanley's life
and art cannot be compartmentalized. Both were a vast rolling
pageant in which each new painting related to what had gone
before and would illuminate those which were to follow.

Consider his emotions on that day of leaving Cookham for the
war. There was natural apprehension about how he would fit into
his new life. But the greater fear was that of the rupture of his
Cookham spiritual life which he guessed must follow, and of the
hurt to his father who valued him and his mother who, despite her
brave front, was anxious for him. He was the last of their sons
young enough to go: 'In the months that followed the declaration
of war, I [Florence] was called upon time and time again to stand
by the younger sons as one by one, letting their little mother down
as gently as possible, they took up their Cross and went.'[2]

Christ Carrying the Cross, an evocation of the Fourth Station
of the Cross, can be interpreted as a flowering of such feelings. It

was not in fact painted until after the war, in 1920, but its detail is so apt to Stanley's recorded description of the day he left home that a correspondence is inescapable. We can begin with the three figures in the centre of the bottom part of the picture to the right of the line of five men looking through railings. This trio, Stanley says, depicted himself and friends: 'As youths we stood in a gate opposite our house [presumably the gate of Ovey's Farm] and watched people go by on Sundays and in the evenings. The three men in the central part of the bottom of the picture form the onlooker part of the scene'[3] – so that by implication all the others

Christ Carrying the Cross

87

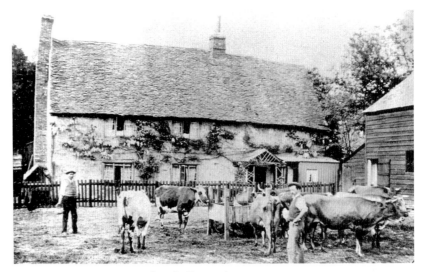

Ovey's Farm, about 1900

are participants. Once more Stanley stands outside an emotional situation in order to watch a transcendence of his feelings into visualized allegory. He later likened the scene and its watching youths to a newspaper account of crowd reaction at the funeral of Queen Victoria. The journalist, anxious to convey the solemnity of the occasion, proclaimed that 'women openly wept and strong men broke down in side streets',[4] an overstatement which became a catchphrase, and one which Stanley would merrily quote on occasion.

'To the left of the picture is a wide street coming towards the spectator, through the iron palings at the side of which other men peer down at the stooping figure of the Virgin.'[5] There being in reality no 'wide street coming towards the spectator' at the side of Fernlea – the house shown in the painting has been coalesced into Fernlea-Belmont – Stanley has emotionally eliminated all the buildings between it and Sutton Road, the 'wide street' down which he went on his way to Maidenhead to avoid lingering memories of Cookham.* He has thus slid together in association

* 'I was very much moved at the thought of doing this picture. I felt so convinced as to great many parts of it. I liked being able to combine the two atmospheres of Fernlea and Belmont.'[6]

the two notions of 'home' and 'departure from home'. Fernlea-Belmont has taken the situation in the village of the Methodist Chapel. Ma, who felt the parting so keenly, has become metamorphosed into the Virgin Mary, not because Stanley saw her sentimentally in that guise, but because he is sympathetically capturing in the transfiguration the utter agony of her feelings. She is a distraught figure barred from her son by the 'iron palings' – Stanley has given them the semblance of military spears – 'at the side of which other men peer down'. Examine these other men. Each is a manifestation of a white-faced, agonized Stanley. They are the five Spencer sons gone to war of Gilbert's *Crucifixion*.

Stanley 'looks down' on Ma, for in the kinesis of emotion in the painting, Ma is now a receding, diminutive figure, appearing as she must have done when in boyhood he climbed the walnut tree in the back garden of Fernlea, the tree from which he could 'survey the worlds not only in our own garden but the other gardens beyond',[7] so giving him once again the feeling of distance and isolation which this sad occasion invokes. As an associative element, the feeling is brought into the picture as the ivy which covered the neighbouring cottage, The Nest, in which an elderly couple, the Sandells, now lived. Stanley's grandmother had come to live at the cottage when old Julius died, his business being continued by a son of the previous marriage, Stanley's 'Uncle John'. Old Mr Sandell had been one of the firm's employees and was allocated the cottage when the grandmother died.

A resolute Christ – with the profile of Pa – is escorted by four soldiers whose winged helmets reproduce those worn in early Renaissance paintings.* Followers, or disciples, are with Christ. He too is about to round the corner into Sutton Road, to leave behind his lingering memories of Jerusalem. On the right, men shoulder the ladders of Bosch's version of the event to mount Christ on the Cross, but for Stanley they are Fairchild's builders' men counterpointing the tension by carrying their ladders to some prosaic job at which they are due, the imagery of Cross and ladders interlinked. They go about their business indifferent to the young

* Wyndham Lewis had used similar military imagery for his six stark costume drawings for *Timon of Athens* which Clive Bell had hung with Stanley's *John Donne Arriving in Heaven* in the 1912 London post-impressionist exhibition. The drawings may have registered with a Stanley visiting the exhibition to see his painting there.

man in a raincoat and straw hat who carries his gladstone bag up the street; just another recruit off to the war like so many other young men of the time. Passers-by hold up their hands to shield their eyes from the low July sun as they watch.* From the windows of Fernlea-Belmont a congregation of figures, echoes of Stanley's family, of himself in childhood happiness, of his uncles, aunts, cousins, friends and family maids, look out to reinforce his memories of home. Old Mr and Mrs Sandell, whom the family loved and who loved them, are at the side window of The Nest. The lace curtains blown out by the draught from the open windows on that sultry summer day have been transformed into wings. The onlookers in their silent commiseration have taken on the protectiveness of angels.

When some years later the Tate Gallery showed the painting, they mistitled it *Christ Bearing His Cross*, which for Stanley implied 'a sense of suffering which was not my intention. I particularly wished to convey the relationship between the carpenters behind him carrying the ladders and Christ in front carrying the cross, each doing their job of work and doing it just like workmen. . . . Christ was not doing *a* job or *his* job, but *the* job.'[8]

The comment is again significant in interpreting not only this painting but much of Stanley's visionary art. He is warning us away from seeing the painting in terms of pure emotion. However sad his feelings and of those around him on that day, the painting is not ultimately about those feelings, and he is not imputing them to Christ. Christ is simply doing *the* job he has to do, as Stanley, off to the war, is doing what he has to do. The job, the fact, the event exists in its dispassionate reality. Stanley's struggle to use recalled emotion in the creation of visionary allegory meant that he had to detach the emotion from whatever event aroused it for him. Throughout his life, the struggle, both in behaviour and in art, will continue, making his actions seem detached at times. When, for example, in his letters or writings he reveals strong feelings about an event, they are seldom concerned specifically with

* Light had allegorical meaning for Stanley, not only in itself, but also in its direction. In those visionary paintings which held joy for him, such as *Swan Upping* and, later, *The Cookham Resurrection*, sunlight is from the east, suggesting a dawning of awareness. But in other Cookham-paintings like *Christ Carrying the Cross* and in future works like *The Betrayal* (1923) in which he is making use of distressful feelings, an equally strong sunlight comes from the west and is the light of evening.

the event itself or with the cause of the event, but with his own or others' ability – or more usually inability – to appreciate the implications, the transcendence, he finds in it.

Such detachment however does not imply that he was anaesthetized to the emotions he was recalling. Twice in his comments on the painting Stanley refers to the three onlookers – himself in recollection – as 'louts', a strongly condemnatory epithet in his vocabulary.[9] The most likely reason is that the dilemma he is recollecting in the incident is so strong that he finds it necessary angrily to belittle it. He transfers the pain of his self-searching to painted representations of himself watching his more visionary self dredging from his memory-feeling the painful visual elements so necessary to composition. Like someone half in and half out of a bad dream he introduces a defensive technique to limit his pain. He turns himself into a doppel-Stanley. Indeed in this case the procedure armours him sufficiently to be able to tell a later friend with some good humour that he is aware that his depiction of Fernlea-Belmont 'looks rather like a diseased potato'.[10] But there speaks the everyday Stanley. The visionary Stanley knows that the imagery, strange though he finds it, is exact to his purpose. It is, he says, 'wonderful'.

In this painting, *Christ Carrying the Cross*, Christ the Son of God is preparing for the final agony which will redeem his creation. Stanley too is entering an agony with the same inevitability. He will endure whatever befalls him in the implicit trust that he too must find redemption in his own purpose and creativity. In the top right of the painting Stanley inserts, out of its true position, one of the cowls of Cookham's malthouses. His grandfather is said to have had the building of them. The eye of God is upon him.[11]

Stanley has given the painting flat tones and an unfamiliar, abstract quality, almost a floating sensation. Looking back, he doubted whether it conveyed the transcendence he sought: 'The Cross, as far as its position in the picture is concerned is right enough. But I still feel it is a pity that I failed to arrive at the notion I had hoped.'[12] The Cross and its transfiguration of the material into the spiritual is the theme of the painting. When Stanley's dealer subsequently asked him if he should catalogue it as *Christ Carrying His Cross*, Stanley again furiously corrected him. Its title, he said, was *Christ Carrying the Cross*.[13] *The* Cross is universal.

It represented for Stanley, as he assumed it represented for all, a necessary submission to the perpetual confusions and frustrations of existence from which it is our purpose to seek redemptive meaning. All Stanley's powers of spiritual awareness would be needed if he was to find the true meaning of the agony of the next four years.

PART TWO

The Confusions
of War

1915–1918

Ablutions

The Burghclere Chapel:
The Beaufort panels

'An ideal place for a sick man. No wonder they so
rapidly recover.'

King George V to Lieutenant-Colonel R. Blachford,
Superintendent of the Beaufort War Hospital,
September, 1915[1]

IN LATER LIFE Stanley was to assert that after 1919 he resolutely
'turned his back' upon the Great War. In the sense that he did not
use his experiences in the way that many of the war poets and
artists used theirs, his assertion is valid enough. But to interpret
his statement as discounting all war influence in his art is patently
absurd. War memories can be traced in many later paintings, and
without some knowledge on our part of their origin in his war
service, the force of these paintings is diminished. For Stanley, as
for countless young men of his generation, the shock of war was
to prove ineradicable. Only time, or in Stanley's case an attempted
sublimation offered comfort, and the greatest of the redemptions
he undertook was the Sandham Memorial Chapel at Burghclere
painted between 1927 and 1932. Of the sixteen side-wall panels
in that masterwork, ten re-create the Beaufort War Hospital.[2]

The hospital, Stanley's 'roaring great hospital' – it had 1600
beds – had been hastily converted three months earlier from the
Bristol Lunatic Asylum. Most of the thousand or so inmates, men
and women, were moved to rural asylums, about eighty being
retained for domestic duties. Assigned to the patronage of the Duke
of Beaufort, the *ad hoc* hospital was a typical 1860s institutional
building comprising a central administrative and service block
from which ward wings extended right and left. Across these, at
intervals, other wards ran transversely, enclosing small courts. The

right half, facing the building, had been the male half, the left the female. The male hospital staff had been 'volunteered' into the Royal Army Medical Corps with rank appropriate to their status; the superintendent and medical staff as officers, the administrative and supervisory staff as sergeants and corporals. The female staff, having no surgical nursing qualifications, became auxiliary nurses, augmented by Red Cross nursing volunteers and supervised by an intake of army nursing sisters from Queen Alexandra's Imperial Military Nursing Service who, as most old soldiers will confirm and as Stanley was to discover, were formidable authoritarians. There Stanley joined a number of young volunteer orderlies like himself. Because they were known only by surname, and Gilbert, having arrived first and being bigger in build, was mistaken as the elder, Stanley was invariably referred to as 'young Spencer'.

The first panel on the left wall in the Burghclere Chapel, showing a *Convoy of Wounded Soldiers Arriving at Beaufort Hospital Gates*, hints at Stanley's impressions on arrival. The wounded were shipped to Southampton from France or to Avonmouth from the Dardanelles and were entrained in 'convoys' to Temple Meads Station in Bristol. From there they were ferried to the hospital in a motley collection of vehicles or, as in the case of the 'walking wounded' in the painting, in requisitioned omnibuses. At this still excited state of the war, they were cheered through the streets of Bristol by passers-by. A convoy could consist of several hundred patients and the duty staff had to work frantically to register, examine, bath and install them with their kit – the *Sorting and Moving Kitbags* panel.

The orderlies, normally two to a ward, came under the jurisdiction of the Ward Sister. Their duties combined those of a modern hospital porter with those of a ward auxiliary. They had to make beds – *Bedmaking*; do dressings, as in scraping the dead skin from a patient's foot in *Patient Suffering from Frostbite*; and scrub and polish everything in sight – *Ablutions, Scrubbing the Floor* and *Washing Lockers*:

I have done nothing else but scrub since I have been here. I think it has done me good. I think with pleasure of the number of men I have bathed every Wednesday morning. I have to bath patients at 6.00 a.m.; I do it in an hour and a half. When I am seeking the Kingdom of Heaven I shall

The Beaufort War Hospital, about 1915.

tell God to take into consideration the number of men I have cleaned and the number of floors I have scrubbed, as well as the excellence of my pictures, so as to let me in.[3]

Stanley found himself fetching and carrying from the Stores and Kitchens – *Filling Tea Urns*; preparing tea – *Tea in the Ward*; and sorting and fetching the ward linen and laundry – *Sorting Laundry* – together with other activities he records in his memoirs but did not illustrate. Later we shall need to ask ourselves why he chose these specific events for painting.

In addition to ward duties, the orderlies were required to attend military parades and to join in physical training: 'I remember being rather glad the sergeant who took us on our morning's route march and double had a girl at one of the cottages en route, so we were allowed a long halt outside this cottage and sometimes she came out and reviewed us pawing the ground and champing at the bit.'[4] It was a long day. Reveille was at 5.00 a.m.; on duty from 6.00

97

a.m. to 6.00 p.m. or even 8.00 p.m., with breaks for parades and meals. Off duty, the orderlies could on occasions get a leave pass into Bristol until 10.00 p.m.; they would be inspected for their turn-out by the gate sergeant, Sam Vickery. Otherwise they could relax in their quarters or play cards, chess or billiards.

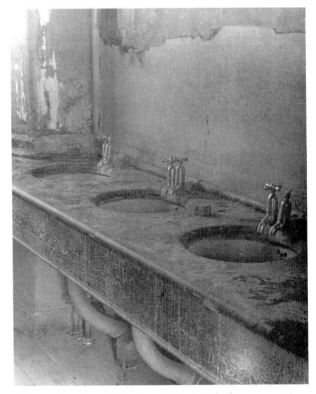

The washbasins of *Ablutions* (Ward 5), before renovation. The hot-water taps were added after Stanley's time at the Beaufort. Although feeling in his composition is subtle, his presentation is observationally accurate.

Their duties were regulated from the office of the Hospital Sergeant-Major, William Kench. He was one of the few men Stanley met who utterly terrified him. Even the 'most martenesh' of the Sisters avoided him if they could. He was, says Stanley, 'a

gigantic man, whose eyes paralysed me. . . . He was quite terrifying enough even when he did not wear puttees. But if you came anywhere near him when he did wear puttees' – that is, when he was in formal parade dress – 'God help you!'[5] Stanley remembered in particular his huge hands, and the way he walked with them stuck into his tunic pockets so that only his 'fat thumbs' protruded. Then aged fifty-three, Kench had served when younger in the Royal Marines and had joined the Asylum staff as Head Male Nurse about 1906. He lived with his wife and family in a hospital house and had the habit of exercising his large Airedale dog in the hospital grounds. Only one orderly, according to Stanley, ever had the temerity to try and make friends with the dog. Stanley himself, in passing it, 'felt all apologetic, sort of, saying to myself, well that's all right. . . . I would imagine the expression on my face would be stern but hopeful and guarded. Not a bit of it – terrified and furtive more likely!'

Kench's office was off the corridor system which runs transversely through the administrative block, windowed and tile-floored at the reception end but darker and stone-flagged where it entered the main service area at the rear. A clerk did the paperwork and one of the male 'loonies', known as 'Deborah', acted as Kench's orderly or runner: 'His face was long and egg-shaped with a short scrubby white beard and bald head. I felt he could claim some mystical discipleship with the Sergeant-Major. If the Sergeant-Major was God, Deborah was St Peter. He slunk about with short shuffling steps and never looked up. If he did, it was only when he thought no one was looking.' Whatever Stanley's strictures on him, Kench was evidently an NCO of the old type doing his best to knock into shape a clutter of intelligent, hard-working, responsible, but largely unmilitary volunteers and, more urgently, to keep control of a rumbustious horde of lively young convalescents delighted to be in Blighty for a while and out to make the best of their luck.

Stanley found himself assigned to a group of wards towards the end of the male wing which surrounded one of the newly built operating theatres.* His reactions in his memoirs and his letters

* These were wards 4, 5, MI and MC. In Asylum days each ward had a separate dayroom and dormitory section, but as a military hospital both sections were used as wards. The dayrooms became the 'a' sections and having wallpaper and pictures, were different in appearance from the 'b' or dormitory

offer a valuable glimpse of the unique way his mind worked. Except for occasional comments, he was not interested in recording his activities. He is silent too on highlight events at the hospital which excited the other orderlies – a royal visit by King George V and Queen Mary,* hospital billiards and chess matches, sports competitions, stage shows and entertainments, the daily gossip of any closed institution. He was not supercilious or forgetful about them, indeed they amused him as greatly as they did the other orderlies, but they had no bearing on his need to analyse and explain to himself his art and vision. It was to the service of his vision that all else had to be subordinated, and he saw the hospital and his life there only in the light of its contribution or damage to his creative life. Thus his writings on the hospital – indeed his war writings generally – give a picture of life which does not intend to be descriptive, but explains only those spiritual or visionary aspects of the total experience which held meaning for him.

With this in mind, we can begin to define more precisely how Stanley saw the individual aspects of his hospital experience. Although disorientated at first, physically and emotionally, it did not take him long to adjust physically. His essentially cheerful nature, his sense of responsibility in his duties, his meticulousness and honesty of purpose, together with his prodigious energy, made him a likeable and respected comrade. Unlike Gilbert, he felt no resentment: 'Please send me my St John's Ambulance Certificate as soon as you can, as they want it. It is quite all right down here. You get your food all right but you have to push for it. But you get plenty, at least for me. They seem to be quite reasonable, I mean the sergeants etc.'[6] But his emotional disorientation was more alarming, because that same sensitivity which so elevated his creative instincts made him fearful of failure in a situation which all his instincts told him he should honour, but to the everyday

wards. This difference is reflected in several of Stanley's Burghclere Chapel depictions. MI was the hospital abbreviation for Male Infirmary, the ward in which male patients in Asylum days were treated for purely physical ailments. MC was the corresponding convalescent ward. The initials gave rise to some confusion. Stanley in his memoirs mistakenly thought MI to stand for Medical Inspection, and Carline assumed it to mean MI (Emm One). Some of the connecting corridors in the building were also used as wards.

* The visit took place on Tuesday, 7 September 1915. The King was escorted round the wards by Lieutenant-Colonel Blachford, the Queen by the Matron, Miss Gilson. The off-duty orderlies were paraded for inspection.

The Burghclere Chapel: The Beaufort panels

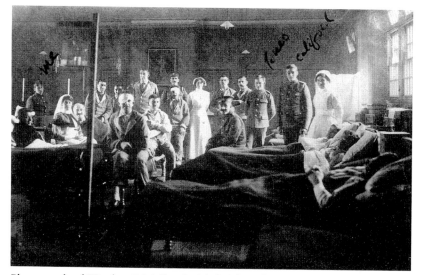

Photograph of Ward 4. 'Me' (Stanley) left. The other named orderlies are Jones and Culliford.

reality of which he knew his values could never fully subscribe.

Stanley could only let impressions flow into him. There was no possibility of any counterflow outwards in imaginative creativity. The disciplined routine of the hospital not only did nothing to encourage creativity, but by the rigidity of its system damped down the least spark of it. Leaves – thirty-six hours every month – were too short for Stanley to do more than turn over his abandoned paintings at Fernlea in nostalgic recollection. As far as the hospital was concerned, 100066 Pte Spencer S. was merely a cipher; two legs and a pair of working hands. Individuality was to be suppressed in conformity with military and medical demands.

Unlike the more restless Gilbert, Stanley, in so far as his duties were concerned, was not at all rebellious. He understood and acquiesced in the need for the suppression of individuality, 'not to be in the least degree out of my slot.' The trouble was not that he was unwilling to adapt, but that he found it difficult to do so, and felt depressed and inadequate when he failed. 'Tickings off' from sergeants and Sisters which washed over the majority of the orderlies haunted the sensitive Stanley, not in a nervous sense, but because he could not integrate them into his more questioning view

of life. Whatever he sensed as natural and instinctive – and therefore joyous – was incomprehensibly forbidden. Even to whistle a few bars of Chopin while passing a ward where a gramophone played was sufficient to earn him a ticking off from a Sister, so that he began to feel that if the sky were blue or the sun shone or the

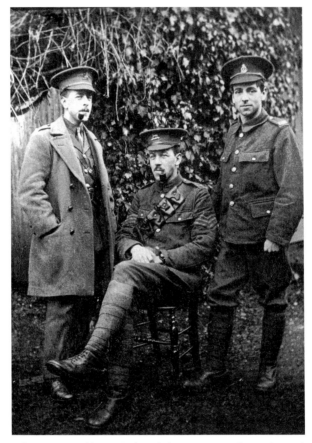

On leave in Cookham. Sydney left, Percy seated, Stanley right.

Sergeant-Major remarked in his hearing to the Colonel that it was a glorious day, none of this related to him. The blue sky and the sunshine became equated in his mind with the hospital itself; all including the 'luscious girls' who visited belonged solely to the Sergeant-Major. Private Spencer was of no more significance in

that world than the stripes on the Sergeant-Major's shirt, on which every stripe had to match exactly every other in willing deference to their owner: 'Why should I have been so sensitive to these things, I wonder? Because I had always been easily crushed and because I was sociable and loved human contact when it was harmonious and [was] horrified at the sign of hatred in anyone of myself.' Stanley's use of language remained idiosyncratic throughout his life. It is impossible that anyone in the hospital 'hated' him; quite the reverse. But by Stanley's etymology anyone who continually ticked him off or criticized him was not being 'friendly', and as the opposite of friendliness can be interpreted as 'hatred', so they were, in a deeply argued sense, giving 'sign of hatred'. By the same reasoning, anyone who kept insisting he do things their way, especially when he was having difficulty in doing it at all, was being 'bullying'. Hatred and bullying combined to produce an 'alien atmosphere' in which he felt his spirit 'crushed' in the sense that he was denied the spiritual 'harmony' in which his free-ranging mind had the comfort to wander at will.

It is of some importance to reiterate that these sentiments pertained mainly to Stanley's inner self. They were feelings that he found difficult to explain easily to most of his comrades. One who understood was Lionel Budden, a young lawyer from Dorset, for he and Stanley had discovered that they shared a common interest in music – Budden was a skilled violinist who often organized hospital concerts – and the pair enjoyed long discussions together in walks around the hospital grounds and into Bristol. To the rest of his fellows Stanley was a friendly, hardworking comrade, as amused as they by the incomprehensibilities of military logic and the antics of authority. Perhaps with his 'obsession for art' as one orderly there described it in letters to his girl,[7] he was rather more than they an unmilitary square peg in a military round hole; but, for all that, none found him a dreamy incompetent who could easily be put down or trifled with. His sensitivity may have inwardly torn him apart at times, but he was never a wilting flower in the exterior sense. He had no hesitation in proclaiming his dogmatically puritanical views on such matters as drink, betting and casual sex, but he had the tact not to force his convictions on others. In any case, most of the orderlies were young men of similar background and held comparable views. Nor would Stanley tolerate

any mockery of himself or his opinions; he could defend himself with waspish quick-wittedness, as surprising to the recipient as it was wounding.

In the middle of the corridor which connected MC Ward with Ward 5 were three steps which were the unwritten dividing line between the two wards. It is intriguing to find Stanley pondering the significance of these steps in the way he remembered his garden walls at Fernlea. Like the party wall between Fernlea and Belmont, the steps became for him subtle symbols of the division, so apparent in his early paintings, between different 'atmospheres'. Like his garden at Fernlea, Ward 5 as 'his' ward was part of his emotional 'cosiness'. But when in his scrubbing he reached the three steps he was in a quandary. If he went on and scrubbed the steps, was he trespassing on another 'atmosphere', another Sister's empire and another orderly's preserve? On the other hand, if he failed to scrub the steps and was thereby ticked off by his own Sister, had he in fact failed to define his proper world? He was perfectly willing to agree to either course of action, but the precise clock-like characteristic in his thinking which made his drawing so accurate in line compelled him to seek mental assurance and to 'know' which alternative was correct: 'I never attempted to dodge any of the inevitable duties. My "dodging" consisted of meeting squarely all the innumerable but analysable shocks which continually beset me.'

All his life, Stanley's greatest dread was disturbance to the equanimity, the 'spiritual harmony' which he continually and painstakingly evolved for himself in any situation. The state of equanimity was built up by 'analysing' the puzzles which had beset him in that situation; it was as though he were mentally and emotionally standing outside the situation and formulating his role in it in the way he showed himself contemplating himself in *The Centurion's Servant* or was to portray in *Christ Carrying the Cross*. The possibility of something happening to disturb that equanimity was to him 'fear of attack', and he was to attribute much of humanity's irrational behaviour – sin, evil – to defence against the possibility. He himself loathed being put into a position of such defencelessness.

Says Sister S., 'Tell Mrs D. [Miss Dunn, the former Asylum Matron] that for the last meal there was barely enough for twenty-two patients, let alone thirty.' So I am called upon to deliver a slap to this formidable lady. I have to say something, as I know I shall be questioned by Sister S. on my return. I was continually having to be a buffer between two opposing parties.

Such orders, which involved competitiveness or the possibility of failure or the humiliation of a disclosure of personal inadequacy, were 'shocks'. Under normal circumstances, Stanley could cope with them, find his way through them. But 'everything at the hospital was so quick'. Shock followed shock too quickly for meaningful adjustment.

There were a few quiet backwaters where Stanley could for a time find calm. He could occasionally slip into the laundry cupboard by the Sister's office in Ward 4B, always leaving the door open, to refresh himself by thumbing through his precious Gowan and Gray art books. These small inexpensive handbooks were a source of mental comfort and several were among his effects when he died. He found congenial too those sections of the hospital wherein the Sergeant-Major's writ did not run – the hospital laundry, even though under Miss Dunn, or the Stores, under the Quartermaster-Sergeant, 'Mr' King, whom he later described as the Pope to Kench's Mussolini. These were havens where he could momentarily recapture something of his Cookham life. For similar opportunities of contemplation, Stanley welcomed being sent on routine journeys to other parts of the hospital such as the X-ray department or the pathology laboratory which were in the original female wing. The mirror-image sensation which had captured his imagination in the Fernlea-Belmont neighbourliness at home continued to fascinate him at the Beaufort. In the former female wing everything was repeated but the other way round, and on each journey he had the sensation of entering a looking-glass world.

None of the daily shocks, the reprimands, the agonies of being made responsible for actions not in his power to accomplish, the long hours of tedious physical work and the barren intellectual atmosphere which gave so little opportunity for the contemplation so vital to his nature – none of these would have mattered if only he could have assimilated them into a revelation of some deeper

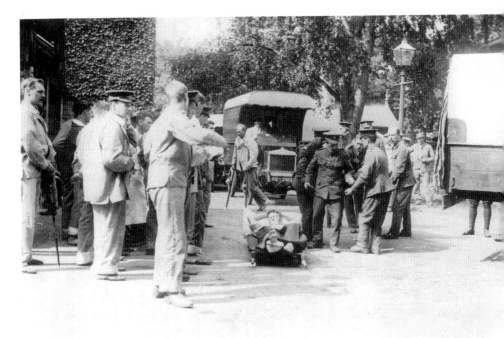

A convoy of wounded arriving at the Beaufort in makeshift vehicles, 1915.

meaning: 'I did not despise any job I was set to do, and did not mind doing anything so long as I could recognize in it some sort of integral connection with the spiritual meaning that demanded to be clarified.' The problem at the Beaufort was that the 'integral connections' would not materialize in his mind, leaving him confused and frustrated. One of the 'shocks' was the frequency with which the 'atmosphere' of his ward kept changing:

Every bit of change, no matter how slight or often, would be felt [by Stanley] and the arrival of a convoy – two hundred or more would arrive in the middle of the night – was the most disturbing change in this respect. One had just got used to the patients one had, had mentally and imaginatively visualized them. One's imagination, once it had taken hold of the whole of an affair, cannot conceive of anything in that affair being altered or different or in any way being added to or detracted from.[8]

But now, at the Beaufort where 'everything was so quick', although

the essential significance of the ward remained inviolable – 'unchangeable' – the visualization Stanley needed to express it would, like a will-o'-the-wisp, disintegrate before he had the time to establish it: 'What will the world be like tomorrow? What about Courtney and Hines when the beds between them are filled? The significance will remain as an eternal factor, but another God-creation takes place in the night, and I will find it in the morning.' In his repeated attempts at image-forming Stanley found himself like a puppy chasing its tail, going pointlessly round and round: 'At Bristol there was no essential change, but on the contrary anything that occurred there was clearly intended to ensure the continuity of its unchangeableness.' Creatively, the hospital was a 'nothing-happening' place.

When thus thwarted, Stanley could give way to anger at those who were apparently baffling him by their obtuseness. There were the other orderlies: 'It is the utterly selfish spirit of these orderlies that makes me wild. . . . being here is wasting time to no purpose. . . .'⁹ There were the ward Sisters: 'Ill-natured, cattish, conceited Sisters who are also incompetent; they make the nurses and orderlies their servants.' And there was the place itself: 'There is something so damnably smug and settled-down about this place. . . . If I can, I am going to transfer into something else. I would give anything to belong to the Royal Berks.'

His frustrations were not improved when in September Gilbert was posted away to the main RAMC depot at Tweseldown in Hampshire; Stanley and Budden took him to *Carmen* at the Bristol Hippodrome on the eve of his departure. Then a fellow-orderly named Tomlin whom Stanley and Gilbert liked took sick and died unexpectedly. Finally, one of the lunatics went berserk and, although Stanley was not shocked in the medical sense, his feeling for the inhumanity of the man's suffering made the event one of horror for him:

I always get the feeling of a man possessed by devils when I see a man in a mad fit. I remember one man, he was perfectly all right, and then suddenly he was cast down and it took about ten men to hold him. He was put into a room, a padded cell at first, but that was not big enough to hold him, so they spread about 12 mattresses on the floor of a room and put him in there. There he raved a day and a night and spat at

everybody, especially when he was being fed. The Sister used to hold his food to his mouth while two or three men held his arms down. His face gave me the feeling that he wanted to pray that the devil would come out of him. He was taken away, but is now all right – in his right mind. Nothing like this is shocking, but to know a man and like him and to know that man is going mad is awful.[10]

So when during October or November of 1915 a notice was pinned on the hospital notice-board asking for volunteers for RAMC service overseas, Stanley thought about it for some days. His parents were the main obstacle. Henry Lamb had written to say that he was about to undertake a crash course at Guy's Hospital in London to complete his interrupted training as a doctor. He would be commissioned in August 1916 and wanted Stanley to wait and become his batman. But, Stanley decided, he was 'too impatient'. When he eventually signed the notice, his was only the second name. But gradually thirty-eight more were added, including that of Lionel Budden. Stanley did not immediately tell Ma or Pa and asked his friends not to do so. In those still early months of the war, even though more than a year had passed, medical standards remained high. Of the forty volunteers, only fourteen were passed. Stanley was youthfully gratified to find himself among them and to learn that Budden too would be going with him. However, army bureaucracy took its time. Some of the volunteers did go, but those like Stanley and Budden in the main batch were kept kicking their heels. In the meantime, several surprising things were to happen to Stanley.

The first was that he was scrubbing the floor of the Dispensary one day when a one-legged Dardanelles patient came in, thrust a newspaper under his nose, and demanded to know, 'Is this you, you little devil?'[11] Flabbergasted, Stanley read an account of a New English Art Club exhibition in November in which his painting *The Centurion's Servant* was highly praised. It transpired that Henry Tonks, having used his surgeon's training to advise on the establishment in France of the many private hospitals and convalescent homes which British patriotism was endowing, had returned to London and, among other activities, set up an autumn exhibition of the New English Art Club of which he, Steer and Brown were the virtual founders. Not knowing where Stanley was, he had

The Burghclere Chapel: The Beaufort panels

written to Pa to ask if paintings were available and, without telling Stanley, Pa had sent *The Centurion's Servant* and another work.* Stanley's reaction was one of fury at Pa's action and of horror at what the press might make of his picture. Mercifully, however, no reviewer put any untoward interpretation on it, and all praised it for a variety of qualities, most of which Stanley had not intended.

In a closed community like the hospital, the news that young Spencer was a 'name' spread quickly. The effect was, said Stanley,

extraordinary. The matron, a great gaunt creature before whom Queen Mary looked quite a crumpled little thing, came down the ward with a veritable sheaf of dailies under her arm determined to track down this great unknown. Even she looked a little less grim and gaunt. These notices were very welcome to me. I had been terribly crushed. They gave rise to such teasing remarks from the Sisters as, 'When are you going to get that commission, orderly?' having scented I was a bit different, or thought I was.[15]

It was not only the hospital staff who found the event of interest. In the residential suburb of Clifton, a tall elegant young man of twenty also read the notices and recalled Stanley as a celebrated predecessor at the Slade. He had studied there with Gilbert, but had not met Stanley. His name was Desmond Macready Chute – the 'chu' pronounced as in 'chew' – and he was a collateral descendant of the great Victorian tragedian Macready. His actor-manager grandfather had run the Theatres Royal in Bristol and Bath and introduced as *ingénues* stars of the calibre of Ellen Terry. Although Desmond had innumerable aunts, uncles and cousins, his own branch of the family had been scythed by consumption. His father had died in 1912, and now only he and his mother Abigail remained to carry on the family theatrical business, centred by then on the considerable Prince's Theatre in Bristol. Tall, good-looking, highly intelligent, literary in bent, deeply read, a capable organizer – he had been Head of School at Downside – a

* It is curious that Stanley says he did not know of Pa's sending of the paintings. Certainly Florence was aware of the arrangements for the exhibition, and knew Pa had sent the pictures.[12] Also Annie, in a letter of 16 November 1915 to the Raverats, told them that 'Mr. W' is 'sending two pictures for Stanley to the New English Art Club'.[13] The family were in the polite habit of keeping the Raverats informed of Stanley's progress. On 19th May 1912, Pa had written to thank them for "their great interest in Stanley's career".[14] Maybe Stanley resented such overweening advocacy.

dedicated musician, sensitive pianist and competent artist, his artistic and religious aspirations soared beyond the limitations of the family theatre. He was, however, withdrawn by nature and showed a tendency to 'nervous prostration'. His indifferent health precluded thought of military service.

The ties between the Prince's Theatre and the Beaufort were particularly close – visiting artistes freely gave their time to military hospital entertainment – and it cannot have been long before talk of Stanley reached Chute. The result was another surprise for Stanley:

It was about this time when I was wondering how to get the mental energy to make the work bearable . . . that I had a visit from a young intellectual of sixteen who, like Christ visiting Hell, came one day walking to me along a stone passage with glass-coloured windows all down one side and a highly patterned tile floor. . . . I had a sack tied round my waist and a bucket of dirty water in my hand. I was amazed to note that this youth in a beautiful civilian suit was walking towards me as if he meant to speak to me; the usual visitors to the hospital passed us orderlies by as they would pass a row of bedpans. The nearer he came, the more deferential his deportment, until at last he stood and asked me with the utmost respect whether I was Stanley Spencer.

This account of their meeting is repeated several times in Stanley's later reminiscences and misled biographers about Desmond's age. In fact it is somewhat dramatized. Writing to the Raverats at the time, Stanley is more factual: 'Desmond Chute is a youth of 20. . . . When I first met him . . . I was on my way to the Stores. . . .'[16]

All his life, Stanley would show a tendency to overcolour some experiences. Invariably they are experiences in which he suffered some 'spiritual' hurt. The tendency was part of his make-up, part of the process by which he transcended the hurt in precisely the way he used his art. At all other times his accounts of experiences are accurate. In this case the spiritual hurt lay some years ahead. At the time Chute's arrival was salvation:

If I were able to express how much this hospital life and atmosphere was cut off and out of the power of any other power than itself, I could make it clear what I felt at the moment of meeting. Compared with the crushed

feeling the place gave me, the army and the war took upon themselves something of the feeling of freedom that one felt about civilian life in peacetime. The appearance of this young man was a godsend. He was terribly good and kind to me and appreciated the mental suffering I was going through.

Desmond Chute, 1916, photographed by Gladys Methuen Brownlee for his twenty-first birthday.

During the first months of their friendship Desmond was fit, and they were able during Stanley's time off-duty to explore Clifton together. Engrossed in conversation, they must have made an odd-looking pair, Desmond well over six feet tall, slim and languid, with reddish hair and the beginning of a beard, and Stanley a slight, dark-haired and brisk figure beside him. They contrasted too in personality, Desmond intellectually reserved, Stanley the

eager terrier zigzagging after ideas which would set his imagination alight. There were visits to Desmond's home, sometimes with Budden, to meet his mother and his aunts. There were visits to the bookshops of Bristol where fine secondhand bargains were to be found. There were 'at homes' at Desmond's friends and with the Clifton hostesses of the day:

I go down to Mrs Daniell's to hear some singing on my half-days. Mrs Daniell has a fine voice and so has her daughter. I felt quite 'crackey' with delight to hear some duets out of *Figaro* and they sang them well. They sing heaps of early French things. A young Slade student named Desmond Chute does the arranging for these visits and he plays the piano. I shall always feel grateful to Mrs Daniell.[17]

Desmond for his part found Stanley an ideal pupil. For although he was four years younger than Stanley and lacked Stanley's intuitive genius, his love of literature and music matched Stanley's instincts.

When I [Stanley] used to visit him, he used to translate so much [of the *Odyssey*] and then read it in the original. Mind you, if he was to read about two pages he could go through to order, whether he had the book or not. Sometimes when we have been out for a walk – wonderful walks – I would begin to ask him about some particular novelist and he would go through the whole novel quoting pages and pages, quite unconsciously.[18]

In the spring of 1916 Desmond suffered one of his attacks of nervous prostration, and their meetings had to take place in Chute's bedroom:

When I think of the wonderful quiet evenings I have spent in Chute's bedroom with the sunlight filling the room and Desmond surrounded by the wildflowers which he loved [in later life Chute became a knowledge-able gardener]. I used to sit looking out of the wide-open window and listen to him translate Homer and *Odyssey*, *Iliad* and Cyclops and the men escaping under the sheep, oh my goodness, it really did frighten me.[19]

It is noteworthy that Stanley is affected as much by the drama of this forefather of all adventure stories as by its verse.

I have looked at different translations of Homer, but nothing to approach Desmond's. . . . Our evenings were so satisfying. He read me *Midsummer Night's Dream* one night and on another night he read me *As You Like It*. I think it is a wonderful play. The colour of Chute's hair is a brilliant rust-gold. It glistened as the sunlight fell on it as he sat up in bed reading. . . . He reminded me in character of John the Baptist. Of course, having studied at Downside, Desmond has a natural grace that makes it satisfying to be with him. [Chute was a devout Roman Catholic]. I mean he has a mind so quickened by God that you can do nothing but live when you are with him.

It was Desmond's patient coaxing which at last gave Stanley a glimpse of the spiritual meaning to be found in his military life. Desmond was reading aloud from St Augustine, and there Stanley found a quotation, a notion, which seemed to provide the key to the redemption he so desperately sought: 'St Augustine says about God "fetching and carrying". I am always thinking of those words. It makes me want to do pictures. The bas-reliefs in the Giotto Campanile give me the same feeling.' The quotation is a paraphrase of a passage from St Augustine's *Confessions*: 'ever busy yet ever at rest, gathering yet never needing, bearing, filling, guarding, creating, nourishing, perfecting'.[20] Other passages in St Augustine could have similarly inspired him:

Therefore He who is the true Mediator – inasmuch as by taking the form of a servant he became the Mediator between God and Man, the man Jesus Christ – in the form of God accepts sacrifice along with the Father, together with whom he is one God. Yet in the form of a servant he chose for himself to be sacrificed rather than to receive it. . . . In this way he is at the same time the priest, since it is he who offers the sacrifice, and he is the offering as well.[21]

The dedication of Stanley's whole existence, the sacrifice of himself to the spiritual sources of his art, destined his art to be a 'mediator between God and Man', a perpetual theme in his writings. If he had not enlisted but stayed at home painting, he would have

continued to 'accept' or 'receive' the sacrifice of himself to his art. But by volunteering into the army, he had yielded the nobility of sacrifice demanded by his art to lesser commitments which had no relevance. He had reduced himself to the role and status of a 'servant'. The function of a servant is to 'fetch and carry', to 'do things to men'. By offering to deny his spiritual destiny as artist, he had deliberately 'chosen to be sacrificed'. The fact that such sacrifice might mean not only artistic but physical death was inconsequential. Sacrifice was a sacrament and Stanley was both priest at this particular sacrifice and the sacrifice itself.

Some such metaphysical revelation – the theme of *Christ Carrying the Cross* – must have come to Stanley as an 'emergence', an exaltation. The meaning to his presence at the Beaufort, ungraspable till now, could at last be visualized. Its impact was joyous. He worshipped and even, in his fashion, loved Chute, who already understood it and had shown it to him. For, at last, with understanding came the urge to compose, to draw, to capture his comprehension:

The sunlight is blazing into the corridor just near the Sergeant-Major's office and I say inwardly, 'Oh, how I could paint this feeling I have in me if only there were no war – the feeling of that corridor, of the blazing light, and the Sergeant-Major and his dog – anything, so long as it gave me the feeling the corridor and the circumstance gave me!' If I was Deborah, the lunatic who doesn't know there is a war, I could do it. His sullen face and shifty eyes – I envied him the agony of being cut off completely from my soul. I thought in agony how marvellously I could paint this moment in this corridor *now*. And if at any time this war ends, I will paint it *now*, that is with all the conviction I feel now; but it can only be done if I feel assured that I am not suddenly going to be knocked off my perch. No! Not quite like that, because that can easily happen. No! Not that! But it was a belief in peace as being the essential need for creative work, not a peace that is merely the accidental lapse between wars, but a peace that, whether war is on or not, is the imperturbable and right state of the human soul; and that is only to be found in the peace of Christ.[22]

The crucial sentence in the passage must be the curious, 'I envied him the agony of being cut off completely from my soul.' It seems

to predicate a notion that in our instinct to find a place in which we cannot be 'knocked off our perch' – a state of being 'home', at 'peace' – we seek those miraculous moments which lift us beyond the physical where we are isolated into our separate existence into a spiritual world in which we are not only at one with each other but with the form and meaning of creation itself. Our lives are odysseys to reach those joyous states. Only in achieving them can Stanley's desire to paint have meaning. Deborah, however mysteriously, was permanently in such a world, and even if his state was not one Stanley sought for himself, he felt it 'agony' that he could offer only sympathy in comprehension, not the empathy of truly spiritual identification.

If the recording of such visionary ecstasy was still impossible at the Beaufort, Stanley at least found the motivation to start drawing again. With his growing reputation came requests for portraits from staff and patients. In later lists he remembered a dozen or so. He was out of practice and the earliest ones dissatisfied him. But later ones 'showed a great improvement'.[23] He invariably gave them to the sitters. Only one seems to have survived, that of 'a tall chap in the cookhouse'. Stanley does not give the sitter's name, but it was Jack Witchell. Having been a grocer in civilian life he had been detailed not to the 'cookhouse' as such, but to the stores. The head was drawn in Jack's small autograph album, and Stanley had to run the top of the head across the fold in the leaves. 'You would smile, dear, to observe young Spencer sketching me,' wrote Jack to his girl. But the event was more of an ordeal than Jack had anticipated, involving two sessions of two hours each. During the second session Jack played chess with Lionel Budden, 'so that I look half-asleep'.[24] Even so, Stanley did not finish Jack's ear, an omission which is artistically comprehensible, but which irritated Jack's precise storeman's mind. He pressed Stanley to finish it, but 'he would not'. However, Jack found the drawing 'very pleasing and quite like me'.

At last Stanley was becoming reconciled. Work went on in the same routine, but even the most fearsome of the dreaded Sisters now treated him with consideration. Being on draft, Stanley was given his overseas injections and was invited to attend lectures and even to watch an operation on an elderly patient named Hawthorn; he was fascinated by the proceedings. But it must have been with

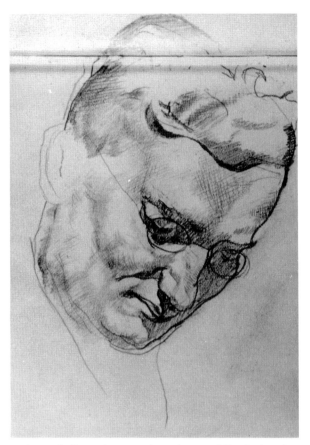

Jack Witchell, aged twenty-four, drawn while playing chess
by Stanley, February 1916.

relief that his draft of ten men learned that their departure was
imminent. It was now well into May 1916: 'I think it will be
Salonika. The Sergeant-Major says so, anyway.'[25]

Suddenly, at short notice, they were off. Jack Witchell, writing
to his girl on 12 May, saw them go:

Budden and nine others have just gone. They had only twenty-four hours'
notice and we gave them a jolly good send-off. Am sorry to lose Budden,
he is one of the best men I have ever met and I trust we have not seen
the last of one another in this world. Spencer was also with them. I should

Jack Witchell, aged sixty-four, still playing chess.

have been with them. I was able to get their autographs just before they left.

There are only nine signatures in Jack's album. Budden's is there, but the missing name is Stanley's. Probably he had permission to spend his last evening with Desmond Chute and so missed the 'jolly good send-off'. Desmond had only just managed to make a pencil sketch of him in time (now in the Stanley Spencer Gallery in Cookham).

Their departure left a gap: 'They will feel us being gone,'[26] declared Stanley, and indeed they did, in more ways than one. To his letter Jack Witchell adds a sad little coda: 'Am feeling a bit down today.'

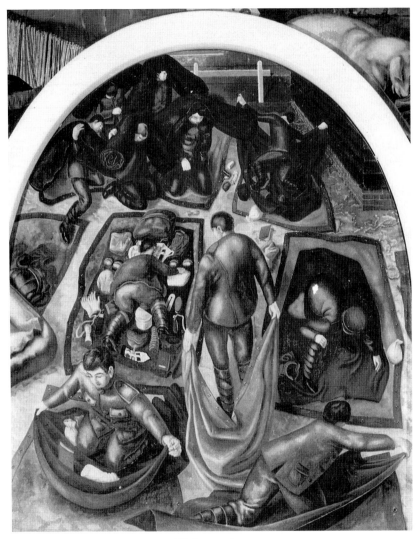

Kit Inspection

The Burghclere Chapel:
Tweseldown

Drinkwater used to work in a place where the clouds
touched the hills where he worked.

Stanley Spencer to Desmond Chute[1]

STANLEY'S group of volunteers was destined for the RAMC
Training Depot at Tweseldown, near Fleet in Hampshire. But
because the Beaufort was administratively responsible to Devon-
port Military Hospital the party had, by the exigencies of military
logic, to proceed to Hampshire by way of Plymouth. Arrived there
he immediately wrote to Desmond: 'We left the Beaufort yesterday
Friday morning. I swept the ward out yesterday morning with
George [one of the inmates whom the orderlies used to tip to clean
their boots]. I felt a bit sad, poor old George was so upset. Have
brought my Shakespeare with me. Remember me to your mother
and aunt.'[2]

The draft, being in transit, had little to do at Devonport apart
from attending morning parades, persuading the mess orderlies
they were entitled to meals, and working out which among the
unfamiliar naval uniforms in the town they were supposed to
salute. Stanley was able to catch up on his correspondence. Gilbert
was in Salonika as an orderly in a Field Hospital. Harold and
Natalie, their orchestral work disrupted, were filling in time as
cinema pianists at Maidenhead, but aiming to move to London
where Natalie, who had fluent Spanish, hoped to work in Intelli-
gence. Horace, back in England, had in March married Marjorie,
'the youngest of the Hunt girls';* 'she is a nice girl and we are all

* The 'three Hunt girls' were daughters of coffee planters in India, educated in England at convent
schools. Marjorie was pretty, and she and Horace shared a love of music and drama. She had been at
finishing school before the war under the supervision of German nuns in the Black Forest, where Horace
sent her letters hidden in books.[3]

fond of her' wrote Pa to Will. Transferred to the Royal Engineers, Horace was then posted to France, but by October was to be back in England in hospital after two bouts of malaria. Percy too was in France, in a Field Headquarters, and had been mentioned in despatches. Sydney was an officer instructor in the Home Training Battalion of the Norfolk Regiment. Henry Lamb was at Guy's Hospital completing his training as a doctor. Edward Marsh, frantically busy, nevertheless found time to propose a small Civil List grant for a struggling writer called James Joyce, then in Zürich. To Switzerland too, Will had departed, to be reunited there with Johanna as two among thousands of international refugees – Lenin also among them – who then crowded that neutral if bureaucratic haven. Will was doing little work and Johanna, barred from returning to Germany, was dependent on infrequent money sent from Berlin; Will had to reduce his monthly allotment to Pa from £8 to £6. Johanna's brother, Max, was reported missing, and Will was anxiously trying to discover from the War Office if he was listed among the Germans taken prisoner.[4] There had been floods at Cookham and fierce gales had uprooted hundreds of trees there.

Stanley was not sorry to leave for Tweseldown after a few days. The hutted camp was on the open slope below the racecourse on the down. He was delighted to be able to see the sweep of the sky again: 'Training is all out in the open, and this is what I like.'[5] It was, however, strict. The *Kit Inspection* panel at Burghclere records Stanley's dislike of the mindless regimentation of depot life. The purpose of the training was to fit him for active service in a Field Ambulance. The function of a Field Ambulance is essentially to collect the sick and wounded from front-line fighting units and to convey them back to Field Hospitals, giving them on the way such emergency aid as could be provided in the Advanced Dressing Stations which the Field Ambulance would set up. Stretcher drill, practical scouting – searching for stray wounded during a battle – the recovery of wounded from the difficult confines of trenches and dugouts, the handling of mules and wagons – normally done in action by Army Service Corps drivers – operation of the vital watercarts with the testing and purification of water sources, and, of course, first-aid and medical procedures, all these topics had to be learned and practised. At the time Stanley thought that the training, though interesting, would not apply to him, as he was

convinced that only the strongest and most resourceful orderlies would be assigned to Field Ambulances; he assumed that he would be detailed to hospital work overseas.

Desmond Chute wrote every day, pouring out the stream of

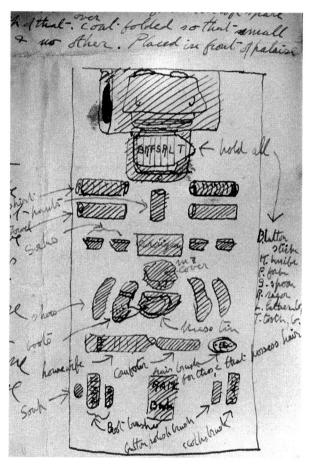

The layout for kit inspection: a sketch by Stanley in a letter to the Raverats.

encouragement begun at the Beaufort. Stanley wrote to the Raverats: 'Chute has sent me a translation of *Odyssey* Book 6, the coming of Odysseus to the Phaiacians [it was a personal, hand-written translation, not a copy of another's] and as I was hut

orderly today I was able to go through it this afternoon. It is all so nimbly written . . . that you feel you have the original wonderful rhythms with you.'[6] To Chute himself he wrote:

It is grand to take your translation out of my haversack and read it during intervals of drill . . . I should like a photo of you. Now that I am here I look back on the time I spent with you and it appears so beautiful to me. It clears my head which gets muddled at times.[7]

The illumination provided by St Augustine's 'fetching and carrying' continued to enthuse his imagination:

When I used to have a full day at the Beaufort, full of every kind of job you could think of, I felt very deeply the stimulating effect 'doing' had upon me. . . . 'Doing things' is just the thing to make you paint. I have washed up the dinner things at the Beaufort a hundred times. How much more wonderfully could a man washing plates be painted by me now than before the war. . . . Every necessary act is like anointing oil poured forth. . . . I am looking back on Beaufort days and now that I am away from it I must do some pictures of it – frescoes. I should love to fill all the hundred square spaces in this [wooden frame] hut with hospital work [paintings] but I have a lot to get over, especially my bed picture propensity. . . .[8]

A curious thing was unsettling Stanley. He was discovering that as his experience and understanding broadened he was seeing his earlier work with fresh eyes. He had just been home on leave and found that his pictures there, although good, were perhaps not as successful in conveying the deeper substance of his vision as he had thought when he painted them. It was a problem which was to engage him all his life. He could only paint from the personal association of a specific time. What was to happen when subsequent associations became more apt?

I really feel at times doubtful if what inspires me will really reach out and achieve all the qualities and perfections that a work of art should contain. I have always gone on the basis that pure inspiration contains *within itself* all the necessary apparatus, practical and spiritual, for carrying it out. If I have found that in carrying out a picture the carrying out was

not doing this or not giving me any great pleasure, then I have concluded that the initial inspiration was somehow wrong or else had to go arm-in-arm with some notion to which it was not perfectly related. But I have not put it down to lack of knowledge; knowledge, that is, as separate from inspiration; something I ought to know and study quite apart from what I want to express.[9]

So in letters home we find Stanley pestering, pleading with, cajoling whoever will listen – Florence, Henry Lamb, Desmond Chute – for books and reading-matter.

An unexpected piece of news which pleased him was that two friends wanted to buy his 'Kowl' painting – *Mending Cowls, Cookham*. One was Henry Lamb, the other James ('Jas') Wood. Stanley had met Wood before enlisting. He was a young man of independent means and outlook who had studied painting in Paris and Germany, and had reluctantly – he saw no point in taking up arms against his old Bavarian friends – joined the Royal Field Artillery. As both were known to Stanley, he wanted both of them to have it, but tactfully he left them to sort it out between them. Lamb won.

As a recruit stationed at Trowbridge in Wiltshire, Jas Wood was miserable for many of the same reasons as Stanley had been during his early days at the Beaufort. Since Trowbridge is not far from Bristol, Stanley thought it might help Wood to meet Chute:

Am going to write to a man named Wood and ask him to come and see you. His military life is getting on his nerves and in fact he has had little chance at any time of doing what he would have done. He has just sent me a book of Donatello, and the other day he sent me a book on the life of Gaudier-Brzeska which you mentioned as having seen in George's [a Bristol bookshop]. I hated Gaudier when I knew him but I agree with you that he is extraordinarily true and certain in his drawing.'*[10]

To Wood, Stanley wrote:

I rather envy you being in the RFA [Royal Field Artillery] and for the

* Gaudier liked to cultivate an outrageous faun-like persona which the forthright Stanley dismissed as the pretensions of a poseur. But Stanley did not extend such criticism into Gaudier's art: 'I think Gaudier has a wonderful sense of living and being, but it is his being I like.'[11]

draft. Chute has been sending me [pictures of] a series of corbels in Exeter Cathedral. . . . This life quickens the soul. I am laying in a goodly store [of ideas]. I am still thinking about the Beaufort War Hospital which the

Gunner James ('Jas') Wood RFA, 1916

more I think about it, the more it inspires me. . . . I am determined that when I get the chance I am going to do some wonderful things, a whole lot of big frescoes. Of the square pictures there will be The Convoy (I have that) and The Operation (and that). . . . I think there is something wonderful in hospital life . . . the act of 'doing things' to men is wonderful.[12]

The Burghclere Chapel: Tweseldown

Stanley's training was nearly over. By August 1916 he was telling Henry Lamb, by then commissioned as a doctor in the RAMC, 'It is true that we are just going. We are even now ready, down to writing our wills. If you have your clothes [uniform] come in them as you will have less trouble getting into the camp.'[13] It must have been a brief visit, but it cheered Stanley: 'It seemed almost too good to be true when I saw you coming down the street. I felt these times were over. It seemed uncanny.'

Pa came over to Tweseldown to see him, because during Stanley's embarkation leave at Fernlea, he had by chance been away visiting Florence in Cambridge. To Desmond Stanley outlined the reading he was taking:

I have sent home my large volume of Shakespeare. Impossible to carry it. Much better to have a play sent [individually] as desired. I am able to take the *Canterbury Tales*, as it is more pocketable. Also the little blue book you sent me [perhaps a Missal]. Some Gowan and Gray art books and, if possible, *Crime and Punishment. The Garden of the Soul*. . . .[14]

News came that he was to leave with Lionel Budden and some 350 others on 23 August. They had been issued with tropical kit. So by train to Paddington and thence to London Docks ('much sound of steel and repairing of ships') and aboard the hospital ship *Llandovery Castle*, 'the wedge widening as we moved away from the quayside, the throwing of letters to be posted by the be-ostriched-feathered Cockney women come to say goodbye.'[15]

The Burghclere Chapel:
The left-wall frieze

Am reading Blake and Keats. I love to dwell on the
thought that the artist is next in divinity to the saint.
He, like the saint, performs miracles.

Stanley Spencer to Desmond Chute[1]

ALTHOUGH in 1916 Salonika with its mosques, narrow streets
and polyglot population still had the appearance of a Turkish city,
it had long been freed from Ottoman rule. Its importance as a port
lay in its situation as the only outlet for Macedonia, the heartland
of the Balkans. Possession of this ancient land of mountains, wild
terrain, pastoral villages and unsurfaced roads had been disputed
by its three neighbours, Greece, Bulgaria and Serbia – the latter
roughly the southern half of modern Yugoslavia – in the Balkan
Wars of 1912. The three contenders, unable to agree on ownership
of Salonika, had been persuaded in the 1913 Treaties of London
and Bucharest to make it a free port.

The outbreak of war in 1914 set the three contenders glowering
at each other again. Serbia allied herself with France in an effort
to avoid the fate of her northern neighbour Bosnia, already gobbled
up by the Austro-Hungarian Empire; it was a Bosnian student
protest culminating in the assassination of Archduke Ferdinand of
Austria while on a conqueror's visit to Sarajevo which had sparked
the Great War. Bulgaria on the other hand allied herself with
Germany, but hesitated to make any aggressive act for fear of
formidable Russian and Romanian armies gathered to her north.
Greece, in whose territory Salonika lay, was neutral but split in
allegiance, her new King favouring Germany and Austria–Hungary
while the Prime Minister, Venizelos, urged support of France,
Britain and Russia.

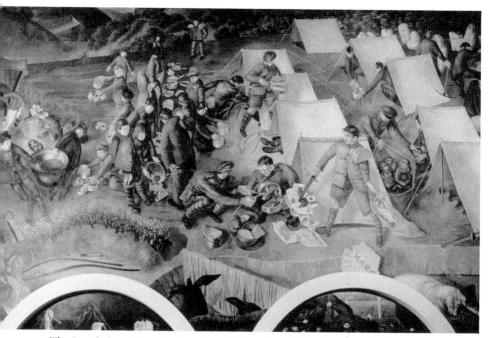

The Burghclere Chapel: the left-wall frieze (part). *The Camp at Kalinova*

By 1915 everything was changing. Russian military power had been virtually eliminated by the German offensive eastwards in the spring. Austria–Hungary had decided to resume her conquest southwards from Bosnia to annex Serbia. The attempt was not very successful until the Bulgarians, satisfied that there was now little likelihood of serious Russian or Romanian interference, decided to join in. The tough Serbs, able to hold off the Austro-Hungarian attack from the north, could not cope with the additional Bulgarian flank attack from the east. They begged help from France, who in turn demanded support from a not over-enthusiastic Britain. Two French divisions and one British were nevertheless landed at Salonika just in time to learn that the battered Serbian armies had given up and were retreating in bitter winter weather away from them over the mountains into a neutral but suspicious Albania. There the French and Royal Navies rescued them and took them down the coast to Corfu to rest and refit. In the meantime the small French and British expeditionary force, meeting head-on the full panoply of the elated Bulgarian armies, fell back to a defensive line around Salonika and howled for help.

The Greeks to their south remained inactively neutral, still undecided which side to join. Reluctant to provoke their hostility, the Germans persuaded the Bulgarians to halt more or less along the Greek frontier. Given this breathing-space and using the free-port status of Salonika as a pretext, the Allies began landing a motley of reinforcements, French, British, Indian, colonial, even a token brigade of Russians. Over the months more formations arrived, including Italians and the Serbian armies from Corfu re-equipped by the French and with British field support. The line lengthened across the peninsula to the Albanian frontier, and the opposing armies settled into an uneasy confrontation across the formidable hills and valleys which divided them.

This was the complex situation into which Stanley and Budden stepped from their lighter on to the waterfront of Salonika. The sea journey had been a wonder to Stanley: 'the sea turning a pale delicate green as it shallowed a little before the straits of Gibraltar . . . the pumice-stone corner of land that is Africa, the sea being a dark-blue lapis colour – a Reckitts blue as Budden called it – and looking west, blood-red as the sun is setting. . .'[2]

But so overwhelmingly did the impressions arrive that even at the sedate speed of a sea journey Stanley found himself unable to digest them as he wanted: 'Change; but more outrage than change. . . . One is going beyond as a human what one is made by God to do. One should grow with experience, and one does not do that at that artificial speed. Had I walked to Salonika, I could have changed in exact proportion as where I got to on the journey. . . .'[3]

There was, however, consolation because he had a companion with whom to share them: 'It was nice to have Budden. I really did not think [his friendship] was so just what I wanted. It was like discovering yourself.'[4] Alas, at Salonika: 'Maybe because of the law of the army, one of which is tallest on the right, shortest on the left, we became separated beyond all hope. It was our only difference. So we were marched off to different camps. We grinned at each other as we solemnly marched off to our various destinations.'

This account to the Raverats – he says the event took place on the quay as they landed – again has a ring of over-dramatization.

The Burghclere Chapel: The left-wall frieze

The losing of Budden was a hurt to his spirit.* At the time, he wrote to Desmond Chute: 'I had to part with dear Lionel Budden at the rest camp here. I have no idea where he went.'[6] He went in fact to the 36th (Serbian) General Hospital at Vertekop, some forty miles inland, one of the hospitals provided by the British to support the reconstituted Serbian army. He had his violin with him. Another disappointment for Stanley was to discover that while he was on the way there, Gilbert had been transferred from his Field Hospital at Salonika to service as a medical orderly on a hospital ship. The brothers must have passed each other in the Mediterranean.

The feel of an army on active service, with its heterogeneous scatter of signposts, tents, camps, dumps, wagons, traffic and groups of khaki-clad men everywhere about their tasks is very different from that of an army at home. Despite the apparent confusion there is an air of purpose. The British front line was some thirty miles north of Salonika. Veterans back from the front were anxiously interrogated by Stanley's newcomers: 'What's it like up there, chum?' From the base camp Stanley could see the hills where the opposing armies lay entrenched. To his left rear lay the impressive massif of Mount Olympus, changing in appearance with the seasons and the sunlight, and pointing the way southwards into neutral Greece. On his left ran the valley of the Vardar (modern Axios), debouching into the Gulf south of Salonika but with its northern source deep in enemy territory. It formed the left boundary of the British sector and was the gateway to the Monastir road, the essential supply route for the other Allied armies inland to the west. On his right a rolling plateau gave way in the distance to the valley of the Struma river (today the Strimon), wide and fertile in its main course, but marshy and malarial at its estuary east of Salonika. Beyond the valley rose steeply a long wall of forbidding mountains forming the main Bulgarian defences in this area, the Struma sector. To attack there, the British had to cross the Struma valley in full view of the enemy, a distance of five miles in places, and the main road across it, the shell-swept Seres road, was to become as notorious to the men of the Salonika army serving on this sector as did the Menin road at Ypres.

* 'Lionel Budden was the only "pal" I had in the army. Since I have lost him I have been silent. My conversation is reduced to Yea and Nay. Not that I am unsociable . . . but I feel estranged from my comrades.'[5]

129

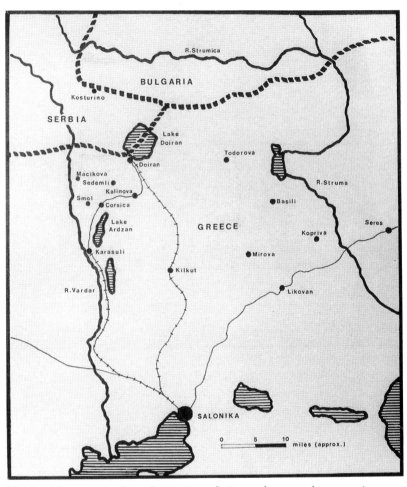

The British sector in Macedonia. Boundaries and nomenclature as in 1914; place-names as spelled by Stanley. Owing to the mountainous topography, the front ran from Seres in the east in an arc north-westwards past Todorova to Doiran and then westwards to the River Vardar near Macikova. The critical sector was that between Lake Doiran and the Vardar, Stanley's 'Vardar Hills'. The front continued westwards of the Vardar, there held by French, Serbian and Italian armies. Main roads and tracks are in thin single lines. The railways to the north were cut at Karasuli and near Doiran. A network of temporary light railways was constructed, but is not shown.

The Burghclere Chapel: The left-wall frieze

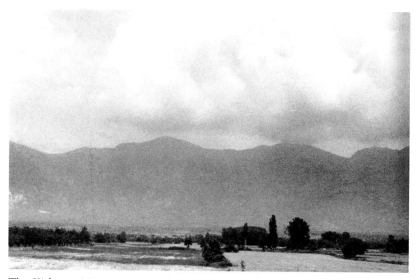

The Kirkenes Mountains near Lake Doiran. Rising abruptly from the plateau north of Salonika, such massifs, seamed by ravines and scarred by precipices, were strongly fortified by the Bulgarians and Germans, and proved an impassable military obstacle. The Couronnés, named by the French after the village of Korona to the west of the lake, constituted part of the formidable mountain defences known to the British troops as The Dome.

If Stanley were to face directly north, he would have seen on a clear day, rising above the plateau which separated the Vardar and Struma valleys, the rounded summits of two hills, known to the French who first made their unpleasant acquaintance as the Grand and Petit Couronnés. Like Monte Cassino in a later war these seemingly innocuous but highly fortified hills effectively blocked any British advance. Beside them lay Lake Doiran, five miles in diameter. Around its fringes and stretching from the Struma to the Vardar, a distance of about fifteen miles, lay the main British front line, the Doiran sector, a maze of trenches and gun emplacements finding what cover they could among the ravines that seamed the slope. It was on this sector that Stanley was to get his first experience of active service.

Stanley cannot have remained many days at the depot after he had lost Budden. He was reading Ruskin's *Modern Painters*, and told Desmond that he was 'starving for music':

Write out little scraps of music that I know. . . . Would it be too much to write out and send me a copy of some of those songs Mrs Daniell used to sing? By Jove, I shall not forget those times! I shall visit Bristol when I come home and we shall have to 'go our rounds' once more. I shall have a lot to tell you. Do send me out some little book, a good Dostoevsky that I have not read or something by Hardy. Send me some Milton or Shakespeare.[7]

He must have been surprised to find himself posted not to a hospital as he had expected but to the 68th Field Ambulance. This was 'up the line' somewhere on the Doiran sector. A twenty-mile train journey took him to the railhead at Karasuli (Polikastron). Sitting on the wooden seats of the carriage and looking out of the window, he had his first real impression of this new land. 'I was entranced by the landscape – low plains with thin lines of trees looking through trees to further plains of fields, and here and there a figure in dirty white. It was not a landscape, it was a spiritual world.' 'A spiritual world': thus the first intimation of the over-powering grip that these parts of the Macedonian landscape were to have on his imagination, and which were to have such influence on both the future of his war service there and on the paintings at Burghclere. The scenery in its changing seasons from spring green to summer brown to winter snow and starkness; the whitewashed stone buildings; the patient peasants in the fields; the wandering flocks of sheep and goats, and the donkeys of this still backward land – all these intensified his admiration for the early Italian painters he so loved: biblical landscapes in an early Renaissance setting. It was as though so many visions of his youth had become reality. A travelling companion offered him a Horlick's Malted Milk tablet. He took it casually, lost in his thoughts, until he realized how 'wonderful' it was, and was profuse in his thanks.

At Karasuli, where the train journey ended, he assembled with a little group of RAMC men and 'my life in Macedonia began'. Travelling with painful slowness in ration oxcarts, they were taken along the main supply road, the 'Karasuli–Kalinova track'. Although busy with traffic and lined with dumps and depots, the road was unmetalled. To Stanley's countryman eye, all such roads were 'tracks'. This one ran at the foot of the south-facing slope of a line of low hills to the right of which was Lake Ardzan and

reminded Stanley of the road at home along Cockmarsh Hill. Over the crests of the hills and down the northern slopes facing the enemy ran the series of deep front-line ravines, the products of violent summer thunderstorms. These ravines were the principal access routes to the British trenches, and where they made breaks in the crests of the hills travellers came into view of the enemy and offered tempting artillery targets. So part of Stanley's slow journey was made in the dark: 'the quiet atmosphere, some man on a horse conducting us to a place in the direction of Kalinova, the oxen swaying from side to side, their heads stretched forward under their yokes, and the grass fire like a huge dragon stretching the length of Lake Ardzan and reflected in it, the wild dogs, and seeing during the night that they did not get at the meat, a heavy stone on the tubs . . . '. Later, he came to know that 'most of what was vital to me in Macedonia was felt along that track. Whatever number of kilos it is, ten or twenty, each is part of my soul. When I think of the places along it and the different parts of this continuous hillside, for me to describe them is to describe something of myself.' Once again Stanley is drawing feeling from his identification with places.

The 68th Field Ambulance was located at 'a place called, I think, Corsica.' Almost certainly this is a soldier's corruption of Chaushitsa, a small, abandoned village some eight miles from Karasuli. 'I slept on the side of the hill with another man, stars overhead, grass fields, and Lake Ardzan twinkling below. . . . Quiet, and murmuring of men's voices, rather comforting. It was dark when I arrived and I had the feeling of not knowing what world I would wake up in. I peered into the hillside and seemed to discern the white objects of bivouacs, or the glowing object of a tent with a candle or hurricane lamp.'[8]

What he awoke to was, of course, his section of 68 Field Ambulance, and the atmosphere of his first impressions is captured in the Burghclere frieze. The bivouac lines are on the right. Each soldier was issued with a waterproof cape eyeletted down the sides. Two of these, lashed together down the ridge and supported like a small tent, made a simple shelter for the two owners. The 'glowing' tents were bell tents reserved for more official or medical purposes. The one in the painting into which an orderly is entering with a cluster of the canvas buckets in which bread was carried,

The Karasuli–Kalinova track, 1988, now little used. The photograph was taken from the slope overlooking the track. The view is towards Lake Ardzan, the remains of which are in the middle distance; it was drained in 1935. Stanley frequently describes this scene in his memoirs. It particularly reminded him of the track along Cockmarsh Hill at Cookham.

was probably the ration tent. The scene is viewed from high above Lake Ardzan, looking northwards across the Karasuli–Kalinova track towards the hillside which rises to the crest of the slope and then disappears down the ravines to the British front line and enemy-held hills beyond.

It was now September. The front was relatively quiet. Much of Stanley's training on active service revolved around new ways of handling patients. In such broken country, wheeled transport was limited to the few main tracks, and stretcher-bearing was prohibitively fatiguing except where unavoidable. The accepted method of conveying wounded in the forward areas was the 'travoy' or French *travoi*. Two long flexible shafts of wood were fastened each side of a mule. The rear ends, steel-tipped, were left free to drag along the ground. The stretcher with its patient was strapped between the shafts. One shaft was longer than the other to minimize bumping over potholes, but as the patient was then tipped sideways and in any case tended to slide down the stretcher, the orderly had the tiring task of holding him under the armpits if he could not

134

The association repeated. Stanley's landscape of the *View from Cockmarsh Hill, Cookham, 1935*. He used the locale again later for a painting of considerable personal significance.

keep himself on. An Army Service Corps driver led the mule.

Over marshy ground, two mules were used, with the shafts slung between them. This was the doolie, or 'dooley' as Stanley calls it, a term possibly derived from the French in India: *douillet* means 'gentle', especially in relation to the sick. When he arrived, Stanley's section was testing a 'cacklet' – French *cacolet* – which comprised two chairs slung in makeshift manner each side of a mule, with a more lightly wounded patient in each. Being light, Stanley was given the part of the patient. He noticed that the harness was chafing the mule and was gratified that his officer took immediate remedial action. Mules, which came mostly from the Argentine, were expensive and Stanley had great sympathy, as he did with all animals, for the hardships imposed on them by man's unnatural demands, even though he frequently complained of their obstinacy – 'my arms used to ache trying to pull them round during turn-out

rehearsals.' Although alert and sure-footed when the going was difficult, they had the maddening habit of simply lying down and dozing off when the weather was hot and the going easy, greatly to the amusement of the lightly wounded occupant of a doolie who sank slowly to the ground while Stanley and the mule driver struggled in vain.

From Corsica it was a relatively short journey northwards over the crest into the ravines leading to the firing line. Periodically the section was called forward to retrieve wounded from the battalion aid posts and take them to field dressing stations. The largest of these ravines was the Sedemli (or Cidemli) ravine, which led to a dressing station in the ruined mosque at Smol, an abandoned village near the entry to the ravine. A local attack by units of 22 Division on an enemy position called Machine Gun Hill had taken place in mid-September, soon after Stanley joined the ambulance, and the shock of the incident and the scene at the Smol dressing station printed themselves on his mind. Often his duties were carried out at night, the stretcher party groping its way in the darkness past ammunition dumps, gun batteries, supply columns of mules and army signallers mending their broken telephone wires. Sometimes, in the confusing maze of side ravines and gullies the simplest method of moving in a consistent direction was to leave the tracks and keep to the watercourses, splashing along in the streams and stumbling among the boulders. Even so, one of their officers – the officers were of course doctors – one night nearly led Stanley's party into the Bulgar lines. The clatter of steel-shod travoys was a sound Stanley never forgot, and all through his life any sudden metallic noise would recall the memory. Artillery fire would sometimes harass them: 'The little man I was with up the Cidemli ravine said he thought he could smell something [poison gas shells] and then became silent. He was in hospital next day and remained silent [shell-shock]. I don't know if he recovered.'

Odd items fascinated Stanley on these journeys – the white shells of tortoises burned in grass fires, or Bulgarian letters, photographs and picture postcards scattered about the ravines from an early French counter-attack of 1915. These abandoned mementoes of another life, of a 'homeliness' even though foreign, seemed to Stanley a link with the universal in man. He 'liked the feel of the Bulgar'. Sometimes, the journeys were even less enviable. He and

a corporal were detailed to open up a new burial ground and chose a spot beside the Kalinova track. They had to bring those who had died of wounds at the dressing station back for burial, doing their best to mark the graves with issue crosses, not always available.*

After a few weeks, Stanley's section of 68 FA moved from Corsica a few miles along the track to Kalinova itself, a former Graeco-Turkish walled village long since abandoned. Stanley loved to wander round the empty streets imagining the life that had been lived there. No longer the raw inexperienced 'rookie' he had been at Corsica, shaken by the first brutal realities of war and gently ribbed by his comrades, Stanley now began to feel himself 'that special being, a soldier on active service.' He was among friendly comrades, accepted as an equal. Emotionally he had 'emerged' from the confusions of his first impressions and had made himself 'cosy'; quite literally so in the physical sense, for as the autumn weather grew colder he and a companion, George Dando, made themselves a comfortable dugout roofed with flattened petrol tins, with even 'a fireplace and a little mantelpiece with a chimney stack'. 'As I look back, I think what a different "me" it was to the "me" at Corsica.'

To his delight, the parcel of books he had requested from Chute duly arrived: 'Mass Companion, Keats, Blake, Coriolanus, Michaelangelo, Velasquez, early Flemish painters, box of chocolates . . .!' He began drawing his comrades again, and as usual when he felt reconciled to his circumstances, a resurgence of his 'Cookham-feelings' occurred.

Such hopes produced by some harmony between myself and my surroundings. . . . I felt that the hope and the consequent constructive and productive resource in me by simple drawing heads and so forth, the war would melt away like a snake charmer . . . the snakes would all forget. I had a Gowans and Gray *Claude Lorraine* and a repro in it of *The Worship of the Golden Calf* – wonderful pastoral scenes, a lot of vases, and men and women dancing. What has happened, I thought? Why doesn't everyone chuck it and behave in this way?

Lifting a stretchered patient over barbed wire in the dark on one

* Stanley was 'ticked off' by an officer for mentioning this detail in a letter home. The letters of Other Ranks were censored by their officers, and exacerbated Stanley's difficulties in describing his feelings about places in Macedonia.

of his details, Stanley accidentally cut a puttee. The new puttee issued to him was of inferior quality and lacked the elasticity of the original. A painful swelling formed on his leg, gently poulticed for him by a fellow-orderly.

His feelings persisted even when the pain in his leg sent him down the line to hospital. He wrote of the patients there, 'I do anything for these men. . . . I cannot refuse them anything, and they love me to make drawings of photos of their wives and children. . . . An Irishman asked me what I thought of the "after-life". I said that as the very being of joy exists in that it is eternal, it is only reasonable to suppose that life which only lives by joy must necessarily be eternal.' This deeply metaphysical answer, the source from which so many of Stanley's greatest paintings sprang, must have flabbergasted the questioner. 'If these men have not gripped the essential, there is one grand thing; they are part of the essential.'

Stanley told Florence that he had heard from Gilbert, whose stint on a hospital ship had now ended and who was serving in a hospital near Alexandria in Egypt: 'I have had a beautiful letter from Gilbert. He is in Mustapha, Egypt, and he wrote me about the possibility of getting to be with me, but on the day his letter arrived my leg was so painful I was unable to walk. . . . I had a swelling on my shin and at last it was opened and the matter removed. It was an abscess, but it was deep down under the flesh so that you could not see it. It is healing well now.'[9]

With the leg healing, Stanley assumed he would soon be back with George Dando in his dugout home. But before he could be discharged, he contracted a high temperature, diagnosed as malaria. So at least another three weeks' hospital sojourn became necessary. The strains of malaria prevalent in the area were not generally fatal to healthy young men, but once in the bloodstream the sickness recurred at intervals and was very debilitating. The usual treatment was seven days in bed with massive doses of quinine, five days as an 'up' patient and then ten days or so convalescence, usually at the depot. Weak and exhausted, the victim would then be returned to his unit for temporary light duties.

Stanley must have spent Christmas at the hospital, although he makes no mention of it. At the end of January 1917 he was

discharged to the RAMC Base Depot. From there, clutching his movement order, he prepared happily to return to his unit. It was only when he opened the order that he realized it directed him not to the 68th but to the 66th Field Ambulance. Dismayed, he felt a mistake had been made, but it was then too late to correct it. Oddly enough, the 66th FA was stationed at Kalinova, where he had left the 68th. So on arrival he felt even more disorientated: 'Now I felt I was what I wasn't. I still felt a lot of unget-at-able me was going on in the 68th' – the 'eternal' quality of experience for Stanley. But 'I fitted in, became a 66th Field Ambulance man and was pleased to note that families in their nice characteristics are not so dissimilar.'

Being convalescent, he was detailed for 'light duties', mainly in his section cookhouse which was simply a limber upended with a tarpaulin over the shafts.

Beginning early in the morning I would cook rashers for sixty men, two each. On my left as I knelt in a little groove cut in the ground for a wood fire, I had a wooden box full of rashers. On the fire was a dixie lid in which the rashers were fried. In my hand I had two flat pieces of wood with which I picked out bunches of rashers. . . . The cookhouse had a cook called The Black Prince, a grim-looking man who . . . Arabian Genie-wise, usually appeared when one had done something wrong. One day I was reading *Paradise Lost* and supposed to be watching a side of bacon that was simmering in the dixie. I smelled faint burning, but I was too late. He loomed out of the darkness with his black dog, gave a kick at the dixie and sent the lid flying, and up rose a column of smoke. . . .

Despite this King Alfred episode, Stanley found the sergeants and men to be as friendly as those of the 68th and settled to enjoying their banter and their different personalities. He spent much time on picket-duty, guarding the camp at night. For him, this was no hardship; he never needed long sustained spells of sleep. His graphic memories of the sights and sounds of the night – the dark shadows of pye-dogs scavenging among the tents, the hooting of owls – remained stored in his mind with the hundreds of others of these war years which were to erupt in such glory at Burghclere.

Many of these memories are incorporated in the left wall frieze.

On the left, a solitary figure washes a shirt, using water heated in a couple of mess tins over an alfresco fire of twigs: 'a more ideal means for scrubbing shirts than one of these smooth shiny granite boulders could not be found'. Stanley jokingly described to Florence how he would wash his shirt 'by numbers' – in army drill fashion – so that none remained unsoaped. Above the bell-tent, the upended limber with its tarpaulin cover shelters the section kitchen where the Black Prince reigned and where Stanley, concentrating on his Milton, dreamily burned the bacon. The ritual washing-up of mess tins is adjacent, and at the first line of bivouacs the cooked bacon and fried bread is being doled out. Towards the foreground, Stanley – all the figures are emotionally Stanley – his mess tin prudently fastened through his epaulette, uses an acquired bayonet to pick up litter; RAMC personnel were unarmed. In the angles of the arches below, a pye-dog scavenges among the heaps of discarded tins waiting to be buried, and the heads of mules, penned into a gully, are visible. The men in the right-hand line of bivvies are receiving a welcome issue of fresh bread. Stanley had few complaints about the food, but fresh bread – which reminded him of bread, butter and jam at tea at Fernlea – was a welcome substitute for the more usual army biscuit. But 'I do not pine for anything now that I've got Shakespeare. He beats the best bread ever baked.'

On the right of the bivouacs some of the section are at work on a fatigue, humping stones to reinforce a track. It may have been the recollection of such a fatigue which prompted one of Stanley's lighthearted letters to Florence, who always insisted that whatever the circumstances, his letters should amuse her:

The other day I was having a rest after working . . . and I was thinking and thinking and pursuing this exercise in the same sort of way that our brother-in-distress the tortoise does. I say 'in distress' because he is so distressful – he is always trying to do the most impossible things. Well, when I had not got any Think – noun substantive – left [the interpolation is a gentle jest to Florence about her grammar lessons in his schooldays] I began reading Joshua, goodness knows why! Well, I saw the High Priests and the mighty men of valour going round the walls of Jericho and blowing on their rams' horns, and then I heard the sound of falling walls and buildings, and then I saw men rushing in on every side massacring

men, women and children. Well, I thought, this seems all very nice [he is either being ironic or he means 'nice' in the sense of a picture building in his mind] but something very nearly stopped me getting to this 'very nice' part; it was the part where God commands Joshua to detail one man out of every tribe to carry a stone from out of the centre of Jordan where the Priests' feet stood firm and to take them to where they would lodge that night. Oh, I thought, if God's going to be detailing fatigue parties, I'll be a Hun![10]

In the angle on the right, one of the party is using an improvised tamp – it appears to be a broken travoy shaft – weighted at the top with a padded stone and rammed down by blows from another tamp. The objective, Stanley says, was to break up the large stones into smaller pebbles, which were then set vertically like cobbles and rammed down to make the surface. The entire scene is a composite of Stanley's recollections of the 68th and 66th Field Ambulances. The orderlies wear winter service dress. There is a preoccupation with purposeful activity, keeping warm and fed, maintaining tidiness and organization – all attributes of Fernlea homeliness, his indication that he had found in the landscape and atmosphere of the Vardar hills another home.

The Burghclere Chapel:
The right-wall frieze

You ought to hear the wild geese out here. They fly
over us night and day and it is mysterious to hear
them in the night.

Stanley Spencer to Florence[1]

STANLEY was with the 66th Field Ambulance for only a few
weeks before 'a rotten cold and running nose' sent him protesting
back to hospital. It was a sinus infection. At the 5th Canadian
Hospital he found two Hardy novels he had not read, and enjoyed
a version of *Lycidas* which he had handwritten for himself: 'as for
Milton, I rest myself upon him'. There were more portrait draw-
ings, many on the large leaves of a big autograph album with
which a Canadian Sister supplied him. He replied to a letter from
Florence: 'I got the London Univ. Coll. Pro Patria and Union
magazine today which contained a lot of real interesting news
about a lot of my old Slade friends. . . . Do tell me about Mrs
Raverat's baby! When I heard about it I laughed for sheer joy.'[2]

At home the war was beginning to bite. The early Zeppelin raids
on London and the east coast had given way to pattern bombing
by fleets of multi-engined German bombers, the Giants and Gothas,
and any who could were seeking refuge outside London. Ma and
Pa were on wartime rations. Stanley had allocated them 3s 6d a
week from his pay, a considerable proportion, and made them a
gift of £5 – perhaps £200 today – from his savings.[3] Coal was
short; 'old' Sam Sandell from The Nest, aged eighty-five, cheerfully
sawed them firewood. Gwen Raverat sent sacks of apples. Sydney's
educational ability and his success in achieving high marks in every
training course he was sent on – bombing, marksmanship, anti-gas
– kept him, to his annoyance, in England as an instructor. Percy

The Burghclere Chapel: the right-wall frieze (part), *The Camp at Todorova*.
Below are glimpses of *Mapreading* (left) and *Making a Firebreak* (right).

was due to be sent to England to train as a staff officer. Harold
and Natalie had moved to London, but the unforeseen slaughter
in the terrible battles of the Somme in 1916 had introduced
conscription; men and unmarried women who had been earlier
required to 'attest' their willingness to be called up now found
their vows invoked. Even the thirty-seven-year-old Harold might
be netted (he was, but only for Home Garrison duty). Horace,
back in France and promoted to corporal, was periodically pulled
out of the line to entertain generals at mess parties.

Recovered and discharged from hospital in the middle of March,
Stanley found himself for the third time back at the RAMC Base
Depot. Once again he suffered a change of destination, being posted
to a newly-formed Field Ambulance, the 143rd, still stationed at
Salonika. The mountain snows were melting and warm spring days
arriving: 'The flowers are out – primrose, violet, celandine and
many others unknown to me; I passed such wonderful ones

today'.[4] The sudden arrival of spring in the remote Macedonian hills is still an event of beauty. But for the combatants of the British Salonika Army the flowers were more a worrying omen than a joyful harbinger. A spring offensive was being prepared.

Gwen Raverat with her firstborn, Elizabeth, 1917.

The armies along the Allied front were under the command of the French General Sarrail, who had distinguished himself in the anxious days of 1914 in France. A head-on attack up the Vardar valley was the most obvious course, but impracticable in view of the impregnability of the Bulgarian defences there. So Sarrail's plan was to start an attack with French and Serbian forces inland. They would fight their way across the mountains of the interior so as to reach the upper Vardar valley in the rear of the Bulgarians on the British sector. As this began to achieve success, the enemy facing the British would be compelled to withdraw troops to counter the

threat, and at this point the British would attack to catch the Bulgarians in a pincer movement. It was a classically obvious plan, indeed the only feasible one, and the best of the Bulgarian troops with German Jaeger and Mountain battalions were positioned in the hills to prevent it. The reason why Stanley was passing such 'wonderful' wild flowers was because 143 FA was on the move to support the coming offensive. However, as a new and untried formation it was evidently being sent to a relatively unimportant sector, the part of the Struma valley about twelve miles east of Lake Doiran where only feint attacks were planned. Its destination was the abandoned village of Todorova.

Stanley, of course, had no idea what was happening. Privates were never 'told anything', although the infantry, watching the build-up of gun batteries and field ambulances in their rear, had a shrewd notion of impending events. The journey to Todorova was excruciatingly slow. It took eight days to cover the forty or so miles. The weather was hot. But 'at least my mind arrived at Todorova with my body'.

The village of Todorova, or such of it as remained from the earlier Balkan Wars, caught Stanley's imagination as Kalinova had done: 'It seemed to me to be a place right in the north or north-east . . . I think some of the flowers there were the remains of private gardens when inhabited; no signs now, no buildings. . . . A rose-bush in the sun, I remember, and I was surprised to see a cloud of dust where it stood one day. The dust blew away and there was the rosebush shaking – a dud shell.'

The French and Serbian offensive in the centre of the Allied line began in early April. But despite initial successes – the capture of Monastir was one – resistance was too strong and the advance petered out. The value of the supporting British attack on the Doiran sector was now in question. Sarrail, indeed, saw no point in it and did not expect it to take place. Nevertheless on 24 April General Milne ordered the assault. The infantry battalions, moving upwards towards their objectives over open ground, were mown down by Bulgarian machine-gun crossfire, and when they sought cover in the ravines of no-man's land they found themselves caught in pre-registered shellfire of pinpoint accuracy. With great courage a few small gains were made, but most had to be yielded as too exposed. Some of the assault battalions – they included the 7th

Royal Berkshires – were decimated. On 8 May the attacks were called off. The result was stalemate. Six thousand men had been lost.

Nothing further was possible. Indents for replacements from home were not welcomed by the War Office. All available manpower was needed for other summer offensives being planned both on the Western Front and in Palestine. The French war leader Clemenceau, asking to know how his 'Army of the Orient' was faring, was told that they were consolidating their gains and digging in. 'Ah!', he remarked caustically, 'les jardiniers de Salonique!' The phrase stuck, and the *Gardeners of Salonika* they remained. The problem now was to keep up the morale of the troops during the heat and boredom of the coming summer and the misery of the next winter. Offensive patrolling, loathed as futile by the infantry, was ordered to maintain their fighting spirit. But at the same time entertainments and sports were organized, *ad hoc* theatres built behind the lines, and a soldiers' newspaper, the *Balkan News*, was published from Salonika by a spirited Englishwoman.

Not that Stanley saw much of this, although a male-voice choir was organized in his Ambulance, of which he became a member. His life at Todorova was essentially one of killing time. His section was camped in the narrow, steep-sided ravine shown in the frieze at a point where the torrent ran down the edge of the plateau to the Struma below, where Todorova itself was sited. He painted a flowery sign for the sergeants' latrine and went swimming with a cookhouse orderly whenever flash-floods formed rock pools. His sergeant allowed him, when off-duty, to wander away and he would seek some lonely gully where among the harmless rock-snakes and lizards he could be alone with his thoughts, his letters and books. The Raverats, with a civilian's incomprehension of a soldier's lot, were urging him to contact a cousin of Gwen's, a rising composer who was also an orderly in a Field Ambulance; his name was Ralph Vaughan Williams. Stanley was pleased to have news from Florence of Sydney – 'Hengy the Henker' – who had continued during his military service to work diligently towards his academic qualifications, and was in the spring of 1918 to be awarded the degree of Bachelor of Arts at Oxford: 'Bless his heart, I would love to see him.'[5]

Percy had been posted for his staff-officer training to Trinity College, Cambridge, where Florence's husband was a don. Stanley was still hoping to arrange for Gilbert to join him, but, as he gently pointed out to the Raverats, the army did not extend itself unduly in the interests of private soldiers. Even Florence was complaining that his letters did not contain much news, to which Stanley replied with some asperity that it was not a fault in him, for nothing was happening. However, he had one piece of good news. Henry Lamb had arrived in Salonika as a medical officer with a Field Ambulance and 'according to the place where he says he is, I must be quite near him'.

Stanley was, he decided, a 'different me' again at Todorova, a more reflective, inward-turning 'me': 'As far as Nature went, I felt on such a personal footing with it, and it had all seemed to have something to do with my individual self, that I forgot the war and the army, and continued to some degree my Cookham life, namely a feeling of integration with my surroundings.'[6] The Burghclere frieze is obviously intended to convey something of Stanley's summer calm and waiting, of men 'forgetting the war and the army'. The figures, in the timeless way of all soldiers, occupy the empty hours by being given something to do. On the left of the picture a line of men pick away at a torrent bed, dislodging the brown and white pebbles of the limestone landscape in order to make a mosaic of regimental badges – the RAMC and Royal Berkshire badges are there – as well as a Red Cross air identity circle. In the river-bed, in the rock pools where Stanley swam when it flooded, more pebbles are collected, used no doubt in the army game of housey-housey played by the little group of men in the centre; it is a form of bingo, and the only gambling game then permitted in the army. Below them a pair of pack mules passes along the watercourse. The figure scrubbing his summer shorts forms a link with the man washing his shirt in the opposite frieze. On the right, an open-shirted orderly, his identity discs dangling about his neck, idly throws a stone at something in the stream. All are dressed in summer kit. These are the days, if not of wine, at least of army tea and roses. For Stanley they celebrate another 'emergence' into his precious world of spiritual peace and creativity, his world of harmony, of 'my integration with my surroundings'.

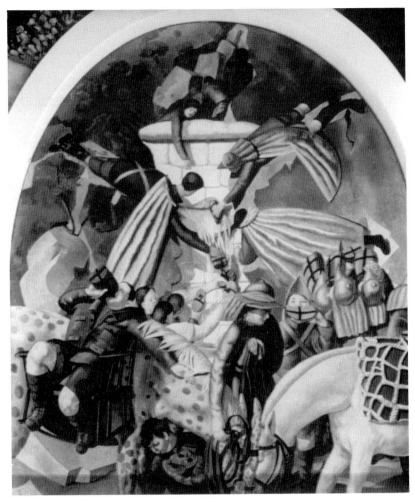

Convoy of Wounded Men filling Waterbottles at a Stream

CHAPTER FIFTEEN

The Burghclere Chapel:
The 1917 summer panels

I saw sparks and thought, 'Is there a fire somewhere?'
but noticed that the sparks went on in a swinging
movement. They were fireflies. I am only able to give
an indication of my state of mind at the time by
describing these things outside me.

Stanley Spencer[1]

THE 143rd FIELD AMBULANCE moved several times during
the summer heat of 1917. First, to 'Basili' – Basjirli – where from
a headland Stanley could see across the Struma valley to the
rampart of mountains, the heavily defended Bulgarian front line:
'The whole range or façade . . . in its entire length disappeared
into a long cottonwool snake of cloud and sloped this way and
that from under it into the long valley, appearing somewhat like
the hem and bottom part of a skirt of some huge deity. Here and
there I could see smoke rising from Bulgar bonfires in their camps.'[2]
 From Basjirli he was moved to a succession of small towns deep
in the plateau where the function of the Ambulance seems to have
been to service the wounded or sick among the administrative units
in the rear areas. The two Burghclere panels *Making a Firebelt* and
Convoy of Wounded Men Filling Water Bottles at a Stream hint
at the activity of those summer days. Before establishing any camp,
the grass around it had to be downed or burned back in a controlled
burning to make a firebreak. While some men guy out their
bivouacs or struggle to erect a bell-tent, others tear old copies of
the *Balkan News* to make spills. (Even some rear areas were within
range of heavy guns and were in any case subject to German air
bombing. The effect, in the drought of high summer, was almost
invariably another grass fire. There was international indignation

149

when a Field Hospital at Salonika was bombed, and on another occasion Stanley escaped with his life only because the two bombs dropped near him – he was sketching a comrade's portrait at the time – were duds.)

Perennial springs, holy to the ancient Greeks in that thirsty land, remained no less respected by their successors, who continued to honour them with stone and marble. To Stanley's artist eye, such fountains were invariably a delight.* In *Convoy*, his ambulance detachment has either stumbled across one or, more likely, made a detour to one they know. A typical V-shaped Macedonian watercourse has been dammed to provide a head of water to supply the jets below. Willing hands pass up the waterbottles of the wounded to the orderlies at the fountain. It has just been raining. The waterproof capes of the orderlies, counterpointing the protective neck-cloths dangling from their helmets, flutter behind them like the angels' 'wings' of *Christ Carrying the Cross*. Other men have gone directly to the headwater or are clearing the watercourse. In the foreground a patient sits in a *cacolet* and two mules are watered.

Again Stanley's letters during this period reflect a continuation of his Todorova feelings:

I saw a pelican the other day. I thought how beautiful was the symbol of a pelican in the marshes, which turned my thoughts to Crashaw. . . . He is more spontaneous than Milton, though I have more respect for Milton. . . .†

am better able to understand what I read than I used to be. . . .[5]

anything I do for anyone is as ointment poured forth, and it is an exercise creating joy which is eternal, and it is the army which has called me to learn this. I do not mean that by being happy in the present state that I am satisfied, but what is wonderful is that by praying for the power to love purely and absolutely you get that power. . . .[6]

* The scene could well be a Stanley-recollection of Giotto's *Miracle of the Spring* in his St Francis scheme as Assisi. Other paintings in the scheme are echoed in Stanley's work, from *The Centurion's Servant* (Giotto's *Death of St Francis*) to Stanley's later *St Francis and the Birds* (see Chapter 29).

† 'Crashaw! There is an almost pagan passion in Crashaw's divine poems which makes them so intense'[3] 'Stanley is in love with the beauty and quiet of Milton. I have had a beautiful letter from him.'[4]

... I have had a letter from Lady Ottoline Morrell. She enclosed photos of a girl diving into a stream, one of Morrell scything at Garsington, and one of Asquith. I don't know why I should have a photo of Asquith whom I do not know. . . .[7]

Asquith, Prime Minister at the outbreak of war, had been super-seded by Lloyd George and the emergency Coalition Government; after the war, Asquith was to become one of Stanley's admirers. The Morrells were registered pacifists and had moved to the Manor House at Garsington near Oxford, where they were able to shelter as 'agricultural workers' the more unmilitary of the Bloomsbury intellectuals like Aldous Huxley, who had serious eye problems. Perhaps Stanley's brusqueness at Lady Ottoline's letter derived from this fact, although it is more likely that Stanley was offended less by the photo of Asquith than by the photo of the girl. No doubt meant kindly as a pin-up to comfort him in his deprivation, its only function as far as Stanley was concerned would have been to set going those fantasies which at that time of his life he regarded as his 'disturber of the peace', the last thing he welcomed.

While the Ambulance was at Mirova, two significant events occurred. One was that a notice was circulated urging volunteers to transfer to the now depleted infantry, and Stanley, evidently to the incredulity of his comrades, put his name down to join the 7th Royal Berkshires.* This would end any hope of Gilbert joining him; but a meeting with Henry Lamb, whose unit, the 30th Field Ambulance, was being switched to support General Allenby's Palestine offensive, became possible. So it was that in September, at a town Stanley called Kil-Kut (almost certainly Kilkush, modern Kilkis), Stanley was overjoyed to see Henry 'come riding into our camp when I was near an old village with a Mohammedan church having the usual minaret. . . . We went and sat under a big tree among the black and white sheep and the two big shaggy goats and we talked about – what did we *not* talk about! Claude and Mozart and Weber and Byrd and Keats and a lot about Blake and he wants to send me a Chatterton. He is going to get me a book

* The 7th Battalion had been raised from Berkshire volunteers in 1914 as part of Kitchener's Army. It was 'blooded' for a couple of months in trench warfare in France and then sent in November 1915 to Salonika as part of 78 Brigade, where it took over from the French on the Doiran sector and became a veteran battalion of 26 Division.[8]

Captain Henry Lamb RAMC. 'I got your photograph and have it with me,' Stanley to Lamb 1917. To judge from its creases, he must have kept it in his pocket or in his 'Small Book', the military passbook or paybook each soldier carried which recorded his personal details. It was one of the few items of personal property Stanley managed to bring home.

on Andrew Marvell. He sent me a book of glees for us boys to sing. . . . He saw the drawings I did last year and said he thought I had made great strides and my drawings gave him the exact feel of the Balkans. . . . Meeting him was like coming across a cool

running stream after a hot day's march. He declared me to be in excellent health, the malaria not having done me any serious harm.'[9]

Stanley's medical inspection had evidently been to assure himself that he was fit to endure the rigours of infantry life. The transfer took some weeks to come through, during which the 143rd FA moved from the plateau down to Kopriva in the valley of the Struma through which, in happier days, the Orient Express had run to Constantinople. Stanley found it 'a wonderful valley; even the despondency and the spiritlessness [of the abandoned farms and villages] is nevertheless something wonderful; but not so wonderful as the Vardar Hills'. 'Not so wonderful as the Vardar Hills'. He had been away from them for almost a year.

Stanley's posting to an infantry training depot in Salonika came through in October. He said goodbye to his RAMC comrades and, humping his kit, set off, a solitary figure, on the road back to base. He had to make his own way, hitching lifts where he could and begging bread and board. 'It wasn't easy,' he recalled. But he arrived without mishap. At the RAMC depot at Sidi Bishr in Egypt Gilbert was contemplating the same step. In 1918, he too transferred to the infantry, to the East Surrey Regiment, at Kantara. Neither brother immediately told Ma and Pa of their decision 'so as not to worry them unduly'.

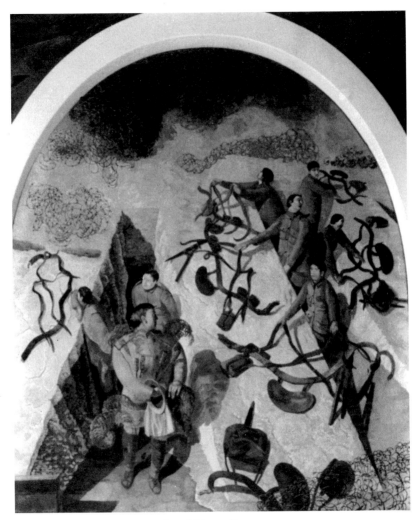

Stand To, or Dugout

The Burghclere Chapel: The infantry panels

Eat and carouse with Bacchus, or munch dry bread
with Jesus, but don't sit down without one of the
gods.

D. H. Lawrence: *Studies in Classic
American Literature*[1]

WHY SHOULD STANLEY have made the quixotic decision to
transfer to the infantry? To his RAMC comrades, he argued the
case of practicality: that, when the armistice came, the infantry
would be demobilized first while the medical units would be
retained abroad for civilian reconstruction, as indeed happened.
But this was obviously not the whole reason. Nor, as has been
later suggested, was he trying to prove his manhood, or anything
so melodramatic. He had, of course, been keen from the beginning
to join the Berkshires, to feel himself home among his own folk,
and the lowering of physical standards now permitted this. His
family's objections were no longer relevant; he had thrown off the
yoke of parental influence.

But by now he knew the infantryman's lot. He had experienced
shelling and bombing. He had been up the line to retrieve the
wounded. He had buried the dead. He knew that in the last
offensive 7th Royal Berks and its sister battalions in 78 Brigade
'had had a thousand casualties'. In fact official figures list 2000.
In the coming year, 1918, there was bound to be another offensive.
What would he do, he asked himself, if faced across bayonets by
a tough Bulgarian peasant fighter – he who had been useless in
village scraps at home? Would he find himself physically and
temperamentally unable to cope with the demands? Would he not
come to be regarded as more of a hindrance than an asset?

Such fears must have recurred when, after three months' training and a Christmas at No. 3 Infantry Training Depot at Salonika – during which he bumped into several of his old Beaufort comrades at the YMCA – Stanley first went up the line to his new battalion, towards the middle of February 1918. There was snow on the hills. He and a veteran returning from sick leave went up together:

and after arriving and being taken hurriedly to the Sergeant-Major with the other man and answering the cold questions of the Sergeant-Major, one of which to me was 'Have you done any bombing practice?' and I said 'Yes,' we were dismissed. I had rather wondered at the humble pretensions to knowledge of my man [when it came to his turn to answer questions] until we were outside, when he informed me he thought I must be 'up the pole' for admitting I had done some bombing practice. 'You don't want to be detailed off on a bombing raid, do you?', he said. But I don't think to this day I could have said 'No'. . . .

Stanley's recollections reveal his anxieties about his fitness for this new life; yet through them all shines his determination not to yield to them. His resolve to carry out his decision honourably was an essential part of his nature. The motto of his comrades – 'Never Volunteer For Anything' – was an instinctive survival attitude comprehensible to Stanley but incompatible with his devoted sense of purpose. But what was his purpose?

The clue lies in those passages in his memoirs and letters in which time and time again he stresses the joy to his spirit of the Vardar Hills, the Doiran sector, or the Karasuli – Kalinova road. He gave us glimpses of it in the train journey from Salonika, in the slow oxcart journey to Corsica and in the companionship of the 68th and 66th Field Ambulances. At Todorova in the 143rd he had been among good comrades but somehow, spiritually, he felt isolated. The meaning of place, so paramount in his Cookham days, still gripped him. But, for a reason perhaps even he could not understand, the Vardar Hills were where his spirit told him he should be, and there could be the comfort that in reaching them again he would be with Berkshire men, stationed at the time at Kalinova:

. . . Kalinova . . . a walled village and nothing living in it, a small bit of

house remaining, and the only inhabitants were wild dogs. I had been a year away from it, being next to the Struma valley, and I longed to be back there. I achieved this wish by transferring into a regiment, the Royal Berks, on that front. I was glad to get back to this deserted spot, to see a little dugout I had made a year-and-a-half before [with George Dando] almost filled [and] covered by a whitish sand . . . that accumulated from the rocky nature of the ground there. I felt something wonderful would happen here – 'and the redeemed shall walk there' . . . and the place seemed to be the culmination that being in that country with the soldiers seemed to lead to. . . .[2]

'"And the redeemed shall walk there."' . . . At the end of February he wrote to Florence, 'The mountains look beautiful covered with snow. It is funny to be back on the precise bit of land I was on with the Ambulance a year and three months ago. In some ways I like the merciless wildness of this country. It makes one curse at times, but the cursing is a fitting part of the wildness. It's just like being in purgatory.'[3] And to Ma and Pa he wrote, 'It will be wonderful to be able actually to express on an ambitious scale some of the impressions I have received on these hills. It will be like coming to life again. . . .'[4]

In March, he told Jas Wood, then training with the Royal Flying Corps, 'When I transferred I hoped to be sent to a certain front where I had been before and wanted to be again, and here I am in that very place. . . . These mountains fill me with eternal joy.'[5] To the Raverats he enthused: 'The snow has been snowing and the wind has been blowing and the tent creaks and cracks and slaps and swings and bangs . . . but now all is still and the moon shines. . . . When I transferred I hoped to be sent to a certain place and now I, 418112 Pte Spencer S, "C" Company, 7 Royal Berks, am in that place where I was a year ago. To personify the nature of this country, I should say that it is like a distracted witch, except on such a serene night as this . . . I have just been trying to draw these mountains. The snow being up them, the ravines are very clear, and they look like spear-wounds. These particular mountains give me the same feeling of remote happiness that some of Mozart's music does.'[6]

'Spear-wounds' – an image stored in his memory to be invoked later in his art. The military life he was enduring was simply a

physical event, a temporal affair, a hiatus which he 'would get through in time'. Stanley could make no 'connection' between the creative aspects of his imagination and any possible life as an infantryman. The miracle to him was that 'being with the soldiers in that place yet had some integral meaning with other meaningful things I felt in myself. It was all indicating and leading to something pertinent to my imagined loves and feelings. [As at the Beaufort, he could] do nothing about it at the time. But one day, later, I would. It may be a wrong thing in me, and attended by certain disadvantages, but I could do nothing of the liking order [the depiction of his feelings] on the spot and at the same time as the thing was experienced.' Later, he would proclaim: 'I tried to take my imaginings home [to that 'peace' which enabled contemplation and composition] and look at them. I re-experienced them in memory. But it is not *just* through memory that I do this. I have a sort of heaven in which I need to relive these parts or imagined pictures. I am only interested in this world in so far as it assists me or is usable as a means of expressing or revealing this other heavenly world.'

In the meantime Stanley had to adjust to his new life as a front-line fighting man. He conveys something of it in *Stand-To*. The men's equipment lies spread out at the entrance to the dugout ready for instant use. There were officers and NCOs he resented for their obtuseness or incompetence; but equally there were others whose judgement and leadership he trusted and to whom, like the Sergeant Challoner in this picture, he would respond with that same loyalty he gave to the handholders in his spiritual life.* The scene reflects the hour at dawn when his platoon, in the line, would prepare itself for a possible enemy raid or attack. But it could equally illustrate those moments at dusk when, having slept and been given a meal, the little party of bombers – the sergeant is hung with grenades and camouflaged with foliage – would move into their scattered foxhole outposts to listen and warn of the

* Stanley describes being detailed for a dangerous night operation to lay wire in no-man's-land. He was astonished how buoyant the officer in charge became at the prospect of excitement: 'They are evidently men made for that sort of thing', he decided. But his astonishment turned to admiration when he found that the officer, for all his gung-ho enthusiasm, took great pains to brief each man and to ensure he knew exactly what he had to do. Meticulous planning to achieve success represented as much Stanley's objective in the spiritually creative as did the officer's in the worldly practical. Stanley recognized a fellow-feeling, even if on a different plane.

movement of Bulgarian night patrols. Among the pages of one of Stanley's later sketchbooks there is an unexpected and incongruous page on which he draws a sketchmap of his outpost on M4 Hill – unspecified features were given code names for military reference.[7] These outposts were approached by the 'Macikova track' – Machukovo was a ruined front-line village – and Stanley marks them as grenade posts; evidently his skill at bombing had not passed unnoticed. To these little foxholes he would crawl at dusk, clutching his pair of hand-grenades, and there, 'in a place more midnight than night', would lie straining eyes and ears to catch any sound of a Bulgar patrol and listening with fascination to the rumble of their supply carts as they brought up their rations. The Macikova track, a 'faintly indicated, foot-trodden path', was often shelled and when one night the shrapnel was particularly alarming Stanley took what he thought to be the sensible precaution of dropping down off the track to walk along the sheltered ravine below, only to find himself unexpectedly tangled in concealed barbed wire. His comrades, plodding heads down along the track above him, saw that he was able to extricate himself, their only comment a cautionary: 'You'll get yourself into trouble if you do things like that.' Barbed wire remained a baleful image for Stanley. In *Stand-To* it forms a kind of cloud, conveying something of the feeling it had for him and his comrades as they crouched in the narrow trenches and saw it lining the parapet above them against a small glimpse of sky.

Not all their time, of course, was spent in the firing line. Every seven to ten days they would be relieved by one of their Brigade sister battalions and moved back into reserve, where they could rest, bath and delouse themselves; one of Stanley's later anecdotes was of how, for delousing, they would search for ant-heaps on which they could spread their tunics. Training continued, and in the panel named *Map Reading* we catch an echo of the release of tension of these occasions. The scene will be jocularly evocative to any soldier who has had to endure a route march in hot weather. The platoon has been given the order to fall out while the young officer on his horse consults his map. Stanley sweepingly embraces the entire front in the scale of the map, with Lake Ardzan prominent. It would be ungracious to suggest that the officer is lost. Let us more kindly infer that he has halted to establish his bearings.

His orderly, a sturdy country boy who understands animals, is making sure the officer's mount is watered. Around them the men of the platoon, in the time-honoured manner of soldiery, have passed each into their private nirvana. Packs have been eased from aching shoulders or set as pillows. Amid a chorus of snores their more adventurous fellows have found bilberry bushes in fruit. One of the miracles performed by any army on the move is the way in which the little luxuries of life – fruit, eggs, vegetables, chickens – materialize from the seemingly empty landscape around.

In these rest periods Stanley could resume his correspondence. In the early summer of 1918 he received from Desmond Chute the surprising news that he had made the break from theatre, home and mother. On a visit to London he had met Eric Gill, then carving the Stations of the Cross in Westminster Cathedral. Gill, with Hilary Pepler, had set up the Guild of St Joseph and St Dominic, a community of Catholic artist-craftsmen at Ditchling in Sussex, and Desmond was overjoyed to join them. He became an apprentice to Gill and, when Gill was later called up, was entrusted by him with the care of his family and his affairs. The two became and remained the deepest of friends. Then, in May 1918, Stanley received the most surprising news of all. It came in a letter from London signed by a Mr Yockney:

In connection with the scheme for utilizing the artistic resources of the country for record purposes, it has been suggested that you should be invited to paint a picture or pictures relating to the war. It is proposed that an application be made to the War Office for your services in this connection. Mr Muirhead Bone, who takes a great interest in your work, has suggested that you could paint a picture or pictures under such title as 'A Religious Service at the Front'. I should like to ask whether in the event of this scheme maturing you would be disposed to do such artistic work.[8]

The use of artists for propaganda illustration had begun early in the war. At first older artists like Muirhead Bone were invited to visit the front and record detail, joined later by volunteer or conscript artists such as Nevinson, Paul Nash and William Rothenstein. The idea of war memorials in the form of Halls of Remembrance hung with large canvases was being promoted in

Canada by Beaverbrook and in the United Kindom by Muirhead Bone, and they were urging the release of the younger, more war-experienced artists to serve the scheme. Among these were Gilbert, Henry Lamb and Darsie Japp, who was in Salonika too, commanding a battery of artillery, although neither Lamb nor Stanley knew where. To further the scheme, a War Artists' Advisory Committee had been formed under the aegis of the Ministry of Information, though the artists serving in the army would be administered from the War Office. The prospect filled Stanley with excitement: 'I have already got plans out and ready for the time when I start on this War Memorial Scheme which I hope will be a success. It will be great.'⁹

But in France the Germans were about to make their final desperate attempt to defeat the Allies before newly arriving American power would turn the tide against them. They had knocked Russia out of the war and were transferring veteran divisions in large numbers from the Eastern to the Western Front. There, every possible defender was needed. Percy had completed his training at Trinity, Cambridge where he joyfully indulged his passion for rowing, and was back in France. Sydney, after years of trying to get to France but being told he was too valuable as a home instructor, was at last with a fighting battalion of the Norfolks in France. Horace too was there in action.

In Macedonia the time had come, it was deemed, for another offensive on the same plan as that of 1917. Allenby's armies in Palestine were routing the Turks and if the Bulgarians too could be hammered, then at least some pressure might be removed from the embattled French and British divisions on the Western Front. There was not the slightest possibility of the British command permitting Stanley's release for anything as footling as drawing pictures. The Army of the Orient had a new commander, Franchet d'Espérey – 'Desperate Frankie' to the Tommies – and he had the advantage of newly arrived reinforcements, Moroccan Goumiers from the Atlas Mountains, fierce tribesmen accustomed to mountain fighting. With most of the crack German formations which had helped block the 1917 offensive withdrawn to France, there were prospects of success. Once more the Serbians and French would strike across the mountains of the interior to get behind the Bulgarians, and once again the British would wait for the offensive

to take effect and then attack straight ahead. Greece had joined the Allies in 1916 and, with her troops now occupying the Struma valley positions, General Milne could concentrate the British on Stanley's vital 'Vardar Hills'. Seventy-eight Brigade, which included 7 Royal Berks, now occupied the sector just to the east of the Vardar river. Their attack would take them over the Sedemli Ravine, past Smol and Macikova. For Stanley there was one heartening piece of news. Mindful of the terrible casualties suffered by the Royal Berks in the previous offensive, they were to hold the line until the last few hours and then 'I was surprised and delighted to find that contrary to what I feared . . . we were being relieved by Ox and Bucks Light Infantry and were going down the line.' This was on the evening of 17 September. The preliminary artillery bombardment was already under way. But in a repetition of the previous offensive, the French and Serbian attacks upcountry, although begun, had not as yet broken through. So when the next morning the British attack went in, disaster again followed. At least one battalion, the 12th Cheshires, according to official histories 'simply disappeared'. Losses on the British sector within two days mounted to 165 officers and over 3000 Other Ranks. Some of the battalions were reduced to 30 per cent of their effective fighting strengths. Already depleted by malaria and by the untimely arrival of the 1918 influenza epidemic – it killed six million in India alone – the battalions simply could not stand the strain. The jubilant Bulgarians realized they faced demoralized attackers. One good counter-attack and they might drive the British back to Salonika and cut the Army of the Orient from its base. Signals were sent to the German headquarters urging such a step. At British headquarters there was alarm. At all costs pressure must be kept up to dissuade any such counter-attack. All reserves were immediately ordered forward. When the order reached the 7th Royal Berks, Stanley was enjoying a bath in a field bath-house: 'while having a good time and beginning to feel more cheerful, suddenly there was a hubbub of conversation in the midst of which I could hear, "Yes you have" and "Who said so?" . . . There was no doubt about it. A man came up to where I was and said, "Hey, you'd better get back to your camp, they're packing up . . . going back up the line tonight, and you have to be ready in an hour.'

Stanley's Burghclere panel *Reveille*, although not specific to this

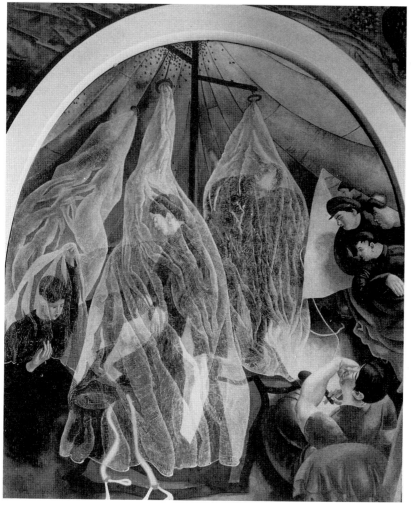

Reveille

incident, records something of the moment. The occupants of a
bell-tent struggle to dress under their mosquito nets. This was not
a simple task, nor was the setting up of the nets. There were some
thirty pockets round the bottom of each net, each of which had to
be filled with stones or earth to weight it insect-tight to the ground.
There could be no skimping. Anti-malarial precautions were strict.
Stanley had done this and gone off to the bath-house when he was

recalled. Most of his packing-up time was taken with emptying the pockets of his net. The panel has, of course, a deeper level of meaning than this superficial description implies. So do all the panels. Stanley has taken the casual recollections of service experience and used them, as he will later show us, in a transcendence to his 'heaven'. During the war he had with his comrades 'pantechniconized one's home' using 'home' in his specific meaning – 'carrying it about with one. . . . But the [wartime] perch that oneself provided was not enough for other than maintaining some sense of home and real being. For the development of what I sought, I needed more extensive accommodation.'

The Sword of the Lord and of Gideon

I have been whirled and whisked through place, cir-
cumstance and experience . . . my life was in a sort
of abeyance.

Stanley Spencer[1]

TO STANLEY the order to move meant only one thing. He would
be going into the attack. 'We at last began to move and the shock
began to subside. We left by a special track which had been very
much camouflaged. As the track turned among the hills the screens
reached out across the track over our heads like a grim reminder
of triumphal bunting. This consisted of chicken wire and rags. It
was mysterious to see them emerging from and passing over our
heads in the increasing darkness, like birds or like heralds coming
from what we were walking into. . . .'[2]

They marched from 3.00 p.m. until midnight, and then halted
at the end of the Sedemli ravine near Smol. Stanley was astonished
to find their mail had followed them: 'When in the midst of some
inhuman happenings there is suddenly this need to supply all the
supposedly human needs . . . it is a bit ominous. . . . My letter was
from Mrs Raverat congratulating me, this bit of humanity lying in
the Vardar valley waiting for orders to go into what is called The
Dome, on the important appointment I was supposed to have got
in doing some work for the Ministry of Information.' They were
then told to tear the letters up and hand them in to prevent unit
identification if captured. Stanley tore his into four large pieces so
that in the event of his getting it back he could piece it together to
re-read. Then 'The sergeant asked me how much ammunition I
had and when I told him he gave me another bandolier of fifty
rounds.'

They were to move forward to the start line for the attack at

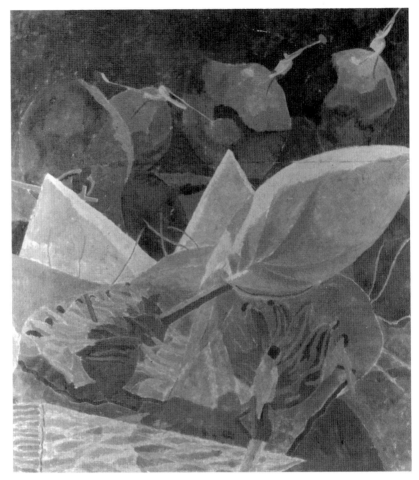

The Sword of the Lord and of Gideon

2.00 a.m. But when 2.00 a.m. came no order to move was issued. Then 3.00 a.m. came and went; the dawn began breaking. Still no order to move. At last, to their surprise, they were told they could stand down and shave. All seemed odd, until the explanation filtered through. The Bulgars opposing them had gone – literally vanished into the night. The French plan had, at last, worked. The Bulgarians in the mountains had given way, and those in the Salonika sector, threatened in the rear, were abandoning positions from which no feat of arms had been able to dislodge them.

The Sword of the Lord and of Gideon

Stanley's feelings on that morning were those which he later used to infuse what was to him an unusual theme for a painting, *The Sword of the Lord and of Gideon*. Perhaps casually reading his Bible one day, as was his wont, he came across the story in Judges 7. There, laid out all those years ago, was almost word for word the story of his own September morning.

In the Bible version, the enemy are the Midianites. They are to be attacked by the Israelites in a surprise night operation, something Stanley knew all about 'waiting on the hillside near Smol'. The Israelite commander, Gideon, needs intelligence and sends patrols to listen at night to the Midianite camp, as Stanley in his foxhole outposts had strained eyes and ears for Bulgarian activity. A picked force of Israelites is to make the assault. They creep forward carrying pitchers concealing lighted torches. At the ordered moment they thunderously beat and smash the jars to reveal to the waking and startled Midianites a crescent of blazing flares – the Very lights and artillery bombardment of Stanley's experience. To a great shout of 'The Sword of the Lord and of Gideon!' the Israelites move forward into the Midianite camp to find, as they hoped, their terrified enemy mostly fled, tents and equipment abandoned. For men keyed up for the terror of combat, such an explosion of relief, such a moment of miracle! In the joy of thanksgiving in Stanley's painting, the Midianite tents struck down become the shapes of blossoming flowers. Death has been transformed into creation. To Stanley and his comrades, it was an unnerving experience to be able suddenly to stroll boldly where for months they had been unable to move except by night:

I looked curiously about the ground in front of me which I had only ever seen in the darkness of night. In the night I had gazed and strained my eyes to see what some object was on the left, and now I could see that it was just the straggling remains of a tree and the slight rise of ground on which it stood. Away to the right, the two hills, one bigger, one smaller [the Grand and Petit Couronnés], which had presented such an eerie appearance at night when the Bulgars had been sending up Very lights, looked just another bit of Macedonian country now.

The surprise over, the pursuit began. With the upper Vardar valley blocked and several German formations trapped there, the

167

main Bulgarian army had to escape into Bulgaria through the few passes in the rampart-like wall of mountains Stanley had seen from Basili. The main one was the Kosturino defile, little more than a track, and towards this defile the retreating Bulgarian army converged, with all its wheeled transport. The Royal Flying Corps – since April the Royal Air Force – bombed them mercilessly.

However, the retreat was orderly, certainly not a rout. The pursuing British had to move with caution. On one occasion Stanley was 'pleased and proud' to have been sent up a valley-slope to make sure there were no Bulgarian rearguard there to ambush the battalion. The temperature was nearly 90°F, and he stopped to take a drink from his water-bottle. Further up again, he stopped to take another, only to discover that the holding strap of his water-bottle had broken and the bottle lost. Panic-stricken, he started to search for it, and 'While I did so, I noticed . . . a man detached from the platoon below and start up the hill making straight for me. There was something menacing and damnable in his hastening towards me and as he drew near me his face had a demon expression. He had his rifle at the "present" with his hand on the trigger and said "I have orders to shoot you. I have got it cocked." I could see there was no time to remonstrate. I blurted out something about losing my water-bottle. . . . "Go on, you bugger," he said. "Get to the top of the hill or I'll shoot." '

Not unnaturally Stanley was badly shaken by such 'bullying' and was particularly incensed at the officious subaltern who had assumed he was defecting in his duty and had sent up the enforcing rifleman. Later that day, when his platoon halted, Stanley's indignation was compounded by his own sergeant who sent him off to look for his bivvy-mate reported as lost. No doubt the sergeant meant Stanley to scout around the camp to see if he could find him. But in Stanley's precise, methodical mind the order was almost a biblical 'Go ye and find.' 'I was sent away without any directions or instructions. In this wilderness I did not know where to look for him and after wandering about for some hours I became quite lost. I had no food or water with me, and was very disturbed.' Mercifully, he stumbled on an artillery battery moving up, and the Major, taking pity on this frightened, exhausted infantryman, gave him a lift to his camp, where 'I found that the man I was sent to look for was quite safe, having only wandered a short distance out

of sight. I was not given an explanation of this matter and no apology was offered. I felt very suspicious as to the true nature of this errand, seeing that it was very likely that the man was not lost at all.'

Stanley's indignation rankled. It was not helped overnight when one of his comrades stabbed himself with his own bayonet. He had 'been too much of the war and this last pending attack had been too much for him. He had asked for leave and been refused. I cannot imagine anything more terrible than the anguish he must have been experiencing.' When next morning 'C' Company paraded to continue the advance, Stanley could contain himself no longer. '[I broke] ranks and, walking up to the officer, I rebuked him for permitting me to be falsely accused. I said, "Under no circumstances had I ever allowed a man to make a false accusation against me." The Sergeant-Major standing by nearly had a fit, but the Captain . . . apologized!!'[3]

It was a miracle he was not put under instant arrest. The Captain was a Captain R. E. Childs, an officer whom Stanley respected. His sympathetic response to Stanley's outburst evidently calmed him. There can be little doubt that in the tough world of infantry in action, Stanley's reactions appeared to his comrades as those of an eccentric. They could not understand, and so dismissed, that dedication in his make-up which compelled him to pursue to the bitter end any objective set him, or which he set himself, and which made any obstacle to its fulfilment – the loss of a water-bottle, the bewilderment of unfamiliar terrain – assume a frightfulness in his imagination they could not comprehend. Only Stanley knew how bitter was the inner battle to overcome it. The indifference to worldly values which made him seem a fool in his comrade's eyes was in a later incident to make him seem a hero. Yet, to Stanley, his behaviour made him neither the one nor the other. He did not live by what he called their 'machinations'.

The 'heroic' incident arose after a dangerous night march the brigade had made to outflank the Kosturino defile. They had made their way, often in single file in the darkness – with Stanley characteristically almost going astray at one point – some 4000 feet up an unfrequented goat track and at the top had crossed the frontier into Bulgaria. There the 7th Royal Berks were ordered to take the lead. 'About an hour before dawn we began the descent

and the sun was well up as we came down the Bulgarian side into a lovely valley and, a little way off, a Bulgarian village. We assembled in a gully at the village, dried up and full of broken rock.'[4] They were preparing breakfast when the surprised Bulgarian rearguard became aware of their presence. Occupying a line of three 'pyramidal' hills overlooking the halted British, they opened up with machine-guns. The official war history records, '*At first there were no casualties among the leading battalions, and the men quickly got into formation. There was, however, no cover, and casualties began to occur. Colonel Dene ordered three companies of the Royal Berks to assault the hill.*'[5] In Stanley's account, 'at 11 o'clock, in the blazing sun, it was strange to see men "smoking" [fixing] their bayonets and I knew some new cause for anxiety was afoot. Apparently up the valley side to our left were some Bulgarians. Up the gradual incline of this line of hills we were single-ranked in extended order with fixed bayonets. We had only gone a few yards when the sergeant came up to me and hissed threats in my ear as to what would be done to me if I did not keep up or behave myself. I thought, "What's the matter with the man?" About ten men from me was the Captain.'

The attack was sufficiently weighty to force the Bulgarians on the first two hills to withdraw back to the third. But 'C' Company was baulked when it reached the third hill. It was formidably steep and the men were exhausted; they had had no sleep or proper food for twenty-four hours, had marched twenty miles the previous day in great heat, spent the night in a difficult scramble in the dark up a mountain goat track, and had even their breakfast disrupted. Captain Childs decided to halt them to rest while he went forward to reconnoitre, calling for a runner to accompany him. 'When we got into the ravine at the foot of the third hill the Captain seemed as exhausted as we were, but said, "Come along" and started up the hill. No one seemed to want to go with him, so I went forward and kept with him.' The pair cautiously made their way to a vantage point from where they could see one of the Bulgarian machine-gun crews and also had a fine view of the main body of the retreating Bulgarian army. Captain Childs lent Stanley his binoculars. 'It was like watching the movement of some sort of germs through a microscope that were dangerous to human life. They made jerky marionette's movements. . . . seeing what sort of

beings inhabited Mars could not have seemed more extraordinary.' The Captain wrote out a report which Stanley took down the hill to a waiting runner. He then went back up the hill to the Captain,

who was sitting there where I had left him. He said when he saw me, 'I did not expect you to come back.' I do not remember his exact words, but he expressed surprise. 'You see, we are in danger of being cut off,' he said [the Bulgarian machine-gunners had seen them]. I sat down and he fired a round at what seemed to me to be a machine-gun crew. I suppose he thought this was a bright thing to do. He did not order me to fire and I was glad he did not. Now and then the combing sound of bullets wafted unpleasantly near. After the Captain had said, 'Well, we can't stay here; there is nothing we can do if the artillery don't get on to them,' we had only gone a few yards, me following him and placing my foot where he had planted his, when I think he said, 'I'm hit!' and felt the lower part of his leg. He then said in a dreamy voice, 'I'm going up, up,' and I held him for a few seconds as he sank to the ground. For a moment neither he nor I could discover where he had been hit, and then slowly his hand went up to his neck and I saw a wound in it. . . . I got his dressing out and bandaged him up as best I could. . . . I then stood up and shouted for stretcher-bearers. Within a few minutes I heard men coming [his comrades from the ravine] and in a moment we were surrounded by men, one of whom gave him some water which I had quite forgotten to offer him. Among the arrivals was a corporal who stretched him out and whispered to me, 'He is paralysed.' When the stretcher-bearers arrived, they were so exhausted that I gave a turn at carrying the stretcher and when not doing that I held his pith helmet between his face and the sun, which was blazingly hot. Then an officer arrived. This officer showed solicitude and sympathy to his fellow-officer, but seemed a little surprised when the Captain said, 'Spencer is not a fool, he is a damned good man.' I felt this was wonderful and not really deserved. . . . I did not like this other officer and thought, 'What's been going on, who's been saying otherwise?' . . . As soon as the Captain had been taken away I lay straight down. I was very exhausted, and there I remained on a patch of grass in the gully which led down to where I knew the Company was.

The attack failed owing to the steepness of the hill and its complete lack of cover and had to be abandoned in the hope that artillery support might be available later. In this action, Lieutenant [Acting Captain] R. E. Childs,

*commanding 'C' Company, received wounds of which he died . . . About
3 p.m. the enemy withdrew apparently due to the appearance of Greek
and British troops in their rear.*[6]

For Stanley, disturbing incidents recalled with typical candour,
accuracy of detail and with no intent to vaunt either his inadequacy
or his courage. By his reasoning, 'they' had begged him to transfer
to the infantry; for whatever reason, he had volunteered to do so;
and as 'they' wanted him, 'they' should have had at least sufficient
consideration to appreciate his gesture and to understand the
limitations of his inexperience. For them to have regarded him as
incompetent and to have 'bullied' him was an injustice. 'What was
bad enough was having to put up with all this sort of thing when
all the evidence of my service shows my goodwill, in spite of my
physical unfitness for many of the tasks set me.'

When 78 Brigade resumed the march, the fighting was effectively
over. Passing through a Bulgarian village, one of Stanley's platoon
casually shot dead an old dog which came out to bark at them.
Furious at the senselessness of the deed, Stanley gave the culprit
one of his stinging denunciations. It was not welcomed. The day,
however, was marked by a more momentous event – the arrival
of a Bulgarian staff car carrying a white flag to discuss an armistice,
which was signed on 29 September. On the 30th all fighting
stopped.

But Stanley was scarcely in any state to acclaim it. His malaria
had recurred. His recollections are now confused. At one point the
battalion medical officer persuaded the padre to give up his horse,
and a dazed Stanley was carried across the saddle. One of the
stretcher-bearers who had helped carry the wounded Captain
walked beside him and kept sponging his mouth with water. That
august figure, the Regimental Sergeant-Major, put in an appearance
and mysteriously asked Stanley whether he would not rather be
painting.[7] Their compassion and gentleness do much to counter
the impression of hostility Stanley occasionally suggests at other
times in his memoirs. The problem was how to get him back to
base. Semi-delirious, he was taken to an overcrowded Field Hospi-
tal where he was left overnight on the ground outside, thankfully
befriended by some Serbian patients; thence to a hutted hospital,
formerly German, where he had a fearsome night of delirium

imagining himself lying helpless on a track while a convoy of mules, their hooves clattering, jangled closer and closer – a nightmare which his fellow-student Isaac Rosenberg had described in his poem *Dead Man's Dump*:

> Even as the mixed hoofs of the mules,
> The quivering-bellied mules,
> And the rusty wheels all mixed
> With his tortured upturned sight.
>
> So we crashed around the bend,
> We heard his weak scream,
> We heard his very last sound
> And our wheels grazed his dead face.[8]

Mercifully for Stanley, every time the mules came closer he awoke in alarm to let the horror subside in the comforting sight of the night orderly sitting quietly by his table with his hurricane lamp.

So, ten days after he began the advance from the Vardar, Stanley found himself at Doiran on the train back to hospital at Salonika. The Army of the Orient he had left behind was to push its way across a disarmed Bulgaria towards the Danube and Constantinople, and threaten that 'stab in the back' which was to help put Germany out of the war for good.

The Years
of Recovery

1919–1924

Christ's Entry into Jerusalem

The form of Stanley's observations, whether in paint,
print or peroration is always so simple and straightfor-
ward as to deceive all but the wary.

Florence, *Image*[1]

STANLEY was longing to get home. His malaria was treated at
the 49th General Hospital and he was posted to the Depot in
Salonika. But no word of his transfer to the War Artists' Com-
mission arrived. Armistice had not yet occurred in France, and in
any case there was to be no discrimination in the sequence the
soldiers would be demobilized. He was alarmed that he might
again be posted to an infantry battalion, or to the Western Front.
On 6 October he wrote to Gwen:

I have had some trying experiences which have rather overtaxed me, but
during the time I stuck it I did rather well, I think. I do not like seeing
such things; I do not want to again. I feel weak, it is awful to feel so
weak, but it is no use being so . . . I received your letter, Gwen, on the
side of a hill and had to read it by moonlight, and then a sergeant called
out that all letters were to be torn up . . . My desire to get back to painting
is almost unbearable at times and my hope of getting the job proposed
by the Ministry of Information seems hopeless . . . I have heard nothing
but that one letter from the Ministry. I feel Gil is not having an easy time
in Egypt. Sydney is back with his battalion. I have only my book of
Richard Crashaw's poems with me now, but he is a great comfort.[2]

Stanley had only his haversack with him. His kitbag, which held
the bulk of his possessions and drawings, was still stacked in the
reserve area where he had had to leave it in such haste.

The desperate last days of the war were causing havoc among

Christ's Entry into Jerusalem

Stanley's family and friends. In August Percy's headquarters in France had received a direct hit and he was brought to a London hospital with wrist and scalp wounds; he would never play the cello or be able to row competitively again, but in compensation met a nurse, Hilda Thomas, whom he was to marry. Horace too was in hospital, in Edinburgh, having collapsed in action from exhaustion. Sydney had been blown up and badly shaken; recommended for the Military Cross, he had been sent down the line to hospital but was now 'back with his battalion'. Though Stanley probably did not know it, Henry Lamb had been transferred to the Western Front where he too was recommended for the Military Cross for courage in tending the wounded during bombardment; but there he had been badly gassed and sent to hospital in England. A weak, impatient Stanley was left to kick his heels in Salonika, pleading for help from friends at home. Pa relentlessly lobbied in his interest; Edward Marsh made approaches to the War Office;

Henry Tonks wrote on his behalf to the War Artists' Committee: 'Spencer is, I should think, not much good as a private soldier, although I am sure very willing. A genius pitched in the mud.'[3]

At last the War Office found the means of justifying Stanley's release by placing him on the special 'Y' list for the repatriation of serious malarial cases; he was to suffer occasional bouts of recurrent malaria in future years. He took the then usual route by train from staging post to staging post through Italy and France, arriving at Southampton on 12 December. Thence to the Royal Berkshire Regimental depot at Reading, fascinated by the returning traveller's unfamiliar familiarity with the sights and sounds of home:

Did I tell you that on the train coming home was a dear little girl seated next to me and she had such a dear little head, rather solemn and meek. Her hair was long and massive and dark, and one of the locks rested on my shoulder. Of course, I only appeared to be interested in Lloyd George and the Coalitionists [in his newspaper]. After such harshness, you know, Desmond, harsh men and harsh sunsets and seeing no women for perhaps a year, and then. . . .![4]

As the formal demobilization scheme had not yet been announced, Stanley was given a month's leave at Reading. So by train to Maidenhead:

As I ran into Maidenhead station I saw the cutting which branches round to Cookham, with its foreign and un-Cookham-like appearance, as if it were trying to kid me it did not go to Cookham. However, I felt assured when walking from the station I arrived at the west end of Cookham Moor. There in the distance were the cowls of the malthouse glistening in the evening sun. Only a few weeks ago I was saying to myself I would have to go three thousand miles if I wanted to see them. So far removed, the cowls looked like huge white moths settled on some twig or wall with wings closed in the midst of the trees of Cliveden Woods and the houses and chimney smoke of the hamlet. I had heard and written about [to Desmond] the anvil of the blacksmith. It was situated at the top end of the village and I knew as I walked over the Moor that soon I would be hearing it . . . When I did hear it, it was as if I had been hearing it when away. It was now late in the afternoon in December. I had hoped to find Syd, but he had been killed in September.[5]

Stanley had arrived before his letters, and his homecoming was a surprise to his family and neighbours. He had not known of the death of Sydney who had been killed on 24 September in German shelling preceding one of their last counter-attacks; no further casualties were sustained by his battalion before the collapse of the German forces and the Armistice.*⁶ Stanley continues his description:

To be able to walk about Cookham not as I did in 1914 when I felt disturbed about the war and not as when every month at Bristol I had a day and a half's leave, but as I did in the 1910 – 1913 years . . . I went and looked at Odney, the weir still running, and I thought as I looked at it, it was running and someone attended those sluice gates while I was in the Macedonian hills . . . I went down Cliveden and saw a little path, dipping with grass but now practically gone because a young copse had been planted there.

It was near a spot where in happier days he and Sydney 'used to sit among some felled trees, and there, while I thought out something, Syd would read about Jacob and Esau or read the Song of Solomon' and of which the feelings of calm and brotherliness were used in Stanley's 1910 drawing of *Jacob and Esau*: 'and I remember the marguerite field of softness just as it was, with Syd walking along the path between it . . . he was a peace-loving person, and he seemed like some Esau or Jacob or Zacharias.' When Stanley came in 1940 to paint *The Coming of the Wise Men*, he covered the head of one of the indistinct figures behind 'Harold' – the Sydney-figure – with red paint.

Although relieved to be there, the Cookham he found was no longer the Cookham he had left. Percy, writing from leave to Will in 1917, had described its 'air of sadness'. The conscripted men had not yet come back. Gilbert was still in Sinai. Percy was aiming to take up a post-service graduate course at Cambridge University. Will was abroad seeking, with Johanna, Swiss citizenship, and he had applied for the post of piano tutor at Berne Conservatoire. Harold and Natalie were in Plymouth where Harold was leading

* Sydney's Military Cross was for an (unremembered) act of bravery on 8 August 1918.⁶ Florence later received the medal at a posthumous ceremony.

an orchestra. Horace, convalescent, came on a visit. Stanley was delighted to see him, 'I had not seen him for four years . . . and when he walked in I trembled and shook for joy . . . his wife is young and simple in the sense that some wildflowers are.'[7] Pa, well into his seventies, was still teaching music but also learning Latin and writing poetry. Ma had become severely bronchial, with distressing spasms of coughing which alarmed Stanley because they could not be cured. His sister Annie, still 'yap-yap-yapping, although what she says is very interesting',[8] was doing her best to cope, but seemed more restless. In the coming months, Florence was to be widowed. Once again, Stanley found himself facing imaginative re-adjustment. The Cookham of 1919 was as different in atmosphere as his Beaufort ward had been on the morning after the arrival of a convoy. He found himself to his chagrin having to identify a new totality through which he could resume his quest for spiritual meaning.

Christ's Entry Into Jerusalem surely conveys his disorientation. Although painted in 1921, it refers to the specific memory-feelings of 1919. A companion painting to the 1920 *Christ Carrying the Cross*, in which Stanley used the memory-feelings of his departure from Cookham, it is painted in the same weightless style and toneless colouring, but uses as compositional elements his feelings on his return to Cookham. The moment of the action is that recorded in Matthew 21:10: 'and when He was come into Jerusalem, all the city was moved, saying, Who is this?' But the crowds of the biblical original are in Stanley's version clusters of Cookham neighbours, curious, but hardly clamouring. A feeling of whispering pervades. The colours, deep reds and blues, are those of chill or depression. Railings and gates isolate the figures. A youth and a girl fling open a garden gate styled like the gate of Fernlea against four women on the footpath who fling back their heads in lamentation. Is this not how Stanley felt on that December day in 1918, the armistice little more than a month old, when he returned so unexpectedly? The village he depicts is no longer the one he remembered. Vegetables are grown for food in gardens once filled with flowers. Women outnumber men. The surprised villagers whisperingly ask each other why it is Stanley Spencer who has returned home early and unwounded. Why not *their* husbands or *their* sons? The four women on the footpath howl in the recollected

funereal ullulations of Islamic women in Macedonia; their men will never come home.

From a preliminary sketch Stanley adjusted the composition to emphasize the two central children. Evidently they are a key element. No longer the worshippers who in the biblical account enthusiastically spread cloaks and palm leaves before Christ, they scurry beside him on his ass as children in his boyhood would run excitedly alongside the novelty of a motor car, their floating attitudes reminiscent of those in *Girls Running, Walberswick Pier*, a painting by his former Slade tutor Wilson Steer. They are ignoring a Christ again shown as a profile of Pa. He seems uncomfortable, frustrated. Are the children ghosts of Stanley, emblems of a past youth when he ran in triumph with Christ in days he can now no longer recapture? Is the painting a cry of despair for times that once were, a threnody perhaps for a brother deprived of his triumph in Jerusalem, the anger of Stanley at the apparent victory of the material? Are we meant to end so in the oblivion of our hopes?

There is no answer. One thing only is certain. Stanley has come home to his Jerusalem for what he hoped would be a spiritual triumph, the miracle of revelation to be expressed in paintings yet to come; but he is numb. If in reality the villagers welcomed him, as most no doubt did, in genuine friendship, then their greetings were as misplaced in relation to Stanley's destiny as were those of the people of Jerusalem for Christ. How Christ must have gazed at the throng in grief and sadness! Could they not see with him that his true triumph lay not in a material kingdom but in a spiritual redemption to come?*

* The painting was one of several works which Stanley kept by him for many years. Its existence was not made public until 1942 when Stanley's second wife Patricia, claiming that he had given it to her, sold it to the Leger Galleries 'for her own benefit', according to Stanley. She received £100 for it. Its title then was, significantly, *The Road to Jerusalem*. With it Patricia also sold more of Stanley's works, including *The Sword of the Lord and of Gideon* (£37.10s) and a drawing of *The Last Supper* (£15.8s).[9]

Travoys Arriving with Wounded Soldiers at a Dressing Station at Smol, Macedonia

But when they bent to look again
The drowning soul was sunk too deep
For human kindness.

Isaac Rosenberg: *Poems*[1]

PERPLEXED though Stanley was at the changes in the Cookham atmosphere around him, his immediate priority was to compose the War Artist commission for which he had been brought home. He did not have long to wait. On 1 January 1919 he told Florence:

The day before yesterday I received a telegram telling me to see Major Todd. On Tuesday at 11 am I saw him and he got the DAAG [Deputy Assistant Adjutant General] to sign a pass granting me another two months' leave, and Major Todd said as soon as the two months' leave was up I must apply to Mr Yockney, and Major Todd will get me another two months' leave, and so on.[2]*

Major Todd was the War Office liaison officer in charge of the Army artists seconded to the War Artists' Advisory Committee. Alfred Yockney was the Secretary to the Committee. Unfortunately the War Office did not tell the Royal Berks Depot of the arrangement, and the Depot, assuming that Stanley had overstayed his initial leave, sent a couple of Military Police to arrest him. The matter was quickly settled, but Stanley felt his honour in Cookham had been impugned and remained throughout his life as nettled

* Stanley was not formally demobilized until April 1919.

Travoys Arriving with Wounded Soldiers at a Dressing Station at Smol, Macedonia

about the affair as he was about having nearly been shot when looking for his water-bottle.

The Committee's fee for the proposed painting was a substantial £200: 'My pay now comes from Mr Yockney and in rather larger quantities than it has been coming from the Army Paymaster. Everybody in the War Office looks so desperately serious . . . I liked nothing at all there except the little girl I had to fly after. Major Todd is very nice, something like Darsie Japp.'[3]

Stanley submitted a number of sketches to the Committee, drawn from memory, for his kitbag with most of his drawings was still in Macedonia. He wrote to the Reading depot for it and was vexed to be told that it had been disposed of ('so I suppose some Macedonian peasant now has my drawings'). The idea selected

183

shows mule-drawn travoys bringing wounded to the dressing station at Smol. It was to be a large painting, nearly seven feet by eight, and too big to paint at Fernlea, so Stanley hired as studio space Lambert's Stables, then untenanted, at Moor Hall. It was January, the stables were cold and draughty and there was no heating in them, and nothing remained to remind him of the horses – long since gone to the war – 'save for their noble names emblazoned in gold and crimson above their empty stalls'. At the same time he worked intermittently to finish *Swan Upping*, for he was keen to re-establish contact with likely patrons; it was bought by Louis and Mary Behrend, who were to become major admirers and friends. Some old friends, he discovered sadly, he would never see again: 'I will always feel sorry for Rosenberg; he was never fit for active service. His suffering must have been terrible. He was in the Middlesex Regiment and was killed in the big push.'[4]

Born within a few months of Stanley, of refugee parents, Isaac Rosenberg was one of Stanley's scholarship group at the Slade. A young man of great promise, in the end more a poet than a painter, he was killed on 1 April 1918 in the German 'big push' of that spring. Edward Marsh was too involved in the international peace negotiations to spare Stanley much time. But Stanley was overjoyed to renew contact with Henry Lamb, who was still convalescent and not yet returned to his Vale of Health studio. He had retained it throughout the war, and it was frequently used by his sister, a don at Cambridge.

Stanley especially looked forward to meeting Desmond Chute again, and later that January Desmond, Eric Gill and Hilary Pepler invited him to join them for a weekend in Staffordshire. The trio had dedicated their Ditchling community as a lay order of Dominicans, and Stanley was to see them 'clothed' or inaugurated as Tertiaries at the Priory of the English Dominicans at Hawkesyard near Rugeley. Although not keen to break the flow of his work, Stanley agreed to meet them at Euston station. Unfortunately Desmond went down in the prevailing influenza epidemic. His ever-anxious mother and a companion had themselves chauffeured to Ditchling to take him, swathed in blankets, back home to Bristol. Pepler, knowing Desmond's past influence on Stanley, argued that the invitation should stand, and that if he and Gill could get Stanley to Hawkesyard, he might be persuaded to convert to Roman

Catholicism. Gill was sceptical but thought that 'at least they would have some sport'.[5] From his pre-war acquaintance with Stanley, Gill sensed Stanley's instinctive suspicion of imposed dogma and ritual. His and Stanley's outlook touched closely on many points, on their respect for the role of the medieval craftsman as artist, for example, and on the correlation of the sexual and the religious. Both had enquiring minds, imaginative wonder, and forthright artistic integrity. But whereas for Gill integrity lay in expressing the external – the line, the curve, the form – for Stanley is rested in the internal, in the compositionally associative. One took stone and forced his feelings out of it; the other strove to bring meaning to his feelings out of memory.

When Stanley turned up at Euston and learned that Desmond was not going, he tried to cry off. But he was, according to his own account, induced to accompany the other two by hints that a commission might result. From Hawkesyard, Gill dropped a note to Desmond in Bristol to say that: 'Stanley Spencer is with us having a fearful wrestle, chiefly with himself. He met us on Saturday [20 January] determined not to come after all, but we persuaded him, and he came just as he was, with his hands in his pockets and no luggage at all. What will be the upshot of it God only knows. He is in a curious mixed state of pride, prejudice, humility and reverence.'[6]

As Gill foresaw, the weekend was an emotional disaster for Stanley. Although Desmond had tried his best to interest Stanley in Roman Catholicism, the war had made the concept of a personal God difficult for him: ' . . . in some of the awful moments . . . I found myself asking the question: "Is Christ adequate in this?" . . . It is an awful shock to find how little my faith stood in my stead to help me.'[7] The figurativeness of God and Christ was to remain a powerful, at times dominant, element in Stanley's art. But neither Being was the personification of accepted piety. Confronted at Hawkesyard by the intellectual arguments of the Dominicans, his instinctive suspicion that constraints might be imposed on his imagination by other authorities was once more aroused. On his return to Cookham, feeling he had been betrayed, he wrote to Desmond to say that the weekend had been 'all right, but I counted on seeing you'. Privately Stanley confided that the weekend had been 'hell'. Richard Carline has suggested that as a result all

contact with Gill ended.[8] But it is more likely that henceforth Stanley resolved to concentrate on his commission.*

The longed-for meeting with Desmond took place a little later. It was another emotional setback for Stanley. Desmond came to Cookham by train, probably on a break in his journey back to Ditchling. Stanley took him to the stables to see *Travoys* on which he was working. To his chagrin Desmond did not seem very interested in it and did not respond with the enthusiasm Stanley had hoped for. Newly recovered from influenza and typically hypochondriac, Desmond did not relish standing in Stanley's cold and draughty 'ice-house' listening to an exposition of a painting about a war outside his experience; and Stanley had not appreciated how far apart they had grown since those heady days in Bristol. The experience of living in the Gill community had been as profound for Desmond as the war had been for Stanley, and his feelings of piety were bound to surface when Stanley went on to show him some of Gilbert's paintings left from before his enlistment. Among them was his *Crucifixion*. Stanley wrote in his memoirs of Desmond's reaction: 'He was so staggered that he could hardly speak. He asked me deferentially if I could possibly part with it, and having received it [here Stanley on re-reading inserted a pencilled 'all wrapped up and paid for'] he departed . . . It was nevertheless a pleasant friendly visit, but when he was gone I was sure of my previous fear when he saw Gil's picture, namely that a God fell and a better was set up. I think I tried feebly . . . to interest him in my then-being-done Travoys, but he seemed preoccupied and impatient to be gone, he had a train to catch or something.'[10]

The recollection touches a deep hurt. Stanley had lost a once-valued handholder. Henry Lamb, it seems, had already bought Gilbert's *Crucifixion* for £20 from the 1914 Slade summer show.[11] It is unlikely that Stanley would have re-sold the picture without consultation, and in fact the sale to Chute did not take place until seven years later when Stanley was living in Lamb's former studio in London: 'Gil is staying here and I have asked him about the Crucifixion and he thinks that you [Desmond] had better take it

* Eric Gill's daughter Petra remembers a mutual family friend bringing Stanley in the 1930s to Pigotts. In that homespun, creative, rural-craft atmosphere Stanley was in his element and at mealtime reduced even the voluble Rene Hague to silence.[9]

and pay when you can. Gil reckons £40 as the price, but if you can't manage that, don't be afraid to say what you can manage ... the point is, Gil wants you to have it. The John Donne picture [an early study by Stanley] is £5 to you, sir.'[12]

If it seems surprising that Stanley's memory, normally so acute, could play such a trick, we should remind ourselves that there have been previous occasions when a hurt overcoloured Stanley's recollections, and that in this case the hurt went deep.* This is the first recorded incident in Stanley's life when a person he worshipped as profoundly influential in his inner life failed to live up to his expectations. Such disenchantments were to punctuate Stanley's life. If they were painful to him, they were often equally so to those who unexpectedly found themselves unable to meet the high aspirations he had sometimes gratuitously attached to them. Perhaps this was the alchemy by which the twenty-four-year-old Desmond became in Stanley's Beaufort memoirs a mere 'youth of sixteen'. However, for the time being, *Travoys* was Stanley's priority, and he even refused an invitation from the Raverats on the grounds of his determination to finish it.

Stanley's full title for the painting makes it clear that the depicted event took place at Smol in the early days of his Macedonia service, when he first joined the 68th Field Ambulance. The village, on the flanks of the Sedemli ravine, is shown on military maps as having a mosque with a minaret:

I was standing a little away from an old Greek church which was being used as a dressing station, and arriving there were these rows of travoys crammed with wounded men ... In the top of the picture mules look in at the enlarged window ... inside of which an operation is in progress. The mules and travoys are coming from the direction of the hill away to

* At the time Stanley's formal code of politeness evidently gave Chute no hint of the havoc he had caused within. But in another account of the visit Stanley let his hurt feelings show: 'Since things cannot be helped, it could not be otherwise. But I felt the loss. Oh, yes, he is a friend of mine as far as I know, and our old esteem and mutual interest is doubtless still in being. All I know is from that 1919 time when he saw that thing of Gil's he never as far as I can remember made a single enquiry as to what I was doing or painting.'[13] Carline points out that the endings to Stanley's letters changed after 1919 from 'your ever-loving friend' to 'yours ever'.[14] But as sometimes happened when Stanley was hurt, his comment is sweeping. His correspondence with Chute, which continued until 1926, then mostly abroad, attended when in London one of his exhibitions, and as late as the 1950s Lady MacFadyean remembers twice being taken by Chute, her cousin, to call on Stanley in Cookham: 'What a *character*!!!,' she recalled.[15]

the right [Machine Gun Hill, the objective of the attack] and lining up outside this old disused church . . . That tall sort of holly scrub in the foreground was very profuse in its growth; there were great tracts of country covered with it and, as I have heard, it was evidently an ancient Greek weed. The wounded have their faces covered in little squares of mosquito netting for the moment.[16]

To Edward Marsh Stanley sent a more subjective description:

Along the bottom of the picture and in the immediate foreground are great thistles. The leaves are large and have great spikes. They have milky lines all over them like variegated holly leaves have. The flowers are mauve and look like great maces. Whichever way the flowers go, the leaves form a kind of halo around them . . . The four wounded I think of as separate groups of nebulae. Each group has the same density but each has a different kind of density. For the feeling they give one, they might be four saints enthroned, the stretcher handles being so to speak ornaments.[17]

'Separate groups of nebulae' – a boyhood recollection of listening to Pa's tales of stargazing in Lord Boston's observatory? – 'four saints enthroned', the stretcher handles like 'ornaments'? Although the details of the picture – the huddled bodies quiescent under morphine, the attentive orderlies, the necks of the mules strained 'like great vases' and their ears pricked as they inquisitively watch the movement within the lighted window – were part of Stanley's recollections, they are not being used in the painting for their dramatic value, but as an invocation. The picture is more than an illustration of a tragic event, more even than the compassionate disillusion of so much contemporary war art. The scene, perhaps the first shock of the reality of war in Stanley's nervous imagination, has been transfigured into that world of spiritual peace which Stanley found in the Vardar Hills; a 'heaven' in which the material and sometimes terrible confusions of earthly experience could be transposed into spiritual meaning. 'In the men and women of that war I felt, as I felt in myself, that there was some sort of indwelling peace.'
 The wounded in the painting are in that state of detachment from the physical which Stanley himself sensed in that place. They

are in that state of 'peace' which he had found for example in
Deborah, the Beaufort patient who 'did not know there was a war
on':

> In the midst of the war there was a species of peace made and sustained
> by the state of those in it but not of it . . . one would have thought the
> scene was a sordid one, a terrible scene, but I felt there was a grandeur
> about it . . . All those wounded men were calm and at peace with
> everything, so that pain seemed a small thing to them. There was a
> spiritual ascendancy over everything . . . Like Christ on the Cross [the
> wounded] belonged to a different world than those tending them . . . I
> have tried to express the fact that these men on stretchers and the orderlies
> attending them are inserting peace in the face of war by means of the way
> I display them in the composition, so that in spite of what is going on
> and although they are conforming to the conditions they are in . . .
> nevertheless all seemed to be taking part in some communion of peace.[18]

The concept repeats the notion which Stanley portrayed in *The
Centurion's Servant*, a conception of the redemption to be derived
from commitment to values beyond the material. Many of the
modernists, influenced by thinkers like Bergson, were beginning to
accept the notion that faced in our lives with the confusion of
existence, we instinctively make those choices by which we hope
to survive most happily. Most daily choices are inconsequential or
can be reversed. But periodically we face choices we sense are
irrevocable. These lie at the heart of drama, literature and art and
are the essence of the religious. They offer a hostage to the future
in that they bring us to a moment in time beyond which there
can be no going back. Rationality demands that we avoid such
decisions, the 'never volunteer for anything' attitudes of Stanley's
infantry comrades. But there remains something which drives us
at some moments of our lives to abandon reason, to face up to the
oncoming point of no return and deliberately to proceed beyond
it. Why? We can seldom say, except to argue metaphysically that
we are abandoning the rationality of self-preservation, becoming
in Stanley's term 'unselfish', in order to attain some objective which
material reason would deny us. Our way to the expected reward
may involve bewilderment, danger, even pain. We must endure it
as a purging, our only encouragement the belief that we shall

emerge beyond it and find a satisfaction, even a serenity, we could not otherwise know.

Stanley believed that our instinct to happiness is an Absolute, directing us towards the universal Good, the creative. The destructive, the Bad, in human nature, he felt, is the result of the imposition of untoward physical or environmental factors – genetic, cultural, social, economic or political. Although they surround us, they are in essence obstacles we negotiate by means of our instinct for the Good, the marvel being that it can carry us over them even when they seem insuperable.

It is in this outlook, I believe, that Stanley paints the soldiers of Salonika who made the assault on Machine Gun Hill. The bitter war was an experience of the physical through which they were carried by their instinctive commitment to values beyond the dictates of the physical. At the blowing of the whistles by which they rose from their trenches, bayonets fixed, they were being forced by the circumstances of existence to face one of its more fearsome obstacles. They did so because their natural instinct for the Good induced them. It was *the* job. The wounded Stanley shows are, in his understanding, only different from their comrades who lay dead around them or those who returned unhurt to the extent that they were visibly undergoing a purgation, 'like Christ on the Cross'. But all the combatants were in his deep sense communicants, 'in the war but not of it', and are, whether wounded, dead or surviving, redeemed and partaking of a 'communion of peace'. Stanley has painted the wounded because they were those he happened to see then. On later occasions he would honour the soldiers in their other states. Just returned from the war, he was not yet ready to paint them in these other states. But in time he would be.

When the painting was hung at the National War Paintings Exhibition at the National Gallery in December 1919, Tonks passed it 'without comment'; from which Stanley concluded 'I suppose he does not like it'. However, Stanley felt that 'there are some good things in it'. Public opinion agreed with him, even though on Viewing Day he had difficulty in getting in to see his own painting; an attendant tried to turn him away on the grounds that he looked too unimportant to have been invited.[19]

Although there was talk of Stanley being commissioned for two

additional War Artist paintings, and two small oils exist which might represent part of his proposals, it came to nothing. In any case, his heart was not in it. He wanted to rebuild his career, and for that he needed to recapture that Cookham peace which had permitted his pre-war vision to be 'going so well when I joined the army'. *

* Stanley recalled that at this time: 'On a canvas two feet square try to paint some men in a ravine and pinning clothes to a tent. Could not do it and felt too muddled, the [new and unassimilated] Cookham atmosphere was all round me.'[20]

CHAPTER TWENTY

The Last Supper

> For fourteen hours yesterday I was at work, teaching
> Christ to lift his cross by numbers and how to adjust
> his crown . . . I attended his supper to see that there
> were no complaints; and inspected the feet to see that
> they should be worthy of the nails.
>
> Wilfred Owen: training conscripts, 1918[1]

STANLEY'S *Travoys* commission had raised his prestige locally,
and he could no longer be dismissed as the 'Master Spencer' of
1914; the boy who went away had come back a man. He calculated
that with his back pay, gratuity and fees for *Travoys* he could
muster some £380. This sum, he felt, was sufficient to sustain him
for the next two years, even though in Macedonia he had not
appreciated the scale of wartime inflation at home; he had reacted
with annoyance when Pa asked for an increase in the allowance
Stanley had made him, although more from exasperation at Pa's
approaches than unwillingness to pay.*

Even so, he could not settle. Neither Cookham nor Fernlea were
the places he remembered. By the middle of 1919, Fernlea housed,
besides himself, an invalid Ma, an ageing Pa, an agitated Annie,
an elderly and faithful servant called Alice, and a Gilbert travelling
to and from his resumed course at the Slade. So when later in 1919
Margaret and Henry Slesser offered the use of a room as a studio
in their substantial house, Cornerways, across the river at neigh-
bouring Bourne End, Stanley accepted with relief.

* 'Father's letters to me lately have been beautiful and I have enjoyed them very much, but in each
letter there has been a reference with regard to the remittance not yet having arrived, and these references
have been full of that "I won't murmur: I'll be silent: I'll be a martyr" sort of stuff, full of the humble
reproach tone that makes one weep and wail with anger.'[2] Stanley preferred forthrightness in everyday
dealings.

The Last Supper (also reproduced in colour)

The devout Slessers were fascinated by the religious content of Stanley's work. Henry was a successful and ambitious barrister and judge. Chestertonian in outlook, he enjoyed organizing his circle of friends into a fraternity jestingly dedicated to 'St Ambularis' and devoted to what Gilbert described as 'fresh air, blue skies and wayside inns'. One member later to play an important role in Stanley's life was a solicitor, Wilfred Evill. G. K. Chesterton himself who lived nearby at Beaconsfield was roped in and on one occasion was compelled to do penance to the fraternity when he was discovered to prefer cocoa to beer.

The Slessers asked Stanley to paint a triptych for the altar of the private chapel above their boathouse. The three paintings, done in a monumental chiselled style, are interesting for their choice of subject. *St Veronica Unmasking Christ* can be seen as a mark of gratitude to Margaret – Stanley was subsequently invited to lodge full-time with them, thus in some sense releasing him by an offer of hospitality in which to pursue his painting. The other two works are on the theme of *Christ Overturning the Money-Changers' Tables*, and the trio continues the Life of Christ series which Stanley

had conceived through his conversations with Jacques Raverat and started just before the outbreak of war: 'When I come home I am going to learn fresco painting and then if Jacques Raverat's project holds good, we are going to build a church, and the walls will have on them all about Christ. If I do not do this on earth, I will do it in Heaven.'[3]

Tragically, the scheme originally envisaged was no longer possible. Jacques' bouts of disabling weakness which had kept him out of the French army would today be diagnosed as the onset of multiple sclerosis, while the failure during the war of his father's business interests in France made the financing of a 'church' impossible. Undaunted, Stanley pressed on alone, and hoped that he might enlist a sponsor who would appreciate its majesty.

The theme of the Life of Christ was to dominate Stanley's visionary work throughout the coming decade and give rise to some of his most cherished and valued works. Superficially the paintings can be regarded as the flowering of a religious idealism, uniquely portrayed. But surface impressions, even in the 'innocent' paintings of Stanley's young, pre-war days, are seldom adequate to unlock the intensity of feeling evident in their composition.

In fact, the theme of *Christ Overturning the Money-Changers' Tables* must be regarded as a sardonic choice for the chapel of a patron who was so patently interested in material success. Moreover, the theme and Stanley's presentation of it betray the ferocity in his nature which often surfaced when he was spiritually or creatively frustrated. Although on one level he was deeply grateful to the Slessers for their kindness and indeed respected the validity of their outlook and way of life, there was a restlessness within him which not merely influenced the choice of themes but compelled him to turn them into personal testaments. It was his unblinking candour, sometimes seen by critics as perversely uncompromising, which bound him to the friends who understood, to the Raverats, Jas Wood and Henry Lamb, himself deeply sincere if sometimes seemingly flippant about his aims. Stanley wrote: 'Machinations are so dull, yet men seem to live by them and the little vainglories that attend their success. I thought what Henry Lamb said about winning the Military Cross was true, that it only added absurdity to feelings of despair.'[4]*

* Alas, Lamb's letter containing his thoughts on the Military Cross is lost.

The Last Supper

In the people with whom he came into contact Stanley looked for the same personal integrity and the same sympathetic search for spirituality. It was not often that he expected to find it, but when he did, the experience was shaking: 'I feel that people and everything are really different, not in inferiority or superiority, but different in beauty. I remember having some friends I was always meeting in the evenings, and I did not see anything special about them until one day I went to breakfast with them, and seeing them at breakfast gave me wonderful feelings about them. I was so overcome that I could not eat my breakfast, not even bread-and-butter.'[5] Evidently a similar experience occurred in the case of the Slessers, a transcendence which lifted them, for Stanley, above the prose of their 'machinations': 'Harry is on the bench today at Berwick-on-Tweed. Margaret is in the armchair opposite me trying to add up her penny-bank balance and filling the whole room with swear. I am getting on with the portrait of her rather well.'[6]

It is in such a context that *The Last Supper* can be approached. Stanley had first thought about the subject in his pre-war years* and continued to do so at the Beaufort, as Jack Witchell told his girl: 'Young Spencer once told me that as he handles food or laundry, his thoughts are actually engaged on biblical subjects, such as The Last Supper.' There is additional interest in the comment because it illustrates a habit Stanley used all his life of throwing out such remarks among companions, to see if anyone reacted in sympathetic response. If so, he knew he had found a kindred spirit. If not, as no doubt in this instance as in many others, he pursued the notion only in his head.

Stanley placed the event in a loft – the 'upper room' of the biblical original – in the malthouses behind Fernlea. The buildings had fired his imagination from childhood. Seen from the nursery window the cowls of the ventilators rising from the buildings – 'great white moths' when viewed from a distance – were 'benign'. They were 'reminders of a religious presence' to Stanley, a feeling he had painted in his *Mending Cowls, Cookham* in 1915. If to the Spencer children these were 'the eyes of God', to Stanley the malthouses were a kind of heaven, particularly as he was not allowed as a small boy to enter them. When at last he went inside,

* Stanley had written to the Raverats on May 8th 1915: 'I have had a great idea about the Last Supper. I feel sure it is good, but I want to be certain.'

his imagination was staggered at the vastness of the malting-floor and the strange ritual of the spreading of the barley on it. 'Will heaven be as surprising as that?' he asked himself. Large enclosed spaces, especially when associated with diffused light, were always a quickening sensation for Stanley. It is traceable from early days when he could not see over the sill of the nursery windows, and so rested his imagination within the walled confines of the room, exposed to light but not knowing where it came from and which was therefore magical. The sensation was repeated for him at worship in his Methodist chapel, and even more so in Cookham Church, where the windows, high in the walls, allowed sight only of the sky, so that the quality of the light and the echoing of the space became associated in his mind with 'holiness'. At the Beaufort, the Laundry and the Stores evoked the same feelings, as did, perhaps significantly in this painting, the lofty Assembly Hall where the orderlies took their meals.

One other association, it seems, was built into the composition – the wall against which the event is depicted. Its brickwork was different from that of the main walls, more red. Christ stands at the table to break the Passover bread. The profound meaning in the Jewish faith of the detail in the ceremony – the drops of wine poured in recognition of the innocents whom God, to bring his people out of Egypt, had afflicted with the plagues, or the sop of unleavened bread given as a mark of respect, of forgiveness, or even of warning – may not have been appreciated in detail by Stanley. But there were many Jewish students at the Slade and, in the intense way of student discussion, he must have picked up the gist. Four apostles occupy the high table with Christ, although the figure on his left, hunched and distorted, trying to hide, suggests Judas. The disciple on his right would appear to be John, who 'lay on Jesus' breast.'

In contrast, the disciples on the side tables are stiff and regimented. Those on the right tensely grip the table edge. Those on the left raise their hands in uniform gesture. The strange patterning of the feet – Christ has just washed his disciples' feet – is sometimes used so by Stanley to indicate contemplation, but may hint at Christ's own feet fastened to the Cross. When a child asked him why the legs were so, Stanley is said to have replied, 'You see, the disciples are a bit bored; they have heard it all before.'[7]

It is unwise to dismiss such remarks as flippant. They often capture some bitter experience. We may look perhaps to Stanley's memory of the ceremonial of the Dominicans at Hawkesyard and his reaction to the arguments used by the Brothers to convert him to Catholicism. He had 'heard it all before'. Linked too are hints of his vivid memory of his first meal in the vast mess hall of the Beaufort: 'The table was nearly full when we went in. I sat down and felt bewildered, as I had just come from where there were only four of us at table, my mother, Father, sister [Annie] and myself. We were served by several loonies. They were all tall and some very gaunt.'[8] Later he was to comment, 'I find watching the men in the messroom having their food very amusing. Some have splendid heads.' Perhaps he has used some as the heads of the disciples, for each is individual, even though attitudes are replicated.

The drama of the moment is tense. In an act of apparently breathtaking presumption, Christ has taken one of the most profound Jewish rituals and appropriated its symbolism to himself. Moreover he is asking his disciples to support the transfer to himself of the venerated doctrine of their forefathers. The disciples are transfixed by the implications of the moment, and by the

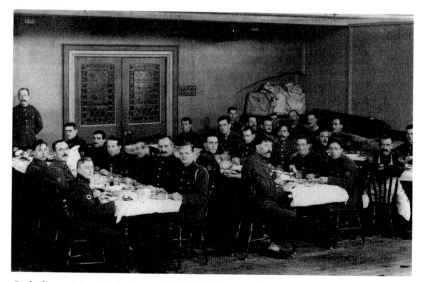

Orderlies at Mess in the Assembly Hall of the Beaufort War Hospital, about 1915.

197

demands being made of them. Can their faith hold? The loyalty of one of them will fail and he will betray his leader to the affronted guardians of the ancient faith whose will is to root out such heresy. Which of them will betray? 'Lord is it I, is it I?', they ask Christ. They are appalled, fearful. By what terrible destiny does God ordain one of them to be the human agent who must act to bring His Son to godhead!

There is some possibility that Stanley used the subject in an effort to redeem a sacrifice of his own to which he was being forced. The dilemma he faced when he enlisted is being repeated. In that experience he had sacrificed the freedom and purity of his creative vision to the dictates of an alien authority. Now a different but equally alien authority seems to be pressing him to conform to its will. In the war the pressure was external. Now it is internal. In the paintings which immediately followed, this would become more explicit.

Looking back at *The Last Supper*, Stanley felt he had not entirely succeeded in conveying his idea. 'I liked the red wall among the sandy-coloured ones but I could not get the feeling of the place, which was indivisible from a concept I had of Christ. But I could not get it into the picture.'[9] Even as he finished painting it in the summer of 1920, he was telling Henry Lamb that 'it has not got the nice feeling that the drawing has got somehow', even though Lamb had expressed a dislike of the drawing.

Stanley's admirers were indifferent to such metaphysical niceties. They saw a composition intriguing in its originality. There was talk of the Contemporary Arts Society buying it, but the Slessers were anxious that it should not leave their house, where Stanley had painted it. They offered a purchase price of £150 – perhaps £4000 or £5000 today – which Stanley was pleased to accept.

The Crucifixion, 1921

Being no adept in the science of his heart, there
remained a good deal of mystery for him about the
appearance of 'Woman' in his life. What was she
doing there, what did she want with him?

Wyndham Lewis[1]

IN 1920 Stanley was twenty-eight. Early in that year, at a musical
evening, he had met and been attracted to a girl called Nancy from
Reading. It was a tender and romantic attachment, to which
she responded. She was, however, only seventeen. Her father,
discovering Stanley's interest, put a stop to it. But he did so with
some brutality, barring his house to Stanley and among other
things calling him 'a little black rat'. The insult hurt. Years later

The Crucifixion

when a rash questioner asked Stanley what he would like to have
been had he not been a painter – rather like asking Christ who he
would wish to have been had he not been the Son of God – Stanley
replied brusquely 'a black rat or a snake',[2] thereby indicating,
could the astonished enquirer have understood, that his question
was as insensitive as the comment of a father who had misinter-
preted Stanley's attentions to his daughter.*

From subsequent correspondence it appears that Stanley still
had no sexual experience. He had not even seriously kissed a girl.
This was not from lack of interest. Wheeling his patients at the
Beaufort around the hospital, he would often be accosted by 'lovely
girls all unfriendly or, if not, at least un-get-at-able, and now and
then . . . some lovely girl would lean over the man, and I would
try to get a bit of kudos too, rather like a footman at the back of
the Queen's carriage. But orderlies were unpopular; they had not
been to The Front. So all I would see was the back of the girl's
head. But I would get more out of the back of her head than the
patient would get out of the front.'[4] Such inexperience was not at
all unusual in the Edwardian upbringing of Stanley's social milieu.

Keen to promote themselves, Stanley, Gilbert and their Slade
fellow-student Tom Nash – no relation to John or Paul Nash –
joined the New English Art Club in London, of which Stanley
remained a member until 1927. Among the new friends they made
were the Carline family, whose home was in Hampstead not far
from Henry Lamb's Vale of Health studio, to which Lamb had
now returned. The father, George Carline, was an artist of repute
who died from a heart attack while on a painting holiday in Assisi
in 1920. His widow, Annie, who liked writing children's stories,
became a naive painter whose work was much admired by André
Lhôte and others; surprisingly, she was the only member of the
Carline or indeed of the Spencer family to be given a one-man
show in Paris.

Three of their five children were professional artists. Sydney was
master of drawing at the Ruskin School at Oxford and did much
to befriend Gilbert early in his career. The youngest, Richard, had
like Sydney been a war artist and had been among the first to

* Marcel Proust, confronted by the same query, answered silkily that 'since the question does not
arise, I prefer not to answer it'.[3] Stanley, as the Proust of painting, certainly in spirit if not in temperament,
was more forceful in his response.

record aerial combat. Hilda, the only girl, had studied at the Slade but later than Stanley. The other surviving son, the eldest, George, was an anthropologist. (The second son, Roly, a student at Oxford had contracted tuberculosis and died at the age of nineteen.) They

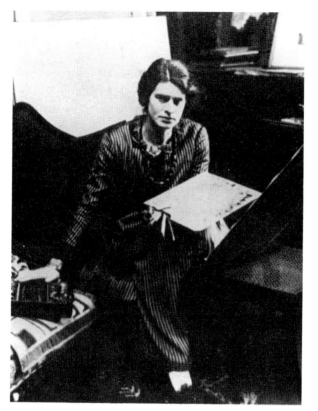

Hilda painting

were a lively and gregarious family who entertained a wide circle of friends in the way Stanley and Gilbert understood from their own family days at Fernlea. Every room in their home at 47 Downshire Hill, Hampstead, the end house in a terrace of late-Georgian-style family houses, was crammed with family paintings and with the mementoes of foreign travel. Each painter son had a room as a studio, but Hilda had to work in one of the corridors. In the way expected of Edwardian daughters, she dutifully helped

shoulder the domestic running of the place, but was never wholly fulfilled in that function, and would ruefully refer to herself as 'the passage artist'. To Stanley she was 'that extraordinary person'*; she was a year or so older than him, and graced by a mass of auburn hair. Sensitive and thoughtful, she had not lacked admirers –

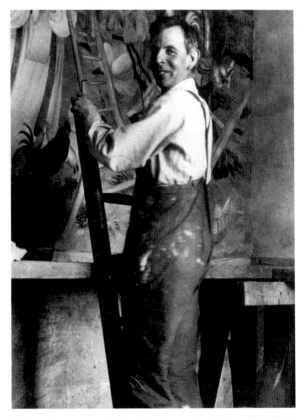

Gilbert Spencer painting *The Legend of John of Balliol* at Holywell Manor, an annexe of Balliol College, Oxford, 1934. The photograph was taken by his son, Peter, aged twelve.

* Stanley recalled in 1942 how 'Hilda I had met at the Carlines as she came round to me and Jas and the rest of us with the soup. I thought how extraordinary she looked. I felt sure she had the same mental attitude towards things that I had, I could feel my true self in that extraordinary person, I saw life with her, and in that visit where her manner was of one familiar to everyone *except* me, I could see me in her manner to everyone . . . But I heard that Gil had been meeting her at the Slade . . . and was himself taken with her. So I lay low and waited.'[5]

Jas Wood had been one – and Gilbert and Stanley joined them.

Stanley's feelings were very mixed. The ascetic streak in his nature made him 'content to bide my time in respect of things like marriage'. On the other hand, his normal male desires were pressing him hard to a compromise. Casual sex was unthinkable to him. Military service had broadened many of the opinionated attitudes of his youth, but his art and morality still rested on the need for exactness and profundity in relationships, physical and spiritual. For the moment he was unable to translate into metaphysical meaning the sensuality of the feelings which Hilda stirred in him. Nevertheless, that trait in his personality which would not let him rest until he had resolved whatever dilemma confronted him insisted that he make a beginning by sorting out whether he had any chance with her. So one day Gilbert escorted her to Cookham, punted her across the Thames to the riverside lawns of Cornerways, and waited while she went in to see 'Stan'. Presently Stanley emerged to say that of the two brothers, Hilda indicated a preference for himself. Gilbert gracefully withdrew from the suit, disappointed, but 'without rancour'. Very down-to-earth, the Spencer family, when vital decisions were at stake![6]

In the summer of 1920, with Hilda away with her family on a painting expedition – an annual Carline event – the two brothers invited themselves to join Henry Lamb in Dorset. Manchester City Art Gallery, impressed by Lamb's War Artist painting *Irish Troops in Judaea Surprised by a Turkish Bombardment*, had commissioned him to paint another war scene, *Advanced Dressing Station on the Struma*, a recollection of his and Stanley's days in Macedonia. Lamb had taken himself to the village of Stourpaine, where he was able to hire a barn as a studio. The brothers took lodgings a mile or so away across the valley of the Stour at Durweston. The break would be a useful opportunity to replenish their saleable stock of landscapes. It was while painting *The Mill at Durweston* that Stanley saw two sportsmen idly shoot a moorhen, an action which earned them as virulent a dressing-down as he gave his infantry comrade who shot dead the old dog when they marched through a Bulgarian village.

The trio worked on their own during the daytime and met in the evenings. Occasionally they visited Augustus and Dorelia John and children at their rambling estate and house at Alderney,

between Poole and Bournemouth, where Stanley enjoyed bathing with the John children in their pond. Lamb's earlier enthusiasm for John had largely evaporated, but he remained quixotically devoted to the beautiful and tranquil Dorelia. (As Dorothy McNeil, she had been first a model then a mistress of John, whom she married on the death of his first wife, Ida.)

Stanley's courting of Hilda was surprisingly protracted, even by the formal standards of the time. This was partly due to an inherent caution in both of them about undertaking so serious a step as marriage; but in any case Stanley needed more patrons. So when in the following year, 1921, the Muirhead Bones invited him to lodge with them in their village of Steep, near Petersfield in Hampshire, Stanley left the Slessers. Despite the failure of Bone's wartime promotion of a National Hall of Remembrance in which to house the War Artist paintings, he remained enthusiastic for the accomplishment of some such scheme. His village had proposed the building of a village hall as its war memorial and, anxious to see it decorated with at least some vestige of his dream, Bone had enlisted the co-operative Stanley. The Bones were not wealthy and the financial inducements were limited, but the project so exactly reflected Stanley's wartime aspirations that creatively he was exhilarated.

In great excitement Stanley began work on the sketches for the murals. It is assumed that *The Crucifixion*, his first surviving venture into that awesome theme, painted while at the Bones', may have been a design for part of the mural. It is a fascinating work. The Macedonian topography, the Mediterranean clarity of light and the strangely scattered composition – bottom left the soldier carrying the spear and the robe of Christ he has won in the lottery, bottom right the centurion in back view, middle right the huddle of spectators with 'priests wagging their heads', and in the distance Christ being mounted on the Cross in the central ravine separate from the thieves in the side ravines – all these suggest the panoramic intent of the design. The painting was, it seems, to have been extended to show the walls of Jerusalem – would they have looked like the walls of Kalinova? – with the Temple beyond and, as Stanley had once tried to imagine the life that had been lived in that deserted village, with figures in their shrouds resurrecting in the streets.

The Crucifixion, 1921

There can be little doubt that its visual source was the moment in the early weeks of 1918 when, by joining the Royal Berkshires, Stanley was able to return to his beloved Vardar Hills and, on a distant mountain in enemy territory, see three ravines standing out in the snow 'like spear wounds'. 'I and some Berkshire men and some Cyprian Greeks were walking over the snow to the [indecipherable] quarters, and away behind it in the dark Christmassy sky were these mountains. This particular one was quite clear and in front of the others, and yet you felt that it would be wonderful to be on it. It seemed so remote, so long gathered to the mountains of its forefathers. . . . At intervals slices seemed to have been taken out of it; three long gashes there were.'[7] It is tempting at this point to conclude that Stanley has called to mind the remembered image and simply transferred it to the canvas to fix the event. Yet 'As I walked towards the range I did not at all think of a Crucifixion. . . . But somehow though some of my worst experiences were ahead of me . . . I felt hopeful.' Again those subtle leaps of Stanley's mind! He is telling us that he has not used the imagery as straightforward illustration; the three long gashes did not then bring to mind a Crucifixion. He is returning to the memory now because he wishes to invoke the feeling he associated with its circumstance: that he was then able to enjoy hope, even though surrounded with dread and threat. First, the hope:

I remember one night arriving on the Doiran sector. It was near Christmas and everything felt very 'Christmassy' and all was muffled in the silence of snow. . . . It was while I was plodding along behind a mule towards our own transport lines – I had a loaf of bread tucked under my arm – that I suddenly had a feeling of the completeness and fitness and ultimate redemption of everything, that everything was really becoming more and more perfect . . . and for one brief moment of my life I felt what a beautiful thing it was to feel unselfish. Oh, how I wish I could have retained that moment! I felt then that I could see clearly, that nothing I might do could destroy or take away from that vision. . . . As I walked in the snow, I felt I was a walking altar of praise; and that night I slept with a blanket over me in a shelter that was open at the front, so that my feet touched the snow, and in front of me the snow stretched right down to Lake Ardzan. . . . Pure imagination can only be obtained by unselfishness, as it is the clear and most perfect understanding of beauty.

If he is to do justice to his Crucifixion theme, Stanley knew he must be now as he was then, 'hopeful'. But what of the other component in the memory-feeling, the dread of physical experiences to come? They are revealed in the composition as a restless, even threatening quality in the rendering, derived from visual inconsistency in scale; distortion. Distortion, the difference in the form of detail in a scene between what a reporting camera would reproduce and what the artist paints, is generally a measure of the power of emotion in Stanley's work. It is particularly evident in the ravines which although distant, deep and wide are made by implication so narrow that the men erecting the crosses are able to do so by standing at the top of the banks. In his description of the painting Stanley is at pains to point this out.[8] He expressly mentions that the only figure actually in a ravine is the Virgin Mary, who, he says, has 'slithered down the escarpment side'. There her 'long robe of dark purple trails and drags a little'. In the distortion of the imagery of the ravines – originally seen as great gashes in the hillside but now reduced to mere slits into which men have inserted the shafts of the crosses, symbols of sacrifice, and into one of which Stanley has placed the figure of the Virgin trailing her 'long robe of dark purple' – he is surely indicating the nature of the dread. Stanley is taking himself to the very limits of his subconscious. It can be given a Freudian interpretation. The substance of the imagery has taken the qualities of a sexual dream; perhaps a nightmare. Stanley was seldom illustrative in an accepted sense, although this fact should never deny the purpose, power or honesty of his treatment of religious subjects. Imagery emerged from his 'contemplation', his subconscious. As a spiritual 'emergence', it came to him as involuntarily as any physical 'emergence'. The physical and the spiritual being to Stanley reciprocal manifestations of one another, the one was as meaningful as the other. In earlier years he had discussed psychology with Sydney, for whom the subject was part of his religious training. If Stanley recognized his imagery as Freudian, this would not necessarily require either its refutation or its rejection. To him there was no inconsistency in juxtaposing the sexual with the spiritual, providing that by doing so they created the majesty he saw; when they did that, they *belonged* together.

Here we perhaps draw near to the instinctive sources of Stanley's

art. His outlook approached that of archaic or 'primitive' man. All things were or happened. To Stanley everything which happened or existed was miraculous. Nothing was better or worse, higher or lower, more or less important than any other. By identifying in his own nature whatever seemed to join him to the miraculous nature of other things, animate or inanimate, he felt he was opening a path to the universal consciousness he called God. Science or logic, which then decreed cause and effect, could not provide total comprehension of such miraculousness because it too was part of the miracle, to be studied as knowledge but also restricted because a contributor to the sustaining concept.

For the rest of his life Stanley was to remain puzzled not only by the emergence of sexual signifiers in his art but equally by how powerfully they seemed to be involved in the formation of his vision. In his early Cookham work his associations were, he sensed, free of the 'inferior desires' which were now beginning to trouble him. They gave to his work then an innocence which he thought the Great War must have shattered. Yet if now he consciously tried to exclude these 'desires' from his work, the vision he sought was lost, whereas when he let them influence a composition, he found he achieved the vision. It was a paradox he never solved. Thus in interpreting the paintings of the years ahead, such sexual signifiers as we can recognize must be kept in perspective. They are contributors to vision, but it is the vision which is meaningful.*

Unfortunately Bone's village project collapsed as completely as had his National Hall of Remembrance, and in December, in some unspecified social breach between them, a disillusioned Stanley was 'given his marching orders', as he put it. He took lodgings in nearby Petersfield, at 10 High Street, having hopes that a comparable commission might be forthcoming from Bedales School. During his waiting he drafted ideas for a Resurrection painting. At

* Stanley later attempted an analysis of the paradox: 'This is what happens. I start off in the direction of vision [and] am drawn towards secular wishes and desires. In expressing them, I come across a religious feeling as if by accident and not ready for it; I am unable to express it as it should be expressed and realised. Conversely, if I [start off] in the same vision way . . . trying literally to find this real religious something, I achieve ordinary uninspired secular feeling like in landscapes. The element I want in the religious picture I find in secular and sexual love and feeling; and the secular element I don't like or want I find when I do a religious picture that is minus the sex element. I am all the time seeing *after* another was formed how exactly that something was *just* what for years I was wanting for something else – that there, where it is, it does not do what it could and would do if it had been in and part of this other thing to which I now see it properly belongs.'[9]

another lodgings, in the Market Square, his room overlooked the graveyard of St Peter's Church and in his loneliness he would occasionally walk round the churchyard, read the names on the headstones, and then, in the quiet of his room, construct a Gray's *Elegy* incarnate – imaginary situations wherein the occupants would come and talk with him. He also began sketches for a series of panels about his army experiences, some of which he had thought about at the time. These could, if opportunity arose, be developed as part of that Life of Christ church he still hoped to achieve.

It is apparent that his post-war restlessness still assailed. He became dissatisfied with many of his paintings of the period. One – *The Bridge* – he wished to destroy, being only with difficulty dissuaded. Another – *Unveiling Cookham War Memorial* – he dismissed as of no interest to him, although it is a charming affirmation of the vitality of life, and a tiny detail in it, a small pot of marguerites or moon-daisies placed on the memorial, assumed great meaning in his art. His 'man-woman' imagery had become in such paintings superficial, sentimental; it did not spring from valid experience. He could no longer make the images do justice to the majesty of which he dreamed. Somewhere in his psyche there was a block that had not been there, or was not of significance, before he went to war.

From Petersfield he corresponded with Hilda, visited her on trips to London, and on one occasion invited her to spend a fortnight or so with him in the town. After discussing with her mother the correct proprieties, she accepted his invitation.[10] In the following summer, that of 1922, the Carline family and friends decided on a visit for their painting holiday to the new State of Yugoslavia. Stanley was invited to accompany them. At one point on the train journey, someone in the party made the idle comment that 'the scenery was better now', to which Stanley retorted that 'it was neither better or worse, only different'. The remark was made sufficiently vehemently for Richard Carline to remember it half a century later.[11]

Ostensibly the visit was to produce a further supply of saleable landscapes, but for Stanley it was an opportunity to test himself close to Hilda. 'In the train going to Sarajevo, Hilda and I slept alongside each other fully dressed, head to feet. Hilda was wearing

a grey dress and a coat with grey braid. . . . In Sarajevo we only got as far as Hilda taking my arm, but *that* I can remember – the first direct and deliberate expression of liking for me. *That* is a mysterious experience. At stand-offish moments she would take it in a more matter-of-fact way, which made it all the more profound.'[12] Scribbled on the back of one of Hilda's Sarajevo watercolours are the words 'Done on the occasion of Stanley first proposing to me.'

On their return Stanley moved from Petersfield to Hampstead. For a while he lodged with the Carlines: 'I used to love passing the open door of her bedroom and see her changing some stockings, and just for a moment her pearly leg, and she loved to show as much leg as possible.'[13] Later in the year Henry Lamb, wanting to get out of the London hubbub, and still it seems enamoured of Dorelia, bought a house at Poole to be near the Johns at Alderney, and offered to sublet his Vale Hotel studio to Stanley. Stanley was delighted. He had at last a nest of his own in which to think and paint, and from the window of which he could look out across the pool and see Hilda walking to visit him. He was near enough to visit her at Downshire Hill and to enjoy strolls with her across the Heath.

Even so, their courting did not run smoothly. They became engaged, but barely was it formally announced than Stanley broke it off; then, equally capriciously, renewed it. This happened over the next few years several times – 'six or seven', according to Hilda. Stanley's doubts about the effect on his vision of surrendering to the untutored demands of the physical were tearing him apart. In a letter to Desmond Chute, he summarized the ascetic source of his indecisiveness: 'I think one catches sight of one's own vulgarity when for a moment one gets hold of something vital. I really feel that everything in one that is *not vision* is vulgarity.'[14]

The Carline family were polite but bewildered. Hilda remained unruffled. As high-minded in her way as Stanley, she understood that the self-intense nature of his genius compelled him to try to turn the everyday reality of their relationship into spiritual meaning. The effort would function to his satisfaction only if she were able and willing to sustain the role in which his imagination cast her. One of their central problems, and indeed one which was to affect Stanley's intimate relationships with others during his life, was

that Hilda could not always know what persona he attributed to her and, even when she did, was not always prepared to adapt her opinions to it. As deeply thoughtful as Stanley, she possessed an independence of outlook which matched his. He was particularly responsive to her painting and to the sensibility which fashioned it. Here Hilda, on a later Carline painting holiday in Devon, is describing in a letter to Stanley a scene which attracts her:

It is the sheep's heaven, and they have their place by right of virtue, and wander in and out in a wonderful sort of quadrille dance that they all know and do without a hitch. There is a minor heaven, a sort of nursery heaven, a little nearer the roadway from the trees, where the geese all sit together and sit in the long grass with a young one. They are just a little bit more frivolous on account of it being only a nursery heaven, but they are complete and are there by right, probably by right of happiness. The cows keep to the trees and keep watch. I imagine they are a kind of angel, and have a certain amount of jobs to do, as well as just being happy. . . . I would like you and me to stay there and paint. It would occupy one probably for months, painting and painting and never moving more than a few inches.[15]

'Heaven . . . happiness . . . by right of virtue . . . a kind of angel'. Which of the couple, one wonders, first proposed such concepts and persuaded the other of their significance? Was Hilda adopting Stanley's ideas? Was he imbibing hers and finding profound meaning in them? Or did both have similar ideas, and was Stanley's joy in her, and hers in him, the recognition of their mutuality?

To help him clarify his thoughts, Stanley at one point invented another 'chapel' devoted to the pair of them: 'I did four large designs for walls, each wall had six different panels, and the entire scheme was my imagined life with Hilda.'[16]

For Stanley, the dilemma which breaks through in *The Crucifixion* is only partly due to hesitance about the physical and material demands of marriage. The greater fear was that in committing himself to Hilda – and she to him – he could find himself still unable to recapture the early Cookham-feelings which lay at the source of his art.

The Betrayal, 1923

The place of vision is a lonely place. To achieve it I
would have to be celibate in mind, body and soul.
What a hope!

Stanley Spencer[1]

THE BETRAYAL of 1923 expands in size and panoramic content
the pre-war version now in the Stanley Spencer Gallery at Cook-
ham. Both paintings are set in the garden of Fernlea, that locus of
the emotional security of home which meant so much to Stanley.
In the new painting the 'young man fleeing naked' of St Mark's
gospel is replaced by the version in St John in which the priests
and Pharisees, taken aback by the personality of Christ, 'went
backwards and fell to the ground'. They lie as inert heaps in the
foreground. Hilda posed for several of the figures in the painting.

In both works Stanley has compressed the action. In the back-
ground of each, ten disciples creep away in sequence behind the
flint wall of the Nest – 'like thoughts' – at Christ's intercession.
Judas has presumably fled, but Simon Peter remains behind. Both
depictions give a sensation of violent climax as Simon Peter's sword
is poised to cut off the ear of Malchus, the High Priest's servant.
In the 1923 version, the sweep of Peter's cloak and the burst of
light on it is continued upwards to carry to the curve of the adjacent
malthouse roof. Christ, hands bound before him, opens them in a
gesture of conciliation, first to stop Simon Peter, and then, when
the deed is done, to heal the ear of Malchus. Harnessed and
vulnerable, Christ remains forgiving. It is the last miracle of healing
he is to accomplish, the last free act he can undertake.

In the new version Stanley has also inserted one of his unexpected
associations, a cameo of three youngsters pausing in their play by
the schoolroom wall to watch events. They are in essence Stanley,
Gilbert and a third figure which seems to be a girl. In a preliminary

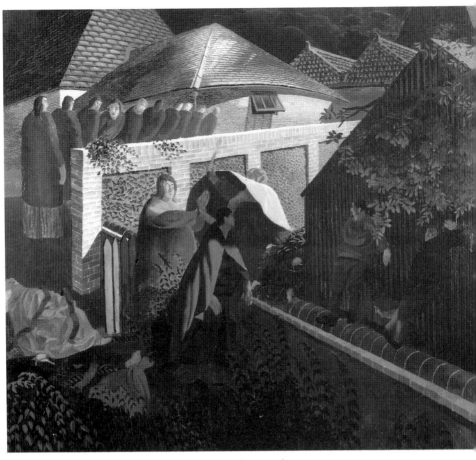

The Betrayal (second version)

sketch of this part of the picture, the Stanley-figure, on the wall left, is wearing puttees, always an emblem to him of the infliction of restraint and pain. This drawing has four figures, two on the wall and two below, but in the final painting these have been coalesced into the single girl.

Perhaps she is an echo of Florence describing part of the Spencer childhood play outside the old schoolroom in the garden of The Nest: 'between our own garden and the cottage garden was a long brick wall pierced by a gate giving access to the schoolroom . . . It was a feat of our early childhood to walk in procession along the top of the wall as far as the gateway, seize the iron bar which bridged it, swing ourselves over on to the wall again on the other

Stanley's drawing of Hilda posing for the figure of Christ in *The Betrayal*, 1923.
In the painting Christ's hands are bound, and he is raising them to heal Malchius'
ear.

side without touching the ground, and so continue to the end.'* Respectable young women then were not supposed to know that long Edwardian skirts gave brief glimpses of elegant laced boots and black-stockinged legs erotic import. Respectable young men were not supposed to harbour such thoughts, or if they did, they should take a cold bath.

Stanley's girl in the painting is a luminous detail: not the theme of the painting, nor specifically an expressed symbol of eroticism, but a remembered catching of the breath, the most adroit association Stanley could quarry from his experience to show the impulse thought of as self-betrayal. The iconography of the painting begins to make sense if we assume that such a memory is being used by Stanley not for its own sake but to trigger the intensity of the feeling he extracts from the biblical original and wishes to put into his painting of it.†

Conjecture? Certainly. Far-fetched? Not at all. Complaining that admirers keep insisting that they see in his early works a piety which they equate with accepted morality and worship, Stanley later exploded in an outburst of self-revelation: 'One had admired the degree of worship in those early works of mine. . . . How did one think they were done? Under what sort of aegis or state of mind? They were done in an atmosphere that was the exact opposite of what one seemed to think. There was no schoolmastering of me, no discipline, no bowing idiotically to any "authority". These early works were done in an atmosphere of temporary contentment . . . in which I would have "fallen" at any moment when the opportunity seemed right.' He never tolerated, even in

* At the end of our garden stood a high and mighty walnut tree. . . . it brushed across our faces as we went along the top of the wall. I can smell it now as I pore over Stanley's painting.'[2]

† Significantly, the girl is between and below the Stanley–Gilbert figures. Although in his autobiography Gilbert makes light of the loss of Hilda to Stanley, in 1921 he left Hampstead, where he was near Hilda, to lodge with the painter Tom Nash and his wife Mabel at Caversham near Reading. Tom, a fundamentalist Christian, had been a Slade fellow-student with Stanley, walking about 'with a Bible in one hand and my ideas in the other', Stanley had quipped. In the summer of 1922, five months into Mabel's pregnancy, Stanley arrived to take Gilbert away on the excuse of a painting weekend which extended into several months. Both Tom and Gilbert disclaimed paternity of the child, a boy registered by Mabel as Peter Spencer, illegitimate. In the ensuing divorce, Gilbert was cited. He never acknowledged Peter as his son, but after his marriage to Ursula Bradshaw in 1930, was persuaded by her to pay for Peter's public school education and to have him to stay during holidays; when strangers asked who he was, Gilbert would reply that he was just someone staying with them.[3] It is not unreasonable to assume that Stanley is using the cameo to suggest that had the complications of sex not entered his and Gilbert's life, the family solidarity so important in his feelings about Fernlea would not have been 'betrayed'. It would also explain the critical place he gave the painting in his development.

his impressionable years, any imposed restraints on the energy of his imagination and its expression in painting, and his adolescent ecstasies – his 'atmosphere of temporary contentment' – occurred precisely when his sexual sensations and their accompanying fantasies were at their strongest.

I used to get so happy with my ideas and to such a pitch of consciousness about everything. All things took on a meaning that made me long and loving. The sight of young girls in the barn among trusses of straw or any accidental view of legs made me feel a glow [Stanley's euphemism for sexual arousal] and I was in such a happy state that I wished *it* had not been followed with such pangs of remorse. I felt in yielding to those dear pathetic and happy moments – and I felt they were full of my most spiritual utterance – were wrong, and I felt terribly ashamed and worried. I felt as I sat in the cellar or kitchen at Wistaria Cottage all by myself and imagined a young girl squatting in front of me such a profound feeling . . .[4]

Why was it that those 'dear pathetic and happy moments' which his upbringing had convinced him were wrong were yet 'full of my most spiritual utterance'? If it seems odd that a mind like his, which seethed with ideas, and a body like his which was fierce in its energy, should have taken so many years to accomplish what today would be described as an adolescent rite of passage, it should be remembered that however startling his outward vitality, his conceptual progress was vigilantly slow and deliberate.

Looking back, Stanley's feelings about the painting divided. In the 1930s he found the painting 'full of the qualities which I know are the only things I have truly felt and meant'. But in 1923 he had not yet become reconciled to them and deplored the confusion which such subconscious influences brought to his composition: 'I keep getting ideas but only sort of part of ideas,' he complained. He was especially concerned lest the pristine 'state of sureness' of his earlier vision be lost. In the 1930s he was convinced that 'This state of awareness [his early vision] continued to about 1922 – 23, when I did The Betrayal. . . . But I knew in 1922 – 23 that I was changing or losing grip or something. I feared I was forsaking the vision, and I was filled with consternation.'[5] The dilemma was very real to him in the 1920s. In order to heighten the meaning of

The Disrobing of Christ

The Betrayal, he set out to give it a support of smaller paintings intended to hang under it to amplify its feeling. The supporting paintings were, in order left to right, *Washing Peter's Feet*; another version of *The Last Supper*; the *Robing of Christ*; and the *Disrobing of Christ*. The last two had been painted at Petersfield. He told students at the Ruskin Drawing School in Oxford to which Sydney Carline had invited him as a visiting lecturer in 1922, 'It is rather interesting to think of pictures in the way musicians think of music. . . . I mean the dramatic integral relation such as one has in a sonata in music between the first, second and third movements . . . each movement being a picture. A Predella is rather like a Prelude to a fugue. . . . I feel there is a fine architectural element in this.'[6] It is evident that Stanley intended a spiritual link within the structure of this scheme of paintings, and it is the nature of the emotion which signifies: the intent to betray, the betrayal, the despair of mockery and the loss of kingship.

But when he came to paint the predella supporters, enthusiasm outpaced discipline, and he made them too large. To express in 1923 the intensity of these situations in Christ's life, Stanley needed a personal parallel which evoked for him similar emotions. Much of the detail in the paintings can be given personal meaning. Jesus, for example, is shown blindfolded in both the *Robing of Christ* and the *Disrobing of Christ*. Stanley cannot see his way forward.

216

The Betrayal, 1923

Autobiographically, he had trustingly moved to the Bones, to undertake a commission which had excited him, his first opportunity to design a scheme in the way he had so often hoped. A few weeks later the project collapsed, the Bones asked him to leave, and the Bedales School project failed to materialize. In his disappointment and frustration he felt mocked and betrayed. In the *Disrobing of Christ* the glorious robe of 'The King of the Jews' has been taken from him and is being spread over a chair. The chair arms are carved to show the heads of lions. But the Lion of Judah stands bereft. He is almost naked, vulnerable. A grimly armoured medieval soldier, described aptly by one modern art historian as 'a black insect'[7] and companion to those in *The Betrayal*, holds out Christ's simple shift in an open tunnel shape. The shape echoes that of Peter's cloak in *The Betrayal*, indeed echoes the same cloak in the 1914 *Betrayal*, and the shape of the chairbacks in the accompanying version of *The Last Supper*. How tenaciously Stanley retains his symbols! It is a shape which has, and will have, profound meaning for him. Are the soldiers, the 'black insects', symbols of the insistence of Stanley's sexual impulse, a persistent

Stanley posing with the 1923 *Betrayal*. A glimpse of *The Resurrection, Cookham* of 1920–21 is on the left. Probably photographed in the Vale of Health studio.

and irrepressible nightmare of doubt driving him into some fear-some tunnel of the spirit?*

As if these spiritual dilemmas were not unsettling enough, Stanley also faced a practical one. He needed to become more widely known – especially because it seemed increasingly likely that he would eventually marry Hilda and would need to support her and a family. Although his landscapes sold well and kept him modestly, he 'never had more than six or eight patrons at this time'[7] for the serious visionary work which meant so much to him, and his admirers could not be expected to continue hanging their walls with his life's work. Like many contemporary artists he was facing competition not only from the growing interest in French painting, but from a new generation of experimental and avant-garde artists. There was no question of Stanley bowing to such fashions. His style was satisfyingly 'modern' – indeed controversially so at times – to appeal to the discerning. But the fact that they saw in his paintings meanings he never intended, and often failed to see the meanings he did intend, was, when it did not occasion wry amusement, a source of despair.

Stanley needed to fulfil some mighty work or works which would crystallize his outlook and blazon his name. But his 'perplexities' were frustrating him. With Richard Carline he spent periodic days in the spring term of 1923 on a refresher course at the Slade, although there is no indication that there was a connection. But he declined an invitation to visit Edward Marsh, explaining that he 'was trying to settle to this new picture of mine and I want a long spell of silent contemplation. I have been too much of a buzz of recent years, and it has got into my work.' With Hilda away for much of the summer on her prolonged Carline family painting expedition, this time to the Pyrenees, Stanley decided he needed to get away from Hampstead to a place where he could talk out his ideas. Another handholder was needed. But where to go? Fernlea was not conducive. Ma sadly had died in May of the previous year, 1922.† Pa was still active, and taking delight in a second grandchild, a daughter born to Marjorie, Horace's wife, who was living there with her young son while Horace re-established his stage career. But none of these could offer Stanley what he needed.

* See the epigraph to Chapter Four
† Ma died on May 16th. Gilbert makes a mention of her funeral in his *Autobiography*, p.69.

Henry Lamb was the answer. Stanley begged Lamb to let him go down to Poole and stay for some weeks with him at his house at 10 Hill Street. It was a redbrick Georgian three-storeyed town house, with an outbuilding at the end of the back garden which Lamb used as a studio. Neither the house itself nor the town of Poole had any intrinsic association for Stanley, but Henry was there to talk to, and on the round table shown in Lamb's painting *The Tea Party*,[9] in periods of intense concentration assisted by Lamb's piano-playing whenever Stanley could prevail upon him, Stanley spent hours on the sketches and drawings for his schemes. The wartime scheme was the first to emerge. The drawings for it, preserved in the Stanley Spencer Gallery, show the walls of his proposed chapel consisted of a line of arched paintings or lunettes, four on each side wall, supported by smaller rectangular paintings below – Stanley's 'predella' – while above them, landscapes of wartime Macedonia filled the space between the arches and the ceiling. All would lead the eye and mind towards the end or altar-wall painting, the *Resurrection of Soldiers*. This was not fully visualized, but would re-create the majesty of his Vardar Hills experience.

Henry Lamb was impressed and became enthusiastic. True to his outgoing nature he generously spread the word among his friends. Edward Marsh was approached. They paid visits to Darsie Japp, by then breeding horses on the downs near Lambourn. Stanley spent some days with the Morrells at Garsington. The Raverats, who had been so helpful before the war, were out of touch, having moved to Vence in France in the forlorn hope of helping Jacques' illness. But neither Lamb nor Stanley was optimistic that he would find the full support the project needed. So in the meantime Stanley continued to ponder ideas for his 'civilian' Resurrection. He thought it might help to write another memoir, a 'miniature Divine Comedy', which might lead his mind towards the design of the composition.[10] Although there seems to be no record of his having done so, his Dantean reflections were eventually to enrich his imagery. He joyfully poured out his thoughts in conversation and in letters to friends and to Hilda. She came down later, on at least one occasion, to visit him. Another visitor was T. E. Lawrence, then enlisted incognito as a private in the Tank Corps but living off-duty in his remote cottage at Cloud's Hill near

Bovington Camp. Lawrence was friendly with Augustus John, and through him had asked Henry Lamb, Gilbert and Eric Kennington to make drawings for the first limited edition of *The Seven Pillars of Wisdom*, Stanley evidently being too preoccupied with his own schemes to become involved. But on this occasion, Stanley told Hilda, Lawrence came specifically to talk with him: 'As Henry was away ['painting duchesses'] he and I were able to have a heart-to-heart talk about God and all the things I like to talk about. . . . He can't rest, and it was so exactly what I feel myself sometimes. He seemed to be appealing to me to think of something to do. . . . The aimlessness of Lawrence is not a pose. I think it is the loneliness of being unable to love through absence of religion. He hates the thought of women.'[11] Stanley echoes the words of Lawrence himself, who confessed at the time that he 'hated the thought of sex'. The compulsion to seek spiritual or idealistic meaning, even through refutation, in the physical demands of their male nature was a characteristic of many of their generation. That understanding would have given intensity to the conversation between Lawrence and Stanley.

In September, Lamb persuaded the Behrends to motor down from their home, Grey House, at Burghclere, to see Stanley's war chapel drawings. The Behrends had moved out of London in 1918, but were determined to continue their enlightened patronage of rising artists and musicians. The effect of the meeting was all that Stanley could have desired. Mary Behrend's brother, Captain H. W. Sandham, had recently died from the effects of war service and she had been thinking how best to arrange a memorial to him.* Stanley's project was ideal. They would sponsor it. Lamb was delighted, but Stanley was ecstatic. To find patrons who would fulfil a dream which had seemed so remote! Undemanding, generous and considerate, Mary and Louis Behrend were to prove ideal patrons. Young enough to meet Stanley on a sympathetic footing, they were sufficiently well endowed to be able to do justice to the sweep of his project, even though some of his ideas – stained-glass windows, for example, or a mosaic floor by Boris Anrep – had to be trimmed out. But of course the scheme needed time to organize. A site had to be found and purchased – preferably,

* He had died from an enlarged spleen as a result of too-frequent bouts of malaria.[12]

the Behrends wished, near Burghclere – and an architect com-
missioned and briefed. It would be some years before Stanley could
begin painting, so in the meantime the Behrends encouraged him
to work towards his 'civilian' Resurrection theme. When Stanley
left Poole in the autumn and returned to the Vale Hotel, taking
extended accommodation there, they paid his rent.[13]

There an event happened to Stanley or was recalled by him
which at last provided the inspiration he needed. Its joyous source
was Hilda. Exactly what the event was we may never know, though
it seems possible it was a sexual experience. He told Edward Marsh
it occurred at a precise hour – 2.45 p.m. – on a precise day – a
Tuesday in May.[14] No year is given, though he was later to hint
that it had been the same year, 1923. Through it he was able to
coalesce his twenty-four 'imagined-life-with-Hilda' drawings into
the one vast altarpiece he sought. In one aspect at least, the creative
block between the sexual and the religious which had for so long
frustrated him was lifted, and he could at last know them not as
conflicting – 'compartmentalized' – elements in his existence, but
as a single connected unity.

The painting which resulted, one of the masterpieces of modern
art, was to illuminate many of the mysteries of Stanley's ado-
lescence, and to point him in a direction he was to journey for the
rest of his life. It was his *Resurrection in Cookham Churchyard*.

The Great Resurrections

1924–1931

The Resurrection in Cookham Churchyard

There is a moment in Beethoven's Ninth Symphony
when a full major chord is sustained by the strings, and
then modulated so as to prepare for the syncopated
introduction of the choral theme, which is continued
by voices alone. There is only a very short pause, like
the taking of a breath, or the space between breathing
in and letting out the breath. The strings are like the
breathing in and the voices like the breathing out.
Thus, in the painting, the place is like the strings, the
figures like the breathing out.

Stanley Spencer[1]

LIKE A MUSICIAN developing a symphonic theme, Stanley had
from earliest days been fascinated to explore the inferences inherent
in the Resurrection concept. *Apple Gatherers* had been painted
over a try-out of 1912. In 1915 he painted his first-known version,
a diptych intended to hang each side of the chancel arch of
Cookham church. The left-hand painting shows *The Resurrection
of the Good*. In bold diagonal composition three figures – young,
mature and elderly – resurrect with ease from bright flowered
graves; a dark-haired angel calls them to rise by sounding a long
elegant trumpet. The companion painting on the right-hand side
shows *The Resurrection of the Bad* – four figures struggling with
great difficulty to rise from sombre, flowerless, grassy, mound-like
graves. They have a fair-haired angel to trumpet them.

At the Slessers' in 1920 he sketched variations on the theme
and continued them at Petersfield in 1921. They culminated in a
painting he called *The Resurrection, Cookham* (1921), whose set-
ting is the churchyard with the church porch top left and the

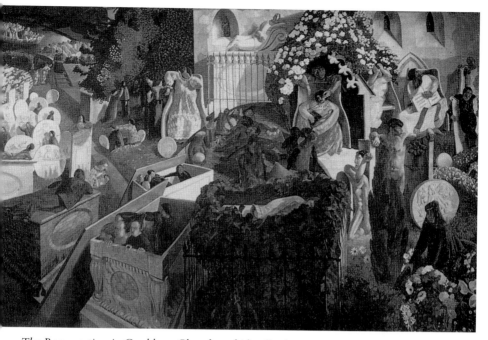

The Resurrection in Cookham Churchyard (detail; also reproduced in full in colour)

long path to the churchyard gate winding diagonally across the foreground, which divides the resurrecting figures. Those bottom left are in darker tones, still emerging. Those on the larger expanse are mostly resurrected and are relaxing against their headstones. Many are identical in attitude, facing their headstones, right arms raised to grip or lean while they read their inscriptions. In this other world – heaven – they are curious to learn the details of their former material existence.

It was from the basic notions of these exploratory works that Stanley was to develop his new Resurrection painting. It too would be set in Cookham churchyard and is titled *The Resurrection in Cookham Churchyard*, but has become more commonly known as *The Resurrection, Cookham* or just *The Cookham Resurrection*. In it previous themes are clearly evident – the role of the female in the sexual and the creative which had already surfaced in *The Nativity* and *Apple Gatherers*; Stanley's unwillingness to accept the literalness of biblical imagery – the Bad struggle not into the terror of hellfire but into the enlightenment in which the Good have long delighted; his esoteric associations of bodily and spiritual emergence; but above all his definition of 'happiness' as those

moments when we experience a joyous redemption from the confusions, perplexities and miseries of the world, a redemption so powerful that we instinctively try to re-create its source in our lives: 'The resurrection is meant to indicate the passing of the state of non-realization of the possibilities of heaven in this life to the sudden awakening to this fact. This is what is inspiring the people as they resurrect, namely the new meaning they find in what they had seen before.'[2]

Stanley began the painting in February 1924. Work on it occupied him for the best part of the next two years. It was – is – a large canvas, nine feet high by eighteen feet long; he was barely able to fit it into his Vale of Health studio. In every sense it was a formidable undertaking. Aesthetically it would amalgamate complexities of thought and feeling he had not hitherto attempted in a single painting. Technically, it would demand all the skill in draughtsmanship he had studied so earnestly at the Slade and all his painstaking attention to detail; more than either of these, it would test to the limit his powers of composition, an endowment he regarded as almost holy in origin.

The setting shows Cookham churchyard much as it still is, the church recognizable if not architecturally exact. Stanley, adapting the imagery from memory in his studio, sees it from that 'short perspective' or aerial vantage-point of which he was so fond, in this case from an imagined vantage-point high above the churchyard gates. By this means he is able to include the Thames in its geographical position in the top left corner. Various figures, some African but the majority white – two of them male nudes – have mostly emerged from their tombs or graves and are sitting, lying or wandering about as they might have done in life during moments of relaxation on a sunny Whitsun holiday. Indeed, in the top left corner a river steamer – Bond's steam launch which Stanley had earlier covered as a holiday subject – proceeds on its journey crowded with trippers while others embark at the landing stage; their attention is drawn towards the orange glow of light across the river. By the 'kissing gate' into the churchyard (which is still there) a group of youngsters casually watch events. A few of the resurrecting figures are having difficulty in clambering out of their graves; some are being physically restrained. On the right, along the church wall, a line of six solemn, seated figures (continued by

a seventh on the left), described by Stanley as prophets, seem dissociated from the event. In the porch of the church, under a canopy of blossom, sits a woman in a flowered dress holding babies; the figure behind her lovingly caresses her hair.

The painting, of course, is not intended to illustrate a literal resurrection. The participants are Stanley's contemporaries, and the content, as in all his visionary painting, is autobiographical. The cameos reflect experiences which held significance for him. Many reconstruct his family and friends. He himself, a slight figure, his dark hair fringing his forehead, appears several times: as the figure on the book-like tomb in the bottom right-hand corner (his 'signature' to the painting): as the figure in the right-hand group of cameos immediately in front of the girl in the flowered dress: and as the right-hand of the two male nudes. These are recognizable portraits. He also appears less recognizably but more startlingly elsewhere, part of the mystery of the painting's conception.

Hilda too is recognizable as the nearby figure looking over the top of a headstone and facing left – Stanley loved to catch these instinctive attitudes of hers – and as the distant figure standing on the step of the stile watching the holidaymakers. But she too is also depicted elsewhere, and such doubling of identity is a new device which Stanley has introduced for heightening the personal, the happened, the remembered, into exaltation.

In a long description,[3] reproduced in considerable detail in Richard Carline's biography of Stanley's earlier years, Stanley explains the recalled feelings behind many of the cameos. Each represents for him a luminous moment, a sudden flash of awareness which lifted his spirit in joy. If only such moments could be strung together with the intervening meaningless longeurs of our lives eliminated, they would become eternal. He – we – would experience 'heaven'. But however occasional, brief or unexpected the occurrence of such moments, we should cherish them, for they are, to Stanley, tokens of that ultimate compassion which is the love of God:

No one is in any hurry in this painting. Here and there things slowly move off, but in the main they resurrect to such a state of joy that they are content and happy to remain where they have resurrected. In this life we experience a kind of resurrection when we arrive at a state of aware-

ness, a state of being in love . . . and at such time we like to do again what we have done so many times in the past. . . . Hilda mooches along and slowly goes over a stile. She wears a favourite dress of hers. The people read their own headstones. By the ivy-covered church tower a wife brushes the earth and grass off her husband. Another buttons a man's coat up and another straightens a man's collar. Further down you see Hilda smelling a flower . . . she wears a jumper that I liked . . . The light on the wall of the church is rather in feeling like the light I would see when swimming underwater . . . I felt drawn towards it in each part of the picture the meaning of the resurrection is conveyed by bringing people into contact with their customary surroundings. . . . I am very fond of the girls taking it easy just below the prophets. Especially I love the girl in the black velvet dress with the black velvet rose gathered at the knees. Hilda had a dress like this. . . . To emphasize the place and bare fact of myself, I have thought of an open book . . . and when you read a book you settle down to it . . . and this me settling down between the two lids of the tomb is my signature to the painting. . . .

How emotionally packed are Stanley's restrained descriptions of his mightier paintings! Each sentence flares like a beacon if we grasp how powerful for him was the feeling, the 'awareness', which the imagery raises. Hilda 'mooches' along – she had a trait of walking to which he will repeatedly refer, for to him it was 'her'. She 'wears a favourite dress of hers' as she climbs the stile – but the grey dress and cloak she wears, was it not the one 'trimmed with grey braid' which she wore on the train to Sarajevo when they slept 'head to feet'? At home he remembered Ma making sure Pa was neat and tidy before leaving to give music lessons in the houses of the gentry; her gesture of affection is enshrined in the cameos near the church tower. Stanley is 'conveying the meaning of the resurrection by bringing people into contact with their customary surroundings' – surroundings in which they are at home, at peace, where he, as artist, finds in their innocent joy a spiritual dimension. The 'light on the wall of the church' was not simply 'like' the light he saw when swimming underwater; it was the light towards which he swam, as he told us in his young rapture, because he knew when he broke surface that he would emerge from a dim world of non-comprehension into the bright clear world of revelation: which is the very substance of the picture.

Detail in the painting is neither as random nor as disconnected as might superficially appear; certainly none of it is superfluous or merely decorative. Although complex, the composition is structured to suggest a triptych. The centre section apexes at the cameo in the flowered church porch. The right-hand section concentrates on Stanley, the left on Hilda. The form – this seems to be the first occasion Stanley made use of it – came to represent for him an interrelationship between a known situation – the right-hand panel – and a new, mysterious, even threatening 'atmosphere' which he predicated in the left. The notion derived originally from the semi-detached neighbourliness of Fernlea and Belmont, where his 'homely' right half contrasted with the reversed layout of the left half, giving him, on his visits there, a disturbing sensation of the familiar assuming unfamiliarity. The sensation was repeated for him in the Beaufort War Hospital where the former male and female wings were duplicated in reverse each side of the central service block; he later likened it to 'the inversion one hears in a Bach fugue', and it remained a device he continued to use when he wished to portray a dependency he sensed between apparently independent opposites.

Setting aside for the moment the line of seated figures along the church wall, the cameos of the right half show us recollected moments in Stanley's pre-Hilda life when he unexpectedly became aware of the spiritual meaning he found in his celibate – 'innocent' – relationship with others: the point in his memoirs, for example, when he describes staying with friends and 'did not see anything remarkable about them' until one day, coming down to breakfast, something was said or occurred which suddenly gave him a perception about their relationship which so moved him that 'he could not eat his breakfast, not even bread-and-butter'. Such moments, like those stimulated by his reading, remained in his memory as luminous details, the catching of the breath, to be savoured in the quiet of 'contemplation'. So in the right-hand section of the painting, lying in his 'book', he is 'settling down' to retreat into his memory-associations, to compose from them. Because in this case the outcome is enlightenment, he is 'consummated', and in the cameos around him honours those who, perhaps unknowingly, succoured him in his journey into vision.

The foreground figure wearing legal robes is the imposing Henry

Slesser. In 1924, the year the painting was begun, Slesser was appointed Solicitor-General, and Stanley evidently honours him by choosing a wreath of expensive hothouse flowers to rest on the humble wildflowers of the graveyard. Flattered though Slesser was at finding himself inserted into Stanley's painting in the name of friendship, his pleasure at the time was, it seems, tempered by some disenchantment at Stanley's figuration of him.[4]

To the right of Slesser, the rugged figure pushing back the lid of a boat-shaped grave on which grow marsh flowers – bog asphodel? – may be Guy Lacey, who taught the Spencer boys the skills of swimming and watermanship: 'the boy we go swimming with is a Gladiator [the 'Gladiator' was a large plaster statue used during Stanley's time at Maidenhead Technical College as a sketching model, and evidently employed as an analogy in some private conversation between himself and Edward Marsh] only his muscles are not "bumpy" but evenly developed over his whole body. I love to watch the vapour rising from his body when he comes out of the water.'[5] The Stanley figure behind him, also rising from a boat-shaped grave, copies his gestures as Stanley would have done when being taught. The two cameos, placed in association, suggest an entity in feeling. Stanley later drew attention to the difficulty each figure has in emerging.*

To their right, a girl reads a wreath-note to another. Stanley records that the scene was derived from seeing a girl bring flowers and a note to the grave of a friend who had recently died, and he thought how marvellous it would be if each could sense the sympathy of the other: 'I think that friendship is a wonderful thing . . . the exact purpose of which is to cause one another and to encourage one another to bring forth the joy of Heaven.' Letters as transference of thoughts between those who value each other's outlook were to become significant symbols in Stanley's later life and work.

Behind the learning-to-swim figure, a girl in a daisy-patterned dress rises among a blaze of marguerites, named after St Margaret, patron saint of innocence. Does the cameo honour his seventeen-year-old first love? To Stanley, love grew from the mutual giving

* Stanley could be intimating recollection of an experience in that phase of adolescence when homoerotic fancies occur. If so, his depiction of the difficulty with which the pair of figures are resurrecting hints at boyhood memories which, if superseded, remained vivid.

and receiving of the partners, and it would seem that this brief affair was the first occasion in his life when he, who had so longed in carnal love to give, found himself also the recipient.

Behind her, three women recline against their headstones, absorbed in conversation. The one on the right, talking agitatedly might emotionally represent his sister Annie. The one with her back to us may then be Florence, and the cameo a tribute to his schoolroom education. The third figure in the black dress facing us is the one of the trio whom Stanley says he 'particularly loved'. The face is Stanley's, but the figure has Hilda's shapeliness and wears a dress of Hilda's he liked. It is a composite figure, the first of his more mysterious emanations in the painting. The imagery has no modern overtones of transvestism. The role-reversal, or rather the compounding of the male and female, has a deeper meaning.

The prophets sitting along the church wall act as a kind of frieze to this right-hand section. They are depicted almost as monuments. Possibly they are the canonical figures from whom Stanley derived his intellectual knowledge: the saints, the thinkers, even perhaps the dogmatists whose views he now questions. The second figure on the left is said to be Moses, but more probably symbolizes the established Church whose doctrine became to Stanley over-literal. All, for a reason which will become apparent, wear white robes. The third from the right wears a christening robe. The face matches a Gilbert self-portrait now in Stoke-on-Trent Art Gallery, which appears to bestow a kiss on the viewer. Gilbert was peripatetic then and often left his paintings in Stanley's London studio to be viewed by interested purchasers. However, the gesture of flicking back the hair is attributed to Richard Carline, who posed for several of the figures. Whenever Stanley needed figures to people a painting, he usually took them, as he took his settings, from models known to him. The Moses figure, for example, is derived from a photograph of Jas Wood's father, a former Mayor of Southport during its Victorian expansion, which impressed Stanley on a visit to Jas' Hampstead home. In such usage, no direct personal reference is intended. (Conversely, as we have seen, whenever Stanley wished to incorporate into his imagery some quality of personality he found in people he had met, he often preserved a sufficient likeness to make his depicted reference to them valid

while using the most exquisite means of disguising their identity.)

The content of this right-hand section stresses the serenity of innocence, the joys of nourishing the imagination through literature, conversation, correspondence, friendship, instruction and hospitality. These are virtues which, in Stanley's experience, foster tranquillity of thought. Does not, he seems to ask, true vision lie in the continuation of these experiences? And yet, and yet . . . is there not a different, untried, perhaps more awesome promise confronting him in the left section of the painting? Should he accept the challenge, even though to do so demands a commitment from which he can never withdraw?

The two male nudes strikingly point his dilemma. The Stanley figure who looks to the right to his 'pure' vision is sublimely drawn, a noble replica of Michelangelo's Adam. His eye is clear, his stance unfettered by doubt. But the other Stanley, the alter-ego figure facing left and portrayed in the likeness of Richard Carline – the type of young man Stanley might once have envied, intelligent, good-looking, socially easy, adventurous, a man of action – is anxious in the eye, resentful even, his posture constricted, his right arm raised in guard or protest, his left arm emphasizing an evocative protrusion on his leg in the semblance of a woman's breast. The attitude suggests a fear of being impelled into an unknown, even disturbing, milieu: an association which Stanley may have visualized from his experience in the early months in Macedonia when as a result of the 'painful swelling on his leg' he was sent to hospital and found himself transferred on recovery from the familiarity of the 68th Field Ambulance to the apprehension of the 66th.

Then on Monday 23 February 1925 Stanley, euphoric at his spiritual progress on his painting and assured through the Behrends of income for the next five years, at last married Hilda. The wedding took place in the parish church of Wangford in Suffolk where Hilda had spent a happy time as a wartime land-girl. George and Sydney Carline were the witnesses. The outfit Hilda wore, a tricorned hat and a coat with 'flapping' sleeves, was as clear in Stanley's memory at the end of his life as it was on that day. They honeymooned in a local farm cottage, and the bedroom in which they first fully shared their love became a shrine for Stanley and a place of pilgrimage in more nostalgic years to come. A week later

Gilbert went to Wangford to join them on a mutual painting holiday.

On the everyday level, the marriage can have been little different from the thousands of that year. Both were trained artists, devoted to their craft. Although their tastes differed – Hilda preferred more modern trends to Stanley's idolization of early religious painters –

Richard Carline, late 1920s

both understood the need to paint, and thoughtfully discussed each other's work. Both too had come from homes in which the Edwardian skills of conversation flourished, the Spencer family round Pa at Fernlea, and the Carlines in lively parties with artist-guests, where a fascinated Jas Wood could be so absorbed in the discussions that he had been known to keep his taxi waiting an hour or more. Stanley, when relaxed from the solitary concentration

Hilda drawn by Stanley the day after their wedding. The portrait is annotated by Stanley 'Tuesday February 24th 1925'.

of painting or contemplation, would talk endlessly, rocketing a succession of verbal fireworks which fascinated his listeners at first; then a gradual surfeit would bring weariness, until by the small hours, even the most polite of hosts became exhausted. If Stanley were to be matched on such occasions, he needed to face the rapier thrusts of a Henry Lamb, the penetrating erudition of a Desmond Chute, the sardonic interjections of a Jas Wood, or the searching briskness of a Darsie Japp. Even then it could be difficult to silence him without causing offence, for his mind in full spate continually cascaded those streams of unexpected associations on which his imagination thrived.

Hilda, by temperament a patient listener, respected but was in

no way awed by these outpourings. She would respond suddenly to some remark of Stanley's or interrupt him to promote equally singular observations of her own. Often a comment of hers would catch his imagination and he would stump off to contemplate it. If the idea appealed – as when in discussing this Resurrection painting Hilda offered comments on the meaning of light which impressed him – he would feel a surge of gratitude to her for her insight, followed by curiosity as to whence the insight had come. So back he would go to her, or by letter if she were away, and the endless but joyful questing would resume. Both continued to read widely and critically, and lists survive of their reading, invariably classical. In the early days of their marriage they adopted the custom of reading aloud to each other and discussing as they read.[6]

But it was especially in the sexual aspect of marriage that Stanley wanted to 'shout for joy'. His delight was not merely physical. It sprang from an answer he had at last found to one of the great puzzles of his adolescence – the meaning of the creatively sexual in his vision. The revelation was his comprehension of the connecting idea which had continued to colour the associations of his post-war paintings: the idea that the feelings, emotions and sensations of the everyday can be used to lift us – to redeem us – into the spiritual wherein lies the source of our true joy; and that, in fact, the physical and the spiritual are meant to unite.

The insight explodes in this *Resurrection*. It introduces a time element into the composition which in metaphysical terms turns time into timelessness. Stanley's life-before-Hilda on the right of the painting recedes into the past, and the transition is made to the Hilda of the left half. For it is through her that he has found this truth, and in this revelation, whatever will happen between them in the everyday world, they can never again be spiritually separated. They are 'fused'.

Now the white dress which the woman wears as she leans near the corner of the church assumes meaning.* A painting by her

* Today the paint on the face of this figure is peeling.[7] So too a section on the right is warping badly, a result according to Sir John Rothenstein, of Stanley allowing a kettle of water in the studio which he was boiling for his tea to steam.[8] Although instinctively sensitive to the use of colour, Stanley's technique of applying the paint suffered from the Slade's lack of training in its use in his day. Stanley himself commented about his work: 'It is noticeable that I am never preoccupied with *how* I paint but with the gradual development of my thought and affection towards life in general, and from that, what in me it emotionally inspires me to do'.[9]

father exists of Hilda when young in such a white dress. Stanley cherished the image and he would re-create it again towards the end of his life, long after she was dead. The imagery seems to extol their conjoining, their new physical and spiritual unity. In his pre-marriage state Stanley was 'black'; now, through Hilda, he has been reborn in awareness as she is reborn in comprehension; and so her white dress has become her symbolic christening or baptismal robe. Stanley's new-found joy in Hilda's capacity to lift the sensual into the spiritual for him is echoed as she bends to the flower on the path. The flower, Stanley stresses, is not simply held. It is pressed to her face: 'She's very curious, she's feeling how momentous the occasion is, so therefore she is pushing it against her face; which I think is rather expressive.'[10] 'Rather expressive' – Stanley's code-phrase for his depiction of any event which held overpowering meaning for him. Hilda's joy in the mutuality of their union is his joy in hers. The flower, Stanley says elsewhere, is a young sunflower, a flower which in future paintings, for example *Sunflower and Dog Worship*, he would use in a more openly phallic way. For both Hilda and Stanley, the erotic and personal has become the sexual, the universal, and the spiritual. In Hilda, Stanley's once dark perplexities about the import of his 'man – woman concept' have been resolved in joy. He – she – has come 'home'.

Behind the Hilda who bends to the sunflower, another figure looks left towards people resurrecting among the white roundels and headstones there. Some are reading their inscriptions, which seem to be portrayed less in words than in pictorial designs. The designs echo some of Hilda's paintings and the figures resurrecting among them have the appearance of visitors to an art exhibition. The male lying on the tomb far left gazes in admiration or fascination. Stanley at various times identified the figures on the foreground tombs as himself, Richard Carline or Jas Wood. All three in their way were emotionally linked to Hilda. Jas Wood had been an admirer and suitor before Stanley met her and was to remain a much-loved friend to Stanley and his family all his life. When in 1926 he published a book of autobiographical vignettes he inscribed it 'with admiration and affection to Stanley Spencer'.

The dedication was no small compliment. Wood was a man of

broad artistic, literary and philosophical leanings.* As with Chute and Lamb, he was not merely fascinated by the artistic trends of the time; he was closely involved with many of its originators and much of their outlook. To have regarded Stanley's personality and thought 'with admiration and affection' marks a tribute to the quality he found in both.

Between the Carline cameos and the church are the couples in which the wives makes sure their menfolk are smart and tidy. Superficially a homely touch in memory of Ma and Pa, the cameos contain the seed of more elemental things. Those like Ma and Pa, who have grown old in the experience of love, achieve their life-meaning not so much by conscious decision or reason as by intuitive response to the life-enhancing instinct in their nature, and through it justify and fulfil their existence, a theme Stanley was to explore in paintings yet to come.

Just as the 'prophets' act as a frieze over the Stanley wing of the triptych, so the river and its trippers suggest a frieze to the Hilda section. It is tempting to see its depiction as allegorical of the souls of the dead being ferried across the Styx. But Stanley himself refers to the Thames in his painting as the 'river of life'. We know from Florence's memories of the little bay in the bank of the Thames beloved of the Spencer children at play, and from Stanley's own comments about such paintings as *Swan Upping* that the river was for him a place of recollected happiness. Everything about it, its boats, its boatyards, its holidaymakers, its bridge, its banks, his swimming underwater towards the light of the sun – a symbolic baptism – all suggest joy, the discovery of comprehension, and when we examine the riverboats and their occupants, the feeling is surely reinforced. The figures are holidaymakers who have come out of London by train and bus to enjoy themselves. The skipper of Bond's steam-launch, in his blue uniform, joins with his passengers in their anticipation of a good day out; a piano has been set

* A Cambridge scholar, Jas Wood had in 1922 collaborated with C. K. Ogden and I. A. Richards to write two seminal books of the time, *The Foundations of Aesthetics* and *The Meaning of Meaning*. Ogden, inventor of Basic English and Director of the Orthological Institute, was at the time also editing with Bertrand Russell and Frank Ramsey the first English translation of Wittgenstein's monumental *Tractatus Logico-Philosophicus*. I. A. Richards was the leading literary scholar and critic of his day, friend, advocate and self-appointed elucidator of T. S. Eliot. James Joyce was so impressed with *The Meaning of Meaning* that he asked its authors to make a linguistic analysis of the *Anna Livia Plurabelle* draft of his *Finnegans Wake*. Jas Wood's sister Lucy Boston became a noted children's writer.

out on the deck for a sing-song. They are the baptised, the resur-
rected, who are learning the delights of finding themselves in
Stanley's heaven; 'this', said John Donne, 'this that we enjoy is
heaven'. The figures point excitedly towards the dawn light in the
distant sky, which Stanley has there tinged with red; the light in
the painting is from the east.* The figures may simply be celebrating
their new comprehension. But equally the reddish light could
symbolize the purgatorial fires through which they have passed to
reach their joy: for it is possible to interpret much of the imagery of
the painting at Dantean, with the excited holidaymakers reminding
themselves of that terrifying moment in the *Purgatorio* when the
traveller finds himself compelled to walk into the fire of cleansing
if he is to arrive in the heaven of the *Paradiso*. On the distant stile
over the church wall Hilda stands preoccupied by the regenerative
meaning of the scene she sees and wears the grey suit of the Sarajevo
days when she and Stanley first came to an understanding of their
love. A youthful Stanley is surely one of the group standing nearby
and looking on.

If the two wings of the triptych state the premises, the central
panel proclaims their resolution: Stanley's joy in his concept of
heaven is a joy all can experience. In it the particular becomes the
universal. The figures in the box-like tombs in the left foreground
are sinners, but Stanley would not have believed that they had
greatly sinned, for his new-found illumination comes through the
female. They are struggling against constraints placed on matters
sexual by ignorance or social convention or economic circum-
stance.

Perhaps Stanley felt that his burgeoning interpretation of the
morality of his day was still too radical to be openly expressed. In
this painting he has masked his hesitation by using associative
imagery which some may view as bizarre and which even he did
not find satisfactory. In later years he admitted that the cameo was
not as compatible with the rest of the detail as he had wanted. At

* Stanley told Florence that the excitement of the embarking holidaymakers was that 'for them, the
climax in heaven lay in the sunlit continuation of the marsh meadows beyond the bend in the river', a
reference to his early feelings about the riverside water-meadows (cf. his John Donne painting, Chapter
3).[11] He offered no reason for tinting the distant sunlight red. In a letter to the Raverats he recalled a
local incident when a hay-rick was fired by a spark from a locomotive and he was fascinated by the
strange effects of sunlight seen through the heat and smoke. His cousin Jack Hatch was leading fireman
on the occasion.[12] Incongruously, Jack Hatch's main occupation was that of village coalman.[13]

the time he confessed to Jas Wood that he was 'still trying to tuck this Original Sin egg under the holy hen'.

The redemption of all embraces race and creed. This must surely explain the presence of Africans in the painting, an unexpected, even incongruous gesture to many in the 1920s. Their inclusion could, of course, be justified on the grounds that the Christian Resurrection is missionary and universal: but such obvious symbolism is unlikely in the context of the painting. The Victorians had mainly seen the native art of the empire they acquired as pagan and irrelevant. It was only by the turn of the century that the discerning were beginning to sense the instinctive and formalized nature of primitive art. In England, the Carlines were in the forefront of its recognition. Hilda's eldest brother George, visiting from the Halifax Bankside Museum where he was Keeper, brought his anthropological expertise to family discussions. Sydney, as artist, understood its implications and talked with Stanley on them. Richard was to publish on the subject, and, with Sadler, to set up the first major exhibition of African art seen in this country. 'If I could have my life over again', Stanley announced in his last illness, 'I would learn from the Africans'.[14]*

What would he have learned from them? Perhaps that their ritual art served the same purpose as his, its apparent grotesqueness a reaching into the spiritual as defence against the fears or as celebration of the joys common to humanity; but in their case a reaching out through the use of object, through the sensation of touch. Perhaps Stanley wished for a deeper experience of the plasticity in their art. Tactile sensuousness, a delight in touching, always had the power to lift Stanley's spirit into exultation. He wished to incorporate the notion into the painting and had thoughts of showing resurrecting figures touching each other or objects around them, their delight springing from joy in gesture and an instinctive identification with natural objects. At first he could locate no associative experience of his own which provided the appropriate imagery. Then, as a result of a conversation with the Carline brothers, the idea came to him of portraying Africans. So the figures exploring the sensations of touch in his painting become

* Stanley's interest in African ritual art was constant. In December 1946, he was to send Charlotte Murray, then working temporarily in a paediatric clinic in London, a 'script on African art and religion' which she found 'most interesting. I hope to get through it before I leave.'[15]

Africans resurrecting. But he still needed to give them objects to touch which sang from his own experience.

The items seem inconsequential. The first woman on the left was intended to hold 'something soft and feathery',[15] perhaps 'a small bird or an animal'. The second touches the 'trunk' of some plant – a 'rock plant' – and also touches the arm of the man in the centre 'slit'. The third figure on the left holds a 'biggish round stone'. On the right the figures are touching the ground, or a 'nugget of some kind of rock which has several different planes or surfaces', or else 'running sand on to a conical pile of sandy earth'. In fact it would seem that the pictorialization became modified as he painted; for of course Stanley was painting his own sensations, bringing them to the surface of his mind as he worked. He saw no point in describing the origins of each sensation, but it remains intriguing to attempt a reconstruction by detection or conjecture. The 'conical pile of sandy earth' – accurately depicted – and the 'nugget of some kind of rock with several different planes or surfaces' which emerges on the canvas as a small pile of mud bricks recall, perhaps, the dugout he built in the 68th Field Ambulance with George Dando at Kalinova: 'We dug down a little and made sun-dried bricks . . .'[16] in a place to which he returned eighteen months later as an infantryman: 'I was glad to get back to this deserted spot, to see a little dugout I had made . . . almost filled and covered with whitish sand and mica that accumulated from the rocky nature of the ground about there.' Did Stanley sit in Kalinova among the rock plants and idly run the sand through his fingers while 'I felt that something wonderful would happen there – "and the redeemed shall walk there",' and did the associations bring to mind the feel of his kitbag, repository of his precious Macedonian drawings, clutched protectively by the figure in the painting like 'some small bird or animal', or the solidity of the 'big round stone' he had to carry when detailed to repair the Kalinova track, its roughness an assault on his artist's fingers, a moment of misery now to be redeemed by his art?

Some such experience lies behind the detail of the cameo. But there is another aspect of its composition which brings it closer to the context of the whole painting. The Africans are in some kind of enclosure which has a mud-dried floor. There is a central line of figures in a 'slit' which Stanley mentions but does not explain.

The Resurrection in Cookham Churchyard

It could be a roofless hut from a kraal. Equally it could represent the 'home' of his Kalinova dugout; it was standard procedure in the forward areas to dig a slit-trench in which to sleep more safely. Equally, it could be a boat. The central line of figures resurrect as though from paddling; they could almost be a rowing crew. The outer line of figures, mainly women, line the bulwarks. In the little bay in the bank of the Thames by the Ferry Hotel in Stanley's boyhood the former Cookham Ferry barge lay abandoned, made redundant by the building of Cookham Bridge. The water allusions in the painting resonate Stanley's vision of the baptismal meaning of the river, and echo the imagery of Beatrice telling Dante to bathe his eyes there, so that to his sight the earthly disguises of people fall away like masks, the flowers are transformed before him, and he sees the courts of heaven made manifest.

The motifs in the painting begin to link. They reveal it as a vast fugue in which themes are first stated, then developed into a form of counterpoint. The Stanley-section with its prophets-of-reason frieze draws attention to the rational aspects of friendship, of instruction, of hospitality, of contemplation: whereas the Hilda-section with its river-tripper frieze extols the passionate, the care-free and the instinctive. The ecstasy of the painting is Stanley's discovery of the linked joy of both. His fusion with Hilda has so uplifted him as to afford a 'fresh realization of the possibilities of heaven in this life'. The experience is the emotional equivalent on the human level of the Christian Resurrection on the spiritual. In their great shouts of happiness the relative calm of the figures is deceptive. They may not immediately suggest force or vitality. Nevertheless it is the energy of creation which has exploded their death into life. The summer blossom, resurgent after winter quiescence, tells us so.

In the painting, Stanley's flowers, so painstakingly depicted, stand in profusion as silent witnesses to fecundity, responding to the instinctive procreative urge despite those who, like the earnest, misguided thinkers along the church wall, try to set human reason above it. In the end even they must come into the comprehension which the painting presents, must be reborn as he, Stanley, is reborn naked, must put on christening robes again, be purified, baptized. Even when those branded as sinners are restrained by error, God will take them back to himself as he takes us all.

Drawings indicating Stanley's evolution of his image for God in *The Cookham Resurrection*. (*Above left*) Austere. (*Above right*) The image modified to the feminine. (*Below*) The image modified to represent Hilda.

Approaching the final image. Hilda holding Shirin, who is clutching kittens, in her right arm, Stanley in her left.

But God was not in fact conventionally masculine to Stanley. When male-female 'fusion' occurs in the truly understood meaning of sex, the resulting unity is asexual. Here the male becomes female as Stanley in Hilda's black dress has become her in her baptismal gown. In the transfiguration of Stanley's union with Hilda both dissolve into the meaning of God, become a microcosm of God, replicate the nature, the identity, of God. In the painting the essential lines of perspective converge on the church porch and the figures in it. They comprise the unifying cameo of the work. The seated figure is Hilda. She is not, in this imagery, the Hilda portrayed on the railed and ivy'd central tomb, asleep in the carefree attitude all lovers know of their beloved, her hand 'nesting' in the sleeve of her gown in one of Stanley's recondite 'tunnel' paradigms. The 'bird-in-the-nest' feeling Stanley deliberately gave that cameo has been transformed into a very different feeling in the Hilda of the church porch. Now she is awakened, conscious of her power. Stanley is using her to image their fusion into God.

He had great difficulty at first in visualizing the cameo. Dante used the image of a floribunda rose. In the *Paradiso*, as Beatrice and he approach the Heavenly Presence, she draws his attention to the meaning of the roses he sees; they symbolize the unifying of the redeemed into the Oneness of God. Stanley evidently thought of continuing the imagery, showing the face of God as 'a never-before-seen thing like a new and never-before-seen flower that is more convincing of its flower-likeness than a rose and with more sweet associativeness than there is in the scent of a rose . . .'.[17] Instead he poured the image into his cameo as the cascades of white roses round the porch; he knew them as a type of rose he called 'the seven sisters'. In the 'language of flowers', they have the figurative meaning of the secrecy of love. Hilda, his Beatrice, is taking him into the presence of God, whom Stanley paints as the figure standing behind her, caressing her hair. Unable to depict God, Stanley has made the face indefinite. Hilda is the female element in God. In feeling, she is as old as the Great Mother. Her manifestation as the Virgin Mary is the Christian celebration of her function. She nurses two babies in her right arm – by the time Stanley came to paint the cameo Hilda was pregnant with their first daughter Shirin – but in her left arm she cradles a naked manikin, hands folded over its genitals. This is surely Stanley's

final appearance in his painting. In his transcendent state he is physically the ardent lover, longing to be taken into possession: 'eat me, darling, let me become you. In the midst of your belly I cry out my love for you'.[18]

Hilda with Shirin, 1926

To the end of his days, Stanley was unwilling to set a verbal definition to God. He could identify God only by moving step by step, painting by painting, towards some ultimate awareness. Because only the instinctive, expressed as religion and common to all cultures, has the power to search out the nature of God, Stanley the artist is nearer God than the rationalist. There were times when he felt himself 'next to God', as did Hilda in her different way. In this Resurrection painting Stanley's spirit has taken a long step into that awareness, one which only Hilda, the symbolic female, could open for him.

To Stanley, the paintings of both were miracles performed by some greater source. Each celebrated a coming of comprehension, the mysterious arrival of the Holy Spirit, the light of Crashaw's 'Ode to the Epiphany', so that with Hilda Stanley could say, 'I think of light as being the holy presence, the substance of God, so that everything is in and part of that substance.'

The entire painting is a hymn to light: to light as the giver of form to our visible world, the light towards which that traditional lover of light, the sunflower of Stanley's picture, turns: to light as the giver of fertility, nurturing the asphodels, the roses, the lilies and the meadow flowers of his painting: to light in its allegorical power to unfold our comprehension, the Miltonic light which dispels Chaos, the Dantean light which enfolded the heads of Dante and Beatrice united in Paradise, the tongues of flame which irradiated the disciples at Pentecost. In Stanley's painting the Holy Ghost, the Comforter, arrives as light, like the dawn in *Swan Upping*, from the east. Its radiance bathes the church wall. The end seated figure looks to the right to see its coming. The naked Stanley looks to welcome it, as do the African women and the startled women in the box-like tomb. The seated figures by the church wall are dazzled by it, as they vainly struggle to retain the rationality by which they try to order the world. 'Moses' clutches his Commandments to him, desperate to defend their dogma against perceived, instinctive truth. Like the sun in its course, the light of comprehension rings the painting, flooding from the east, to the north making the mysterious glow which prompts the river-trippers to become aware of their happiness, on the west suffusing the inspiration of Hilda's paintings, and to the south, to the front, illuminating the pivot of Stanley's great wheel of light, the God-cameo in the porch. All the spokes of his wheel, all the radii of his circle close on it.

In Stanley's great painting, as in Eliot's triumphant conclusion to an odyssey of his own in *Four Quartets*, 'the fire and the rose are one'.[19] Stanley's God may not be entirely the God of traditional Western worship, but one he was to tell Hilda was 'The Thing Which Is'. In the exaltation of such comprehension we can begin to understand why Stanley is reborn as the naked manikin in the Absolute Being of God – the spiritual Virgin Birth symbolic to us all – and why he is also reborn twice naked in joy, his and Hilda's

disparateness now fused in the semblances of their Spencer-Carline unity. For Stanley, the Flesh has been made Spirit.

Look again at the cameo of Stanley in his book-tomb, his signature to the painting. The figure has something of the attitude of the figure of himself on the bed in *The Centurion's Servant*. Contemplative he may be, but in the turning of his head from the scene, in the extended arm and clutching hand, it is a contemplation suffused with mental wrestling.* Moreover the shadow of his arm falls across the surface of the tomb, a minor detail apparently, but as so often in Stanley's paintings a possible clue to the conception of its composition. For when Dante made his journey through Hell and Purgatory, he alone among the multitudes there possessed a shadow; and by that shadow they knew him to be mortal. No other figure in Stanley's painting has such a shadow. They are the shades of Stanley's memories. Glance at Slesser. His lawyer's wig has taken the semblance of the medieval cap Dante wears in depictions such as that of Luca Signorelli at Orvieto. Not, one imagines, that Stanley literally saw Slesser as Dante. Rather that Stanley is using the figures of his past, as Dante used his, to point a personal odyssey of his own. He is turning his resurrecting shades into emanations of himself in a symbolic and triumphant wrestling into the spiritual.

If the painting is indeed an allegory derived from *The Divine Comedy* – did not Stanley contemplate writing one of his own?[21] – it can be so only as subliminal imagery drawn from personal allusion. But its essential message surely reflects the advice Virgil gave Dante when they had emerged on the foothills of Paradise and had to part:

> I with skill and art
> Thus far have drawn thee. Now thy pleasure take
> For guide. Thou has overcome the steeper way,
> O'ercome the straiter. Lo, the sun that darts
> His beams upon thy forehead! Lo, the grass,
> The arborets and flowers which of itself
> This land pours forth profuse! . . .

* 'The open book shape and my resting on it is the shape of my soul.'[20]

Stanley Spencer

> . . . Expect no more
> Sanction of warning voice or sign from me,
> Free of thy own arbitrement to choose,
> Discreet, judicious. To distrust thy sense
> Were henceforth error. I invest thee then
> With crown and mitre, sovereign o'er thyself.*

In the lower right of the painting the mortal Stanley lies wrestling with the confusions of the everyday. In the upper left, the resurrected trippers drift downstream, taking their pleasure. Between the two lies the imagery of Stanley's odyssey to find his way among the obstacles of existence. As Dante climbed the Mount of Purgatory his toil became easier, until at last he had the feeling of floating, like a ship on a river. Virgil had left him 'sovereign o'er' himself, and in that free and transcendent spiritual state he was in grace for his encounter with the Beatrice through whom he would be taken into the final comprehension of heaven. In this painting Stanley is joyously proclaiming that he too has met his Hilda–Beatrice and through her knows the meaning of a resurrection.

The painting was a watershed in Stanley's art. In it he boldly undertook a creative procedure he had until then overtly excluded, that of openly exploring his sensual feelings in order to bring them to the surface as imagery. He discloses in the painting his sensuality of sight in the dresses he gives Hilda to wear and in his pleasure at 'a glimpse of leg'; his response to smell in Hilda with her sunflower and in the cascades of roses suffusing the God-cameo at the porch in perfume; in touch in the sensation of a woman's dress next to his skin and in the Africans' instinctive pleasure in the feeling of natural things; in sound in the noise and holiday joviality of the crowds of river-trippers, contrasted with the silence and stillness of the churchyard figures, as Stanley was sociable and voluble in company but silent and still in the solitude of private contemplation. Only taste seems missing, and that was to be rectified in later work. In subsequent paintings Stanley was to separate out and develop many of the themes woven into this work. Indeed in some of the great unfinished paintings at the end of his life he seemed still to be exploring the concept of the coming

* *Purgatory*, Canto XXVII, in the Rev Francis Cary's translation of 1865, the version Stanley read in youth. 'It must be poor, but it gives you some idea,' he told the Raverats.

of the Holy Spirit. But never again was he to compress so much germinal meaning into a single painting as he did in this, his *Cookham Resurrection*.

Long before the painting was finished in the spring of 1926 it attracted attention. Friends and admirers came to watch him at work on it. Requests reached him for its exhibition, but he maintained his resolve. It would be the showpiece of his first one-man exhibition, an event which would broadcast his name. The exhibition was held in the spring of 1927 at the Goupil Galleries of William Marchant in Regent Street, and created a sensation. Opinion was divided for and against it as a painting, but all were agreed that it was a remarkable work. It was purchased through the Duveen Trust for the then considerable sum of £1000 and passed to the Tate Gallery. Stanley's aim was achieved. Thenceforth his name and activities were of public interest.[22]

Afterwards, Stanley began some of the paintings for the Burghclere Chapel, now nearing completion. Both the present and the future looked bright. He was more prosperous financially than he had ever been. Unsolicited leaflets from Rolls-Royce cars arrived one day through his letter box, a flattering gesture, as Rolls-Royce then were selective in granting ownership of their cars. Although Stanley had no intention of buying one, the pamphlets were followed, it seems, by a visit from a Rolls-Royce dealer to the Vale of Health studio, at which point Stanley's inappropriateness as a possible owner was embarrassingly revealed. Suspecting that Richard Carline and Henry Lamb were the instigators of one of Lamb's puncturing practical jokes, Stanley sent Lamb a long letter which initially reads as almost incoherent with outrage. But through the fury, Stanley's relentless logic prevails. He never minded comment or criticism, nor indeed practical joking against himself, provided it came from someone whose judgement he trusted, did no harm to an innocent third party, and was done with honest intent. But if the criticism resulted from mischief-making or block-headed ignorance of his true intent and was done 'without knowing what I am feeling at all', then, as he told Lamb, 'irritation' would ensue: 'If you and your friend's idea was to give and cause me annoyance and irritation you have both succeeded admirably, but that is the irritating part of it; that you neither of you did it for this purpose.'[23] It was Stanley's overpowering sense of integrity

Chapel View, Burghclere. Hilda and Stanley at the gate.

which was affronted by the incident. The thing he loathed about the caper was 'making me a party to a jest which entails lying, deceit and the desire to make a fool of somebody'. He expected others to deal with him in honest purpose, even if they hurt him; and in exchange he expected to be allowed to confront them in honesty, even if in their eyes he appeared 'smug'. If he found that

a confrontation resulted not from honest intent but from 'deceit and lies', he would become implacably unforgiving even when his social contacts with the offender continued, an almost priestly attitude of condemning the sin but forgiving the sinner. When Lamb persuaded him to sit the following year for his portrait, he was still incandescent with reproach about the incident.

Later in 1927, he, Hilda and Shirin left the Vale of Health Hotel – Lamb had given up the tenancy – and moved to Burghclere, lodging first at Palmer's Hill Farm until Ash House, the cottage which the Behrends were building for them was ready. Hilda was given the opportunity of designing the layout of the interior, a task she thoroughly enjoyed even if the results were, by some accounts, not altogether practical. She renamed the house Chapel View, for the chapel lay within a short walking distance. The house was newly built in what was an open field, and Hilda spent many hours creating a garden and using her wartime farming knowledge to grow vegetables. Burghclere was then connected by a local railway line with Newbury and Winchester, and on one occasion the couple presented a departing visitor with one of Hilda's cauliflowers wrapped in brown paper. By chance the paper had their address on it. A few days later, an anxious postman returned the parcel to them, saying it had been found alongside the railway line. Evidently the visitor had taken the first opportunity to throw the unwanted gift out of the carriage window, a tale Stanley and Hilda would recount with hilarity.[24]

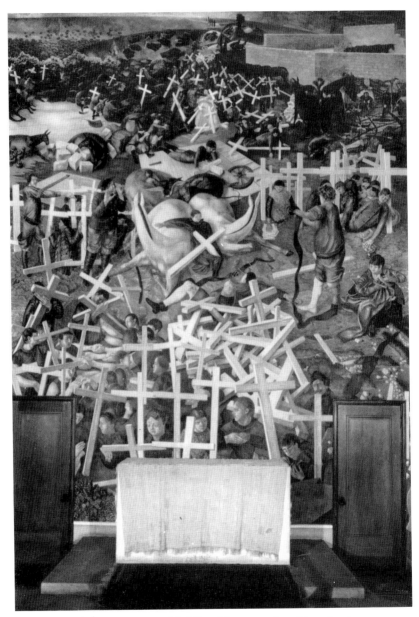

The Resurrection of Soldiers (also reproduced in colour)

CHAPTER TWENTY-FOUR

The Resurrection of Soldiers

I did not intend this as a 'War Book' – it happens to
concern the war. I should prefer it to be about a good
kind of peace . . . We find ourselves Privates in foot
regiments. We search how we may find formal good-
ness in a life singularly inimical, hateful to us.

David Jones, *In Parenthesis*[1]

'WHAT HO, Giotto!' Stanley's exclamation on hearing that the
Behrends had agreed to sponsor the chapel at Burghclere gives a
clue to the system he devised for its decoration. His admiration of
Giotto's frescoes in the Arena Chapel at Padua was as much
spiritual as technical. Giotto's main panels depict the life of Christ.
In Stanley's chapel the main panels would portray the life of Christ
too, not in biblical literalness, but in a transfiguration of those
aspects of his wartime experience in which he sensed a universal
Christ-like redemption.

Architecturally, the chapel was to be a simple oblong brick box
– Stanley's 'Holy Box' – with the front facing south. High windows
in the south wall would provide the only source of that diffused
light which so held his imagination. The two long side walls would
each contain the four arched panels. Below them would be the
rectangular panels, only slightly smaller; Stanley's predellas. The
residual expanse of each wall above the arched panels would be
filled with the two panoramas, that of his beloved Vardar Hills on
the left wall, and that of Todorova on the right wall. The fourth
wall, the altar wall opposite the windows, would display the
unifying composition, a vast *Resurrection of Soldiers*. Outside,
two flanking almshouses would provide a rotation of accessible
caretakers and keyholders.

The building was designed specifically to house Stanley's paint-
ings. In practical terms it was – is – a gallery, but because Stanley

The Burghclere Chapel: exterior.

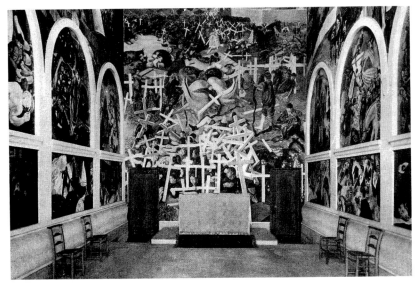

The Burghclere Chapel: interior.

felt his work in it to be, in his terms, 'religious', he wanted to give it the form of a chapel. In fact the Behrends were more interested in the project as a scheme of painting than as a sacred building, but were able to justify his wish for a chapel form by making it a memorial to Captain Sandham. Stanley had calculated his designs to the last inch, but the architect whom Henry Lamb first suggested, his friend George Kennedy, was so critical of the proportions that Stanley felt him to be unsympathetic; Lionel Pearson, who was willing to work more closely with Stanley, was preferred.

The dedication of the building as an Oratory of All Souls took place in March 1927. The ceremony was performed by the Suffragan Bishop of Guildford and it was deemed tactful that no hint of the proposed paintings be revealed lest he be disquieted. It was then open as a public chapel, with an annual service on All Souls Day until the early 1970s. Its decoration was to occupy Stanley for the next five years. He had planned to paint in fresco and spent time in 1926 learning and practising the skill. But he found his efforts quite fruitless, and the murals were finally painted on canvas giving the appearance of frescoes. There were no looms in Britain capable of weaving the larger canvases, which were instead prepared in Belgium.

Today the chapel appears from the outside to be simple and unadorned. But on a sunny day, walk inside – it is in the care now of the National Trust who have renamed it the Sandham Memorial Chapel – and the effect is overwhelming. Here Stanley is doing two things: he is going back in memory in each panel to show a personal triumph of the spirit; and he is asking us inwardly to hear the symphonic totality they make when orchestrated into union.

The first predella on the left – *Scrubbing the Floor* – gives an insight into Stanley's procedure. The setting is a point in one of the corridors which bisects the Beaufort hospital from the main entrance to the rear service areas. The end near the main entrance was where Sergeant-Major Kench had his office. On some long-remembered occasion Stanley had had there one of his sudden illuminations: 'The sunlight is blazing into the corridor near the Sergeant-Major's office, and I say inwardly, "Oh, how I could paint this feeling I have in me if only there was no war . . ."'[2] But when fifteen years later Stanley came to paint the feeling, it is the other end of the corridor he chose, marrying the feeling of the one

place to the situation of the other, as he had done long ago with his orchard in *Apple Gatherers*. The part of the corridor he shows is the functional flag-stoned service end, still lined then by drab terracotta tiling, its gloom deepened by the headline of black tiles. In fact it is lit by a series of small barred windows, but Stanley has eliminated them to make the gloom still more claustrophobic. Up and down that corridor many times a day the orderlies would have to scurry between the stores or kitchens and their wards. Here 'bread, butter and monkey brand' has been casually slapped on their trays; one orderly has to lean his tray against the wall to adjust the balance.* Off the picture to the right is an exit door to the court across which Stanley would have to scuttle to gain access to his group of surgical wards; a glass-covered perimeter walkway gave shelter when it rained. Stanley's dread while crossing the court was a chance encounter with the Sergeant-Major, from whom he was convinced he would suffer yet another reprimand for unsoldierliness. In that tray-carrying detail of the painting Stanley is telling us of his agitation about everything at the hospital being 'so quick', of his dejection at being prevented from pausing to collect his thoughts.

Compare that detail with the orderly scrubbing the floor: he is another Stanley-figure taking part in the same frantic activity, detailed off to the misery of yet another floor-scrubbing duty. But look more closely at the figure, and at its strange posture, arm extended straight, captured by Stanley in a very unscrubbing-like attitude. It is the image of the long-term mental patient 'Deborah': 'When he washed the floor, he knelt down with his back to you but now and again peering sideways ... across his shoulder at you. As he lifted the wet rag out of the bucket, he slowly raised himself into a vertical kneeling position, arm extended straight out in front of him, rag hanging down; then, open goes his hand and plop! goes the wet rag. Down he bends, takes hold of the rag and slowly swishes it about ...' The mannerism is too accurately depicted to be coincidental. Stanley as the scrubbing orderly has taken upon himself the detached persona of Deborah. A metamor-

* 'Monkey Brand' was a bar soap impregnated with fine sand or powder, and used for scouring or scrubbing. It is typical of Stanley that he instinctively makes a counterpoint by placing on the tray two contrasting items, one of which – bread and butter – was joyous to him, and the other – Monkey Brand – indicative of all he detested about his life at the hospital.

Scrubbing the Floor

phosis has occurred: 'All this maybe was part of his mental illness, but I thought I would like to do things that way. I felt that in that state and moving at that speed, I could take things in. I could contemplate. Nothing would disturb me.'[3] The comment might at face value seem extraordinary. But there is a depth in Stanley's understanding of Deborah. The pain of mental illness derives from a disordering of the cerebral processes; the mind and body instinctively try to circumscribe this by routines of thought and behaviour – mannerisms. The sane are also subject to such mannerisms, whether or not they are aware of them: all are subject to the confusions of existence, and instinctively rationalize them, circumscribe them. In this sense Stanley's visionary paintings too are mannerisms. In the sensitivity of his feeling Stanley intuitively understood his kinship with Deborah.

Thus a panel which at first sight might seem aesthetically undistinguished uses that very quality to emphasize the emotional sterility inherent in the mechanical repetitiveness of hospital work. But within that repetitiveness Stanley has taken one aspect, the tray-carrying, and counterpointed it with another, the floor-scrubbing. He is telling us that the two are different in the opportunities they offer for contemplation. The former is creatively damping; the latter offers at least a brief chance to 'catch hold of

257

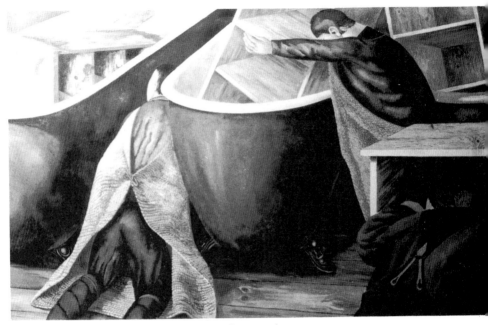

Washing Lockers

a little bit of spiritual life'. Within the monotony of an inescapable existence, Stanley has found a modest redemption. It is his interpretation of the Vice and Virtue of Giotto's predellas. In the Arena Chapel the depictions alternate, but, Vice and Virtue having little meaning for Stanley apart from their damage or contribution to his spiritual creativity, he has in his version pointed their distinction by bringing them into the one picture. The painting is the celebration of an epiphany, a fleeting moment of redemption, an embryonic resurrection.

Such intentions also underlie others of the seemingly prosaic predellas. One, *Washing Lockers*, shows orderlies using baths to wash hospital bedside lockers. These were not cupboards in the modern sense but simply contrived though sturdy shelves. Stanley liked these particular magenta baths because they were more colourful than most in the hospital.* Like the tray-carrying of *Scrubbing the Floor* the task is menial and tedious. But between

* Stanley set his scene in the bathroom of Ward 4, which had a wooden floor and 'large magenta-coloured baths'; there was little enough colour for him in the Beaufort.

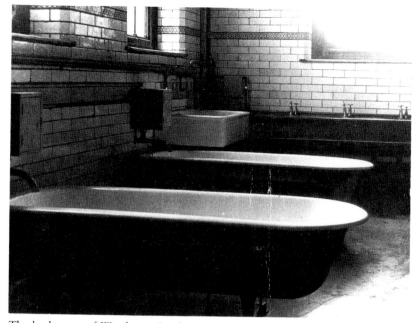

The bathroom of Ward 5 as Stanley would have known it. Although the baths in this ward were less colourful than those of Ward 4, which he used for his painting of *Washing Lockers*, this bathroom was 'more jolly'. It had a coloured stone floor Stanley liked. The accuracy of his depictions is again reinforced.

the baths, his back to us, another orderly scrubs the floor. Again it is Stanley, once more able to catch hold of a 'a little bit of spiritual life'; the piece of sacking on which he kneels is 'a prayer-mat'. But his posture is not simply a repetition of himself as Deborah. He is *between* the baths. Their shapes loom over him protectively, close him in, provide a security not available to the orderlies standing exposed above him.

The arches or lunettes are less intense. The impression is that Stanley, having stated his premise in the predellas – the fact of his redemptions from the material into the spiritual – is now moving towards more communal occasions identifiable by those who shared the experience with him. He is bringing them into the orbit of his moments of happiness. This can be perceived, for example, in the first arch on the left, *Convoy of Wounded Soldiers Arriving at Beaufort War Hospital Gates* usually shortened to *Convoy*

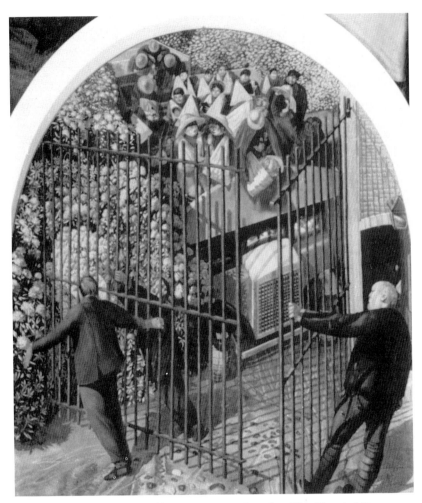

Convoy of Wounded Soldiers Arriving at Beaufort War Hospital Gates

Arriving. The gates are being opened by the gatekeeper, Sergeant Vickery, another huge man with 'bulging eyes', whom Stanley jokingly likened to the Keeper of the Gates of Hell in Milton's *Paradise Lost.* He is shown as a rough gaoler, the pair of keys hanging from his belt apparently modelled by Stanley on those of the chapel. The wounded exchange tales. One shows a shrapnel or bullet hole in his sun helmet to a comrade. These are Dardanelles wounded. Those sitting in the rear bus are quieter, more dispirited.

The Resurrection of Soldiers

The painting contains intriguing references. Stanley shows the mood as joyous by transposing its minor details into his current happy circumstances. Bristol buses were never red; Stanley has given them his Berkshire livery. The rhododendrons grew round Burghclere and have been painted in place of the laurels which, as he records in his memoirs, in fact lined the Beaufort drive. Even the unwieldy title has significance. The wounded are arriving not at the hospital, but at the *gates* of the hospital. The picture looks south. The shadows – the gatekeeper is striped by them – are those of early morning, the eastern light of *Swan Upping* or of *The Cookham Resurrection*; Stanley is telling us that built into the composition is a powerful element of illumination, an allegory to him of the coming of a comprehension. The gates in actuality, as he himself described them – 'I love such things' – were massive Victorian cast-iron affairs, not the prison bars he shows; they too may have been copied from gates he knew round Burghclere or transferred from a subsidiary entrance to the hospital. Moreover

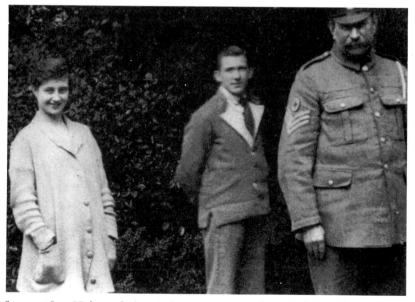

Sergeant Sam Vickery, the hospital gate sergeant, in the main drive of the Beaufort. A patient in hospital blue is looking on. The pretty girl is Vickery's daughter Dolly. The more adventurous of the patients would stand him drinks in his local in the hope of being allowed to date her.

by making Sergeant Vickery capless, Stanley has imputed to him the military sin of slovenliness, a misdemeanour of which he would certainly not have been guilty; his zeal in checking outgoing orderlies for correctness of military dress was legendary. Although known as officious, no recollections suggest that he was brutal or rough. Indeed, Stanley specifically states that he 'rather liked him'.[4]

Once more we face that paradox which recurs time and again in Stanley's visionary painting. He seems so patently to be saying one thing; yet he is often saying something quite different and more subtle. In this example, it has been generally assumed that the panel reflects a view of the hospital as a prison, and conveys Stanley's bitterness at what the place did to his creativity. The first interpretation can be accepted, but the second does not follow from it. To indicate the deeper meaning of the painting, Stanley saw no reason why he should not have smiled wryly with his comrades and poked gentle fun at the idiosyncrasies of those who, like Sam Vickery, decided their daily fate. His memoirs, unlike those of Gilbert, do not, overall, convey a sense of bitterness; he was seldom interested in depicting the negative aspects of his existence unless he was able to celebrate the conquest of them through the coming of a spiritual comprehension – which is what he is doing here through the use of gentle humour. If Stanley was always serious about his deepest feelings, he nevertheless showed in his everyday life a great sense of fun and an amused tolerance of humanity when it was not, by its blindness or indifference, unsettling him. Friends, especially in later life, frequently stress this side of his character. He shone at parties, loved to join in games and charades; he had inherited Ma's gift of mimicry and when called upon could hold everyone amused. Equally he could, on suitably stag occasions, keep his end up by chanting army songs or bawdy limericks.

In 1927 when Stanley began the painting – and this was his first panel – there were many thousands of staff and ex-patients who remembered the hospital and its personalities. Among the stream of visitors to the chapel – including Nancy, Stanley's seventeen-year-old love, now in her mid-twenties and accompanied by 'some man; I was pleased to see her again' – were many former comrades who came to talk with him and watch him at work. Henry Lamb,

Darsie Japp and Jas Wood came. On 14 September, 'A General of 17 Div. [a companion division in Macedonia] arrives. Talk about Macedonia.'[5] Lionel Budden came. He had given up the law, taken two further university degrees – one in French, the language of his conversations with the Serbians in Macedonia – and was now headmaster of a grammar school in Lancashire, occasionally playing cricket for the county.

We can carry Stanley's amused tolerance for the frailties of men and women, and his same gentle admiration for their true nobilities, into all the arch paintings. He is 'tucking up' inside himself those characteristics of others which could be isolated to make them

Lionel Budden in the 1920s

'lovable' to him. It is surely this all-embracing and unsentimental characteristic, the human quality he displayed in his relationships in life and used in the composition of the arches, which makes them so different in feeling from the predella paintings. The absorption of people's personalities into Stanley's imagination was a kind of rebirth both of them and his feelings about them. In his real-life persona Vickery exists in Stanley's memoirs as Milton's Keeper of the Gates of Hell. As such he appeared to the orderlies, and the gates he kept were the forbidding Victorian constructions Stanley accurately described. But this is not the Vickery Stanley now sees. In the less fearful gates of Stanley's depiction and in the unexpected detail of the keys at Vickery's belt we may catch echoes of that other Miltonic gatekeeper, the one Stanley met in his admired *Lycidas*:

> The pilot of the Galilean lake
> Two massy keys he bore of metals twain
> (The golden opens, the iron shuts amain).

Through the gentle subtlety of Stanley's presentation we may touch his real feeling in the painting. To the orderlies incarcerated in the hospital Vickery kept the gates of 'hell'. But for the arriving wounded – ill, unkempt, exhausted, coming from a genuine hell – he was 'the pilot of the Galilean lake': St Peter, opening the gates of heaven. For Stanley, the figure of Vickery in the painting becomes the archetype by which a 'change' is made palpable. A 'God-creation' is taking place.

Not only is the concept implicit in all the panels of the chapel, but in the chapel as a whole too. Stanley painted the keys at Vickery's belt from those that open the chapel doors, not perhaps simply because they were at hand, but because symbolically they opened for Stanley the doors of a heaven of his making. The left-wall predella and arch paintings extol the Augustinian notion of 'fetching and carrying'. They marry with the theme of the Vardar Hills panorama at the top to give a winter scene where the emphasis is on the practicalities of keeping active, fed and warm. In contrast, the four predella paintings on the right wall celebrate the Augustinian notion of 'doing things to men' and the arches link to the Todorova panorama above, those 1917 days of heat and inactivity

when Stanley had time to wander off among the harmless rock-snakes and the lizards and lift himself out of the everyday into the comfort of the contemplative. The Burghclere Chapel is another of Stanley's complex fugues, in which the themes of his redemptions rise and fall and interweave. Its summation occupies the altar wall as *The Resurrection of Soldiers*. Although it does not appear to be so, it is in fact the centre panel of a triptych. Its side panels are the last arch on the left wall – *Stand To* – and the corresponding panel on the right wall – *Reveille*. Stanley found the composing of the painting as difficult as he had *The Cookham Resurrection*. Then suddenly it all came to him. He does not actually say where from. But in Giotto's great *Last Judgement* in the Arena Chapel can be discerned fascinating corollaries with Stanley's presentation. In both, the dead rise from their graves at the lower edge of the picture. In Giotto, the emotional movement is upwards, past a scene in which the donor dedicates his chapel to the Virgin Mary, then up again towards the central Christ in his mandorla. There, surrounded by the apostles and the canonized saints of the Church, Christ gives judgement. His right hand approves those who are to be saved and they assemble, the ranks of the redeemed, in the upper part of the picture. But His left hand condemns the damned to the flames of hell in the lower right of the picture. Unusually for his time, Giotto avoids depicting tortures and avenging demons, a restraint which would have appealed to Stanley.

If we now compare Giotto's emotional progression with Stanley's, we find the same triangular movement of the risen figures towards Christ, except that in Stanley's vision Christ is now a small white-robed figure towards the top. If Stanley's composition is seen, as he saw it, as a series of 'waves' breaking on the altar 'foreshore', a traditional Byzantine interpretation of the subject, then Christ is on the third wave. The dominant central Christ of Giotto has been replaced by Stanley with a scene in which two resurrecting mules turn their heads as he once remembered those of the horses of an oil-delivery man doing in the Vale of Health. The curve of their necks echoes that of Giotto's mandorla. The essential difference in Stanley's interpretation arises from his unwillingness to accept the concept of the Last Judgement as the division of resurrected into the redeemed and the damned. The traditional force in Giotto's depiction is, in Stanley's, muted. Christ

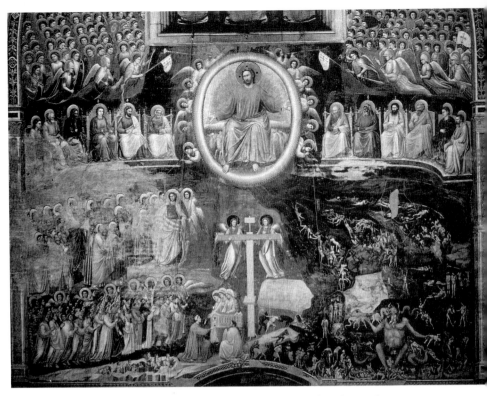

Giotto's *Last Judgement* in the Arena Chapel at Padua.

in Stanley's painting is there not as judge, but as the compassionate receiver of the crosses the soldiers bring to him, for in his painting each man or mule resurrects from the circumstances in which he was killed. The fierce hell of Giotto, still sited by Stanley in the lower right-hand corner, is now simply an incinerator with a pile of tins, waiting to be burned. Near it an uninspired soldier polishes his great-coat buttons with the aid of a button stick,* a duty which with all the other 'looking-smart' duties – boot-blacking, haircutting – Stanley loathed. In his purposeful use of the imagery we sense that Stanley is intending us to understand his meaning of hell:

An ordinary Englishman is a dull object when compared with a Serb or Frenchman. An Englishman, when he is not washing, is shaving; and when he is not shaving, he is blacking his boots; and when he is not blacking his boots, he is cleaning his buttons, or putting his puttees on, or combing his hair down the middle. This last drives me to distraction. I want to shout: 'When are you going to THINK . . . ?'⁶

Hell for Stanley is existence in a state of unimaginativeness, imperviousness to spiritual enticements.

Thus, too, Giotto's overpowering symbol of the single Cross becomes in Stanley's version the multitude of individual crosses which marked their owners' graves. Each of us, in Stanley's vision, treads our own path to Golgotha, each of us carries the cross. We say that the Cross of Christ is universal; which by Stanley's reasoning implies that it is individual. Unneeded now, the soldiers' crosses tumble in apparent confusion in the foreground of the painting.

But it is in the inescapable central motif of the painting, the flattened transport wagon with the two resurrecting mules and the soldier between them, that its full force begins to be felt. Stanley has pushed Giotto's central scenes upwards, so that Giotto's central Christ becomes Stanley's small Christ, and in its place one could expect a parallel version of Giotto's dedication scene, that in which the donor of the Arena Chapel, Enrico Scrovegni, is shown presenting a visual facsimile of the building to the Virgin Mary.

* A button stick was a thin rectangular brass plate with a central slot open at one end. It was slid under the button to prevent polish from staining the fabric. The long row of central uniform buttons could be squeezed up into the slot to save individual polishing.

It could be assumed at this point that if Stanley were logically following Giotto's pattern he would now substitute a matching scene showing the dedication of the chapel by Louis and Mary Behrend. But the Behrends played no part in the personal memory-feelings of the war which Stanley is re-creating. The inclusion of such a scene would be a forced irrelevance.*

Stanley had a better idea for replacing the missing dedication cameo; to make it an orison for Captain Sandham. A lieutenant on temporary war promotion, Captain Sandham was commissioned in the Royal Army Service Corps, the arm responsible for organizing transport and supplies. For his imagery Stanley cast around in his mind for recalled and relevant incidents. One, he told Richard Carline, was the 'gruesome' sight of a bombed Bulgarian driver near the Kosturino defile, dead among the wreckage of his cart.[7] Another, Gilbert remarks, must have been the sight of British army wagons offloaded on the quay at Salonika with their components laid flat for assembly in the way Stanley has depicted his bombed cart; Gilbert retained a lifelong fascination with farmcarts and farmhorses. Once again Stanley brought together isolated recollections to unite them in a single image.

But his presentation of the image is not random. It carries a profound personal significance, for here Stanley shows how the dead driver is waking between the shapes of his rising mules to that remembered comfort he himself experienced in infancy when, after nightmares, he was taken to sleep in his parents' bed and found himself lying snug and secure between their protective bodies; the same feeling he depicted when he painted himself between the baths in *Washing Lockers*.

The secret of the painting is unlocked. Sandham has passed through nightmare and now is safe. So joyous is Stanley in his exaltation that he even joins himself to the feeling in the cameo by, it seems, placing a small image of himself as the prone figure lying at the cameo top and gazing in contemplation at his cross. The figure is akin to that of Stanley in *The Cookham Resurrection* gazing towards Hilda, or the Stanley on his book-tomb in the corner of that painting, his 'signature' to the work. Now at last

* Stanley was not opposed to commemorating their beneficence. In fact he suggested honouring it in a separate series of ancillary paintings, and worked on sketches for such a series in the late 1920s. One shows Hilda looking into a cardboard model of the Chapel. But the project did not materialize.

we are assured why he joined the infantry. He had to get himself, as he does in this painting, back to the Vardar Hills, the only area in Macedonia where he knew such miracles of personal redemption might occur.

One question remains. Why did Stanley make the figure of Christ so small? Gwen Raverat, visiting the chapel while he was painting the scene, commented on this point. He smiled and said he would do something about it. But he didn't. Conventional religious painting promotes a representation which respectfully shows Christ as dominant. But to Stanley the persona of Christ, as he told Desmond Chute, had become modified by the experience of war. Stanley's Christ is distant in the scene, but he is no less holy, his Cross no different from the soldiers' crosses. The soldiers' crosses are not merely symbols of submission to worldly necessity, of a sacrifice to idealism, nor even of Rupert Brooke's cleansing of the stains of earthly profanities. Each soldier has carried the cross as Stanley did in *Christ Carrying the Cross*, has conquered as in the spirituality of *Travoys*, and is now rediscovering in the heaven of his and Stanley's redemption the communion of peace each knew at home, when the lattice of their cottage windows made the patterns of the cross, or when the frames of the texts on their walls were extended into the little crosses the soldiers hold up as their grave markers. To Stanley, each of us carries within us the meaning of Christ. We respond to that meaning by our instinct to conquer the imperfections of material existence. In achieving such conquest we find ourselves one with the transfigured Christ. There is reassurance. The resurrection is that moment, or those moments, when we become aware of redemption in the most perfect ways vouchsafed us; or, to reverse the reasoning, at those moments when we find ourselves able to transcend the handicaps of material existence or the limitations of our corporeal selves, we become one with the totality of creation. Stanley is drawing very near, whether deliberately or intuitively, to those time-honoured beliefs in the fusion of the physical and the metaphysical, the corporeal and the spiritual, which surfaced early in Hellenic Greece, became in India Tantric Buddhism, pushed Coptic Christianity towards Gnosticism and periodically stirred in Western Christendom, only to be suppressed by the Churches as heresy.

To Stanley there was no incongruity in placing the cameo of the

wagon and the mules in the centre of the painting where Giotto placed his Christ in glory. His mules awake 'to the loads of hay waiting for them. I am sure this would convince them that the Resurrection had taken place!' Below the walls of Kalinova, the tough canvas tapes, pegged to the ground, by which they were once tethered, are being lifted for the last time. Nearby a soldier touches 'brother tortoise'. A jackal forages at the incinerator. The crosses which Christ receives in this spiritual heaven are the reciprocals of those Stanley once gave the soldiers he took from the mortuary tent and buried beside the Karasuli–Kalinova road. All – Stanley, the soldiers and the animals – are united. In their resurrection, Stanley is redeemed.

Return to Cookham

1932–1936

The Church of Me

I am Treasure Island. The most exciting thing I ever
came across is myself.

Stanley Spencer[1]

STANLEY'S PLAN during the years of *The Cookham Resurrection*
and of the Burghclere Chapel of making his person and work
known to a wider clientele succeeded triumphantly. New com-
missions arrived, which the enlightened Behrends encouraged him
to accept. In 1927 he drew a series of charming autobiographical
pen-and-ink sketches to decorate an almanac for Chatto and
Windus, of which some 3000 were printed for sale at a shilling
each and 250 presented in a de-luxe edition as a Christmas gift to
clients. In 1929 the Empire Marketing Board commissioned a series
of five paintings on the theme of Industry and Peace. As Stanley's
first public venture into industrial illustration, they were to have
influence on later work. Demand for his pictures grew. Individual
patrons, many of whom were to become loyal and lifelong friends,
approached him for portraits and landscapes. But, as he explained
to Desmond Chute, most wanted his 'pretty' work and not the
visionary paintings which meant so much to him: 'It has always
puzzled me the way people prefer my landscapes. I can sell them
but not the Joachims. This fact of recent years has had a wearing
effect on me.'[2] He tells Gwen Raverat, widowed now, back in
England and settled near Cambridge, of an occasion when the
ninth Earl of Sandwich, one of his most valued patrons, paid a
visit to Burghclere, stood in front of the Resurrection scene, and
chattered excitedly about a post-impressionist painting he had
acquired showing a girl in front of a mirror stretching her arms
over her head.* Stanley was hurt: 'I can understand and enjoy

* Stanley first met the Earl of Sandwich at the Vale of Health Hotel at Christmas 1925. The Earl
continued to take an interest in Stanley and to buy his work.[3] In 1956 Sandwich invited Stanley to stay
with him in his cottage near Huntingdon and took him to visit Frances Cornford, the poet and a relative
of Gwen's.[4]

Stanley's 'churchhouse'. This is one of many such drawings and plans Stanley was to compile during his life. In this version, evidently dating from the mid-thirties, the upper panel on the left is marked *River Pic* [Swan Upping, 1915–19], with *Zac* [Zacharias and Elizabeth, 1914] adjacent. Next comes *War Mem* [possibly Unveiling Cookham War Memorial, 1922] with *Ch & Cross* [Christ Carrying the Cross, 1920] beside it. The last on the left is *Betrayal* [version not indicated]. The lower panels on the left are *Domestic* [pencilled in: not known], *Hell* or *Hill* [not known], *Nativity* [1912] and *S. Tubb* [Sarah Tubb and the Angels, 1933]. The top panels on the right begin *Centur* [pencilled in], then *Bed Pic* [The Centurion's Servant, 1914], *indecipherable*, another *indecipherable* [*Cont* or *Coat pic*?], and *John Donne* [1911]. The lower panels on the right are *Henry*[?], *Resur*, *Res.* and *indecipherable*. The altarpiece is *Resurrection Pic* [presumably The Cookham Resurrection, 1924–6].

French pictures. Why is it that lovers of French art are such philistines about mine?'[5] For the Earl to speak of such a piece of artistic froth, however fashionable and expensive, in the face of the deep spirituality of Stanley's masterpiece, was an affront. Stanley was aghast at what he saw as the peer's insensitivity:

What is so disconcerting to me is to find that people are not in the least moved by the sort of religious 'urges' I get . . . How is it they cannot see that this picture is a sort of vast communion of saints? From the muddle and confusion of this life the soldiers resurrect into a thought one through the true knowledge of God and Christ, and that fills them with such joy that now and then in their contemplation they embrace the cross because it means oceans of marvellous meaning to them; and this is the kind of thing I have to explain to Lord Sandwich, Eddie Marsh and Henry Lamb. True, they try to be kind and reverential towards my feelings in this matter, but really they think I am a bit 'funny' about those sort of things.*

Stanley knew that his outlook was personal and his orthodoxy fluid, as he gently tells the still devout Desmond: 'What a funny thing it is, as soon as I contemplate the doings in the Gospel, I am fired at once; and yet I am not entirely in love with Christianity. I think it's this, that one can love Christ without fearing that one is going to be brought up with a sudden jerk, whereas with any other passion one fears a cul-de-sac. But several things during the years since the war have done a considerable amount of havoc to my "faith" as an artist.'[7] Certainly Stanley had given up the intense interest in Roman Catholicism which Desmond had stimulated, a further distancing perhaps of their former intimacy, for Desmond was now in Switzerland completing his training as a Dominican priest. In any case, Catholicism was anathema to Hilda, who like other members of her family adhered to Christian Science and placed no trust in any ritualized form of worship. Sometimes during differences of opinion she would annoy Stanley by condemning his earlier earnestness towards Catholicism. Because of his fascination with her outlook, and no doubt as curious as always, Stanley made

* Florence recounts that, when on one occasion she was visiting Stanley painting the chapel, a family called. Politely, Stanley descended from the scaffolding to explain his work to them. After his peroration, the attractive girl of the family said, 'Oh!' When they had gone, he rounded on Florence, protesting that all the girl could say about his explanation was 'Oh!' and accusing Florence of not joining in to help make his meaning clear; mainly, Florence confesses, because she herself did not understand it either.[6]

efforts to convince himself that Christian Science could help him. But in the end the emotional jump was too great. Through Christian Science, Hilda saw God in a particular way. His function was to promote her husband, her family and their well-being. Indeed, she was convinced she was closer to God than was Stanley, despite his

Elsie Munday

'religious urges'. Stanley's God was never so intimate. 'I never know what to say to people when they ask me if I believe in God', he told one surprised admirer.[8]*

However, with his career plans under way and the extra responsibilities of married life to face – he and Hilda had engaged a local girl of sterling character, Elsie Munday, as maid at Chapel View –

* 'It is for me to go where the spirit moves me, and not to attempt to ally it to some known and specified religion.'[9]

Dudley Tooth

Stanley told Desmond that he was resignedly fulfilling demands for his landscape paintings: 'The temptation in respect of the landscaping I am to go in for lies in the fact that both the landscapes, the one of red houses you saw at Goupils and the one I have done of a big heap of stinging nettles, are now sold, one for £45, the other for £55. No, that isn't a temptation, it's just an irritating fact that people – to Hell with them! – prefer my landscapes.'[10] Indeed, by 1929 Stanley was finding it advisable to seek the services of a full-time dealer. William Marchant of the Goupil Galleries had recently died, and although his widow hoped to continue the business, Stanley began to use Arthur Tooth & Sons. The firm were long-established and respected dealers with branches in Paris and New York; they already represented Augustus John, Matthew Smith, Edward Wadsworth and Paul Nash. Later, in 1933, Stanley

agreed with their managing director, Dudley Tooth, to use them alone. It was to prove one of the most fortunate decisions of his life.

In the spring of 1929 Hilda's brother Sydney, the Ruskin Drawing Master at Oxford, went down with influenza. It turned quickly into pneumonia and he did not recover. He left a widow, Gwen, formerly Harter; they had been married only a few months. The suddenness of his death came as a great shock to the Carlines. In the summer of that year, as a break, Hilda's mother, Richard and friends joined Stanley and family for three weeks' painting at Cookham. The party lodged locally, for Pa had died in the January of the previous year and Annie now occupied Fernlea alone.* The Spencer family were becoming concerned for her. She was showing symptoms of mental instability and her attacks of arthritis were so bad that she sometimes had to push a kitchen chair as a walking frame. Stanley took it upon himself to clean the house, literally with a spade in some rooms, and it was while he was giving the front gate a coat of paint that Lionel Budden turned up again to see him. So Stanley was able to 'show him the outside of the house where I was born'. He did not take Budden inside.

But that visit to Cookham – it extended from three to six weeks – was noteworthy for another meeting, with Patricia Preece. Stanley, with Hilda and Shirin, arrived one day at the Copper Kettle Tea Rooms in the High Street where Patricia was holding the fort for Mrs Buckpitt, the proprietress. The trio got into conversation and discovered that each at various times had studied at the Slade. Patricia had heard of Stanley there, but had no idea he was the son of that village character, old Mr Spencer of Fernlea. Similarly, Stanley was intrigued to learn that Patricia had settled in Cookham with an artist friend, Dorothy Hepworth, because she remembered it as one of the few homes she had enjoyed as a girl during her father's peripatetic army career. It was an item of information which was bound to catch Stanley's fancy. There

* Pa died on 14 January, aged eighty-two. The funeral was planned for the 18th, but postponed to the 19th as there were heavy snowfalls which disrupted travel. Only Percy (who arranged the funeral) and Gilbert managed to attend, presumably because of the weather. Two cabs had been ordered, so some of the undertakers' men rode in the second. At a bend on the way to Cookham Rise cemetery, the chauffeur of an oncoming limousine attempted to raise his cap in respect, but lost control and skidded into the cortège, tipping the second cab on its side. The Maidenhead magistrates fined him two pounds with fifteen shillings costs, (more than half a week's wages) for careless driving.[11]

followed an invitation to Patricia and Dorothy to join the Carline party for picnics.

Stanley's daybook for the following year, 1930, offers insights into the activities of those Burghclere years. In January, returning from a three-day visit to Gwen Raverat in Cambridge, he was caught at Liverpool Street station in a bad fog. During March he worked on the *Reveille* panel, the mosquito nets in particular needing much time and attention. On Sunday the 30th he has 'an awful lot of visitors' and 'a lot more work to do'. On the following Sunday he lunches with the Behrends at Grey House, and in the afternoon takes the now-pregnant Hilda and her friend Bridget Evans for a walk to the foot of Beacon Hill. On 29 April he takes

Patricia Preece as Stanley first knew her.

Hilda, heavily pregnant and not well, in Behrend's chauffeured Daimler to the Carline family home in Hampstead because she needed a Christian Science practitioner.

On 12 May Stanley is 'unwell in the morning' and at some later date annotates the entry 'first and severe attack of renal pain', the initial indication of a debilitating gallstone which was to plague him and make him uncharacteristically irritable at times during the next three years. Later, Elsie is despatched to London to be with Hilda. On Saturday, 24 May, he receives the expected telegram: 'Girl arrived 3.10 am. Both splendid. Love. Writing. Hilda', and two days later he notes: 'To London by train. Hilda looking radiant. Baby looks awful but will look lovely later on.'

On Sunday, 1 June, 'Henry, Gil and Percy' visit Burghclere. The following weekend he travels to see Henry and Pansy Lamb. Henry had met Lady Pansy Pakenham as an assistant in the London offices of George Kennedy, the friend of Henry who had been proposed as the architect of Burghclere. Henry's divorce from Euphemia having come through at last, they had married in 1928 and after honeymooning in France moved to a pleasant Georgian house in the quiet downland village of Coombe Bissett, near Salisbury. There Stanley bathed in the afternoon in a pool in the River Ebble (a stream at the bottom of the Lambs' garden) with 'Henry, Gathorne-Hardy and Banting. Chaps very amusing'. The Hon. 'Eddie' Gathorne-Hardy and his brother Robert – both Eton and Oxford – were Bloomsbury bibliophiles specializing in antiquarian books; both were scintillating conversationalists with a ribald sense of humour. The surrealist artist John Banting worked from Chelsea, a 'true bohemian lovable eccentric' according to Rosamond Lehmann.[12]

On 19 June Stanley visited Hilda and walked with her on Hampstead Heath. On the following two Sundays, back at Burghclere, he 'goes to Christian Science Church in Newbury'. On 1 October he was back in London on a longer visit. He went to London Docks to greet Richard Carline, just back from an adventurous schooner trip to South America, and 'draws Dick's cabin'. On the 17th, 'in the evening to Sir W. Orpen's studio to meet Gil and Ursula'. Ursula Bradshaw was Gilbert's fiancée. She had been one of his pupils at the Ruskin Drawing School in Oxford when Sydney Carline was Master and Gilbert one of the lecturers.

On the 22nd Stanley went the rounds of London galleries with 'Dick and Jas' and in the evening accompanied the Carlines to the theatre to see *The Barretts of Wimpole Street*.

On 25 October 'all go to Cookham – me, Hilda, Shirin, Unity, Miss Herren and Elsie'. Unity, significantly named by Hilda, was the new baby. Miss Herren was a Christian Science contact of Hilda's who joined the family as a temporary nurse. She was a comfortably built Swiss lady, 'rather heavy and humourless', whom Stanley dubbed 'Miss Swiss Alps'. At Cookham they saw 'Odney, Cookham Bridge, the river. Called Preeces, Reminghams, Spencers'. The Spencers were his Belmont cousins. Eddie Remingham was an engineer who had married the Dorothy Wooster of *The Fairy on the Waterlily Leaf*. On the following day, Stanley 'brought Preece and Hepworth to Burghclere and returned to Cookham'. On 9 December he 'goes to Bristol' and next day 'returns in fog'; the visit may have been to refresh his memory of the Beaufort; but Desmond Chute was also in Bristol from Rapallo in Italy where he had settled for his health. He was visiting his mother, who was ill with cancer. On 31 December, the family attended Gilbert and Ursula's wedding in London. Percy's daughter Pamela was one of the bridesmaids. The painter John Nash was best man.

By the close of 1930 Stanley was to all intents settled at Burghclere where he still had the best part of a further two years' work to complete. Yet within a few weeks, by the spring of 1931, he was announcing his intention to leave Burghclere and make his home back in Cookham. He could paint the remaining panels from there and would buy a motorcar to travel to Burghclere. Friends thought his motives self-defeating. Why move? Or if he must move, why not to London where he could consolidate his career? Their advice served only to irritate Stanley, which suggests that he had some deeper purpose in mind which he would not for the moment reveal: 'It is odd the way that neither the Behrends nor any of my London supporters, my usual patrons, never believed in the way of loving *my own* wishes regarding myself. That they rather distrusted. For instance, when after Burghclere I wanted to return to Cookham, Louis [Behrend] said "You don't want to be a stick-in-the-mud, do you?"'[13] To compare dwelling in the holiness of Cookham to 'sticking in the mud'! How fragile our dreams in

the eyes of others! Hilda, of course, would have welcomed being with her family and friends in London. But at least they would have a car.

Stanley with Mrs Mary Behrend on the terrace of Grey House, Burghclere, 1930s.

So in January 1932, money now no real obstacle, the Spencer family, with loyal maid Elsie and 'Miss Swiss Alps', installed itself in Lindworth, a substantial and secluded semi-detached villa in the middle of Cookham. There was a spacious garden with plenty to occupy Hilda's interest, and sufficient room for the erection of a

large wood and asbestos shed as a studio for Stanley. Neither Hilda nor Stanley was greatly interested in possessions or furnishings, but they lined the drawing-room with bookcases Stanley made, set up their gramophone with its collection of records, and installed Stanley's celebratory purchase, an upright Bechstein piano. The adjoining house, Quinneys, was occupied by Bernard Smithers,

Lindworth as Stanley and Hilda would have known it. The hutted studio was by the pergola on the right.

whose wife was a collateral second cousin of Stanley – she was descended from Grandpa Julius' first marriage. He was back among the people he knew; he was, as he told Gilbert, 'home'.

But in another house in the village, at Moor Thatch cottage at the other end of the High Street, there was consternation. Patricia had joined the Carlines occasionally on their subsequent visits to Cookham, and was on first-name terms with 'Dick', 'Kate' (Richard's friend Kate Foster) and 'Jas' (Wood). She enjoyed their company, but found their liveliness 'rowdy'. She and Dorothy Hepworth were finding it difficult to make ends meet. In the

economic recession their paintings were slow to sell, and much of the family income on which they had depended was being drastically curtailed. There was a strong possibility that the mortgage on their cottage, held on the Hepworth family business, itself in prospect of liquidation, would be foreclosed, and they were eking out a living as best they could in a genteel but genuine poverty. This midwinter January was particularly depressing. The cottage was damp, they owed for fuel, they were not eating properly, they were suffering from headaches and sleeplessness, and the insecurity of their circumstances made the future bleak. Stanley had called on them during visits to Cookham in 1930 and 1931, and it was becoming apparent, to Patricia's surprise and Dorothy's resentment, that his attentions were more than social. Now that he was a buoyant and financially successful figure in the art world, they viewed his permanent residence in the village with 'dread', as one more unwanted social burden to deplete their already meagre emotional and economic resources.*

It is sometimes asserted[15] that Stanley made the move because *The Cookham Resurrection* and the Burghclere Chapel had exhausted his ideas and he hoped that in Cookham he would recapture his former inspiration. The latter part of the statement is certainly true. But even though he found the finishing of the chapel tedious there is little evidence that his ideas in general were exhausted. Quite the reverse. Many of the themes latent in *The Cookham Resurrection* were beginning to bubble in his mind during the long hours of work in the chapel. The ideas would be separated out, explored and developed in associated sequences of visionary paintings. Each sequence would develop an intrinsic notion and each individual painting indicate an aspect of that notion. But all the sequences, when assembled together, would compose a totality which as at Burghclere would lead the viewer towards an ultimate awareness, a majestic celebration, vast in scale, of the redemptive joys of life. The project would be undertaken in the most sacrosanct of outlooks and would in effect constitute a great cathedral. Since

* Patricia noted in her diary for 22 January, 1932: 'Stanley Spencer came to Cookham to live yesterday. H [Dorothy Hepworth] thinks he will not be fortunate and that Cookham will not prove a lucky place for him. Now that he has decided to live here, I wish we had not chosen to come, I must say, as he is such a nuisance to us, and so jealous and quarrelsome unless one is continually praising his painting.'[14]

it would spring from Stanley himself, he would be its founder, its architect, its mason, its chapter, its dean, its bishop. It would be a 'church of me', constructed not in self-aggrandizement but in the honouring of the compulsive spirit which possessed him. Where else could he envisage it but in Cookham? So the geography of Cookham would determine its physical form: 'The next chapel [after Burghclere] was to be planned somewhat thus: the village street of Cookham would be the nave, and the river which runs behind the street was to be the aisle.'[16] School Lane would be the other aisle, Sutton Road a transept, the Bourne End road to Cookham Bridge the other, Odney and the Bathing Place the choir, Cookham Moor the Cathedral Close.

Typically Stanley began to calculate the dimensions of his new dream and found them formidably large. Undaunted, he tried out the idea on his dealer, Dudley Tooth: 'I am making no Benvenuto Cellini boast when I say that I am now ready and equipped in almost every spark of detail to carry out the decoration of a church containing three 15 or 20 foot altarpieces, two transept large walls, a "run-of-wall" frieze going from picture to picture, and I could do it in about fifteen years.'[17] Tooth, stunned, but ever patient with the flightier fancies of his charges, made a cautiously prevaricating reply: 'Commissions for the decoration of churches are very few and far between. If I hear of anything I will always recommend you in this connection.'[18]

Perhaps in his heart Stanley knew that finding patronage for his project would be as difficult as it had been for his projected Life of Christ chapel or his imagined Life with Hilda scheme. Although he occasionally alluded to his 'church house' among friends he was unusually reticent about it in the 1930s. Even when he was launched into the scheme, Gwen Raverat was granted only a glimpse:

The only subject to which these half-dozen or so pictures belong is a sort of memory or souvenir of Cookham. Everything takes place in some final state of realisation. It only wants opportunity to do the whole scheme in order to make clear all that now appears in such inconclusive and ambiguous pictures to come to a far more coherent realisation in a big scheme. I am having to do all my work, which could be a quite comprehensive scheme, in disjointed chips of notions. The Tate Resurrec-

tion is a scheme in which many varied activities are made comprehensive by being unified in a scheme. The Burghclere work is the same, or so I think. It is only when the carrying out of some such scheme becomes possible that whatever has been half-apprehended before is given that extra push into greater and more comprehensive meaningfulness. I would like, as I used to be able, to do small pictures [individual, unrelated paintings] but have now trained my powers into the direction of elaborating a scheme, until it is what I truly love to do and what I am sure I should do.[19]

But no patron like the obliging Behrends came forward. The project was too vast and too amorphous for even the most understanding of admirers to comprehend. Their lack of encouragement in no way dampened Stanley's enthusiasm. He simply withdrew into himself to continue exploration of the concept. Its importance in his art cannot be over-emphasized. Henceforth, to the world at large, Stanley would seem to be producing a succession of individual paintings, imaginative and sometimes strange in character. But to himself he knew he was painting what he would have painted had he been producing the panels and predellas, the friezes and ceilings of his mighty church house. The paintings would not always be to the size and shape of the scale of the scheme, for he became resigned to the need to sell these masterpieces in order to live. But emotionally their content would reflect the varied facets within the totality of the vision he sought. Henceforth each visionary painting would be a reproduction in miniature of that totality, a blueprint in detail, colour and design of an intangible but recognizably organic whole.

For the rest of his life, this approach was to dominate Stanley's art, give it purpose and grow with his experience. Like the apparently inconsequential progression of a dream, his church house was to mushroom in size and concept, sprouting side-chapels each of which would enshrine new associated revelations. It would become his *magnum opus*, its impetus drawn from deep in the psyche, its compulsion to exactitude or truth the well-spring of the religious. The enterprise would become an exposition of linked and unified colour and pattern directing the spirit to what he felt would be the eventual climactic paintings, the altar-pieces. When at last these were achieved the meaning of the entire scheme – his

life's vision – might, he hoped, be clear to him and us.

Although settled at Lindworth and anxious to get to grips with his new enthusiasm, Stanley had first to concentrate on the remaining Burghclere panels. The Behrends were beginning to worry that he would never finish, and at Easter 1932 drove to Lindworth to make sure of *Making a Firebelt* and *Washing Lockers*. The latter was carried half-sticking from the unhooded rear seat of their landaulette, and they had to motor fast as thunder threatened.[20] Stanley was under pressure from Dudley Tooth too for saleable landscapes and still-lifes which he felt he dared not refuse: 'I had a howling rotten time doing the last few panels at Burghclere because I was having to do landscapes in order to keep going, and I am in no hurry to do that again.'[21]

In December he was elected an Associate of the Royal Academy, and received 'shoals of letters' in congratulation, including 'one from Lady Boston, quite a long one. In it she says "My mind goes back to the morning at Hedsor Wharf . . . when your father called to show us a drawing called *The Cookham Fire Brigade* [one of Stanley's earliest drawings]." She asked me if I still had this drawing, and I have! She wants it, so I shall send it to her as a gift'[23] – a generous gesture of recognition, not only because Stanley's work now changed hands among collectors at good prices, but because he regarded his drawings as his 'children' and never willingly parted with any that had meaning for him. Back now in Cookham, he was looked upon with local pride as a celebrity and a man of means.* The farmer (a 'grim-faced Samuel') whose field Stanley used as a vantage point to paint a may tree had had no hesitation in demanding £2 – perhaps £50 today – as compensation for Stanley's trampling of his hay. So when one of the more redoubtable ladies of Cookham insisted that he paint her a vase of flowers – a patrician request which he was, he amusedly

* Patricia's diary records the effect of Stanley's honour. *Monday, 5 December*: 'Stanley came round to see me and ask me to go to him, but I could not as I was polishing the painting room floor. He came later to tell us he had been made an Associate of the Royal Academy. He seemed very pleased, although he would not say so.' *6 December*: 'Stanley is receiving telegrams all the time to congratulate him on his being made an Associate of the RA. I think they [local people she had visited that afternoon] thought a lot of Stanley being made an ARA.' *7 December*: 'Stanley is very bucked with his new honour! There is a long piece about him in the *Evening News* and many other papers, calling him the heir to the Italian, Dutch, primitive artists, etc. Reporters from the *Illustrated London News* came this morning to take photographs of him in the garden and also painting one of his pictures.' *8 December*: 'Stanley has a lot more letters today, one from Lady Boston, and Eddie Marsh, and lots more.'[22]

reported, 'too frightened' to refuse – he decided to have the worth of his £2 by going back to the hayfield and picking a suitable bunch of wildflowers. The lady was delighted with her picture.

Stanley's work on the Burghclere paintings was at last completed late in 1932. A thanksgiving service was held, followed by a celebration dinner for all involved with the project. A press preview was called for the middle of December. Only after that did Stanley feel himself sufficiently free to be able to turn his full creative attention to the themes which had compelled his return to Cookham.

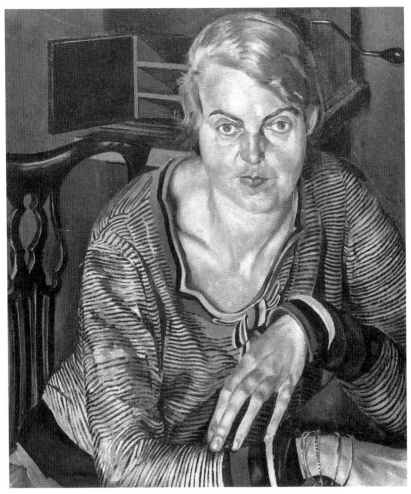

Portrait of Patricia Preece

Portrait of Patricia Preece

I wonder what event in God's life causes the Alps?

Stanley Spencer[1]

TO GARNER defeat, as Stanley was to do in the coming years, from the victory for which he worked so hard, may seem folly to those who see life pragmatically. But no artist can be entirely a realist. He explores a world, not of fantasy, but of our universal and ancestral dreaming which, unlike the material world, knows no consequences, suffers no limits, and lives by image and symbol. In his exploration Stanley had had companions at times – Gwen Raverat, Desmond Chute, Henry Lamb, Jas Wood – but for the loneliest trails he could take with him only a *Doppelgänger*, as Dante took Virgil. The biblical Christ was Stanley's *Doppelgänger*. Stanley was not imagining himself to be Christ in any overheated manner, nor was he 'accepting' Christ in evangelical terms. The Christ Stanley took on his odyssey was a Christ who sufficed until the day when at last they reached the foothills of heaven. Then, as with Dante's Virgil, the handholding image of Christ was to fall away, and a new image, the Great Lady, the Beatrice-figure, would appear as harbinger to escort him in the ascent to the glory of the true Christ and Being of God.

For Stanley, that harbinger had arrived in the person of Hilda, and was bidding him follow her into his Dantean circles of light. 'I am all the time seeing your you-ness in you, in your turned-in foot, in the limpness of your bent knee, in its unexposed-to-the-weatherness. The is-ness of you to me is like the is-ness of God.'[2] For Stanley, the bonding of his existence with that of Hilda became an experience which seemed to him more and more miraculous. For the conjoining, Stanley used the word 'fusion'. But no word exists which fully illuminates his understanding. Similes abound in

289

his writing, as when he sees his and Hilda's lives as puddles overflowing into each other to become one. In his early writings he explains to Hilda his concept of her 'you-ness' fusing with his 'me-ness'. Presently the phrases coalesce into the single 'you-me-ness'. Later, when she objects that fused though they are each has a separate individuality in the eyes of God, the phrase becomes 'you-in-your-life-together-with-me-in-my-life'. In the end his thought convolutes into even more elaborate forms as he struggles to express in terms of Western symbolism the perceptions of non-duality which permeate much Eastern thinking.

So overwhelming for Stanley was the concept that for the rest of his life it was to override even the frustrations of the real-life Hilda: 'Dear darling Hilda, you are so precious to me, why cannot I love you *completely*? In spite of your somewhat sad outward appearance – only very superficial, that is – you are still to me the most revealing person of essential joy that I know.'[3] At the spiritual level, Stanley's worship of Hilda was absolute. But at the everyday level he conceded a number of limitations. One was that on principle Hilda abjured mechanical forms of birth control, so that Stanley was inhibited from loving her '*completely*'. Another was that Stanley was developing the implications of his interest in the elegance of women's dress and accessories which he had intimated in *The Cookham Resurrection*. Perpetually driven to find spiritual meaning in even the least of his physical 'emergences', these interests were becoming linked with the feelings of excitement which had persisted from his boyhood at the beauty of the Cookham wildflowers. Both represented the urge of sexual invitation in its life-perpetuating function. In associating Hilda's dresses in *The Cookham Resurrection* with the wildflowers of that painting he had tried to show her as the signifier of his 'Cookham-image'. But now that he had brought her to Cookham to develop the imagery, the link was more tenuous. The qualities which he admired in her made her very much her own person. In Cookham she was partially in an alien environment, there not so much as Hilda but as Stanley's wife. Her girlhood had been spent in Oxford and London, and it was in the ambience of those urban places that her intense powers of concentration developed. Moreover her individual style of dress – her 'somewhat sad outward appearance' – which he valued as an expression of the

uniqueness of her personality did little to reinforce his longed-for Cookham wildflower associations.

As Stanley became increasingly a celebrity he found himself the subject of local invitations, to which he responded with an enthusiasm Hilda could not raise. He was gratified to discover that women as well as men were becoming fascinated with his personality and conversation. At parties Stanley would, in his picturesque simile, 'emanate delicious lovely Stanley-qualities; all the time, bits of me thrown freely about . . . some hungry ones [guests] rush to pick them up'.[4] But the 'hungry ones', to his chagrin, seldom now included Hilda. Often diffident in unfamiliar company she seemed increasingly uninterested; and as Patricia remarked of Hilda's reaction to Stanley's conversation at their first meeting she – Hilda – 'had heard it all before'.

Stanley was a notoriously demanding and at times an exhausting companion. He knew this. His vitality and his skill in living continuously at the nerve-ends of his feelings could make him explosive at times, at best mercurial, at worst, as Richard Carline commented, savage. His frustrations at the real-life Hilda were the more despairing because she above all others should have tried to co-operate in assisting him to the imagery he was trying to define: 'Sometimes when I come in . . . quite bright and happy and I catch sight of you looking miserable or indifferent or uninspired I feel as though you had caught me by the sleeve and swung me round away from life and joy.'[5]

The fact was that Hilda, although she continued to love him deeply, could not let her identity be swallowed up in his. She resolutely retreated at times into a life of her own, inviting family, friends and Christian Science acquaintances to stay at Lindworth, and ignoring Stanley's complaints that 'This is what is so funny about you. I, when I am alone with you, never want anyone else. Yet directly there is a chance for you to be alone with me, you at once fish round to see who you can have to come and stay. I was absolutely astonished when eight days after we were married you asked Gil to come [to Wangford] and stay.'[6] He preferred to concentrate on his contemplations or his paintings. She enjoyed trips to the cinema or shops at Maidenhead: 'I am not a bit surprised that I bought the car when I did. There was no prospect of home life at all, with you all the time

Stanley on a motoring trip. Jas Wood left, Hilda centre, Shirin and Mrs Carline. Stanley was not a confident driver, and, after a minor mishap when he left the road at the Widbrook Common bend, preferred Hilda to drive.

hating the place and wanting all the time to be hopping off.'[7]

If the effects of Hilda's 'hopping off' had meant a rejuvenation of her attempts to meet his demands, Stanley would not have been so thwarted. But she developed sudden interests in, to him, irrelevant activities like embroidery and architecture which, she said, she would like to study formally. She did not entirely give up her painting, but she allowed it to take second place. This to Stanley was sacrilege: 'You can't expect me to have any harmony which is what you and I both want between us when to my symphonic efforts you keep up a dreary beating of old tin cans . . . which is all your gardening and sewing means to me . . . I do hate the feeling of not painting pictures during the baby-having periods and waiting until the children are grown up . . . It makes painting all wrong, and the having of babies all wrong.'[8]

Stanley's plaints, no doubt exacerbated by his painful gallstone, were not those of the uncooperative male. In boyhood he had

happily undertaken family chores in Fernlea – lighting fires, peeling potatoes, digging and planting the vegetable patch and so forth. Now he cheerfully washed and ironed nappies, and when necessary painted with one of the babies in his arms. Hilda, however, continued to manage affairs in her own individual manner, which took little account of time-keeping, a further source of irritation to the energetic Stanley, who liked to organize his day in parcels of planned activity. With this went a growing unresponsiveness to his monologues. He would notice her drifting off in daydreams while he was expounding, even at times doing him the dishonour of going to sleep on him. He realized that such behaviour was part of her personality and that in thinking deeply she needed to proceed slowly and carefully. He knew too that none of the deliberateness in her nature was directed at alienating their love for each other. But it was becoming inevitable that he would contrast her increasingly inflexible manner with the quickness and vitality of other women in his life: 'My admiration for the different women you rather despise me for admiring . . . all this is admirable. It is the same thing I admire in Elsie and the Preece girl . . . it is when I feel that their joyfulness and readiness to have a good time is clearly the result of a forthright instinct and desire for real life that I know then that they are on the threshold of experience, that hunger and thirst are going to be filled . . .'[9]

It should not be inferred that Stanley was in any deep sense growing away from Hilda. She was still essential to his concept of marriage. But the feelings which bound him to her were now extending to other women, and he was, as usual, curious: 'There are heaps of things which puzzle and worry me, darling. One is this: that I feel this spiritual marriage, this oneness and consequent feeling of rejoicing, with several women. I did not mind or bother a bit when yesterday, when P.A [their friend Peggy Andrews] said any really happy or vital thought, I felt I would like to hug her.' Stanley was making the surprising discovery that 'the joy was just the same as our joy, and its slight difference seemed to make it harmonise better with our happiness. In a sense I take it for granted that I am really, at times when I feel that vital unity, married to all the women with whom I get that oneness feeling.'[10]

'That oneness feeling' . . . If in simplistic terms he was becoming flattered at attentions paid to him which, if only in his imagination,

exceeded the merely social, nevertheless in his visionary terms their source was also 'love'. But, always concerned to render abstract feeling into concrete expression, Stanley was beginning, in his formal and detached style of reasoning, to evaluate what was happening. Bodily desire – 'lust' in Stanley's love of Anglo-Saxon earth-words – was to be 'feared' as a powerful invader of private

Moor Thatch cottage in the 1930s. Beyond the garden can be seen the entrance to the stables of Moor Hall – 'Lambert's Stables' – in which Stanley painted *Travoys*.

aspiration, personal and visionary. It was to be feared not on conventional moral grounds but because it turned his definition of the purity of love – 'giving-and-receiving' – into the more disturbing 'giving-and-taking'. In his marriage with Hilda, Stanley was discovering that the female also has needs, and must make demands. This realization was to fuel over the next decade or so a number of his drawings and paintings from which it has been wrongly construed that he felt himself victimized by women, or was masochistic.

For Stanley the new sensations were intriguing and, typically, he wanted to know what might lie beyond them which might further assist him in his search for the 'identity' of God. 'I believe that *fear* of lust and the thought of such a thing existing does a terrible lot of harm . . . It may be a nuisance that with me a strong sex impulse plays a big part at these times, but I think the more confident I get, and the more I know the truth and source of these happy feelings, the freer I shall become from any inconvenient or disintegrating or inferior desires.'[11]

During 1932 and 1933 the friendship between the Spencers and the Preeces became more marked; although they were not related Patricia and Dorothy were usually lumped into Stanley's plural for convenience. It was only a short walk down the High Street to their cottage, Moor Thatch. His head buzzing with the ideas he longed to unburden and to which Hilda no longer seemed as responsive as he wished, Stanley would be politely welcomed, seated in the lounge, and encouraged to talk his head off. Dorothy held her distance and Stanley found it impossible to make close contact with her, but Patricia found him 'intriguing' and 'quite unlike any other man I had ever met'.[12] Her initial apprehension at his arrival began to evaporate in covetousness of his material circumstance. She relished Lindworth and in particular their collection of art books – there was 'money to spend'. She envied him also his wide circle of patrons, which she lacked. She was doing her best through acquaintance with Roger Fry to build contacts with the Bloomsberries. Stanley was reluctant to help in that direction, but he did his best to arrange invitations for her to private functions at which she could introduce herself to other influential figures.

Occasionally the Preeces would accompany Stanley, Hilda, the Carlines and friends on walks and picnics. It is easy to argue that Stanley, now in his early forties, and literally at the 'seven-year-itch' stage of marriage, was becoming restive; indeed some of his more worldly acquaintances saw developing events in that light. But such interpretation would be out of character. Whatever Hilda's shortcomings in Stanley's 'real' life, she was still cast as his heavenly Beatrice, and trite sexual wandering smacked too much of the facile to someone of his precision of thought.

Gradually, through Stanley's writings, we can build a picture of

the meaning he was beginning to attach to his friendship with Patricia. She was elegant and stylish in a way Hilda was not. She was vivid and lively in a way Hilda was not. She was socially sophisticated where Hilda was indifferent or gauche. She was direct and forceful in personality where Hilda was complex, thoughtful and circumspect. But conversely Patricia was superficial where Hilda was deep, teasing where Hilda was sincere, opportunistic where Hilda was considerate. There was no question of Patricia replacing Hilda in Stanley's dreaming. But she supplied it with something he needed.

Patricia, in the early 1930s. She had a cast in her left eye about which she seems to have been so sensitive that she normally averted her gaze if photographed or stared at. Stanley made use of the trait to emotional effect in later portrayals of her.

The Dustman, or The Lovers

Usually, in order to understand any picture of mine,
it means taking a seat and preparing to hear the story
of my life.
 Stanley Spencer[1]

SOME TIME towards the end of 1932 – the letter is undated –
Gwen Raverat found herself once again employed by Stanley as an
agony aunt:

You who guided me in those early days could give me valuable assistance
in these my somewhat more complicated conditions. In some ways it was
best that in those early days you did not really know me, know what my
difficulties were; you both kept to my artistic development and its growth.
But all my present troubles I put down to the woeful habits I gave way
to at that time, when I was doing *The Nativity* and *The Apple Gatherers*.
There are two important things that happen when vice has a hell of a
hold on you as it had and has always had on me. One is that your vision
is snatched away from you, and the other is the fear that that will happen,
and this completely upsets your feelings of confidence. It gave me the
feeling that everything I went to touch would blow up and burst into
smithereens before I could get at it, so that I could never go to a thing
with confidence and take it; but fearing I should be denied I rushed at
things in a greedy, selfish, not-to-be-denied sort of way. This early
disturber of the peace was so great that I almost felt I lacked that quality,
and when Patricia said lately to me: 'Stanley, you are not balanced, Hilda
is more balanced than you,' I thought to myself: 'Yes, missy, you are
right . . .' I apologise for parading all this about my absurd little self, but
. . . it might help to explain a lot of my difficulties and help me attain a
more peaceful state. Hilda has been away for three months . . . she rang
me up to say she was not returning yet as her brother George was worse.
It looks as if I shall have Christmas all by myself . . .[2]

The Dustman, or *The Lovers*

George Carline was seriously ill, and with memories of Sydney's sudden death, the family were anxious. As the only girl of the family, Hilda was expected to cope and since August had been committed to being in London, where George had been brought, and visiting Cookham only occasionally. Circumstances were complicated. Hilda was alarmed not only by her family troubles but at the developing relationship between Stanley and Patricia in Cookham. The paucity of Stanley's letters to her and their unusual tone was disturbing her.

Gwen's reply to Stanley's *cri de coeur* is lost but seems to have been, like herself, practical and down to earth. A joyous Stanley

replied on 20 December, addressing her as his 'Dear, dear Gwen' and entreating the Lord to 'bless and keep you for his name's sake, Amen'. He then proceeded to pour out his ideas for a new composition in his church-house scheme:

Dustbins are looking up! Today, Tuesday, is the day the dustcart comes round, and all the dustbins of each house are placed by their gate or on the edge of the pavement, and I note that everybody has their own ideas about dustbins, just as I have mine. The Hon Mr O'Brien, for example,* who is the gentleman who lives in our own Fernlea, he puts his in boxes . . . He says 'Good morning!' to me and I say 'Good morning' to him, only I haven't such a nice voice [accent] as he has,† and Patricia, whom I should like you to meet, says that the fact [of being acknowledged by the 'gentry'] meant that I was definitely one of the elite of Cookham. She also said a year or so ago that I have a nice speaking voice and when one heard when one was talking in another room [Patricia said] it sounded good. Curious how one remembers these things. Well, to return, it appears – as our maid Elsie says when she loses the thread when relating the *whole* of a cinema story she has just seen – it appears that I became so enamoured of the dustman that I wanted him to be transported to heaven while in the execution of his duty. So [visualizing the composition] I got a big sort of wife to pick him up in her arms while two children in a state of ecstasy hold up towards him an empty jam tin, a tea-pot, and a bit of cabbage stalk with a few limp leaves attached to it. This scene occurs – Cookham people will say: 'We have seen strange things today' – a little away from the centre of the road in the village, and the street goes away in perspective, and the dustbins go all up the side of him, so to speak. So now you know my little trouble; and there are two sorts of cryptic things on either side, the left group is a sort of washerwomen onlookers, the right group is the other dustman and a poor old ragged man expecting and hoping for a ride also. This is all very nice in its way, but some sort of terrible quality has crept in, I do not seem to have got all my beloved self into it somehow, and I am afraid everyone will wonder what it means, just as I do myself, and Roger [Fry] will be obliged to reiterate his remarks that I fail as an illustrator.³

* The O'Briens were the new occupiers of Fernlea. Percy had decided to move Annie to a smaller house at Cookham Rise, called Cliveden View, which had been the retirement home of their paternal grandmother after the death of Julius.

† Stanley spoke quickly in a light tenor voice not unlike that of Charlie Chaplin in his talking films – films which both Stanley and Hilda adored with those of the other cinema comedians of the time.

The composition was modified slightly in the final painting, dated to 1934 and titled *The Dustman*, or *The Lovers*. Stanley lost the perspective effect he described, made the grouping more claustrophobic and especially gave the figures a grotesqueness quite new in his work, as though he was being forced to distort even more forcibly his early Cookham-feelings. And yet the painting is a paean of joy. As in so many of Stanley's visionary paintings, the content can be seen at various levels, any of which – or all of which – may be 'right'. The threads of Stanley's feelings were so interwoven that even he pretended to wonder 'what it all means'. The main intent of the painting must be to assert his joy at being back in Cookham and among its denizens. Their activities, even those so prosaic as setting out dustbins, become visual metaphors for the re-creation of the Cookham-feelings of his childhood. Stanley is telling us of the magic of being back 'home', of being small in a warm female embrace wherein comfort and security lie. But the comfort and security is not mere sensuousness. It is the precondition of creativity. The large wife is imposing herself on her small husband, lifting him up into those remembered moments when, carried on the backs of the maids in childhood games of 'knights on horseback', Stanley experienced a 'warm glow', a feeling comforting yet exciting. The large wife in the painting is the Fernlea of his boyhood, the Cookham of his adolescence, the Hilda of *The Cookham Resurrection*, the cameo of the God-figure there. For in that icon lies both safety and adventure for Stanley, trust and exploration, certainty and vision, the merging of past, present and future.

The diminutive figure of the dustman-lover-husband could be in feeling the Stanley-manikin of *The Cookham Resurrection*. Few, one imagines, see a dustman, and especially a small one, as symbolic of the joy of heaven. But Cookham, even in the 1930s, was still rural. Lindworth lacked gas, electricity or main drainage. Elsie cooked on a coal-fired range which Stanley lit and cleaned. Lighting was by oil or pressure lamp. The sight of dustbins lining the street was novel to Stanley, for there had been no house collection in his boyhood. Refuse then had been burned in the kitchen ranges or placed on garden compost heaps. Large rubbish was brought to village dumps like that at Ovey's farm and only periodically cleared; the interest of all the Spencer

children had been roused by the unexpected treasures to be found there.*

If the dustman is Stanley in feeling, the actual figure of Stanley is the smaller of the two worshippers kneeling before the central lovers. In such configuration Stanley is experiencing the experience he is re-creating. It is clear that the figures, one male, the other female, are adult. But in his letter to Gwen, Stanley describes the figures not merely as children, but as 'children in ecstasy'. Stanley is recasting the onlooking couple in the emotion of that same sexual discovery he experienced as a boy when girls were disturbingly transformed for him from companionable tomboys into 'touch-me-not' females. The couple represent a state of being on the threshold of a comprehension, the pivot of the painting. The High Street of Cookham in which the happening takes place is the nave of Stanley's 'church of me', and this painting one of its early celebrations: so the couple have been transformed into Cookham worshippers at a religious ceremony at which the dustman and his wife are priest and priestess, the whole a contemporary *Adoration*.

But if Stanley is one worshipper, who, one may ask, is the other, the woman? It is tempting to assume that she is Patricia, not yet the recognizable figure she will become in future paintings. She is being presented as a new handholder in his Cookham-feelings, introducing him to excitements he could only previously imagine. She had no reservations in later life about telling the world of what these consisted, his longing for her to wear striking clothes, flimsy underwear, patterned stockings, high-heeled shoes, and would describe how he took her shopping to buy them, spending lavishly.[5] As yet Stanley had not dared to go that far, but already his anticipation is apparent and with it, more importantly, a creative stimulus which she never admitted:

I want love, and I hate hate, and I must have meaning in it, and it comes to me direct through desire. God speaks eloquently through the flesh, that's why he made it . . . If I had had enough faith in what I sought, there would have been no harm in all the apparent vanities I sought . . .

* Rubbish heaps had much the same fascination for Stanley as they had for Picasso; the most surprising things were to be found. Stanley had carried the excitement into his Macedonian experience and painted it in his *Resurrection of Soldiers* at Burghclere. 'Even when I was in Salonika I used to find myself gravitating towards incinerators; out there they used to remind me of sacrificial altars.'[4]

One of the chief influences and stimuli was the longing to really *be* the essential beings that should and ought to inhabit those mysterious gardens in Cookham.[6]

As his relationship with Patricia developed, a number of interpretations are possible. On the elemental level, it can be seen as no more than a married man's sexual fling; at the aesthetic, as the fling transmuted into arresting visual symbolism, sometimes trite and perhaps only afterwards rationalized. But Stanley must be allowed his say, which was that he genuinely found in it a spiritual dimension he could find in no other way. In this painting, place-feeling and personification have again become one. The apparently grotesque figures of the painting are distorted to the degree that they are awakened to Stanley and joyfully absorbed through the still unclarified filter of his new Cookham-Patricia-feelings. But in their spiritual intention the figures are universal, emanations of his love:

The artist wishes to absorb everything into himself, to commit a kind of spiritual rape on everything, because this converts all things into being or revealing themselves as lovable, worshipful things snugly tucked up in the artist to his own special glory and delight.[7]

The Stanley-figure and the female alter-ego beside him are holding up a tea-pot, a jam-pot and a cabbage stalk in an ecstasy of celebration. The dustbins from which the objects have been retrieved are those not of any ordinary villagers, but of Cookham villagers. Their dustbins, a sort of fantastical collective unconscious, enclose those private past loves of their owners by which they join their identity to his and reveal for him the sense of their home, a home as sanctified to him as their kitbags or their gardens. The small trees or shrubs in the scene are inserted, he says, because when he first saw them somewhere, their topiary reminded him of shelves in his boyhood Fernlea home. Stanley has returned for his detail in *The Dustman* to his boyhood memories of Cookham to sanctify through them his new Patricia-Cookham-feelings. In the painting it is forever dustbin Tuesday and the items offered up are forever the love-objects of his home – the old family tea-pot which once made countless welcoming cups of tea in his boyhood, the

cabbage stalk which is all that remains of the family event of the week, the Sunday dinner, and the jam-pot which celebrated his homecoming at tea-time in his adolescence; all three, he says in his new awareness, as hallowed as the Holy Trinity.

Stanley has painted those objects and occasions which had memory-meaning for him. But it scarcely matters in the intention of the painting what they are. We each in our lives rummage to find those items which once gave us joy, offer devotion and fellow-feeling to whatever in our lives represents Stanley's holy garbage, his daemon of the discarded. His dustman is our joy made manifest. He wears the prevailing symbols of his calling, corduroy trousers tied at the knees and held at the waist by a stout leather belt. His mate stands behind him, shirt half off, hoping that he too, like the 'ragged old man' behind him, will be given a 'ride'; taken into joy, revelation and understanding.

In this and comparable paintings of the period, Stanley is delighted to be able to clarify new and exciting feelings. But behind them lurk uncomfortable doubts about their validity, and he cannot yet depict them in the open detail he would like ('people will say: "We have seen strange things in Cookham today"'). He puts his hesitation into the painting as the three 'washerwomen' on the left, arms akimbo, puzzled by the happenings. Two have their hands behind their backs in an impossible pose, thumbs reversed; is Stanley using an unexpected detail, as he so often did, to draw particular attention to them? The figure in the left foreground lacks Hilda's shapeliness, but wears her hair dressed in the 'bun' in which from now on he will often portray her watching events from the sidelines; whereas the woman in adoration with Stanley has Patricia's waved hair. The other figure with impossible hands but a rounded face, may represent Gwen Raverat, who Stanley knew he was surprising with his confessions. The housewife in the background is disappearing indoors, apparently scornful. A white cat – Unity's 'Tiddles' – sleeps unconcernedly through it all.

The Christmas of 1932 was marred by the death of Hilda's brother George on Christmas Eve. She could make only infrequent visits to Lindworth. When on one occasion she telephoned to say she would be looking in, Stanley refrained from warning Patricia, hoping they would meet. They did, and Stanley would dearly have loved to be present but retreated into the kitchen on the pretext of

peeling the potatoes for lunch. Hilda, as he had feared, was away for Christmas – the first time they had been so separated – and Stanley spent Christmas Day with Patricia. In the evening he took her to a party where they played charades and mystified their host because 'Patricia made me "Cookham" and she "Ireland".' (Patricia's father had connections with Ulster.)

Stanley's daybook for 1933 describes his entanglement in unaccustomed detail.[8] Early in January he took Patricia on a visit to the Carlines, and she was 'horrified' that she had forgotten to take presents for Shirin and Unity. Later Hilda came for a brief visit to Cookham and they 'have a long chat'. On another visit Stanley 'sets Hilda' to painting Patricia's portrait. Interspersed with exasperated comments on the kitchen range at Lindworth – it kept failing to hold the fire overnight so that Stanley would have laboriously to relight it and wait for it to heat up before he could make tea or cook his breakfast – are detailed notes on what Patricia was wearing when she visited. Sometimes he is delighted that she is 'elegant'; at other times disappointed that she comes casually dressed or wearing 'the same old jumper'. At one point he breaks into verse which he interrupts to tell himself that 'In spite of my excitement at Hilda's inelegance, I have a passion for feminine daintiness and elegance, and in one way, if I can as it were get there, it more fits with my sexual needs than with the more usual kind of attraction.'[9]

Such was the situation Hilda faced when she returned to Lindworth. There was no overt ill-feeling between her and Patricia. It was not in Hilda's nature to express bitterness. But she was hurt. In the portraits she and Stanley were painting of Patricia, Stanley's shows her challenging the onlooker, whereas Hilda's shows her looking askance, sad and doubtful. Both women saw his attitude as puzzling and bizarre, Hilda from dismay, Patricia from amused indulgence. Of the two, Hilda was understanding and accommodating. Had Patricia shown the same consideration the ensuing domestic tragedy might not have happened. She began to play Stanley's interest in her as a game. It amused her to exercise the power she had over him by taunting and teasing him, not viciously or hurtfully, but sufficiently to keep him on edge. Hilda felt for him. There were times when his frustration boiled over into anger, occasions not helped by the increasing pain from his gallstone,

which had not diminished despite an earlier operation at a Reading hospital. When these moods came on him Hilda would remove herself and the children back to Hampstead until she felt he had calmed sufficiently for her to return.

Patricia painted by Hilda, 1933. She signed it in red paint.

Love on the Moor

Love on the Moor

His pictures have that sense of everlastingness, of no
beginning and no end, that we get in all masterpieces.

Isaac Rosenberg of Stanley Spencer[1]

IN JUNE 1933 Stanley told Dudley Tooth: 'During the last three
weeks I have received two commissions for big pictures, but neither
of them say they will have anything to do with you. They were
both given me, as they said, as a token of their admiration of my
work at Burghclere. These two works, which are not landscapes
and will take me months and months to do, will put me out of
action as far as you are concerned for at least eight months.'[2]

The letter was written shortly after Stanley had been descended
upon by an enthusiastic new patron, whom he describes to Gwen:
'Behrens and Behrend are two pretty men, they both buy my
pictures again and again. They both like my work very much, so
they say, and make my life happy. But they are no relation and
don't know each other. Behrens went to Burghclere and afterwards

306

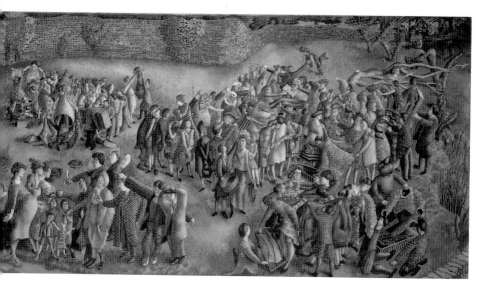

descended on Lindworth just bursting with it all. The house at the
moment was full of in-laws not at all anxious to witness such an
unbosoming or unbuttoning as in Behrens' case seemed necessary.
He breathed hard, dilated his nostrils, expanded his chest and
commissioned me, as you know, to do a picture.'[3]

Edward – later Sir Edward – Beddington-Behrens (not, as Stanley
carefully pointed out, to be confused with Louis Behrend, who had
sponsored Burghclere) was one of those men whose golden touch
turns all to success. Tall, well made, presentable and easy in social
manner, his public school education had been terminated by service
in the Great War, first as a regimental officer winning the Military
Cross and then, when his organizational abilities were recognized,
as a staff officer. A post-war university course endowed him with
a PhD. There followed a dilettante period of decision on choice of
career. Finance won, and his merchant-banking operations became
so successful that he was able to open affiliated offices in New
York. These were to lead him to Hollywood in its heady days as
financial adviser to United Artists and to close friendship with,
among others, Charles Chaplin. It was largely on Behrens' advice
that Chaplin chose Switzerland in which to settle after his virtual
expulsion from the USA in 1952.

It would appear that Stanley mentioned the project of his two
'big pictures', so dear to his heart, to the admiring Behrens. In that
same summer of 1933 he told Gwen: 'I am doing a very big picture,

ten feet long and three feet high. I began it some weeks ago knowing that I would never show it, and although you may not like it, I think you will agree that it is a good composition and well painted.'[4] But whatever hopes Stanley may have had of Behrens' patronage of 'the big pictures' foundered on the clash between Behrens' unwillingness to accept an unnecessary middleman's commission and Dudley Tooth's polite but determined refusal to relinquish his contractual rights. Moreover, it is apparent from the light and somewhat mocking style of Stanley's letters that he found Behrens' enthusiasm for his religious painting too conventional to sustain sponsorship of the startling content of the 'big pictures' he was proposing. Some time later, probably early in 1934, Stanley tells Gwen that he has stopped work on the project.

By catalogue chronology the most likely contender for this 'big picture' is *Love Among the Nations*. But unexpected though that painting was, there seems no evidence that Stanley felt he could not show it, nor that he stopped work on it at any time. The interesting possibility thus exists that he refers to the companion 'big picture' of the time, *Love on the Moor*. Looking back in later life Stanley thought that it dated from about 1936, but he was seldom sure when he first contemplated a composition, drew it or painted it. There was often a long gap between the several stages, depending on other commitments. In all other respects *Love on the Moor* fits the description. Stanley in his memoirs remembered starting work on it, then having to stop; many years passed before he finished it or dared to exhibit it; and the subject-matter legitimizes Stanley's now overt interest in Patricia.

The scene is set on Cookham Moor, a favoured haunt of promenaders and lovers. In the centre of his scene Stanley plants a statue of a diffident goddess of delights. As the painting exists today, the statue is said to represent Hilda in feeling,[5] but when begun it must have been more redolent of Patricia. To the right of the statue frenzied groups of youngish men and women excitedly open boxes of dresses or stockings. One of the young men offers a peeled banana to pregnant women. To the left of the statue, the atmosphere is calmer, with men and women walking towards Cookham; this section of the canvas was at some time detached, then later rejoined. The plinth of the statue is decorated with stockings and a corset like the armorial bearings of Venus, at the sight of which

some of the onlookers are transfixed in amazement and adoration. A small figure crouches at the legs of the goddess in worship. Several old men stand adoring pregnant mothers and their children. Behind the statue a man and a woman retrieve a letter from a litter basket, and in the distance a group of boys idly kick a football; a subject already painted by Gilbert. The redbrick wall of Moor Hall closes the background.

At first glance jejune in content – a fact Stanley evidently realized – the painting takes formal meaning when set against his visionary comprehension. Many of the cameos sustain a link with past imagery; the boys playing football, for example, match the group of youths at the gate of *The Cookham Resurrection* or those who watch *Christ Carrying the Cross*; the woman reading the letter from the litter basket matches the two girls on the right of *The Cookham Resurrection*; and the figure embracing the legs of the goddess seems to match Stanley's fascination with his 'glimpse' of Hilda's legs. But the introduction of these past themes is not mere repetition. Stanley's fertile imagination is already moulding them into new associations for future development. In the group of boys playing football Stanley is the small figure crouched behind the goal. He is detached from the main action, sensing himself separate from his companions in his 'metaphysicals' in which they are not interested, and seeing the happening on the Moor as a vision they cannot know. The woman reading the letter is not merely the girl of the churchyard scene who took a note to her lost friend, but someone to whom his 'lovely Stanley-qualities' are being imparted, so that she is joyously coming into comprehension of the true meaning of her female sexuality and the dress she wears appropriates the pattern on the adjacent cow. Stanley is finding new visionary metaphors, of which cows are one. Others, the old men and pregnant women of the scene, for example, are already stirring in his mind towards their celebration in paintings yet to come.

To convey the revelation of his comprehension, Stanley needs, as he did in *The Cookham Resurrection*, a 'big picture'; space in which to depict another of his Cookham 'holy suburbs of heaven'. Equally significant is the fact that Stanley has used for the setting Cookham Moor, the Cathedral Close of his 'church of me'. His use of the personal is as irrelevant in the purpose of the painting

as it was in *The Dustman*, although bitter experience had taught him that not all would see his associations so.

Later in the summer of 1933 Behrens, having to visit Switzerland on business, thought that Stanley might like a painting holiday there: 'I [Behrens] invited him as I thought that in view of his interest in religious subjects, it would be an inspiration for him to visit a village like Saas Fé which can only be approached by mountain paths on a mule and where old village customs and dress were maintained and where the constant danger of the mountains to man and beast help maintain a strong religious belief.'[6] So Stanley wrote to a no doubt surprised Gwen, 'a fortnight ago he sent me a telegram saying "Come to the mountains. Nothing required except strong boots and a spirit of adventure." So I went. He has strong feelings about the mountains and all my job was to try and understand what his feelings were; or it didn't really matter if I didn't understand them so long as I listened; or it really didn't matter much about that either as long as I just stood there while he said it. So I have been making drawings of the Swiss and a painting of one of those Swiss skittle alleys. I will bring it and let you see it, although both the Behren(d)s are after it. Behrend staying in Zermatt and Behrens in Saas Fé will fight for it unless like Moses breaking the tablets on the rock I split it in half across the summit of The Dom which, as a learned lady like you will know, separates Zermatt from Saas Fé and is the highest mountain in Switzerland.'[7]

As soon as he had arrived, Stanley evidently told Behrens of his new-found delight in Patricia. Behrens, ever the forthright man of action, immediately sent her a telegram on the assumption that her presence might inspire Stanley. Surprised, Patricia thought about it and then, under the impression, she claims, that Behrens' wife was with them, went. Stanley disclaimed any persuasion in the matter: 'When I was at Saas Fé two days or more, Mr Behrens said he thought he would telegraph to Patricia and tell her to come here. I was greatly surprised and, needless to say, more than delighted, but I did not think she would come. I had made no sort of suggestion of her coming.'[8]*

* Hilda accepted Stanley's explanation, as she later told Dudley Tooth: 'Stanley and she had been more or less inveigled into going to Switzerland by a man who seemed to feel that if any marriage had lasted more than a few years, it ought to be broken up'; an understandable but perhaps sweeping view of Behrens' unorthodox action.

After a few days Behrens left on business, 'So there they were alone in this remote little village, and fortune placed them in a position difficult to emerge from the same as entering it. I [Hilda] don't mean that they shared bedrooms, they certainly didn't. But the fact of sharing each other's daily life marks a new step which is difficult to retreat from. It marked the first big break from me and I went away for a month feeling terrified of him. When I plucked up courage to return, to my relief he was apparently all right with me again.'[9]

Stanley 'terrifying'? Not of course in the physical sense, but in the psychological disorientation Hilda was suffering at finding her husband transform himself into a new, strange and disturbing personality. As sensitive as Stanley, she was undergoing the same dislocation as he had so eloquently depicted in the two very different male nudes of *The Cookham Resurrection*. Two visionary Stanleys were at loggerheads. When that happened, as we know from his comrades at the Beaufort, Stanley could be 'fierce'. Like a Laocoön in the grip of a serpent, he was struggling in coils of a frustration he knew not how to master.

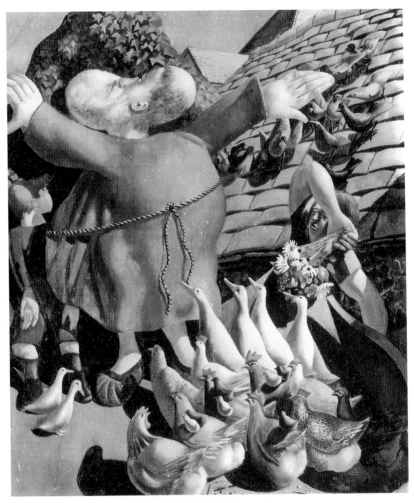

St Francis and the Birds

CHAPTER TWENTY-NINE

St Francis and the Birds

The title of the painting was an afterthought.

Stanley Spencer[1]

If you do not know names, the knowledge of things disappears.

Ezra Pound[2]

FOR CHRISTMAS 1933 Florence had sent Stanley a present of a pair of bellows. His thank-you letter contained no mention of his visionary excitements. He listed for her his proposed commissions for 1934. They comprised three pictures of Swiss life for Beddington-Behrens: the decoration of a canteen at Burton's Leeds factory, a suggestion perhaps from Behrens' wife, daughter of the tailoring tycoon Sir Montague Burton: the possibility through Gwen Raverat of decorating the ceiling of the new University Library in Cambridge: occasional lecturing at the Central School of Arts and Crafts in Birmingham: and a commission to 'write a book on religion and art for The Studio for a book they are publishing'.

But in the quiet of his studio another Stanley dreamed and gleamed. There he was in his 'personal' life. At their best the paintings of this period contained some of the intensity of those games of childhood which are temporary substitutes for an adult reality which the participants know is there but which they cannot yet experience in full. In the grip of such games Stanley might, with some justification, have paraphrased the argument Dante gave Ulysses in Hell:

> Nor fondness for my son, nor reverence
> Of my old father, nor return of love
> That should have crown'd Penelope with joy,

313

Could overcome in me the zeal I had
To explore the world and search the ways of life,
Man's evil and his virtue.[3]

In the astonishing outpouring of visionary paintings in the next
five years, the dichotomy can clearly be sensed. All look into
himself in search of outward transcendence. All too are universal
in intent. But whereas the majority derive from happy memory-
feelings and grow into a symphony of creativity, some make use
of the tensions and frustrations of contemporary experience and
remain isolated in mood and disparate in content. When, for
example, in his roving round Cookham he came across a scarecrow
in a field, the pathos of this decrepit figure, 'like a person slowly
changing into nature',[4] became a symbol for him of a crucifixion
– always a personal image of himself seeking transcendence from
crisis. Then, later in 1934, the commission to paint Burton's
canteen having fallen through – Stanley envisaged vast shop win-
dows seen from inside and looking past tailors' dummies to

Stanley posing for his photograph in the drawing-room of Lindworth. He is
working on *Parents Resurrecting*, dated to 1933.

shoppers in the street beyond: Cookham High Street, of course –
Behrens compensated by getting him a commission on the subject
of 'Builders' for the boardroom of a developer he was financing
named Charles Boot. The fee was to be £400. Stanley planned a
tall picture in which the top half would be an exterior building
scene and the lower an interior. Either because the project was too
tall for the boardroom or because in December 1934 Stanley was
still weak from the prolonged treatment at a Reading nursing home
which had finally rid him of his gallstone trouble,* the idea was
painted as two separate pictures at £200 apiece. He titled the
exterior scene *The Builders* and the interior *Workmen in the House*.
But the two are so different in mood that one can only conclude
that they reflect the two halves of his emotional dilemma. *The
Builders* is an amalgam of joyous images, of Fairchild's men of his
boyhood lifting hods of bricks in the building of a house amid the
springtime nesting of birds in the garden trees. Everything is
redolent of home, cosiness, security. But *Workmen in the House*
is composed of very different Stanley-images. His writings offer a
factual description of the painting[6] but make no reference to what
must be the emotional source of the imagery, an incident he angrily
describes in letters to intimates when smoke began to filter from
the skirting board of the kitchen of his newly built cottage at
Burghclere, Chapel View. He called the builders promptly but they
refused to accept his diagnosis – that the kitchen range had been
incorrectly installed. Colours are dark, claustrophobic. Space is
filled, overwhelmed, threatened by the maleness of the two work-
men. Stanley is not 'home' in the painting, he is merely at home,
the ignored incompetent in a situation of supposed artisan effective-
ness.† Elsie sits putting on her gaiters. Unity plays with a clothes-

* Stanley's first operation in March 1932 was unsuccessful, and he suffered bouts of pain which on occasion forced him, unusually, to take to his bed. Despite Hilda's adherence to Christian Science, he was made the patient of consultants in Reading. During 1934 attacks became so frequent that in October he underwent a second operation at a Reading hospital. This too was unsuccessful and not until a further operation, on 18 December, was he finally rid of the trouble. He stayed at the White Hart Hotel in Cookham over Christmas and then went to a nursing home for three weeks' convalescence early in January 1935. He was not back home, still weak, until 22 January. Although he continued to respect Hilda's adherence to Christian Science, he henceforth gave it no personal credence.[5]

† Imputations that he was 'dreamy, impractical and incompetent' invariably touched a raw nerve in Stanley. So did assertions that he was an 'innocent'. The art critic D. S. MacColl, Keeper of the Wallace Collection, described Stanley at the time as 'queer, almost a village simpleton, but waywardly inspired', a patronizing comment which Stanley tolerated in silence because MacColl meant it in praise of his painting at a time when he needed artistic support.[7]

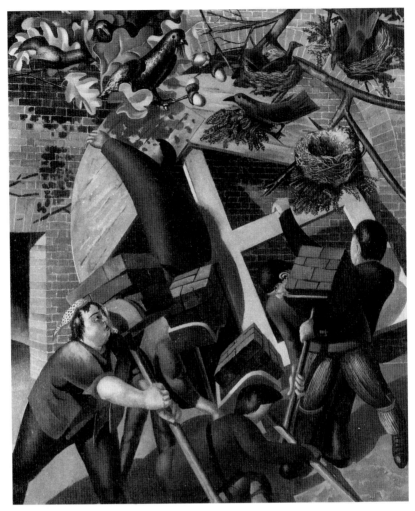

The Builders

peg and a gaiter. There is what Stanley called a 'wedge' motif in the painting, a forcing apart. If the workmen will, like the world at large, accept his precepts, they will be as amazed as were the workmen in the real-life incident when they had broken out the range and discovered that he was not only right but that had he not called them the cottage could have burned down.

If the pictures had, as was originally intended, been hung one

above the other – *The Builders* presumably the upper – was the eye supposed to travel from the anguish of the lower to the rapture of the higher, or downwards from the joy of the upper to the frustration of the lower? We have already seen Stanley's propensity for stressing the duality inherent in experience in his use of triptych

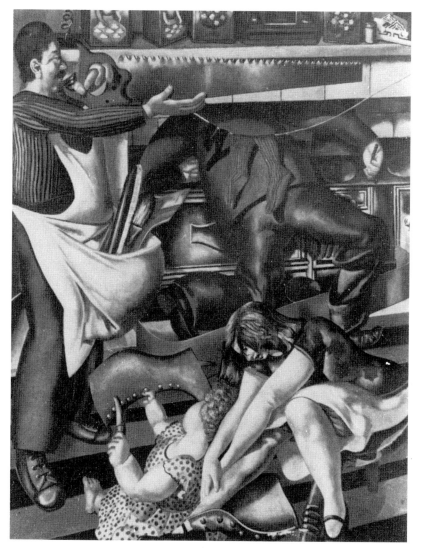

Workmen in the House

compositions and of systems of predellas to support related master paintings. In his 1914 *The Centurion's Servant*, he had wanted to set the terror of the messenger running to find Christ against the relief of the accomplishment of the miracle. Unable to catch the required imagery, he had contented himself with amalgamating both elements into the single painting. Although a year later he painted *The Resurrection of the Good and the Bad* as a diptych, the emotional conflict in the content was muted and the presentation simple. In the predellas at Burghclere he once again fell back on the composite, although he provides hints of double-painting in the contrast between the intensely personal scenes of the predellas and the more universal war-experiences of the arches.

Now, in these two building examples, Stanley has found the spark of his desired composition. Presented as a pair, one expresses internal anger or frustration, and is of necessity a private depiction. But the other strives to purge, to cleanse the hurt. Stanley was to continue such double paintings at intervals throughout his life.

The patron, Charles Boot, rejected both paintings, complaining that people would laugh at them. A furious Stanley riposted: 'Of course they will. What else do you suppose people ever do to my pictures?'[8] Behrens, angered by Boot's 'betrayal of a defenceless man like Stanley', bought *The Builders* and presented it to the Museum of Modern Art in New York, whence it passed to Yale University. *Workmen in the House* remained unsold. It was later accepted by Wilfred Evill (one of Henry Slesser's fraternity of St Ambularis), who became Stanley's solicitor, as part payment of his fees. Evill was to acquire a substantial collection of Stanley's more esoteric paintings in this unexpected way.

Early in 1935 Stanley once more employed his disturbed emotions in making another of the remarkable sleights of hand, or rather of the spirit, of those days. He later called the painting *St Francis and the Birds*. We shall deceive ourselves if we imagine that it has anything to do with a simple lovable interpretation of the legend of St Francis of the flowers and the wild creatures: indeed it seems that when he began the painting, Stanley did not have St Francis in mind at all. In Stanley's depiction, a grotesque old man in robe and slippers dominates the scene. He is apparently striding off left preceded by a small boy and accompanied by a clutter of birds, wild birds on the nearby roof and domestic fowl

and geese on the path beside him. There a woman squats holding a bunch of marguerites and apparently shielding her gaze from the presence of the old man. The contrast between the distorted forms of the figures and the conventional imagery of a St Francis is very stark at a first viewing. It was certainly too much so for the public of the day.

According to Gilbert, the composition was painted over one Stanley had done of Hilda sitting in a haystack with hens and ducks feeding around her. Stanley had used it for one of the drawings in the 1927 Chatto and Windus daybook, and other sketches of the scene are among Stanley's drawings. To most, such a picture is one of romantic and happy sentiment. But not, one suspects, to a Stanley in the grip of his new-found Patricia-vision. What may well have begun as a charming vignette has been metamorphosed from an image of Hilda as the female procreative element of 'fusion' surrounded by parallel signifiers in the natural world – ducks, geese and hens with their chicks.

But the woman in the painting, stylized though she is, does not resemble Hilda, and in a description of the painting Stanley remarks that the figure was based on his memory of a servant at Fernlea who used to throw out cut flowers at the slightest sign of drooping or decay, another of the pen-and-ink illustrations in his Chatto and Windus daybook.[9] Thus we can suppose that the composition has to do with events at Fernlea. The setting is the backyard of the house, abutting as it does against the wall and low roof of the Nest. The ducks and hens would then be the domestic fowl the Spencers at one time kept in the back-garden. So it is not unreasonable to suppose that the figure represents Stanley's father, Pa, in his slippers and dressing-gown as he padded about the garden to feed the hens and ducks. From the cord which ties the gown the three Franciscan knots of poverty, chastity and obedience are missing. The dressing-gown was painted from one Gilbert gave Stanley when he went into hospital for his first gallstone operation. But towards the close of his life Pa was to be seen in Cookham in such garb. The sympathetic villagers understood that he was in his dotage and thought nothing of it.

Pa was never so plump as Stanley has painted the saint. Gilbert asserted that the shape of the saint derived from the shape of the haystack in the underpainting.[10] The St Francis whom Stanley

discussed with Jacques and Gwen Raverat or with Desmond Chute was more likely to have been that mystical yet uncompromising saint of whom Michael Sadler, the patron who so narrowly missed acquiring *Apple Gatherers* and who was now Sir Michael Sadler, Master of University College, Oxford, wrote to his son:

I have been going through exciting times with St Francis. . . . The subject is extraordinarily interesting; it branches out in all sorts of directions. . . . His life makes me cry every time one reads it. It is surely much the nearest to the life of Christ. The course of events that led up to him – the preparation for him – the sum of the influences which predisposed the world to recognise his teaching as one of its greatest needs; all these I have hardly touched. But what followed after him is deeply interesting. It was among his followers that the first movement of the reformation began. Rome and the University of Paris crushed it to death – but it was *all but* successful. Very extravagant, mystical, socialistic, connected with the East rather than the West, it ramified all over Western Europe. . . . Its chief motive was the literal enforcement of the economic doctrine of the Sermon on the Mount. Its earliest upholders went so far as to magnify St Francis into a sort of later Christ; hence the incessant emphasis on the stigmata. . . .[11]

Faced with subsequent criticism of the saint's unascetic appearance, Stanley argued that his amplitude represented the influence of St Francis spreading far and wide, as it did historically.[12] But such an explanation – one feels it must have been one of Stanley's more arcane remarks – conceals more than it reveals. Pa had indeed spread his influence far and wide: but through conceiving eleven children and by his effect on the generations of pupils who remembered him with affection. He was, in Stanley's imagery, a symbol of the instinctive force of creation, and just as God in *The Cookham Resurrection* could be represented in part by the female procreative image of Hilda with the babies, so the procreative symbolism of the old man could be linked in Stanley's mind to a Hilda-and-haystack association which required that the saint be huge, female in form, indeed pregnant, his head, his mind, equated in form to the function of the female breasts; for Stanley has placed the neck of the old man where a woman's breasts would be.[13]

If St Francis in the painting is such a marrying of association,

who does the woman represent? Gilbert believed she indicates the 'fatal figure of Patricia Preece'.[14] Stanley's portrait of her is accurate even to a suggestion of the cast in her eye. The bunch of flowers she is holding are wildflowers. Prominent among them are wild daisies or marguerites. They are the wildflowers of Stanley's early Cookham-feelings; the marguerites are those poignantly placed at the foot of the monument in *Unveiling Cookham War Memorial*, and which surround and indeed clothe the young girl resurrecting in *The Cookham Resurrection*. St Margaret symbolizes feminine innocence and purity. Innocence or purity in Stanley's usage meant a withdrawal from the sexual as creative urge, or being as yet unawakened to it. The implications begin to gather meaning. Patricia embodies for him his early Cookham wildflower feelings. Just as he wished then to 'marry', to absorb himself into their existence to extract the meaning of his own, so now he must fuse himself with Patricia to find the new enlightenment he discerns. To the left of the saint the small acolyte is perhaps Stanley himself. The saint is less Pa than an emanation manifested in the person of Pa. (Years later Stanley likened the figure of St Francis to 'one of the many emblematic figures of the Holy Ghost visiting the places [in which Stanley set his pictures] in the form of disciples, preachers etc.' In this painting Stanley is discerning a vision which he sees in metaphorical – religious – terms as a coming to him of the Holy Ghost).[15]

St Francis as a daft old man? Why, it was pointed out,[16] look at the way Stanley even paints St Francis' hands backwards, gestures giving the same surrealist touch which reminded Gilbert of boyhood memories 'of Miss Mignon Jay . . . a victim of St Vitus' Dance . . . having one of her attacks, her arms thrashing and her head twisting at right angles'. The surrealism probably derives from Stanley's convenient trick of modelling his own hand in front of his face. But is not the incongruity again deliberate, emphasising the visionary aspect of the emotion he is expressing? To the same end the swollen shapes of pregnancy are given to a male. Birth – creation – is female only in conventional minds. Stanley sometimes startled listeners by announcing that he would like to have been a mother. They usually took it as one of his joking remarks. But about such matters Stanley did not jest. He meant it literally. He would like to have experienced within his own body conception,

pregnancy and the miracle of birth denied the male. 'I painted this picture of St Francis from a motive of sincere regard for that person and because of the graphic nature of the story. In his preaching to the wild birds I have conceived that St Francis is expressing his union with nature and the romantic wildness of it. The shapes and forms of St Francis are continuous with the surrounding shapes and forms.'[17] To Stanley, fecundity remained the manifestation of religion in thought and feeling as in the body. To Stanley creativity in all its processes is one and indivisible.

His critics could not see that the picture represents not St Francis as a daft old man, but a daft old man as St Francis. In the way that the lunatics at the Beaufort had, in the pain of their withdrawal, rid themselves of corporeal reality, and as the genius of the real St Francis had induced him to rid himself of the material values by which Western society sets such store, so an old man has come into his inheritance and entered another world. In his being he has honoured the call of creation as forcefully and as single-mindedly as did St Francis. His will is the inevitable will of God. It is not in his power or gift to betray the destiny to which God has called him.

In this remarkable painting Stanley has invoked the spirit, if not the form, of one of Christianity's most austere saints in order to explore the implications of a situation of his own. He too, the artist striving towards ultimate vision, longs to be an instrument of creation, an acolyte of God. But he faces the possibility that a significant element from his corporeal world, Patricia, now intrudes. He cannot reject her physical enticements, for they offer a new field of visionary exploration. But her depiction suggests that the natural purpose of her life is denied like the unwanted flowers discarded by the old Spencer family servant. She is, Stanley fears, spiritually incapable of matching him in the full force of his aspirations. Should he renounce her, or should he yield? As the saint turns his head from the pleadings of reality, his arms are flung out, said Stanley, in the attitude of crucifixion, the icon with which he always represented himself in crisis.

Through his marriage with Hilda, Stanley had been brought to the understanding that the purpose of sex was to distil from the physical the essence of the creative, and that in its highest form its functioning is spiritual, religious. There is no information on when

he first had – or was permitted – sex with Patricia, although hints suggest that it was in the same year, 1935. There is, however, every indication that when it happened a comparable metamorphosis of meaning failed to occur for him as gloriously as it had with Hilda. This realization may have lain at the root of a plan which began to form in his mind, to provide himself with facilities for sexual access to both Patricia and Hilda: to the one for new potential in his creativity, and to the other for her continuing power to lift him into the spiritual. The details of his plan will emerge only slowly over the next two years, and because he kept them to himself at first, not always clearly.

CHAPTER THIRTY

By the River

> An image is a stop the mind makes between uncer-
> tainties.
>
> Djuna Barnes, *Nightwood*[1]

STANLEY RECORDS with almost poetic pleasure the summer walks he and Patricia began to take at this time round Cookham. She was a daughter of James Duncan Preece, a retired lieutenant-colonel of the Welch Fusiliers. She always maintained she had been born in 1900 but was actually born in 1894 and christened Ruby Vivian. She began studying art at Brighton, and during the Great War had a dignified romance with a naval officer. It seems to have ended in 1916, but as he had pleaded with her that none but his lips be allowed to utter the hallowed name of Ruby, she began calling herself Patricia, and became 'Peggy' to friends, though never to Stanley. In 1917 she studied under Roger Fry and trained at the Slade. There she met Dorothy Hepworth, with whom she lived for the rest of her life. She had a brother and a sister, but often referred to Dorothy as her 'sister'.* For a while the couple set up in a studio in Gower Street, then moved to Paris where they studied with André Lhôte. Returning to England, they were provided under a Hepworth family arrangement with the mortgage for a house. Having just failed to buy Studio Cottage at Cookham, they settled for Moor Thatch. But although their painting was appreciated and they were often invited to exhibit in mixed exhibitions, they had difficulty in maintaining the lifestyle to which they aspired, and constantly needed family handouts. At one point Patricia became a genteel agent for bric-à-brac, dolls and antiques. Dorothy was never particularly concerned about her appearance, but Patricia resolutely refused to compromise. Not a beauty in the conventional

* In the contemporary *Dictionary of British Artists* Patricia had herself entered as 'née Hepworth'.

By the River

sense, she had however a slim figure, and continued to dress with stylish taste. The appearance of Stanley, willing for his own reasons to have her well dressed, was a godsend.

Even without Stanley's involvement, the set-up at Moor Thatch provoked village curiosity. Dorothy in particular kept herself very much to herself, and regarded it as Patricia's function in the partnership to socialize. Dorothy was the better painter, an accomplished portraitist and miniaturist. Patricia constantly encouraged her to keep working. But she would sign her work only reluctantly. Whenever the pair got work into an exhibition, Dorothy's paintings would be submitted with Patricia's under Patricia's name. It is apparent that Moor Thatch was a joint Preece-Hepworth painting factory. Patricia's assiduous cultivation of Roger Fry during 1932 had brought her to the attention of Augustus John, Helen Anrep, and Clive and Vanessa Bell. Their consideration was more of her plight than of her art, but Duncan Grant promoted her, and Virginia Woolf and Kenneth Clark bought work.*

* Virginia Woolf to Ethel Smyth, 12 March 1935: 'There is a Miss Preece, much admired by Roger and Vanessa. She is poor. She longs to draw you. She is shy. She lives at Cookham. Will you sit? If she did a passable drawing, I want to get it published in *Time and Tide*. Could you go to Cookham? I think

Dorothy Hepworth in the 1930s

This modest success, which did much to relieve for her the depression of 1932, took place at the same time as Stanley's growing interest in her. At the other end of the High Street, in Lindworth, was another painting factory. Hilda's work she admired, but she found Stanley's incomprehensible, other than

one sitting would be enough. She's afraid of failing in a strange studio . . . She – Preece – is in a twitter.' The detail suggests that Patricia intended Dorothy to make the drawing; it was Dorothy who was 'shy' and 'afraid of failing in a strange studio'.[2]

the landscapes, which were greatly in demand. But his output appeared to be so successful financially that to her it seemed absurd for Hilda to be opting out, leaving Stanley to struggle with business matters in which he had little interest. Why not amalgamate the enterprise at Moor Thatch with that at Lindworth? Patricia could assist with domestic affairs there, free Hilda to 'hop off' to her interests in family and Christian Science, organize Stanley's work schedules to their mutual profit, take charge of the tax and money problems which worried him, and free more of his time for the visionary paintings which were his main preoccupation.

The scheme unfolded gradually. There was a certain practical logic to it, although the nuances of detail are not readily discernible. In the beginning it was sufficient for Patricia that Stanley was interested in her. His reasons seemed to her nonsensical – 'unbalanced' – but as they benefited her financially, they could be turned to account. She did not discourage his passion for buying her clothes but gradually diverted his spending towards jewellery, some of it bought expensively in Maidenhead and at Asprey's in Bond Street. There is evidence that the arrangement was partly in operation by 1934: soon after he stopped work in 1934 on his 'big picture', presumably *Love on the Moor*, Stanley told Gwen Raverat that he had done 'fourteen paintings', an astonishingly prolific quantity by his standards; they were mostly landscapes or still-lifes seemingly done, for financial reasons, at Patricia's urging.

By the autumn of 1934 Patricia's involvement with Stanley was so extensive that Hilda was more often in Hampstead than at Lindworth. In the spring of 1935 Stanley began negotiations to make Lindworth over to Patricia. A deed of conveyance was drawn up by Evill, then cancelled in April 1935, having been 'resisted', presumably by Hilda. A month later a Land Registry Certificate, dated 23 May 1935, records the transfer. Hilda was left isolated and vulnerable.*

* Neither Stanley nor Hilda clarified the reasons for the transference of Lindworth to Patricia. Patricia, questioned by Maurice Collis after Stanley's death, commented merely that she 'needed some form of security'; her diaries for the period, which might have provided light, no longer exist. The transfer was possibly precipitated by the likelihood of the liquidation of the Hepworth family business, a drapery and hosiery concern in Leicester, on which Dorothy's mother relied to pay the mortgage on Moor Thatch. If the mortgage were called in, the women, without resources, would have to leave Cookham. But Stanley may have been persuaded by Patricia that ownership of Lindworth would provide sufficient inducement to remain in Cookham until his proposals could be implemented.

But it was not Stanley's intention that she should remain so. At the back of his mind was the idea of a tripartite commune, with him at one angle, Hilda and the children at another, and Patricia, presumably with Dorothy, at the third.* Ménages-à-trois were commonplace in artistic circles. Augustus John had had one with Ida and Dorelia; Lytton Strachey a complicated one with Dora Carrington and her husband Ralph Partridge; even Gwen Raverat, until she put her foot firmly down, had faced the prospect of sharing Jacques with Ka Cox. Stanley's desires were forcing him to a comparable arrangement of his own. Typically he moved step by step towards it, knowing both women too well to risk refusal by broaching it openly.

Why did Stanley, normally so cautious, put himself into such a fraught situation? Patricia, although fashionably well read, was not intrinsically intellectual, was patently manipulative, and could when baulked become aggressive. Perhaps at a superficial level these qualities gave her a colourful unexpectedness to which Stanley responded, something which he was also to find attractive in other women in later life.† But in the way that we can discover from his memoirs exactly why at Salonika he transferred to the infantry, so there are writings, letters and paintings which reveal a deeper and more influential source of his Patricia-fascination. There is, for example, a photograph taken of her in Switzerland. She is sitting on an Alpine slope, head turned, hair awry, pensive among the burst of flowers. But reverse her left to right, set her among flowers on Cockmarsh Hill, place a necklet of jewels around her throat and show her caressing them with the long fingers he found so intriguing and we have first a drawing and then a painting of *Patricia on Cockmarsh Hill*,‡ of the origin of which he writes:

Then I went to just along by the big nut trees below the gravel pit, just

* Lindworth had seven substantial rooms on three floors. Stanley's idea was that each party should have a separate suite.[3]

† Stanley's work from this time reveals evidence of a contrast he was finding between the active in women's personality – what he called the Leah quality he found for example in Elsie and Patricia – and the contemplative, which he assigned to Rachel and found in Hilda.

‡ *View from Cockmarsh Hill* shown in Chapter 13 is the reverse of the hillside in this painting. Its associative significance to Stanley was already strong, and is evident in this Patricia-painting, triggered perhaps by the photograph. Such double, often reversed, use of localities as both place in landscape and as emotion in visionary interpretation can be seen in many examples, for example *Bellrope Meadow, Cookham* and *By The River*, or *The View from Cookham Bridge* and *Swan Upping*.

before you get to Cockmarsh Hill, and there I wanted to do a landscape that was to be a mixture of those deserted spots where there are one or two straggly bushes and harebells and purple thistles inhabited by rabbits, only this time I wanted this place to be as unobtrusively inhabited by Patricia whose hair was to join in the expression of the hot sultry summer sun as also I wished the necklet of diamonds and amethysts to mix and look as natural as the purple thistles.[4]

Patricia had at last become for him the embodiment of that early 'Cookham-image' which was so mysterious to him and of which the physical expression had for so long eluded him. She was 'exquisitely the thing. She was the exact incarnation of the infant memory of those flowers. It was a thing I never believed could have happened.'[5] She showed him that same directness of life-force which he had long ago caught in the burst of the summer flowers of Cookham when, like the young Proust, he found himself stirred by a sensuous beauty which mirrored the dress and appeal of the village girls, the 'buds', towards whom he found his adolescent feelings so similarly and so mysteriously compelled: 'As you [Hilda] remember, P was the first and only time this Cookham Image which had always haunted me came to me in the flesh. I did not sexually want her,'[6] not in the manner and meaning he attached to his love for Hilda. But at last he had found the meaning of one of the impulses of his 'disturber of the peace', a miracle to him even if astonishing to us. It is certain that Patricia never voiced the slightest understanding of his feelings for her, even though he told her that his gratitude matched that which he had felt for Captain Childs, a 'gratitude which made me risk my life for him', and went on to tell her that 'You seem to have redeemed me from some horrible muddle in my mind. I hope you will always have the same sympathetic attitude to my affairs that you have now. I feel ennobled and strengthened since I have known you. When Dante came out of Hell and arrived at the grassy slopes of Purgatory, Virgil placed his hands on the wet grass and washed the grime off Dante's face. This is the effect you have on me.'[7] She must have been flattered by his simile, even if she perhaps thought it preposterous.

It is here that the sensual impetus behind *Love on the Moor* becomes apparent. By continually buying for Patricia a variety of

dresses and jewellery, Stanley could, through her 'mannequin' stylishness and 'steady walk in high heels', transform her into the profusion of the wildflowers of his Cookham-image, and so once again recapture the ecstasies of those early feelings which he had not been able to achieve through Hilda.

Patricia in Switzerland. She and Stanley made two visits to Switzerland at Behrens' invitation, the first in 1933, the second in 1935. This photograph by Stanley was probably taken on the 1935 visit.

So the seeds were sown of an objective which became more and more compelling for Stanley. If he could have full domestic and sexual access to both women, he would be able to fuse his God-image (Hilda) with his Cookham-image (Patricia) and produce

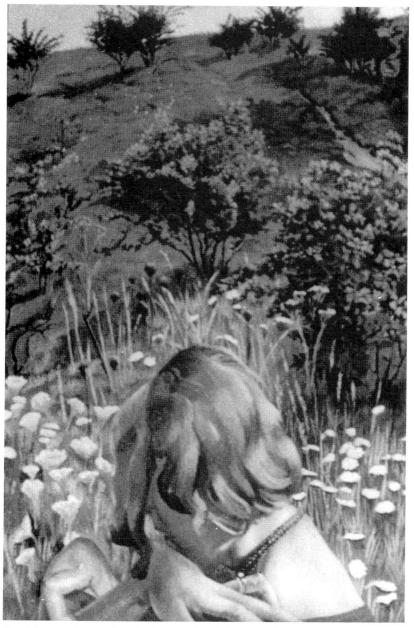

Patricia at Cockmarsh Hill. The painting brings together a number of powerful associations for Stanley – Patricia, flowers, jewels and Cockmarsh Hill. In this same year he also painted *View from Cockmarsh Hill.*

masterpieces as yet undreamed of. As he later explained to Hilda: 'Patricia supplies what I miss in you. You supply what I miss in Patricia. You each make the other supportable and enjoyable.'[8]

But his problem with Patricia, clandestinely intimated in *St Francis and the Birds*, persisted. Hilda highlighted to Stanley her understanding of the difficulties he faced:

I have been talking to Dick about it, and he has told me one or two things about Patricia which surprised me. I don't know what you would feel about it, you might not mind, but in the back of your mind I think you would. My feeling is that you need to be careful and make very sure, and not live in a fool's paradise, but try to find out definitely what she is like. I don't suppose my opinion is of much value to you, but definitely I don't think she would MARRY you. She might not mind something else to a limited extent.'[9]

Stanley was well aware of what she was saying. Of Patricia's love-making, he was to write: 'Patricia, steeped in her Paris love-interests [the bohemianism of the Left Bank in the 1920s when Patricia and Dorothy were there openly flaunted sapphic liaisons] seemed unable to distinguish me from that sort of love of hers as to prevent her subjecting me to those artificial, affected and prescribed and approved Patricia love-games, such as when she said she liked a certain kind of teasing of me, "getting me all tightened up and tense like a violin string", because, she says, the least touch is [then] at once sensed and will respond.'[10] When they at last made it to bed 'Patricia had a terribly difficult job to perform. . . . Why she never knew me was because she was only able to do [her] prescribed stuff. As to giving herself to me, she removed all of herself up into her head which she buried in a pillow, and sub-let the rest of her shifting body . . . at high rental.'[11]

Patricia thought sexual activity 'ribald'.[12] So in a down-to-earth sense did Stanley; he enjoyed robust humour on the topic. But whereas Patricia's feelings stopped at that point, Stanley's went on to seek visionary implication. Patricia's incapacity to share his sacramental exaltations was to mean to his distress that they could never 'know' each other in the way he and Hilda were 'fused'. Not unsurprisingly, Patricia described his urges to her friends as those of the 'working class'. She, the colonel's daughter, was convinced

that she was his social superior. As to his talent, she admired his early painting, particularly *The Nativity*, which she had seen in her student days at the Slade, but thought his contemporary visionary work a sideshow in which he needed to be indulged. In an existence in which she and Dorothy made only a hazardous living from painting, it seemed to her extravagant of Stanley to waste time on unsaleable work when there was a constant clamour for his landscapes. The fact that he begrudged the time painting them was only weakness in her dismissive view: 'There has always been a lot of talk about destitution in connection with Stanley. He was never near it in his lifetime, as I know, he simply had to paint, preferably landscapes, to sell them, he always had patrons. In that respect he was more fortunate than many very good artists. I never saw why he should not paint landscapes, as they were no worse in my opinion than his figure pictures. He hated painting landscapes as they were much more trouble to him whereas his figure pictures he would set down in comfort at home.'[13]

Although written years later, the comment may be assumed to summarize her view of Stanley then. In her opinion he was impoverishing himself through his own improvidence. If she had charge of him she would insist that he concentrate on money-making work like landscapes. She would allow him the limited sex of which she was capable, but his other sexual needs could be satisfied outside their relationship, with Hilda if he wished. She would have no objection provided the scheme were agreed between all parties.

But could this scheme materialize? And would it work to Stanley's satisfaction? Hilda appreciated his perplexities. 'Uncertainty is another of his everlasting qualities. . . . we were engaged and broke it off continually, six or seven times or more, over a period of three or four years. When I last saw him, he was in the same state over Patricia, unable to know whether he really loved her or no, although he is desperate about her.'[14]

Such perplexities were bound to surface in his painting. They can be adduced, for example, in another of the more private pictures he undertook at this period. He titled it *By the River*. It shows Bellrope Meadow, the tract of common land lying between the backs of the buildings along Cookham High Street and the river, one of the boyhood haunts he found so compelling. His local

names for many of the flowers which grew there – 'marsh mallow, ragged robin, bell-flowers, cranes' bills', uttered by Stanley 'like a sigh',[15] moved him in the mystery of that 'touch-me-not' quality he was now perceiving in Patricia. Bellrope Meadow was – still is except at high holidays – a place of peace and contemplation:

The Meadow has a charming appearance at dusk. It was slightly wedge-shaped and fairly long. The hedges were white with may, and dark trees were above. The grass got more milky-green as it paled to the white of the cow-parsley near the hedges. . . .* The place is much frequented by people on [summer] Sunday nights after church. They sit on the grass against the fence and you just see bowler hats, ties, shoulders stuck about here and there, looking like so many portrait busts in colour. In this picture [*By the River*] the people are doing nothing in particular, which gives a better opportunity of conveying the essential atmosphere of the place. Neither the chestnut trees in the distance nor the near shrubs are doing anything. They are all just 'being', and the people are thinking at their ease and, in my opinion, are expressive. The standing figure in a striped coat is carrying a lady's fur coat bandolier fashion.[16]

There is the calm of a restful summer evening in Stanley's observation of the sitting figures, even a hint of loneliness. They are 'thinking at their ease' and are 'expressive'. The shock comes when we venture to deduce what in the painting they are expressing. Indeed, but for the fact that we have long since suspected that Stanley's public descriptions of his paintings give little evidence of their emotional intensity, we would be bewildered by the contrast between Stanley's restrained account of the composition and the strangeness of the emotions it displays.

The figure standing in the striped coat – presumably a blazer – is no doubt a Stanley-figure. Both hands are in the pockets at the front of his trousers. The lady's fur worn 'bandolier' fashion – with a summer blazer? – could be the fur jacket which appeared in one of the first of Stanley's Patricia-paintings, *The Meeting* (1933). In that painting a man and a woman meet among the brick and flint walls behind Fernlea. They must be Patricia and Stanley in origin. The woman wears a fur stole, one of the sleeves of which

* An impression which Stanley conveyed a year or so later in the bucolically saleable landscape he called *Bellrope Meadow, Cookham.*

she lifts to present to the man, who touches it with his right hand so that the imagery of a swan's neck is induced. A similar imagery was carried into *Separating Fighting Swans* (also 1933). In the painting the necks of two swans are entwined in anger. One is trying to dunk the other's head under water to drown it. Stanley struggles to separate them, as he once did in real life in Poole Park. The angels, it can be argued, applaud his respect for natural life.

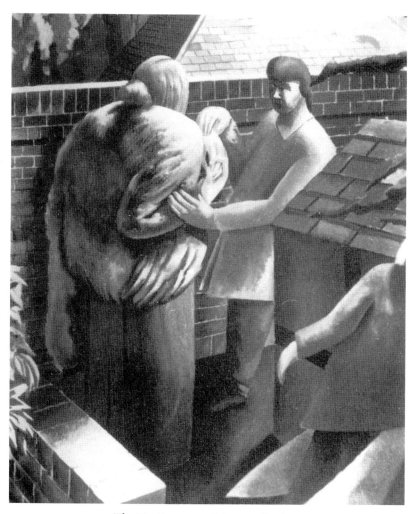

The Meeting 1933. Private collection.

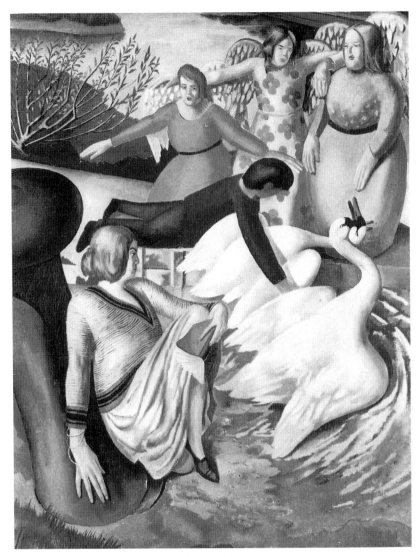

Separating Fighting Swans

It is a sympathetic and no doubt justified interpretation. But there is another: the swans are his sexual aspirations in conflict; an obviously portrayed Patricia reclines against a bollard so exaggerated in size that it would moor an ocean liner. In her left hand she

rests a book, indifferent to the struggling Stanley. Her right hand, her long fingers emphasized, strokes the bollard. Stanley is in the throes of his Patricia-sensations and the angels sanctify his struggles to resolve his spiritual dilemma.

In *By the River* the Stanley-figure is again isolated, but now his Patricia-sensations wind round his neck as did the weighty cartridge bandoliers of his wartime infantry memories. The figure is indeed 'expressive', and could be an allegory of a Stanley in the persona of his Patricia-feelings gazing at the family on the right who are simply 'being': images in a landscape paralleled in nature, the 'being' of the distant chestnut trees and the 'near shrubs in the foreground'. The seated man bears a strong resemblance to the Richard Carline of *The Cookham Resurrection* and could be the same Stanley alter-ego who in this painting has Hilda's auburn hair, which he loved. The woman is strikingly similar to the Patricia of *Separating Fighting Swans*. That they represent another, longed-for aspect of Stanley's visionary life is clear from his portrayal of the two children, Shirin in the foreground and the curly-haired Unity behind her, the products and purpose of perfect 'fusion'. The bunch of marguerites which the perfect father-figure thrusts out, a phallic bunch of flowers, is repeated in the pattern of the daisies on Unity's dress below. They are images called up from Stanley's complex transfers of associations between his boyhood flower memories, his sexual/spiritual feelings for Hilda and his family, and his new imagery of Patricia. The letter she holds out, which the father-figure is reading, and at which the lonely, fur-clad Stanley seems to be gazing so wistfully, could signify separation, distancing, a lack of togetherness; yet it can equally be seen as a bridge across distance, an invitation, perhaps even a demand.

At one level, it can be argued that the painting catches Stanley's anguish at the possibility of Hilda's departure with the children to the Carline side of the family, the distressing outcome of his interest in Patricia. But again one suspects that such an obvious use of emotion would have little imaginative appeal for Stanley. Perhaps he is using the idealized family to portray the innocence of the human-love, creative spirit, God-love his vision sees and strives for and into which he will be redeemed through fusion with that perfect female concept, the Hilda-plus-Patricia whom he will achieve in

his ménage-à-trois; for in an imaginative sense both women are now one to Stanley, harbingers of a new revelation. If only both would understand and co-operate! But as yet he is unsure they will. Such 'angels' as there are in the painting – one wears an

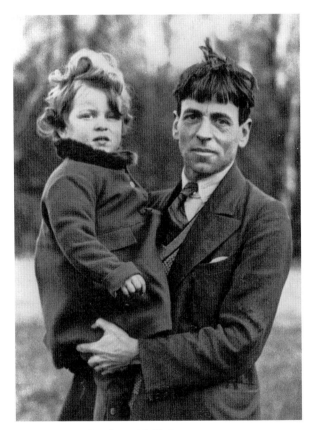

Stanley with Unity, *c.*1934

elegant flowered dress of Patricia's he liked – lie indifferent in the grass or look out across the river in the hope of deliverance, ears stopped to his pleading, casting his frustrations to the winds.

At the 1935 summer exhibition of the Royal Academy, to which he had the previous year been elected a Full Member, Stanley submitted five of his paintings. They were *The Dustman: St Francis and the Birds: The Scarecrow, Cookham: Builders*: and *Workmen*

in the House. At the Hanging Committee preview in April, *The Dustman* and *St Francis and the Birds* were rejected, a rare but not unknown rebuff to the Members' normal hanging privileges. A polite letter of explanation was sent to Stanley: 'The President and Council yesterday received a request from the Hanging Committee that you be asked to withdraw from the exhibition your two pictures St Francis and the Birds, and The Lovers (The Dustman), as they do not think these works of advantage to your reputation or the influence of the Academy ... The Committee have much pleasure in placing your other works in good positions.'

Stanley's reaction to the implied criticism of two paintings which were to him such powerful expressions of his vision was predictable. He fulminated. In a furious letter to the Academy he demanded that they return to him all five paintings; only to receive from the Secretary, Walter Lamb – a brother of Henry – a reply meant to be conciliatory but which Stanley read as even more insulting:

Dear Mr Spencer,

I have shown your letter of yesterday to the President [Sir William Llewellyn] and he asks me to point out that in sending your works you placed them at the disposal of the Council who have approved the exhibition and included three of your works. The laws of the Academy which you undertook to observe state that no application for changing the situation of any work after the arrangement has been sanctioned by the Council can be attended to or permitted. The three works therefore, *Scarecrow Cookham*, *Workmen in the House* and *Builders* must remain in the exhibition. . . . The other two . . . which are not in the exhibition can be moved at any time.

The press reported the affair. The artistic world was divided. Some supported Stanley: Augustus John pointed out that if people were finding Stanley's work 'funny', had not Breughel the Elder in his time been nicknamed 'Le Drôle'? But others argued that even celebrated painters had in the past accepted rejections without demur. However, nothing would mollify Stanley. He cut the Gordian knot by the conclusive step of resigning from the Academy and publishing the correspondence in *The Times*.[17] The Academy was offended by the unwanted publicity but Stanley remained

inexorable: 'My resignation is final. I should not have allowed it to be known but for the fact that it is to be final. You will understand that you are showing these three pictures of mine against my express wish and earnest desire that you do so. If by doing this you wish to show me that you can have what pictures of mine you like and not those you do not like, I will take care you never have another picture of mine as long as I am alive.' The Royal Academy had no option but to accept Stanley's resignation. On Stanley's instruction Dudley Tooth arranged in late April for all five paintings to be collected from the Academy and set up for later exhibition in his gallery.

In May – the month not only of the aftermath of his Academy quarrel but of the transfer of Lindworth to Patricia – Beddington-Behrens invited the couple for another trip to Switzerland, this time to Zermatt.[18] The weather was unseasonably cold and their hotel rooms unheated. Patricia sent a stream of postcards to Dorothy longing to get back. While Stanley got down to his sketching, she kept herself amused by teasing the marmots in the cage behind the hotel, and by flirting with the blond and hearty hotel manager, estranged from his wife, accompanying him alone on long walks, and claiming that he wanted to marry her. Stanley returned to Cookham irritable.

With Stanley volatile and Lindworth made over to Patricia, Hilda had had enough. She had not formally lived with Stanley since October of the previous year and now removed for good with her daughters to her Hampstead home. From his dwindling resources – he was spending money on Patricia more lavishly than his income allowed – Stanley allocated her £2 10s a week, which she found despairingly inadequate.

Love Among the Nations

Dear ducky, when we were looking at the book of
Indian temple sculptures, I felt you were the way to
what I wanted, to what the Indians and the Chinese
evoke in me. You are the essence of it.

Stanley Spencer to Hilda[1]

THE GENERATION of visionary paintings which followed *The
Cookham Resurrection* and *Love on the Moor* are sometimes
referred to as Stanley's 'erotic' paintings. The epithet, however, is
misleading despite the fact that as they appeared admirers gasped.
Few sold. Tooth's protests at their apparent waste of profitable
painting time multiplied despairingly. But if they seemed to many
to be the bizarre emanations from some infantile frenzy of the
imagination, they were not so to their creator. To Stanley they
were the resounding opening cadences of the great symphony of
creation he could at last begin to assemble in its totality. In that
composition each painting was not merely a chord modulated from
those which had preceded it, but one so tuned that it had the power
to bring into being the chords yet to come. In these pictures Stanley
makes that awesome demand all artists of genius make on us, on
the one hand compelling us to lose ourselves in the depth of their
experience, yet on the other, raising us to comprehend a universality
which we sense to be true but cannot reach unaided. We need only
eyes to see and ears to hear.

Catalogued to 1935 but undoubtedly composed earlier and
called at various times *Harmony, Romance, Ecstasy* or *Negroes,
Love Among the Nations* must be the companion of the two 'big
pictures' Stanley mentioned to Tooth.[2] In it, whites, blacks and
some Eastern peoples joyfully meet, touch, explore and caress each
other. In the right half of the painting the whites are correct and
restrained in attitude; the coloureds in tribal dress uninhibitedly

prod and investigate them, inducing in the whites startling feelings they did not realize they could possess. Stanley joins himself to the feelings of the occasion by showing himself as the figure in the check coat being poked by Africans. He is being lifted in surprise from the world of accepted convention into another and more meaningful world, and as our eyes travel to the left of the painting we see that it is a world of 'the joyful inheritances of mankind'. The sensuality with which the figures, even missionary nuns, explore each other is evidently a development of the theme of touching Stanley introduced into *The Cookham Resurrection* and is here extended to emphasize its function in establishing identification. To Stanley, love involves wishing to explore the beloved more and more closely and so establish a clearer and more accurate comprehension of its feeling:

If there is the desire to love anything, the first instinct will be for the lover to be clear as to the exact nature and identity of the thing loved. There must be no vagueness. The love of God is the true form of this desire and

Love Among the Nations

is the one sole identifying capacity of our natures. The identity of a thing in nature such as a rabbit or a turkey is that although it will have points of similarity, there will never be any confusion or vagueness as to its identity.[3]

To Stanley, it was vital to know and identify the instinctive nature of the feelings which impel us to love a person or object; the highly personal detail so apparent in his paintings of the period was his delight at the moments of their discovery. But his exploration had a further and more significant objective. Through it, and only through it, he felt he could better identify the nature of God: and this was the ultimate justification of his art:

With this ever-increasing delight in the miraculousness of sacred life I acquired greater and greater ability to define God or, as others might put it, to identify art. . . . When I have reached a certain degree of awareness of the 'touch-me-not' quality of things I am filled with a desire to establish this thing revealing quite clearly this quality. Love is the essential power

in the creation of art, and love is not a talent. . . . It establishes once and for all time the final and perfect identity of every created thing.[4]

In producing *Love on the Moor* and *Love Among the Nations* as a pair of paintings, Stanley was developing the notion he had already begun in, for example, the predellas and arches of the Burghclere Chapel, or in double paintings like *Workmen in the House* and *Builders*. In the one painting, *Love on the Moor*, he was using his art to identify the nature of love through personal sensual feelings; in the other, carrying the identity into a higher and more universal context.

These were the years of the Great Depression and worldwide poverty. Gandhi was agitating against British rule in India. Mussolini ruled in Italy. The Japanese had invaded Manchuria in 1931, and were soon to turn on China. In 1933 Herzog in South Africa formed a coalition government of whites united against the blacks. In the same year Hitler was made Chancellor of Germany. By the end of 1934 Germany was almost totally Nazified. There were riots in Spain as harbingers of the Spanish Civil War. In the year of the painting of *Love Among the Nations*, Mussolini invaded Abyssinia, and poison gas was used.

The Carlines were left-wing politically. Hilda herself was very concerned with contemporary society, particularly with economic theories and land reform. Her friend Muriel Ellis, a Russian speaker, worked in the Secretariat of the League of Nations in Geneva. Stanley was certainly not ignorant of nor immune from the international problems of his time. But his nature was such that he could devise no imagery of protest.* As in his departure for war in *Christ Carrying the Cross*, happenings in everyday life were matters over which he had no personal control and were therefore to be accepted willingly or unwillingly as they occurred. He could only, through his art, strive to achieve a redemption.

Not unnaturally, the unexpectedness of the imagery in *Love on the Moor* led to the claim, still frequently asserted, that Stanley advocated 'free' love. His professed wish to have both Hilda and

* Richard Carline notes that the Carline family had met Fiske Warren, an American pioneer of Single Tax, when they stayed at his villa in Andorra on their painting holiday in 1923. Fiske Warren was impressed with Hilda's social concern, and became an 'ardent admirer'. He later joined the Carline family party in Cookham in 1929 and became friendly with Stanley.[5]

Patricia as 'wives' is cited in support. Some of his writings have been suborned to the same purpose:

During the war, when I contemplated the horror of my life and the lives of those with me, I felt that the only way to end the ghastly experience would be if everyone suddenly decided to indulge in every degree and form of sexual love, carnal love, bestiality, anything you like to call it.[6]

But such statements, like many of his wartime diatribes, were the defensive reaction to the suppression of creative freedom rather than a support for unbridled sexuality. There is in fact no evidence that Stanley ever advocated free love. He advocated nothing. He adopted no 'isms', offered no precepts, proposed no panaceas. He inaugurated no movement and invited no disciples. He could be offended by ignorance but was ultimately indifferent to approbation. He was in the strict sense of the adjective a 'pure' artist – one who in wonder interpreted the mystery of his own experience. He asks of us not empathy, still less sympathy, but something more astringent: our acknowledgement that we also find existence awesome and miraculous. He knew that to take stances would limit what should be infinite. When he came to preface his 'writing on art and religion for The Studio', which became his contribution to the Golden Cockerel Press's *Sermons by Artists*, he took as his text 1 John 4:8: 'He that loveth not knoweth not God: for God is Love.'

Western culture, he argued in his sermon, has compartmentalized love. The age is 'secular'. All 'prison-wall tapping' is forbidden. As a result we find ourselves ascribing values to our feelings and introducing divisive codifications of conduct which 'confuse and contaminate' the instinctive nature of love. But, he stresses, love is not secular; it is a spiritual experience. Indeed it is the 'state of spiritual experience', not episodic but a continuum. In a discussion of identity, he proposes that the things which constitute the world have each an identity independent of us. We cannot know that identity. We can only construct through our sense-impressions a version of its identity, so that it assumes a thing-plus-us identity. Thus his definition of love – 'giving and receiving' – is not seen as simple acts of intention, but as a transference of identity. Only when each partner has the capacity to act as the object of the

345

other's transferred identities can love prevail. That the power existed and worked between participants was to him a miracle. It must motivate all creativity, physical and spiritual. It is the meaning of existence. God is Love.

If read in this way, Stanley's concept of love was in no way muddled or mystical, romantic or sentimental, any more than the way he represented it from his personal experience was self-indulgent. If he sometimes thought of his experience in Freudian or Thomist terms and his interpretation of it in exotic or New Testament imagery, there was to him no inconsistency.

Bridesmaids at Cana

The first myths arose when a man walked into non-
sense, that is to say, when some very vivid and unde-
niable adventure befell him and he told someone
else who called him a liar. Thereupon, after bitter
experience, perceiving that no one could understand
what he meant when he said that he turned into a
tree, he made a myth – a work of art, that is – an
impersonal or objective story woven out of his own
emotion, as the nearest equation he was capable
of. . . .

Ezra Pound: *The Tree*[1]

IN STANLEY'S imagination *Love Among the Nations*, large
though it is, became only a part, perhaps no more than a third, of
an even greater scheme. It included a now separate painting, *The
Turkish Window*, probably based on a reported wartime incident
in which soldiers had broken down a grille over a window to get
into a harem. Intended to extend to the right of the larger painting,
it continues the feeling of 'lovemaking, in which can be seen veiled
women in black veils and white shroud-like clothes. A youth gazes
up to the women, and other youths make love to women through
the bars.'[2]

In that same traumatic year of 1935, Stanley composed 'a series
of fifty small drawings on long strips of wallpaper'.[3] These were
the sketches for his Marriage at Cana scheme. Stanley had begun
to ponder the scheme in the previous year. He worked up one of
the sketches into a drawing called *Legs* which in order to convey
the significant vision patently used the interest he now allowed
himself in women's legs, especially when black-stockinged. During
a weekend houseparty at Bryan Guinness's (Lord Moyne's) home,
to which Stanley and Patricia had been escorted by Henry and
Pansy Lamb, Stanley showed the drawing to Guinness.[4] Among

Bridesmaids at Cana

the guests were Augustus John and his daughter, Lord and Lady Hastings, and Man Ray.* Guinness was impressed with the pattern of the limbs and offered to purchase the forthcoming painting at Stanley's asking price of about £100. Afterwards Patricia and Stanley travelled back with Augustus John to his home, then at Fryern Court near Fordingbridge, where the two men argued

* At one point during the weekend, instead of the tennis or golf customary elsewhere, the guests were asked to help with the dibbling of young cabbage plants. Stanley refused point-blank, arguing that he had dibbled too many cabbages in his life.[5]

about T. E. Lawrence. Stanley thought Lawrence's later lifestyle somewhat 'bogus', but John disagreed vehemently.[6]

When the painting reached Guinness, he was 'a little over-whelmed by the amount of pink flesh',[7] but, keen to encourage Sarah Purser's Friends of the National Collection of Ireland, offered the painting to the new Municipal Art Gallery in Dublin. The cautious city councillors refused it. It was then offered to Belfast, who accepted it. Formally, the painting became *The Bridesmaids at Cana*, and was composed from the memory-feelings of long-ago

Sunday afternoons in the living-room at Fernlea when Stanley sensed that 'the banks of legs gave me the security I used to feel as a child when my view did not extend beyond the crest of bent knees'.[8] The scene, for the participants, is quiet and homely. Gilbert and Stanley sprawl under the table with their backs to the viewer, absorbed in leafing through a wallpaper pattern-book obtained, Gilbert suggests, from William Bailey. The cameo catches one of Stanley's gentle associations — had he not just drawn the entire scheme on the backs of sheets of wallpaper? On the left of the picture the men of the family, discussion exhausted, are absorbed in their Sunday newspapers. In the centre, the 'bridesmaids' and their long legs face the viewer, engrossed in conversation in the manner of Stanley's sisters and their friends in those family Sunday afternoons of his boyhood.

In spite of the fact that only one painting from the fifty found patronage — and other equally ramified schemes were gestating in Stanley's mind — his enthusiasm for the Cana project remained undimmed. He was possessed by the need to express its spiritual meaning. In the biblical account of that long-ago marriage at Cana, an everyday event was sanctified by the presence of Jesus and Mary, an ordinary wedding made symbolic of the meaning of all 'fusion'. When the wine ran out, Jesus, in a vestigial ritual of older mysteries, miraculously provided more by turning water into wine. All in Stanley's terms can drink the water which has been turned into wine. In the other forty-nine paintings there were to be scenes of festivity in the dining-room of Fernlea, in the hall or in the kitchen; there would be guests examining wedding presents or leafing through family photo-albums; there would be casual visitors, even gatecrashers, gladly received; the bride and bridesmaids would be seen happily tucking into slices of wedding cake; all would be welcoming, joyful, busy, noisy. Of these ideas many were later drawn for painting, but only a few were completed at intervals when the mood to do so seized their creator. For the Cana series was only part of a vast interlocking pattern of schemes, of stupendous complexity, which Stanley's ever-fertile mind was now conceiving. There would be an entire series devoted to getting the house ready for the wedding, the Domestic Series, its imagery reflecting memories of Hilda or Elsie or Florence or Annie at home. After the wedding, the assembly would proceed to another series, the

Baptism, taking place at Odney and the Bathing Place. In that symbolic resurrection the entire village would become transfigured into a village in heaven in which a state of emotional or spiritual unity – love – prevailed, in a vast series of Adorations; and all would be contained within the unifying concept of the Last Judgement which naturally followed the resurrections and which, like those paintings, would bear little visual connection and only the slenderest association with biblical exposition, but which would draw as near as Stanley guessed he might ever get to the mystery of his totality, the fusion of humanity into God. To have achieved his dream Stanley would have needed several lifetimes. Obsessed, he tried once more to interest friends in at least some semblance of it, as when he told Gwen Raverat: 'Could you find someone who would let me do one of these schemes in their house; or better still, could I not be paid so much a year to fill this house here in Cookham? As the payment would be supplemented by two or three monthly landscapes in the summer, I might manage to work for £600 a year. If this were divided into subscriptions from different patrons, this might be possible.'[9]

If Stanley had hoped to recruit Patricia to his visionary aspirations, he must have been quickly disillusioned. There is no indication that she was interested in anything of his work more than the money-making 'two or three monthly landscapes'.* One of her complaints against him was that he gave her no help at all with her painting. By 'help' she meant finding her new patrons; she did not consider he had anything of value to teach her about the techniques of painting. In his early enthusiasm Stanley did in fact introduce her to patrons of his own, such as the Behrends and Edward Marsh, for example. But in a later letter to Jas Wood, he confirmed his indifference to her art and to the Bloomsbury circles in which she was welcomed: 'I know nothing about her artistic activities. I have never seen her paint, or with a paint brush in her hand. When that show of hers was being arranged, I always sat in the taxi when she called at Lefevre. . . . Patricia, as you know, is very friendly with Mrs [Vanessa] Bell, Mrs [Helen] Anrep and Duncan Grant, and it was through their agency that she had her

* Patricia told Maurice Collis in 1960: 'I have no opinion of Stanley's work and I never have had, with the exception of his work up to 1920. In fact I very much dislike it.'[10]

show. Mrs Bell hung the pictures. I don't know any of Patricia's friends at all. I don't even know her father, poor little bugger.'[11]

Duncan Macdonald, one of the directors of the Reid and Lefevre Gallery, 'a kindly and prudent man',[12] told John Rothenstein that Patricia, whose work he was encouraging, had asked him for solo exhibition time in the hope of raising sufficient funds to enable her and Dorothy to settle in France, which both loved; she told Macdonald that unless she were given an exhibition, 'she would have to marry that dirty little Stanley Spencer'.[13] According to Gilbert she had made similarly disparaging remarks about Stanley to Roger Fry and Helen Anrep. Macdonald was apparently so shocked that, having to leave for New York, he asked a colleague to tell her he was unable to help.[14]

But he evidently misjudged Patricia's determination. Vanessa Bell had earlier undertaken commissions to decorate the Lefevre Gallery. Both she and Duncan Grant had connections with it sufficiently close for the Gallery not to risk losing their patronage. Patricia appealed to Duncan Grant, who in turn applied judicious pressure. The Gallery offered Patricia her exhibition for the New Year of 1936. Unfortunately she went down with one of her not infrequent illnesses, and Vanessa Bell and Helen Anrep rallied round to prepare the exhibition. Duncan Grant wrote the introduction to her catalogue, an 'unheard of act', according to Clive Bell.

Stanley knew most of the Bloomsberries socially. He had had talks with Boris Anrep about mosaics for the floor at Burghclere, and occasionally accepted invitations after the war to visit the Morrells at Garsington. But none of these were his intimates. The Bloomsberries' claims to intellectual honesty and social liberation led them in Stanley's opinion to pursue an aestheticism and an apostasy which was the opposite of the spiritual, so vital in his own art. His refusal to get out of the taxi may have been because he feared that through Patricia he would accede to their standards; because he thought that they would almost certainly find his association with her a source of amusing gossip; and because he resented the fact that whereas their backgrounds and resources allowed them relative creative freedom, his did not.

Augustus John, Edward Marsh, Kenneth Clark, Mary Behrend and Lord and Lady Hastings were among the visitors to Patricia's exhibition. In its critique, *The Times* referred to her penchant for

retiring 'into the shade, very deeply into the shade, in the excellent interior *The Green Divan. . . .* her still-life work in general has dignity. . . . Miss Preece paints figures well.'[15] In fact it was Dorothy who specialized in figure studies, and the exhibition, although in Patricia's name, must have been their joint work. However, Patricia expressed satisfaction at the result, 'my ideas were worthy of note. I had worked hard without the slightest help from Stanley and been successful'.[16] But either because the exhibition had not raised enough for a move to France – though it made a substantial profit for them of £110 – or because Patricia now felt that her liaison with Stanley might prove more financially rewarding, she and Dorothy remained at Moor Thatch.

In the weeks that followed, with Stanley still finding it impossible to deprive his imagination of the stimulus Patricia offered, Hilda came to the conclusion that it would be kinder to give Stanley the divorce which would settle the matter. In May 1936 she commenced proceedings. A decree nisi was granted in November, after which a further interval of six months was required before a decree absolute could be issued in May 1937. She told him, 'My desire for you is for your happiness in the way you want it. . . . as soon as I saw it was impossible for you to pursue any course other than the one you were pursuing, I left you, never to return.'[17] It reads as the letter of a calm, high-minded woman. High-minded, yes; calm, no. She was bereft. 'Physically and mentally I am going under. . . . there are so many degrees of dying, it is a long and increasingly painful way before one gets just there; what you are doing is nevertheless a degree of murder.'[18]

In a series of unposted letters probably written to clear his own mind, Stanley outlined his proposals for reclaiming her. They were to him logical and in accord with the forthrightness of his feelings. As soon as the decree absolute was granted, 'I shall at once marry Patricia and then, I imagine, I shall at once, or as soon as I have found what my new feeling is, try to get into communication with you. It has never been Patricia's wish to stand between anyone and their likes, and if I still wish to cling to you, she wishes me to.'[19] Stanley was to carry out his plan to the letter.

The Marital Disasters

1936–1939

CHAPTER THIRTY-THREE

Self-Portrait with Patricia Preece

> she is so pretty, truth to tell, wildwood's eyes and
> primarose hair, quietly, all the woods so wild, in
> mauves of moss and daphnedews, how all so still she
> lay, neath of the whitethorn, child of tree, like some
> losthappy leaf, like blowing flower stilled, as fain
> would she anon, for soon again 'twill be, win me,
> woo me, wed me, ah weary me!
>
> James Joyce: *Finnegans Wake*[1]

ANYONE COMING for the first time across Stanley's stunning
nudes of Patricia must admire his sensuous appreciation of her
body. The nude is not a traditional English art form, and Stanley's
pride in his accomplishment sprang from his achieving an intensity
of feeling in them which transcends the merely representational.
In some her head lies awkwardly, as though he had not thought
to leave sufficient space for it on the canvas, a mistake to which
he was sometimes prone. But evidently her face was not the part
which interested him. He brings the eye close to the flesh as if, in
his own simile, he were an ant crawling over it. In some versions
Patricia is solo, but in others Stanley appears.

If the paintings are Adorations, they are not of Patricia in her
real-life persona but of the mystery Stanley experienced in his
visionary feelings about her. Indeed, he recognized that the essential
fulfilment he derived from Patricia was imaginative, for being in
the central aspects of sex unable to satisfy him, in most of the
nudes he uses a pose in which she turns her head from him. Their
composition suggests separateness. In the *Leg of Mutton Nude* the
mutton and the chop incongruously occupying the foreground are
but butchered flesh incapable of life or feeling. In the deep sense
in which Stanley and Hilda were forever fused, he and Patricia
were impotent.

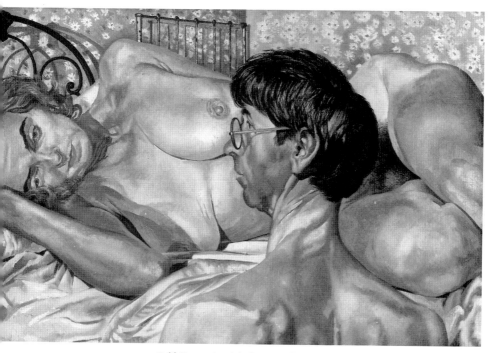

Self-Portrait with Patricia Preece

In the circumstances of the time it was tactless for the paintings to be seen in public, a prohibition which Stanley constantly lamented: 'I wish I could include [in one of Tooth's exhibitions] the nudes I have done. I think to have them interspersed in a show would convey the range of my work. They are quite different. I wish I had more of them. . . . they have such an effect on my other work.'[2] There were other, more practical problems. As Stanley's vision soared, his everyday life was moving towards shipwreck, bumping dangerously from reef to reef. To Patricia he was wasting time painting nudes of her or large visionary paintings like *Love on the Moor* which could not be shown. As for his *St Francis* or his *Dustman*, even Dudley Tooth was warning that such paintings were doing nothing to fill Stanley's purse. They were too overpowering for the private patron and too outlandish for purchase by the more cautious public galleries.

As early as 1934 Stanley had begun to ask Tooth for advances against his credit. The normal arrangement between them was that Tooth would notify Stanley when a painting had been sold but would delay sending the cheque, less his standard one-third com-

mission and framing charges, until the purchaser actually paid. The waiting period became a paper credit to Stanley. By 1936 Stanley was drawing profusely against this credit, and Tooth had to keep a tight rein on his advances. At the one-man show arranged for him by Tooth in June, sales amounted to £1825; but his advances had been so substantial that after Tooth's reimbursements and expenses had been met Stanley was left with only £415.[3]

In all fairness, Stanley did his best to keep Tooth supplied with saleable landscapes and still-lifes, for which there was a continual, even avid, demand. But, despite Patricia's urgings in that direction, he was not a machine. He had to feel drawn to paint a landscape, could do so only on the spot, and it could take him a month or more to produce one to the standard which satisfied him. In any case he found it difficult and uncomfortable work in the colder months. Then he sometimes wore his pyjamas under his clothes as extra insulation and made use of a huge car-muff which Louis Behrend had given him, a vast sack like a sleeping bag into which he inserted himself and a hot-water bottle while he painted.

In the autumn of 1936 he turned increasingly from landscapes to his Domestic Series, having discovered that he could paint them quickly, though they only fetched £20 or £30 as against £150 for a landscape. It hurt him to have to part with them but, as he had told Tooth, there was little likelihood of finding a patron for his envisaged schemes: 'I *love* painting this kind of picture, and I shall be very sad to part with any of them. The reason for their cheapness is (i) that I want to encourage a sale for these figure pictures and (ii) I can do *twelve* such pictures in the time it takes me to do one landscape. Why I suddenly decided to do small pictures is because last year was such an example to me of the remoteness of any chance of a commission for a big scheme.'[4] The paintings sold well, but Stanley continued to spend well too, especially on Patricia. Every two or three weeks now brought requests or pleas from Stanley for more advances from Tooth. With the requests came a succession of imperious demands about his work to which Tooth was expected to attend. There were instructions that Tooth should on no account lend any of his work to public or municipal galleries, on the grounds that few ever bought his 'proper' work and wanted them merely out of curiosity for temporary exhibition. There were similar prohibitions against sending his work to other art dealers

for mixed exhibitions; there were arguments with Tooth over the copyright in his work, over the choice of style and colour in framing, over why his 'proper' paintings were not more forcibly promoted, over being charged for a stack of catalogues which

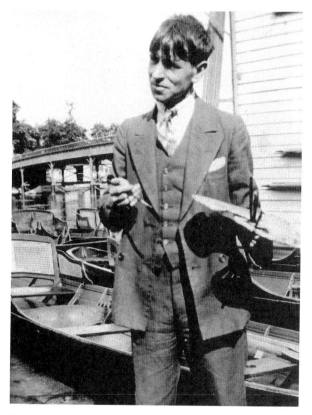

Stanley painting a landscape at Turk's boatyard, with Cookham Bridge in the background, *c.*1936.

Tooth printed to accompany a one-man exhibition arranged in 1934 but which Stanley, for reasons unknown, cancelled at the last minute.

On the whole Dudley Tooth steered Stanley through these shoals tactfully and firmly, evidently appreciating that many of them sprang from the emotional uncertainties of his domestic and financial situation. But even Tooth's patience was strained at times

and, at Christmas 1936, finally broke. The cause was a nude painting of Patricia which Stanley had made earlier in the year. Although Patricia had no objection to posing for it, she was, given their current ambivalent relationship, less happy about its public display. When Stanley sent it to Tooth's gallery for his one-man exhibition of 1936, she made him, to his chagrin, withdraw it: 'I am sorry that the "nude" cannot be included in the show. It is a great pity as this was just the kind of thing that was needed to give variety. Please show it alone to a buyer who is on his own and only if he would contemplate purchase.'[5]

In October Tooth told him that the painting had been bought by a patron 'who is a very serious collector. . . . I could not have found a better home for it.'[6] In December the new owner was approached by 'the most powerful dealer in France' for its loan to a Paris exhibition. Courteously the owner informed Stanley of his intentions. Stanley, happy enough, evidently told Patricia. Her anger or distress was such that Stanley was impelled to reply to the owner forbidding its exhibition. The owner, who had every right to show the painting where and when he wished, protested to Dudley Tooth.[7] Tooth reacted with uncharacteristic asperity. The 'time had come for plain speaking':

You are an artist for whom we have worked very hard and want to continue to do so if you will allow us. We are firm believers in your work and greatly admire the paintings you have done. We want you to express yourself and should never think of dictating to you what you should paint and far less how you should paint. We, as Dealers and I hope good ones, expect the same consideration from yourself. . . . We do not accept dictation from, nor have we ever been offered it by any other artist for whom we deal . . . and I regret that I can no longer offer you special privileges. . . . I know that the basic reason for all your worries is that you think your pictures show to disadvantage when hung with paintings by other artists and that, for this reason, you feel you will lose your reputation and your market. I sympathise with your feelings, but I do not agree with them one jot and frankly I think this is a ridiculous obsession you would do well to get out of your head. . . . So in future I must insist on a free hand if you wish to continue dealing with us. . . .[8]

The threat was obvious. In going over Tooth's head and laying down the law to one of his clients, Stanley had overstepped the

bounds of form and custom. Torn between delight that his painting was wanted, terror that its exhibition would anger Patricia, and alarm that the event would deprive him of Tooth's future support, Stanley had to make a vital decision. Prudence won:

I am sorry there has been this bother about my pictures. I can see that in having my say in the matter of how and where my pictures are shown may interfere in your matter of properly dealing with them, and will therefore in future make no stipulation as to what you do with my work when it is in your hands. I *shall* expect to be allowed to give advice in this matter but you will have the right to act without it.[9]

Tooth was obviously relieved at Stanley's reply. 'I very much appreciate the spirit in which you took my last letter. I want you in future to give us all your confidence, and can assure you that we shall not let you down even if occasionally we do things with which you are not in complete agreement.'[10] He kept his word.

In the emotional tangle in which Hilda, Stanley and Patricia now found themselves it may be unwise to assign blame or responsibility. Stanley so wanted Patricia to share his visionary life that he was prepared to yield to her suggestions that she manage his affairs. He desperately wanted Hilda back, but knew that it would take time and tact. In any case, the divorce proceedings had now reached the stage when petitioner and respondent were advised to remain incommunicado. At what point Stanley propounded his ménage-à-trois plan to Patricia may never be established. But, in whatever way she understood it, subsequent events indicate that she agreed to co-operate in a project which, however outlandish, would retain Stanley in her interest. By an astute balancing act, she could arrange affairs to benefit her materially while freeing her from the full sexual obligations of marriage, for which Hilda would be available. Thus she was able to stipulate that initially their marriage would be only a legal formality. There would be no cohabitation until Hilda too had agreed to take part in the plan. Until then Patricia's prevailing relationship with Dorothy would not be disturbed. She would run Stanley's business affairs from Moor Thatch.

The hearing for the final divorce plea was fixed for 25 May. The divorce was granted, and Hilda was awarded weekly maintenance of £4 10s. The wedding between Stanley and Patricia had already been arranged for the following Saturday, 29 May. It was to be

followed by a honeymoon, which in the circumstances was no more than a six weeks' painting holiday – with Dorothy. Through a friend she had arranged to rent from 1 June a cottage – the Cobbles, Harry's Court – in St Ives in Cornwall.[11]* Anxious to avoid any last-minute hitch in the arrangements – Hilda's complaint that Stanley's maintenance payments were erratic might hold up the hearing – Patricia had written to Hilda to seek her assurance that the proceedings would go through smoothly, and to suggest that Hilda come to Lindworth after the wedding to take possession of any personal property there, even, if she wished, to join the party in Cornwall. As Stanley needed to finish a landscape near Cookham to repay Dudley Tooth, from whom he had obtained an advance of £86 (£65 for travel and accommodation, £5 to silence a creditor, and £16 to reduce his overdraft at the bank, which was stopping his cheques) he would remain behind for some days to finish his painting and would contact Hilda, persuade her to come to Lindworth, and there broach his plan.

The divorce confirmed, Patricia and Stanley were married as arranged at Maidenhead Registry Office. Photographs show a smiling Patricia and a Stanley honouring the occasion by wearing his favourite felt hat. After the wedding, the couple returned to Cookham, Patricia as agreed to Moor Thatch, and Stanley to Lindworth. That same evening he phoned Hilda. To his disappointment he could not reach her, so sent her a note. 'I am longing to see you. I rang you up on Saturday evening, the day of my marrying Patricia, and wanted then to talk to you, but you had gone to Mrs Harter's.† There are many things which cannot be explained until or unless we meet, so do come.'[12]

He left her instructions where to find him. He was working near Rowborough House and the landscape was a view across the valley of the Thames. A few days later, during which Patricia and Dorothy went on to St Ives, she came. Among the property she wished to reclaim were her letters to Stanley, but 'I found that he had arranged

* Patricia's diaries reveal a constant longing to escape from Cookham to some Shangri La where she and Dorothy could be free of financial and emotional worries. France was favourite, but she had happy memories of Cornwall, where they had settled for some time. On one occasion there, in 1922, she had been rescued from drowning by a Jack Solomons, who received the medal of the Royal Humane Society.

† Mrs Harter was mother of Gwen, widow of Hilda's brother Sidney. After his death, Gwen had moved to her mother's house then in Epsom.

Stanley and Patricia marry at Maidenhead Registry Office on Saturday 29 May 1937. The witnesses were Dorothy Hepworth (left) and Jas Wood (right).

them so beautifully in order, his and my corresponding ones, all numbered and tied in knots and so on, and I had not the heart to separate his from mine and undo all his work and take half away. . . . They all seemed to belong together, and as I knew that he often re-read those early letters of mine, and sometimes of his, I decided to leave them there untouched.'[13] The effect on Hilda of their meeting was a surge of the love they had shared: 'I can tell you that the joy and relief of finding he not only liked me, but seemed to be just like his old self to me, was overwhelming. He assured me that Patricia *wanted* me to spend the night with him and it would in no way be harming her.'[14]

So she yielded. Stanley's dream was materializing. 'The next day Stanley began explaining the whole scheme to me and then I began to realise that I might have been beguiled by the whole atmosphere. . . . all the same, I did not regret it, as that perfect day seemed to wipe away all the last few years and to have put things right between Stanley and me.'[15]

What happened when Stanley reached St Ives, joyous at his progress, is unclear. But a furious argument between him and Patricia about their respective interpretation of affairs evidently developed. Patricia, keen in later years to absolve herself of responsibility, gave her version of the argument:

As we were returning from Carbis Bay some days after his arrival he told me that Hilda had been at Lindworth. It had been arranged that Hilda should call at Lindworth and collect some articles belonging to her. He told me she had stayed the night with him there, and with commanding gestures and a dominating and shouting voice and manner, he said he intended to sleep with her whenever he wished and that he required two wives, his work needed absolute sexual freedom. I was dumbfounded.[16]

She probably was; not at Stanley's success, which she intended, but at his insistence that they should now cohabit. She later claimed publicly that she was so shocked that Dorothy moved her into her room and 'was ready to throw him down the stairs if he tried to get into me, miserable little man that he was'.[17] She had miscalculated.

In Stanley's writings there are two accounts. In one, prepared for later legal purposes, and the gist of which he relayed to friends, Dorothy confronted him at the door on his arrival 'in her men's trousers' and told him that, as at Moor Thatch, he was welcome but must occupy separate accommodation. Stanley implies that this meant under a separate roof. There was even, he claims, a period when he had no access to either woman. The second of Stanley's accounts, however, written later to Hilda, if oblique in detail, is more private and balanced. From this it seems that he and Patricia did at first try to have sex, but so unsatisfactorily that Patricia decided not to continue. This, one suspects, was the reason for Patricia's retreating to Dorothy's room. The frustrated Stanley, grumbling that 'she said she would not live with me until I had fixed up with Hilda and persuaded her to share the marriage',[18] may have stormed out of the cottage to find himself other lodgings. But calming after a while and in any case short of money, he returned to the cottage and accepted his solitary room, deciding that he had perhaps pressed himself on Patricia too fiercely: 'I was still clumsy with Patricia and she tried to face the possibility of my

having Hilda also. Until my marriage to Patricia, Hilda did not know of this, but Patricia had arranged with me that as soon as she and I were married, I was to tell Hilda.'[19]

In the meantime, back in Cookham, Hilda, with characteristic consideration, 'thoroughly spring-cleaned Lindworth, put up new curtains, made everything comfortable, and made everything as perfect and inviting as I could, as I knew Stanley wanted to make it nice for her'.[20]

For the remainder of the six weeks Stanley stayed in St Ives with the two women, made friends with the local fishermen, and despite unseasonable weather and a six-day week – work on the Sabbath was frowned on by the locals – painted some six different views of the port which capture the lucid summer light of that coast. The whole holiday had been in Patricia's words 'simply a money-making project'.[21]

On their return to Cookham, he to Lindworth, they to Moor Thatch, Patricia, says Stanley, again took charge of his efforts to retrieve Hilda. Evidently she did not want to court the possibility that another furious row over their sexual relationship might jeopardize her hold on him. She 'told him', according to Hilda, to write to her, and supported his efforts with a long letter to Hilda confirming her desire for the arrangement. Hilda answered Patricia with an equally long letter declining the offer; although she understood Stanley's notion, she felt she could not become a mistress where she had been a wife.[22] But she signed the letter 'Yours affectionately', and accompanied her answer with a separate letter to Stanley telling him with irony that she 'had had a *nice* letter from Patricia' and explaining her refusal.

Stanley, knowing Hilda, wanted to allow matters to take a gentler course. 'But Patricia always tried to force the pace and in a case like this where it was my own wish, she insisted on arranging how and when it was to be done.'[23] The letters accomplished nothing, so Patricia 'insisted' that Stanley should not only visit Hilda in Hampstead with the purpose of persuading her, but even stay there for the remainder of the summer until his aim was achieved.[24]

So, dubious but ever hopeful, Stanley set out to follow her advice.

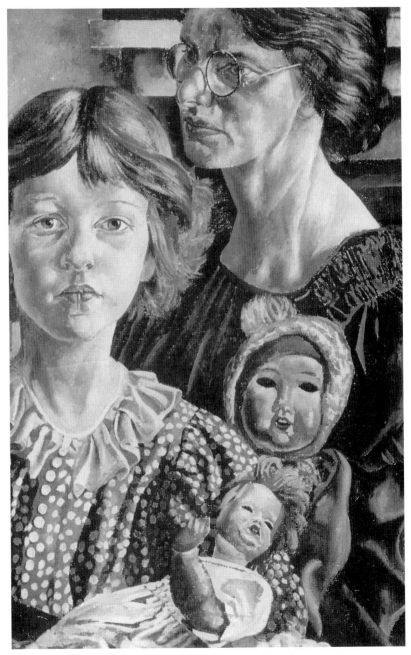

Hilda, Unity and Dolls (also reproduced in colour)

CHAPTER THIRTY-FOUR

Hilda, Unity and Dolls

My personal life is up-in-heaven life. My impersonal
life is a separate-from-me thing, and my behaviour is
quite difficult.

Stanley Spencer[1]

WHEN HE arrived at Downshire Hill, Stanley, said Hilda, 'pro-
pounded the scheme all over again'. But in the meantime she had
been having second thoughts. 'I got so confused with his irrefutable
arguments that I did not know what to think.'[2] Her heart urged
her to go where her deeply held principles told her it would be
folly. Lindworth was no longer her home. Stanley, in her view,
had robbed her by bestowing on Patricia something of himself
which rightfully remained hers: 'My greatest joy in you, and you
may think it is a puny choice was the fact that you were pure; that
you had not even kissed anyone but me. No matter what happens,
no matter how unhappy I was at times, I always felt with the
dearest, deepest, strongest and most grateful feelings that you had
given me a jewel beyond price, that you were pure. So I always felt
you were the best husband in the world.'[3]

Still in pursuit of his dream, Stanley hatched the idea of going
on from Hampstead to Wangford to finish for Tooth two land-
scapes he had begun there during an earlier visit. To tempt Hilda
to go with him, he arranged to stay with the Lamberts in the same
cottage and in the same bedroom as on their honeymoon, and 'said
that everything was arranged for me to go there and would I come?
But I did not go.' Stanley stayed there long enough to finish the
two landscapes and to seethe with frustration. From Wangford he
drafted a report to Patricia, apparently unsent: 'It is terrible to
have that futile visit to Hampstead hanging over my head. I
cannot stay any longer as I have the strain of the thoughts of that
Hampstead visit hanging over me. The whole thing is so *frightening*

and *alarming* that I am unable to write or think of any other thing to say to Hilda. I *cannot* bear sleeping in her house if I am in any other room than Hilda's. ... The strain of keeping a curb on myself in that house is so great that it takes all my vitality and energy to be able to stand this sort of thing.'[4] However, in a despairing effort he returned from Wangford to Hampstead and stayed with the Carlines a further ten days during which he painted or started one of his most moving portraits, the magnificent *Hilda, Unity and Dolls*. Hilda is in profile, contemplative. Unity looks out with candour and a questing look. The dolls counterpointing mother and daughter are eyeless. The painting was in a sense an adieu: 'I shall be glad when this visit is over. If it continues in this manner, it will be a waste of time. When I opened my door I saw that Mrs Carline's door was open. ...'[5]

One of Hilda's characteristics was a genuine concern and nobility of sentiment which Stanley admired except when it was directed at thwarting his own wants. She did her best to console him for her obduracy by sending him a flow of admonitory letters: 'Surely your marriage with Patricia cannot be perfect without that side is perfectly achieved too; and if you know there is nothing else, you will make more effort to bring that to perfection. Stanley, do take her to the best gynocologist – is that the word?'[6] Sometimes he found the gratuitousness of her advice insulting and berated her for it. But when she mused on their lost love, his heart went out to her. One such letter indicates her feelings about the measure of their love and its losing:

Oh my darling, why do things always come too late? There seems to have been tragedy throughout our marriage. When there should have been complete happiness, it was never quite so, and when there should have been sexual freedom, there never was. ... You would reckon to shape your own destiny, and therefore forcing things and riding right over them is part of your outlook. To you that seems right, to take the matter in your own hands and shape it as you will. My feeling is that I know my life has been planned from the beginning. ... You know, it is a funny thing that you know my shade and hue, my shape, the glowingness of my colour, but you don't know the realm in which my mind wanders. ... I too know your nature, your colour, your potentialities, your intense beauties, your beautiful lovely form and being, and no-one else, I am

sure, does. And yet I am not in your mind and I know I never will be. That is why we cannot pull together.[7]

Back in Cookham, Stanley was nevertheless outwardly buoyant enough. He was relieved to allow Patricia to take charge of his saleable production and in the role of business manager do her best to organize an escape from what had by then become their acute financial difficulties. This was no sinecure. Stanley later claimed that in the years preceding their wedding he had spent between £1200 and £2000 – £30,000 or more today – running up bills on his purchases for her. He who all his life had scrupulously accumulated funds and handled them punctiliously now found that the fervour of his Patricia-feelings had left him unable to settle bills, to sustain an overdraft at the bank, to keep up regular maintenance payments to Hilda, or meet the accumulation of income tax demands. His daybook for 1938 contains little but hastily scribbled notes of payments in and out; items which in earlier years he had seldom bothered to record.

Even before the wedding, financial disaster had loomed. At Patricia's urging, Stanley sought cash where he could. He turned to friends like Gwen Raverat, not for loans but for purchases or commissions, anything he could paint and sell quickly. He cut off the more inoffensive sections of some of his large 'erotic' paintings for sale. As there was a ready market for his landscapes, Patricia specified a production routine – one landscape every ten days. A list shows that at one period between 13 February and 10 August Stanley completed no less than twenty-four landscapes and still-lifes.[8] Every morning, whatever the weather, he trudged out with his huge umbrella and his painting materials in the children's old pram to locate and paint the scenes on which his and Patricia's livelihood now depended. Stanley would take each finished painting to Moor Thatch where, according to his own no doubt ironic account, he would receive a cup of tea in the kitchen and the reward of being allowed to kiss Patricia's hand. To keep him working, she would take the paintings to Dudley Tooth and bring back the payments from previous sales.

A month or so before their wedding they had discovered that the Charing Cross Road bookseller Anton Zwemmer was extending his interests into a new art gallery in Soho, and would offer cash

advances against suitable work which could be bought outright. Patricia persuaded Stanley to offer some of his cherished drawings. Zwemmer came down to Cookham and arranged to buy fifty for £100, and when he later came again to collect them, he also bought for £20 each two visionary paintings on which Stanley was working, *Adoration of Old Men* and *Adoration of Girls*. The correspondence on these deals, although in Stanley's name, was addressed to Moor Thatch.[9] Left to himself it is unlikely that Stanley would have placed himself in a position which might jeopardize his obligations to Tooth. He later implied that there was a venal streak in Patricia which startled him: 'One day Patricia said that Mrs X was very silly to take those plants from the flower beds outside someone's house as "she could so easily be caught". That's about it, *nothing matters if you don't get caught.*'[10]*

A few weeks later, Dudley Tooth discovered what was happening at Zwemmer. He had every right to impale Stanley, but decided that to do so would be counter-productive, and accepted Stanley's explanation that the trouble sprang from his having placed all his business arrangements in Patricia's hands. Tooth then devoted his considerable skills to restoring the situation. He agreed an arrangement with Stanley whereby Patricia, although continuing to manage Stanley's production, would in future channel it exclusively to his firm. In return he would send weekly to Stanley a cheque for £8 to cover everyday necessities. Patricia found the arrangement 'insulting', but Tooth argued that he could not 'serve two masters'; he had to deal with one or the other, and it could only be with Stanley. He then began negotiations with Zwemmer.[11] They took him into the following year and Tooth had, using Stanley's credit, to pay £150 for just one of the major paintings Patricia had sold to Zwemmer for £20. However, a deal was finally completed in August 1938 whereby Stanley would agree to surrender drawings for which he had been paid £100, and Zwemmer would sell back four paintings for the £60 at which he had bought them; Tooth found the £60 through the sale of *The Bridle Path*, one of Stanley's best-loved landscapes.[12]

* Patricia had no compunction about following Mrs X's example. In her diary for 1932 she mentions two occasions on which she and Dorothy walked down Mill Lane to Formosa, where one of the large residences was apparently unoccupied. From the garden they dug up plants and shrubs for their own garden at Moor Thatch.

However disgruntled Stanley may have been at Patricia's every-day behaviour, the fact remains that he saw her, as he saw Hilda, through eyes which beheld a vision of them to which the real-life women could not conform. Certainly it was a vision which the public at large could not begin to comprehend. Stanley's behaviour seemed erratic, curious, even bizarre, and the imaginative figure paintings which followed equally so.

A Village in Heaven

CHAPTER THIRTY-FIVE

A Village in Heaven

To me there are two joys, the joys of innocence
and religiousness, and the joys of change and sexual
experience; and while these two selves seem unrelated
and irreconcilable, still I am convinced of their ulti-
mate union.

Stanley Spencer[1]

DURING THE marital and financial tensions of this difficult period
Stanley continued to escape when he could into his studio to
lose himself in his 'up-in-heaven' life and to develop his major
preoccupation, producing paintings in the several series which
would flow together like tributary streams to form the Great
Processional of his church house.

Two major themes dominated the Processional at this time.
Already in existence was *The Marriage in Cana* series with its
subsidiaries *The Domestic Series* and *The Baptism Series*. But now
a further concept was under consideration. Stanley was determined
to envisage not merely a series of isolated even if associated

redemptions but a *continuous state* of redemption. Needing a biblical paradigm, Stanley decided on the Last Judgement.

The choice was not as recondite as it might first seem. The Last Judgement is the final biblical happening before the redeemed are confirmed into their inheritance of heaven. The Last Judgement – Stanley preferred the term the Last Day – was in his interpretation the event whereby everyone is finally brought into mutual comprehension. In that ultimate all-encompassing sway of universal love, the barriers which on earth keep everyone separate and individual will have melted away and all will be 'liked'; that is be made alike, find the identity which earthly sense denies, be made one in universal consciousness. From then on all will be permanently in heaven, 'home', at peace. For Stanley the concept was to be approached in his forthcoming paintings by drawing on the memory-feelings of adolescence, when he extended his comprehension of love from 'home' – Fernlea – to the wider context of Cookham – 'heaven'. His 1937 painting of *A Village in Heaven* exemplifies the notion.

The title of the painting was a compromise between Stanley's choice, *The Celebration of Love in Heaven*, and Dudley Tooth's suggestion, *A Village Fête*, which he recommended as making the subject more saleable. The scene is set on the part of Cookham Moor near the War Memorial, the association of the moor with lovers being repeated from *Love on the Moor*. The war memorial is truncated by the top edge of the picture, so that it rises priapically.

The cross is cut off, being as redundant in this spiritual heaven as are the soldiers' crosses in the Burghclere altar-piece. Standing on the plinth the figure of an elderly man – Pa – gestures in delight as the redeemed explore their revelation, echoing the similar figure which appeared, less obviously, in *Love on the Moor*.

The figure – Stanley calls him a 'disciple' – was important to him in manifesting the power of the feelings he tried to put into his work, and appears in much of his 'erotic' output. It represents a personification of his feelings in the same state of ecstasy – 'adoration' – as that in which the composition was conceived. The figure is there to justify or perhaps to glorify the portrayed sensations, and so that the real-life Stanley imaginatively composing the work can experience the experience he is re-creating: 'a revealer of ourselves together; me taking part in what is being adored'.[2]*

The figure is no longer the self-figure of earlier paintings, but is usually in the form of an ecstatic old man, often portrayed in the image of Pa. Old men were becoming venerated by Stanley as having acquired the wisdom he was himself now seeking. Their wisdom was not necessarily that of everyday knowledge or commonsense. Stanley's old men have survived, and in their survival know, even if they cannot describe, the mystery Stanley seeks to understand. The figures are icons. As icons they are in a line of descent through Pa, through the old men being brushed down in *The Cookham Resurrection*, through *St Francis and the Birds*. They can be interpreted as God; not God as totality, but God as that tiny fraction of the concept of God applicable to the situation given in the painting, becoming in Stanley's terminology 'disciples'.

On the left side of the painting the redeemed explore their new understanding rapturously. Many embrace each other or the trunks of trees, the roots of which lace the foreground, 'just as snakes are worshipped as they climb about the branches placed in an aquarium in a Buddhist temple', wrote Stanley. In fact he seems to have developed the imagery from his study at the time of 'a book of

* Stanley's figure has antecedents in the occasional figure in high Renaissance paintings who looks not at what is being staged but straight out of the canvas at the viewer; sometimes the figure is a portrait of the artist. The figure has been called the *Sprecher*, the 'I-was-there, the secretary to posterity'. Stanley's disciple, however, invariably looks at what is happening, and is emotionally involved in the event being celebrated.[3]

Indian temple sculptures' in which the archaic priapic symbolism of trees and snakes caught his imagination.[4]

Among the roots lie or sit figures in contemplation. Many are emotionally Stanley, but one seems recognizably him, lying prone on his stomach, legs raised and crossed like one of the foreground figures in *The Cookham Resurrection*. He grasps the root of a tree as he gazes at the black-stockinged legs of a girl who is looking towards the trunk of a tree. The imagery seems to relate to Stanley's feeling about Elsie. He craved her youth, her unaffected good nature, her joyousness in the simplicities of life, that 'desire to have a good time' which conveyed to him the understanding that she was 'on the threshold of life' and which he described as 'cinemas, motor-bikes, boys, and local socials and calling on friends and going off on jaunts and sending presents to innumerable baby nephews and nieces and quick and not prolonged chats to the tradesmen and then ironing and washing and picking beans and pulling off brussels sprouts, and judicious and reflective in it all … much singing of common love songs.'[5] Her liveliness and busy-ness, which he contrasted with Hilda's languor, became equated for him with his interest in female legs, so that 'Elsie's legs in their willingness in conveying her varied wishes, and their quick immediate response, expressed in these activities and actions so much of what her wishes and thoughts were that one could see what one loved in them. All she does is joy because it is on the way to joy, if it is not joy itself, so that the hanging up of the stockings and contracting of calves and tiptoeing is all part of the coming evening-out or social or general atmosphere of her life.'[6]

He had intimated the feeling in his earlier *Workmen in the House* in which he showed Elsie sitting on the floor of the kitchen to put on her gaiters; she rode a motorcycle to and from the cottage at Burghclere. But now in this painting he has found the means to link himself with the essense of the erotic feelings of his Elsie-image, to absorb her meaning into his up-in-heaven life, and to celebrate the delight of a spiritual conjoining denied him in the prosaic realities of actual existence.

So too he carries his feelings into all the figures in the painting, to the nearby girl, a Patricia-image in feeling perhaps, who is deep in thought and stared at by another girl – perhaps Dorothy. Both

grasp the tree-roots. In the centre two girls – Patricia and Dorothy again? – embrace in celebration of their love, while a couple of 'Stanleys' gaze at them, anxious to join in the joy of an experience outside their maleness; one offers the gift of a flower. Behind them, a younger, more isolated girl holds her hand before her eyes while her young companions to the right look on. Possibly she is crying, and the others are jeering at her; but more probably she is peeping to see what the adults are doing, and her companions are gingerly curious. In the lower right, an older girl at the entrance to a house presses to her chest a large closed book, an album of some kind. She is taking it home to explore it. There is a feeling in these cameos of expectancy, of a desire to enter the closed world of others. In the distance, near the wall of Moor Hall, a solitary figure wanders, wearing the fur stole which appeared in *By the River*.

As a composition, the painting continues Stanley's interest in the triptych form. The emotional centre of the painting is the group comprising the embracing women watched by the small Stanleys. The right half is dominated by the patently Freudian symbol of the war memorial past which other groups of youngsters, emerging from the National School in School Lane, are ushered by shooing parents; the children are too young yet to be introduced to the meaning of what is occurring. Like the boys playing football in *Love on the Moor*, their innocence counterpoints the discoveries their elders are making and for which the elderly man, the disciple who knows it all, is giving thanks. How often must Stanley as a young man, sitting as he described at the open window of Fernlea and pondering on these mysteries, have listened to the chatter of village children as they came out of their school just the length of two gardens away!

The figures looking on – Stanley, the schoolgirl – are witness to the meaning implicit in the painting. Stanley has illustrated specific sexual activity, in this case the lesbianism of Patricia and Dorothy. He is curious about it, and becomes as physically stimulated by it as he is elsewhere by the sight of black-stockinged legs. But his curiosity and excitement is not voyeurism. On the contrary, he and the schoolgirl are becoming aware that individual sexual activities, in whatever form and however foreign to one's personal incli-nations they may be, are essentially aspects of the universality of love. It is this universality he seeks to emphasize. However bizarre

this and similar expositions may at first seem, their message remains the same. Through comprehension, through spiritual redemption, the barriers of earthly compartmentalization, of 'prison-wall-tapping', can be broken down, and all can share in the true identity and heavenly meaning of love.

Adoration of Old Men

> In this drawing the man is lying sideways and back
> view along the bottom of the picture. It was a most
> passionate drawing of his vertebral column, and he
> was full of that wonderful romantic aura that belongs
> to an old man. . . . I could have kissed every bone of
> his spine.
>
> Stanley Spencer[1]

THE PROCESS of absorbing experience into his consciousness
and then finding himself compelled to reproduce its meaning
through an associate reconstruction was so awe-inspiring – 're-
ligious' – to Stanley that only profound and soul-shaking imagery
could do it justice. He was entering a world of imaginative rapture
unfettered by the material. He was in the Adoration of God.

So he moved into another of his Last Judgement series, his
Adorations. Girls in their 'sacred image' were to be adored. So
were old men. In his *Adoration of Old Men*, also set in what
appears to be School Lane, another crowd of schoolchildren came
upon the activities of their elders. The scene they are witnessing
occupies the foreground and comprises a group of old, mostly
bearded men. Some look upwards as though in ecstasy. Only one
is young; he is dark-haired and not unlike early photographs of
Will. On the left of the group one old man is falling forward and
is held by a young woman sitting sprawled on the ground. Another
woman supports her, bending over and wearing a summer dress
so thin that her buttocks are clearly delineated, her calves stretched
as she bends, her black shoes high-heeled. Other women are
stretching out their arms, appealing and excited.

The painting, of course, is not a depiction of a group of grotesque
old men being greeted by a gaggle of attractive and adoring girls.
It is, Stanley explains, a painting of his esoteric comprehension.

Adoration of Old Men

The old men continue to be for Stanley those who have in their span of life instinctively honoured the demands of the physical world, and are now in retreat from the life-creating instinct whose regenerative demands they can no longer satisfy. They are moving into a memory-world in which experience is being redeemed into the spiritual. 'Old men', said Eliot, 'should be explorers'.[2]*

The young women in Stanley's painting understand this notion. The physical reality of School Lane has become sacrosanct. The old men and the women are not 'real'. Stanley himself has become the women in the painting in order to convey the force of his experience. His 'disciple' is now an apparent Patricia figure bending

* Old women, too, as Stanley argued in his painting of *Sarah Tubb and the Heavenly Visitors*, based on a village memory of Granny Tubb who was so awed by an apparition in the northern sky – Halley's comet in one account, but in another an Aurora Borealis – that she came out into Cookham High Street and knelt to pray. In the street Stanley surrounds her in his painting with the everyday items she would have loved. Her physical home has become her spiritual 'home'. She is 'at peace', 'redeemed'.

forward to support the girl on the ground. By Stanley's logic such images contain within them the miraculous power to make connection with the spiritual meaning he seeks. Thus his later description of the painting by such reasoning becomes valid: 'I only admire what is meaningful to me, this time I am the girls and I have imagined a girl who is supposed to be me and to have my feelings sexually. . . . The thing that is prompting their awe is the thought of going to bed with any of them. The disciple here is one of the girls who supports another woman who is rejoicing as the old man bends forward on to her supporting hands. She is almost fainting with the joy that she is to be alone with him.'[3] 'Going to bed with any of them' . . . 'to be alone with him' . . . The notion may appear unconventional, but not for Stanley. He is taking us into another of the labyrinthine passages which punctuate his psyche. This one appeared in *The Resurrection of Soldiers*, without any sexual or erotic connotation, as the figure resurrecting between the fallen mules – Stanley as a child safe from nightmare between his parents' sleeping bodies. It appears too in his writing, again without sexual or erotic overtone, as a recollection of the first visit to Hilda's bedroom in the days when he lodged with the Carlines at Downshire Hill: 'And one night as I was lying in bed it suddenly occurred to me to go down to your bedroom. I was in my nightshirt. I was trembling so much I could hardly stand, and as I came in you said 'Oh!' and then 'Oh, ducky!' I got into bed and we talked about God and Christian Science, and I remember thinking how nice it was.'[4]

The schoolchildren in his painting have not yet attained such possibility. Theirs is still a physical world of vigour and directness. They are all girls. Those in the distance clutch picturebooks or albums like that in *The Village in Heaven*. But now most are opened and are being marvelled at. Surely their future is intended to counterpoint the old men's past.

In this *Adoration* Stanley is entering the situation he depicts. He is once again overwhelmed by the discovery that he can do more than envy those whom, like the old men in his picture, he perceives to be in the state of spiritual peace. He can, by his art, join with them, make their comprehensions his, commit his 'spiritual rape' on them. In the intensity of his feeling he himself is his cluster of girls, and his too is their longing to fuse with the life-experience of

the old men. 'I felt such a passion and a longing when I did that old man, he was so real and vivid to me when I drew him engaging in contemplation of his wife. Writing this has given me an erection. Don't you [Hilda] think there is some meaning in it? You once said when I asked you to dance about, which you did, that there was always something in all my wants . . . that it was said not from emptiness of feeling but from fulness of it.'[5]

'Fulness of feeling': just as Stanley would have liked to have been a mother in order to join himself to the fact and meaning of creation, so he badly wanted to experience love in whatever form it appears; not in its specific physical sensation, but in the feelings which give it consciousness:

You know, ducky, I wish I had the experience of being a bugger.* I am sure I would show more real understanding of it. What convinces me that most buggers I have heard of have no understanding of it is that they always try to isolate their experience to one thing, usually with pride saying: 'We love men.' My reply to that is: 'I love', and when one says 'What?', I say 'Where I can find it.' I don't like meaningless things, and no one has yet been able to express any feeling for a man that has given me any feeling. . . . I want the female but I also want the male, because the evocation of sexual desire comes from a sense of worth and worthiness of a living thing regardless of sex.[6]

It was, of course, inevitable that the public of the 1930s did not see this new generation of paintings in the same light. Their comments roused him to indignation:

Existing laws and conventions interfere to a serious degree with my paintings. My art depends on emotions and wishes. If they are interfered with, my work suffers. I know the excellence of these wishes. I know the powers these wishes have. It is ghastly that my art should be made subject to what vulgarity happens to lay down in law and morality. Such values, applied to my pictures, are quite inadequate to elucidate their true meaning. I am not against anything I know of. I will examine a religious scale of values as carefully as a non-religious scale. If anything, I am prejudiced to the religious side. But I am not going to have the religionist

* Stanley is not being derogatory; we would use the term 'gay' today.

telling me what to worship. In all my sex experience I notice the same degree of emotion as in religious experience. But I feel lonely in finding myself the only worshipper when I am convinced the erotic side I am drawn to belongs to the very essence of religion. I feel that I am actually discovering a hoard of significant meanings to life, but am being hampered in my task. The intention of all my work is towards happiness and peace.[7]

Looking back in later life, Stanley did occasionally ask himself if the attempt in these pictures to reach the spiritual through the physical had not over-emphasized the erotic aspect, so that the spiritual was not established with sufficient clarity. Comparing them with his early, pre-1915, paintings in which in his 'innocence' he had achieved a finer equilibrium, he thought that a 'lack of balance' in these paintings might have been due to his inability to find complete sexual fulfilment through Patricia and Hilda. At one point, he refers to these paintings as his 'sex-pictures', meaning not that they were erotic in purpose, but that he had in them over-used the specifically erotic to achieve vision. He named *The Resurrection, Cookham* as the first of these.

The Beatitudes of Love

'Rat!' he found breath to whisper, shaking, 'Are you
afraid?' 'Afraid?' murmured the Rat, his eyes shining
with unutterable love. 'Afraid! Of *Him*. O, never,
never! And yet – and yet – O, Mole, I am afraid!'

Kenneth Grahame: *The Wind in the Willows*[1]

THE ECONOMIC depression of the thirties was an unfortunate
time for an artist to have squandered his capital. There was little
incentive for investment in major works of art. Stanley's landscapes
sold well, but Tooth had to accept reduced prices. Much of the
acclaim Stanley had won with the Burghclere Chapel and *The
Cookham Resurrection* evaporated as his 'erotic' paintings came
on the market. The result of the 1938 Venice Biennale, at which
five of Stanley's paintings and five of his drawings were hung in
the British Pavilion, was disheartening. One of Patricia's nudes
was included. Stanley was powerless to prevent it being shown,
and had to endure her nagging: 'It was always something *I* had
done which put *her* in an awkward position.' If that were not
trouble enough, Stanley's more visionary paintings at the Biennale
were received only with curiosity, or were scorned as decadent;
the police had to be called to quell one protest.[2]

The fierce political polarization of continental Europe in the
twenties and thirties gave a sharpness of definition, a sense of
agitation and protest to continental painting against which contem-
porary British painting, to European intellectuals, seemed bland
and uninventive. The United Kingdom, reluctant to be drawn into
events in Europe, was seen as aloof and smug, and its painters as
passionless. Stanley's refusal to indicate overtly the least political
stance – to go nowhere where he could not trust his judgement –
combined with his seeming dedication to an outmoded religious
idealism, made his work of little concern in a Europe where the

The Beatitudes of Love: Contemplation (also reproduced in colour)

dance of the innovative, of the expressionists, the cubists, the dadaists and surrealists, was focussing, surprising and dazzling world attention.

Stanley retreated in 1937 into his memory-feelings. His writings began to include strange little anecdotes in which the characters are given imaginary personalities, as though he were seeing them as friends in some personal yet fantastic dream. They were all 'couples'. There was 'the Gardener Couple', 'the Clerk Couple', 'the Bride Couple' and others. The allusive association of 'coupling' is obvious. The 'couples' represented a metaphysical partnership; Stanley linked himself to a perceived aspect of 'love' in each of these partners. In paint, he began to reproduce the cameos in yet another series for his expanding church house. He gave them the biblical heading *The Beatitudes of Love*, but saw them as a continuation or sub-branch of his *Adorations* series. In some of the *Beatitudes*, he portrays himself with one other figure of the opposite sex, a couple fused together into 'a single organism'. In others, the Stanley-figure is coupled with several women who collectively form the opposite entity in the partnership. In a few, several Stanley-figures partner several women, but each pair is a 'couple' in feeling; and in at least one painting he reverses the sexes as he did in the disciple in *Adoration of Old Men* to make himself female in the presence of a male partner.

Superficially, the paintings astonish for the apparent deformity or ugliness in their figures. He was later to tell his daughters that as it was the emotional connections between the figures which mattered to him, anatomical correctness was simply sacrificed where it got in the way: their physical expressions are expressions of their emotional involvement with one another. To Stanley, the former medical orderly, the biological was never ugly. When a radio interviewer in the 1950s asked him why the figures in his paintings were so strange, it was typical of him at first to pretend polite surprise that she found them so, and then, tongue-in-cheek, to suggest that she should look out of the window and imagine how the passers-by would appear without their fashionable dresses or their tailored suits, without corsets, stays, belts or the benefits of buttons and elastic. Did not his art make them more real?

But in *The Beatitudes* there is in addition a deeper astonishment in that for the first and only time in his art Stanley divorced

figures from their surroundings. At first sight they seem abstract emanations of his imagination, like the figures in *Apple Gatherers*. But those were related to place-feeling. In *The Beatitudes* there is no place-feeling. The figures are real people in Stanley's experience, chosen because in some way they became bonded to him. Their distortion arises only partly because he wished to conceal their identity. More validly he was showing them as spiritual objects of his bonding. Few probably recognized themselves. Fewer still could have had an inkling of the imaginative use Stanley was making of them.

At one level, *The Beatitudes* can be seen as the purest distillation of feeling Stanley ever achieved. They represent his Herculean struggle to achieve a clarity and concentration as yet unreached; but only at the cost, dangerous to him, of freeing his imagination from the anchor of place-feeling. The experiment – if such it was – was not sustained, and in other series he reverted to his former standard style. Nevertheless, 'This group of paintings expresses two of my longings. One was that I wanted to look upon people in the same "possessive" way I looked at nature or at anything especially "mine" – mine, only because in no other way could I express what I liked in them. In the first six [the *Adoration* paintings] one has a completely uncritical and forthright love and adoration expressed freely and in a sense indiscriminately. Something of the same covetous motive directed me in doing the Couples series; and yet they still belong as 'guests' to the Cana series and as 'being liked' (judgment) to the Judgment idea.'[3]

In the painting called *Contemplation*, Stanley provides an insight into this process. The painting shows a Stanley-figure in the foreground of a group of strangely distorted women as though at a party. The woman beside him at whom he 'gazes' is his 'partner'. She extends her arm to draw him to her. He holds the extended arm and rests his other arm on her shoulder. The couple are 'contemplating' each other. The woman is dressed in a skirt and blouse, and wears a lace decoration at her throat which, Stanley remarks, is her 'bridal veil'. Over her shoulder lies a fur stole. In their gestures of contemplation the couple are metaphorically being wedded. She is a memory-feeling from the days when Stanley found himself sexually responding to the several women who stirred his imagination, a memory-feeling transformed in this picture into

imagery which manifests the desire of the beholder to savour his love by simply gazing at the beloved. A frequent refrain, for example, in his early passion for Patricia was the stimulation he derived from watching her: 'I like the sexual business to be the result of a conscious joy and pleasure we find in each other, and love to sit and stare and watch you.'[4] But if Patricia sensed he was watching her thus, she would, he says, stop him; so that his 'contemplation' of her had to be surreptitious.

Stanley enjoyed similar 'contemplations' of Hilda, and in his later writings he acknowledges his feelings at watching Elsie too as she went about her work. Her matter-of-fact joy in physical movement raised a response in him which, in his imaginative terms, wedded him to her:

The understanding which has been reached between the two chief figures in the picture ... is expressed through their staring at each other in this never-to-stop way. ... It is of people making themselves endlessly acquainted with each other through passion and desire. The strength of their desire *alone* tells them that everything they wish for and nothing they don't wish for is there before their eyes. ... The thoughts as they gaze at each other are different but never clashing.[5]

Love has performed its miracle of redemption, so that in this composite Hilda-Patricia-Elsie figure – and how many other un-identified women are in there? – Stanley's 'passion and desire' transcend their physical origins.

Behind the couple another group continue the feeling. A bald-headed man is placed as an almost exact reverse-image of the foreground woman; he is contemplating a large-faced woman who gazes back at him. The forcefully depicted woman on the left, also wearing the fashionable fox fur, seems less contemplative than watchful. There is disapproval, severity, even envy in her frustrated look.

In the example entitled *Knowing* – the Grocer couple, or Hus-band and Wife – a small daft-looking woman in absurdly old-fashioned ringlets stretches out an elastic arm towards the chest of a huge moustachioed man seen as though distorted through the wide-angle lens of a camera. His gigantic fist is thrust out towards the viewer and is clasped round a slightly bowed staff. The man is

The Beatitudes of Love: Knowing, or The Grocer Couple

masculine and powerful but seems tamed or subdued. The woman, though small, is triumphant and fond.

The painting must be autobiographical, but who do the couple represent, and what experience sparked the painting? Gilbert believed that 'almost invariably the key to his [Stanley's] paintings are our experiences at home', and saw the painting as based on a

memory of one of their girl-cousins so dwarfed 'that her head scarcely reached above the table':

Amy [Gilbert writes] always dressed in black used to come to Sunday tea with us at intervals, and the tea party usually ended with my father going to the piano and playing 'The King of Love my Shepherd Is' while Amy stood at his elbow and sang. If he did not shed a tear, we knew he was much moved. Children are swift to catch the mood, and sympathy and understanding of Amy's feelings flowed from us naturally. My interpretation of Husband and Wife, which some see as cruelly misshapen, is that it represents the triumph of love over every physical disadvantage.[6]

Perhaps in essence it does, and no doubt Amy's handicap, reflecting Stanley's own slight stature, played a part in the recapturing of his feelings. But for the physical representations of the painting let us venture an alternative suggestion. The man represents the powerful Sergeant-Major of the Beaufort, William Kench. The huge fist – 'I remember', wrote Stanley, 'his hands, the thickness of them' – grasps his military parade stick elongated phallically like the carpenter's monstrous saw in *Workmen in the House*. The woman in the painting is Stanley in feeling, grotesquely distorted into a feminine aspect, one breast full of the milk of humankindness; or else her breasts are the male testicles, or perhaps both. The elastic arm she stretches out points significantly to 'Kench's' striped waistcoat. Kench was still alive when Stanley made the painting and he may have felt it prudent to disguise the shirt as a waistcoat: 'but he had a blue striped shirt. I might imagine myself disappearing from his sight and becoming one of the stripes on his shirt. There now, I am feeling more comfortable. . . . I would look to the other stripes on his shirt to ensure that I looked the same.'[7]

The recollection was a memory of twenty-five years before. Perhaps some Beaufort association, such as Jack Witchell, the 'tall chap in the cookhouse', who was also a big man and a grocer, or some memory-link with the hospital stores and kitchens, with their 'big men loonies' clumping about in heavy boots and striped aprons, may have triggered for Stanley the personification of the figures as a Grocer couple.

Significantly there exist two Beaufort postcards of Kench which

From William Kench's photograph album. (*Left*) Kench in full service uniform. (*Right*) Kench posing with one of the smaller orderlies in fatigue dress. This photograph, taken as a jest, is said to have been used as German propaganda emphasizing the deterioration in British manpower as a result of casualties.

seem to be linked. In one a 'God-help-you' Kench stands in full-dress dignity, Sam Browne belted, 'wearing puttees', and carrying his parade stick. In the other, a more relaxed Kench poses good-naturedly with one of the shorter of the hospital orderlies. Neither postcard exists among Stanley's Beaufort mementoes but it seems that he must have seen them at some time and the memory stuck. The husband in Stanley's painting wears Kench's army boots and the wife wears the orderly's indoor canvas shoes. Such correspondence cannot be coincidental. Stanley has been able to absorb his old terror of Kench, to transmute it into 'love'. He and Kench are

'liked', and the meaning of his wartime sentiment fulfilled: 'I am working in a hospital that is his and in a sort of way I am part of him myself.'[8] The Kench figure further reminds him of a boyhood memory of the Cookham baker, Mr Francis, a fervent preacher at the Methodist chapel; so that Stanley's Kench-grocer figure in the painting becomes 'more intensely a grocer, crumpled, his face turned up in a wonderful ecstasy, expressive of the Wesleyan conception of goodness'[9] and his antipathy to Kench becomes tamed by love, that love which he and Gilbert knew when Amy sang her Sunday hymn and their boyish hearts went out to her. There was a reciprocation from Kench which would have fascinated Stanley had he known of it. Kench kept a photograph album of his own which contains a collection of Beaufort photographs. Stanley is present in one of the groups. When Stanley became celebrated, Kench would point him out in the photograph to family and friends, commenting proudly that Stanley Spencer had been one of 'his' orderlies.[10]

This painting, like all the *Beatitudes*, became another example of the feeling Stanley so yearned to achieve. 'When I [Stanley] feel a certain degree of strength in my feelings and passions has been reached, I instinctively make my way into forms and things, anything belonging to the visible world, where I have found myself unable to get or have feelings for . . . I want then to transform some disliked thing into something I shall love, and so my kingdom and dwelling-place shall be enlarged.'[11]

Stanley's slow detachment in *The Beatitudes of Love* from the dimensional restraints of place and setting normally so necessary in his work, his uncharacteristic soaring into free association, was parallel to the deterioration which was occurring in his physical circumstances. In the spring of 1938 Patricia, always sensitive about comments on her relationship with Dorothy, was accusing Stanley of being the source of gossip that she was lesbian. He denied it, but she threatened to put private detectives on his tail with a view to legal action.* In March she had her name on

* After Patricia's death, Maurice Collis asked Dorothy outright whether they had had a physical relationship. Dorothy was adamant that they had not. Collis was 'convinced she was telling the truth'.[12] There is, however, ample evidence that the relationship was highly charged emotionally on both sides. In spite of her mannish appearance, Dorothy was essentially the conventional wife in the partnership, taking charge of the heavier domestic duties and leaving organizational matters to Patricia.[13]

the Land Registry Certificate of Lindworth amended to Patricia Spencer, but that month she also announced her intention of taking Dorothy to Paris to investigate again the possibility of living permanently there. Stanley's creditors, formerly content only to dun such a well-known figure, were threatening prosecution. The Inland Revenue were particularly pressing. Stanley was regularly overdrawn at the bank and was having his cheques stopped. He owed money to his solicitor Wilfred Evill who, having come to an earlier arrangement with Tooth to commute some of the debt by accepting paintings direct from Stanley, was now declaring an unwillingness to continue his services. Hilda's solicitors were pressing for arrears of maintenance and in May, when Patricia and Dorothy were in Paris calculating how they could best capitalize their resources to allow them to move there, Stanley was in court telling a judge that he could not offer Hilda more than £4 10s a week, and being reminded that imprisonment might result if the arrears continued. In fact £4 10s was a considerable portion of the weekly cheque he was now receiving from Tooth, for he and Patricia had drawn so heavily against his credit that Tooth had been forced to reduce his £8 weekly to £7. The result was that Stanley's efforts to pay Patricia's allowance were also spasmodic, and in August he was persuaded by her to instruct Tooth to 'please in future make [his weekly cheque] payable to Mrs Patricia Spencer and send it direct to her'.

To maintain his credit with Tooth Stanley continued his landscapes and still-lifes. But he was nearing bankruptcy both financially and in his imagination. Hilda was unable to help and Patricia unwilling: 'I found myself, no matter what effort I made, having no spiritual functional relationship with her whatever. I was an interloper, an unwanted intrusion. I lost confidence in myself . . . became anxious, apprehensive and finally *impotent*.'[14] It is unlikely that Stanley meant impotence only in sexual terms. His comment touches the heart of the mystery which had preoccupied him from adolescence and was to baffle him metaphysically towards the end of his life – the nature of the connection between sexual feeling and effective or 'religious' creativity in art. Whenever his sexual feelings rose, so did his artistic creativity; and whenever he found himself excited to artistic creativity, his sexual feelings were stirred. Which caused which he did not know; both simply happened.

Conversely, if one was diminished, so was the other. His frustration at such times was almost unbearable. It was Hilda's increasing tiredness and incapacity to attend to him practically or emotionally which, he felt, had made the final paintings at Burghclere so difficult for him. Then her frequent departures from Lindworth to care for her mother or brother had frustrated much of the creative joy his return to Cookham had been intended to induce. Patricia had at first relieved the tension. The burst of creative activity she provoked had proved satisfying, even though many of the paintings she had unknowingly stimulated were not immediately admired. But now the sexual access and inspiration she offered were evaporating, and with his frustration came indignation that despite his spending on her and his gift of Lindworth she was pronouncing herself a 'wronged' wife. Above all came anger with himself that he had been compelled by his imaginative sexual needs into situations in which he could both be deceived by others and deceive himself, so that in losing Hilda and the children he had betrayed their trust and ignored their emotional and material welfare.

In the late summer of 1938 Patricia decided to let Lindworth. With Elsie now married to a Cookham man, Ken Beckford, and Hilda showing no sign of co-operating in Stanley's tripartite arrangement, the house in her opinion was too big for Stanley's small needs. First it was necessary to arrange modernization and to install electricity, so once more Dudley Tooth was approached to extend his advances. Stanley could retain the garden studio in which to work, and after renovation use an outside lavatory.

Stanley was alarmed. Another Preece-Hepworth show was being planned for October, and the BBC were interested. It would bring in cash. Lindworth, once modernized, would be saleable and Stanley would have no say in the disposal of the proceeds. In fairness to Dorothy, a move to Paris was more Patricia's wish than hers and she was complaining bitterly to friends of Patricia's lack of principle in taking what she could from Stanley. But if the move took place, Stanley's project for making Lindworth the centre of his ménage-à-trois would be ended and any immediate chance of recovering Hilda lost.

The time had come for action. In September he interrupted work on a landscape he was painting near Cookham Dean to journey to North Wales where Hilda, her mother and Unity were holidaying

with friends. He stayed for a week or so, lodging with a Mrs Johnson in Llanfrothen, near Penrhyndeudraeth, and using the time to paint another two landscapes. If Hilda would support his plan and come back to him, all might be saved. But he found her 'ill with a bad attack of sickness and it puts her in the wrong mood for discussion.'

Stanley found that in this desperate situation he could be decisive. He composed a letter to Patricia to tell her that he was proposing to increase Hilda's alimony to £5 a week with 'a latitude of £1 extra at such times as *I* was satisfied it was needed'. The offer was unconditional. There was no intent to bribe her. Even if she refused to come, he would still pay her, and could do so provided he earned at least £1000 a year.[15]

Stanley was forcing Patricia to show her hand. If Hilda accepted his offer and agreed to his ménage-à-trois at Lindworth, Patricia would have to concur; if she did not, she would have to declare openly her hypocrisy in never having intended it in the first place. Conversely, if Hilda refused to come back, Patricia as his financial manager would have to agree to finding the extra money he had promised Hilda and allow him to decide for himself how it was found. The consequence for Patricia in either event was the loss of her managerial control over him. In effect he was forcing on her his own realization that Hilda was equally, if not more, important in his inner life.

He well knew how Patricia would react: 'I have felt very nervous in writing this in view of the consequences.' There would be dismay, alienation and accusation. She would mask her fury by going on to the attack, blaming his intentions as 'dishonourable' and his behaviour as 'hard'. Her complaints would exacerbate for him that 'disapproving' trait in her personality from which Hilda was so admirably free.

Patricia's response arrived by return of post. It was as he expected. He was 'selfish'. His proposals were 'caprice'. He replied that if his plan was caprice, then it was the same caprice which had over the years been the inspiration of what he believed to be his most important paintings. He was sad that she would never understand. There had been no change in his visionary feelings for her. 'What you said in your letter was true and I could not dispute it, but it was not the total of all or anything I felt for you.' He

announced his intention that they should 'part'. He wanted, he said, 'peace'; that is, a tranquillity of spirit which no longer denied the deepest source of his contemplation. The arrangement by which he painted landscapes to assure an income to Patricia would continue. But he was freeing himself from her management. He was 'ambitious' and 'making a desperate attempt at bettering myself'. What did she want him to do about the two landscapes he had painted?* Did she want him, in fact, to return to Cookham?

Patricia did not want to be humiliated, and Stanley came back. He moved his furniture and effects into Webbers' store at Maidenhead and went into the lodgings which Patricia arranged for him, a small room in The Nest which overlooked the back garden of Fernlea and upset him. He was still deprived of Hilda, who had not agreed to return. But he had declared independence from Patricia and was again creatively and spiritually free.

* The two landscapes were *Landscape in North Wales*, now in the Fitzwilliam Museum in Cambridge, and *Snowdon from Llanfrothen*, now in the National Museum of Wales.

Christt in the Wilderness

I love to walk up to one of my past selves – the
Dustman, or the couples in The Beatitudes – which
stand about in the land of me. My picture people are
among my loves. They meet the Hildas, the Elsies. I
love and feel and touch them.

Stanley Spencer[1]

IN OCTOBER 1938 Stanley accepted an invitation from the
Rothensteins to a house-warming at their new home in Fellows
Road in Hampstead. John Rothenstein had just moved to London
to take up his appointment as Director of the Tate Gallery. Stanley
arrived early, and the maid who opened the door to his ring thought
she was facing a tramp. His battered overcoat was fastened with
nothing but a large safety-pin. As an ex-soldier whose kit had
included a 'hussif' ('housewife') – a small holdall containing
needles, thread and a thimble – Stanley was perfectly capable of
sewing buttons on. His appearance was a signal that he would
welcome help.[2]

Generously the Rothensteins asked him to stay for some weeks
while they did their best to sort out his difficulties. Dudley Tooth
seemed to be the key to his financial problems. If Tooth could be
persuaded to extend his role from dealer to business manager then
there would be hope. It is to Tooth's credit that he accepted the
task, although not without misgivings. Stanley was delighted and
Patricia's objections overruled or ignored. Gradually over the
next two years or so Tooth managed Stanley's affairs in such a
businesslike way as to stave off prosecutions, negotiate with the
Inland Revenue over payment of tax arrears, persuade Wilfred
Evill to resume accepting paintings in return for his continuing legal
services, and convince trade creditors that bankruptcy proceedings
were pointless as in the end they would all be paid. Learning that

Christ in the Wilderness. No. 4. 'Consider the Lilies of the Field'

Hilda was in distress from the legal expense of enforcing Stanley's arrears of maintenance – their cost swallowed up their value – Tooth saw her,[3] promised her space in mixed exhibitions, sorted out with her solicitors an undertaking to pay Stanley's weekly maintenance direct, and in the following year congratulated her on acceptance of her work at the Royal Academy summer exhibition. She was delighted: 'Apart from the joys of being able to start afresh and on a better basis, I feel so grateful for the mental relief arising from this new system. It is a load off one's mind to feel that one can dispense with solicitors and such-like. . . . If I feel relieved, I imagine that Stanley must feel far more relieved.'[4]

He was indeed. He opened his heart to the Rothensteins, particularly to Elizabeth. Captivated, she kept notes of the ideas Stanley expounded. To her later regret she destroyed them* when it seemed that a bomb in the Blitz might scatter such private papers in a very public blast, not an unlikely possibility. During the Blitz all the windows of their house were blown out. Percy's Bedford Square flat over the Building Institute was destroyed. Edward Marsh's flat was wrecked, although *Apple Gatherers* survived. Jas Wood's house off Haverstock Hill received a direct hit, leaving one of Stanley's early masterpieces, *The Visitation*, hanging on one of the ruined walls, dusty but undamaged; and Tooth's 'beautiful gallery' at 155 Bond Street, founded by his grandfather, was destroyed when adjacent buildings were razed, although most of the paintings fortunately survived.

By November 1938 Patricia was holding another exhibition at the Leger Gallery and annoying Stanley by sending accounts to Tooth for framing and for sherry and whisky. In his opinion the women's painting should pay for itself. This time Clive Bell wrote the introduction to her catalogue. Stanley himself was still hoping to publish his autobiography. He told Patricia that he was approaching Batsfords and the OUP, being unhappy with Rothenstein's efforts to involve Gollancz, whose stipulations he felt too restricting. Tooth also was warning him that 'a book written by you alone about yourself would appear a sort of self-advertisement and would not be in the best interest of your reputation or your career'.[5] Stanley continued for some months to approach other publishers, but as the results were always the same, he shelved the plan. He did not however allow the setback to interrupt the flow of his writings about himself and his paintings.

At the end of November the Rothensteins passed Stanley to Malcolm MacDonald, who had followed his and Gilbert's careers with interest. The son of Ramsay MacDonald, he was devoutly Christian and would willingly have been a 'Boswell to Stanley's Johnson'.[6] How Stanley must have relished being a guru to such influential admirers! But MacDonald's duties as Minister for the Dominions and Colonies made sustained residence at his home, Hyde Hall in Essex, impossible in the face of the developing war

* Though she later incorporated some of them into her introduction to her 1945 Phaidon edition of some of Stanley's paintings.

crisis. As Stanley was unwilling to return to the treadmill of his former life in Cookham, in mid-December MacDonald found him a room at 188 Adelaide Road in Hampstead, and for a while paid the rent. The Rothensteins lent him furniture.

At Adelaide Road, relieved at last of everyday anxieties, Stanley's numbed feelings reasserted themselves. He turned for reassurance, as so often, to the imagery of the Bible, to his Life of Christ series, and in particular to the parallel of Christ's Forty Days in the Wilderness. From this theme he evolved a scheme of paintings in the form of forty square panels which could be installed to decorate the ceiling of his church house,[7] deriving the idea from the roof over the chancel in Holy Trinity Church Cookham where there are also forty square panels: his paintings correspond in size also to those in Cookham. Each panel was planned to represent one day in the biblical event and to be based on a relevant text. Stanley sketched the entire series in outline and continued over the following months to work up selected drawings; but only nine were painted.

The pictures were intended to be seen from below; their compositions are bold and their designs inventive. Each is dominated by a powerful stubble-bearded Christ quite unlike the conventional Victorian 'pale Galilean'. Stanley's Christ is a workmanlike figure fashioned in the image of the medieval master-masons he so admired. Christ in the Wilderness looks sometimes contemplative, sometimes in spiritual struggle.

In feeling, the paintings continue the 'contemplation' of *The Beatitudes of Love*. But Stanley has abandoned the distortion of those works, produced a more realistic portrayal and, more significantly, returned to the physical familiarities of his Cookham and Macedonian experiences, to the landscapes, rocks, flowers, plants and creatures, shown as a scorpion or a fox. He has gone back to the wonder of his early memory-feelings and is, in maturity, reproducing them: 'In Christ, God again beholds his creation, and this time has a mysterious occasion to associate himself with it. In this visitation, he contemplates the many familiar humble objects and places: the declivities, holes, pit-banks, boulders, rocks, hills, fields, ditches and so on. The thought of Christ considering all these seems to me to fulfil and consummate the life-wishes and meaning of all these things.'[8]

Perhaps in the way Christ overcame the Devil during the Forty Days, Stanley was excommunicating his 'erotic' impulses. But neither his memoirs nor his subsequent compositions give any indication that this was so. A more feasible explanation is that Stanley continued to be as devoted as ever to the link between the sexual and the religious, but that having been reduced temporarily to 'impotency' he was, by sublimating them, returning instinctively to those early memories of his boyhood Cookham place-feelings, to that mysterious, atavistic awe which possessed him when he roamed Cookham's 'declivities, holes, pit-banks, boulders, rocks, hills, fields, ditches and so on'. Even though they were 'things', they took on 'life-wishes and meaning'.

As no former experience, especially a 'religious' one, was ever discarded by Stanley, so the feeling in his first 'innocent' art would ever be the genesis of new composition. The feelings became compositionally, as they did chronologically and metaphysically, the starting-point for a painting: place and time. Only in *The Beatitudes* had he forsaken them, and now he was retracing his steps, re-forming his vision.

In January 1939 Tooth sent Stanley a statement from the firm which printed picture postcards of some of his paintings and quoted sales of cards in the first half of 1938. It gives an indication of the popularity of his landscapes compared with that of his visionary work:

Magnolia	2200
Upper Reach, Cookham	1585
Cows at Cookham	1295
Swan Upping	1000[9]

In March Stanley wrote to Patricia from 188 Adelaide Road to say he was planning to undertake 'the enormous notions and ideas for pictures I have had during the last fifteen years', and asked if it would be convenient for him to work again in the Lindworth garden studio, even if necessary to sleep there.[10] But in that month he chanced to meet on a bus a friend of Hilda's, Constance Oliver, who lived nearby at 179 Adelaide Road. At Easter he was staying with friends near Oxford, painting a landscape and expecting a commission from the Pakenhams;[11] in June Constance offered him

the use of one of her attic rooms, and Stanley gladly accepted, bringing his few possessions in carrier bags, and asking Tooth to send the Rothensteins ten shillings in gratitude for the loan of their furniture.[12]

During this period he discussed with Father d'Arcy a project to decorate part of Campion Hall, the Jesuit College in Oxford. It came to nothing, mainly through Stanley's refusal to compromise; by all accounts the priests were far from impressed by Stanley's vociferous interpretations of his personal religious beliefs. Another valuable commission, to decorate the lounge of the *Queen Mary*, then under construction, also failed to come his way. The designs he submitted, although admired artistically, were felt by the Cunard management to be too avant-garde for the conservative tastes of the clientele they hoped to attract.

If indeed Stanley did reoccupy the studio at Lindworth – his major canvases were still stored there, although bundles of drawings had gone to Webbers – it cannot have been for long. Events were about to make Stanley's proposal irrelevant.

PART SEVEN

Resurgence

1940–1950

CHAPTER THIRTY-NINE

Village Life, Gloucestershire

You are like a coral reef in the Indian Ocean, with strange and beautiful fish darting in and out, and other curious creatures.

Hilda to Stanley, 1939[1]

IN THE early summer of 1939 at a London party, Stanley met Christopher Nevinson, the fellow-student of his Slade days whom he had not seen since the 1920s at the Carlines'. Nevinson's spontaneous response to the meeting conveys a hint not only of his student feelings about 'our genius' and his creative energy, but also of a resurgence of Stanley's spirit:

Stan, I would like you to know how glad I am that we have met again. My gratitude to you is boundless. It has been an experience to me to talk and share not only jokes but those problems which eat at so much of my energy. You have a clarity which is superb; I feel like a giant refreshed after being in your company. . . . As you know, I consider you the only man with that indefinable touch of genius. I felt it for Picasso years ago. . . . I have met most of the so-called great men during the last twenty years, so I hope you will take this bouquet in the spirit in which it is offered.[2]

A generous tribute from a fine painter. At that party Stanley also met the couple who were the midwife of his resurgence, George Charlton and his wife Daphne. George, approaching his forties, was a lecturer at the Slade; his prodigious knowledge of anatomy made him a specialist in medical drawing. Daphne had been one of his students and they had married some ten years before. In addition to art they shared Stanley's love of music. Daphne was an excellent pianist, her favourite composer, like Stanley's, J. S. Bach. Stanley became a frequent visitor to their home in New End Square, Hampstead.

Village Life, Gloucestershire. Also known as *Village Gossips, Gloucestershire*.

In March and April Tooth arranged a one-man exhibition of his work at the Leger Galleries. In the summer, Stanley was invited to accompany George and Daphne for a painting holiday at the Gloucestershire village of Leonard Stanley, where they lodged in the village pub, the White Hart. The Rothensteins had family connections nearby, and the vicar's son-in-law Edward Payne, an artist in stained glass, was known to George. Leonard Stanley lies in the Vale of Berkeley at the foot of the Cotswold scarp. It was then a small rural community around its ancient church, St Swithun's, its village green and war memorial, an old priory and tithe barn, its village post office and pub. Like many local villages it had been noted in the Middle Ages for cloth-milling. The packhorse path, Gypsy Lane, up which the bales of cloth were carried over the Cotswold scarp to the Bath road, still exists. In Stanley's day the lane was lined in part with a magnificent avenue of elms, gone now. The views of the village, with its trees and ancient buildings set against the Cotswold cliff, were a constant attraction to artists. The trio went about painting landscapes.

Plans had been made in the event of war to evacuate the Slade to shared premises with the Ruskin School in Oxford. When war was declared on 3 September, George returned to London to help organize the transfer. He, Daphne and Stanley had arranged with the pub landlord to stay indefinitely and make it their base. It was near enough to Oxford to enable George to return at weekends during term-time, and it was immaterial to Stanley where he settled. They were given upstairs front bedrooms. Stanley turned his into a studio by having the carpet removed and most of the furniture taken out; all that remained was a single bed, a trestle table, a couple of chairs and a washstand. In October he wrote to Tooth: 'I am feeling that as there may be an indefinite suspension of the actual trading of my work, whether I could have some sort of official art employment – not painting – that will give me a small income and [allow me] to spend the bulk of my time doing some of these big picture ideas that I have. Your cheques still continue and I am grateful to you for having sent them. . . . the £1 15s od I receive from you every Saturday morning is the exact amount I am charged here for my board and lodging, so that I have been dependent on the £4 or £5 you paid me when I came here on 30th July, and I need a small extra cheque or £2 a week instead of the £1 15s.'[3] But for Stanley's patient acceptance of Tooth's financial arrangements – the sums he mentions were minuscule at a time when inflation was rising – and his own astonishing frugality, occasionally misconstrued as parsimony by the unaware, it is unlikely that even Dudley Tooth's acumen would have been sufficient to have saved Stanley from bankruptcy. But he was back on course, and the ideas he mentions would soon begin to emerge.

At Leonard Stanley, often alone with Daphne, Stanley felt himself reborn. George was intrigued by Stanley's 'notions' and personality, but Daphne was overwhelmed. All her caring feminine instincts rose to cherish Stanley in his tangled circumstances, a reaction as fascinating to him as it was germinal. At the creative level, its effect was startling. Nothing like it had happened to him since boyhood and even then he had had to share his mother with Sydney and Gilbert. His mind inevitably worked towards the totality in any new situation, and he seized on Daphne's caring attention for him as an aspect of what he thought of as that divine love to which his imagination responded all his life. We know from

Beaufort days the meaning he attached to the idea of service – God 'fetching and carrying'. Now, Daphne's offers to cut his fingernails for him or to sew on a button became holy through the love-feelings which impelled them. In the way that he worshipped Hilda for the love-in-marriage she had brought him from the God with whom she talked, and in the way that he admired Patricia for justifying to him the meaning of his Cookham image, so he esteemed Daphne for revealing to him that concern for others which must be another part of the true nature of God.

These feelings pervade many compositions he made at this time. In them, he transfigures village incidents and scenes by joining them with his feelings for Daphne to create a new 'religious' place or atmosphere, so that Leonard Stanley takes on in his depictions something of the mysterious aura he gave to the Cookham of his boyhood. But landscapes were still the principle source of his meagre income. In the daytime of that autumn of 1939 the three-some – the twosome during weekdays – tramped around the surrounding countryside sketching and drawing. Settling them-selves one day by mischance too near an aircraft factory, the trio were arrested and put into police cells in Stonehouse. The vicar of Leonard Stanley was called out to vouch for them. There were constabulary apologies next day, but Stanley's annoyance at such official buffoonery seems to have dissolved in the general hilarity with which the event was greeted in the village. His country hosts were astonished at how little he ate or slept. His main needs were a good fire by which to keep warm, and quiet when he worked. At night, he would often be heard bumping about in his room as he rose from bed to write or sketch.

Perhaps because he was unable to acquire drawing paper locally, Stanley bought in Stonehouse four simple scrapbooks of the type he had seen his own two children use, together with loose sheets, and these he used for many of his new compositions. Some he turned into paintings, and in them we can trace his joyful return to 'potency'. In *The Wool Shop*,[4] for example, set in one of the little shops of Stonehouse which so reminded him of Cookham, he uxoriously helps Daphne match wool for a cardigan she was knitting. She holds a skein against her cardigan to match the colour, but her eyes have a faraway look. A small Stanley, almost enveloped in huge coils of wool, is virtually flinging a coil over her, lassooing

her, trapping her. In *The Tiger Rug* Stanley takes his vision of their association even further. Arms around each other, he and Daphne lie prone in front of a fire on a rug transformed by Stanley's imagination into a tiger skin. The bare boards suggest his bedroom

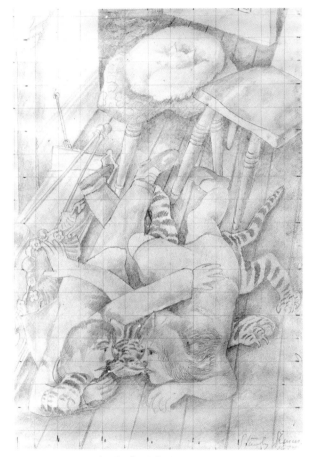

Study for *The Tiger Rug*

studio. The couple gaze wondrously into each other's eyes. A cat curled on a stool behind them slumbers like Tiddles in *The Dust-man*. Something has happened or is about to happen between the couple, the joy of which they share. Their 'rapt staring', as Stanley describes it, is one of mutual discovery, of revelation. The experi-ence has lifted them into the sublime. It is the 'gazing' of *Contem-*

plation, the 'rapt staring of two people awakening in Paradise'. Looking back later on the picture, he saw the paws of the tiger as pyjama sleeves and trousers. The rug itself is the man-plus-woman's joint chrysalis, discarded as, now a single entity, they awaken into their new comprehension. Theirs is a resurrection, and to this perennial theme Stanley's numbed feelings are returning.[5]

It is likely that Daphne did not in these early days fully understand the imaginative use Stanley was making of their association, which was in no way concealed.* The village was divided between amusement and reproach. George's benign tolerance seemed to them just another facet of that different London world from which their trio of celebrated artists had descended on them. For his part, Stanley was deeply grateful to Daphne as the source of creative recuperation. But, if he were to do justice to the paintings which would celebrate his resurrection, he still needed the emotional association of the only handholder who could manage the miracle – Hilda. If only she could be restored to him!

Stanley's conflicting emotions are evident in one of the major paintings of the time, *Village Life, Gloucestershire*. It shows a small Stanley clutching his jacket pocket and sheltering timidly behind a large, protective and forceful Daphne, her arms folded resolutely across her chest. She confronts an elderly village couple and a small girl. The small girl points at Daphne. The man, moustachioed and bucolic in bowler hat and gaiters, is brandishing a lady's nightdress as though suggesting that his shocked and desiccated companion had found it in Stanley's bedroom and was demanding an explanation. Stanley cowers shamefacedly, but the vigorous Daphne is defiantly contemptuous of their insinuations.

The painting, Stanley tells us, was composed by linking two of his scrapbook drawings, each made from somewhat different feelings, the join being at the distant wall. Cautiously he describes only the left half. The group, he says, shows a pair of grandparents with their grandchild surprised while taking in the washing by an unexpected sight in the sky. They 'see God'.[7]

The components of the group can be reconstructed, with some

* The effect on Stanley was rhapsodic: 'Our bedroom love was taken up Gypsy Lane and over the stiles and across the meadows and along the roads back up to our room. Then, after more love in the bedroom, we went out among the elm trees and cattle and chickens, and were conscious and did as we had just done in bed, so that our private life was public. I liked having trees and grass and puddles and chickens and the sun in the same association as bedclothes.'[6]

accuracy, from surviving memories. There was indeed a grandchild
in the pub family, a small boy whom George and Daphne took to
their hearts. His mother, the young daughter of the pub, whose
husband was in the forces, came in each day to help her parents
with the dining-room meals. An elderly 'shrivelled'[8] woman came
in to do the cleaning and the laundry. She would hang the washing
in the orchard behind the pub, the landlord helping her with the
heavier sheets and tablecloths. On fine days a hammock was slung
in the orchard and Stanley could be seen rocking Daphne gently
in it. On one such occasion Stanley may have caught sight of the
washing being brought in. While doing so, something in the sky
caught the group's attention – a new type of warplane, perhaps –
and Stanley registered in his mind the cameo of their gestures as they
pointed. Back in the quiet of his room he brought the associations
together to convey a new meaning to the events. The trio would
be pointing not at a warplane but at the transformations of
Stanley's holy feelings about Daphne. In depicting the figures he
would as usual disguise their identities, yet needed to base them
on real people; so the small grandson was drawn in the semblance
of his mother as a girl. Innocuous enough, the drawing was
'married' to another to complete the mood. But once again Stanley
surprises us: the apparently minor figure in the painting, the sixth
figure on the extreme right, is Hilda, and she turns sadly from the
scene.

The inferences are intriguing. Daphne is overwhelming Stanley.
He, in their association, is the led, she the pacemaker. He cannot
flee from her or let her go while she offers the means of exploring
another imaginative world; but he is reluctant to commit himself
to yet another fraught relationship with a handholder, however
enticing. He must take and appreciate what Daphne offers because
it can be made meaningful in his art, but any such relationship
cannot supplant the function of Hilda in his vision. His fusion with
Hilda is the only true fusion. He wants her back.*

* In June 1946 Stanley made a scrapbook drawing from which he later (1950) made a painting, *The
Farm Gate* (chapter 44). The compositions, superficially bucolic recollections of younger days when he
would help bring the cows into Ovey's farm, glow in arcane allusion. Cows were becoming for Stanley
symbols of a demanding or possessive female instinct which he sometimes admired (*Love on the Moor*),
at others resented. In the drawing they press headlong through the gate, which is being opened by Hilda.
Trapped in the angle of the opening gate, Stanley struggles to put the locking bar in place. The visual
effect is that Hilda is hiding him or keeping him out of the press of cows. In the 1950 painting the same
imagery will suggest a more urgent emotion.

In fact, to judge from their continued correspondence, Hilda was genuinely pleased for Stanley that he had found a new friend in Daphne. He describes her to Hilda as 'in certain ways being quite sophisticated, but I have found certain things in her which are touching. She is a restless, turbulent spirit.'[9]

Hilda told him that she was arranging for Unity to join Shirin to stay for the foreseeable future with Mrs Harter and Gwen at Epsom. It seemed a practical arrangement. Mrs Harter, herself a trained pianist, was already helping Shirin with her musical education, and the house in Downs Road was large enough to accommodate the girls comfortably. Mrs Harter would send the bills for the girls' board, clothes and school fees directly to Dudley Tooth. Hilda's only reservation was to wonder whether Epsom was sufficiently distant from Croydon aerodrome to be entirely safe from the dangers of bombing. She herself was proposing to remain with her mother in Hampstead. They had moved in 1937 from Downshire Hill to 17 Pond Street, Hampstead: 'Mum and I are here with Miss Arnfield and Mabel and everything is as usual except that the house is well barricaded up. It has been sad for the children to do without you for so long. Unity, I know, has longed so much for her Daddy.'[10]*

In London, vigorous proposals were being made for commissioning war artists. It was urged that they should be employed from the outset and not, as in the Great War, be introduced as an afterthought. A War Artists Advisory Committee (WAAC) was again formed, headed by the Director of the National Gallery, Kenneth Clark. In considering invitations to suitable artists, the Committee was well aware of Stanley's status and was particularly impressed by his 1929 panels for the Empire Marketing Board. Beddington-Behrens had purchased them and loaned them to the Tate Gallery where they were on display. But there may have been reservations among some members of the Committee about Stanley's reputed intractability, for at Christmas 1939 we find Stanley telling Tooth that a rumour had reached his ears to the

* In her long letter to Tooth of 7 August 1939 Hilda describes these arrangements. But she had reservations about Mrs Harter's proposals for the girls' future education, a molehill that was to grow into a mountain. Miss Arnfield was a Yorkshirewoman who had been housekeeper to George Carline and on his death remained in London as housekeeper to Mrs Carline. Mabel was the maid. Richard, caught in America by the outbreak of war, was on his way home to use his Great War aerial experience to develop camouflage techniques at the Air Ministry's Camouflage Centre at Leamington Spa.

effect that, 'if I am to believe my informant, I am left out of the lists altogether. Also Sir Muirhead Bone is on the Committee and I have heard recently the most astonishing statements about myself emanating from that quarter. It is my business to ignore such matters but I would be glad if, without my having to appear in the matter, you and Mr Smart [a colleague in the business] could find out what the body are intending to do for me.'[11] Evidently Stanley's hope of some undemanding job which would allow him to continue his imaginative work had faded. Tooth dutifully took up cudgels on Stanley's behalf, telling the WAAC that 'I very much hope you will be able to use Spencer in some official capacity. . . . these eventful days will certainly bring out the best in him and I am sure he will prove amenable to work, as he is terribly in debt all round.'[12]

Called to London for interview, Stanley took the opportunity to show Richard Smart his current work – *The Wise Men, The Tiger Rug, Christ Praying* (one of the Christ in the Wilderness series), *Snowdrops, Gloucestershire in the Snow, The Duck Pond*. Stanley proposed an allegorical crucifixion illustrating the agony of Poland overrun by German armies. However, the Committee was limited by brief to eye-witness compositions. Recalling Stanley's submissions to the *Queen Mary* competition, it was suggested that he might like to do a sample shipyard scene at a fee of £50. Stanley contacted the Admiralty and was sent in March 1940 to Glasgow, where he chose Lithgow's yard at Port Glasgow, some fifteen miles down the Clyde from Glasgow proper, rather than Brown's yard in the city itself, which he thought might be in more danger from bombing. There, the yard workers' initial curiosity satisfied, Stanley's presence was accepted and ignored, except on one occasion by patrolling policemen suspicious of his sketchbook. Their challenge brought out the rough edge of his tongue: 'They themselves looked like Germans and I told them so.'[13]

Fascinated by what he saw – the communal life of the shipyard and its surrounding streets, the flame, fire and mystery of so many of the processes which he likened to those of his boyhood's blacksmith shop in Cookham, magnified a hundredfold – Stanley filled so many notebooks that he eventually evolved a technique of assembling his compositions on rolls of toilet paper. This as-

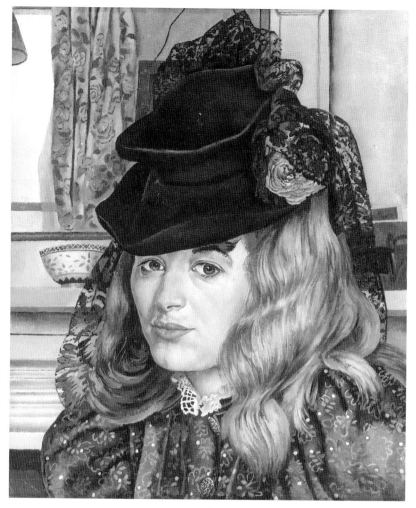

Daphne

sembly was known to him as 'the Roll', and its sudden unscrolling across the floor became one of his party tricks.

These sketches he brought back to Leonard Stanley to work up into formal drawings in April and May. At intervals he continued landscape painting, and made portraits of Daphne. At the end of May he paid a visit to London, taking with him the drawings

and paintings. The drawings were delivered to the WAAC, the landscapes to Tooth. John Rothenstein bought one of the portraits of Daphne, wearing a hat, for the Tate Gallery at £100.* At the time Percy still lived with his family in his Bedford Square flat above the offices of the Building Institute, of which he was Director. When Stanley and Hilda visited him in the autumn of 1938, the three of them had watched workmen digging the square for air-raid trenches, a slow process from formerly unemployed men unaccustomed to such labour. Percy's professional eye saw their inefficiency with amusement, but Hilda shuddered. 'They look like graves,' she said.[15]

* The hat was bought in Bond Street in December 1939 especially for the portrait; it cost three guineas. The painting occupied three weeks of daily sittings.[14] Another portrait of Daphne shows her hatless, but Stanley was not altogether pleased with it.

CHAPTER FORTY

Shipbuilding on the Clyde: Burners

> People generally make a kind of home for themselves
> wherever they are and whatever their work which
> enables the important human elements to reach into
> and pervade in the form of mysterious atmospheres
> of a personal kind the most ordinary procedures of
> work or place.
>
> Stanley Spencer[1]

THE WAR ARTISTS Advisory Committee was impressed by
Stanley's shipyard drawings and at the end of May 1940 proposed
a fee of £300 for a commission for five paintings to be worked
up from the sketches. Stanley, typically, decided to produce the
commission as six paintings in the form of two triptychs. He
worked on the first, *Burners*, during the summer months at Leonard
Stanley. 'Burning' was the use of oxy-acetylene flame to cut the
thick sheets of metal into shape. Stanley included himself in the
central panel of the work, so metaphorically joining himself with
the workers. Each is engrossed by the isolation of his own activity,
yet a participant in some greater process, a communicant in an
experience collective to them all, a firing of individual into universal
dynamic energy.

He completed the painting at the end of August and set it up in
the garden of the White Hart for the villagers to see. The following
month it was exhibited at a War Artists Exhibition at the National
Gallery, where it drew excited comment. Shortly afterwards, it was
shipped with other war paintings to the Museum of Modern Art
in New York to impress on Americans the character of the British
war effort. The Admiralty wrote to Stanley expressing the hope
that 'you will be able to continue producing for the country
masterpieces of this kind throughout the war'.

The accolades came only just in time. In the August Stanley

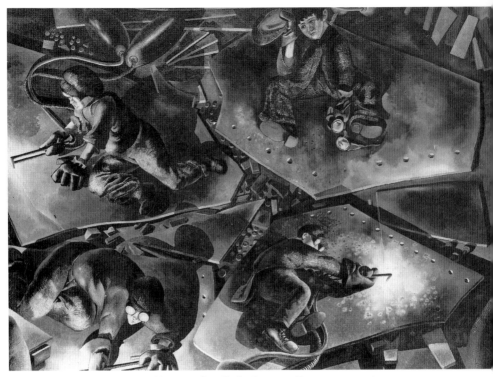

Shipbuilding on the Clyde: Burners. Part centre section.

finished the picture, the August of the air combats of the Battle of Britain, Dudley Tooth told Stanley that 'there was no trade at all; nothing sold that month', and, due himself to be called up, Tooth must have wondered whether his commitment to clear Stanley's financial problems while also keeping Hilda, the children and Patricia in funds may not have been over-optimistic. The handling of much of Stanley's business was delegated to Richard Smart. Stanley found him a sympathetic interpreter of his work, and was to open his heart to him.

In September, the Blitz on London was launched. At Leonard Stanley, work on the second triptych, *Welders*, was begun. Once more Stanley put himself in emotional sympathy with his figures by placing himself in the foreground. Lithgow's yard was by then fully stretched on government contracts for the building of the wartime Y-design merchant ship, which made extensive use of welding in addition to traditional riveting. Stanley had also completed two more landscapes and wanted to bring them personally to Tooth, for the Blitz had so disrupted rail communications that

the Great Western Railway would not accept his paintings as freight. The prospect alarmed Daphne:

We hear varied reports of the difficulties of getting about in London . . . and of the danger. . . . I am terribly worried at the idea of his coming up. . . . He is, as you know, ready to take risks and go anywhere . . . but he is very sensitive and highly strung, and my husband won't hear of the idea of my accompanying him. . . . Our windows have been blown out at our house at Hampstead, the square is half-wrecked. . . . I *don't want* him rushing about in London, even if he might meet people. His life is very valuable.'[2]

She evidently managed to delay his visit until the New Year of 1941. Then, on 14 January, Tooth received a telegram: 'Calling midday. Stanley.' The thin line between Daphne's protectiveness, which Stanley admired, and her possessiveness, which he resented, was nearly reached. However, the visit to London made little difference, for the landscapes he brought could not be sold and were simply packed into store. Patricia's allowance was reduced from £3 to £2 a week, because she was drawing rent from Lindworth. Hilda had to be refused the money for a tonsil operation for Unity. Stanley's income depended entirely on his WAAC commission.

Welders, completed in February 1941, was as acclaimed as *Burners* had been, and the Committee offered a second commission to continue the theme. To plan this, Stanley returned to Port Glasgow, encouraged by £5 expenses from Smart: 'It is good news that the Ministry of Information have bought the second series [*Welders*] of your big project, and better still that they want you to proceed with it.'[3] The interest in his comment lies in the phrase 'your big project'. As might be expected, Stanley had already sensed exciting possibilities in forming his shipyard paintings into another vast integrated scheme. The scheme would comprise 'the four walls of a room hung with 68 separate panels, including a double predella on two walls and a single predella on the other.'[4] 'Grandiose' is an adjective which has been applied to the scheme,[5] but it was no more breathtaking than his forty panels for *Christ in the Wilderness*, his fifty panels for *The Marriage at Cana*, or the plethora of pictures needed to do justice to the rest of the church house. He

must have foreseen that, however long the war continued, he was unlikely to complete it. But without a sense of the unifying, the totality, the individual components could not effectively be brought to life.

He returned from Port Glasgow – it had been an Easter visit, staying at the Star Hotel – and set about planning *Riveters*. He composed it once again in triptych form to approximately the same dimensions as *Welders* – twenty feet (580 cm) long but only two feet six inches (76cm) high. But by now the prospect of a third summer at Leonard Stanley was becoming daunting: Stanley had had good times there with the Charltons, they had made a number of local friends and there had been entertaining visits from George's Slade colleagues and students. John and Elizabeth Rothenstein had called, for the Tate Gallery had been badly bombed and its preservation was being co-ordinated from Sudeley Castle, some fifteen miles away. But it was now apparent that Stanley's daemon was once more taking precedence over his everyday circumstances. Pleased though he was that his shipyard paintings were well received, he badly wanted to turn towards a different project, one for which Hilda was essential. He spoke frequently about her and the children in the pub. He felt isolated and wanted to be near them. Daphne's attentions, vital though they had been for his creativity, were no longer sufficient. Some time in the early summer he asked Mrs Harter and Gwen at Epsom if they could provide him also with a room in which to work.

Daphne was once more alarmed. It hurt her that her 'unique and vulnerable little artist' whom she had gathered up, and who fascinated her, was withdrawing from her, especially for a Hilda who, she thought, existed essentially in his imagination. She fought back. Their hosts heard noisy quarrels from their rooms and, occasionally, the crashing of china. Daphne's 'turbulent spirit' was acknowledged by their landlady, who substituted her second-best crockery. Once, Stanley emerged from his room soaking wet and complaining that Daphne had poured the water from his washing jug over him. She later commented, 'Stanley's inner and extremely secret life did not make sense to me nor contribute to sanity and serenity between us.'[6]

Once again Stanley was in a dilemma. He tried to work out his feelings in a long self-appreciation:

First, belief in grandeur and great Art and Religion of the grandest kind. Ambitious to achieve same thing in this direction. Second, caught by Hilda. Don't believe in it but can't shake off sex desire. Marry to satisfy desire and some ideas, but not believing in marriage. Unhappy, and ambitions and high ideals being destroyed in me. Utterly unattainable in her atmosphere (Christian Science etc) inimical to all I believe in. Some sort of other me develops. I get back to Cookham as forlorn hope. I meet Patricia and fall in love. See in her my former ambitions and beliefs. Feel a need to marry her. But know I shall never be able to believe in the marriage because of my being already married. I *know* I am cheating *but* marry her. Quickly that fact destroys my sex feeling for her. My growing impotence destroys my passion for her. I can't stand it and leave. Hilda feelings increase. I try to have them both, but it would have been a patchy affair. They refused anyway. Alone in London and still trying for Hilda – but trying to avoid it as it might not do. Would have gone back to Hilda if I could have been alone. In a very sexy state in London. Meet Daphne. I was in love with her. But knew she would never any more than anyone else mean what Patricia had meant to me [presumably Stanley is saying that Daphne meant no more to him than Patricia or than anyone had meant to him other than Hilda]. I knew I was rooted in Hilda and said so. And would have preferred to have continued whatever there was in me and Hilda affair. Will do so as soon as I can.[7]

Daphne's protestations were in vain. In May, Stanley left Leonard Stanley for Epsom. Mrs Harter's house had a large room he was able to convert into a studio, for which the Ministry of Information offered to pay his rent of £1 a week. His new arrangements, as he told Florence, were congenial: 'I am pleased to be with the children, who are quite good company. Everybody rises early in this house, so that one can get a lot of work done.'[8] There, between painting sessions on *Riveters*, he began setting his thoughts in order in a long memoir which has become known as his 'Epsom writings'.[9] On Saturday mornings he taught at Epsom Art College where he was delighted by the students' understanding of his notions. The girl students were particularly sympathetic; they were 'such pets, such *darlings*!' and he 'longed to kiss them'.[10] In addition, when the mood took him, he continued with further scrapbook drawings.

Riveters, finished at Epsom, was delivered to the WAAC in

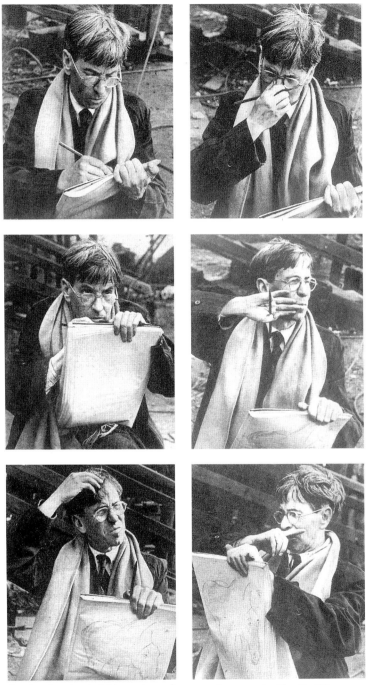

Stanley drawing in Lithgow's yard, 1943, photographed by Cecil Beaton. Beaton took his shots while Stanley worked 'oblivious of noise, war, onlookers and cameraman'.

September and was followed by a third and more prolonged visit to Port Glasgow to collect notes and sketches for the next painting. The Admiralty, uncertain how to categorize this breed of semi-civilian, semi-service personnel, gave Stanley the rank of Ordinary Seaman. He had no objection, except that he was not issued with suitable kit, so that in the autumnal wind and rain of the Clyde, he was frequently soaked. His allowances ran to only modest accommodation, in this case with a landlady at 8 High Holme Street, but the kindly Scots did their best to dry his clothes, feed and tend him in the plain but honest way he liked.

Stanley returned to Epsom in October and began assembling the drawings for *The Template*. In shipbuilding, a template is a full-scale pattern in wood or metal used in cutting and assembly. Working quietly with his daughters around him, Stanley's prospects of peace seemed good. Tooth was continuing to keep him financially afloat, frugally allocating him £2 a week, Hilda £5 10s, and Patricia £3. Daphne was an occasional visitor. Patricia called during a visit to an aunt who coincidentally lived at Downs Avenue, Epsom. Hilda stayed at intervals. There is no doubt that Stanley must once again have raised the prospect of their reunion. But the practical obstacles were considerable – Stanley's marriage to Patricia, his penury and homelessness, and Hilda's continued reluctance. Whatever hopes Stanley may have had were to founder on one of those altercations which so beset them, a difference of opinion which seems insignificant when set against their abiding love for each other, yet one on which once again they found themselves uncompromisingly divided and intransigent.

The source was the future of Shirin and Unity. Hilda's earlier fears that Epsom was not sufficiently far from Croydon aerodrome – in fact it was on a flight path to London – to be safe from bombing were realized. On one occasion when Hilda was playing chess there in the lounge, a jettisoned bomb fell at the end of the garden, shattering the glass conservatory. Her reaction was merely to look up and remark, 'That must be the loggia.' Unconcerned for herself, she was, however, anxious for the girls. Richard had suggested they be sent under a Government scheme to America, and Hilda had begun plans to that effect which she abandoned when the liner *City of Benares*, carrying some of the child evacuees across the Atlantic, was tragically torpedoed. Keen for them to be

offered the chance of the most progressive education possible, Hilda, with the backing of Richard, visited several schools out of London. Badminton School, a girls' public school normally in Bristol but then evacuated to the Tors Hotel in Lynmouth, offered bursaries. It would encourage Shirin's musical and Unity's artistic abilities. Shirin, now aged 15, given the opportunity of enrolling there, accepted. The decision upset Mrs Harter, who had come to look on the sisters as 'her' girls and wanted them to continue their schooling locally. Stanley openly demurred. He had no wish, he argued, to have his daughters brought up as 'ladies'. Hilda, determined to support Shirin's decision, tried to convince Stanley that making the girls into 'ladies' was not at all the school's intention. Stanley refused to yield, and Mrs Harter supported his protest by proclaiming that the disappointment was making her ill.

Hilda's reaction was to put her foot down. Shirin would go to Badminton School, and so would Unity later if she wished. She countered Stanley's fury by cutting him out of her life. The act was the courageous desperation of a mother in defence of her children, and her defiance of Stanley whom she revered, and of Mrs Harter to whom she was indebted, left her isolated. The price she was to pay for her courage was terrible indeed.

With family recriminations mounting and Stanley's frustrations making him irritable and excitable, the domestic situation at Epsom became intolerable. Towards the close of 1941, Mrs Harter asked Stanley to leave. Once more he had to cast round for a suitable studio for his large shipyard canvases. Although Lindworth house was now occupied by an executive from the John Lewis Partnership, Stanley still had many effects and canvases stored in the garden studio. He continued to receive only £2 a week from Tooth, but there was some consolation in that Tooth had been released from war service to look after his stable of war artists. Determined that he would not be under obligation to Patricia, Stanley asked Tooth to arrange for the Ministry of Information to provide rent for the garden studio. They offered ten shillings a week, enough to encourage Patricia and Dorothy to clear away sufficient of their impedimenta to enable Stanley to work there. He moved in on 8 January 1942 and lodged with his cousins the Bernard Smithers at the neighbouring house, Quinneys. 'It will be nice to be back in

Lindworth garden,' Stanley told Unity: 'On the snow-covered space outside this window I look bang at Fernlea where I was born and bred. It looks much the same, only no Virginia creeper on it as there used to be. I can't quite see my old nursery window, but from here I have the same view as I had from that window when I was a little boy, and hear the same 10 to 9 school bell as I did then.'[11]

Stanley was back home, even if deprived of Hilda. The Smithers' daughter Yvonne was training to become a ballet dancer, and in one of his notebooks Stanley traced a family tree to show her their relationship.[12] He could join the Smithers for company when he wished, but he could also shut himself away in his room undisturbed. Even the Smithers' maid was not allowed to enter. Stanley did his own cleaning. There, between sessions to finish *The Template*, he continued, at Tooth's urging, to paint further panels for *Christ in the Wilderness*; to write the material for his memoirs; to nurture his still unformed new scheme; to compose long letters to Hilda expounding his notions, unsent because except on financial matters she would have nothing to do with him; and especially to compose and annotate the myriad 'notions' sketched in his scrapbooks.

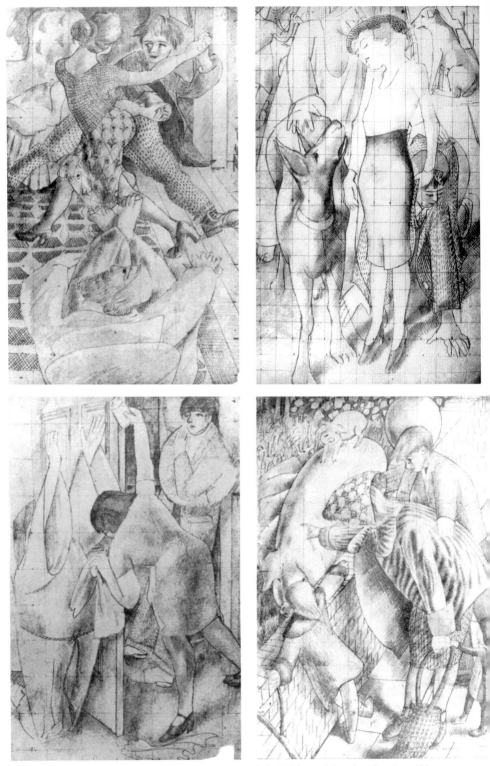

Selection of scrapbook drawings. (*Upper left*) Hilda and Stanley dancing. (*Upper right*) Patricia and Stanley with dogs. (*Lower left*) Elsie polishing a doorknob. (*Lower right*) Daphne and Stanley with village children looking at pigs.

The Scrapbook Drawings

'I am subtle, Richard, subtle!'

Stanley Spencer to Richard Kennedy[1]

MANY OF Stanley's scrapbook drawings can be seen at the Stanley Spencer Gallery at Cookham. A few are *aide-mémoires* or try-outs, but most are finished compositions drawn in the heat of creativity and were intended to be the sketches for further paintings for the church house. Some are already squared up for that purpose.

Their prolixity shows how Stanley's imagination ever outran his capacity to accomplish. In *The Beatitudes of Love* series, for example, he lists as additional subjects: 'Nakedness, Presence, Loving, Playing, Sharing, Giving, Effectualness, Assisting, Holding, Fervour, Gaiety, Festivity, Marriage, Feminism, Masculousness [sic], Living, Talking'.[2] Some of the drawings must align with these, but as Stanley did not title them there is no way of knowing which might be which. It is, however, possible, with the help of Stanley's relevant writings of the period and of the occasional annotations he subsequently pencilled on the drawings, to reconstruct some of the thought processes which went into their composition.

Each finished drawing recalls for Stanley a physical sensation or experience which surprised him by the intensity of its feeling. But the recall is not, as the drawing of pornography would be, a species of gloating. On the contrary, it is the *surprise* which Stanley is examining, the eternal 'Why? Why?' of his mind which demanded not explanation but rather the placing of the experience in the totality he was convinced existed.

The effect for Stanley was a transfiguration of the physical event into a spiritual concept fierce in its emotional complexity and intensity. Here he tries to put into words the feelings from which he composed the couple in *Contemplation* (see page 384):

425

All their life and all the varied moments of their days, he is moved by her, because of his sexual union with her. His ordinary daily interests are as much her looking at him and he at her. . . . In that bridal veil she was a walking hidden mound of potential domestic facts and happenings. These holy hidden things are now doing simple jobs. He sees her thin knees breaking wood for the fire. It comforts him to see it. The passionate association he felt for her arms at the wedding, like a small bent church pillar, now sweeping the floor takes him from church to heaven. . . . It fills him with joyfulness, in looking at himself or her the question: 'What is her need?' is asked and 'Himself' is the reply. He feels a blessedness as he views her now less-covered breakfast-getting legs and shopping arms.[3]

The singularity of the language should once again not blind us to the power of the imagery and the intensity of the feeling. Stanley's imagination is turning the four women of his most moving experiences – Hilda–Patricia–Elsie–Daphne – into a universal woman-concept in an almost religious ecstasy, from his anticipation of her as a bride at their metaphorical wedding to his subsequent joy at his discovery of her willing acceptance of domesticity on his behalf, and thence into his wonder, his 'comfort' and 'blessedness' at her continued need of him. In her giving herself to him through the humblest actions of caring – 'breaking wood for the fire' – or in applying her erotic arms and legs to the practical function of 'shopping' or 'getting breakfast', Stanley sees the two aspects, the physical and the spiritual, conjoined. The cement is love. The beloved female through her love-feelings becomes an icon for his perpetual contemplation and adoration; as he for her.

The four women thus understandably feature in many of the Scrapbook drawings. The sight of Elsie's body moving or stretching or kneeling as she cheerfully and innocently went about her work was for Stanley unashamedly erotic. But, transformed into their 'religious' context, his feelings were not wrong, because they were instinctive – he could not prevent them – and because they drew his consciousness of Elsie into an awareness in which his spiritual identity, his 'love', imaginatively fused with hers: 'I don't know any similarity of aim and thought, only that we both knew what we liked and knew how not to interfere. She and I naturally thought in the same "rhythm" and had the same sense of joy.'[4] The fact that he knew Elsie did not think of him in the same way made no

difference. 'Stanley often talked to me about his pictures,' Elsie was later to say, 'but I found it difficult to understand. He was a very nice man, and I'm glad he became famous.'[5]

Patricia appears in the drawings detached and elegant. In one drawing she leads Stanley along a street by his tie. He has a shopping parcel in his hand and is on all fours alongside her, a dog with another dog she holds leashed. The drawing meets the eye as an apparent statement of Stanley's submission to Patricia, with even sado-masochistic overtones. Yet from Stanley's subsequent annotations, it is clear that these are not intended. The drawing is 'religious'. At the time Stanley was discovering a parallel between the activities of dogs and his fascination with female buttocks. The excitement which this gave him is used in the drawing as a cross-association with the excitement he finds in dressing Patricia stylishly, to express his glory in finding universal meaning in the sensations. 'God' pats the haunches of the dog Patricia holds:

It has no meaning of leading me a dog's life, or anything of that kind. I want Patricia and I want a dog, and so I do a dog; and then I do another dog, something of the same mental weight, and so I am the other dog; and then in the midst of these homely forms and domestic character I want a fashion-plate Patricia because I am sure the dog-surrounding will give the fashionable figure a completely different meaning, a meaning I want to express. . . . In doing these Patricia-and-dog drawings I felt such an extension of my love, such a ramification of it into unlikely corners and, like the dogs, sniffing out almost anything and feeling a love strong enough to absorb almost anything into it.[6]

'A love strong enough to absorb almost anything into it': only when such love is experienced and valued can earthbound constraints be shed in favour of visionary metamorphosis. Only then can we comprehend and share Stanley's feelings expressed in other drawings, as when 'God' kneels to adore Patricia's stylish shoes while Stanley, loaded with parcels, excitedly returns with her from some spendthrift shopping expedition of his fancy; or when at Lindworth Stanley rummages in a laundry bag to find a dress he wants her to wear while she, waiting in her underwear for him to make his choice, dances to his gramophone.

The Hilda drawings, by contrast, express their togetherness. She

is Juno, Genius of Motherhood, or Athena, goddess of truth and wisdom. When they dance they do so clothed, happy, in unison. If Stanley draws her nude, it is in some chaste and homely act of mutual domestic happiness. At a party they make an arch for the game of 'Oranges and Lemons'. When Stanley remembers their courtship on Hampstead Heath, his love for her is poured out in his adoring exaggeration of her 'rather sad outward appearance'; in one of the drawings he portrays her in the old-fashioned garb her mother wears in one of the photographs in their family album. Walking alongside her he begs her to stop and lie in the grass so that they can emulate the adjacent courting couple, a replica of themselves: 'We greet our love in the Heath and greet it again in bed. We love our walking selves in the Heath, and your coat and spirit bring Heaven with loving.'[7] Alas for Stanley's stimulated feelings, in this drawing she strides on, uncooperative.

Daphne in some respects is Vesta, goddess of the hearth and of sanctuary. She draws heads of the village children at Leonard Stanley, dries her hair by his studio fire while he looks on, takes with him a couple of small children to look at the pigs, hangs up handkerchiefs while he works on a design:[8] 'I like to celebrate all lovable acts. All ordinary acts such as . . . Daphne sewing a button on my waistcoat are religious things and a part of perfection.' The pair dry themselves after sharing a hip bath – an 'annunciation' to Stanley – or, in the equally primitive arrangements at the pub, they sit side by side on a double seater loo often to be found then in rural garden-closets. In another drawing, Daphne brings him a pair of walking shoes and sits on his lap while he puts them on; possibly they are her brogues – she wears them in some other drawings – and he is joyfully trying them on: 'a part of the religious expression of desire. All things such as these incidents, the many ordinary happenings between two lovers is all a part of the love experience. They make love through everything between themselves.'[9]

In other drawings in the scrapbooks, Stanley continues to 'contemplate' through sexuality the wonder of creation as though he were God taking a second and surprised look at what he had fashioned and falling in love all over again with what he had made. A pair of girls on a walk stop at some small dogs in a garden. One girl bends to pet them so that her skirt is drawn tight across her backside. Another small dog waits behind her. In other drawings,

dated to 1947, a powerful male figure carries bound women. Their wrists and ankles are tied and then linked together over his shoulders, so that as he carries them dangling, their skirts and long hair flow downwards; in one, a reverse view, we see mainly a girl's long stockinged legs. Stanley showed one of the drawings to Patricia, telling her she was one of the women. He evidently hoped to derive some amusement from hearing her comments. She did not disappoint him. The drawing in her opinion added 'sadism' to his 'lack of balance'.[10] Stanley explained to a later friend that they represented his wish to carry off both Hilda and Patricia as his wives. The man carried them with their heads behind him as he would then not need to hear their cries of protest. But the explanation may be incomplete. A list exists in which he adds that he was thinking of, or had drawn, 'several men carried by several men, and men and women being carried on a long pole.'[11]* However, a comparable theme is continued in less surprising drawings. In one a Stanley-figure leans his elbows on the shoulders of two women who are bending down with their backs to the viewer to tend children at their feet; and in another, in a flight of unfulfillable fancy, Stanley is 'at home' euphorically greeting the arrival of Hilda and the children.

Different forms of symbolism occur in other drawings. Domestic fowl, turkeys and geese have the meaning they had in *St Francis and the Birds*. Doves mate above ecstatic human worshippers. Elephants, rhinoceros and snakes denote male sexuality. In one drawing a vast telegraph pole, which also serves as a bus stop, rises from between the legs of a sitting Stanley-figure. A chapel behind is reminiscent of one in Leonard Stanley. The telegraph pole is adored by women. Its explanation, which at first seems quaintly side-stepped by Stanley – 'While waiting at a bus stop, the waiters [the queue of waiting women] are approved and hear a religious man' – is nevertheless meaningful if interpreted in his terminology. He is the 'religious man' to whom the women are responding. They understand that his message is cosmic in a creative sense; it is 'approved', for it comes from God.[12] Like many of the scrapbook

* The notion may have developed from scrapbook drawings on the Deposition from the Cross (Astor 20, p. 40 and 22, page 22). In both Christ is recognisably Stanley. In Astor 20 two women (Daphne and Patricia?) are preparing to lower him. In Astor 22, two figures are being lowered and one is carried across the back of a figure who seems female. But a connection is unspecified.

drawings, it was meant for a painting in his Last Day series. Elsewhere there are unexpected drawings of a girl with her footballer hero. Stanley says they derived from a girl he greatly admired, and may reflect the time at Port Glasgow when he stayed with the wife and family of the renowned Scottish sportsman Joe Buchanan, 'whose name produces a hush in all but ignoramuses such as us', he tells Gilbert. Stanley's feelings for her evidently drew him as an imaginative participant into her and her hero's feelings for each other. 'I could not understand this non-envy of others' lot. I coveted as I have ever done almost any man's wife and felt how marvellous I could be to that person.'[13] He longed to share in the metaphysical meaning of their love as another exploration of that universal sensation of giving-and-receiving which meant so much to him; and jubilantly, in his outgoing way, he tried to tell everybody so. The effect in that down-to-earth community was to make him appear a little touched, and merrily he reports to Gilbert:

Anything I say nowadays – doesn't matter what it is, 'Nice day', anything, a look of apprehension comes into the face of the listener. They seize the back of a chair for support. I have to calm them down first, and say 'Now it's all right, I am only going to say it's a nice day!' Perhaps in view of my more pithy statements [even] that would be a bit of a shock. Up at the Port sometimes when I had let fly to a considerable extent on my more peculiar views – you know the sort of thing, 'I'm married to everybody really in varying degrees' etc etc, Joe, the boxing champion, looks up from poking the fire and in a quiet voice says 'Yee'l go oot of your nut'.[14]

Among the welter of symbolism in the sketchbooks there are many nostalgic drawings of Cookham, his boyhood and life there. Groups of male bathers lie sunning themselves at the bathing pool at Odney or Spade Oak, catching us by surprise as Stanley for once forsakes his 'tubular' representation in favour of a throwback to his Slade life-class line and shading. There are people storing apples, the Cookham milkman and his cart, women sitting in deckchairs perhaps near Wangford or Southwold. There are sketches of 'disciples', of flowers, of soldiers outside a bell tent. One drawing shows a maid talking to a boyfriend, which remained a trace-theme to which he reverted all his life: 'I have done a rather nice big study

in oil of my servant-girl flirtation half-in and half-out of the drawing-room back window at one of which the servant is looking.'[15] Repeated in his scrapbook drawing the theme was to recur at the end of his life in a composition of even greater meaning. In another drawing, a crucifixion is under way outside Fernlea-Belmont. The two families are at the windows watching the event, but separated from it by an imaginary high garden wall. The cross is being tamped into position, and the bearded victim, tall and thin, may well be an echo of the tragic early breakdown in Will's life. Workmen are about to hammer in the nails, and Stanley is fascinated by the matter-of-factness of the operation; once again he was to use the idea in years to come in an even more startling version.

The last drawings in the scrapbooks date from 1948 and 1949 and were yet to come. In the spring of 1942 Stanley was 'flabbergasted' to learn from Tooths that he owed his framemakers, Bourlets, £164. Tooth was arranging a one-man exhibition at the Leicester Galleries, but this would not account for the heavy charge, and Stanley's own bills seldom amounted to more than £10. Tooth asked Daphne to find out what Patricia was doing. She met Patricia for the first time and 'rather likes her personally'. It transpired that Patricia was framing paintings for another of her exhibitions to be held shortly at the Leger Galleries. Daphne cannot understand the situation. Either Dorothy is 'the villain of the piece' and incites Patricia, 'whom I suspect of a sort of weak-mindedness', or else Patricia 'must be very indifferent and cold-hearted, and I cannot bear to see, nor can any of his friends, any exploitation of such a vulnerable little person and unique artist like Stanley. . . . I dare say Patricia is a sort of irresponsible child who has been given lovely things and cannot give up such indulgence.'[16] Tooth gave a hoot of disbelief and wrote to Patricia threatening to deduct the cost of the framing from her allowances. Patricia was politely apologetic, but stood on her dignity. She was, after all, Stanley's wife and he must expect to further her interests.

In Hampstead the strain on Hilda of her isolation was beginning to tell. In that same spring, while her mother was visiting Richard at Leamington Spa, she suffered a breakdown. Stanley hurried to help Miss Arnfield. He kept his presence concealed from Hilda, for the knowledge that he was in the house might, it was felt, have

aggravated her distress. On her recovery, she started to write intimately to him again, although from the tone of her letters she was still somewhat distracted. On 30 May she reminded Stanley: 'This is the month Unity was born, the month when we named her Unity with God,'[17] and she longed to 'help you, I long to do some good, to be of some help, to return some of the blessings you have given me'.

In June Hilda broke down completely. She started up in the night and woke her mother and Miss Arnfield to announce that they were all about to be murdered by Mrs Harter and should barricade the house. Nothing would convince her otherwise. She was taken to St Pancras Hospital and thence to Banstead Mental Asylum. Stanley, shaken, hastened to visit her, ignoring warnings from the doctors that she might be aggressive, even murderous, towards him. Insisting that she have a private room, he returned to Cookham to complain to Patricia about the doctors' obtuseness. They were treating her wrongly. He, Stanley, knew how she should be handled. She was now, in her opinion, in direct communication with God. Stanley, Patricia thought, accepted this literally, announcing that 'God talked to her. It was just that he talked a little more inconveniently than usual.'[18]

Perhaps here we touch a profundity in their relationship which demands the most delicate and sympathetic understanding. From his earliest days Stanley's quest into the metaphysical was all-embracing. No thought, no poetry, no religion, no philosophy was to be scorned if it offered him an insight into the meaning he could attach to the concept of God. His Cookham chapel fundamentalism, his Cookham church exaltations, his essays into Catholicism under Chute's tutelage, his respectful ventures into Hilda's Christian Science, his investigation into Buddhism and Eastern thought, all were directed to that end. If each was superseded in turn, none was discarded. Each became a new edifice built on the foundations of the previous one. God, to Stanley, lay somewhere in the imagination and intuition of each of us, and to achieve the fullest understanding we can manage, all earthly impediments must fall away. This was the state which Deborah, the 'loonie' at the Beaufort, had achieved; whatever his suffering in orthodox terms, he was in that state and in Stanley's estimation nearer God than the rest of us. Stanley himself longed to attain that state, and now to his joy

and excitement, Hilda had. A revelation must be being afforded her, and although in rational terms she must be brought back like a hypnotic from a trance, he, Stanley, must needs ·explore her revelation with her in whatever form it took. She was truly 'up in heaven', and he longed to go there with her and see and know what she knew and saw. And she in her turn was desperate to help him come to her and share her comprehension, for by so doing, she could 'return some of the blessings you have given me', and together they could achieve that unity with God which both sought.

So, during visiting hours, on the summer Sunday afternoons of 1942, Stanley, clutching his weekly sweet ration, for Hilda loved chocolates, would make the tedious wartime journey from Cookham to Banstead, and they would have long talks, or read aloud to each other letters which they had written to each other during the week. 'I went yesterday where she was sent suffering from a nervous breakdown to Banstead and saw Mrs Hilda S who seemed to me considerably better. We sat at a little table and chatted the whole afternoon about Chopin, Schumann and Wagner.'[19]

But behind these conversations lay the mutual comprehension which the world outside could not possibly share. They were closer than perhaps they had ever been, but in a way which made little sense to others. When after these visits Stanley went to Moor Thatch and outlined their conversations, Patricia and Dorothy thought him 'a little infected with madness himself'.[20] Frantic to pass God's blessing to Stanley, Hilda on one occasion gave him a letter to be delivered to Buckingham Palace. Accompanied by Daphne, he devotedly tried to deliver it; even Daphne found him 'not quite himself'.[21] On another occasion, Hilda sent him an impossibly generous cheque which he duly tried to present at the bank in such a way as to convince Hilda it could have been honoured. It would have been simpler – and certainly more rational in Patricia's terms – to have ignored these nonsenses, but it was not in Stanley's nature to betray a promise. If he was to bring Hilda back with her experience intact from this present state, there had to be complete trust between them.

The Template had been completed in May. To help Stanley meet the medical fees, Tooth persuaded the Ministry of Information to increase their payments by the substantial sum of fifty guineas a picture, a practical indication of the esteem in which they held his

work. Richard Carline too made loans to help with his sister's expenses and nieces' school fees. In September and October, Stanley revisited the shipyard. (This was the occasion on which he lodged with the footballer Joe Buchanan and his family at 9 Derol Avenue, Joe's wartime occupation being that of a blacksmith in the shipyard.) He returned to Cookham to start designing *Bending the Keel Plate*, another long narrow frieze. But he did not feel sufficiently composed to begin painting it until March or April 1943. In the meantime, he told Tooth in February, he remained 'merry and bright', and completed a seventh in his *Christ in the Wilderness* series. For much of this period Stanley worked on compositions in his scrapbooks — eighteen in five or six weeks in January and February. Such concentration on personal work at the expense of the WAAC commission suggests that he was moving towards a new visionary project, using the inspiration he was deriving from his 'up in heaven' conversations with Hilda. In May we find him telling Tooth — still not having completed *Bending the Keel Plate* — that he wished he could have the opportunity to 'get going as well on the religious track. Anyway, I have the material and notions for something good in that direction.'

In the meantime Hilda had been moved at Stanley's instigation and with Richard's help from Banstead, first to Camberwell, then to Westminster Hospital for an unspecified medical disorder, and finally in July into a room in a house adjacent to a private psychiatrist, Dr Bierer, at 224 Finchley Road, whose patient she became and who was happy to accept paintings from Stanley as fees. Stanley, Hilda and later Unity all painted portraits of him.

By July Stanley had finished *Bending the Keel Plate*, and Hilda was well enough for him to take her for a week's holiday to Lynmouth to be near Shirin and Unity. He had often visited his daughters at Badminton School there, sometimes by invitation to give talks to the staff and pupils — described as 'fascinating' — but at other times turning up, as he often did with friends, unannounced and without luggage, and on one occasion cheerfully sleeping overnight in the school beach hut.[22] Penguin Books was proposing a volume on him in their *Modern Painters* series, for which a fee of £100 was offered. Dudley Tooth was telling Stanley that his credit now amounted to the reasonable sum of £900, 'which is more than ample to satisfy any Income Tax demands that may

Stanley and Hilda on a visit to Shirin and Unity at Badminton School, then evacuated to the Tors Hotel at Lynmouth, July 1942.

come along', and that 'furthermore you have paintings which could bring you in £1500 after our commission has been deducted if they were all sold. At present they are not saleable, but they will be in time.'[23]

This news, though encouraging, did not mean that Stanley could relax his economies. Tooth still had to maintain Patricia, meet the children's expenses, pay Hilda's heavy medical charges, and repay some of the loans from Richard, for which he was now pressing (he was intending to marry). Henceforth, as Tooth assured him, he would have 'no financial worries', but he was still asked to manage on the £2 a week Tooth sent him, and even though that figure was expanded in later years, Stanley to the end of his days relied on his weekly cheque or postal order from Tooth. Hilda too was becoming anxious about what might happen to her and the children if Stanley died, and pressed Tooth for clarification: 'I

wonder whether you have realised that if Stanley died – which he won't – there would be nothing whatever for me and the children. . . . Patricia on the other hand would be well off, for everything Stanley died possessed of would automatically go to her, and he has hundreds of drawings.'[24] She had evidently conveyed her fears to Stanley, who told Tooth that he had at last been able to go to his store at Maidenhead and recover 'a lot of my drawings. . . . I trust that Mrs Spencer [Patricia] and Miss Hepworth are not allowed to go to my store.' Tooth told him not to worry: 'I will keep the ship on an even keel.'[25] In fact arrangements were eventually made for trustees to be appointed to administer Stanley's estate in the interests of Patricia and of Stanley's two children in equal shares.

Hilda remained at Finchley Road for the following two years, her condition fluctuating, but generally improving. Her experience had been so traumatic that in her letters to Stanley, which he was to read and re-read with great intensity, she seemed to grow more remote from him as she became more rational:

Stanley, all my life I have one overruling passion, and that is for God. . . . it is the central motive of everything in me. . . . It is a passion such as a longing for a person one loves, but without any physical side to it. It is a sense that that is my home and my one eternal love, such as you were describing on Friday about love and what represented 'home'. . . . All that part of me that is really *what I am* is folded up in God, and I cannot get at it without I reach God. . . . I felt married to God, I felt no person could be my husband in so complete a way as God was. . . . I felt that I could never marry humanly because I felt that no marriage could be what that marriage was. . . . And you remember I used to say that we would never be married till we were married in God; and that meant that our marriage was an offshoot of God, of my marriage to God and your marriage to God, and yet we get nearer and nearer to our own perfect marriage all the time, for we are each of us getting nearer to God, or The Thing Which Is, all the time.[26]

To Hilda, God was real and personal. To Stanley, God was The Thing Which Is. Both were drawing nearer to God all their lives, but Hilda's love for God was 'a passion . . . without any physical side to it'. For Stanley, the 'physical side' was the essence of the

meaning of creation and the manifestation of The Thing Which Is. In passages in Hilda's letters such as these we catch a glimpse of the power which held him imaginatively to her; against its force Patricia and Daphne, for all their value to Stanley, had no strength. But we find in them also evidence of that deep difference which was to keep them apart, and on which neither could compromise.

The Port Glasgow Resurrections: Reunion

I still hope for this life to be a continual parcel-opening
experience, a permanent birthday, no ups and downs,
but love on love.

Stanley Spencer to Charlotte Murray, 1945[1]

A MAELSTROM of ideas was whirling in Stanley's head. In the
spring of 1944 he announced a return to Port Glasgow for a
'prolonged' visit of some three to five months. He lodged for most
of the time with a Mrs Whiteford at her boarding house, Glencairn,
in Glasgow Road. She was able to provide him with a large attic
space as a studio, which he had to share in inclement weather with
the pens of family chickens. He was continuing to stock Tooth
with landscapes of the Port Glasgow area, but this was not the
reason for taking the studio. It was big enough for large canvases.
He was careful to reserve the attic for use on future visits.

At some point on this visit he was found wandering round the
corridors of Port Glasgow High School. Challenged, he announced
that he was looking for one of the schoolgirls he had met while
painting a landscape in the streets. She had said that he ought to
visit the school and meet their art master, Graham Murray. A
surprised Graham was called forth to identify this unexpected
visitor.

Although in his memoirs Stanley implies that in Port Glasgow
he was a lonely artisan painter living a simple life among working
people there, it was in fact not long before the local community,
as at Leonard Stanley, began to appreciate who they had among
them. The widely circulated magazine *Picture Post* had already
published an illustrated feature on Stanley's shipyard work. Invi-
tations arrived, most of which Stanley declined. However, he did

accept Graham's invitation to join a small circle of friendly ama-
teurs in Glasgow who played music in the large salon of the house
of William Bennett and his wife Minnie. The pianist was Graham's
wife, Charlotte. They lived in Glasgow, Graham travelling to Port
Glasgow each day by train.

Charlotte was from a well-known family in Stuttgart. Her father
had been a Professor of Mathematics. In the early 1920s she had
trained as a physician at Heidelberg, where Goebbels was a 'very
clever' fellow-student of philosophy, and then studied psychiatry
under Jung. She had come to Britain as an émigré from Hitler, and
had met Graham when both had served at a school for refugees.
She was unable to use her undoubted talents because the British
Medical Association was reluctant to recognize her German quali-
fications. She was bowled over by Stanley as completely as Daphne
had been. Deeply read, cosmopolitan and cultured, she understood
instantly the spiritual basis of his idealism. But, unlike Daphne,
she was adamant that her association with him should be covert.
For one thing, Graham was not so complaisant a husband as
George, and more importantly, she wanted no hint of scandal to
jeopardize her medical aspirations.* Like Stanley she was fasci-
nated by Eastern religions, particularly Hinduism, in which she
followed her former professor, Jung. Like Stanley too, she was
devoted to the search for the spiritual – 'genuineness' – as opposed
to concern for the material – 'artificiality': 'It is strange that in a
very different way, I have been gnawing away most of my life at
the problem of genuineness – or with you, vision – and artificiality.
I went through artificiality knowing it all the time as such. But I
think our hope for real harmony after these experiences [the
destructions of war] lies in realising our intuition. It seems to lead
and correct me and go towards a state of "mysticism".'[4]

Occasionally Charlotte came south to visit friends who shared

* Charlotte was one of the few correspondents apart from Hilda and his family whose letters Stanley
kept. The last of his major handholders, she confirmed his faith in the creative conjoining of the spiritual
and the sexual. Returning from a visit to him in Cookham in 1945, she told him: 'How happy you have
made me again . . . we are both so tender and tentative with each other not to disturb each other's pace.
It nearly is like two Parsifals not daring to pronounce the redeeming word.' She went on to tell him that
'I have the same story as last summer, question of a baby, but premature to know really. I would love
it and it shall not be a burden to you, even if Graham should behave unreasonably'.[2] Graham nevertheless
remained patient, and sympathetic to the 'strange, excitable, not-to-be-put-upon' Stanley who was their
mutual friend. He recognized that much was due to Charlotte's career frustrations and to the need in
those difficult war years, as he put it, 'to keep Stanley on an even keel'.[3]

439

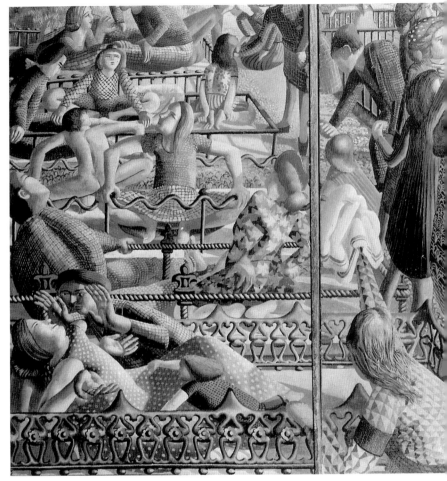

The Port Glasgow Resurrection series: Reunion

her interests and to persuade the British Medical Association to accept her German qualifications so that she could practise. During one of these trips, Stanley took her to the Behrends' and to Burghclere. She wrote to him afterwards: 'Your Chapel and your early work reaches the absolute height of great painting. This immortality may weigh heavy on you, especially in our age when you are not supported by a religious atmosphere but have to create individually.'[5] It was above all a true meeting of minds. In such

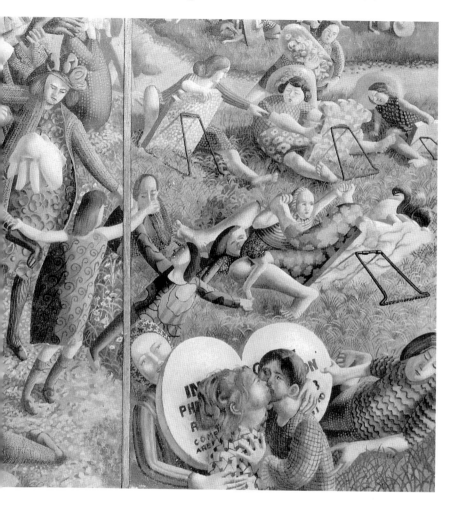

an atmosphere the feelings which Hilda had kindled for Stanley
during their conversations about God were blown into flame by this
new handholder. Stanley's landlady, Mrs Whiteford, supplemented
her income by laying out the dead, once a common practice in
indigent rural or industrial communities; Stanley's mother, Ma,
had occasionally performed the service. Stanley was intrigued and
used his Field Ambulance experience to help Mrs Whiteford on
appropriate occasions. To the 'normal' mind – Patricia's, for

example – Stanley's preoccupation with death and graves was as excessive, even as sinister, as his fascination with sex. Most of us, at least in the West, tend to see death – extinction – as the opposite of birth – creation. In our ceremonies we deplore the one and celebrate the other. But it is more likely that Stanley, who always sought association in antithesis, saw them as reciprocal. To him the function of religion and art was to liberate the spiritual from the corporeal. We become liberated, at least momentarily, in the

Graham and Charlotte Murray, about 1944

act of sex; so do we in death. If love is the recognition of a spiritual quality in the person or object loved, then when in love we are continually in a state of liberation from the corporeal, and the effect is joy. Liberation into this joy must, Stanley felt, be the meaning of the Resurrection, the ultimate symbol of our return to 'home'. Love, sex, death, resurrection, joy – these were to be the themes of the new scheme forming in his head. Then 'One evening in Port Glasgow when unable to write due to a jazz-band playing in the drawing-room just below me* I walked up along the road past the gasworks to where I saw a cemetery on a gently rising

* Mrs Whiteford's son had acquired a drum-kit and invited young friends in for impromptu sessions.

slope.' It was Port Glasgow cemetery. He had often seen it on strolls round the town. But on this occasion 'I seemed then to see that it rose in the middle of a great plain and that all in the plain were resurrecting and moving towards it . . . I knew then that the Resurrection would be directed from that hill.'[6]

In that vision, Stanley's new Resurrection would achieve a dimension greater even than his splendid shipyard paintings. In those he had joined himself in feeling to the workers in the yard. In the new Resurrection painting Stanley would extend the meaning of that 'fusion' to embrace all the people of Port Glasgow.

To give visual form to such abstract feeling Stanley would continue the structure of the shipyard scheme. There he had taken each worker's activity and shown it correlated into its ultimate purpose, so that had the scheme been completed the eye would have been able to travel through the sequence of yard processes, from the morning arrival of the workers to the final launch of a ship. But there was to have been more to the scheme than industrial illustration. The whole was to have been a panoply, a vast concourse of feeling, in which the viewer would achieve fulfilment, as Stanley himself had, by joining himself to the purpose and activity of the workers. The assembly of triptychs by which this was to have been achieved would be incorporated into the design of the new Resurrection, and Dudley Tooth, through Richard Smart, received another of Stanley's bombshell explanations:

I mentioned in my letter to you that I was very pleased with an idea I have and have drawn for a Resurrection. I am still pleased, but some practical and some otherwise difficulties come in the way of it being carried out. First when I finally drew the thing out after about three weeks of drawing studies and contemplating a dozen sections of it, I look, and I see that it looks good. Then as a matter of interest I see what size it would need to be. I think to myself that it must at the very least be three feet high. Now for the length. I find that every inch of forty feet is needed. Then I think, could I do it in sections? Here I find that that would only facilitate my carrying it out but no further in making it saleable. For if it sold, and that would be highly questionable, the sections could not be sold apart from each other; I should object to that. Then what about making it into three or more Resurrections, each a separate picture? This *might* be possible, not by me desirable unless it was *as* satisfactory to me

as the bigger picture. In this picture there is one important-to-me effect that I must presume to have. The emotion in the picture is dependent on there being two parts divided by a third part, and it is this kind of division that is important. It gives to each side section something similar to the meaning for me that subsists between the people who live in 'Fernlea' and next-door 'Belmont', the dividing Hill of Zion being the party wall. I might run up a few more Zion Hills and make five pictures of it, with a hill apiece. . . . Another illustration of this feeling in the difference between the two side sections is to compare it with the effect that is produced in a Bach Fugue when the *inversion* of the subject is heard.'[7]

The practical Dudley Tooth was suspicious: 'One large painting 40 feet long and 3 feet high, and five separate pictures . . . unless you can eliminate the "elements which people object to" in your recent work I can see little hope of the picture or pictures helping to reduce your debts. . . . May I see the compositions before you start? If you could paint religious pictures without any element of sex creeping in, I would rather have them than landscapes. There was nothing to offend people in your "Christ in the Wilderness" series. However, you must do as your inner feelings dictate.'[8]

'As your inner feelings dictate': nothing would divert Stanley once possessed of an idea. But even he saw the practicality of compromise. With the end of the war in sight, the WAAC were beginning to press Stanley, through Tooth, to simplify his closing commissions, *Plumbers* and *Furnaces*. At the same time, prudent with public funds, they halved his expenses on the not unreasonable grounds that as he made the transition to peace he would be giving only half his time to their work.* It was becoming apparent that Stanley's first Resurrection concept was financially impracticable, and later in 1944, while working on *Plumbers*, he sent Tooth a

* Because of the large number of WAAC paintings during 1939–46 – 5570 from all theatres of war – there was never as in 1919 a comprehensive exhibition, and the paintings were generally dispersed into national collections, galleries, even embassies worldwide. Stanley's shipyard paintings were assembled for an exhibition by the Scottish Arts Council in 1975 and four years later shown in London at a joint exhibition by the Imperial War Museum and the Science Museum. They are today held in the Imperial War Museum. When they were painted, Sir James Lithgow, who became wartime Director of Merchant Shipbuilding, was unhappy at Stanley's representation of his yard, and Henry Rushbury was commissioned to do 'three large and blameless drawings'.[9] By coincidence Rushbury and Stanley had in 1918 left the Berkshire Depot at Reading together. Failing to salute a staff officer, they were rebuked and told to crank-start his car; neither had the least idea what to do. They met again at the Carlines in the 1920s.[10] Rushbury went on to become Keeper at the Royal Academy and, like Stanley, to a knighthood.

modified plan comprising some seven triptychs.[11] Even that plan had to be adjusted during progress, but essentially it would consist of the main painting, *The Resurrection, Port Glasgow*, abbreviated from its original forty feet to a still considerable twenty-two feet – seven metres – above which would be hung a trumpet scene in which Christ and the disciples call the faithful to rise – *The Hill of Zion* – and above that again a sky scene showing the arrival of *Angels of the Apocalypse*. On each side of this vertical triptych would extend a series of thematic paintings, some single, some triptychs, showing the people of Port Glasgow *Waking Up, Tidying* themselves and each other, *Rejoicing* in their new experience, finding friends – *Reunion* – and relatives – *Reunion of Families*. These were to have been extended by further paintings to show the surrounding houses and tenements, so that local people leaning from their windows or sitting in deckchairs in their gardens would have been drawn joyfully into the event, but they were never done: 'I was so thankful that I was able to do as much as I did, because while through the war years I was dealing with the shipbuilding pictures and being free to treat them as I wanted, I knew that this was only Part One of my Port Glasgow visit and that there was a Part Two, which was the Resurrection series. When the end of the 1930s drew near I felt I would never win my way back to Cookham, and the discovery of Port Glasgow was a great joy, so much so that I felt at rest when I came to the Port Glasgow resurrection. It did what it could to satisfy a loss I knew I had.'[12]

At the end of October 1944, when Stanley was still struggling with the 'practical difficulties' of composing the paintings, he told Dudley Tooth that he had received a letter from Percy to the effect that 'it was no longer possible for my elder sister [Annie] to live alone in a cottage [Cliveden View] which up to recently she had been doing. . . . The authorities have now put her in a home and are only willing to consider her return if and so long as she can be with relatives. . . . I went nearly every day when in Cookham to see her, as I know and understand her ways.'[13] Percy wanted to know if Stanley would be interested in an arrangement whereby Annie and he would share the cottage. Stanley most certainly was. Bernard Smithers now needed his room at Quinneys for relatives bombed out from London, so when in Cookham Stanley was having to take lodgings again. More disturbingly, Patricia had

indicated that she wished to sell Lindworth, which would deprive him of his garden studio. Earlier, in February, Tooth had been obliged to seek assurance from her that she would not do so immediately, and she had replied that she would wait until the end of the war. But if Stanley could acquire Cliveden View as his permanent home, such worries would be over. He might at last 'win his way back to Cookham', and even accomplish the recovery of Hilda:

My wish, simply put, would be this:
1. To be remarried to Hilda S.
2. To have this cottage, to buy it if possible by small weekly payments, so that:
3. I could have somewhere to have Hilda and the children if they wished; so also that:
4. I could have a place to put my furniture and belongings [still] in Webbers Store, and my belongings now in the studio.[14]

He was paying ten shillings a week storage fee at Webbers', an appreciable proportion of his weekly allotment from Tooth, who was urging him to sell the stored property to save money.

The sale of the cottage and the arrangement of the mortgage took time, especially as Stanley was often in Port Glasgow. In the meantime Annie's condition deteriorated to the extent that she had to be kept permanently in care. It was not until some ten months later, in August 1945, that Stanley was able to take possession. He brought in such of his possessions as he could locate, although a large eight-foot by eight-foot bookcase he had made for Lindworth could not immediately be found. But he arranged the rooms in his simple fashion, using the front bedroom as his studio and furnishing it with a plain metal army bed. The place was quiet, and he had space to arrange his books and drawings. There was gas for cooking, but no electricity. Oil stoves provided heating. The garden was overgrown, but after a vain battle with the nettles in which he badly stung his hands, he found a local man to do the tidying. He occasionally had a woman in to do the cleaning, and later had a more permanent daily housekeeper, Mrs Price. But at first he did his own cooking: 'I have three very fresh chops per week from the

butcher. I hate this meat business,* but with the present food supply it is difficult to do without it.'[15]

In September 1945, Dudley Tooth obtained for him an unexpected commission which temporarily interrupted the progression of his work. A Hollywood film, released in 1947 as *The Private Affairs of Bel Ami* and starring George Sanders and Angela Lansbury, was

Cliveden View

to be made of the Maupassant novel, and a painting of St Anthony's Temptation was needed in the film. The studio decided on a competition among twelve artists of international repute – Salvador Dali and Max Ernst among them – for a substantial prize. However, there was a consolation award of $500 for each loser, and all the paintings would be widely exhibited in the USA and Europe to

* He is probably empathizing with Charlotte's vegetarianism, as he often did with the tastes and beliefs of his intimates.

promote the film. They would then be returned to their makers. The deadline gave Stanley a gestation period far shorter than he normally required. But in consequence he was forced to use the ideas which were currently engaging him.

St Anthony's temptation, or the legend of it, occurred some seventeen centuries ago when the saint, intent on living as a hermit, retired into the Egyptian desert to occupy a discarded tomb as a cell. Although later followed by acolytes, Anthony was solitary for a period, during which he underwent an experience similar to Christ's Forty Days in the Wilderness. The object was self-purification, but at times the Devil sent phantasms to torment him. To surrealists like Dali and Ernst, the opportunities for depicting the phantasmagoria were inviting. Among these was a beautiful temptress urging him to carnal intercourse, the subject Stanley chose for his version of the picture. But, with a genius entirely his own he turned the story inside out.

In Stanley's version, it is the three temptresses who are 'real' and the saint the phantasm.[16] The event takes place not in an Egyptian desert, but in the Garden of Eden before the Fall at the period of the 'naming of the animals' (Genesis 2.20).* The naked women in Stanley's painting are all Eves, but Eves in their first creation, as the perfect counterpart of Adam. Stanley is showing us a version of his heaven. When everything in the Garden was 'named' it acquired its identity in its perfect and whole state; for then every animate thing was, in Stanley's terms, 'liked', and so had total consciousness. The symbolism of the Fall was that it divorced animate life from the totality of consciousness which must once have prevailed; so making it difficult, if not impossible, for us to identify anything in its true state. The artist's task, his joy, should be so to streamline his thinking into 'purity' that he will be able to draw as near to each thing's perfect identity as is possible in our earthly condition.

The saint is saintly precisely because he is striving to reach the 'purity' which will provide such revelation. But he is still earthbound. Unlike the freely drawn figures of the women, he lies in his sarcophagus like a Russian doll, portrayed in Stanley's

* 'And Adam gave names to all the cattle, and to the fowl of the air, and to every beast of the field; but for Adam there was not found an helpmeet for him.' So God created Eve.

The Temptation of St Anthony

'tubular' style, in which the texture and pattern of fabric is used to convey solidity and roundness. The contrast with the women – 'I just emptied all my Slade life drawings into it' – is deliberate: 'I like the lower half of the picture where Anthony is, but the top

half seems a bit muddled.'[17] St Anthony eschews temptation – sex in this case, as in the legend – not because he wishes to deny it, but because he longs for sex in its perfect form. Far from repelling the women, he longs to join them: 'He is not turning away from what he sees, but waiting for a time when he finds his own spiritual niche in the harmony. He *can* be merged. But he has a perfection to reach and is aware of some imperfection in himself and is aware that he cannot *immediately* join, so to speak, in what goes on around him.'[18] One of the three women who gaze down at the saint is recognizably Hilda; the others too are probably her. Only if Stanley can, through Hilda, achieve that 'now-God-seeing state' which she enjoys can he continue his resurrection and sustain his vision.

Although Stanley was pleased with the notion of the picture, he was unhappy about the quality of the paint. Wartime austerity still prevailed and, having no priority for canvas, he had to make do with scene-painters' linen. The result was that 'the paint goes dead and putty-like when applied; it will just do'.[19] It was shipped to the USA in the New Year of 1946, but did not win the prize, which went to Max Ernst, though it was highly praised.

For Stanley, its themes were to be even more gloriously expressed in the Port Glasgow Resurrections to which he could at last fully address himself. In these extraordinary pictures, the dead resurrect in a series of homely cameos typical of their former lifestyle. The cemetery is accurately reproduced; Stanley saw the encircling paths as the Circles of Light in Dante's *Divine Comedy*. With the resurrecting dead are also the living, the biblical 'quick and the dead' in Stanley's fancy. Gardeners at work in the cemetery and mourners visiting with flowers are joyfully caught up in the happening and join in celebration with those resurrecting. As in the shipbuilding series, figures on the edge of one painting are meant to be moving into the adjoining picture to maintain continuity of action. The triptych forms are apparent, there being an insistence in several of the pictures on a central Stanley–Hilda subject linking the events on the flanks. Thus in *Waking Up*, Stanley's 'yawning and stretching' picture painted at the Murrays in 1945, a pair of mourners with a gardener in the foreground form a link with the awakened in the two side panels. Hilda is the woman mourner and holds a small child moving towards the right side,

The Psychiatrist. According to Graham Murray, this fine portrait of Charlotte was not posed, but composed from drawings of her head and hands; these were collaged into one of her dressing-gowns and the whole set against background cushions.

while her partner points to the left. A similar device links the next painting in the series, *Tidying*, a single painting but in effect a triptych painted mostly at Cookham in the same year. There the centre is dominated by a pink granite column from behind which a mourner with a small child in her arms looks towards events on the right while the child views the scene on the left, 'a sort of Janus-head nursemaid effect, and I like the two worlds of happenings they look into'. In the large central panel of the scheme, *The Resurrection, Port Glasgow* painted later at Cleveden View during 1947–50, the centre is identified by a table-like tomb in front of which a man and woman crawl to meet, as Stanley remembered once doing with Hilda during their courtship days on Hampstead Heath twenty-five years before.

In *Reunion* Stanley appears to honour some of his handholders. The left panel shows couples resurrecting from joint graves. The graves are railed – they are 'prams' or 'cribs' in Stanley's description. Stanley and Hilda, her hair dressed in a bun, recognizably occupy the second grave. The right-hand panel shows individuals resurrecting mostly from single graves, of which the headstones are folded like chairbacks. These are those whose isolation is being ended and who are about to be reunited with loved ones. The figures on the central panel again link the two side panels. They are visitors on a footpath who have been caught up in the joy of the occasion and who excitedly draw the attention of those on the right to their loved ones on the left. They wave handkerchiefs to attract attention and form a ring to dance in joy. The woman in the decorated hat before whom a handkerchief is being waved suggests Charlotte.

The excitement of the figures in this and all the paintings is equivalent to Stanley's own at the visionary leap forward he has accomplished. Their portrayal dynamically continues that vigorous physical movement Stanley had so gloriously painted in the ship-yard series. It is as though through Stanley's understanding the men are continuing the rhythm of their working lives into the entire panoply of the tightly-knit community they had fashioned for themselves. With them go their wives and children, their parents and sweethearts, a life-pattern of such meaning for Stanley that he was compelled to share it, 'in some way to fulfil it'.

The Resurrection with the Raising of Jairus' Daughter

Hilda was the love I felt for what I looked at, she was
the smoke coming from the factory chimneys. I want
and need her in *all* my experience.

Stanley Spencer[1]

DURING 1946, Stanley, still relying on conversations with
Charlotte to stimulate his ideas, alternated between Glasgow and
Cookham. *Furnaces* was completed and delivered to the Imperial
War Museum in June. Stanley continued to work on *The Hill of
Zion* and *Rejoicing*, travelling with his ration book and his rolls
of canvas by train between Cookham and Glasgow, and absent-
mindedly leaving his paints behind at one address or the other. In
Glasgow he stayed with the Murrays at 7 Crown Circus, or with
the Bennetts in whose salon the music circle met.

Although Stanley's paintings reveal him in his 'up in heaven' life
and this aspect of his personality dominates, it was as important
as ever to keep himself in the public eye, and he was always
delighted by any formal opportunity to talk about his paintings.
Elizabeth Rothenstein had published her Phaidon book on his art
the previous year – 'I think it will do me some good' – and other
publishers were interested in preparing monographs. He was still
putting together his writings in the hope that Victor Gollancz
would publish them, and pressed Charlotte in her capacity of
handholder – she had made a précis of *Bel Ami* to help his
composition – to read and comment on them; but she told him they
were very 'disjointed'. His shipbuilding paintings were beginning to
bring him further celebrity and he was invited to undertake 'heads'.
One was for Dr Lee, the organist of Eton College, where the
Provost showed him the art galleries – 'huge collection, magnificent

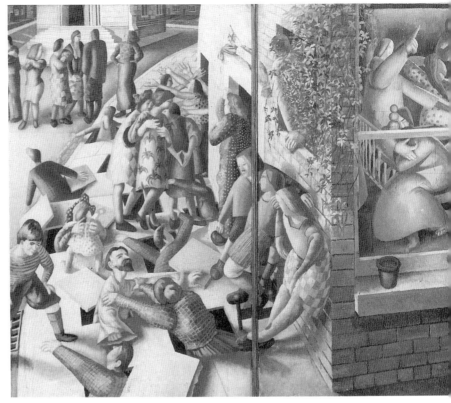

The Resurrection with the Raising of Jairus' Daughter

rooms'.[2] Another was for the Martineaus at Taplow. Asked to make a head of one of their young sons, Stanley arrived to find his subject preoccupied with watching a dead laburnum tree being felled in the garden. Infuriated by the boy's lack of co-operation, Stanley rebuked his parents, unfavourably comparing the 'self-important, self-assertive and competitive' boys of the 'upper classes' – it wasn't their fault, he argued, it was the way they were trained at public school – with those of the 'working-class children' who were always 'obliging and unobtrusive'.[3] It is a measure of the esteem in which Stanley was held that the Martineaus, like the Slessers before them, took no offence at Stanley's frankness and indeed became valued friends. At the next sitting the boy sat properly.

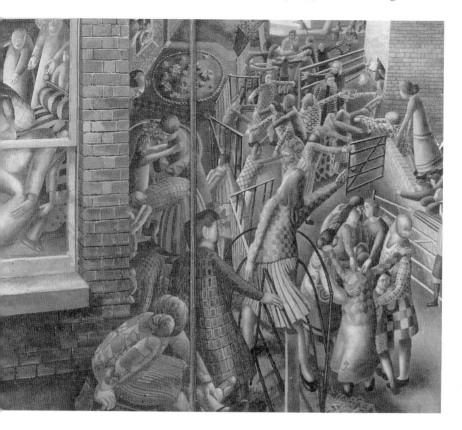

Sometimes the Murrays came south, staying with friends at Gerrards Cross. Charlotte was still trying to get her psychiatric qualifications recognized by the British Medical Association. As she hoped to settle near London, Stanley did his best to suggest jobs of all kinds, recommending to her G.B. Animation Ltd, who had taken the empty Moor Hall in Cookham – 'there are all sorts of electric machines they have in making these Disney-sort of films'[4] – on the grounds that there might be something for her because of her excellent musicianship; but the idea did not attract her. Daphne, now permanently back in London, was constantly wanting to visit Stanley and was concerned that he look after himself properly; she was a good cook, proud of her steak-and-kidney pies. She introduced him to Francis (Ffrangcon) Davies,

455

then at the beginning of his career as a concert pianist. Stanley, whose playing was always accurate but, in Charlotte's opinion, too deliberate, was encouraged to take piano lessons from Davies to improve his touch. Patricia remained at Moor Thatch with Dorothy. During the war years they kept goats, chickens and a pig, and had periodically travelled as lecturers and tutors for the Council for the Encouragement of Music and the Arts (CEMA). Patricia was evidently suffering from some nervous tension – Stanley asked Charlotte to examine her, and instructed Dudley Tooth to make sure she had money for medicines – 'she is so thin it is terrible to see'. However, she enjoyed accompanying Stanley to occasional social functions as Mrs Spencer. In the March thaw after the heavy snowfalls of 1946–7, one of the bitterest winters on record, Patricia and Dorothy were marooned in their cottage. It was typical of Stanley, just returned from helping out at Hampstead, to come to their aid, lifting furniture upstairs, and making sure they received supplies. He even suggested they evacuate to Cliveden View, an invitation they preferred, to his relief, to decline.[5]

But it is in his relationship with Hilda that the difference between the private visionary artist and the outgoing everyday Stanley can be most clearly seen. The visionary still sought her: 'When away from my association with Hilda I have a feeling of suspension. I have to shelve all that you [Charlotte] feel in my writing to be not-me, and that to me is such a vast amount of what I feel to be myself that it amounts, as I say, to my being suspended when away from her.'[6] Yet the everyday Stanley knew that even if Hilda yielded, his dream was unrealizable: 'Having lived so much by myself, I have developed bachelor characteristics. I don't like anyone around me. I am not able to dovetail into others' ways, even the most restful persons. While there at 17 Pond Street I can see her faults and the impossibility.'[7] In October 1945 Stanley had stayed at Pond Street with Hilda and Richard over the death and funeral of Mrs Carline, and there did much of the painting of St Anthony. He continued to visit them and responded to any emergency. When Hilda felt unwell in the bitter cold of February 1947, he was there again, helping Miss Arnfield with heavy tasks like carrying coals, staying with Percy and his family, who now occupied a flat in Hampstead. (Richard was in Paris as Arts

Moor Thatch under floodwater. A line of trees has now matured behind the cottage.

Counsellor to the newly formed UNESCO.) With the death of her mother, Hilda's interest in Christian Science had waned, not because she believed it any less, but because 'I can't do any concentrated thinking.' But she too saw the impracticality of reunion: 'I feel sad [she had told him] when you plan your cottage for us, including me. I can come and stay with you sometimes, but I will not want to live in Cookham, in fact I will not live anywhere but in London, and anywhere I go there would be a part set apart for you if you wanted to be there, but actually I will not live in

any house that is your house, but I do even want *you* to live with *me*.'[8]

During the spring months of 1947, Hilda's condition worsened. It became apparent that she was physically ill. Stanley insisted on the services of a trained nurse. It was she who found the tell-tale lump. Hilda was rushed to hospital and a mastectomy performed. The surgeon afterwards pronounced all well and asked for one of Stanley's paintings in lieu of fees as 'there are not many luxuries obtainable now, but fortunately we can still have beautiful surroundings'.[9]

At the same time, while a major retrospective of sixty-eight of his paintings was being held at Leeds, Stanley diverted from his main Port Glasgow series to begin work on an associated Resurrection triptych which he called *The Resurrection with the Raising of Jairus' Daughter*. Although it is contemporaneous with and usually included in the Port Glasgow series it is an interloper in subject and location. The two side panels had been drawn as early as 1940 when Stanley was beginning to conceive the Resurrection under Daphne's influence at Leonard Stanley. The left panel is based on a wedding photograph Stanley had seen there of a church which struck him by its position at a road junction, and his fancy saw those who had worshipped there rising from under the paving stones of the adjoining street. They are welcomed by the living, even to the extent of hanging out a 'welcome home' banner like those which had greeted soldiers returning from the Great War. The right-hand panel is a memory of a street in Cookham, the Pound, with its row of cottages, front gardens and railings painted as they appear in both a scrapbook drawing and a landscape derived from it.*

The central panel, *The Raising of Jairus' Daughter*, links the 'home' feelings of the right-hand panel with the 'religious' feelings of the left-hand panel. The fact that there is no connection other than in Stanley's feelings did not invalidate the juxtaposition for him. The window scene echoes the lighted interior of the church in *Travoys* and can itself be read as a combined 'home' image, 'religious' image and resurrection. The father sits clutching the bedpost in despair. Christ, with arm raised, is apparently com-

* The left and right panels were developed from scrapbook drawings 124 and 129, both done in 1940. Daphne in 129 has been transposed to Hilda in the painting.[10]

manding Jairus' daughter to rise and at the same time ordering from the room those onlookers who were sceptical of his powers. They are still in the room but have turned away.

But two dismissed onlookers, a man and a woman – obviously Hilda and Stanley – are outside, at the corner of the building. In at least two places in his writings Stanley draws particular attention to them. 'Below and outside the window are the unbelievers who were turned out in the story ... I do not know if there is any logical connection between the old unbelievers people at the foot of the central panel who are just around the corner from the people resurrecting, and being very happy about it, in the left-hand panel. One of the unbelievers is looking up and is clearly aware. I thought there was something in having this particular resurrection – Jairus' daughter being raised – in the middle of a general resurrection.'[11]

Read in the context of Stanley's recondite language, a meaning can be made to emerge. Stanley cannot see any 'logical connection' between himself-and-Hilda and the happiness of the resurrecting figures. One of the unbelievers is 'looking up' – it seems to be Hilda – and is 'clearly aware'. There was 'something' for Stanley in inserting Jairus' daughter being raised from the dead into a 'general resurrection'. Perhaps Stanley is hymning Hilda's contribution to his series. But more probably he is conveying an alarming prospect, one in which even his faith may not be strong enough to sustain him. Hilda is seated. Is she too weak to stand? The excitement of the resurrecting figures is merely a curiosity to her: she is interested but emotionally uninvolved. In the attitude of both there is a feeling of isolation and withdrawal. Stanley wears a strange metallic coat, almost as though he· is armouring himself against some battle of the spirit he dreads.

In the late summer of that year Hilda, convalescing after her operation, was persuaded to visit a friend in Edinburgh. She was accompanied by Shirin, who put her mother in First Class for comfort and herself in Third for economy. The friend, a convinced Christian Scientist, spent much time telling Hilda that she was ill because she was in error. At the end of the visit, to Shirin's relief, Stanley travelled up from Cookham and took them to Glasgow to meet his friends there and to show them the locations of his Port Glasgow Resurrections.[12] He was later to proclaim that the association of Hilda with Port Glasgow was the key which

unblocked for him his troubled composing of the main Resurrection painting, which he had not yet begun.

But the visit must have done more. It became a turning-point. Although he continued to keep in touch with the three other women in his life – his daybook for Christmas 1947 indicates that he spent Christmas Eve in Hampstead with the Charltons, the morning and afternoon of Christmas Day with Hilda and the girls, and the evening in Cookham at a party with Patricia at the Bel and the Dragon Hotel – it is apparent that he was increasingly turning back to Hilda as his great handholder, not in practical matters, but for her old power to stimulate his imagination. Two years later, for example, following the illness of his crippled cousin Amy, now elderly and helpless, an illness during which Stanley had cooked for her and tended her until he could make arrangements for her to be admitted into a nursing home, he had Hilda to stay with him at Cliveden View to give Miss Arnfield a holiday. Stanley reported to Charlotte that 'She manages very well and cooks a nice lunch. She easily gets tired in the head. But she has such wonderful thoughts.'[13] The three other women in his life caught the warning signals. Faced with the prospect of redundancy, each reacted in her own way. Daphne, as might be expected from her portrayal in *Village Life, Gloucestershire*, had no intention of going quietly. She insisted on keeping contact with Stanley despite his protestations that her too-frequent visits broke his concentration. He tried for a while – farcically at times – to deter or elude her. But she persisted and he surrendered. She was to continue her visits to the end of his life – 'God is on her side,' Stanley amusedly told Sir John Rothenstein[14] – but by then he had found an ingenious way of adapting her attentions to his real needs, as Daphne, to her exasperation, came to realize: 'He was never with me, but always in his fantasy marriage with Hilda. I was a sacrifice offered up to his divinity, the sacred Hilda.'[15]

Charlotte, back in Glasgow and not well, accepted the situation with more resignation: 'Your work is so very important that only what furthers it and your well-being is of consequence. You know that I fully realise this, and that you are in command of me if you need me.'[16] But even she was not prepared to cede him to his dreams of Hilda without protest. There is a touch of pique in the way she had clear-sightedly gone on to analyse their association,

reminding Stanley that 'human relations always have been through imposition which you resented.'[17] By 'imposition' she evidently meant the subtle distinction between Stanley's definition of a creative relationship – 'giving-and-receiving' – and the more forceful interpretation of 'giving-and-taking'. It was the latter to which she referred. The comment stung. Among Stanley's voluminous unsorted correspondence, probably unsent, is a letter – a draft or a copy – he evidently composed in reply: 'My human relationships have not always been through imposition and I told you where and when they were not. I feel I must be allowed to explain a little about "putting my work above everything". What is my work? In 1924 I did four large designs for walls, each wall had six different panels and the entire scheme was my imagined life with Hilda. James Bone [brother of Muirhead] has one of them and Lord Sandwich has the other. Since then, as you know, a large portion of my work has been an attempt to reach some point in that association. Friends of Patricia years ago described my work as "a form of self-indulgence". They may be right – I am not interested – but is that work going to come first? Have I to make a division between what is my work and what is my ancient craving for that person?'[18] It was impossible for him to separate Hilda from his vision. His craving for her presence in it was 'ancient', primordial. Charlotte's feelings were of regret but understanding: 'It meant more to me than I am able to express to have met you and seen your creation with all this destruction around.'[19]*

Years later, looking back on his life, Stanley questioned whether he had been capable of a committed love in the everyday sense. Unable to yield to those compromises which make normal relationships supportable, he felt that despite his natural wishes he had sometimes been compelled to betray many who were close and dear to him.[21]

Stanley's immediate problem was how best to withdraw from Patricia, now a stumbling-block to remarriage with Hilda, symbolic even if not physical. When he suggested divorce, he found her surprisingly compliant, but on condition that the proceedings

* Charlotte eventually acquired British recognition of her medical qualifications. For a while she practised, against BMA advice, at a private paediatric clinic in London, but became disillusioned. She and Graham returned to Glasgow permanently in November 1948. She suffered from nephritis, and was never physically well thereafter. Stanley was not in Glasgow again after 1949, but continued to send news of his activities until 1951.[20]

should in no way reflect adversely on her or Dorothy. In her opinion, grounds would have to centre on Stanley's willingness to plead 'adultery' even with Hilda on his honeymoon. Angrily he told acquaintances that he was 'trapped' by Patricia. Some assumed him to mean that he had found himself betrayed into a loveless liaison because he had not suspected her relationship with Dorothy; an unlikely explanation, for he had not been innocent in worldly matters. Temporarily blocked, he set out to prepare a surprise for Patricia. Hilda, to whom he outlined his plan, was not sure whether it was advisable. Nevertheless Stanley went ahead. His action, he was convinced, would prepare the way for bringing her back to him.[22]

Stanley sprang the surprise over the Christmas of 1948. Patricia, complaining of being unwell, wanted to spend the worst winter months with Dorothy in Nice. No longer strapped for money, Stanley drew on his account with Tooth, paid their fares, saw them off from Victoria, and according to Patricia even urged them to send back plenty of picture postcards. When they got back to Moor Thatch, a petition of annulment of their marriage awaited Patricia on the grounds of non-consummation, described in Patricia's version of events more genteelly as desertion.[23]

The grounds had been carefully chosen. If Patricia were to defend, then her relationship with Dorothy, about which both were so sensitive, would have to be openly explored. One likely influence on the choice of grounds may lie in a splendidly Old Testament tirade which Hilda had poured forth to Stanley in May 1947: 'I will not in any way be associated with Patricia. I cannot bear to be near her. I cannot bear to touch her. I cannot bear to be in her house. I cannot bear to eat or drink out of any vessel of hers. I couldn't bear to touch anything that has been hers. That is why a divorce is no use, for a divorce means you have, supposedly, had Patricia for a wife.'[24] If Stanley could in law persuade Hilda that an essential part of him had never been Patricia's, Hilda might relent.

Christ Delivered to the People

> Being with Stanley is like being with a holy person,
> one who perceives. It isn't that he is consciously or
> intentionally good or bad, or intentionally anything,
> for he *is* the thing so many strive for and he has only
> to *be*.
>
> Hilda to Dudley Tooth[1]

THE YEAR 1950 was to prove one of the most traumatic in
Stanley's life. Negotiations about his divorce from Patricia dragged
on between their respective solicitors, but more important for
Stanley was the recurrence of Hilda's illness. For the last three
years he had been working on his painting of *The Resurrection,
Port Glasgow*, the only one of the series on the original scale of
the enterprise, and his mind had been casting forward to further
paintings for his Baptism, and for his Marriage at Cana series. In
addition, ideas for new series had presented themselves. Among
them were a series on the Madonna and Child, foreshadowed
in *The Dustman*, and another on the Pentecost, a development
from the presentation in *The Cookham Resurrection*. Although
he had strong feelings about the meaning of both, he could not
crystallize the imagery for them: 'My thoughts are too much
like a number of chickens when a limited amount of grain is
thrown. They flock from all quarters of my being except perhaps
the one for which the grain was especially cast, and she is a
lame and very poor hen.'[2] He envisaged the Pentecost series
taking place in the malthouses at Cookham, but could find no
appropriate associations. He was in difficulties too over the Port
Glasgow Resurrections, mainly because at Cliveden View he did
not have sufficient space to spread such large canvases. He was
annoyed with himself that he had not made the style of *The
Hill of Zion* tally better with the main painting below it, *The*

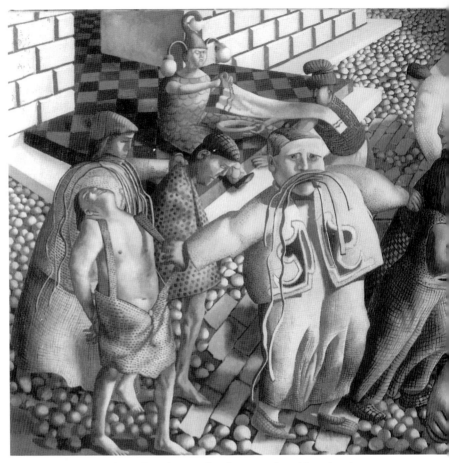

Christ Delivered to the People (also reproduced in colour)

Resurrection, Port Glasgow, which, when almost finished, he found lopsided. Indeed, it was not until he was able to take it to Tooth's new gallery at 31 Bruton Street and see it spread on the floor that he decided to sew another section to bring the left-hand side into balance.

He had ascribed much of his troubles to the dichotomy in his Hilda-feelings. Compelled by his vision to continue to try to persuade her to remarry him, both recognized the 'impossibility' of returning to their former life. His difficulties in finding associations which would lead him to 'take the first steps forward' in composition denied him that essential of earlier days, a totality of antici-

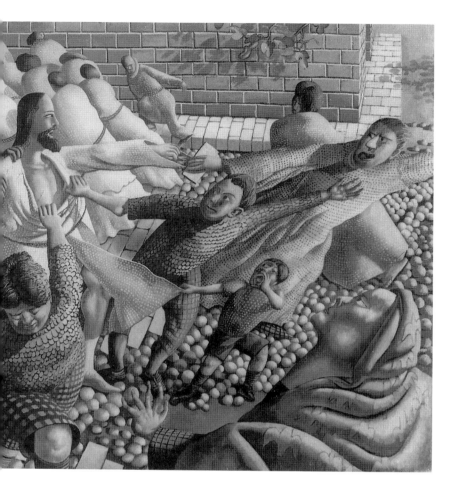

pation. The consequence was that 'It is only when I get to the end of painting some thing that I get these unexpected glimpses of its real beginnings.'[3]

The Spencer family had at various times visited Will, by now a widower, in his little house on the hillside near Thun. In January Stanley and Unity travelled to Switzerland to see him, Stanley carrying his minimal luggage in a carrier bag. Will had suffered a severe heart attack and was in the care of considerate Swiss ladies, 'Will in one room and his piano and music in the other'. They found him weak, but comfortable, and his formidable memory was unimpaired. 'Even if I go blind,' he said, 'I

shall always have my books with me.'[4] They stayed a week, and of the portraits of Will they managed, Stanley preferred one Unity had drawn.

In that same month, at committee meetings of the Royal Academy, the outgoing President, Sir Alfred Munnings, was infuriated by (but overruled on) the incoming President's proposal that a number of the more modern and controversial artists, whom the Academy had ostracized during previous years, should be offered Associate membership. Stanley was among them. Munnings bitterly disagreed with the proposal, and the row was reported in the press. There was embarrassment all round, and to make amends the Committee upgraded their offer to Stanley to Full membership with seniority appropriate to the date of his original election.* He accepted the proffered reconciliation and attended Sir Gerald Kelly's Presidential Dinner in April; the guests included the Prime Minister, Clement Attlee, and Winston Churchill. In the Summer Exhibition in May, the Academy went out of its way to give Stanley space to display the bulk of his Port Glasgow Resurrections, the first time he had the opportunity to see them *in toto*. Public acclamation was overwhelming. Edward Marsh, retired and knighted, wrote to congratulate him:

My dear Stanley,

I have seen your new Resurrection and I can't refrain from telling you how completely it bowled me over. I always said that of all your contemporaries you were the most certain of future fame, and this picture puts the matter beyond all doubt. There's no one living who could come within a mile of it. . . . all congratulations from your proud and happy old admirer,

Eddie[6]

More practically, the paintings, with their quiet but touching detail and their quirky, atmospheric religious content, caught the public imagination and quickly sold. The Bennetts had already bought *Reunion of Families* (now in Dundee Art Gallery). *The Hill of Zion* (now in Preston Art Gallery) sold for £800, *Tidying*

* Dudley Tooth was laconically amused: 'Congratulations on your move from ARA to Upper Circle. They have certainly wasted no time!'[5]

(Birmingham Art Gallery) for £450, *Waking Up* for £650,† and
the large *Resurrection, Port Glasgow* was bought for the Tate
Gallery by the Chantry Bequest for £1800. In celebration, John
Rothenstein brought out *The Cookham Resurrection* on display –
it had been stored away during the war years – and Stanley drew
a pencil portrait of him. Dudley Tooth was highly pleased, and
informed Stanley that not only was there now no danger from the
income-tax authorities, but that he was 'released from debt'. Faber
proposed a monograph on the paintings, with notes by Stanley
and commentary by the eminent art critic R. H. Wilenski, who
lived at Cookham Dean and whose support Stanley valued. It was
one of the few occasions on which he welcomed such public
presentation. In the Honours List of that year, he was awarded a
CBE.

But the euphoria, pleasing though it was to Stanley on the
everyday level, did not extend into his 'up in heaven' life. Hilda
was clearly not well. For his Academy Diploma painting, Stanley
portrayed *The Farm Gate* of his boyhood memory, developed from
the scrapbook drawing. The gate of Ovey's Farm is being opened
to admit the cows and is being forced back upon a diminutive
Stanley who struggles to slip the locking bar into place. But the
figure opening the gate is not one of the farmhands; it is Hilda,
and the detail this time suggests that Stanley feels himself in danger
of being crushed.

Moreover Stanley was concluding that the Port Glasgow Resur-
rection scheme, although being publicly acclaimed, was not being
understood in the way he wished. He had, he felt, suppressed too
heavily the sexual element so important to him, so that the paintings
acquired a mechanical quality. It hurt him that he had to remain
mute in explanation. He could only allude with his customary tact,
and hope his meaning would be grasped. This possibly explains
his co-operation with Wilenski and the way, for example, he
describes in his Faber notes one of the groups on the right of *The
Resurrection, Port Glasgow*: 'The whole of this group is like a lily,
just the flower and the baby-receiving mothers being the petal, the

† *Waking Up* was bought from the Royal Academy Summer Exhibition of 1950 by a former Slade
student, who so admired it that she sold inherited jewellery in order to possess it. On behalf of her
grandchildren the purchaser's daughter put it to auction at Christie's in March 1990, where it made
£770,000.

arms being the stamens and the babies being the little pollen-covered anthers.'[7]

The notion is not a romantic or poetic conceit. Mothers, babies, flowers: Stanley is returning to boyhood memories of the school-room in which he first understood the meaning of botanical repro-duction. The journey from his adolescent awareness of sexuality to his comprehension of the imagery of universal creation was long, subtle and, to him, miraculous. If the Port Glasgow Resurrec-tions lean, as Wilenski thought, towards Eastern concepts of spiri-tual and sexual unity, they do so not through conventional Eastern symbolism but through the power of emotion transfigured into the spiritual in a profound interpretation of personal experience.

So when Tooth asked for an explanation of Stanley's *Angels of the Apocalypse*, the 'sky painting' of the vertical triptych, Stanley gave Richard Smart an esoteric description.[8] The source of the imagery was the passage in Revelations 16: 'And I heard a great voice out of the Temple saying to the seven angels: Go your way and pour out the vials of the wrath of God upon the earth'. In the biblical account, the effect of the poison from the vials was devastating. An undecided Stanley felt that 'somehow I did not want the contents pouring [from the vials] to be so dread as they are in the Apocalypse, I did not want the flying angels to be on so wrathful an errand . . . and so hoped that it could be thought that some less potent poison was being poured upon the wrongdoers'.[9] What this 'less potent poison' might have been becomes apparent when we learn that the vials in Stanley's painting are in fact Beaufort bed bottles. But even then the idea of those contents being poured on wrongdoers was too malevolent for Stanley, and he was moved to transform the imagery into one in keeping with his concept of the Creator-God. The angels would not be avengers but creators. So he draws them like Clydeside barrage balloons, suggesting pregnancy. The imagery of the bed bottles becomes even more startling, for 'then I thought I would regard the angels . . . not strictly as Angels of the Apocalypse but as one of the few compositions I have done of the Creation, this being angels assisting in fertilizing the earth with distributing seed etc',[10] and we find ourselves back in time some forty years, when an adolescent Stanley found joy in the fecundity of the fields and flowers of Cookham. But now a specific image was needed, and Stanley turned to a

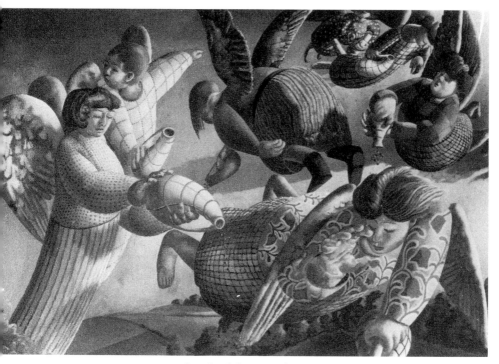

Angels of the Apocalypse

remembered use for bed bottles other than as receptacles for urine. He continues his description to Richard Smart: 'The most intensely felt painting I did for the Burghclere Chapel was a preliminary small painting . . . It showed men washing, and culminated in an orderly walking across the big bathroom on the way from the lavatory to the ward and carrying one of the bottles under a towel . . .'[11]

Stanley is alluding to a sketch which still exists as *Men Washing*. But at Burghclere Stanley did not paint it. Instead he transferred its implications to the *Ablutions* panel. In the tense closed male atmosphere so feelingly conveyed in that painting, many young men in that hospital must have occasionally used a bed bottle for the relief of sexual tension. So the 'culmination' of 'the most intensely felt painting I did for the Burghclere Chapel' was rendered as the image of the orderly raptly polishing the tap. His bed bottles contain semen: '. . . I hope I shall be understood. In a picture I usually wish for something with which I am personally familiar. This is because, in such, something of myself will be found; and because so, helps in joining myself to what I am wishing to join;

469

and thus my ability to reveal and express my way of getting inside a thing is sometimes done in this way ... In these associations reside potent elements which have the power to bring me to those vision-achieving states I wish to attain. They are not the vision, but they help to set me on the path there and when I have achieved vision, I have found that those familiar things are in the resulting picture.'[12]

During the year, Hilda's condition worsened. Stanley anxiously helped take care of her. In October, she was admitted to hospital, and her condition recognized as serious. Then, on 16 October, the *Daily Express* and other newspapers carried a report that Munnings was proposing to have Stanley prosecuted for obscenity; he had passed photographs of some of Stanley's drawings to the police. A shaken Stanley, pursued by the press, hid other drawings and paintings which might be misinterpreted; the *Leg of Mutton Nude* – now in the Tate Gallery and often diplayed – went under his bed. Sir Gerald Kelly, returning from a visit to the USA, first learned of the storm as he disembarked from his ship into a pool of waiting reporters.[13] Convinced that the standing of the Royal Academy would be diminished by another unseemly row like the one which had caused Stanley's resignation, he made moves behind the scenes to have the prosecution dropped. He wrote to Stanley to express his hope that he had 'suffered no material damage' from the affair. Stanley replied that he was grateful for Kelly's intervention, but was not convinced that he had not suffered 'lasting damage'.[14*]

During the following fortnight, it became clear that Hilda's condition offered no hope. With Stanley almost constantly at her bedside, she died on 1 November. 'I [Stanley] saw her in hospital on Monday when she was still conscious. On Tuesday she went into unconsciousness and on Wednesday evening from 7 to 8.30 I was at her bed, she still unconscious. At 8.45 she died, just, so the

* Munnings had found the drawings at a London dealer who said they came from Zwemmer. Stanley could not understand how either came to possess them, as they were not among the Zwemmer drawings he had selected for sale. Munnings borrowed them and had them photographed. It was not until a year or so after the incident that Kelly had sight of them, and found them unpalatable. As there is no evidence that Stanley ever seriously indulged in gratuitous pornographic drawing, they were probably sketches for some of his scrapbook drawings. The implication is that they were drawings which Patricia had retained without Stanley's knowledge and sold to Zwemmer on her own account, or covertly put into circulation to harass Stanley at the time of their divorce proceedings.

sister told me, ten minutes after I left.'[15] He had slipped out for a few minutes to a café. She was brought from London to the cemetery at Cookham Rise where Stanley, Richard and Shirin arranged a family plot. She was sixty-one.

We cannot know the private depths of Stanley's grief. Friends say he did not talk of it. But he stopped work on further panels in the Port Glasgow Resurrections and undertook a number of stylistically linked paintings all of which feature Christ. One, apparently a response to the Munnings hostility, he first called *Christ Led Away* but later *Christ Delivered to the People*. Both Hilda and Patricia appear in it. It is an outburst of anger and despair. On the left of the painting is an imposing building of dressed stone. One of Stanley's redbrick buildings occupies the centre background. Both face a courtyard of cobbles on which the main action is set. The tiled pavement of the first building is continued into the courtyard to form an exterior dais. Seated on it is a small gnome-like figure in the semblance of a Fool, wearing on its head a cap which looks like an inverted light fitting with pendant glass globes. Stanley might well have copied it from an actual light fitting, arguing that he did not know what regalia a Roman Governor of Jerusalem would wear. The figure is overtly Pontius Pilate at his palace who, having just passed judgement on Christ, is ritually washing his hands of responsibility, 'Pilate drying his hands as if he regrets the follies of these charlatans, which is how he would regard Christ who caused so much trouble'.[16]*

Christ, an idealized figure, is being dragged away by shouting officials and townsfolk. One, on the far right, has been identified as Munnings.[17] He catches at Christ's sleeve and holds a document. It could be the warrant of execution or the inscription – 'King of the Jews' – to be nailed on the Cross. But it could also represent Munnings' threatened writ of prosecution. Two substantial figures in Turkish dress, marshals, military policemen of Stanley's wartime experience, carry lengths of twine with which to tie the two malefactors to their crosses. One officer carries the twine in his

* In the early Renaissance religious painting Stanley so admired, for example in some treatments of the Annunciation, the symbolism of three linked lights is used to indicate the Holy Trinity, as the bowl of water and towel is used to suggest ritual purification. If their use in this painting has such a reference, it can only be as visual sarcasm to emphasize Stanley's anger.

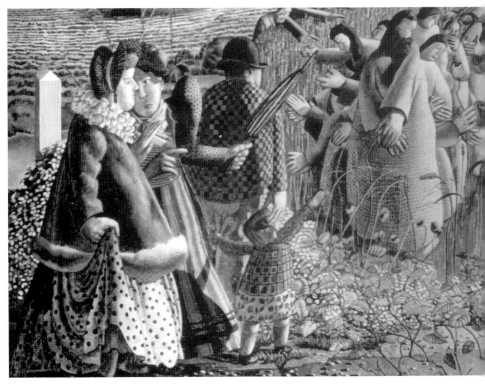

Caption: *The Sabbath Breakers* (also reproduced in colour)

teeth. When a young undergraduate put it to Stanley that in such a situation the policeman would have been unlikely to carry it that way, Stanley furiously pointed out that what he had painted was the flat raffia-like twine, sometimes called bass or bast, which gardeners use. He had painted it being held in the mouth 'instinctively', for that is how he recalled it being used. He was so annoyed at what he saw as the student's presumption that he checked with an old gardener, who told him that his version was indeed correct, and that the twine was carried in the mouth to moisten it so that it would knot more firmly.[18]

In the background the disciples creep away as they did in the two *Betrayals*. Among them is a Hilda-figure, hair rolled in a bun. She appears again back view just behind 'Munnings'. She, even she, can no longer offer support or consolation. A Patricia-figure in the bottom right-hand corner, wearing a shawl decorated with fleurs-de-lys, extends the long fingers Stanley once admired into a claw-like hand and gazes fiercely, even gloatingly at Christ. He has

been abandoned by those who should have sustained him in his agony. The fury, the energy, the pain are palpable, as they are in a companion painting, *The Daughters of Jerusalem*, in which Christ is driven amid howling women – 'Weep not for me but for yourselves and your children' – over the redbrick bridge at the end of Cookham Moor. One can hear the tumult in these paintings, feel the injustice.

Yet with them, Stanley also painted other pictures which show Christ in contentment in Cookham. In *The Sabbath Breakers* Stanley chides starched-stiff members of Cookham's Lord's Day Observance Society as they pause in shock on a Sunday country walk to see Christ and his disciples dancing towards them, joyously flouting the interdict on Sabbath work by plucking ears of corn. Had one of them complained of Stanley painting a landscape on a Sunday? In *Christ Calling the Apostles*, later renamed *Christ in Cookham*, a quiet scene is set in the back garden of Quinneys, stretching away to an orchard bordering School Lane. The school playground can be seen with children playing hopscotch. In the upper part of the picture a gardener in a green apron carries bushel baskets to collect apples. In the foreground is arranged 'an irregular row of seated disciples including the seated Christ'. He is sitting in a basket chair. The disciples 'look rather like a football team being photographed' and may well have been copied from one taken of the Cookham football team. Villagers – mothers promenading with their young children – occupy the foreground, mostly kneeling in wonder at the scene. The hedge against which the disciples sit is 'of that snowball-white flower stuff, the fronds of which impinge on the tarmac lane'.[19] The light is from the west, sunset, and casts long shadows. 'In the Fernlea days', Stanley told Charlotte in 1946, 'it was a characteristic for families to assemble in the evenings or on special occasions, Sundays etc, outside the front door, some in the front garden and some in the road, and exchange chat with villagers. On these occasions my mother sat in her bathchair, her arms loaded with photographs of every member of the family.'[20]

It is again difficult to escape the conclusion that some of these paintings act as release for unavoidable irritations of the spirit and their counterparts redeem the anger. Seen together, each points up the other. They were not, Stanley said, necessarily meant to hang adjacently; often they were intended to face each other on opposite

walls of his church house, as he indicated in a reference to Charlotte about the two paintings which support *The Resurrection of Soldiers* in the Burghclere chapel.[21] On the left wall *Stand To* shows infantry cautiously emerging from their claustrophobic dugout at the dawn period when an attack might be expected, and Stanley described the moment as 'frightening. The two words – Stand To – usually meant being called from happy dreams to reality.' Opposite, on the right wall, is *Reveille*. There the soldiers are also emerging from confinement, this time of mosquito nets, and being 'called from happy dreams'. But the emotion is quite different. Stanley based the *Reveille* painting on what his feelings might be at a moment of armistice; the soldiers seen poking their heads into the bell tent are announcing this joyous event. Stanley is 'being called from happy dreams' not as in *Stand To* to frightful reality but to its redemption through a miracle of the imagination, his entry into the joy he knew as heaven he shows in *The Resurrection of Soldiers*. When Stanley paints in anger, hurt or frustration, his imagery betrays acidity, or irony in its detail. But when the sunnier redemptive side of his nature inevitably breaks through in a companion work, the acidity mellows into wit and irony into joy.

If in physical terms the fusion of Hilda and Stanley was over, it was not so in Stanley's vision. To both, God was perfection and redemption. To Hilda, God was perfection *from* the physical. To Stanley, God was perfection *through* the physical. Here had lain one of the sources of conflict in their story. The proximity of death, which had shattered Stanley in the Great War, gave him a powerful compulsion to seek redemption through art. Hilda found a different way to the same point. She once told Stanley that, as a young woman walking alone, she had been suddenly seized, flung to the ground and sexually assaulted. In the physical terror of the ordeal she had felt herself slipping away to God, coming into the presence of God, in Stanley's terms, 'redeemed'. She thought that she might actually have died for a few seconds. For each, physical death was the prelude to spiritual resurrection. Now that Hilda's vision was fulfilled, Stanley could – indeed must – seek her in it, as he had sought her in her going to God at Banstead, and as a desolate Dante found in a transcendent Beatrice his guide through the foothills of heaven.

PART EIGHT

The Reclaiming of Hilda

1951–1959

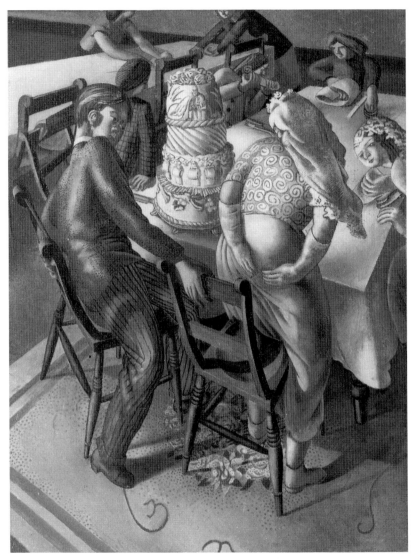

The Marriage at Cana series: Bride and Bridegroom

CHAPTER FORTY-FIVE

The Marriage at Cana: Bride and Bridegroom

> I am only concerned with the reality of what is in
> front of me in so far as it can and does assist me in
> revealing and expressing the reality of my thoughts
> and feelings.
>
> Stanley Spencer[1]

FOR THE remaining nine years of his life, two Stanleys patently
existed. The everyday Stanley whom people thought they knew
became Cookham's prized resident, regarded as a buoyant grass
widower relishing the support of friends and admirers to whom
he was easily accessible and outgoing, and cheerfully greeted as he
pushed the old pram round the locality to settle to some landscape.
His Port Glasgow Resurrections, his Christ paintings, and particu-
larly the continual flow of admired portraits and landscapes for
which he was now commissioned, not to mention the public
curiosity which surrounded the more newsworthy aspects of his
activities, made him a national, indeed an international, celebrity.
His paintings were sold over the world, although mainly in the
English-speaking countries. The press vied to print photographs of
his latest works.

He was always ready to talk about his ideas, and developed a
lecture which he called his 'famous talk'. He was a welcomed guest
at social functions, viewings, meetings and exhibitions. He acquired
a dress suit, and had to limit his acceptances, even though he
enjoyed the opportunities they offered. He spent periods at times
teaching at his old alma mater, the Slade, and was both amused
and flattered to find himself lecturing on his ideas to the august
Royal Institute of Philosophy: 'I gave them my famous talk . . .
and managed to keep going for $1\frac{1}{2}$ hours.'[2] He became interested
for a while in tapestry design, and then in lithography, in which

he took lessons from Henry Trivick, who lived near Cookham and lectured at the Regent Street Polytechnic.

In the summer of 1951 Stanley terminated his annulment proceedings against Patricia. He was advised he had little chance of success, and prolonging them was pointless. A formal deed of separation was drawn up, maintenance agreed, and the couple thereafter kept their distance. At the invitation of friends, he visited Northern Ireland. He stayed near Belfast with his elder brother Harold and his family – Harold had made a second marriage – and drew portraits of his niece Daphne. It was the first of several such visits: 'am having a lovely time. I think all the time about my brother Harold; he is delightful. He has played quite a lot to me – five of the 48 Preludes and Fugues. The cat runs after his undone bootlaces . . .'[3]

Although major projects – one was a proposal in 1953 for the decoration of the pulpitum of Llandaff Cathedral to match Epstein's *Majestas* – did not materialize,* his many commissions for landscapes and portraits meant that he had to discriminate. The choice seldom depended on the commissioner's means. The pompous or the condescending were usually rejected tactfully through Tooth, whereas the unaffected would appeal. Many of the landscapes he painted at this time were among the most magnificent he made, as were the portraits. He was never to be wealthy – his total estate at death was just over £6000 – but financially his worries were ended. It had, however, been a close thing. His income for the tax year 1948–9 was £246 and for the following year £705. Only in 1950–1 did it rise appreciably, from the sale of the Port Glasgow Resurrections. Then it was £3484, and in August Patricia applied through her solicitors for an increase in maintenance to £500 a year. By 1957 his credit with Tooth, free of all debt, was £2500. Its current value would be at least ten times that figure. He was still drawing a weekly allowance, but major expenses were met by sending the bills to Tooth to pay. In December 1951 he took out a seven-year annuity for Unity; he organized support for the painter Tom Nash, for whom times were difficult; he subscribed to Walter Lamb's retirement from the Royal Academy in 1952;

* 'Stanley's contribution was excluded not on artistic grounds but because the pulpitum scheme was modified.'[4] Stanley's proposal was for a Last Judgement. He requested a fee of £2500.

and he shared the expenses when Percy went out to Switzerland on behalf of the family at Will's death in 1954.

The recollections of Stanley's family and friends stress his un-affected charm and consideration. He was delighted when his niece Sylvia (Horace's daughter) determinedly gained her qualifi-cations as a teacher of music and art; he had had her to stay with him at Cliveden View to help with part of her teaching practice, and described her as his 'dark niece'. Pamela (Percy's daughter) was his 'fair niece', perhaps a reference to his pair of angels in *The Resurrection of the Good and the Bad*. Local children who called to ask for his autograph, or even for a drawing, were never rebuffed. He spent hours talking to classes at the primary school across the road from his cottage, sometimes sitting contentedly with the children to draw whatever subject the teacher had set; his small frame fitted comfortably into one of their desks. After the lesson he would discuss their work with them as gravely as he would his own. When a Scotsman on the Isle of Arran wrote to say that he had recently heard of Stanley's fame and would he kindly send an inexpensive example of his work, Stanley gently sent a study in oils he had made of the altar-piece at Burghclere. He had recently repurchased it for £25, but as he was offering it to the Scot for £30, he argued that he was in fact letting him have it for a fiver.[5]

He was invited to broadcast on regional and national radio; he patiently undertook press and radio interviews, some of staggering banality; he was frequently asked to pose for media photographs, and appeared in 'time-wasting' documentary films of his life and work. Having at some time casually signed with several hundred other British luminaries a petition for improved cultural relations with China, in September 1954 he unexpectedly found himself one of five signatories invited on a month's visit to that country. The party included A. J. Ayer. The confrontations which ensued between the ebullient Stanley speaking a self-allusive language of his own, and the assertive Ayer chillingly declaiming the rationality of the intellect must have been fascinating to hear. The pair certainly baffled and exasperated each other.[6] Stanley liked the Chinese people, was impressed by the respect and facilities afforded artists there, and stayed on to paint after the main party left. But he found the visit physically exhausting.

Exhibitions of his work continued to be held in Britain and in Canada, and in 1955 the Tate Gallery staged a major retrospective for which Stanley provided his own introduction: 'At last I can have my say about my paintings' and then proceeded to the familiar refrain of his loss of vision after the Great War and the time-consuming demands of landscape work which limited his 'figure picture schemes'. However, 'I believe in my associations and always have done. I believe in them as having the power of realising the meaning I seek because they are guided by another and deeper belief, namely that only goodness and love and Christian and other benign beliefs are capable of creative works.'[7]

The exterior Stanley whose courtesy and charm shine through the recollections of his friends of those years was sociable, cheerful, still fascinated by new ideas and continually interested in people and their lives. But the interior Stanley had entered another country, and into a monastery of the imagination in which spiritual meditation would bring him through his Hilda–Beatrice to God. In the quiet of Cliveden View – it was really a small detached brick-built house rather than a cottage – when the occasional cleaning lady had gone, Stanley became his 'up in heaven' self. There his routine was fixed as he liked it: an early rise, an 'army' breakfast of strong tea and bacon rashers; wash up, tidy his studio, the small front bedroom; paint till lunch, perhaps a boiled egg, or a rest which he would take wrapped up warmly and sitting on his bed propped up by pillows with a book on his knees: 'In the afternoons when having my rest, which I have found for the last three years better than lunch, I read four volumes of Gibbon's Decline and Fall. Prior to this, I had been reading three volumes of Queen Victoria's letters.'[8] Sometimes he would take a catnap in that position, putting a blanket over his head, a habit picked up during his wartime days in confined trenches and dugouts. Then perhaps a spell at the piano, or writing or thinking or walking or painting, as the mood took him. Tea was that joyous hour of bread, butter and jam. If a visitor had called, he or she too would be brought downstairs, after seeing the current picture, to share in the repast. After tea, more writing or painting. In 1952 he arranged for electricity to be installed, and was able to use blue daylight-type bulbs for painting after dark. Then bed about midnight.

He had a number of favourite books which he read and re-read

with great enjoyment. There was always the Bible, in which he continued to find unexpected things: 'St Paul is the supporter of all that "get your hair cut" business that has caused me such suffering all these years. Paul says: "Doth not even nature itself teach you that if a man have long hair it is a shame on him" (Cor.11.14). He sounds like a Nazi to me.'[9] He continued to read Milton for relaxation, as others might read a light romantic or detective novel. *The Wind in the Willows*, set nearby on the Thames, was always a delight. He was fond too of *The Golden Ass of Apuleius*.* He complained even during his last illness of his disappointment at Robert Graves' 1959 translation, much preferring his older 'Allingham's [Adlington's?] translation'.

Now, in the quiet of his cottage studio, Stanley could settle to manifesting such Hilda-thoughts in paint. He spent time going back over their life together, re-reading their letters and re-creating episodes which had significance for him. In *Silent Prayer*, for example, Hilda dozes in the quiet of a Christian Science Reading Room, a painting which took its form, Stanley tells us, from an unexpected bouquet of flowers from Florence delivered to him when he was contemplating the subject. He was so moved by her gesture that he composed the painting round the flowers on the foreground table, and patterned other readers in the room like a flower arrangement.[10] Had Hilda at last become a symbol for him of his Cookham flowers? He paints her as a cameo on the vase in the attitude in which he remembered her sketching one of the children.[11] It is a painting of the fulness of love.

In such paintings, Stanley is contemplating those moments of their life when he became intensely aware of the meaning of their fusion. The works were intended for the Hilda-chapel of his 'church of me'. Their feeling is continued in other schemes in his series. In *The Marriage at Cana* sequence, the *Bride and Bridegroom* settling to the wedding ceremony in an imagined Fernlea are in feeling

* This classical Roman novel tells of a young man who, through magic, is turned into a beast of burden, an ass; suffers hopeless miseries; and is then, after adventures in unfamiliar lands, restored through faith to human form. It can be seen at various levels as a travel yarn, a satire on the religions of the time, or an allegory of humanity's search for spiritual meaning, and of the humiliations a materialistic society heaps on those who piously undertake it. At one point Apuleius as the ass has to carry an image of the goddess Isis, an Egyptian manifestation of the Great Mother. In the end it is by owning allegiance to Isis that he is redeemed to human form. The subtle anology with Stanley's vision of Hilda cannot have been lost on him. In one of his last great compositions, his *Apotheosis of Hilda*, he will introduce imagery which strangely parallels the known ceremonial worship of the Great Mother.

Silent Prayer

himself and Hilda. He reminds himself of his fascination with female buttocks in the way he has her smooth her dress as she prepares to sit, and in the anticipatory glance with which he observes the gesture. The sensuality is the prelude necessary to their forthcoming spiritual fusion. 'There was such agreement! There was the seeing our vital selves. There was your realisation of what in my painting I was trying for, my rush to joy in your wall-pastel, your flying leaps to join me in every turn of my ideas and my writing.'[12]

Once more Stanley and Hilda are, in his imagination, as they were in the early days of their marriage. The intervening years of physical frustration have melted away, and in his writings during these closing years, we catch an echo of what their conversations must once have been like. For example, we find him at one point addressing his Hilda–Beatrice on the subject of a candle, which they once saw as a simile of their love, he the wick, she the wax, the flame their passion: 'The candle simile gives me some feeling

of the forming of our love and of our loves forming us. No step has to be taken; the movement is the flowing of our love and the cause is the flame of it, all being formed from and caused by one simple cause. So much flows over the outer hardening of each burst, and little runnels leap over the now-hanging-permanently and splash down into the saucer.'[13] A Freudian would argue that the candle is a vivid phallic symbol, the flame the libido, the dripping wax a succession of orgasms, and indeed Stanley himself thought so. But the symbol itself is used as a symbol of the even more intangible image of his and Hilda's love as a spiritual thing, a candle lit by God, so that the wax melted by the flame runs down into the saucer to produce a new entity, a Hilda–Stanley.

Having invented a piece of imagery in this way, Stanley proceeds to elaborate it, often to recondite lengths, so that thought becomes compressed. He goes on to tell Hilda that the imagery 'is as if our life was the saucer of the candle and the gutting of the candle-flames forms and re-forms in it. Now and again a "casting" is taken of the hardened gutting, and you have those Port Glasgow Resurrections. The shape of our love-child was that series . . .'[14]. Once formed, the casting is a 'now-hanging-permanently'. New bursts of melting wax – 'little runnels' – do not destroy the old but shape themselves over it. Moments of understanding achieved in love are indestructible. The future is moulded by them.

Stanley also developed the habit of taking extracts from Hilda's letters and explaining them to himself as though he were talking to her. He came across the following excerpt from a letter of hers to him of September 1945:

I have missed you since my return and yet, curiously, the more I miss you, the more I realise that it is really that I miss God even more (and now you will be jealous of God, or say that it is just nonsense). But afterwards I think there is a synchronising of these two things; in fact, I think there has always been, and the more I want you, the more I want God.[15]

Stanley was profoundly moved, and impelled to 'explain' the passage; and of course his explanation whirls off into astonishing Stanley-talk:

Let me answer this bit, Ducky. The contemplation of me by you when a

love-feeling comes leads you into that deeper, uncatastrophic maelstrom of God-love. And when and after the whirling stuff has eased up to the surface, don't you find me among the oozing froth and scum? . . . What is marvellous is to feel that I am an experience in you that is 'on the way' to your God-love. It gives me a hint, but only a hint, of what this God-love of yours is and what God is. I wonder if my feeling of need for you in me – a need for that you-quality, for you yourself, in me – is at all like your God-need, if your flesh-and-blood body was a part of my own body, like you have in some plant forms of life?[16]

If read quickly, excerpts like these – and his writings are full of them – may make little immediate sense. But if they are read slowly, they become imagery which powerfully illuminates Stanley's feelings; glimpses of the unique, intense way his mind worked towards the absorption of experience. The pieces in the jigsaw of his mind are so interlocked that the whole is incomprehensible without any of them; and yet concentration on an individual piece for its own sake renders the whole difficult to understand. Words are simply not the most satisfactory instrument by which to express concepts which Stanley could capture more powerfully in his art.

In the same way, emotional intensity in his paintings is created by equally personal use of shapes, forms, colours, objects – the basic raw material of the artist. Skylines, for example, affected him; he sees a line of women as 'a landscape of women, and just as I liked to see the intersection of hills etc, so also I liked to see the intersection of women. I see them like a number of small hills, some rising strongly, some covered with flowers and some plain,' and so they appear in *The Promenade of Women in Heaven* or indeed in *Love on the Moor*. Later, 'walking down the High Street [Cookham], I could see how the skyline of the roofs of the houses formed by their perspectiving away to the east end of the village a kind of basin shape in which I could see this [other] shape wedged right across the street like a crashed airliner.'[17] Where did Stanley derive such an unexpected association – from a newspaper photograph or a newsreel? In one of the most significant compositions yet to come, part of the design was built round 'the shape of a flea'. At times when Mrs Whiteford's attic chickens became particularly infested Stanley would seek refuge with the Murrays to rid himself and his clothing of these – to him – curious insects,

although the association of flea and design arose, he said, from a transference of idea from a photograph in a book he was reading, *Wonders of Animal Life*, in which 'a female white ant is many times larger than her husband'.[18] So personal are the associations that it is impossible to follow him with his own degree of excitement into such territories of the imagination.

Stanley's sensitivity to atmosphere, so productive in his art, remains another enigmatic area, as when walking in Switzerland with Beddington-Behrens he suddenly shied at the sight of a distant group of chalets which struck him as 'unfriendly', or when at the Beaufort he saw the laundry room in the guise of a place of worship, or in the shipyard: 'When I went into the room where big pieces of stiff material were being sewn, at the top end was a woman standing with her back to me. She was working at her table. . . . She did not look up and I was as disinclined to disturb the atmosphere as I would a religious service, even more so as in the religious service it is prescribed that you should not do so, whereas here there seemed something in the very work itself that made for me respect and peace.'[19] The scene, a sailmaker's loft, is painted not with the factual eye of everyday but through Stanley's visionary eye: he saw at the left side of the woman at her sewing machine 'a great camouflaged tarpaulin heaped up and heaping up as it emerged from her side like some sort of spawn coming from her'.[20]

Creative composition for Stanley could never be contrived. True creativity depended on the power with which personal feelings could be transmuted through associative imagery into a design which, as it was drawn or completed, he saw as truthful to his vision. On those stupendous occasions when the process functioned to perfection, Stanley thought himself to be in harmony with all things which were themselves part of the harmony of creation. But in addition to the problems inherent in this struggle, Stanley's 'peace' could be disturbed by the condescension of handholders – even Hilda accused him at times of a 'lack of decorousness' towards God – or by the blindness of officialdom, public morality, self-styled artistic criticism and misinterpretation of his aims by patrons who he thought should have known better: 'If my way of understanding or drawing near to people, namely through an experience which I feel to be with myself and themselves combined, is not what they like . . . then I am certainly out of it, as that is completely

beyond my power. . . . I have very great powers of understanding people indeed, but I have not *that kind* of capacity.'[21]

It was, he felt, public morality which had shrivelled him over the Munnings obscenity charge, taken the mystery from the Port Glasgow Resurrections, vitiated meaning in *Angels of the Apocalypse*: 'the purity of the vision would have been better preserved had I retained the shapes of the bottles. . . . It hurts me that I tried to conceal their purpose, namely that they are hospital bed bottles.'[22] In one of the last completed paintings of the 1950s, the old lion was to roar back for the last time.

The Crucifixion

Therefore speak I to them in parables; because they
seeing see not; and hearing they hear not, neither do
they understand.

Matthew 13:13

IN 1956 Stanley was commissioned to paint a portrait of his
friend and patron Jack Martineau in his robes of office.
Unfortunately for Stanley's 'peace', Jack was Master of the
Brewers' Company, one of the Guilds of the City of London.
During the time he was painting the portrait, Stanley was also
working on a small Crucifixion study which Daphne, visiting
him in Cookham, took back to Tooth early in January 1956,
the paint still wet in places. He was also composing a series on
The Entombment of Christ, remarkable works which may
represent the last and indeed the only examples of the design
idea which forty years earlier Stanley had wanted to capture in
The Centurion's Servant. That painting had been intended as a
pair, vertically divided, expressing the agony of the messenger
running to Christ in the one scene, and the centurion's redemption
in the other through his portrayal of the miraculous recovery.
But unable to capture the image of the first of these Stanley in
the end incorporated both notions into the redemption scene by
giving the figure on the bed a running posture.

In these current works, however, he has managed both scenes.
The Deposition with the Rolling Away of the Stone, for example,
is a double painting of which the Deposition is the main subject
and the Rolling Away of the Stone from Christ's tomb a smaller
and divided supporter beneath, the separation in this case being
horizontal.* In the lower painting, two angels roll back the

* The Deposition was another of Stanley's trace-themes. While still at the Slade he had made a
drawing of the subject, purchased by Tonks.[1]

487

The Crucifixion

stone to free a bearded Christ from a tunnel-shaped tomb. It is
depicted as a large drainpipe, and undoubtedly refers to a time
in the mid-1950s when Cookham High Street was dug up for
the laying of main drainage, an undertaking which made a great
impression on Stanley. The tunnel form is that which has
occurred in many of his paintings. It seems to indicate a state
of 'home' or protectiveness. The shape is repeated in a number
of red-vested disciples – the red vests of the workmen in
Cookham High Street? – rolled into remarkably ball-like atti-

tudes, presumably in grief. A distant one shows a Stanley-plus-Hilda reminiscent of Andrew Marvell's 'all our strength and all our sweetness rolled up into one ball'.* Within the tunnel the body of Christ is at rest. But the angels are preparing to free him and he will emerge not in the form in which he entered it but, as in the biblical account, in a redeemed form.

The main painting may be seen at first sight as depicting agony. Apparently gruesome – workmen are withdrawing the nails from the flesh to lower the Christ-figure – its imagery may reflect an operation Stanley underwent in September 1949 at Cliveden Hospital for the removal of the top joint of the second toe on his left foot. During a swimming party at Spade Oak, he had cut his foot and his toe became infected. The doctor shocked him by recommending amputation: 'It seemed rather a drastic thing to do for so small a trouble,' he complained, and had to waste a week in hospital.

The analogies – the men costumed for male swimming, the pincers held like surgical cutters, the figure in the corner holding the hammer posed like a doctor examining the sole of the foot – may seem ludicrous in terms of the event depicted, the Deposition of Christ. But once again we must not deceive ourselves that Stanley is offering a simple illustration of a sacred event. Stanley had throughout his life a visionary's concern that no part of him, physical or creative, should ever be lost. 'Who touched me?' asked Christ amid the crowd, knowing that some essence of himself had been taken from him. Stanley found, to his surprise, that he suffered no inconvenience from the loss of the joint, and was not normally aware that it had been taken. The painting must be an interpretation of another very personal redemption for Stanley. He appears in the painting as a shadowy figure behind the Mary who watches the deposition. Is it Mary the Mother, or Mary the Magdalen? Is he clinging to her, pulling, or pushing?† The figure being lowered from the Cross is not the Christ in the tomb. He is not dead. There are no wounds, no blood, no pain. The head does not hang. On the contrary, the figure is awakening to a new awareness.

* The reason for the ball-like attitudes is unclear. It may be imagery which Stanley derived from watching workmen roll a ball through sections of the laid drainpipes to test the gradient for freedom of flow.

† According to notes from York City Art Gallery, the two figures represent John supporting Mary the Mother.

Something which was physical has been redeemed into the spiritual.

Such startling counterpoint was used even more forcibly for another pair of paintings. Jack Martineau had suggested Stanley for a commission for the Brewers' School at Aldenham, which was extending its chapel. Stanley prepared sketches in 1957 for two paintings. As with the commission for Charles Boot, one of the paintings was gentle and relevant, a boyhood memory of Sunday service in Cookham church; Stanley titled it *In Church*. With homely touches it showed the choir in procession and proud parents in the congregation surreptitiously admiring their choirboy sons. Stanley exhibited it at the 1958 Royal Academy Summer Exhibition where it was favourably received. *The Times* published a photograph of it.[2]*

But the companion painting, *The Crucifixion*, is an explosion. In a terrifying composition, it portrays Christ being nailed to the Cross. Christ's back is to us. Only his profile, eyes lifted to heaven in seeming resignation, can be seen. He is wearing the crown of thorns. Carpenters hammer home the nails, spares held spiked between their teeth, counterpointing the thorns. The effect is one of almost gleeful sadism. They wear the puttees of his infantry comrades. The two thieves face the viewer: one seems apprehensive, the other reviles Christ. The composition of the crucifixion – Stanley's 'crashed airliner' – is exploded and splintered as the image from which he took the memory must also have been. The event occurs below the bowl of a Cookham sky, the same 'bowl' he had noticed on his walk down Cookham High Street, and he has placed the Cross on a 'Golgotha' comprised from the heaps of earth exposed when Cookham High Street was dug up for the laying of the drainage. Mary Magdalen lies prostrate at his feet, insensate in grief, a corpse flung from wreckage.

The painting was publicly shown for the first time in 1958 at an exhibition of Stanley's work mounted in aid of Cookham Church funds and sponsored by the John Lewis Partnership, who had established their country conference and staff centre at Odney in Cookham. Twenty-five thousand visitors came, and the exhibition had to be extended to three weeks. Stanley's *The Crucifixion* was

* The year before, Stanley's niece Sylvia had shown him one of her paintings, of a service in a church. 'I must do that,' Stanley remarked.[3] Sylvia included the face of her grandfather (Pa), whom she remembered with affection. Stanley's painting too has Pa in the congregation.

The Deposition and Rolling Away of the Stone

hung in the church.* There was praise for its dramatic vividness but also surprise at its violence, so uncharacteristic of Stanley's proclaimed beliefs. More disturbingly there was concern about its suitability for a school chapel. Stanley felt impelled to write a long letter to *The Times* explaining the sources of the composition, but made no reference to the complaint of unsuitability.[5] He later admitted that he was angry at the public raising of the complaint, since he could only paint in the honesty of his feelings, and the Brewers who gave him the commission were well aware of his abstemious convictions.† It has been pointed out that the board behind the thief on the left, awaiting its inscription, is a segment of a beer barrel. The two workmen hammering in the nails wear brewers' caps. As forthright as ever, Stanley later told the boys at Aldenham School: 'I have given the men who are nailing Christ to the Cross – and making sure they do a good job of it – brewers' caps because it is your Governors, and you, who are still nailing Christ to the Cross.'[8] The depth of violence in the painting must surely reflect the anger Stanley felt at a public, even friends, who showed no understanding of the purpose of his painting and who with the best of intentions trumpeted their ignorance of his ideals.

* In May 1990 the painting was sold at Sotheby's on behalf of Aldenham School for £1,320,000, the highest price paid at the time for a work by a modern British painter. In an article in *The Independent*, two residents of Cookham at the time, Patrick and Mary Gribbin, told journalist Joseph Williams that they recognize themselves when young among the family group looking on from the balcony of their High Street house. As a family they were 'vilified' in Cookham as Irish Catholic and abstemious with alcohol, particularly by some Freemasons, one of whom they see as shown nailing Christ. The other 'looks like an odd character who used to cycle endlessly round the square'. The left-hand thief, they suggest, was the butcher's son, while Patrick has 'nostalgic memories' of the right-hand thief as a schoolboy character 'so hard he could tackle boys three years older'. The woman lying at Christ's feet they think 'resembles a foreign evacuee who was unpopular in the village at the time', while Christ himself was more sympathetically 'the Queen's swan-upper in Cookham'. The interpretation is fascinating in its indication of the visual and emotional use Stanley made of appropriate personalities as models in his paintings.'[4]

† Stanley although socially not teetotal was himself abstemious. His feelings about drinking were perhaps partly the result of his brother Horace's decline and death. Horace died on Saturday, 15 March 1941. His career as a celebrity conjurer, which could have made him wealthy, had deteriorated. His wanderlust (he enjoyed engagements on ocean liners) had become vagrancy, his generosity penury and his conviviality alcoholism. That weekend, obviously ill, he had called on Marjorie near Maidenhead and at the piano played some of the Bach and Chopin he loved.[6] In the evening he borrowed his son's bicycle and cycled to a pub in Cookham where he entertained with card tricks, a drink a trick. Towards midnight a local man, an amateur boxer, found him in the High Street in a state of collapse, but insisting on trying to cycle back. Alarmed for his safety (it was wartime blackout and vehicles had masked headlights) the man accompanied him, steadying him where he could. Near Boulter's Lock where the road runs alongside the river, his companion lost control of him, and Horace fell, rolled under the railings and dropped five feet into the river. The alarm was raised and the police searched the river, but his body was not found for a fortnight. The inquest verdict was accidental death.[7]

'To have no knowledge of it is to have no respect for my work,' he protested.[9]

Why then did Stanley undertake the painting? As a theme, the Crucifixion, like the Resurrection, was one he had for long years

Stanley at his 1958 Exhibition in Cookham. Gilbert is on the left, back view. Tom Nash on the right. Fourth figure not known.

held constantly at the back of his mind. The idea was hinted at in *Travoys*, where the wounded are seen at peace 'like Christ on the Cross'. He approached it again in *The Scarecrow, Cookham*, in the figure of the saint in *St Francis and the Birds*, and in some of

493

his scrapbook drawings.* After Hilda's death, he returned to the theme again. In his notes of 1951 he began to work out how a new Crucifixion might be accomplished, returning for his theme-source to the 1921 Petersfield *Crucifixion* and in particular to that moment in 1918 when he had been tramping through the snow and suddenly felt his overwhelming ecstasy of 'unselfishness': 'To understand what I am hoping for [in the new version he is pondering] first we go back to the mountain and the ravines. It was remote, not lonely because so momentous as to be peaceful, but miraculous if one thought of a human happening there. . . . In this second ravine notion I want to heave out of that upper dark region [the sky of the 1921 painting] something that will be as remote and have all that in the mountain top one feels and yet be completely surprising.'[11] In these 'contemplations' of 1951, he even thought that one of the men nailing Christ to the Cross should wear 'a sort of brewers' tammy with a flopping peak', perhaps a Stanley-memory of his reading of Blake's comment on Rubens' Crucifixions (whose ferocity, with that of Grünewald, Stanley's shares): 'I understand Christ was a carpenter, And not a brewer's servant, sir'; and from such sudden, almost unconsidered detail the great connections spring, worked through in studies in 1956 and 1957. Jack Martineau, himself a brewer, asking for a Crucifixion painting; Stanley, finding new imagery in the skyline of Cookham village, to 'heave out' of the dark sky of 1921; the crashed airliner to represent the physical agony, the awe of disaster; the mounds of earth dug from the High Street as a rupture of all that signified 'home';† the figure of Mary prostrate: the result was certainly 'surprising', for from it Stanley was producing a redemption to be gleaned in even the most terrible afflictions of the real world: 'the Head of Christ, arms outstretched and face turned upwards'.[12]

From his earliest days Stanley's existence and his art had been devoted to a single aim: to search through the happenings of his existence to find an order in their apparent contingency. The pragmatic world would inevitably mock his struggle, assure him it was pointless, tell him he was wasting his time. Why not give in

* 'In about 1934 I tried to do a crucifixion for Mr Hobday in Canada. It was too hurried. I used the Scarecrow landscape as the idea.'[10]

 † The laying of the main drainage in Cookham was a major undertaking, with some trenches fifteen feet deep.

and paint what people in the 'real' world wanted from him? The validity of their point of view was justified in their terms, but Stanley held firm. Like Christ, he knew that in the end he would be betrayed by his dedication, be unable to achieve his quest in any significant sense, be crucified by the incomprehension of others.

In the quiet of Cliveden View, Stanley returned to seeking visionary peace in sorting and re-sorting his life's experiences: 'I wish I could have all my real selves round me like objects in a museum. My great losses are my pictures and Hilda.'[13] As he worked through his memories, his family photographs, the reproductions of his paintings, they formed for him the comforting shapes of his moments of comprehension: 'The cross [in the Burghclere *Resurrection of Soldiers*] is one of the forms through which this state of peace has been expressed. Here it is caressed like a sweetheart, and there it is forming a kind of door to a house, so that a soldier can re-enjoy his old joys of sitting in his doorway and chatting to his neighbour. It forms a home for him. [The feeling in the composition] is a series of waves receding upwards and backwards. . . . First there is *awareness*; then there is gratitude and the desire to express it in something; and then they remember their cross, their last piece of earthly impedimenta . . .'[14] For a crucified, redeemed Stanley, the final resurrection was at hand.

Christ Preaching at Cookham Regatta

Only on the way to heaven have I eyes and can see.

Stanley Spencer[1]

DURING THESE final years, Stanley began a number of paintings which suggest by their size that they may have been intended as the altar-pieces of some of the rooms of his church house. There is no documentary evidence that they were so, but their content is a clear exposition of aspects of his outlook. If these final paintings were composed with this end in mind, then we find him celebrating the wonder of the coming of fulfilment in an Elsie altar-piece; the majesty of the coming of fulfilment in a Hilda altar-piece; and the sanctity of the coming of fulfilment in a Cookham river-aisle altar-piece.

The Elsie altar-piece came to light only in 1984. It is a considerable canvas, drawn but unpainted, showing a servant-girl at a garden gate, evidently that of Fernlea. She is surrounded by admiring swains, each of whom is anxious to escort her on her evening out. While she chooses, the small figure of Stanley kneels at her feet in worship. The composition must be the climax of that 'servant-girl flirtation' he described to Henry Lamb, one of the many themes which run through his art. The drawing celebrates a moment in Stanley's boyhood when the arrival of young men at Fernlea to walk the family servant on her night out took meaning for him. In those days, although he sensed the power of the sexual urge, its spiritual function was still a mystery to him. The young men around the girl are in effect the pairs of lovers in *The Nativity*. They partake of a sacrament the young Stanley sensed was holy, but which he did not then understand and they could not see as such. But now he knows its meaning. In his final tribute to Elsie and her gladness in living, he draws her standing, as he once did,

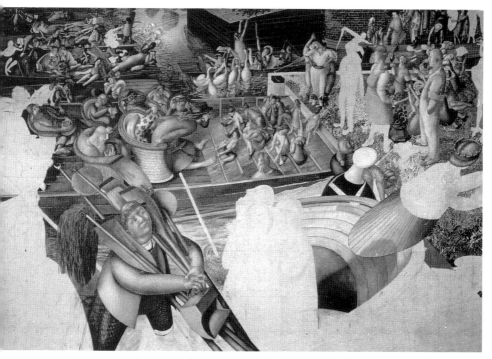

Christ Preaching at Cookham Regatta (part)
(also reproduced in colour)

on the threshold of a life to be fulfilled, and with profound commitments to make. She is discovering the meaning of love in its true and honoured sense, and he, Stanley, is adoring that love.

For what else is love but the worship of some spiritual quality discerned in a material being or object? Patricia, Daphne and Charlotte were to have been other celebrants in his transfiguration. But of his handholders Hilda was the goddess, and her altar-piece was to be the greatest. It remains today as he left it, a vast twenty-foot (seven-metre) canvas drawn but only patchily painted. The scene is set on Hampstead Heath in the days of their courtship and early marriage. The setting is geographically precise: 'in the west side of The Priors and facing SW by S. To our spectator's left we take in a prospective over Well Walk and at the junction of that road with East Heath Road we have the pillar box . . . I used to see Hilda coming across along the switchback track when she used to walk up from Downshire Hill to see me; it is the place I have taken for revealing this aspect of my feeling about her [Hilda walking towards him and *wanting to see him*, a wonder and a

miracle]. She is for the most part a grand figure and is meant to be walking in a trance of joy.'[2]

The work is a vast composite. There are several Hildas and several adoring Stanleys. It is a celebration of their joy and especially of their fusion. The pillar box symbolizes their togetherness through the letters they continually wrote to each other. 'This is a land of joyful happenings, and Hilda is entranced with it, and I tried to make it a manifestation of the joy of our united souls. It is a kind of Vale of Health Paradise or Heaven.'[3]

The central Hilda stands rapt, her arms extended and her fingers spread. Stanley looks on in delight. Before her, a crowd of children joyously processes, as though returning from a party. They are the youngsters of a *Village in Heaven*, the ecstatic children with arms raised of the *Rejoicing* panel of the Port Glasgow Resurrection. They wave streamers or blow on those party toys which, when puffed, squeak and shoot out a rolled-up paper tube. They are 'hailing Hilda's arrival'.[4] Hilda wears the tricorned hat she wore at their wedding, together with her 'flapping coat', the sleeves of which were webbed like a cloak to the sides. The 'Bosnian shoes' she bought on their Yugoslavian visit cover her 'slithering feet'; for Stanley the 'purposelessness or directionlessness' of her legs as they 'glide along' are her 'essential dance'. She is a bride adorned for her husband; a mystery willingly offered for his exploration.

Around them, their letters are scattered like litter over the entire canvas. Strollers stoop to pick them up, or rummage in a waste-paper basket to retrieve them like the woman in *Love on the Moor*. As they read them, they draw the attention of others to thrilling passages; as they understand them they are transported with that same delight which suffused the figures in the Port Glasgow Resurrections. In fact Stanley first called the composition 'Litter' or 'Litter on Hampstead Heath', and it was only later that he gave it a title more representative of its feeling, *The Apotheosis of Hilda*.* The letters dot the grass like wildflowers, the marguerites of Stanley's adolescence or the bluebells of his sager years. They are the sunflower and the roses of *The Cookham Resurrection*, the blossom of Bellrope Meadow, the bearers of the pollen, the seed,

* Preliminary drawings for the *Apotheosis of Hilda* are held at the Stanley Spencer Gallery in Cookham. They were considerably modified in the final composition, which has been given only occasional exhibition. The unfinished picture itself has to date never been photographed.

the 'little bits of me thrown freely about'. The strolling passers-by are metaphors of all the 'hungry ones' who have come to understand the sexual–religious meaning embodied in his Hilda 'you–me' fusion: 'I make her [Hilda's] hand spread and fingers stick out fanwise, indicating that she is in her mental "you–me" home.'[5]

The orgasm is corporeal; the fusion spiritual. It is a mutual giving-and-receiving in which all in the composition are 'liked'. From the specific a universal is created, an all-embracing Oneness. The sexual, the religious, and the artistic are fused:

One evening when Hilda had come to see me [in the Vale of Health studio] and the stove was sending a glow over the plain deal boards of the floor and we were sitting peacefully, we were looking at each other in the glow and both felt at peace and smiled as we did when we were happy. We felt hot and when I took my coat and waistcoat off, she said she would remove some things herself. I said 'Let's undress' and Hilda put her head sideways and said 'Um' quietly. We were soon completely undressed and oh how we loved it and stood about on the warm floor and gazed at each other, Hilda's eyes shining in the glow with joy. . . . You wagged your head from side to side and 'darling'd' me. I 'ducky'd' you. We cooed and laughed and peacefully rejoiced in each other's presence. I could *feel* being seen by you all over me. You would do things about the room being stared at. . . . I was so pleased after all the years of wanting to see you . . . I felt your face. That was wonderful, like an ancient Elixir of India, and here was all my precious one. We stood in full consciousness of each other, we could put our arms round one another. . . . I wanted you for ever. . . . *Nothing can stand in the way of the will to love. . . .*[6]

In December 1958, still at work on his altar-pieces in his bedroom studio at Cliveden View, Stanley fell ill. In great pain he had to summon help by calling from the window: 'Stanley Spencer is very ill.'[7] He was taken to the nearby Canadian War Memorial Hospital in the grounds of Cliveden. Cancer was diagnosed and he underwent an operation, a colostomy. When he was discharged in February of 1959, the vicar of Cookham, Michael Westropp and his wife Rachel, installed him with them in the Vicarage for several weeks' convalescence. Although Stanley recovered sufficiently to continue painting and even to undertake commissions,

his influential patrons felt that he should not be encouraged to return to live alone at Cliveden View.

By chance, his old home Fernlea, then called the White House, had come on the market and Stanley told Dudley Tooth confidentially that 'I think Jack Martineau and his Lordship have bought my old home in Cookham to be presented to me to live in all my days . . . and then on ceasing to need it, to be given to the children.'[8] 'His Lordship' was William Astor, grandson of the Waldorf Astor who had built the high brick wall along the Sutton Road to protect his son, William's father, who had married the redoubtable Nancy. Stanley and Astor had been introduced in 1956 and become close friends, Stanley often being invited to dine at Cliveden. Stanley was flattered at their gesture but was 'still hoping to be able to hold on to the Cookham Rise cottage. . . . I shall be sorry to lose it,' for it had been the retreat which had produced some of his most inspired contemplations.

However, steps were taken to put the cottage up for sale and, with Stanley's agreement, to transfer the paid-up part of his mortgage to defraying the cost of the more expensive Fernlea, renamed Fernley. Stanley was installed there in April, Michael Westropp personally carrying the *The Leg of Mutton Nude* tightly wrapped in brown paper from under Stanley's bed at Cliveden View to its place under the same bed at Fernley. For company, Ffrangcon Davies, who needed a practice room, was invited to move himself and his grand piano in too. To Stanley it seemed like the days of his youth, to be painting upstairs while the piano sounded below, although Davies' Celtic renderings were more fiery than the measured interpretations of Pa or Will.

In May Stanley was fit enough to visit the new Coventry Cathedral. His knighthood was gazetted in the Royal Birthday Honours on 13 June. Friends recall that on the morning of the announcement he installed himself with his easel beside the Causeway over Cookham Moor so that those on their way to the railway station would have an easy opportunity of congratulating him. The gesture would have seemed to him as natural as that of his mother when she had herself wheeled out in her bathchair to sit outside Fernlea and show her family photo albums to whoever passed by.[9] That evening, some hundred or so of his friends held a celebration party for him in an artists' rendezvous in Redcliffe

Gardens, West London.[10] From Moor Thatch Patricia posted a rebuke to Stanley's solicitors for failing to address her in correspondence as Lady Spencer; they replied she was not Lady Spencer until his Investiture.[11]

On 4 July he was awarded his degree of Hon. Litt at Southampton University; he was already a Fellow of London University. On 7 July he received his knighthood from the Queen Mother,

Stanley with Unity on the occasion of his Investiture, 1959.

the Queen herself being on a state visit to Canada. Accompanied by Unity, Stanley took with him to Buckingham Palace a small painting of two roses stuck in a fish-paste jar as a 'little present' for the Queen Mother. He was so disappointed to discover that protocol forbade such gifts that the Queen Mother later wrote to say that, personally, she would be delighted to receive his gift. Unfortunately by then Stanley had given it to Mrs Barrett, wife of the owner of the Torquil Café in Cookham High Street. In a harassed kitchen moment in the days before the widespread introduction of detergents she had complained to Stanley that she longed for a grease-remover. Consolingly, Stanley fetched the painting and presented it to her as a 'grease-remover'. She was so surprised and delighted that she promptly changed the name of the café to

Self-Portrait 1959. Private collection.

The Two Roses.[12] So Stanley had to promise the Queen Mother another little flower painting.

Later in July and into August he stayed with good friends and patrons, Joy and Dennis Smith, in Dewsbury, Yorkshire. There he painted his last *Self-Portrait*. In it he looks at himself in a mirror and at us quizzically. No longer is he the Stanley of the 1914 *Self-Portrait* which Sydney and Edward Marsh had so much admired, eyes filled with the dreams of visions yet to come. Now he knows what he sees. Do you too, he seems to ask, know what I see?

In August Patricia, though now receiving rent from a London property which had come her way, resumed attempts to have her maintenance increased. At the end of August, due to make a drawing of Sir Anthony Eden, Stanley had to go back into hospital for a regulation of the colostomy. It was apparent that the cancer was causing concern. Unity came every weekend from her teaching post in Kent; Shirin, teaching in Africa, made arrangements to come home. Friends frequently visited. Stanley remained jovial.

On 1 September he left hospital for Fernley: 'I shall miss hearing the morning greetings passed from one man to another like rook sounds.'[13] Lord Astor had offered the use of a private room, but Stanley preferred the companionship of an open ward. In late September, Shirin returned and stayed with him. She read aloud for him passages from his autobiography. Delighted, he asked her to help him organize its preparation, so she started to learn to type. The BBC conducted a radio interview which revealed both his subtlety and his patience in the face of questions largely uncomprehending of his ideals. Had the format been popular then, he would have made a splendid guest on television chat-shows, talkative and ebullient, but with a hint of the thrilling and the untameable. On 1 October he spoke for an hour about his work at the Cheltenham Festival of Arts and Literature.

But the respite from his cancer was only temporary. In November he was back in hospital again. Tooths sent him their last letter:

Dear Sir Stanley,

Dudley is away for a few days and I thought it would cheer you up to know that Mrs Whitney, the wife of the American Ambassador in London,

telephoned to say that the Ambassador is very keen that you should paint his portrait when you are up and about and fit to do so.

I told her that you were in hospital and she asked me to give you their joint best wishes in which we all, of course, join.[14]

The end came peacefully on 14 December. During the morning Rachel Westropp had read to him the last chapter of *The Wind in the Willows*. In the afternoon Shirin and Unity visited. Stanley was unable to speak, but watched them and drew pictures for them with his finger in the air. He asked them to sing *Jerusalem* for him, which they did. In the evening Michael Westropp came and sat with him. Stanley proclaimed, with pencil on pad, that 'sorrow and sadness is not me'. Westropp pronounced for him the great blessing which Stanley loved to hear – 'The Lord bless you and keep you' – knowing it as the blessing which Moses had given Aaron. Presently the nurse came and gave him his injection. 'Beautifully done,' the former medical orderly indicated approvingly. He seemed to sleep, but a little while later, before Westropp had time to realize, Stanley had gone.

He had been unable to finish his Hilda altar-piece. He had done nothing towards his altar-piece for the Patricia room, a scene in which nude studies of her would be set, as once he set her, among the grass and flowers of Cockmarsh. Her images would have been dotted 'like cows'; not insultingly, but as manifestations of that Cookham-feeling which had meant so much to him. The Daphne room would have used some of the powerful images of her he had begun in his scrapbook drawings. His Elsie altar-piece – *Her Evening Off* – had been rolled up, put away and forgotten.

Had Stanley been spared another ten years – he was sixty-eight at his death – these powerful compositions might have resolved more of the messages of his life's work. Only one is currently on display, a painting which may have been intended as the altar-piece of the river-aisle of his church house. It is on loan to the Stanley Spencer Gallery from the fourth Viscount Astor. Stanley titled it *Christ Preaching at Cookham Regatta*. He had drawn it at Cliveden View, taken it to Fernley, brought it to the Vicarage during his convalescence, then back to Fernley, painting it as and when he could. During progress he occasionally exhibited it, unfinished though it was. It was composed from a series of drawings now

Portrait of Shirin

mostly dispersed into private collections, and for much of the work he had to roll the canvas at each end, unfurling it like a scroll to whichever section he decided to work on. Even while painting he made modifications. To view it now is a poignant experience. Through it one can see how at the everyday level Stanley went

about the practice of his work; and yet at the compositional level he lifts us in it to the threshold of his meaning of love and joy.

For its feeling, Stanley takes himself and us back to the memories of his youth, to the holiday days of the Cookham Regatta, when the gentry and aspiring gentry came in their hundreds to enjoy themselves in punts, the excursionists from London to picnic noisily or to enjoy their drinks on the lawn of the Ferry Hotel and the locals to watch from the riverbanks. No wonder Stanley shows Mr Turk in the foreground enraptured in profitable satisfaction; the Spencers could never afford the inflated prices of his punts during Regatta Week. The participants crowd on to the canvas, and we are intended to see each in his or her transformed state:

This all expresses to me the fact that I want all to know that what they wish for will be received. That if the Regatta [Stanley's personal symbol of whatever in our own lives gives us similar anticipation of happiness] is voluptuous, then let it be so. The Christ talk is that their joy may be full. If it is carnal wishes, they will be fulfilled; if it is creative wishes, they will be fulfilled. If it is sexual desires or picture-making inspiration that is to be satisfied, then Christ will heave the capstan round. . . . All will be met. Everything will be fulfilled in the symbol of the Regatta. The complete worshipfulness and lovableness of *everything* to do with love is meant in this Regatta scene. In that marvellous atmosphere nothing can go wrong.[15]

Christ himself, a bearded figure wearing a straw hat – was it the summer straw hat of Stanley's youthful regatta days, ruined in his walk to enlist? – sits in the old horse-ferry barge leaning forward to preach over the heads of the children in the barge who will inherit the truths he proclaims.*

The setting of the picture was not one which had suddenly occurred to Stanley. As early as the 1920s he had been thinking of using the regatta as the theme of one of his schemes of multiple paintings. He sketched part of it in the 1940s at Leonard Stanley, and in the 1950s painted a number of scenes which were intended as an integral part. These he grouped under the generic title *Christ Preaching at Cookham Regatta*, the title he used for

* Stanley told the Westropps that the children are 'like little frogs which have jumped accidentally into punts from the river bank'.

the eventual main picture. One part, *Girls Listening*, painted in 1953, shows a patch of riverside meadow exquisitely painted with the craftsmanlike detail of grass and flowers Stanley always gave to the best of his landscapes. From the 'infant memory' of Cookham wildflowers had sprung some of his earliest metaphysical contemplations, and in this mighty series of paintings, grasses and flowers would form not merely the background to the onlookers and their behaviour, but also became in simile the source of their and Stanley's feelings.

On the grass a table has been spread, round which sit four girls in Stanley's distorted style of the *Beatitudes of Love*; from which we may infer that they are figures known to him, used as emanations of feeling but set in a precise landscape. The arms of the girls are extended over the table to form a cross, suggesting in Stanley's iconography a 'religious' symbolism. The woman on the left is a reversed figure of Elsie in *Workmen in the House*. Two of the women are distracted by children seeking their attention. The children, the bare arms – a potent erotic symbol for Stanley – and the religious implication of their patterning suggest that we are to see the figures as the maternal and domestic women who once stirred Stanley's consciousness. But now Stanley has subsumed those functions into the greater creative purpose he is celebrating. The women have no need to listen to Christ's preaching. They are already transfigured and aware of his message and meaning.

If such an interpretation is accepted, then a meaning for a companion painting in the series, *Dinner on the Ferry Hotel Lawn*, is reinforced. Diners await their meal. The busy waitresses fling tablecloths over tables whose shapes echo those of the punts on the river in the main picture. The tablecloths descend on the diners and the cutlery is being brusquely laid: 'I got this notion . . . from the somewhat unceremonious way our maid Elsie passed things across the table.'[16] The foreground table is occupied by a stylized Stanley-figure resentful of his three female companions. Renunciations are in progress; from the determined lady sitting with arms and legs akimbo (Daphne?); from the slim and contemplative figure at the end of the table (Charlotte?); and from the third figure attracted by another (Patricia?). Few of the figures in the painting, hungry and eagerly anticipating their meal, pay attention to the

voice of Christ who is preaching to the left of the scene, off-frame;* except, that is, for a couple of lonely figures in the top left. One is a figure sitting on a cushion and gazing riverwards, arms outspread and emotionally detached from the rest of the scene. She wears a fur stole.

Someone to whom Stanley showed the paintings queried the absence of food on the tables, the maids laying the cutlery back to front. Stanley pretended astonished dismay. How clever of the questioner to raise points he had evidently overlooked! But he offered no explanation. 'I never answer questions put to me by the public because they don't want an answer and because they are pleased to have that question to ask. It is to them your identification mark. . . . The natural egotism and pride and conceit of the public constrains them to regard only the question and the cleverness in the question and their cleverness in asking it, so that the din of self-congratulation is so great that they cannot hear anything else and would not understand it if they did.'[17]

'They would not understand it if they did.' What was Stanley saying in these last great paintings? We cannot say in detail – perhaps neither could he in the complexity of his associations – but the gist of them seems clear. He was returning to that mighty theme which was at the centre of *The Cookham Resurrection* – the Coming of the Holy Spirit. From God, through Christ, the Spirit descends; and Stanley's art, his visionary paintings, were in their ultimate inspiration an honouring and celebration of the Pentecost all must experience even if it is an allegory they do not admit or recognize. In the 1940s, he told Charlotte, he had envisaged his Pentecost paintings as essentially urban scenes: 'In the Pentecost I like and want the notion of the leaven of Christ's teaching to make its way through all circumstances and happenings of life . . . giving to everything its special meaning and import; and I, mentally so to speak being one of the disciples or judges, in making my way through the streets and through the rooms of the houses, so love all that is love . . . so that nothing that is happening in any incident is meant to be other than good.'[18]

We know he could not fix the urban image, and there seems

* 'I believe Christ talking is really me lovemaking to everybody.' The comment in a letter to Unity refers to *Christ Preaching at Cookham Regatta*. If taken out of context it appears almost blasphemous. But by then Stanley knew, and those who knew him knew, what he meant.

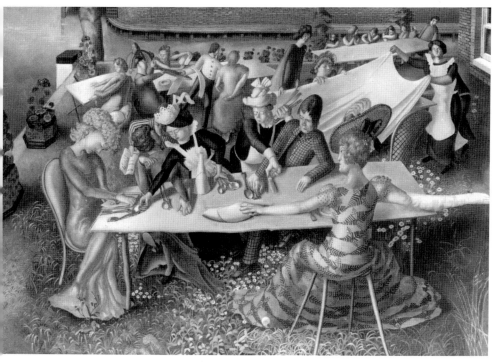

Christ Preaching at Cookham Regatta series: Dinner on the Ferry Hotel Lawn

no painting representative of it, unless *Christ in Cookham* is a derivation. But *Christ Preaching at Cookham Regatta* may be an apt parallel of the emotion, if not of the imagery. The 'houses' and 'rooms' of Stanley's original notion have been reproduced as crowded punts, each occupied by their different groups of families or friends, each punt-load separate but in Stanley's imagination united into love through Christ's preaching. In a series of letters to Unity he described in detail how he saw each punt-load in their separate-yet-united aspects. Here is his notion of one of the punt-loads, in this case of middle-class ladies of the period, which he is proposing to paint: 'They are nearly all middle-aged ladies and all either asleep or nearly so. They have had a tiring day dismissing servants, and they are all going byes under a shared-by-all blanket. Ah, then my Puck magic gets to work. The Christ-talk o'ercrows all those bothersome things, and they sleep their way into this critical, no-servant-dismissing joy and peace. I don't love them in their hoity-toity-ness, I love them because I know this is not them at all and that they are just as lovable as the servants they dismiss, and that's saying a lot! Bringing them to the Regatta

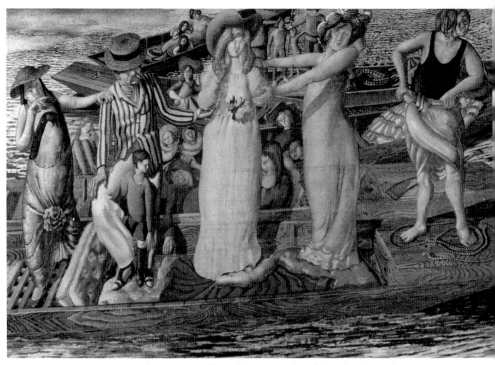

Christ Preaching at Cookham Regatta series: Listening from Punts

I so to speak ensnare them, and bring them to my joy, which in this painting is Christ's joy.'[19]

In describing to Charlotte the earlier ideas for incorporating into a painting Ma sitting in the garden in her basket chair – ideas, we suggested, which may have determined the design of *Christ in Cookham* – we find Stanley announcing that there is 'somehow an analogy between what takes place in the Pentecost upper room, and the creation and the concept of new life they had then, and the great taking of it out into the world.'[20] The eventual depiction of Christ himself was not as Stanley's first notion. That, he told Unity, would have been of 'the lone figure of Christ just glorying in his gorgeousness, and I wanted him there in a great gallivanting lying-down sprawl. Well, I thought, rather far from Holy Writ. But I love it and still hope to draw it . . .'[21] But does he? No, in the end he sits Christ on the barge *in a basket chair*. Christ's feelings are those of Ma, anxious and proud to show photographs of her family to all who will listen, her 'great taking out into the world' of the 'creation and concept of the new life' which came at Pentecost.

In the top left corner of the picture, drawn but not yet painted, is a replica of one of the earlier paintings. The original is called *Listening from Punts*. In it a young woman wearing a white dress and holding a bouquet of flowers is being gripped by those around her on her punt. Stanley told his daughters that she is so overwhelmed at Christ's preaching that she needs to be supported or she would faint with joy. Look at her closely. Surely she is being *presented* to the message of Christ. She is a metaphorical bride of Christ on the day of her coming into understanding. Stanley has given her the tricorned hat his Hilda wore at their wedding, shaped now into a heart. At her feet, discarded, lies the coat she wore that day. She is opening herself to her Stanley–Christ. Her white dress is her baptismal gown, her bouquet of flowers the gift of love. Stanley's Hilda–God-image has at last become his Hilda–Cookham-image. All are one in that message which has so long possessed him, and still holds him.

In these closing paintings the fugal themes of Stanley's personified feelings once more rise and fall, harmonize and counterpoint. The details are personal but in their transmutation through his understanding of the Holy Spirit they become universal and exalt his meaning. Only through true comprehension of the transcendence of love – redemption – can we know, as joy, that compassion in the discord of experience for which all humanity searches and in the existence of which we must believe or else we perish.

CHAPTER FORTY-EIGHT

Envoi

This exists that is its after having been said we know.

James Joyce: *Finnegans Wake*[1]

ALTHOUGH STANLEY and Richard Carline had arranged the family vault in Cookham Rise cemetery, it was felt by Stanley's executors – not all the family concurred – that he should rest not with Hilda but in the churchyard of Cookham Church. The churchyard was by then closed to burials. On Wednesday the 16th the coffin was placed in the Lady Chapel. The children's Nativity play was being rehearsed there, and two of the 'angels' leaned their arms comfortably on the coffin while they chatted to each other. Stanley's body was cremated at Reading Crematorium in a private family ceremony on Thursday, 17 December. The following day his ashes were brought to Cookham Church for the committal service. Michael Westropp officiated, Jack Martineau read the lesson, and Viscount Astor gave an address. Stanley's ashes were laid to the left of the path which leads through the churchyard from the lych-gate towards Bellrope Meadow; a small marble plaque marks the spot. A memorial service was held at St James's Church, Piccadilly, on 27 January 1960. Sir John Rothenstein read the lesson, and Sir Charles Wheeler, President of the Royal Academy, gave the address.

How is Stanley regarded thirty years afterwards? A consummate painter, surely, of the identity of things: of places as landscapes, of natural forms as still-lifes, of sitters as portraits, in these the equal of any at his unhurried best; but also a questing visionary showing forth in the quiet of his studio an odyssey chaptered into compositions which satisfy aesthetically, even if on occasion their content is disturbing, the uniqueness of each sometimes obscuring its contribution to the odyssey, and comprehensible only when the

happenings of his life are known and the meaning of his words examined.

Attempts to define Stanley's art have occasionally faltered, largely through post-modernist notions that form and pattern have priority over content. Stanley's art lies as far outside the mainstream of modern artistic convention as does Dante's poetry outside that of today's academic literary criticism. The comparison may seem forced. But both had the medieval instinct for cohesiveness of thought, and the ability, seemingly strange to us now, of metamorphosing intense spiritual feeling into galaxies of associations which are given expression in direct and lucid images. Superficially the imagery may appear on the page or canvas simple to the point of naïveté. Yet its compositional form has implications which can startle and bewilder. If the visual range and expression of both artists seems restricted, the limitation is self-imposed, and is disciplined by a rigour whose roots lie in the logic not of reason but of sensibility. The result is a concentration on the exaltation we call the religious, so evident in the medieval and Renaissance art from which Stanley drew much of his inspiration. Each artist, taking what he needed from the historical forms in which his beliefs happened to be cast, strove to construct a unity, a totality in which we understand the meaning of the whole only when we know each part, and understand each part only when we comprehend the whole.

The ultimate aim of Stanley's art was, I have argued, redemption. It was an ideal common to the thoughtful among his contemporaries. Eliot, acquiescent but hesitant, was hounded by the need to know how it could be achieved. Gerard Manley Hopkins, more certain, had earlier plunged rapturously into its exploration. Joyce experimented obliquely and sometimes comically with the profundity he recognized in its implications. Stanley, convinced that redemption was not only possible but imperative, drew anticipation from perception, and content from memory, to find the joy which was his life's lodestar. He is among the happiest of artists. Our valediction should convey gratitude that he offers a glimpse of the means he found to peace amid life's discords, a means which we too can perhaps accept.

Time has taken most of the friends of Stanley's early years. **Edward Marsh** retired from public service with a knighthood, but

continued his patronage of the arts as a Trustee of the Tate Gallery and as Chairman of the Contemporary Arts Society. At his death in 1953 his substantial collection was bequeathed to national galleries. *Apple Gatherers* and the *Self-Portrait* of 1914 among others went to the Tate.

Henry Lamb continued his high reputation as a portrait painter and became a home War Artist during the Second World War. He too became a Trustee of the Tate Gallery. He and Lady Pansy remained at Coombe Bissett with visits from friends including Evelyn Waugh, Kenneth Clark, Anthony Powell and John Betjeman. His and Stanley's paths diverged as the years passed, although they occasionally met. Towards the end of his life Henry became cruelly crippled by arthritis. He died in October 1960, the year in which his former house at Poole was demolished to make way for a multi-storey car park.

Lady Ottoline Morrell remains one of the legendary figures of the Bloomsbury Group. She died in 1938, and she and her circle have become the subject of numerous memoirs and biographies.

Jas Wood was valued as a loyal friend to Stanley and Hilda all their lives and was adored as an 'uncle' by their daughters. His interests ranged from philosophy to Proust, and he became as enthusiastic for the music of the Beatles as any teenager. He spent many summers with his family in the rural isolation of the Llanthony Valley near Abergavenny where **Eric Gill** and his family had lived for a time after Ditchling.

Darsie Japp gave up serious painting after his marriage and pursued business interests in France and Spain connected with his wife, Lucila's, family. In the Burghclere years they remained in contact with Stanley and Hilda, with the Lytton Strachey–Dora Carrington ménage at Ham Spray, and subsequently with Ralph and Frances Partridge there. The Japps and the Lambs kept closely in touch and in 1926 Darsie commissioned Henry Lamb to paint a portrait of his family. After the Second World War Japp and his family lived mostly in Portugal, where he died in 1973. By coincidence, one of his daughters married the psychiatrist son of Euphemia Groves, Henry Lamb's 'Euphemia'.

Rupert Brooke is sufficiently well documented to need no further comment here.

Jacques Raverat was one of his closest friends, and in their

student days Gwen Darwin too was a member of the group of 'neo-Pagans' at Cambridge. One of Jacques' saddest moments was when he hung up his walking and climbing boots for the last time. After his death in 1925 **Gwen Raverat** settled at Harlton near Cambridge and achieved a considerable reputation as a wood engraver. Stanley was high-handedly dismissive of her concentration on this activity. He thought the results were 'bloody' and that she should have used her talent for higher artistic expression. But Gwen as a widow with two young daughters had to earn a living, and book-illustration was her bread and butter. Unlike Stanley, who constantly rebelled against the necessity of painting landscapes – 'they will pay you handsomely for the mud off your boots', he once expostulated, 'and nothing for your soul's longing' – Gwen accepted her lot with practical commonsense, a characteristic in her of which, as we have seen, Stanley was happy to make use when he needed. During the Second World War she worked for a time at her uncle's Cambridge Instrument Company, but was later seconded to the Admiralty to illustrate in naval intelligence handbooks coastline panoramas drawn by a system she invented. After the war she moved back to Cambridge, not far from the Newnham Grange where she had spent her childhood. A stroke in 1951 partially paralysed her and she had to use a wheelchair, but kept up an active social life. She wrote *Period Piece* in 1952, an account of her childhood which to her surprise became a bestseller and a Book of the Month in the USA. She died in 1957.

Cathleen Nesbitt made her last stage appearance as late as 1978 and was a familiar voice as a radio actress. She died in 1982 in her ninety-fourth year.

Henri Gaudier-Brzeska – he added the Brzeska in recognition of an older Polish woman who became his companion – was the same age as Stanley, always short of money and working at menial jobs to provide himself with the means to shape his highly original forms. Of necessity they were always small. The stone for the largest piece he sculpted, the *Hieratic Head of Ezra Pound*, was provided by the then equally impecunious subject. A profound influence on the work of Henry Moore, and a decorated sergeant, he was killed leading his men in an infantry attack in June 1915.

Isaac Rosenberg's patron, the wealthy **Sidney Schiff**, who wrote under the pen name of Stephen Hudson and was, coincidentally,

an uncle of Beddington-Behrens, had a remarkable moment of glory in the spring of 1922 when he and his wife gave a Paris dinner party which assembled as guests Diaghilev, Stravinsky, Picasso, Proust and James Joyce. It was the first time the two last-mentioned had met, and neither writer, according to subsequent account, was impressed by the other.

The Beaufort War Hospital was decommissioned in February 1919 and the buildings returned to their original function as a mental hospital, later renamed Glenside Hospital. It may seem strange that such a prosaic institution should have been given so glorious a memorial as Stanley gave it at Burghclere. Yet in one way it deserved it. Of the 29,434 patients admitted in the four years of its existence, only 164 died there, and of these 30 were civilian emergencies rushed there during the influenza epidemic of 1918–19. The dedicated men and women who worked there, whatever their grumbles, served better perhaps than they knew. In the last two years of its existence, the hospital achieved international recognition for the work of its orthopaedic surgeons. **William Kench** and **Sam Vickery**, due for retirement at the age of fifty-five, were persuaded by the Superintendent, Dr Richard Blachford – the Colonel during wartime – to continue until his own retirement in 1924. Kench died in 1941. **The Royal Berkshire Regiment** (the 'Royal' warrant was granted by Queen Victoria in 1885 after the battle of Tofrek, a then unique regimental honour) was amalgamated with the Wiltshire Regiment in 1959 to become the Duke of Edinburgh's Royal Regiment (Berkshire and Wiltshire). Its regimental museum is in the Close of Salisbury Cathedral.

Lionel Budden continued in the teaching profession. He was persuaded to present the unique collection of Serbian folk songs he had made while on active service in Macedonia to Yugoslavia, for which he was honoured by the University of Belgrade. Meningitis compelled him to retire in 1939, and he and his wife, a concert pianist, returned to Dorset where he continued his musical interests as Programme Annotator for the Bournemouth Symphony Orchestra. The demands of the Second World War took him back to temporary teaching at Poole Grammar School. As a widower in his final years, his illness sadly made him blind.

Jack Witchell married his girl and returned from France to the

family grocery business in Weston-super-Mare. Its compulsory purchase for civic development in 1938 broke his heart. During and after the Second World War he returned to hospital work, although in a less arduous capacity. He died aged eighty-one in 1972.

Desmond Chute sold his interest in the family theatrical business after his mother's death in 1931 – the Princes Theatre was later destroyed in the Blitz on Bristol – and settled permanently at Rapallo where he became an active member of the 'Tigullian Circle' of writers, musicians and artists surrounding Ezra Pound. As a priest, the Germans allowed him freedom in the Second World War until 1944 when they removed him to a remote monastery behind Genoa. There, characteristically, he began a history of St Columban and reorganized the local convent hospital with the help of a captured communist Yugoslav officer. After the war he returned to Rapallo and during Pound's incarceration did much to befriend Pound's mother and his daughter by Olga Rudge, Mary. His visits to England became less frequent, but he maintained contact with Stanley, mainly through Gilbert. He stayed particularly close to Eric Gill's family and to the artist-poet David Jones, whose work on *The Anathemata* he was annotating when he died in 1961. Pound, elderly and frail and never a lover of the clergy, paid him the deep respect of attending his funeral.

Of the personalities of Stanley's artistic youth, **Henry Tonks** became Slade Professor of Art at University College London on the retirement of his friend and mentor Ernest Brown. 'What a brood I have raised!' he is reported as saying. Of Stanley's generation of students – Bomberg, Nash, Gertler, Currie, Nevinson, Wadsworth, Allinson et al. – much is substantially documented in art history and biography.

Louis and **Mary Behrend** continued to collect works by Lamb, the Carlines, the Spencers and others, and in their parallel interest in music actively supported Benjamin Britten and Peter Pears. At the outbreak of the Second World War they housed and hosted at Grey House the ballet school of the Ballet Rambert, evacuated from London. In 1951 they moved to North Wales. Stanley maintained his friendship with them, frequently visited and sought their advice. In 1963 they moved to Jersey. In the 1970s the Borough of Camberwell proposed a reception in their honour, but both

were too ill to attend. Louis died aged ninety-one in 1972, Mary in 1977 aged ninety-four.

Sir Michael Sadler made substantial bequests from his vast collection to the National Art Collections Fund, and his works – carvings by Henry Moore, sculpture by Barbara Hepworth, paintings by Corot, drawings by Millet and Gauguin, sketches by John Constable, Wilson Steer, Augustus John, Walter Sickert, Muirhead Bone and Henry Lamb among others, all noticed and purchased long before they became fashionable and expensive – were distributed to major national and provincial galleries. Stanley had met him – 'a magnificent old man' – in 1920 when he was invited to Leeds to discuss his share in a scheme by Sadler to decorate Leeds Town Hall. Like that of Bone at Steep, the venture was aborted. Sadler died, aged eighty-two, in 1943.

Henry Slesser, later knighted, became a Lord Justice of Appeal from 1929 to 1940. He retired to Devon where he became active in Devon County affairs. He died in 1970.

Edward Beddington-Behrens, also knighted, continued personal and public careers of distinction. He was closely connected with the Secretariat of the United Nations, and as a Eurocrat determinedly furthered the union of the United Kingdom with the EEC. He died in 1968.

Malcolm MacDonald continued to buy Stanley's work. He became a Royal Commissioner to the Government of Canada during the Second World War, and died in 1981.

George Charlton retired from the Slade in 1962 at the age of sixty-three. He and **Daphne** remained on good terms with Stanley. Both continued to paint, and at an exhibition of their work in 1950 Stanley delighted them by buying a painting. George died in 1979.

Tom Nash was art master at Newbury and Wallingford Grammar Schools in the 1920s, but re-married soon after his divorce and moved to teach in Yorkshire. He died in 1968. After the divorce **Mabel** initially supported herself and **Peter** by setting up a boarding house for students in Oxford, but life was never easy for her. She died aged ninety-one in 1983. Peter became a naval officer during the Second World War in which he met his wife, a WRNS officer. He became a press photographer in Fleet Street, specialising in featuring country affairs. His younger daughter, Dr Katharine

Anne Lerman, became a University lecturer in political science, and has published on German political history.

Alfred Munnings, later knighted, wrote an extensive autobiography in three volumes but made no mention of the Stanley prosecution incident. His biographer, Reginald Pound, asserts that Stanley had never intended the disputed drawings 'to be circulated, either privately or otherwise, and it was a mystery to him how they had passed into other hands'.

Gerald Kelly, also later knighted, held Stanley's landscape work in great respect – 'a lovely and skilful craftsman', he called Stanley – but was unresponsive to his visionary work. Munnings died in the same year as Stanley, Kelly in 1972.

Clive and **Vanessa Bell** feature extensively in memoirs. Vanessa died in 1961, Clive in 1964. The artistic theories of Clive Bell and **Roger Fry** are widely published. In fact Clive Bell remained more sympathetic to Stanley's work than did Roger Fry, who was consistently dismissive of it. **Helen Anrep**, whose flat in Charlotte Street became a meeting place for young artists after Roger Fry's death, died in 1965. The ninth **Earl of Sandwich** remained as enthusiastic a patron of Stanley as his predecessor had been of Samuel Pepys. Among his many public interests was a Trusteeship of the Tate from 1934 to 1941. He died in 1962.

Of Stanley's later friends – and there are many scores who feel honoured to be so counted – little has been written in these pages. But some contributed to **Sir John Rothenstein**'s compilation *Stanley Spencer the Man: Correspondence and Reminiscences*, in which their recollections give a vivid picture of the artist in his final years. Among the contributors was **Elsie**, Mrs Ken Beckford, still enjoying regular folk dancing in her eighties.

Dudley Tooth continued as Managing Director of his family firm until his death in 1972. Although his business letters to Stanley read as succinct and sometimes terse, he was in fact a man of kindly understanding and great good humour. Stanley's earlier complaints at having to pay the standard commission should be seen against the practice of the time. Even in the 1930s galleries derived the bulk of their work and virtually all their income from the handling of traditional paintings and old masters, and their encouragement of the younger modern artists was undertaken as a sideline investment venture, not always immediately profitable.

The reconstituted firm of Arthur Tooth and Sons now operates from 180 New Bond Street.

After a distinguished career in this country, **Francis Davies** took a post as lecturer in piano at a college in Adelaide, Australia.

Viscount Astor died suddenly of a heart attack while holidaying in the Bahamas in 1966. Cliveden, already taken into the care of the National Trust, has at the time of writing been converted into an exclusive country hotel.

Richard Carline married Nancy Higgins, a former Slade student, after the Second World War and travelled widely in Africa and Asia in his capacity as Arts Counsellor to UNESCO. He later became Chairman and then Honorary President of the International Association of Artists. He exhibited in the United Kingdom and USA and in 1978 published as a tribute a book on the early years of his brother-in-law. He played a substantial part in helping to organize the definitive 1980 exhibition of Stanley's work at the Royal Academy but died in the same year.

Patricia, pleading ill-health, did not attend the memorial services for Stanley and refused all press interviews. She and **Dorothy Hepworth** remained at Moor Thatch. In March 1960 she applied for a Royal Academy pension as the widow of an Academician. They continued to exhibit at the Academy Summer Exhibitions, the last being recorded in 1968. Both became increasingly reclusive. Patricia died aged seventy-two in 1966, Dorothy aged eighty in 1978, tended in her final years by a younger sister. Their combined work was sold at Christie's in 1984, the 159 paintings realizing £21,020. Four pencil heads of Stanley were included; most went to the USA. **Charlotte Murray**'s continued ill-health prevented her from finding a post which gave her satisfaction. She was distressed by the news of Stanley's death in 1959. Her nephritis was later diagnosed as cancer of the kidneys and she died in 1972. **Graham Murray** moved to a teaching post in Glasgow proper from which he retired in 1974 and remarried. He died in 1987.

The **Vale of Health Hotel**, with Stanley's third-floor studio overlooking Hampstead Heath, was demolished in 1964 and the site developed as an apartment block named Spencer House. At the outbreak of war in 1939 **Lindworth** was let to the Northern and British Shipping Agency Ltd as a temporary lodging for seamen awaiting ships, but after complaints from Patricia of neglect –

pipes had burst during the very cold frosts of January 1940 – a married couple were installed. In 1946 it was occupied by an executive from the John Lewis Partnership. The property was certainly sold by 1958. **Fernley** remained in family occupation until 1984.

Of the talented family of Spencers, **Will** went on to become a Professor in the Berne Music Institute. **Annie** had some years of relative freedom in the early 1920s when Horace's wife Marjorie and her two young children moved for a time to Fernlea. Annie travelled, visited Will in Switzerland, stayed with Florence and became briefly engaged. By 1925 she was back in Fernlea to look after Pa, but after his death in 1928 her behaviour became increasingly distracted. During the Second World War a local policeman discovered her trying to dig her own grave on Cookham Moor. She was institutionalized in 1944 and remained so, largely supported by Florence and Percy. In later years she could have been removed had there been a chance of providing the twenty-four-hours attention she needed; she died in 1965. **Harold**'s family eventually moved to England. **Florence** occupied a flat in Cambridge after her husband's death and served as the family 'postmistress'. During the 1930s she, Percy and Gilbert and their families rented holiday farm accommodation in Dorset, and in the 1950s Florence, then elderly, moved as a paying guest to a friend at Old Forge Cottage in Shaftesbury, where she had a bedroom and sitting-room. She died in 1962. **Percy** retired from the Building Institute in 1954 to settle at Shiplake near Henley-on-Thames where he was near enough to Gilbert and Stanley to visit; he died aged eighty-five in 1970. **Horace**'s lifestyle meant that his wife, son and daughter were left largely to fend for themselves. His son Sydney, named after his uncle killed in the war, became a hospital orderly, mourned at his death in 1988; his daughter Sylvia, brought up from the age of four in a convent orphanage, became a successful sculptor and painter, teaching at times at Bedales and later at Millfield. **Gilbert** maintained his reputation as a landscape artist and was particularly noted for his quiet farmland scenes. For sixteen years he was Professor of Painting at the Royal College of Art. He then became Head of the Painting School at Glasgow College of Art and in 1950 returned to his former school, Camberwell School of Arts and Crafts, as Head of Painting and

Drawing. He was elected to the Royal Academy in the Gerald Kelly clean-sweep Presidency which brought Stanley back. Ursula died in the same year as Stanley. At the close of his life Gilbert lived at Walsham-le-Willows near **Jack** and **Catherine Martineau,** who helped him to publish both an autobiography and a book on Stanley. He died in 1979, and his ashes were scattered by his daughter Gillian along one of his favourite walks near his former home in Upper Basildon.

At its closure, Stanley and Gilbert's old Methodist Chapel in Cookham was given over to secular use – at one time it almost became a fishmonger's store – but was acquired and opened in 1962 by the Friends of Stanley Spencer Trust as **The Stanley Spencer Gallery,** a worthy memorial to the work of an artist in his own village and in one of the most delightful spots in the Home Counties. Over ten thousand visitors a year are welcomed, especially during the summer months when special exhibitions are arranged. During winter months the Gallery is open at weekends.

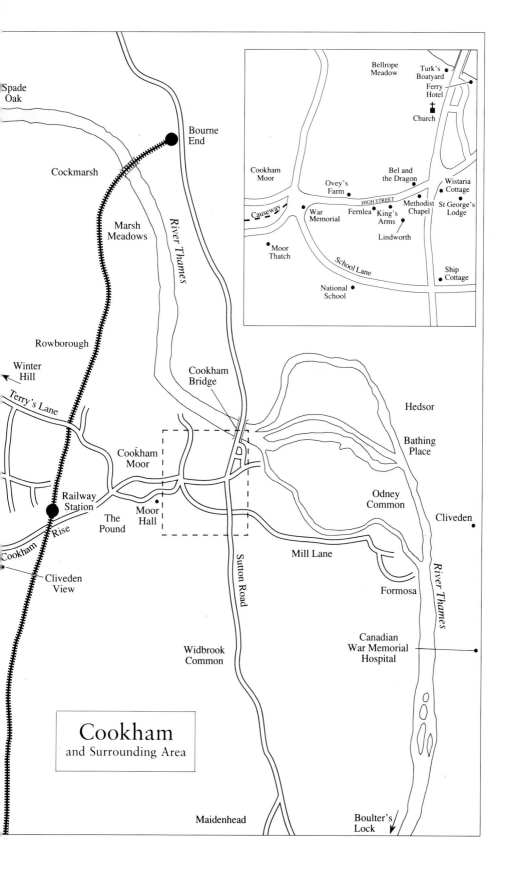

Bellrope Meadow

Turk's Boatyard

Ferry Hotel

Church

Cookham Moor

Ovey's Farm

Bel and the Dragon

Wistaria Cottage

HIGH STREET

Methodist Chapel

St George's Lodge

Causeway

War Memorial

Fernlea

King's Arms

Lindworth

Moor Thatch

School Lane

National School

Ship Cottage

Spade Oak

Bourne End

Cockmarsh

Marsh Meadows

River Thames

Rowborough

Winter Hill

Terry's Lane

Cookham Bridge

Hedsor

Bathing Place

Cookham Moor

Railway Station

The Pound

Moor Hall

Cookham Rise

Cliveden View

Odney Common

Cliveden

Mill Lane

Formosa

River Thames

Sutton Road

Widbrook Common

Canadian War Memorial Hospital

Maidenhead

Boulter's Lock

Cookham
and Surrounding Area

Stanley's family tree drawn for Yvonne Smithers

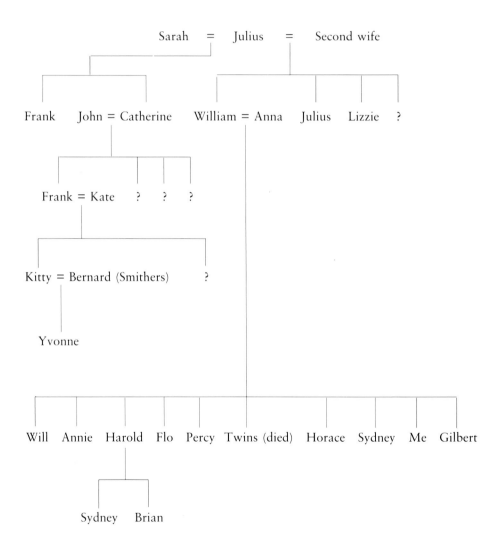

SOURCES AND ACKNOWLEDGEMENTS

My indebtedness to Shirin and Unity Spencer is absolute. The book would have had little value without their insistence, with the fierce integrity which characterized their parents, that I question and examine every interpretation that I ventured, not in armoured interest, but in order that I should establish as far as possible the validity of my deductions. Although there has been considerable agreement, the general tenor of the book and the views expressed are my own. No claim is made that the interpretations are either exhaustive or conclusive; only that they appear to offer a justifiable entry into Stanley's complex thinking.

The essential source-material for Stanley and Hilda's lives and art is the extensive collection of their writings and drawings preserved in the Tate Archive, which are copyright to the Stanley Spencer Family Trust. In addition to this primary source, from which the majority of the quotations are, by permission, reproduced, much detail of Stanley's later activities is covered in his business correspondence with Dudley Tooth, and I am indebted to the late Nicholas Tooth and to Simon Matthews of Arthur Tooth & Sons of Bond Street for generously allowing me to use these archives.

For much light on Stanley's earlier years I am grateful to the helpfulness of Pamela Spencer, to whose devoted care descended many of the Spencer family diaries and records lovingly preserved by Florence. Gilbert's chatty memories, recollected with typical Spencerian candour and published as *Memoirs of a Painter* (Chatto & Windus, 1974) and his *Stanley Spencer* (Gollancz, 1962), contain relevant detail.

The Slade student life of Stanley's day is reconstructed from several memoirs, particularly those by or of Nevinson, Gertler, Brett, Carrington and Paul Nash. Rupert Brooke and his milieu, and particularly his friendship with Jacques and Gwen Raverat, has been vividly brought to life in *The Neo-Pagans: Friendship and Love in the Rupert Brooke Circle* by Paul Delany (Macmillan, 1987). Cathleen Nesbitt described her love affair with Brooke in her autobiography *A Little Love and Good Company* (Faber & Faber, 1975). Marsh published a number of his *Georgian Poets* each year between 1912 and 1921 (The Poetry Bookshop). The problems of young artists like Stanley in acquiring patrons and establishing their careers is highlighted in John Wooder's *Mark Gertler* (Sidgwick & Jackson, 1972) and in the *Collected Works of Isaac Rosenberg* (Chatto & Windus, 1979), in which Ian Parsons includes many of the letters Rosenberg

wrote to his cosmopolitan patron Sidney Schiff mentioning Stanley and his work. Jean Moorcroft Wilson's *Isaac Rosenberg* (Woolf, 1976) outlines his sadly short life.

Henry Tonks is remembered in Joseph Hone's biography (Heinemann, 1937). Permission to quote from Gwen Raverat's *Period Piece* (Faber & Faber, 1952) and much information on her parents was kindly given by Sophie Gurney. For access to Stanley's revealing letters to Gwen Raverat, I am obliged to the assistance of Clare Colvin, formerly of the Tate Archive. Some of Gwen's work was published as *The Wood Engravings of Gwen Raverat* by Reynolds Stone (Faber & Faber, 1959). The young Jas Wood appears in his sister Lucy Boston's charming evocation of their childhood, *Perverse and Foolish* (The Bodley Head, 1979). His autobiographical vignettes of 1926 dedicated to Stanley were published as *New World Vistas* (Routledge).

A selection of Stanley's early letters to patrons has been published in biographies of the recipients, and I acknowledge those I have reproduced from Christopher Hassall's *Edward Marsh* (Longmans, 1959). Corroborative details of Stanley's friendship with Henry Lamb are given in Keith Clements' *Henry Lamb, His Life and Works* (Redcliffe Press, 1984) and in Peter Davies' *Art in Poole and Dorset* (Poole Historical Society, 1987). The Morrells' account of their meeting with the Spencers is given in Sandra Johnson Darroch's *Ottoline* (Chatto & Windus, 1976) and is based on *Lady Ottoline's Memoirs* (Faber & Faber, 1963), edited by Robert Gathorne-Hardy, with whom Stanley spent such an entertaining afternoon at Coombe Bissett. It would be fascinating to locate the photographs the Morrells took on their visit, but Julian Vinogradoff bewails the fact that her parents were such prolific snapshotters that a tracing of the negatives is unlikely. However, intriguing visual glimpses of the Bloomsbury period and its personalities are given in *Lady Ottoline's Album* (Richard Joseph, 1976), in *Rosamond Lehmann's Album* (Chatto & Windus, 1985) and in Frances Partridge's *Friends in Focus* (Chatto & Windus, 1987).

Richard Carline's *Stanley Spencer at War* (Faber & Faber, 1978) is a tribute to his brother-in-law, fulfilling a request Stanley made to him originally in 1928 and giving sympathetic insights from experience and by quotation into Stanley's art and life until his marriage with Patricia. A short account of the Beaufort War Hospital exists in *Bristol at War* (Arrowsmith, 1921), but the events there were brought to life through the courtesy of the *Bristol Evening Post*, which enabled me to trace the last staff survivor of those days, Edward Orme, and through Doreen Hutton and Dr Donal Early of the Friends of Glenside Hospital, who identified locations in the hospital and put me in touch with William Kench, son of the Beaufort Sergeant-Major. The helpfulness of Edward Orme and William Kench, together with their detailed memories of events and personalities, was invaluable, as were the unpublished letters of Jack Witchell. A small but fascinating museum has been inaugurated at Glenside and is open to the public by arrange-

ment. It contains much material from Stanley's time there, and gives perspective to the accuracy of his narrative and depictions.

Desmond Chute, mentioned in Stanley's memoirs as a 'youth of sixteen', is described so in the biography commissioned by the executors of Stanley's estate, Maurice Collis' *Stanley Spencer* (Harvill, 1962), an accurately researched chronology of the events of Stanley's life but published too close to them to be always reliable in their interpretation. On further investigation Chute became a considerable personality to me, and I am indebted to the many correspondents who helped me place him, especially to Dorothea Lady McFadyean and to Colin McFadyean for his early life; to Petra Tegetmeier for his life at Ditchling and his close friendship with Eric Gill; to Don Carleton for his family theatrical interests; to Professor Massimo Bacigalupo for his life at Rapallo; and to his friend Walter Shewring, Eric Gill's literary editor, who saved Stanley's letters at Chute's death and permitted me to quote from his *Letters of Eric Gill* (Cape, 1947). There are further references to Chute in Robert Speaight's *Eric Gill* (Methuen, 1966), in Malcolm Yorke's *Eric Gill: Man of Flesh and Spirit* (Constable, 1981), in Fiona MacCarthy's *Eric Gill* (Faber & Faber, 1989), and in Mary de Rachewiltz's account of her life with her father Ezra Pound in *Discretions* (Faber & Faber, 1971). Stanley's letters to Chute are preserved by the Stanley Spencer Gallery Trust, and transcriptions are available on request for visitors who may care to catch a flavour of his writings.

The Salonika campaign was recorded in H. Collinson Owen's *Salonika and After*, published in 1920, but more recently in Charles Packer's *Return to Salonika* (Cassell, 1964) and in Alan Palmer's *Gardeners of Salonika* (Deutsch, 1965). The major source for the campaign remains the *Official History of the War*. But *The Royal Berkshire Regiment*, by F. L. Petrie, from which some excerpts are reproduced, gives a more detailed account of Stanley's last ten days of fighting and reinforces the accuracy of his recollections. The unpublished *Leaves from a Salonika Diary* of Charles Budden – no relation to Lionel – was a vivid source of background information on, for example, how easy it was to get lost in the ravines, or the miseries of being a malarial patient in hospital. Many of these sources were consulted at the Imperial War Museum, and I am indebted to the splendid services of the Department of Art there, the Map Room, the Department of Printed Books, and the Library of Photographs. Through their patient help, it was possible to trace the fate of Sydney Spencer in another of F. L. Petrie's regimental histories, that of *The Royal Norfolk Regiment* (Jarrold & Sons, Norwich), vol. II. Ralph Vaughan Williams' experience is recorded in *RVW*, his biography by his wife Ursula (Oxford University Press, 1964). The soldiers whom Stanley and his corporal buried beside the Kalinova track were subsequently removed to the large British War Cemetery near Doiran. Stanley's evocative, almost poetic, descriptions of Macedonian scenery are matched visually in *The Salonika Front* (A. & C. Black, 1920) in a series of watercolours by William T.

Wood with descriptions by A. J. Mann. The photographs of the present-day area which illustrate the text were taken for me by the very kind Nikos and Tina Paralis, of Thessaloniki, who, themselves artists, hold Stanley and his work in esteem.

From the 1920s Stanley's name begins to appear in reviews and critiques. A comprehensive list of these, together with his Exhibition Record, is provided in the invaluable *Catalogue* to the 1980 Royal Academy Exhibition. From the 1930s his work is increasingly mentioned in newspapers, and from the 1950s his personal activities and statements sometimes adorn the equivalent of today's gossip columns. The cuttings he kept are unsystematic, but those in the Tooth Archives are filed in chronological order. His name frequently crops up in biographies and autobiographies of the personalities of those days. Of particular interest are those of Sir William Rothenstein in *Men and Memories*, vol. II (Faber & Faber, 1932) and the first volume of Sir John Rothenstein's autobiography *Summer's Lease* (Hamish Hamilton, 1965). Gilbert mentions Henry Slesser's company of 'St Ambularis', but no comment seems to exist in G. K. Chesterton's own autobiography. An unusual tribute to Stanley is given in Guy Davenport's poetic evocation of *The Resurrection in Cookham Churchyard* in his collection *Thasos and Ohio* (Carcanet, 1986).

George Behrend's *Spencer at Burghclere* (available from Jersey Artists, Villa Mon Contour, Fliquet, St Martin, Jersey, CI) provides an account of the origin of the chapel, and describes and illustrates the panels. I am obliged to the author for his helpful comments on Stanley's activities there. The BBC later commissioned an art filmstrip with photographs by Zoltan Wagner and text by John Prescott Thomas. Eric Newton's *Stanley Spencer* in the Penguin series includes illustrations and notes on the chapel among its other splendid illustrations. Richard Carline described the murals in *Studio*, November 1928. The Behrends are mentioned by I. M. Rawson in *Country Life* (October, 1978). The life of Sir Michael Sadler has been published by his son Michael Sadleir (Constable, 1949) and that of Sir Edward Beddington-Behrens by himself in *Look Back, Look Forward* (Macmillan, 1963). Behrens' invitation to Stanley and Patricia to visit Switzerland is described in a letter by him to Maurice Collis in the Tate Archive.

The Hilda–Patricia triangular affair is described by all three participants in different ways. After her divorce Hilda sent Dudley Tooth a long letter describing the sequence of events as she saw them. The early part of the missive has been removed at some stage but there is enough detail in her contemporary letters to furnish the gist of what the lost part said. Stanley penned his version at the time he was assembling his thoughts to brief his solicitors for the proposed divorce of Patricia. He also used much of the material in private letters to Hilda to explain his reasons for the undertaking; in these the slant in many details is less emphatic. In *A Private View of Stanley Spencer* by Louise Collis (Heinemann, 1972) Patricia voiced her angle after Stanley's death; Louise Collis has kindly permitted

quotation. A more focused view of Patricia's role in Stanley and Hilda's life was made available by the courtesy of Christine Hepworth, who generously offered me access to and comment on the bulk of Patricia's and Dorothy's surviving papers. They include relevant correspondence with many of the Bloomsberries – Augustus John, Helen Anrep, Virginia Woolf, Clive and Vanessa Bell, and Duncan Grant, as well as private papers and diaries.

Stanley's quarrel with the Royal Academy is outlined in an exchange of correspondence in *The Times*, Stanley's viewpoint being expressed in a letter printed on Friday, 26 April 1935. His financial and creative realignment is indicated in Sir John Rothenstein's further memoirs *Brave Day, Hideous Night* (Hamish Hamilton, 1965) and in the final volume, *Time's Thievish Progress* (Cassell, 1970). Stanley's soliloquies to Elizabeth Rothenstein were later developed into an introduction to her 1945 Phaidon edition of his work, *Stanley Spencer*. The wartime evacuation of the Slade is given in a Centenary article in the *Catalogue* of the Royal Society of Arts Exhibition in 1971, and its subsequent wartime history described by George Charlton in *The Studio*, October 1946.

For the Leonard Stanley period there are surviving memories. I am indebted to Daphne Charlton and to her sister Dorothy Reith for their comments and recollections of this and subsequent times, and to Daphne for allowing quotation from her letters. The Rector of Leonard Stanley, Rev P. L. Chicken, kindly circulated local enquiries on my behalf, Audrey Ravenscroft helpfully followed them up, and Violet Poulter provided intriguing recollections of the days when as the young married daughter of the inn landlord she used to cook and serve meals to her resident trio of artists.

Stanley's shipyard commission is detailed in his correspondence with Tooth, and in his communications with the War Artists Advisory Committee through the Admiralty. The latter correspondence is now filed in the Art Department of the Imperial War Museum. It has been collated in *The War Artists* by Meirion and Susie Harries (Michael Joseph, 1984). Stanley's activities were earlier summarized in illustrated monographs *Spencer in the Shipyard* (1981) and *Stanley Spencer: War Artist on Clydeside* by the relevant Arts Councils. His spell at Epsom and his departure to Cookham were reconstructed from family comments and letters. I am indebted to the late Graham Murray for providing background information on Stanley's later visits to Port Glasgow, particularly with regard to the Port Glasgow Resurrection paintings. *Stanley Spencer: The Resurrection Pictures 1945–51*, with notes by Stanley (Faber & Faber, 1954) is a monograph on the series by R. H. Wilenski, a critic whom Stanley admired and of whom he was fond.

It would seem that Charlotte's interest in Eastern thought had little, if any, direct influence on form in Stanley's paintings. He had read Edwin Arnold's *The Light of Asia* many years before, but was equally familiar with the essentials of

classical imagery from *The Odyssey*, from *The Golden Ass of Apuleius* and from his and Hilda's joint readings in earlier days of Greek classical plays: those of Sophocles and Euripedes are listed. Robert Graves' *The White Goddess* (Faber & Faber, 1952) is a modern interpretation of the Great Mother concept. But there can be little doubt of Charlotte's considerable contribution to his art as a confidante and sounding board for his ideas during the critical 1945–50 period when he was switching his mind from his War Artist and Port Glasgow work to his last great visionary paintings. In this connection, comments made by Graham Murray during an interview were invaluable, and I was subsequently greatly obliged to Beatrice-Helen Murray for offering me the opportunity to read and use the letters Stanley wrote to Charlotte, and to Maureen Lambourne for her typed transcriptions.

For Stanley's final years, Sir John Rothenstein's *Stanley Spencer the Man: Correspondence and Reminiscences* (Elek, 1979) is an invaluable record of John and Elizabeth's long friendship, containing excerpts from much of Stanley's correspondence with Hilda and with Tooth, and recording the varied recollections of many who knew Stanley in later years. A. J. Ayer's *More of My Life* (Collins, 1984) devotes a chapter to the visit to China. I acknowledge with gratitude the help given by Rev Canon Michael and Rachel Westropp in their account of Stanley's exhibition in Cookham Church in 1958 and for their description of much of his final year.

The documentation of two substantial areas of Stanley's life – his philosophical outlook and his artistic technique – remains largely unsystemized. The first, as this study indicates, has mostly to be extrapolated from his writings. The most noteworthy of his own writings on the subject is his contribution to *Sermons by Artists* (Golden Cockerel Press, 1934) in which he offers a homily on the universal aspects of spiritual love and on the difficulties of sustaining them in a material society. Unfortunately no record seems to have survived of what might well have been his most comprehensive statement, the long lecture he gave to the Royal Institute of Philosophy. On the question of Stanley's technical accomplishment, again no single publication attempts an exhaustive analysis. One reason may well be that he did not innovate in the use of paint, nor adopt a consistent style in its application. Little conventional development is traceable in his changing styles, which were too often at variance with contemporary fashion to be fitted comfortably into the art categories of their period. Andrew Causey presents a scholarly investigation into possible painterly influences in an Introduction to the 1980 Royal Academy Exhibition *Catalogue*, and Carolyn Leder offers a sympathetic analysis in her edition of Stanley's scrapbook drawings, *The Astor Collection* (Thomas Gibson Publishing, 1976, limited edition). Duncan Robinson's *Stanley Spencer: Visions from a Berkshire Village* (Phaidon, 1979) gives an illustrated summary of Stanley's life and art. General monographs of interest include R. H. Wilenski's *Stanley Spencer* (Benn, 1942); the Arts Council Exhibition *Catalogue*

of 1976 with comments by Richard Carline, Carolyn Leder, Anthony Gormley and Duncan Robinson; *Richard Carline* by Nancy Carline, Francis Carline and Hermione Hunter, with contributions from Richard Morphet and Elizabeth Cowley (London, 1983); and *Stanley and Hilda Spencer* (Gillian Jason Gallery, London, 1983).

Of the films in which Stanley took part, David Rowan's documentary on his life and art, which includes scenes of Stanley talking about both, can be seen at some Arts Council regional venues. Two TV films were made in 1988; both dramatized the conflicts and loyalties of Stanley's love for Hilda and his relationship with Patricia. Many of the radio recordings which Stanley undertook can be listened to by arrangement at the British Library of Recorded Sound in Knightsbridge.

Sources of illustrations are acknowledged in the text. In this connection I must record the invaluable helpfulness and comment of Peter Spencer Coppock, Gilbert's son. I offer my apologies in those few cases where it has not been possible to trace sources.

I must express my deep appreciation of the patient support provided by the Trustees of the Stanley Spencer Gallery, and especially by their Chairman, Alec Gardner-Medwin, and by their Archivist, Carolyn Leder. The admiration they and the many other Friends of the Gallery hold for Stanley and the practical ways in which they show it are testimony to his achievement. The admiration is further evidenced by the kindnesses of the many individuals and organizations who have made his work available to me or have so readily responded to my enquiries. In addition to those already named, I should further mention, in no order of priority except alphabetical: Irene Abenheimer: Aldenham School: Christopher Aslet: Viscount Astor: Mrs Bronwen Astor: Avon County Libraries: Major Peter Ball: Kathleen Barker: J. Barnett: Elsie Beckford: Per Luigi Benatti: Berkshire Record Office: Ursula Boulding: Esme Buckley: Camberwell School of Art: the late Gloria Carleton: Adam Chodzko: Dr Charles Chubb: Keith Clements: the late Douglas Cleverdon: Dr Judith Collins: Contemporary Arts Society: Richard Cork: John and May Dallenger: Dorset Education Office: Downside School: Barbara Duncan: Richard Elsden: Derek Fisher: Honor Frost: Lindsay Graves: N. K. Green: N. J. Gilpin: Rev Peter Hale: Michael Higginbottom: Bill Hopkins: Bernard Jacobson: Lady Pansy Lamb; the late Rosamond Lehmann: Mary Lightbown: Maidenhead Registry Office: Catherine Martineau: Dr J. McHugh: Lord Moyne: The National Trust: Anthony d'Offay Gallery: Roger Orme: Father Conrad Pepler: Henrietta Phipps: Poole Grammar School: Harry and Kitty Pople: Mary de Rachewiltz: Sir John Rothenstein: David Rowan: Royal Institute of Philosophy: Olga Rudge: John Sansom: Father Brocard Sewell: David Shean: Tessa Sidey: Mario Sidoli: Father Paul Sidoli: Slade School of Art: the late John Boulton Smith: Sylvia Spencer; George Stone: Jean Storry: Dr A. D. Taliano: Tate Archive: Pauline Tooth-Matthews: Ruth Trapnell: Denzil Underwood: Adrian Varcoe; War Graves

Commission: Westfilms of Bristol: John B. Witchell: Elizabeth Wood: Monica Young: W. F. Young.

I gratefully acknowledge the substantial guidance provided by the editing staff of Collins, particularly by Stuart Proffitt, and by Jonathan Warner, Inigo Thomas, Philip Gwyn Jones, James Pargiter and Peter James; by Ronald Clark as art editor; and by Simon King as publisher.

Finally I must place on record my gratitude to my own family whose practical support was so heartening in the face of what began ten years ago as a passing interest on my part and ended as a virtual obsession, especially to Sheila who solaced my disappointments, suffered my silences, celebrated my successes and, in the manner of a true wife, kept me going through it all.

NOTES AND REFERENCES

The following abbreviations are used in the Notes and References:

Astor: *The Astor Collection*, ed. Carolyn Leder, Thomas Gibson Publishing, London, 1976.

AT: Archives of Arthur Tooth & Sons. The section filing the correspondence between Tooth and Stanley is now held in the Tate Archive as 8917.

Carline: Richard Carline, *Stanley Spencer at War*, Faber, London, 1968.

Clements: Keith Clements, *Henry Lamb: His Life and Works*, Redcliffe Press, Bristol, 1984.

Collis: Maurice Collis, *Stanley Spencer*, Harvill, London, 1962.

CRAE80: *Stanley Spencer*, Catalogue of the Royal Academy Exhibition, 1980.

EM: Christopher Hassall, *Edward Marsh*, Longman, London, 1959.

GS: *Memoirs of a Painter*, Gilbert Spencer, Chatto & Windus, London, 1974.

LC: *A Private View of Stanley Spencer*, Louise Collis, Heinemann, London, 1972.

Mosaic: The unpublished Spencer family record collated by Florence Image, Berkshire County Record Office, Reading.

PA: Private Archive.

PHA: Preece-Hepworth Archive, collection of Christine Hepworth.

Rothenstein: *Stanley Spencer, The Man: Correspondence and Reminiscences*, ed. Sir John Rothenstein, Elek, London, 1979.

Sermons by Artists: The Golden Cockerel Press, 1934.

SSG: Archives and Collection of the Stanley Spencer Gallery, Cookham.

TA: Tate Archive, The Tate Gallery, London. (Some items were uncatalogued [U] at the time of writing.)

Preamble
1. AT May 1938.
2. AT May 1938.
3. Annotation to drawing, Photocompo Sheet 34. TA.

Chapter One.
1. G. K. Chesterton, *Autobiography*, Burns, Oates and Washbourne. London, 1937, p.143.

2. Sydney Spencer: diary, 20 January 1912. PA.
3. Rosamond Lehmann in letter to author, 26 February 1986.
4. TA 733.3.7(ii)–10(i).
5. In 1897. Will: diary, PA.
6. Sydney Spencer: diary, 30 June 1912, Stanley's birthday. PA.
7. Pa to Will, recorded by Will: diary. PA.
8. Will: diary, 2 December 1917. PA.
9. TA 733.3.1
10. Will: diary, 11 January 1916. PA.
11. Stanley to Lamb, undated. TA TAM 6a/52.
12. AT October 1941.
13. Stanley to Gwen Darwin from Clayhiden, 1911. TA U.
14. Stanley to Raverats, 5 May 1913. TA U.
15. TA 733.4.2.
16. Sydney Spencer: diary, 3 July 1911. PA.
17. Stanley to Florence, July 1911. Florence's *Mosaic*. PA.

Chapter Two.
1. TA 733.3.16a.
2. GS p.197.
3. Barbara Duncan, Slade School of Art, to author, 6 November 1989.
4. TA 733.3.45. In 1907 Stanley had tried without success to stimulate his artistic inspiration by writing fairy stories: TA 733.3.33.
5. Stanley to Ruth Gollancz: Victor Gollancz: *Reminiscences of Affection*, Gollancz, 1968, p. 110.

Chapter Three.
1. John Donne's *Sermons*, ed. Henry Alford, John W. Parker, London, 1839, Vol. VI, p. 128.
2. Stanley to Raverats, September 1912. TA U.
3. Stanley to Desmond Chute, March 1917. SSG. Reproduced in Hilary Pepler's magazine *The Game*, Vol. I 1917, and in Rothenstein, p. 20.
4. Stanley to Raverats, 23 December 1914. TA U.
5. Stanley, lecture to the Ruskin School at Oxford, 1923. Quoted Carline p. 30.
6. John Donne's *Sermons*, ibid. Vol. III, p. 177.
7. Florence: *Mosaic*. PA.
8. For example, *The Connoisseur*, November 1912, p. 192.
9. Photocompo sheet 36. TA.
10. Florence: *Mosaic*. PA.
11. TA 733.2.57.
12. GS p. 110.

Chapter Four.

1. Stanley to Florence. Florence: *Mosaic*. PA.
2. TA 733.3.1 et. seq.
3. Stanley to Gwen Raverat, 12 September 1912. TA U.
4. Gwen Raverat: *Period Piece*, Faber, London, 1952, pp. 141–2.
5. The accepted catalogue title *Apple Gatherers* has been used throughout although Stanley often refers to the painting as *The Apple Gatherers*.
6. Gilbert Spencer: *Stanley Spencer*, Gollancz, London, 1961, p. 161.
7. TA 733.3.1.
8. TA 733.3.16 (ii) et seq.
9. TA 733.3.21.
10. Stanley to Raverats, June 1911. TA U.
11. Postcard Raverats to Stanley. PHA.
12. Rachel Gurney in conversation with author, 1987.
13. TA 733.2.83–91.
14. EM p. 567.
15. TA 733.2.85. Also Stanley to Hilda 4 June 1930, quoted Rothenstein p. 37.

Chapter Five.

1. John Donne, *Poems* : A Nocturnal upon St Lucy's Day.
2. TA 733.2.83–91.
3. CRAE80 p. 21.
4. Mario Sidoli in conversations with author, 1988.
5. Florence: *Mosaic*. PA.
6. TA 733.3.1.
7. Stanley to Desmond Chute, 1916. SSG.

Chapter Six.

1. R. H. Wilenski, *The Modern Movement in Art*, Faber and Faber, London, 1927, preface.
2. Edward Marsh to Rupert Brooke, October 1913, EM p. 254, et seq.
3. Rupert Brooke to Edward Marsh, October 1913, EM p. 249.
4. Sydney Spencer, diary, 2 October 1913. PA.
5. Stanley to Lamb TA TAM 15a 1/152, undated.
6. Now at the Tate Gallery. Reproduced in Clements.
7. For ten guineas: Stanley to Raverats, 21 January 1912. TA U.
8. Stanley to Raverats, undated. TA. U.
9. Stanley to Lamb, quoted in Clements.
10. Stanley to Raverats, 19 April 1914. TA U.
11. Stanley to Raverats, undated, TA U.
12. EM p. 258.

13. Michael Sadleir *Michael Ernest Sadler: A Memoir*, Constable, London, 1949.
14. Paul Nash: *Outline*, Faber and Faber, London, 1939, p. 138.
15. EM p. 283.
16. Stanley to Raverats, 19 April 1914, et seq. TA U.
17. Sydney, diary, 1 July 1914. PA.
18. GS p. 33.
19. Sydney, diary, 7 July 1914. PA.
20. Postcard Stanley to Raverats, undated but 1914. TA U.
21. EM p. 289.
22. Stanley to Raverats, 30 December 1913. TA U.
23. Stanley to Raverats, incompletely dated, but 1914. TA U.
24. The event was to have been staged on the lawn at the Old Vicarage, Grantchester.
25. Stanley to Raverats, incompletely dated, but 1914. TA U.
26. TA 733.1.210.

Chapter Seven.
1. Sydney Spencer, diary, 31 December 1913. PA.
2. Florence, *Mosaic*, PA.
3. Stanley to Raverats, August 1914. TA U.
4. Sydney Spencer, diary, 12 January 1915.
5. TA TAM 15a 1/52, urging Lamb to come and see Gilbert's *Crucifixion*.
6. TA 733.3.21, various.
7. TA 733.3.1 various.
8. Stanley to Charlotte Murray, undated. PA.
9. Stanley to Raverats, undated, but postmarked 1915.
10. Andrew Causey, CRAE80.
11. AT May 1938.

Chapter Eight.
1. Stanley to Raverats, 18 July 1917.
2. Florence: *Mosaic*. PA.
3. CRAE80 p. 49.
4. Courtesy Alec Gardner-Medwin.
5. TA 733.2.258.
6. For ten pounds: Stanley to Raverats, 8 May 1915. TA U.
7. EM p. 567.
8. To Desmond Chute, letter 17 November 1926.
9. TA 733.3.1.
10. TA 733.2.52.
11. TA 733.3.375.

12. P. G. Konody in *The Observer* for 4 January 1920, quoted CRAE80, p. 49.
13. TA 733.3.33.

Chapter Nine.

1. Picasso in the hearing of Roland Penrose, quoted by Patrick O'Brian in *Picasso*, Collins, London, 1976 p. 286.
2. Stumbling on a broken paving stone, Proust had a sudden 'memory-feeling' of the happiness associated with a similar incident years before when, inspired by Ruskin's *The Stones of Venice*, he had made a pilgrimage to that city. Proust, *A la recherche du temps perdu*, III, transl. C. K. Moncrieff and Terence Kilmartin. Chatto and Windus, London, 1981, pp. 899–910.
3. M. Proust, *Swann's Way*, transl. C. K. Scott Moncrieff, Chatto and Windus, London, 1922.
4. TA 733.2.105, 1942.
5. TA 733.2.27, 1940.
6. TA 733.3.7(ii)–10(i).
7. Desmond Atkinson, The Cookham Society.
8. Stanley to Desmond Chute, March 1917: SSG.
9. One was a Miss Griffiths. TA 733.1.182.
10. Stanley to Hilda, 1930, TA 733.1.1593–1734. Quoted Rothenstein p. 39.
11. Stanley to Hilda, ibid. Quoted Rothenstein p. 45.
12. Cubism: Frances Spalding: *Sacred and Profane: the Vision of Stanley Spencer*, Connoisseur 205, November 1980 pp. 168–175. Vorticism: Andrew Causey: CRAE80 p. 23.
13. TA 733.1.1725.
14. Stanley to Raverats, undated but envelope postmarked 1914. TA U.
15. TA 733.4.1, September 1951.
16. Stanley to Raverats, 23 December 1914. TA U. *Et seq.*
17. Stanley to Raverats, 8 May 1915. TA U.
18. Stanley to Raverats, 23 December 1914. TA U.
19. Sydney Spencer, diary, June 1915. PA.
20. Stanley to Raverats, undated, but 1915. TA U.
21. ibid.
22. TA 733.2.30.
23. Postcard Stanley to Raverats, 23 July 1915. TA U.

Chapter Ten.

1. TA 733.2.419.
2. Florence: *Mosaic*. PA.
3. CRAE80 p. 62.
4. Tate Gallery catalogue 1968, p.660.
5. CRAE80 p. 62.

6. TA 733.3.4 (41).
7. TA 733.4.1.
8. Stanley to the compiler of the catalogue of the Tate Gallery exhibition of 1955.
9. In letters both to Florence and, later, to Charlotte Murray.
10. Stanley to Charlotte Murray. PA.
11. Florence: *Mosaic*. PA. Florence's comment on the painting is that it is 'light, numinous. Not a man going to his death, but to resurrection'.
12. Stanley to the compiler of the catalogue to the Tate Gallery exhibition of 1955.
13. AT May 1938. The painting was about to be hung at the Venice Biennale.

Chapter Eleven.
1. As reported in the *Western Daily Press*, 8 September 1915, after a royal visit to the Beaufort War Hospital.
2. Stanley's first draft of his war memoirs, begun about 1919, is catalogued as TA 733.3.28. He later expanded it in a notebook to clarify his thoughts for the painting of the Burghclere Chapel; this is catalogued as TA 733.3.84. In January 1948 he arranged for the latter draft to be typed, and this version is catalogued as TA 733.3.85. He subsequently added a later section, TA 733.3.128. The majority of the quotations in this and the following six chapters, where unattributed, are from these sources, especially TA 733.3.85. However, further references to Stanley's war service are widely scattered in his letters and writings, and these are quoted where applicable.
3. Stanley to Florence, *Mosaic*. PA.
4. TA 733.6.9.
5. TA 733.3.85 et seq.
6. Stanley to Florence, July 1915. PA. Florence acted as the family archivist.
7. Jack Witchell, unpublished letters. PA.
8. Stanley, notebook 1939, p.64 TA.
9. Stanley to Raverats, undated, et seq.
10. Stanley to Raverats, 12 June 1916. TA U.
11. TA 733.3.85.
12. Florence, *Mosaic*, PA.
13. Letter Annie Spencer to Raverats, TA U.
14. William Spencer to Raverats, TA U.
15. TA 733.3.85 et seq.
16. Stanley to Raverats, undated, PA.
17. Stanley to Florence. TA 733.1.716–764.
18. Stanley to Florence TA 733.1.719.
19. Stanley to Raverats, 13 May 1917, TA U *et seq*.
20. CRAE80, p.97. The author has been unable to identify the quotation. Father

John E. Rotelle O.S.A., of the Augustinian Press, Pennsylvania, suspects 'that the quote is a collage of words from Augustine or a spurious work of Augustine', Fax 18 May 1990.

21. St. Augustine: *Confessions*, Loeb edition, Books V–XX, p.341 transl. David Weisen, Heinemann, 1919.
22. TA 733.3.85.
23. TA 733.4.1.
24. Jack Witchell, unpublished letters, PA.
25. Stanley to Florence. TA 733.1.716–764.
26. Stanley to Chute 13 May 1916. SSG.

Chapter Twelve.
1. Stanley to Desmond Chute from Tweseldown, SSG.
2. Stanley to Chute, 13 May 1916. SSG.
3. Sylvia Spencer to author, 16 June 1990.
4. Will, diary, October 23rd, 1916. PA. There was still no news on 27 December.
5. Stanley to Chute, 16 May 1916, SSG.
6. Stanley to Raverats, June 1916. TA U.
7. Stanley to Chute, 25 May 1916. SSG
8. Stanley to Raverats, undated, but 1916. TA U.
9. Stanley to Gwen Raverat, from Burghclere, October 17th, no year. TA U.
10. Stanley to Chute, 19 June 1916. SSG.
11. Stanley to Wood, 27 July 1916. TA TAM 19H 1/4.
12. ibid.
13. Stanley to Lamb, TA TAM 29/52.
14. Stanley to Chute, August 1916. SSG.
15. TA 733.3.28 p. 69

Chapter Thirteen.
1. Stanley to Chute, 18 July 1917. SSG.
2. Stanley to Raverats 18 July and 10 August 1917, apparently written on board the *Llandovery Castle* but posted later. TA U.
3. TA 733.3.85.
4. Stanley to Chute, August 1916. SSG.
5. Stanley to Florence, 23 October 1918. PA.
6. Stanley to Chute, 28 October 1916. SSG.
7. Stanley to Chute, November 1916. SSG.
8. TA 733.3.85. Also annotation to drawing, TA Photocompo.
9. Stanley to Florence. TA 733.1.728.
10. Stanley – Florence. TA 733.1.734.

Chapter Fourteen.
1. Stanley to Florence, undated but from 66th Field Ambulance. TA 733.1.725.
2. Stanley to Florence, 24 February 1917. TA 733.1.723.
3. Will: diary, 8 April 1917. PA.
4. Stanley to Florence, 25 March 1917. TA 733.1.724.
5. Stanley to Florence, 17 May 1917. TA 733.1.731.
6. Stanley to Florence, undated. TA 733.1.736.

Chapter Fifteen.
1. Stanley: TA 733.3.85.
2. Stanley to Raverats, 22 April 1918. TA U.
3. Stanley to Florence. *Mosaic*, PA.
4. Will, diary, 21 August 1917. PA.
5. Stanley to Raverats, 15 July 1917. TA U.
6. Stanley to Raverats, undated. TA U.
7. ibid.
8. F. L. Petrie, *The Royal Berkshire Regiment*, Reading, 1921.
9. Stanley to Florence, 2 September 1917. TA. 733.1.756. Also Stanley to Raverats, undated. TA U.

Chapter Sixteen.
1. D. H. Lawrence, *Studies in Classic American Literature*, Martin Secker, London, 1924 and William Heinemann, Phoenix edition, London 1964. Thomas Seltzer, New York, 1923. The author is obliged to Desmond Hawkins for the quotation.
2. TA 733.2.290–298 p. 27.
3. Stanley to Florence, *Mosaic*. PA.
4. Stanley to Ma and Pa. ibid.
5. Stanley to Wood, 3 March 1918. TA TAM 19H 2/4.
6. Stanley to Raverats, 2 March 1918. TA 733.10.154: also 733.10.62.
7. TA 733.3.81.
8. Yockney to Stanley. Copy retained by Florence, *Mosaic*. PA.
9. Stanley to Florence undated, but 1918. TA 733.1.716–764.

Chapter Seventeen.
1. TA 733.3.85. Stanley recollects his experience as though from 49 General Hospital, Salonika, 1918.
2. TA 733.3.85 et seq.
3. TA 733.3.67.
4. TA 733.3.85.
5. F. L. Petrie: *The Royal Berkshire Regiment*, Reading, 1921. The Imperial War Museum.

6. ibid.
7. TA 733.3.85.
8. *Collected Works of Isaac Rosenberg*, ed. Ian Parsons, Chatto & Windus 1979.

Chapter Eighteen.
1. Florence, *Mosaic*, PA.
2. Stanley to Raverats, 6 October 1918. TA U.
3. Imperial War Museum. File GP 55/31A. Quoted in *The War Artists*, Meirion and Susie Harries, Michael Joseph, London, 1983, p. 110.
4. Stanley to Chute, 10 January 1919. SSG.
5. TA 733.3.128.
6. F. L. Petrie: *The Royal Norfolk Regiment*, Jarrold, Norwich, Vol. III p. 206.
7. Stanley to Raverats, 6 February 1919. TA U.
8. Stanley to Raverats, 21 January 1912. TA U.
9. AT 30 April 1942 and 25 May 1951.

Chapter Nineteen.
1. Isaac Rosenberg, poem, *Dead Man's Dump*, from *Collected Works of Isaac Rosenberg*, Chatto and Windus, London, 1979.
2. Stanley to Florence, *Mosaic*, PA.
3. ibid.
4. Stanley to Raverats, early 1919. SSG.
5. *Letters of Eric Gill*, ed. Walter Shewring, Cape, London, 1947.
6. ibid.
7. Stanley to Chute, 25 January 1919, SSG.
8. Carline p.111.
9. Petra Tegetmeier in conversation with author, 1987.
10. TA 733.2.370–1.
11. Clements, p. 232. There is no record of why the painting was at Cookham in 1919, nor why Lamb was willing to dispose of it.
12. Stanley to Chute, posted 26 August 1926. SSG.
13. TA 733.3.370.
14. Carline p. 111.
15. Lady McFadyean to author, 1982.
16. TA 733.3.1.
17. EM p.459.
18. TA 733.3.1.
19. TA 733.3.7.
20. TA 733.3.1 (21).

Chapter Twenty.
1. Wilfred Owen to Osbert Sitwell, June 1918, quoted in Jon Stallworthy, *Wilfred Owen*, Oxford University Press, 1974, p. 265.
2. Stanley to Florence, 2 September 1917. *Mosaic*. PA.
3. Stanley to Florence, *Mosaic*. PA.
4. Stanley to Florence, *Mosaic*, PA.
5. Annotation to drawing. TA Photocompo: Sheet 69.
6. Stanley to Florence, 1921, *Mosaic*.
7. Catherine Martineau, Rotherstein, p. 130.
8. TA 733.3.28.
9. TA 733.3.1(28).

Chapter Twenty-One.
1. Wyndham Lewis, *Tarr*, Methuen, London, 1951.
2. TA 733.3.105.
3. Marcel Proust, aged thirteen, in the birthday book of Antoinette Felix-Faure, quoted in *The Quest for Proust* by André Maurois, transl. Gerard Hopkins, Constable, London, 1984, p. 26.
4. TA 733.3.28.
5. TA 733.2.105. Quoted Rothenstein p. 24.
6. GS p.68.
7. TA 733.10.154 *et seq.*
8. TA 733.10.154: TA. 733.10.62.
9. TA 733.3.375.
10. TA 733.2.83–91.
11. Carline, p. 133.
12. TA 733.2.83–91. Written at Epsom, 1942.
13. ibid.
14. Stanley to Desmond Chute, SSG.
15. Hilda to Stanley, from Thurlestone, S.Devon, June 1931.
16. TA 733.1.1084, March 1947.

Chapter Twenty-Two.
1. TA 733.2.417–429.
2. Florence, *Mosaic*, p. 174.
3. Peter Spencer Coppock to author, 1988. Also at interview with Linda Grant, *The Independent on Sunday*, 8 July 1990.
4. TA 733.2.27.
5. Introduction to catalogue of the Tate Gallery exhibition of 1955, p. 3.
6. Carline, p. 138.
7. Fiona Pearson to author, 1988.
8. Stanley to Charlotte Murray, TA 733.2.351–5.

9. Private collection. Reproduced Clements.
10. Carline, p. 168. Also Stanley to Marsh 4 May 1922, EM p. 505.
11. Stanley to Hilda, June 1923.
12. George Behrend to author, 1989.
13. Mary Behrend to Maurice Collis, 1960. TA 8413.
14. EM p. 505.

Chapter Twenty-Three.
1. Collis, p. 103.
2. TA 733.3.1.
3. ibid. Quoted extensively in Carline, pp. 172–5.
4. Stanley's commentary to John Read's BBC TV film 1956.
5. Stanley to Edward Marsh, 8 December 1914.
6. One such list is given in Rothenstein, p. 28.
7. Dr Judith Collins, Tate Gallery, to the author, 1990.
8. J. Rothenstein, *Summer's Lease*, Hamish Hamilton, London, 1965.
9. TA 733.3.33.
10. As note 4.
11. Florence, *Mosaic*, PA.
12. Undated, probably early 1914. TA U.
13. CRAE80, p. 49.
14. Stanley to his daughters, 1959.
15. TA 733.1.1060.
16. TA 733.1.727 *et seq*.
17. As note 4.
18. Annotation to drawing of Hilda. TA.
19. Generally accepted as a reference to Dantean imagery of the fire of purgation and the rose of redemption.
20. As note 4.
21. References are quoted by Andrew Causey, CRAE80, p. 26.
22. Quoted in Clements, p. 231.
23. Carline, p. 204.

Chapter Twenty-Four.
1. David Jones: Preface to *In Parenthesis*, Faber & Faber, London, 1937.
2. TA 733.3.28.
3. TA 733.3.84.
4. TA 733.3.28.
5. Stanley's Almanac for 1927. TA.
6. Stanley to the Raverats, 7 November 1918. TA U.
7. Carline, p. 186.

Chapter Twenty-Five.
1. From a lecture by Stanley to students at the Ruskin Drawing School at Oxford, 1922. Carline, p. 136.
2. Stanley to Desmond Chute, 17 November 1926. SSG.
3. Stanley, annotation to photocompo sheet 84. TA.
4. Lord Sandwich to Maurice Collis, 1960, TA 8413.
5. Stanley to Gwen Raverat from Burghclere, 17 October: no year. TA U.
6. Florence. *Mosaic*, PA.
7. Stanley to Desmond Chute, 17 November 1926.
8. Stanley to Joan George, Rothenstein, p.122.
9. TA 733.3.21, 1935.
10. Stanley to Desmond Chute, 17 November 1926.
11. GS, p. 183. Also *Maidenhead Advertiser*, 15 February 1928.
12. Rosamond Lehmann: *Rosamond's Album*, Chatto & Windus, London, 1985.
13. Stanley to Unity Spencer. PA.
14. Patricia Preece, diary, 22 January 1932. PHA.
15. For example, Causey, CRAE80, p.29.
16. There are numerous references to the church house in Stanley's writings, but TA 733.3.6 offers a succinct description.
17. AT May 1933.
18. ibid.
19. Stanley to Gwen Raverat, undated, apparently 1933. TA U.
20. George Behrend to the author, 1989.
21. Stanley to Gwen Raverat, as note 19.
22. Patricia Preece, diary, December 1932. PHA.
23. Stanley to Florence, 9 December 1932. *Mosaic*, PA.

Chapter Twenty-Six.
1. TA 733.1.1084.
2. Stanley to Hilda. TA 733.1.1593–1734. Many of the letters from which this and the following quotations are taken are given more fully but without comment in Rothenstein, pp. 31–47.
3. ibid.
4. ibid.
5. ibid.
6. ibid.
7. ibid.
8. ibid.
9. ibid.
10. ibid.

11. ibid.
12. LC, p.32.

Chapter Twenty-Seven.
1. Reference mislaid.
2. Stanley to Gwen Raverat. TA U.
3. ibid.
4. EM, p. 505.
5. LC, pp. 72–3.
6. TA 733.2.96–104. TA 733.2.27.
7. A favourite quotation of Stanley's e.g. commentary to BBC TV film, 1956.
8. Stanley's daybook, 1933. TA.
9. ibid.

Chapter Twenty-Eight.
1. Isaac Rosenberg to Sidney Schiff, quoted in *Collected Works of Isaac Rosenberg*, Chatto & Windus, London, 1979.
2. At 28 June 1933.
3. Stanley to Gwen Raverat, 1933. TA U.
4. Stanley to Gwen Raverat, undated, but evidently 1933. TA U.
5. CRAE80, p. 219. The painting was not publicly exhibited until 1955.
6. Edward Behrens to Maurice Collis, 1960. TA T8413.
7. As note 4.
8. Stanley to Hilda, from Hotel Monte Moro, Saas Grund, 28 August 1933.
9. Hilda to Dudley Tooth. TA 733.1.1724–32.

Chapter Twenty-Nine.
1. TA 733.2.28.
2. Quoted in Hugh Kenner, *The Pound Era*, Faber & Faber, London, 1972, p. 533.
3. Dante: *The Divine Comedy*, Hell, Canto XXVI, Cary's translation.
4. TA 733.3.7.
5. AT January 1935. Also references in PHA.
6. TA 773.3.2: TA 733.3.91.
7. Collis, p. 117.
8. TA 733.2.30.
9. TA 733.3.1, also 733.4.3.
10. GS, p. 199.
11. Michael Sadleir: *M. E. Sadler. A Memoir.* Constable, London, 1949.
12. Stanley to compiler of Tate Retrospective Exhibition, 1955.
13. Prof. Massimo Bacigalupo to the author, 1987.
14. GS, p. 199.

15. TA 733.2.30.
16. Sir Gerald Kelly to Collis, TA 8413.
17. Stanley to *The Times*, 26 and 27 April 1935.

Chapter Thirty.
1. Djuna Barnes: *Nightwood*, Faber & Faber, London, 1936. 2nd edn, 1950.
2. *Letters of Virginia Woolf*, vol. V, ed. Nigel Nicolson, The Hogarth Press, 1979, p. 277.
3. Collis, p. 128.
4. TA 733.2.30.
5. ibid.
6. TA 733.2.27.
7. Collis, p. 109. TA 733.1.1747–57.
8. As note 6.
9. Hilda to Stanley, from Epsom, 1932.
10. As note 6.
11. ibid.
12. Patricia, notes prepared for Collis, 1960. PHA.
13. ibid.
14. Hilda to Dudley Tooth, 14 June 1935.
15. Stanley, exhibition notes, Leicester Galleries, 1942.
16. ibid.
17. Stanley to *The Times*, 26 and 27 April 1935.
18. In the Chronology in CRAE80, this visit is dated to 1936. But all documentary evidence points to 1935.

Chapter Thirty-One.
1. Stanley to Hilda. TA 733.1.1682.
2. Stanley's preferred title was *Humanity*. AT 18 May 1936.
3. *Sermons by Artists*.
4. ibid.
5. Carline, p. 175.
6. Anthony Gormley: *The Sacred and the Profane in the Art of Stanley Spencer*, catalogue to the Tate Retrospective Exhibition, 1955.

Chapter Thirty-Two.
1. The quotation is a note by Pound to his poem *The Tree* included in an early collection titled *Hilda's Book* dedicated to HD [Hilda Doolittle]. Pound went on to develop his theme in terms of verbal imagery, but it could equally apply to visual imagery.
2. TA 733.3.1.
3. CRAE80, p.136.
4. Lord Moyne to the author, 1989.

5. ibid.
6. A recollection of Patricia. PHA.
7. As note 4.
8. TA 733.3.2.
9. Stanley to Gwen Raverat, probably October 1935. TA U.
10. Patricia, notes for Collis, 1960. PHA.
11. Stanley to Jas Wood. TA 733.1.2213.
12. Sir John Rothenstein: *Time's Thievish Progress*, Cassell, 1970, p.60.
13. ibid.
14. Lefevre Gallery to Patricia. PHA.
15. *The Times*, 18 January 1936, p. 6.
16. LC, p. 79.
17. Hilda to Stanley, 1 May 1935. TA 733.1.1593–1734.
18. ibid.
19. Stanley to Hilda (unposted?). TA 733.1.1593–1734.

Chapter Thirty-Three.
1. James Joyce: *Finnegans Wake*, Faber & Faber, London, 1939, p. 556.
2. AT 18 May 1936.
3. AT 30 July 1936.
4. AT 3 March 1936.
5. AT 18 May 1936.
6. AT 24 October 1936.
7. AT 22 December 1936.
8. AT 29 December 1936.
9. Stanley to Dudley Tooth, 29 December 1936. AT.
10. Dudley Tooth to Stanley 31 December 1936. AT.
11. PHA.
12. Stanley to Hilda, 31 May 1937.
13. Hilda to Dudley Tooth, 733.1.1730.
14. ibid.
15. ibid.
16. Patricia, notes prepared for Louise Collis. PHA. Published version, LC, p. 93.
17. LC, p. 96.
18. TA 733.1.1732–69.
19. ibid.
20. TA 733.1.1730.
21. As note 16.
22. TA 733.1.1594, dated 23 August 1937.
23. As note 18.
24. 733.1.1752.

Chapter Thirty-Four.
1. Annotation to drawing, photocompo sheet 111, neg.33, TA.
2. Hilda to Dudley Tooth. TA 733.1.1730.
3. Hilda to Stanley, 9 May 1947. Quoted Rothenstein p. 70.
4. TA 733.1.1752.
5. TA 733.1.1748, August 1937.
6. Hilda to Stanley, 8 June 1937. Quoted Rothenstein, p. 64.
7. Hilda to Stanley, 5 August 1937. TA 733.1.1593–1734.
8. Stanley's daybook, 1938. TA.
9. PHA.
10. Untraced letter to Jas Wood.
11. AT September–October 1937.
12. AT June–July 1938.

Chapter Thirty-Five.
1. Anthony Gormley: *The Sacred and the Profane in the Art of Stanley Spencer*, Arts Council catalogue, 1976, pp. 21–3.
2. Cf. Stanley, annotation to scrapbook drawing 60a: 'I am taking the part of the adoring bearded me who is being adored collectively with "Phyllis",'Astor p.26. Phyllis was Elsie's sister.
3. Jonathan Miller, quoted by Penelope Gilliatt in the *Guardian*, 8 January 1990, p. 19.
4. As note 1.
5. Carolyn Leder, notes to SSG summer exhibition, 1990.
6. Stanley, annotation to Elsie scrapbook drawing 56a, Astor, p. 25.

Chapter Thirty-Six.
1. TA 733.3.2.
2. T. S. Eliot, *East Coker*, line 202.
3. As note 1.
4. TA 733.1.1593–1732.
5. TA 733.2.27.
6. ibid.
7. Stanley's daybook, 1938. TA.

Chapter Thirty-Seven.
1. The '*Him*' was the god Pan whom Rat and Mole saw on the riverbank.
2. Note by Patricia. PHA.
3. TA 733.1.1687–90.
4. Annotation to drawing, photocompo. TA.
5. TA 733.3.10.
6. GS, p. 198.

7. TA 733.3.85.
8. ibid.
9. Stanley to Charlotte Murray. PA.
10. William Kench (son) to the author, 1988.
11. TA 733.1.1687–90.
12. Maurice Collis: *Diaries 1949–69*, ed. Louise Collis, Heinemann, London, 1977, p. 142.
13. PHA.
14. Stanley to Charlotte Murray. PA.
15. Stanley to Patricia, September 1938. PHA.

Chapter Thirty-Eight.
1. Stanley, annotation to drawing. TA.
2. Elizabeth Rothenstein, in Rothenstein, p. 98.
3. AT 27 October 1938.
4. AT 29 July 1939.
5. AT 14 July 1938.
6. Rothenstein, p. 83.
7. The forty drawings, as three-quarter-inch squares, are TA 733.3.76.
8. TA 733.3.62.
9. Statement from the Soho Publishing Co. Ltd, 18 Soho Square, AT 19 January 1939.
10. PHA.
11. At Mrs Harrison, Sandlands, Boar's Hill. She was an artist who 'years ago had introduced me to Lord Oxford and Asquith and she has known Gilbert and I for years'. TA 5 April 1939.
12. AT 17 June 1939.

Chapter Thirty-Nine.
1. Reference mislaid.
2. TA 733.1.1107, 15 June 1939.
3. Stanley to Dudley Tooth, AT 6 October 1939.
4. Stanley's description. TA 733.3.79.
5. Collis, p.162.
6. Annotation on the reverse of drawing, TA photocompo.
7. Astor, p.23, drawing no.10.
8. Violet Poulter, the daughter of the inn-keeper, to author, 1987.
9. TA 733.1.1593–1724.
10. Hilda to Stanley, 2 September 1939.
11. AT 21 December 1939, written from Oxford.
12. Imperial War Museum file GP55/31A, Tooth to Clark, 25 December 1939.
13. Stanley to Charlotte Murray, PA.

14. Daphne Charlton to author, 1989.
15. Florence. *Mosaic*, 1938, PA.

Chapter Forty.
1. TA 733.3.34.
2. Daphne to Dudley Tooth, AT 2 October 1940.
3. AT March 1941.
4. Meirion and Susie Harries: *The War Artists*, Michael Joseph, London, 1984, p. 205.
5. ibid.
6. Daphne to Maurice Collis, 1960. TA 8413.
7. TA 733.3.82, written at Leonard Stanley, 1940.
8. AT 16 May 1941.
9. TA 733.2.105.
10. ibid., p. 136.
11. Stanley to Unity, 20 January 1942. PA.
12. See Family Tree.

Chapter Forty-One.
1. Richard Kennedy, quoted in Rothenstein, p. 125.
2. TA 733.3.10.
3. TA 733.3.82.
4. Annotation to drawing. PA.
5. See also Rothenstein, p. 97.
6. TA 733.1.1691–3.
7. Annotation to drawing, photocompo sheet 111, neg.34. TA.
8. Annotation to scrapbook drawing, Astor 34.
9. Annotation to scrapbook drawing, Astor 24.
10. LC, p. 138.
11. Annotation to drawing, photocompo sheet 66. TA.
12. Annotation to scrapbook drawing, Astor 16.
13. TA 733.3.16 (ii), p. 88.
14. GS, pp. 202–3.
15. Stanley to Henry Lamb, February 1942.
16. Daphne to Tooth, from New End Square, probably April 1942.
17. Hilda to Stanley. TA 733.1.1593–1734.
18. LC, p. 140.
19. AT, undated, but probably June 1942.
20. LC, p. 143.
21. Daphne to Dudley Tooth from Leonard Stanley, AT June 1942.
22. Jean Storry, who taught music at Badminton, to the author, 1988.
23. AT 17 July 1942.

24. AT 20 September 1942.
25. ibid.
26. Hilda to Stanley. TA 733.1.1593–1734.

Chapter Forty-Two.
1. PA.
2. TA 733.1.1050.
3. Graham Murray to the author, 1986.
4. Charlotte to Stanley, 6 January 1943. TA 733.1.1045.
5. Charlotte to Stanley, 22 October 1945. TA 733.1.1053.
6. Stanley's notes to Wilenski: *Stanley Spencer Resurrection Pictures*, Faber & Faber, London, 1951. Also Stanley to Hilda. TA 733.2.419.
7. AT May 1944.
8. ibid.
9. Meirion and Susie Harries: *The War Artists*, Michael Joseph, London, 1984, p. 208.
10. Carline, p. 143.
11. Sketched in a letter to Tooth. AT 1944.
12. TA 733.4.11.
13. AT 22 October 1944.
14. AT October 1944.
15. Stanley to Charlotte, 3 December 1945. PA.
16 AT January 1946.
17. ibid.
18. Stanley to Smart, AT January 1946.
19. Stanley to Charlotte, 1946. PA.

Chapter Forty-Three.
1. TA 733.1.1082.
2. Stanley to Charlotte, 10 January 1946. PA.
3. Stanley to Charlotte, 28 May 1946, PA.
4. Stanley to Charlotte, 6 June 1946, PA.
5. TA 733.2.290.
6. Stanley to Charlotte, undated, probably 1947. PA.
7. Stanley to Charlotte, 31 December 1946. PA.
8. Hilda to Stanley, 9 May 1946.
9. AT 4 November 1947.
10. Astor, pp. 28–9.
11. Stanley to Charlotte, 4 February 1947. PA.
12. Shirin to the author, 1988.
13. Stanley to Charlotte, 11 September 1949. PA.
14. John Rothenstein: *Time's Thievish Progress*, Cassell, London, 1970, p. 72.

15. Daphne to Maurice Collis, 1960. TA 8413.
16. TA 733.1.1047.
17. TA 733.1.1076, 7 March 1947.
18. TA 733.1.1084, March 1947.
19. TA 733.1.1048, 16 April 1945.
20. Graham Murray to the author, 1986.
21. Reference mislaid.
22. TA 733.1.1593–1734, 2 December 1947.
23. LC, p. 151.
24. Hilda to Stanley, 9 May 1947.

Chapter Forty-Four.
1. 733.1.1730
2. Stanley to Charlotte, April 1946, PA.
3. Stanley to Charlotte, 7 September 1947, PA.
4. Unity in conversation with author.
5. AT 20 March 1950.
6. Quoted in a letter from Stanley to Charlotte, 1950, PA.
7. R. H. Wilenski: *Stanley Spencer: The Resurrection Pictures 1945–51*, Faber & Faber, 1954.
8. AT 4 May 1949.
9. ibid.
10. ibid.
11. ibid.
12. ibid. Also TA 733.2.27.
13. Sir Gerald Kelly to Maurice Collis, 1960, TA 8413.
14. ibid.
15. Stanley to Charlotte, December 1950, PA.
16. ibid.
17. Fiona Pearson, Scottish Gallery of Modern Art, to author.
18. Stanley to Charlotte, 27 May 1950, PA.
19. Stanley to Charlotte, 20 December 1950, PA.
20. Stanley to Charlotte, 1946, PA.
21. Stanley to Charlotte, 7 September 1947, PA.

Chapter Forty-Five.
1. TA 733.3.1170.
2. The lecture was given on 2 March 1951, AT 31 March 1951.
3. AT 30 June 1951.
4. George G. Page, architect, to Maurice Collis, 1960, TA 8413.
5. AT January 1955. The transaction took place in May 1955, TA 8413.
6. A. J. Ayer: *More of My Life*, Collins, London, 1984, p. 101.

7. Introduction, *Stanley Spencer, a Retrospective Exhibition*, London, 1955, Tate Gallery.
8. TA 733.2.30.
9. TA 733.4.7.
10. AT 8 September 1951.
11. Stanley's diary for 1951, TA 733.4.8, records his progress on the painting during March and April.
12. Stanley to a posthumous Hilda, PA.
13. ibid.
14. ibid.
15. Hilda to Stanley, 16 October 1945. PA.
16. as 12.
17. Stanley, letter to *The Times*, June 12th 1958.
18. Stanley to Charlotte, PA.
19. TA 733.3.34.
20. TA 733.2.27.
21. Stanley to Charlotte, PA.
22. AT May 1949.

Chapter Forty-Six.
1. TA 733.2.46.
2. *The Times*, 29 May 1958.
3. Sylvia Spencer to the author, 1990.
4. *The Independent*, Saturday, 9 June 1990.
5. *The Times*, 12 June 1958.
6. Sylvia Spencer to the author, 1990.
7. *Maidenhead Advertiser*, 2 and 23 April 1941.
8. Rothenstein, p.131.
9. TA 733.4.1.
10. ibid.
11. AT January 1946.
12. *The Times*, 29 May and 12 June 1958.
13. TA 733.3.82.
14. TA 733.2.27.

Chapter Forty-Seven.
1. Stanley to Charlotte, April 1946, PA.
2. Stanley to Unity, 11 March 1957, PA.
3. Stanley to Hilda, posthumous, 12 March 1957.
4. TA 733.1.1862.
5. As note 2.
6. TA 733.2.86–91. Author's italics.

7. Cookham folk-memory.
8. AT February 1959.
9. Michael and Rachel Westropp to author, 1987.
10. Bill Hopkins to author, 1990.
11. PHA.
12. Michael and Rachel Westropp to the author, 1987.
13. AT September 1959.
14. AT November 1959.
15. Stanley to Unity. PA.
16. Stanley to Charlotte, June 1946, PA.
17. Stanley to Florence, undated. *Mosaic*, PA.
18. Stanley to Charlotte, June 1946 and February 1950, PA.
19. Stanley to Unity, August 1957. PA.
20. Stanley to Charlotte, April 1946. PA.
21. As note 2.

Chapter Forty-Eight.
1. James Joyce: *Finnegans Wake*, Faber & Faber, London, 1939, p. 186.

PAINTINGS AND DRAWINGS

DETAILS AND SOURCES

Ablutions
Sandham Memorial Chapel, Burghclere. 1928. Oil on canvas. 213.4 × 185.4
cm: 84 × 73 ins. The National Trust.

Adoration of Old Men
1937. Oil on canvas. 92.7 × 111.8 cm: 36½ × 44 ins. Leicestershire Museums,
Arts and Record Service.

Angels of the Apocalypse
1949. Oil on canvas. 70 × 88.9 cm: 24 × 35 ins. Private collection.

Apple Gatherers
1911–12. Oil on canvas. 71.5 × 92.5 cm: 28 × 36¼ ins.
The Tate Gallery.

The Beatitudes of Love: Contemplation
1937. Oil on canvas. 91.4 × 61 cm: 36 × 24 ins. Stanley Spencer Gallery,
Cookham.

The Beatitudes of Love: Knowing
1937 Oil on canvas. 65 × 55.9 cm: 26 × 22 ins. Private collection.

The Betrayal
1913–14. Oil on canvas. 40.5 × 51.5 cm: 16 × 20 ins. Stanley Spencer
Gallery, Cookham.

The Betrayal
1923. Oil on canvas. 122.7 × 137.2 cm: 48 × 54 ins. Ulster Museum and
Art Galleries, Belfast

Bridesmaids at Cana
1935. Oil on canvas. 84.2 × 183.3 cm: 33 × 72 ins. Ulster Museum and Art
Galleries, Belfast.

The Builders
1935. Oil on canvas. 111.8 × 91.8 cm: 44 × 36¼ ins. Yale University Art
Gallery, Connecticut.

Burghclere Chapel, left wall frieze: The Camp at Kalinova.
Sandham Memorial Chapel, Burghclere. Oil on canvas. 854 × 305 cm:
336 × 120 ins. Part shown. The National Trust.

Burghclere Chapel, right wall frieze: The Camp at Todorova.
Sandham Memorial Chapel, Burghclere. Oil on canvas 854 × 305 cm: 336
× 120 ins. Part shown. The National Trust.

By the River
1935. Oil on canvas. 113 × 182.9 cm: 44½ × 72 ins. University College
London.

The Centurion's Servant
1914. Oil on canvas. 114.5 × 114.5 cm: 45 × 45 ins. Tate Gallery.

Christ Carrying the Cross
1920. Oil on canvas. 153 × 143 cm: 60¼ × 56¼ ins. Tate Gallery.

Christ Delivered to the People
1950. Oil on canvas. 68.8 × 149 cm: 27 × 58 ins. Scottish National Gallery
of Modern Art, Edinburgh.

Christ in the Wilderness
No. 4. 'Consider the Lilies of the Field'. 1939. Oil on canvas. 56 × 56 cm:
22 × 22 ins. Art Gallery of Western Australia, Perth.

Christ Preaching at Cookham Regatta
Unfinished. Oil on canvas. 205.7 × 535.9 cm: 81½ × 211 ins. Collection of
Viscount Astor. On loan to Stanley Spencer Gallery, Cookham.

Christ's Entry into Jerusalem
1921. Oil on canvas. 114.3 × 114.7 cm: 45 × 57 ins. Leeds City Art Galleries.

The Church-house
Drawing. Date unknown. Pen and ink. Tate Archive.

The Coming of the Wise Men
1940. Oil on canvas. 93 × 62 cm: 36 × 24 ins. Private collection.

Convoy of Wounded Men Filling Waterbottles at a Stream
Sandham Memorial Chapel, Burghclere. 1932. Oil on canvas.
213.4 × 185.4 cm: 84 × 73 ins. The National Trust

Convoy of Wounded Soldiers arriving at Beaufort Hospital Gates
Sandham Memorial Chapel, Burghclere. 1927. Oil on canvas.
213.4 × 185.4 cm: 84 × 73 ins. The National Trust.

Paintings and Drawings

Cookham
1914. Oil on canvas. 45.1 × 54.6 cm: 17¾ × 21½ ins. Carlisle Museum and Art Gallery.

The Crucifixion: Gilbert Spencer
1915. Oil on canvas. 86.3 × 99 cm: 34 × 39 ins. Tate Gallery.

The Crucifixion
1921. Oil on paper mounted on canvas. 66.7 × 107.9 cm: 26¼ × 42½ ins. Aberdeen Art Galleries and Museums.

The Crucifixion
1958. Oil on canvas. 216 × 216 cm: 85 × 85 ins. The Letchmore Trust.

Daphne
1940. Oil on canvas. 51 × 61 cm: 20 × 24 ins. Tate Gallery.

The Desposition and Rolling Away of the Stone
1956. Oil on canvas. 110.3 × 57.2 cm: 39½ × 22½ ins. York City Art Gallery.

Dinner on the Ferry Hotel Lawn
Christ Preaching at Cookham Regatta series. 1956–7. 94.9 × 135.9 cm: 37¼ × 53½ ins. Tate Gallery.

The Disrobing of Christ
1922. Oil on wood. 35.9 × 63.5 cm: 14 × 26 ins. Tate Gallery.

The Dustman or *The Lovers*
1934. Oil on canvas. 114.9 × 122.5 cm: 45¼ × 48¼ ins. Tyne and Wear Museum Service, Newcastle-on-Tyne.

The Fairy on the Waterlily Leaf
c.1909. Pen and ink. 41.9 × 30.5 cm: 16½ × 12 ins. Stanley Spencer Gallery, Cookham.

Harvesting walnuts
1926. Pen and Ink. A drawing for Chatto and Windus Almanac, 1927. Private Collection.

Hilda, Unity and Dolls
1937. Oil on canvas. 76.2 × 50.8 cm: 30 × 20 ins. Leeds City Art Galleries.

Hilda, drawing for The Betrayal
1923. Pencil. Bernard Jacobson Gallery, London.

Hilda, portrait on honeymoon
Pencil. Dated 24 February 1925. Bernard Jacobson Gallery, London,.

John Donne Arriving in Heaven
1911. Oil on canvas. 36.8 × 40.6 cm: 14½ × 16 ins. Private collection. On loan to Royal Albert Museum, Exeter.

Kit Inspection
Sandham Memorial Chapel, Burghclere. 1930. Oil on canvas. 213.4 × 185.4 cm: 84 × 73 ins. The National Trust.

The Last Judgment: Giotto
Arena Chapel, Padua. *c.*1305. Reproduction SCALA, Milan.

The Last Supper
1920. Oil on canvas. 91.5 × 122 cm: 36 × 48 ins. Stanley Spencer Gallery, Cookham.

Listening from Punts
Christ Preaching at Cookham Regatta series. 1953. Oil on canvas. 96.5 × 149.8 cm: 38 × 57 ins. Private collection. On loan to Stanley Spencer Gallery, Cookham.

Love Among the Nations
1935. Oil on canvas. 95.5 × 280 cm: 37½ × 110¼ ins. Fitzwilliam Museum, Cambridge.

Love on the Moor
Oil on canvas. 79 × 310 cm: 31 × 122 ins. Fitzwilliam Museum, Cambridge.

The Marriage at Cana: Bride and Bridegroom
1953. Oil on canvas. 66 × 50.1 cm: 26 × 20 ins. Glynn Vivian Art Gallery and Museum, Swansea.

The Meeting
1933, Oil on canvas. 63.5 × 61 cm: 27 × 24 ins. Private collection.

The Nativity
1912. Oil on panel. 102.9 × 152.4 cm: 40½ × 60 ins. The Slade School of Fine Art, University College, London.

Patricia at Cockmarsh Hill
1935. Oil on canvas. 76.5 × 51 cm: 31 × 21 ins. Private Collection.

The Port Glasgow Resurrections: Reunion
1945. Oil on canvas. Triptych. Left and middle panel: 75.6 × 50.8 cm: 30 × 20 ins. Right panel: 76.2 × 50.1 cm: 30 × 19¾ ins. City of Aberdeen Art Gallery and Museum.

Paintings and Drawings

Portrait of Patricia Preece by Stanley Spencer.
1933. Oil on canvas. 83.8 × 73.7 cm: 33 × 29 ins. Southampton Art Gallery.

Portrait of Patricia Preece by Hilda Spencer.
1933. Oil on canvas. 77.2 × 63.4 cm: 30 × 25 ins. Private Collection.

Portrait of Shirin Spencer
1947. Pencil on paper. 49 × 38 cm: 19 × 15 ins. Southampton Art Gallery.

The Psychiatrist
1945. Oil on canvas. 74.9 × 49.5 cm: 29½ × 19½ ins. Birmingham City Art Gallery.

The Resurrection of Soldiers
Sandham Memorial Chapel, Burghclere: altar wall. Oil on canvas.
641 × 519 cm: 252 × 207 ins. The National Trust.

The Resurrection in Cookham Churchyard
1924–26. Oil on canvas. 274 × 549 cm: 108 × 216 ins. Tate Gallery.

The Resurrection in Cookham Churchyard: Four drawings:
The God-image: austere. Pen and ink. Tate Archive.
The God-image: modified to feminine. Pen and ink. Tate Archive.
The God-image: Hilda. Pencil. Bernard Jacobson Gallery.
The God-image: approaching the final image. Pencil. Tate Archive.

The Resurrection with the Raising of Jairus' Daughter
1947. Oil on canvas. Triptych. Centre section 76.8 × 88.3 cm: 30¼ × 34¾ ins.
Side sections 76.8 × 51.4 cm: 30¼ × 20¼ ins. Southampton Art Gallery.

Reveille
Sandham Memorial Chapel, Burghclere. 1929. Oil on canvas.
213.4 × 185.4 cm: 84 × 73 ins. The National Trust.

The Sabbath Breakers
1952. Oil on canvas. 63.5 × 76.2 cm: 25 × 30 ins. Bernard Jacobson Gallery, London.

Scrapbook Drawing: Daphne, Stanley, children and pig
The Astor Collection, Vol. 2, p. 37. Pencil. Approx. 40.5 × 28 cm: 16 × 11 ins.
On loan to Stanley Spencer Gallery, Cookham.

Scrapbook Drawing: Elsie polishing a doorknob
The Astor Collection, Vol. 2, p. 8. Pencil. Approx. 40.5 × 28 cm: 16 × 11 ins.
On loan to Stanley Spencer Gallery, Cookham.

Stanley Spencer

Scrapbook Drawing: Hilda and Stanley dancing
The Astor Collection, Vol. 2, p. 26. Pencil. Approx. 40.5 × 28 cm: 16 × 11 ins.
On loan to Stanley Spencer Gallery, Cookham.

Scrapbook Drawing: Patricia and Stanley with dogs
Prepared for a painting in the Adoration series. The Astor Collection, Vol. 2,
p. 10. Pencil. Approx. 40.5 × 28 cm: 16 × 11 ins. On loan to Stanley
Spencer Gallery, Cookham.

Scrubbing the Floor
The Sandham Memorial Chapel, Burghclere. 1927. Oil on canvas.
105.4 × 185.4 cm: 41½ × 73 ins. The National Trust.

Self-Portrait
1914. Oil on canvas. 63 × 51 cm: 24¾ × 20 ins. Tate Gallery.

Self-Portrait
1959. Oil on canvas. 50.8 × 40.6 cm: 20 × 16 ins. Private collection.

Self-Portrait with Patricia Preece
1936. Oil on canvas. 61 × 91.2 cm: 34 × 36 ins. Fitzwilliam Museum,
Cambridge.

Separating Fighting Swans
1933. Oil on canvas. 91.4 × 72.4 cm: 36 × 28½ ins. Leeds City Art Galleries.

Shipbuilding on the Clyde: Burners
1940. Oil on canvas. Triptych. Centre section 106.7 × 153.4 cm: 42 × 60 ins.
Side panels each 50.8 × 203.2 cm: 20 × 80 ins. Imperial War Museum.

Silent Prayer
1951. Oil on canvas. 101.6 × 127 cm: 40 × 50 ins. Wadsworth Atheneum,
Hartford, Connecticut.

St Francis and the Birds
1935. Oil on canvas. 71 × 61 cm: 28 × 24 ins. Tate Gallery.

Stand To, or Dugout
Sandham Memorial Chapel, Burghclere. 1928. Oil on canvas.
213.4 × 185.4 cm: 84 × 73 ins. The National Trust.

Swan Upping
Begun 1915. Finished 1919. Oil on canvas. 146 × 115.5 cm: 58¼ × 45¾ ins.
Tate Gallery.

The Sword of the Lord and of Gideon
1921. Oil on paper stuck to cardboard. 62.2 × 56 cm: 24½ × 22 ins. Part
inserted. Tate Gallery.

Paintings and Drawings

The Temptation of St Anthony
1935. Oil on canvas. 121.9 × 91.4 cm: 48 × 36 ins. Private collection.

The Tiger Rug
Study for. 1939. Pencil on buff paper. 40.1 × 27.3 cm: 16 × 11 ins. Ashmolean Museum, Oxford.

Travoys with Wounded Soldiers Arriving at a Dressing Station at Smol, Macedonia
1919. Oil on canvas. 182.9 × 218.4 cm: 72 × 86 ins. Imperial War Museum.

View from Cockmarsh Hill, Cookham
1935. Oil on canvas. 71.1 × 91.4 cm: 28 × 36 ins. Bernard Jacobson Gallery, London.

A Village in Heaven
1937. Oil on canvas. 45.7 × 182.9 cm: 18 × 72 ins. City of Manchester Art Galleries.

Village Life, Gloucestershire: or *Village Gossips, Gloucestershire*
1940. Oil on canvas. 79.4 × 111.8 cm: 34¼ × 44 ins. Cheltenham Art Gallery and Museum.

Washing Lockers
Sandham Memorial Chapel, Burghclere. 1929. Oil on canvas.
105.4 × 185.4 cm: 41½ × 73 ins. The National Trust.

Pte William ('Jack') Witchell RAMC
1915. Pencil in autograph album. Approx 13 × 10 cm: 5 × 4 ins. Private collection.

Workmen in the House
1935. Oil on canvas. 113 × 92.7 cm: 44½ × 36½ ins. Private collection.

PHOTOGRAPHS

SOURCES AND ACKNOWLEDGEMENTS

Peter Spencer Coppock: p.201; p.202; p.217; p.233; p.250; p.493; p.501.

Alec Gardner-Medwin: p.5 upper; p.5 lower; p.282.

Glenside Hospital Museum: p.98; p.259; p.390 left.

Sophie Gurney: p.34; p.144.

Christine Hepworth: p.278; p.281; p.242; p.294; p.296; p.457; p.314; p.326; p.330; p.359; p.363.

Hulton-Deutsch Picture Agency: Back jacket cover.

Imperial War Museum: p.420

William Kench: p.390 right.

Colin McFadyean: p.111.

Beatrice-Helen Murray: p.442.

The National Trust: p.254 lower.

Nikos Paralis: p.131; p.134.

Henrietta Phipps: p.47.

David Shean: p.263.

The Stanley Spencer Trust: p.6; p.7; p.9; p.11; p.60; p.79; p.83; p.88; p.101; p.102; p.152; p.245; p.250; p.275; p.338.

Jean Storry: p.435.

Pauline Tooth-Matthews: p.276.

University College London: p.16.

Elizabeth Wood: p.124.

Author: p.97; p.106; p.117; p.197; p.254 upper; p.261; p.384.

INDEX

Page references in *italic* denote illustrations or captions.

Ablutions (S.S. 1928) 94, 96, 98, 469
Adoration of Girls (S.S. 1937) 370, 378
Adoration of Old Men (S.S. 1937) 370,
 378–82, *379*, 385
Advanced Dressing Station on the Struma
 (Lamb) 203
Allinson, Adrian 15, *17*, 517
Andrews, Peggy 293
Angels of the Apocalypse (S.S. 1949) 445,
 468–9, *469*, 486
Anrep, Boris 220, 352
Anrep, Helen 325, 351, 352, 519
Apotheosis of Hilda (S.S. 1959 unfinished)
 481n, 497–9, 508n
Apple Gatherers (S.S. 1912–13):
 main interpretations *30*, 31–5, 36, 43,
 44–7; other refs 65, 224, 225, 256,
 386, 398, 514
Arena Chapel (Padua) 253, 258, 265, *266*,
 267
Arnfield, Miss (housekeeper) 411, 432,
 456, 460
Arnold-Foster, Will and Ka (*née* Cox *qv*)
 16
Ash House *see* Chapel View
Asquith, William 55, 151
Astor, William Waldorf, 2nd Viscount and
 Lady Nancy 26, 500, 503, 504, 512,
 520
Attlee, Clement 466
Ayer, A. J. 479, 528

Badminton School 422, 434, *435*
Bailey, Dorothy and William 12, 77, 350
Banting, John 279
Baptism Series (S.S. 1935–55) 351, 372,
 463
Barrett, Mrs (café owner) 501–3
Beatitudes of Love, The (S.S. 1937–8)
 384, 385–91, *388*, 399, 400, 425,
 507
Beaton, Cecil 420
Beaufort, Duke of 95
Beaufort War Hospital *see also* Burghclere
 Chapel
 paintings 84, 95–110, 115–17, 122,

229, 255–6, 261–2, 389–91, 468–9,
 516, 524
 photographs 97, 98, *101*, *106*, *197*,
 259
Beaverbrook, Lord 161
Beckford, Elsie *see* Munday, Elsie
Beckford, Ken 393
Beddington-Behrens, Sir Edward and Lady
 306–7, 310, 313, 315, 318, 340, 411,
 518, 526
Bedmaking (S.S. 1932) 96
Behrend, Louis and Mary *281*
 patronage and friendship with S.S. 184,
 251, 272, 280, 358, 517; Burghclere
 chapel 220, 253, 255, 268, 286, 307,
 440; patronage of Patricia and others
 351, 352, 517–18
Behrens *see* Beddington-Behrens, Sir
 Edward and Lady
Belfast Art Gallery 349
Bell, Clive and Vanessa:
 Apple Gatherers incident 45, 51–2,
 519; Patricia Preece and other
 patronage 26–7, 89n, 325, 351–2,
 398, 519; Vanessa's works 27,
 352
Bellrope Meadow 28n, 334, 498
Bellrope Meadow, Cookham (S.S. 1936)
 328n, 334n
Belmont 4, 6
Bending the Keel Plate (S.S. 1943) 434
Bennett, William and Minnie 439, 453,
 466
Bernard Smithers family 422–3
Betjeman, John 514
Betrayal, The (S.S. 1914) 57, 58, 90n, 217,
 273, 472
Betrayal, The (S.S. 1923) 211–18, *212*,
 273, 472
Bierer, Dr (Hilda's psychiatrist) 434
Birmingham Art Gallery: works housed
 467
Bloomsbury Group 44, 45&n, 279, 295,
 325, 352, 514, 527
Bomberg, David 15, *17*, 80, 517
Bone, James 461

Bone, Sir Muirhead and Lady 204, 216–17
 war paintings projects 160, 161, 204,
 207, 217, 412, 518
Boot, Charles 315, 318
Bosch, Hieronymus 89
Boston, Lord and Lady 4–5, 12, 286
Boston, Lucy 237n, 524
Botticelli, Sandro: *Primavera* 37n
Bourlets (framemakers) 431
Bradshaw, Ursula *see* Spencer, Ursula
Brett, Dorothy 15, *16*
Breughel the Elder 339
Brewers School 490, 492
Bride and Bridegroom (S.S. 1953) 476,
 481–2
Bridesmaids at Cana, The (S.S. 1935–6)
 348–9, 349–51
Bridge, The (S.S. 1920) 208
Bridle Path, The (S.S. 1938) 370
British Broadcasting Corporation 479,
 503, 526
British Medical Association 439, 440,
 455
Brooke, Rupert *16*, 43, 48, 56, 81, 269,
 514
 artistic circle 44, 48, 50n, 52–3
Brown, Ernest 18, 108, *517*
Brown, Frederick *16*
Browne, Thomas: *Urn Burial* 29
Buchanan, Joe 430, 434
Budden, Lionel 263
 friendship with S.S. 103, 107, 112,
 128–9, 277; career 263, 516; war
 service 108, 115, 125, 128
Builders, The (S.S. 1935) 315–18, *316*,
 338–9, 344
Bulgaria: in 1st World War 126–8, 144–5,
 162, 166–8, 170
Burghclere 251, 280
Burghclere Chapel *see also Resurrection of*
 Soldiers 95, 124, 249, 253–5, *254*,
 265, 287, 318, 440, 526
 Beaufort War Hospital panels 94, 95–7,
 255–64, 469; Tweseldown *118*, 120;
 left wall *127*, 133, 140–1; right wall
 143, 146, 147; 1917 summer *148*,
 149–50, 286; infantry panels *154*,
 158–9, 162–4, *163*, 265, 278, 474
Burners (S.S. 1940) 415, *416*
Burton, Sir Montague 313
By the River (S.S. 1935) 325, 328n, 333,
 337–8, 376

Camp at Kalinova, The (S.S. 1931) *127*,
 143
Campion Hall project 401

Carline, George, Annie and family 200–3,
 208, 218, 239, 277, 282, 292, 344,
 411n, 456
Carline, George (son) 201, 232, 239,
 297–8, 303
Carline, Gwen 277, 362n
Carline, Hilda *see* Spencer: Hilda
Carline, Nancy 520
Carline, Richard 233
 background and artistic career 200–1,
 218, 239, 456–7, 520; friendship with
 S.S. and help for family 249, 277,
 279, 421–2, 433–4, 435, 512;
 opinions of S.S. and biography 185–6,
 208, 227, 291, 344n, 524; wartime
 expertise 411n; depictures 231, 232,
 236, 337
Carline, Sydney 200, 216, 232, 239, 277,
 279
Carrington, Dora (*later* Partridge) 15,
 16–17, 328, 514
Carroll, Lewis (C. L. Dodgson) 44
Causey, Andrew 37n
Centurion's Servant, The (S.S. 1913–14):
 main interpretations 54, 59–66, 81, 86,
 189, 318, 487; other refs 75, 104,
 108, 150n, 247, 273
Cézanne, Paul 27
Challoner, Sgt. 158
Chapel View (Ash House) 250, 251, 315
Chaplin, Charles 299n, 307
Charlton, George and Daphne 404–7,
 409, 418, 439, 460, 518, 527
 Daphne's relations with S.S. 406–7,
 409–11, 417, 418–19, 433, 439,
 455–6, 460, 487; Daphne and
 Patricia 431; portraits and depictures
 of Daphne *405*, 407–8, *408*, 409,
 413, 413–14, 424, 428, 504, 507
Chatto and Windus almanac sketches *78*,
 272, 319
Cheltenham Festival of Arts and Literature
 503
Chesterton, G. K. 193, 526
 quotation 3
Child, Charles Koe *17*
Childs, Captain R. E. 169, 170–2, 329
Christ Carrying the Cross (S.S. 1920):
 main interpretations 86–7, *87*, 114,
 269; other refs 85, 104, 180, 273,
 309, 344
Christ in Cookham (*Christ Calling the*
 Apostles) (S.S. 1952) 473
Christ Delivered to the People (*Christ*
 Led Away) (S.S. 1950) 464–5,
 471–3

Index

*Christ Overturning the Money-Changers'
 Tables* (S.S. 1921) 193
Christ Praying (S.S. 1939) 412
Christ Preaching at Cookham Regatta
 series 497, 504–11, 509, 510
Christ Preaching at Cookham Regatta
 (1959 unfinished) 26, 497, 504–7,
 509
Christ in the Wilderness series (S.S. 1939)
 397, 399–400, 412, 417, 423, 434,
 444
Christian Science: Hilda's and Stanley's
 attitudes 274–5, 279, 315n, 419
Christ's Entry into Jerusalem (S.S. 1921)
 177, 180–1
church house project 52, 208, 273, 283–6,
 299, 372, 399–400, 417–18, 473–4,
 496–9, 504
Churchill, Sir Winston 43, 56, 466
Chute, Desmond *111*
 background 109–10, 517, 525;
 friendship with S.S. 110–13, 117,
 121, 123–4, 184–6, 517; Guild of St
 Joseph and religious vocation 160,
 184–5, 274, 517; illnesses and death
 112, 280, 517
Clark, Kenneth 325, 352, 411, 514
Clemenceau, Georges 146
Cliveden View 299n, 446, 447, 463, 480,
 500, 520
Cliveden Woods 3, 5, 39, 178
Collis, Maurice 327n, 351n, 391n
Coming of the Wise Men, The (S.S. 1940)
 2, 10n, 179
Contemplation (S.S. 1937–8) 384, 386,
 399, 408, 425–6
Contemporary Arts Society 44, 49–50,
 198, 514
*Convoy of Wounded Arriving at the Gate
 of the Beaufort War Hospital* (S.S.
 1927) 96, 259–64, 260
*Convoy of Wounded Men Filling Water
 Bottles at a Stream* (S.S. 1932)
 149–50
Cookham, 1914 (S.S.) 67, 68–72, 69
Cookham Moor 3, 5, 178, 284, 308–9,
 373
Cookham Resurrection, The (S.S. 1920–1)
 224–5
Cookham Resurrection, The (*Resurrection
 in C. Churchyard*: S.S. 1924–6):
 main interpretations 225, 225–32,
 235–49, 242–3, 283, 290, 309, 320;
 other refs 66n, 90n, 217, 221, 268,
 300, 311, 337, 342, 374, 382, 463,
 467, 498–9, 508

Cookham village 3–4, 5, 23–4, 178–80,
 226, 300, 423, 473, 512
 inspiration for painting 40, 68, 226–7,
 280, 284–5, 299–300, 302–3, 309,
 351, 430, 506–11
Coppock, Peter (Gilbert's natural son) 202,
 214n, 518
Cornford, Frances 272n
Council for the Encouragement of Music
 and the Arts (CEMA) 456
Couples series *see Beatitudes, The*
Cox (*later* Arnold-Foster), Ka 16, 328
Crashaw, Richard 150, 176
Crucifixion, The (Gilbert Spencer) 59, *59*,
 89, 186–7
Crucifixion, The (S.S. 1921) *199*, 204–7,
 494
Crucifixion, The (S.S. 1958) 488, 490–1
cubism 73, 80, 385

dadaists 385
Dali, Salvador 447, 448
Dancers, The (Raverat) 33, 35
Dando, George 137, 157, 240
Dante Alighieri 82, 241, 244, 246, 247–8,
 313–14, 329, 450, 513
Daphne (S.S. 1940) *413*, 413–14
d'Arcy, Father 401
Darwin, Gwen *see* Raverat, Gwen
Daughters of Jerusalem (S.S. 1951) 473
David, Gerard: *Flight into Egypt* 37n
Davies, Francis (Ffrangcon) 455–6, 500,
 520
Death of St Francis (Giotto) 150n
*Deposition with the Rolling Away of
 the Stone* (S.S. 1956) 487–90,
 491
Diaghilev, Sergei 516
Dinner on the Ferry Hotel Lawn (S.S.
 1956–7) 507–8, *509*
Disrobing of Christ (S.S. 1922) 216, *216*
Divine Comedy, The (Dante *qv*) 247–8,
 450
Dodgson, C. L. (Lewis Carroll) 44
Domestic Series (S.S. 1935–6) 350–1, 358,
 372
Donne, John *see also John Donne Arriving
 in Heaven* 23, 25, 36, 238
Dublin Municipal Art Gallery 349
Duck Pond, The (S.S. 1940) 412
Dundee Art Gallery: works housed 466
Dunn, Miss (Asylum Matron) 105, 109
Dustman, The or *The Lovers* (S.S. 1934)
 298, 299–300, 309–10, 338–9, 357,
 408, 463
Duveen Trust 249

Ecstasy see Love Among the Nations
Eden, Sir Anthony 503
Eliot, T. S. xiii, 379, 513
 books and quotations 68, 75, 246
Ellis, Muriel 344
Empire Marketing Board commission (S.S.
 1929) 272, 411
Entombment of Christ series (S.S. 1956)
 487–90
Epsom and Epsom Art College 419–22
Epstein, Jacob 45
Ernst, Max 447, 448, 450
Esperey, General Franchet d' 161
Evans, Bridget 278
Evill, Wilfred 193, 318, 327, 392, 396
expressionism 27, 385

Faber and Faber Ltd 467
Fairy on the Waterlily Leaf, The (S.S.
 1909) *14*, 19–20, 26, 27
Farm Gate, The (S.S. 1950) 410*n*, 467
Fernlea (*later* Fernley) 4, 6, 79, 79–80,
 104, 192, 277, 423, 500, 521
 inspiration for S.S.'s work 23, 58, 61,
 88, 211, 319
Filling Tea Urns (S.S. 1927) 97
Flight into Egypt (David) 37n
Forrest (*later* Lamb; Groves), Nina 51,
 279, 514
Foster, Kate 282
Four Quartets (Eliot) 246
France, 1st World War 126–8, 131,
 144–5, 161–2
Friends of National Collection of Ireland
 349
Friends of Stanley Spencer Trust 522
Fry, Roger 26–7, 44, 45n, 295, 299, 324,
 325, 352, 519
Furnaces (S.S. 1946) 444, 453

G.B. Animation Ltd 455
Gathorne-Hardy, 'Eddie' and Robert 279,
 524
Gaudier-Brzeska, Henri 47–8, 52, 56, 123,
 515
Gauguin, Eugène Paul 27, 518
George V, King 95, 100
Georgian Poets (ed. Marsh) 52, 523
Gertler, Mark 15, *17*, 47, 48, 52, 517
Gide, André 34n
Gill, Eric 52, 160, 184–5, 514, 517
Gill, Petra 186n
Gilman, Harold and Dorothy *16*
Gilson, Miss (Beaufort Matron) 100n
Giotto di Bondone 18, 150n, 253, 258,
 265–8, 270

Girls Listening (S.S. 1953) 507
Girls Running, Walberswick Pier (Steer)
 181
Glenside Hospital *see* Beaufort War
 Hospital
Gloucestershire in the Snow (S.S. 1940) 412
Golden Ass of Apuleius (tr. Graves) 481
Gollancz, Victor and Ruth (*née* Lowy) xi,
 20, 306, 398, 453
Goupil Galleries: exhibitions 44, 249, 276
Grafton Galleries: 1912 exhibition 27
Grahame, Kenneth: *Wind in the Willows*
 383, 481, 504
Grant, Duncan 27, 45n, 48, 325, 351–2
Greece: in World War One 126–8, 162
Green Divan, The (Preece) 353
Gribben, Patrick and Mary 492n
Grocer Couple, The see Knowing
Guild of St Joseph and St Dominic 160,
 184–5, 197
Guinness, Bryan (Lord Moyne) 347–9

Harmony see Love Among the Nations
Harter, Mrs 362, 411, 418, 419, 422
Hastings, Lord and Lady 348, 352
Hatch, Amy 38, 389, 460
Hatch, Jack 48, 83, 238n
Hatch, Peggy 75
Hepworth, Barbara 518
Hepworth, Dorothy 326
 relationship with Patricia Preece 277,
 282–3, 324, 332, 353, 361–2, 376,
 391–2, 393, 520; painting 283, 324,
 333, 353, 393, 520; marriage of S.S.
 and Patricia 362, 363; relations with
 S.S. 280, 283, 295, 364, 456;
 depictures 375–6
Her Evening Off (S.S. unfinished) 496–8,
 504
Herren, Miss (nurse) 280, 281
Hieratic Head of Ezra Pound
 (Gaudier-Brzeska) 515
Hilda and Unity with Dolls (S.S. 1937)
 367, 368
Hill of Zion, The (S.S. 1946) 445, 453,
 463–4, 466
Hopkins, Gerard Manley 513
Humphries, Ruth 16n
Hunt, Leigh 45
Hunt, Marjorie *see* Spencer, Marjorie
Huxley, Aldous 151

Image, Florence (*née* Spencer; Stanley's
 sister):
 life at Fernlea 7, 7, 8, 19–20, 26;
 marriage and widowhood 49, 180,

521; relations with S.S. 142, 147, 313, 481; on paintings 26, 38, 68n, 81, 176, 274n; on wartime service 55; depictures 11n, 212, 231
Image, J. M. 49, 147
Image, Selwyn 49
impressionism and post-impressionism 27–8, 44
In Church (S.S. 1958) 490
Imperial War Museum 444n, 453
International Association of Artists 520
Irish Troops in Judaea Surprised by a Turkish Bombardment (Lamb) 203

Jacob and Esau (S.S. 1910–11) 179
Japp, Darsie:
 friendship with S.S. 46, 47–8, 51, 219, 263; wartime service 56; career and interests 219, 514; paintings 161, 514
Japp, Lucila 514
John, Augustus:
 artistic career and views 51, 276, 325, 339, 352; domestic life and friends 203–4, 220, 328, 348; paintings 48, 518
John, Dorelia 203–4, 209, 328
John Donne Arriving in Heaven (S.S. 1911) 22, 25–8, 32, 68, 89n, 273
John, Ida 204, 328
John Lewis Partnership 422, 490, 521
Jones, David 253, 517
Joyce, James xiii, 120, 237n, 513, 516
 books and quotations 75, 356, 512
Jung, Carl 439

Kandinsky, Vasily 27
Keats, John 45
Kelly, Sir Gerald 466, 470, 519, 522
Kench, Sgt-Major William 98–9, 105, 255, 389–91, 390, 516
Kennedy, George 255, 279
Kennington, Eric 220
King, Quartermaster-Sgt. 105
Kit Inspection (S.S. 1930) 118, 120, 121
Knowing (*Grocer Couple*: S.S. 1937–8) 387, 388

Lacey, Guy 51, 230
Lamb, Henry 47
 background and personal life 16, 51, 204, 209, 279, 514; patronage of S.S. 44–6, 123, 198, 219, 255, 263; friendship with S.S. 49, 51–2, 108, 151, 152, 184, 194, 219, 249, 347, 524; wartime service 56, 108, 120, 125, 147, 177; patronage of Gilbert

Spencer 49–50, 186; portrait of S.S. 251; other works 27, 46, 161, 203, 219, 220, 514, 518
Lamb, Horace 51
Lamb, Nina (Euphemia) *see* Forrest, Nina
Lamb, Pansy (Lady Pakenham) 279, 347, 514
Lamb, Walter 339, 478
Last Day series (S.S.) 430
Last Judgment (Giotto) 265–8, 266
Last Supper, The (S.S. 1919–20) 181n, 193, 195–8
Last Supper, The (S.S. 1922) 216, 217
Lawrence, D. H. 16, 39, 75
 quotation 155
Lawrence, T. E. 219–20, 349
Lee, Dr (organist) 453–4
Leg of Mutton Nude (S.S. 1937) 356, 470, 500, 519
Legend of John of Balliol (Gilbert Spencer) 202
Lehmann, Rosamond 4
Leicester Galleries: 1942 exhibition 431
Lenin, V. I. 120
Leonard Stanley 405–9, 418, 419, 428, 506, 527
Lerman, Dr Katharine 518–19
Lewis, Wyndham 27, 39, 89n, 199
Lhôte, André 200, 324
Lindworth 281, 282, 300, 327, 328n, 340, 393, 400, 422, 446, 520
Listening from Punts (S.S. 1953) 510, 511
Lithgow, Sir James 444n
Lithgow's shipyard 412, 416, 434, 485
Litter on Hampstead Heath (S.S.) *see Apotheosis of Hilda*
Llewellyn, Sir William 339
Lloyd George, David 151
London Group 16, 44
London University: S.S.'s fellowship 501
Love Among the Nations (S.S. 1935) 308, 341–4, 342–3, 347
Love on the Moor (S.S. 1937–55):
 main interpretations 306–7, 308–10, 329–30, 344; other refs 327, 357, 373, 376, 410n, 484, 498
Lowy, Ruth *see* Gollancz, Victor and Ruth

MacColl, D. S. 315n
MacDonald, Duncan 352
MacDonald, Malcolm 398, 518
Macedonia *see also* Burghclere panels; Vardar Hills 126–8, 130, 131, 132–4, 136–7, 144–6, 150, 153, 156–7, 159, 161–2

MacFadyean, Lady 187n
Madonna and Child project 463
Maidenhead Technical College 12, 230
Making a Firebelt (S.S. 1932) 143, 149, 286
Manchester City Art Gallery 203
Map Reading (S.S. 32) 143, 159
Marchant, William 249, 276
Marriage in Cana project (S.S. 1952–3) 347–51, 348–9, 372, 386, 417, 463, 476, 481–2
Marsh, (Sir) Edward:
 patronage of S.S. 43, 44, 46–7, 70, 177–8, 219, 503; relations with S.S. 49, 50n, 188, 218, 466; patronage of arts 52, 120, 351, 352, 513–14, 523; 1st WW peace negotiations 184; house bombed 398
Marsh Meadows 3, 5
Martineau family 454
Martineau, Jack 487, 490, 494, 500, 512, 522
Matisse, Henri 27
Meeting, The (S.S. 1933) 334–6, 335
Men Washing (S.S. sketch) 469
Mending Cowls, Cookham (S.S. 1915) 123, 195
Mill at Durweston, The (S.S. 1920) 203
Milne, General 145, 162
Milton, John 150, 260, 481
Ministry of Information 417, 419, 422, 433
Miracle of Spring (Giotto) 150n
modernism 17, 27–8, 73, 189, 285, 513
Moor Hall 184, 294, 309, 455
Moor Thatch 282, 294, 295, 324, 353, 456, 457
Moore, Henry 515, 518
Morrell, Lady Ottoline 44, 50, 51, 151, 219, 352, 514, 524
Morrell, Philip 50, 151, 219, 352, 524
Moyne, Lord *see* Guinness, Bryan
Munday (*later* Beckford), Elsie 275, 275–6, 279, 281, 299, 300, 393, 519
 S.S.'s awareness 375, 387, 426; depictures 315, 375, 387, 424, 496, 504, 507
Munnings, Sir Alfred 466, 470, 486, 519
 depictured 471
Murray, Graham and Charlotte 239n, 438–40, 442, 453, 455, 484, 520
 Charlotte's 'handholder' role 439–40, 453, 460–1, 527–8; portrait and depicture of Charlotte 451, 507
Museum of Modern Art, New York 318, 415
Mussolini, Benito 344

Nash, John 48, 280
Nash, Paul 48n, 48, 52, 160, 276, 517
Nash, Tom and Mabel 200, 214n, 478, 493, 518
National Art Collections Fund 518
National War Paintings Exhibition (1919) 190
Nativity, The (S.S. 1912) 36–41, 37, 65, 68, 75, 225, 273, 333, 496
Negroes see Love Among the Nations
Nesbitt, Cathleen 48, 52, 515, 523
Nevinson, Christopher 15, 17, 52, 80, 160, 404, 517
New English Art Club 44, 108, 200

Odney Common 3, 32, 48–9, 351
Ogden, C. K. 237n
Ohlers, Johanna *see* Spencer, Johanna
Ohlers, Max and family 8n, 120
Oliver, Constance 400
Owen, Wilfred: quoted 192

Pakenham, Lady Pansy *see* Lamb, Pansy
Paradise Lost (Milton) 260
Parents Resurrecting (S.S. 1933) 314
Partridge, Ralph and Frances 17, 328, 514
Patient Suffering from Frostbite (S.S. 1932) 96
Patricia on Cockmarsh Hill (S.S. 1935) 328, 331
Payne, Edward 405
Pearson, Lionel 255
Penguin Books 434
Pentecost project 463–4, 508
Pepler, Hilary 160, 184
Perceval, Spencer 44
Period Piece (Raverat) 515
Picasso, Pablo 17, 27, 73, 75, 516
Picture Post magazine 438
Plumbers (S.S. 1944–5) 444
Port Glasgow: *see also* shipbuilding series: 412–13, 417–18, 421, 430, 438, 442–3, 445
Port Glasgow Resurrection series (S.S. 1945–50) 66n, 440–1, 443–5, 450–2, 458, 463–4, 466–7, 478, 498
Portrait of Patricia Preece (S.S. 1933) 288
post-impressionism *see* impressionism and post-impressionism
Pound, Ezra xiii, 515, 517
 quotations 313, 347
Pound, Reginald 519
Powell, Anthony 514
Preece, James Duncan 324
Preece, Patricia *see* Spencer, (Lady) Patricia
Price, Mrs (housekeeper) 446

Index

Primavera (Botticelli) 37n
Prince of Wales (*later* Edward VII) 6
Prince's Theatre, Bristol 109, 110, 517
Private Affairs of Bel Ami (film) 447, 453
Promenade of Women in Heaven, The
 (S.S. 1938) 484
Proust, Marcel 34n, 41, 73, 200n, 329, 516
Psychiatrist, The (S.S. 1945) 451
Purser, Sarah 349

Queen Alexandra's Imperial Military
 Nursing Service 96, 107
Queen Elizabeth, the Queen Mother 501
Queen Mary project 401, 412

Ramsey, Frank 237n
Raverat, Jacques 34
 at the Slade 15, 16, 33; friendship with
 S.S. 33, 109n, 146, 514–15, 523;
 domestic life 328, 515; Biblical project
 52, 194; wartime activities 56; illness
 219; *The Dancers* 33, 35
Raverat (née Darwin), Gwen:
 relationship with S.S. 15, 18, 25, 29–30,
 52, 165, 272, 297, 369, 515, 523; and
 Spencer family 109n, 142; domestic
 life *144*, 219, 328, 515; artistic talent
 and interest 33, 269, 284, 313, 515,
 524; depicted 303
Ray, Man 348
Rejoicing (S.S. 1947) 445, 453, 498
Remington, Eddie and Dorothy 280
Resurrection in Cookham Churchyard,
 Resurrection, Cookham see Cookham
 Resurrection
Resurrection of the Good and the Bad,
 The (S.S. 1915) 224, 318, 479
Resurrection, Port Glasgow, The (S.S.
 1947–50) 445, 452, 463–4, 467–8
Resurrection with the Raising of Jairus'
 Daughter, The (S.S. 1947) 454–5,
 458–9
Resurrection of Soldiers, The (S.S.
 1926–8) 66n, 219, 252, 253, 265–70,
 374, 380, 474
Reunion (S.S. 1945) 440–1, 445, 452
Reunion of Families (S.S. 1945) 445, 466
Reveille (S.S. 1929) 162–3, *163*, 265, 278,
 474
Richards, I. A. 237n
Riveters (S.S. 1941) 418, 419–20
Road to Jerusalem (S.S.: *Christ's Entry*
 into Jerusalem q.v.) 181n
Robing of Christ, The (S.S. 1922) 216–18
Rolls-Royce Ltd 249
Romance see Love Among the Nations

Romantic school 285
Rosenberg, Isaac 15, *17*, 52, 173, 182,
 184, 306, 515, 523–4
Rothenstein, (Sir) John and Elizabeth 352,
 396, 398–9, 401, 405, 418, 512
 Sir John as Tate director xi, 235n, 396,
 414, 467; books on S.S. 453, 519,
 527, 528
Rothenstein, William 160
Royal Academy: and S.S. 286, 338–40,
 466, 490, 520, 527
Royal Air Force 168
Royal Army Medical Corps (RAMC) 56,
 96, 119, 120, 132, 134–6, 139, 147,
 151
Royal Berkshire Regiment 56, 145–6, 147,
 151, 155, 162, 165–72, 205, 516
Royal Institute of Philosophy 477, 528
Rushbury, Sir Henry 444n
Ruskin, John 8, 17, 18, 41
Ruskin Drawing School 216, 279, 406
Russell, Bertrand 237n
Rutter, Frank 67n

Sabbath Breakers, The (S.S. 1952) 472,
 473
Sadleir, Michael 48n, 320
Sadler, (Sir) Michael 44, 46, 48n, 320,
 518, 526
St Francis and the Birds (S.S. 1935) 150n,
 312, 318–22, 332, 338–9, 357, 374,
 429, 493
St Veronica Unmasking Christ (S.S. 1921)
 193
Salonika 126, 128, 146, 149–50, 173,
 525–6
Sandell, Sam and Mrs 89, 90, 142
Sandham, Captain H. W. 220, 255, 268
Sandham Memorial Chapel *see* Burghclere
 Chapel
Sandwich, ninth Earl of 272–4, 461, 519
Sarah Tubb and the Heavenly Visitors (S.S.
 1933) 273, 379n
Sarrail, General Maurice 144, 145
Scarecrow, Cookham, The (S.S. 1934)
 338–9, 493
Schiff, Sydney (Stephen Hudson) *17*,
 515–16
Scottish Arts Council 444n
Scrapbook drawings (S.S.) 308, 419, 423,
 424, 425–31, 434, 458n, 493–4
Scrubbing the Floor (S.S. 1927) 96–7,
 255–8, 257
Seabrooke, Elliott 52
Self-Portrait with Patricia Preece (S.S.
 1936) 357, 359–61

Self-portrait (S.S. 1914) 42, 50, 503, 514
Self-Portrait (S.S. 1959) 502, 503
Separating Fighting Swans (S.S. 1933)
335–8, 336
Serbia: in World War I 126–8, 129,
145–6, 161–2
Sermons by Artists: S.S.'s contribution
345, 528
Seven Ages of Man, The (Gilbert Spencero
49–50
Seven Pillars of Wisdom, The (Lawrence)
220
Shipbuilding series 412–13, 415–23, 416,
433–4, 443, 444, 453, 527
Sidoli, Mario 37n
Silent Prayer (S.S. 1951) 481, 482
Slade, the:
S.S.'s attendance 12–13, 15–19, 26,
196; other students 5, 15, 16, 33,
214n, 277, 324; wartime evacuation
406, 527; S.S. teaches at 477
Slesser, (Sir) Henry and Margaret 192–3,
195, 198, 318, 454
Sir Henry's high office 230, 518;
depiction of Henry 229–30, 247
Smart, Richard 412, 416, 417, 468
Smith, Joy and Dennis 503
Smith, Matthew 276
Smithers, Bernard 282
Snowdrops (S.S. 1940) 412
Sorting Laundry (S.S. 1927) 97
Sorting and Moving Kitbags (S.S. 1927) 96
Southampton University: S.S.'s fellowship
501
Spencer, Annie (Ma; Stanley's mother) 79
background and home life 6, 6, 7, 50,
262, 441; relations with sons 7–8,
24–5, 56; infirmity and death 49,
180, 192, 218; depiction 11n, 89,
237, 510
Spencer, Annie (Stanley's sister):
home life 7, 7, 8, 11, 49, 180, 192, 521;
mental and physical disabilities 277,
299n, 445, 446, 521; depictions 11n,
231
Spencer, Daphne (Harold's daughter) 478
Spencer, Florence (Stanley's sister) *see*
Image, Florence
Spencer, Gilbert (Stanley's brother) 493
upbringing and family life 7, 7, 8, 10,
11, 19, 50, 277n; at Slade 49, 192,
200; wartime service 56, 82, 84, 96,
107, 119, 129, 138, 153, 179; war
memorial project 161; admirer of
Hilda Carline 203, 214n, 233; Mabel
Nash affair 214n; engagement and

marriage 214n, 279, 280, 521;
paintings 49–50, 59, 89, 186–7, 202,
220, 231, 309, 521; fascination with
farmhorses 268; memoirs 214n, 262,
522, 523; memories of S.S. and
paintings 29, 31, 319, 321, 350, 388,
522; depiction 11n, 211, 231, 350
Spencer, Gillian (Gilbert's daughter) 522
Spencer (*née* Harter), Gwen (Sidney's wife)
362n, 411, 418
Spencer, Harold (Stanley's brother) 7
musical career 7, 49, 179–80; wartime
activities 55, 119, 143; later life 478;
depicted 11n
Spencer (*née* Thomas), Hilda (Percy's wife)
177
Spencer (*née* Carline), Hilda (Stanley's first
wife):
background and character 201–3,
209–10, 234–5, 291–2, 368;
Christian Science and ethics 274–5,
279, 290, 315n, 344, 419, 436, 457,
474, 485; artistic talent 201, 201,
210, 233, 292, 305, 326, 397;
courtship and marriage to S.S. 201–4,
208–10, 219, 221, 232–5, 497–8;
married life 250, 251, 275–6, 281,
291, 292, 304, 387, 393, 419; birth of
children 244, 245, 278–9, 280;
George's illness and death 298, 303,
393; 'fusion' with Stanley 221, 235,
289–91, 329, 332–3, 356, 367–9,
407, 499; Stanley's affair with Patricia
298, 304–5, 310–11, 327–8, 331–2;
departure and divorce 337, 340, 353,
361–2, 421; ménage-à-trois rejected
328, 361, 363, 365, 367, 393–4, 419,
526–7; post-divorce relations and
break-up 368, 392, 393–5, 396–7,
410–11, 418, 419, 422, 423; own life
and children 411, 421–2, 435,
435–6; illnesses and new inspiration
for Stanley 431–4, 436–7, 441, 453,
456–8, 459–62, 463, 464–5, 467,
470; death and continued vision for
Stanley 470–1, 474, 481–4, 497–9,
511; portraits 234, 319, 366, 368;
depicted (*Cookham Resurrection*)
213, 227, 228, 231, 235, 238, 242–3,
244; (other pre-war paintings) 303,
320, 387, 410, 424, 427–8;
(Resurrection series) 450–2, 459; (last
paintings) 467, 471, 472, 481, 489,
497–9, 508, 511
Spencer, Horace (Stanley's brother) 7
conjuring talent and career 7, 10, 49,

Index

192, 492n; marriage and family
119–20, 143, 180, 218, 521; West
Africa and wartime service 55–6, 82,
83, 143, 161; death 492n; depicted
11n
Spencer, (née Ohlers), Johanna (Will's
wife) 8, 10, 49, 55, 120, 179
Spencer, Julius (Stanley's grandfather) 4,
89, 282
Spencer, Julius (Stanley's uncle) 4, 6, 8
Spencer (née Hunt), Marjorie (Horace's
wife) 119–20, 143, 192, 218,
521
Spencer, Natalie (Harold's wife) 7, 49,
119, 143, 179–80
Spencer, Pamela (Percy's daughter) 280,
479, 523
Spencer (née Preece), (Lady) Patricia
(Stanley's second wife) 278, 296, 330
background and character 324–5, 328,
370n, 394, 431; relationship with
Dorothy Hepworth 277, 282–3, 324,
332, 353, 361–2, 376, 391–2, 431,
461–2, 520; painting and exhibitions
324–6, 333, 351–3, 393, 398, 431,
520; pre-marital involvement with
Stanley 277, 282–3, 291, 295–6, 298,
299, 303–4, 308, 310, 326–33, 330,
340; inspiration for Stanley 296,
302–3, 321, 328–30, 344, 387, 393,
407, 427; sexual incapacities 332,
356, 361, 364, 382, 419; contempt
for Stanley's work 326–7, 333, 351,
357, 358, 429; management of his
affairs 327, 361, 369, 394, 396;
marriage and post-marriage relations
361–2, 363, 364–5, 391–2, 393–5,
421, 431, 456, 478, 526–7; illnesses
352, 456; divorce proceedings 461–2,
463, 470n, 478, 519; money and
house affairs 181n, 398, 417, 421,
436, 445–6, 456, 478, 503; Stanley's
knighthood and death 501, 520;
portraits and nudes 288: 305: 328–9,
331, 356–61, 357, 383, 504 see also
Leg of Mutton Nude: depicted 301,
303, 321, 332, 334–6, 375–6, 387,
424, 427, 471, 472, 507
Spencer, Percy (Stanley's brother):
at Fernlea 7, 7, 9, 49, 179; career 8, 10,
49, 161, 414, 521; wartime service
(1st WW) 56, 82, 102, 120, 142–3,
147, 177; marriage 177, 414; care of
Annie and family matters xii, 277n,
299n, 445, 479, 521; house bombed
398; depicted 11n

Spencer, Shirin (Stanley's daughter):
childhood and schooling 244, 245, 251,
280, 292, 411, 421–2, 434, 435; later
life 459, 503, 504, 523; depictures
and portrait 242–3, 337, 505
Spencer, (Sir) Stanley
personal chronology:
early life and 1st WW; birth and
upbringing xiv, 6–10, 7, 11, 12–13,
23, 80, 179; at Slade 12–13, 15–19,
16, 523; acquires London studio and
patrons 46–8, 523–4; joins Civic
Guard and St John's Ambulance
Corps 56, 82, 83, 84; RAMC and
Beaufort Hospital 84–5, 95–109,
101, 102, 108, 119, 120, 125; in
Macedonia with FA 128–37, 139,
142, 143, 146, 149–50; injury and
illness 138–9, 142, 172–3, 176, 178;
transfer to infantry and action 151–3,
155–6, 158–60, 162, 165–72, 240;
inter-war years; return home and
Ditchling Community 178–81, 182,
184–6; New English Art Club and
new friends 200–3; courts and
marries Hilda Carline 201–4, 208–9,
232–3, 419, 428, 499; moves to
Hampstead and Vale Hotel 209, 217;
lectures at Oxford 216; failure of
Bones' project 217; move to
Burghclere and daily life 250, 251,
262–4, 278–9, 281; Rolls-Royce
incident 249; gallstone affliction 279,
292, 304–5, 315; return to Cookham
280–3, 291, 292, 292–3, 314, 338,
359; elected ARA 286–7; Patricia
Preece affair 291, 295–6, 298,
303–5, 308, 310–11, 324, 326–40;
Behrens patronage and Swiss holidays
306–8, 310–11, 315, 340, 485;
ménage-à-trois idea and Hilda's
departure 328, 337–8, 340, 345, 361;
elected RA and exhibition row
338–40, 527; divorce 353, 361–2;
marriage to Patricia and
ménage-à-trois idea 353, 361–5, 363,
367–8, 393–4, 419; Zwemmer affair
369–70, 519; disillusion and
break-up 385, 391–5; Rothensteins,
MacDonald, and resurgence 396–9,
404; 2nd WW and after; Leonard
Stanley, Port Glasgow and Daphne
Charlton 405–9, 412–14, 416–18,
420, 421, 434; Epsom and break-up
with Hilda 418, 419–23; return to
Cookham 422–3, 435; Hilda's

Spencer, (Sir) Stanley – *cont.*
breakdown 431–7; Port Glasgow again
and Charlotte Murray 438–40,
442–3, 445, 453, 458; sale of
Lindworth and move to Cliveden
View 446–7, 453–6, 463;
amputation of toe 489; divorce
proceedings from Patricia 461–2,
463, 478; Hilda's illnesses and death
458, 459–60, 463, 470–1; created
RA and CBE 466, 467, *501*;
Munnings and obscenity charge 470,
486, 519; public recognition and
engagements 477, 529; visit to China
479, 528; illness and return to Fernlea
499–500, 503; knighthood and
honorary degrees 500; death and
burial 504, 512, 520
character:
visual memory 8–9, 187, 268; gift of
mimicry 6, 262; sociability xii–xiii,
100, 233–4, 262, 291, 438–9, 477,
479, 480; quirks of behaviour xiii,
200, 208, 233–4, 291, 321, 348n,
385, 430, 434, 500, 508; honesty of
purpose and reaction to cant 51,
100–3, 105–7, 156, 168–9, 194–5,
249–50, 485–6; sharpness of tongue
11, 104, 172, 203, 412, 454, 515;
reputed intractability 283n, 291,
411–12; indifference to mundane
things 46, 52, 100, 249, 344, 383,
407; precision and perfectionism 10,
13, 69, 100, 104, 158n, 203, 293,
485; view of human nature 24, 33n,
190, 195, 262, 415; sexual awareness
20, 21, 33, 151, 200, 203, 209, 215,
220, 290, 294, 301-2, 468; fulfilment
with Hilda 221, 235–6, 290, 356,
363, 407, 419, 450, 468; but not with
Patricia 329, 356, 364–5, 382, 393,
419; sexual feelings and creativity 40,
75, 207, 215, 235, 297, 344–5,
392–3, 400, 409, 442–3, 474
metaphysical and spiritual dimension:
home-cosiness and Cookham-feelings
10–12, 25–6, 29, 32, 40, 76–8, 81,
137, 268, 380, 507; post-war
attempts to recapture 209–10, 300,
330, 399–400; Cookham flowers 10,
39, 40, 73, 290–1, 321, 329, 468,
481, 507; outward projection 24, 31,
70, 237–8; place-feelings 78, 133,
147, 156, 386, 407; religious
searchings xi, 25, 30–1, 33, 36, 75,
184–6, 197, 274–5, 315n, 432;

expression of concept of heaven 25–6,
195–6, 238, 241, 474; fascination
with Macedonia 132–4, 136–7, 139,
153, 156–7, 188, 205, 219, 399;
dilemma of war 56–8, 63–5, 81–2,
114, 137, 157–8, 190–1, 198, 256–7,
345, 480; search for redemption
63–7, 73, 189–90, 225–6, 241,
269–70, 373, 387, 489–90, 494–5;
desire for spiritual harmony 104–7,
114–15, 158, 189–90, 258–9, 344,
425, 442–3, 494–5, 513; fascination
with death and concept of afterlife 40,
138, 190, 267, 433, 442–3, 474;
post-war confusion of feeling 180–1,
185–7, 192, 208; search for fulfilment
214–15, 227, 289–90, 302, 375, 463,
494–5; understanding of God 242–6,
275, 295, 320, 342–3, 399, 407, 432,
436–7, 450, 474; fusion with Hilda
see Spencer, Hilda; Patricia-vision
302–3, 311, 319, 321, 328–32, 344,
394–5, 427, 437; creation and life 32,
114–15, 322, 341, 367, 428, 430;
nature and transcendance of love
301–2, 342–4, 345–6, 373, 381,
442–3, 483–4, 509–10, 511; spiritual
and sexual unity 32, 206, 372, 376,
381–2, 392–3, 400, 428–9, 468,
482–3, 496–7; Hilda and 'up in
heaven' vision 432–3, 436, 456,
459–60, 461, 464, 474, 480, 481–4,
497–9
relationships:
in childhood and family 6–10, 445, 460,
465, 479; commitment to 'spiritual'
friends 12, 15, 110, 194–5, 203,
230–1, 439n; influence on creativity
10–11n, 89, 264, 409; with Gilbert
56, 82, 107, 203–4; pre-war coterie
15, 25, 29–30, 45–8, 52–3, 109, 114,
121–2, 123–4, 515–17; wartime
family stresses and reunion 82, 85,
109, 153, 155, 180; wartime
comradeship 100, 128–9, 137, 139,
151, 156; post-war disillusions
184–7; new liaisons 195, 200–3,
218–21, 236–7, 517–20; with Hilda
see Spencer, Hilda; Burghclere period
279–80, 289, 517–18; Christ as
Doppelgänger 289; feelings for
women 20, 293–4, 297–8, 301, 304,
386–7, 410n; Patricia Preece *see*
Spencer, Patricia; view of
Bloomsberries 351–2; resurgence
period 398–9, 404, 406–10, 416,

418, 518–19, 528; Daphne Charlton
see Charlton, George and Daphne;
Charlotte Murray *see* Murray,
Graham and Charlotte; post-war
friendships 454–5, 479, 487,
499–500, 518–19; analysis 230–1,
461
books, music and writing:
musical talent and significance of music
8, 49, 51, 131–2, 157, 404, 456;
habit of Bible reading 8, 75–6, 167,
399, 481; literary influences 25, 29,
39, 41, 82, 112–13, 527–8; wartime
comfort 121–2, 125, 126, 131, 137,
140, 142, 151–2, 176; shared interest
with Hilda 235, 528; letter writing xii,
230, 298, 308, 353, 362–3, 423;
(wartime) 100, 140–1, 147, 150, 156;
'writings on art and religion' and
Sermons by Artists 345, 528; 'Epsom'
and other writings xi, 385, 398, 419,
453, 482–4, 495; autobiography plan
xi–xii, 398, 503; expressiveness of
language xii–xiii, 233–4, 426, 483–4;
reading in late life 480–1
financial affairs:
sales of early paintings 45, 46, 50, 52,
192; support for parents 52, 142,
192; post-war recognition and sales
192, 198; income from landscapes
218, 276, 358, 369, 383, 400, 407;
sale of *Cookham Resurrection* and
improved prosperity 249, 272, 315,
348, 358–9; Patricia's help and
hindrance 301, 327, 340, 351, 358,
369–70; subscription scheme 351;
barren years and Tooth's help xi,
357–60, 362, 369, 391–2, 396–7,
406, 421, 431, 434–5, 519;
maintenance of Hilda and Patricia
340, 362, 392, 394, 397, 417, 421,
435; shipyard commission and other
sales 412, 415, 417, 433, 435, 444;
Penguin contract 434; RA exhibition
sales and security 462, 466–7, 478–9
chronology of art:
*page references to paintings, etc., are to
establish chronology only. For full refs
see individual titles*; urge to paint and
Maidenhead College 12, 230; at the
Slade 12–13, 15–19, 26–7, 31, 277;
Fairy on the Waterlily Leaf (1909)
19–20; *Two Girls and a Beehive*
(1910) 24; *Jacob and Esau* (1910–11)
179; *John Donne Arriving in Heaven*
(1911) 25–8; first exhibited 27;

growing recognition 27, 49–50, 52;
Apple Gatherers (1911–13) 31–5,
44–8; *The Nativity* (1912) 36–41;
Self-portrait (1914) 50; *The Betrayal*
(1914) 58; *St Francis and the Birds*
(1935) 318–22; *The Centurion's
Servant* (1913–14) 59–66; *Cookham,
1914* 68–72; *Mending Cowls,
Cookham* (1915) 123, 195; *Swan
Upping* (1915–19) 76–81, 184; War
Memorial scheme and War Artists
Commission 160–1, 178, 182–4,
190–1; *Travoys Arriving with
Wounded . . .* (1919) 184, 187–90;
The Last Supper (1919–20) 195–8;
Christ Carrying the Cross (1920) 85,
86–92; *The Bridge* (1920) 208;
Tryptych for Slessers 193–4; *Christ's
Entry into Jerusalem* (1921) 180–1;
Bone's village hall project and *The
Crucifixion* (1920–1) 204–6, 207,
518; *The Sword of the Lord and of
Gideon* (1921) 167; *Resurrection,
Cookham* (1921) 224–5; *Unveiling
Cookham War Memorial* (1921) 208;
The Betrayal (1923) 211–18; war
chapel drawings 219, 220; *Cookham
Resurrection* (1924–6) 221, 224–32,
235–48; Burghclere Chapel project
(1927–32) 95–6, 147, 249, 253–65,
286, 287; first one-man exhibition
(1927) 249; *Resurrection of Soldiers*
(1927–8) 253, 265–70; recognition
and success 249, 272, 276–7, 526;
church design ambition 52, 283–4,
299–300, 372–3, 399, 473–4,
496–9, 504; elected ARA 286–7;
Separating Fighting Swans (1933)
335; *The Dustman*, or *The Lovers*
(1934) 299–303; *The Turkish
Window* (1934) 347; *Love Among the
Nations* (1935) and *Love on the Moor*
(1937–55) 308–10, 341–4; Domestic
Series (1935–6) 350, 358, 372; *The
Builders* and *Workmen in the House*
(1935) 315–17; *Patricia on
Cockmarsh Hill* (1935) 328–9; *By the
River* (1935) 337–8; RA exhibition
row and resignation 338–40, 527;
Baptism series (1935–55), Madonna
and Pentecost projects 351, 463, 508;
Marriage at Cana project (1930s–50s)
347–51, 372, 417–18, 463; *Leg of
Mutton Nude* (1937) and exhibition
row 356–7; Patricia nude and row
with Tooth 359–61; *Hilda and Unity*

Spencer, (Sir) Stanley – *cont.*
with Dolls (1937) 368; *Adorations*
(1937) and Zwimmer affair 370–1,
378–82; *A Village in Heaven* (1937)
373–7; Venice Biennale (1938) 383;
Beatitudes of Love (1938) 385–91,
425; *Christ in the Wilderness* (1939)
399–400, 417–18, 423, 434;
Campion Hall and *Queen Mary*
projects 401, 412; *The Wool Shop*
and *Tiger Rug* (1939) 407–8;
Leonard Stanley period and Shipyard
commissions (1940–6) 407–10, 412,
413–14, 415–18, 421, 433–4, 458,
527; *Village Life Gloucestershire*
(1940) 409; *St Anthony's Temptation*
(1945) 447–50; Resurrection series
(1945–50) 443–5, 450–2, 453,
458–9, 463–4, 467–70; Elizabeth
Rothenstein's book and other
publishers 453; Leeds exhibition
(1947) 458; elected Academician,
exhibition and public recognition
466–7, 477–8; *The Farm Gate* (1950)
467; Christ series (1950) 471–3;
Christ Preaching at Cookham Regatta
series (1953–9 unfinished) 504–11;
Tate exhibition (1955) 480; Brewers
School commission: *In Church* and
The Crucifixion (1958) 490–3; John
Lewis exhibition (1958) 490, 493;
1980 definitive exhibition 520
concepts of painting:
*see titles of paintings for individual
concepts and interpretations*;
transcendant outlook xiii, 28, 90–1,
297, 314, 391; power of recall and
projection of imagery 8–9, 61, 80,
122, 226, 268, 425–6; conception of
the artist 17, 126, 302, 345; imagery
subservient to emotion 19, 63–4,
90–1, 205–6, 378, 385, 513;
transference of place-feeling 32, 70,
195, 229, 255–6, 385–6; sexuality
(pre-war works and post-war imagery)
33, 35, 39, 206–7, 217–18, 225;
(inter-war) 236, 244, 248, 290,
301–2, 329–30, 341–4, 356–7, 374,
376, 382, 429; (later work) 400,
467–9, 499, 507; enigmas of
composition 36, 61–2, 65–6, 71–2,
180–1, 300, 491–3; dominance of
religious expression 35, 39, 64–6, 75,
113–14, 185, 207n, 373, 468;
reversal of images 37n, 71n, 231, 244,
320, 328n, 380, 385, 387, 448;

revelation of redemption 63–7, 95,
189, 248–9, 283–4, 337, 373, 474,
513, 1354; observed paintings and
'memory-feeling' 68–70, 80–1, 262,
268, 350, 373, 386–7, 494; wartime
influences 87–8, 114, 115, 122,
158–9, 167, 188–9, 205, 232, 240,
269, 389–91; paradoxes in visionary
work 32, 65–7, 70–2, 262, 265–7,
285, 452, 470, 474, 483, 489,
512–13; post-war disorientation
188–9, 215–16, 344; dominance of
Life of Christ theme 52, 194, 196,
253, 350, 399; sense of the
miraculous 61, 207, 269, 345, 346,
380; spiritual dilemmas 215–16,
255–62, 269–70, 314; Resurrection
imagery 219, 224, 235–6, 242–3,
442–4, 450, 458–9, 508; absorption
of personalities and God creation 63,
65, 76, 216, 227, 264–5, 330–1, 351,
492n; Patricia-feeling and Leah
quality 328n, 337, 356, 427;
symphony of creation and nature of
love 264–5, 322, 341–4, 347, 373,
376–7, 379, 387, 425–6, 480, 506;
dog imagery 427, 428; self-portrayal
(to WWI) 60–1, 62, 87–8, 90n, 91,
104; (*Cookham Resurrection*) 227,
229, 232, 238, 244–5, 247, 248;
(Burghclere panels) 140, 256, 259,
268; (other inter-war works) 211,
301, 309, 334–7, 350, 375, 385, 386;
(resurgence and later) 407–8, 409,
410, 415, 416, 450–2; (post-war
work) 459, 467, 489, 496, 498, 507;
(scrapbook drawings) 427, 429
genres and techniques:
visionary paintings *see* concepts of
painting *above*; visual work
misunderstood xi, xiii, 19, 21, 36,
214, 218, 310, 381, 467–8, 492;
critics' standards meaningless 27, 35,
109, 322, 339; landscapes 68, 286,
333, 417, 477, 478, 519; (saleability)
xi, 272, 327, 358, 369, 383, 400, 407,
515; 'observed' paintings 68–70,
80–1; still-lifes 327, 358; nudes
356–7, 357, 360, 383, 428, 504;
portraits and 'heads' 50, 328–9, 368,
453–4, 477, 478, 487, 503; 'erotic'
paintings 329–30, 341–4, 374, 382,
383; influence of family 10–11n, 89,
388–9; inspiration of mediaeval and
Renaissance art 17–18, 113, 122,
132, 150n, 241, 246, 247–8, 253,

Spencer, (Sir) Stanley – *cont.*
265–8, 374n, 471n, 513; affinities with
modernism 17, 27, 73–5, 80, 218,
285, 513; influence of African art
239; evolution of expression 27–8,
73, 122–3, 231–2, 248–9, 318,
385–6, 487–9; use of interiors 61–2,
195–6; interpretation of composition
28, 36, 63–7, 71, 214–15, 247,
284–5, 400, 485–6, 508–10,
512–13; high-angle viewpoint 78,
226; allegorical meaning of light 27,
90, 196, 228, 246, 471n; diptych and
tryptych structures 193, 224, 229,
238, 265, 317–18, 376, 415, 443,
445, 450–2; application of paint 24,
81, 91, 235n, 450, 528; attempt to
learn fresco 194, 255; modelling of
hands 321; use of 'discipline' 374,
380, 385; forms and skylines 484,
487–8, 494
Spencer, Sydney (Stanley's brother):
upbringing and education 3, 7, 7, 8,
49, 78, 146; relations with S.S.
13, 31, 45, 58, 179, 503; wartime
service and death 55, 83, 83–4, *102*,
120, 142, 161, 177, 179; depicted
11n
Spencer, Sydney (Horace's son) 521
Spencer, Sylvia (Horace's daughter) 479,
490n, 521
Spencer, Unity (Stanley's daughter):
childhood and schooling 280, *338*, 411,
421–2, 434, *435*; later life 465–6,
478, *501*, 503, 504, 523; depicted
315–16, 337, 366
Spencer (*née* Bradshaw), Ursula (Gilbert's
wife) 214n, 279, 280, 521, 522
Spencer, Will (Stanley's brother) 9
family background 8, 10; musical talent
and career 6, 7–8, 9, 179, 521;
married life 8, 10, 49; wartime
activities 55, 120, 179; widowerhood
and death 465–6, 479; depicted and
portraits 11n, 378, 466
Spencer, William (Pa; Stanley's father) 60,
83
background and upbringing of family
4–5, 6, 7, 8, 9–10, 12, 17, 277, 320;
wartime tribulations 56, 85, 142, 177;
visit to opera 50; exhibition incident
109; old age and death 180, 192, 218,
277, 319, 521; depictures 11n, 59, 89,
181, 237, 319, 374, 490n
Stand-To (S.S. 1928) *154*, 158–9, 265,
474

Stanley Spencer Gallery 4, 522, 529
works housed 117, 211, 219, 425, 498n,
504
*Stanley Spencer the Man: Correspondence
and Reminiscences* (Rothenstein) 519
Steer, Wilson 108, 181, 518
Stoke-on-Trent Art Gallery: works housed
231
Strachey, Lytton *17*, 46, 328, 514
Stravinsky, Igor 516
Sunflower and Dog Worship (S.S. 1937)
236
surrealism 321, 385
Swan Upping (S.S. 1915–19) 74, 76–81,
90n, 184, 246, 261, 273, 328n
Sword of the Lord and of Gideon, The
(S.S. 1921) 166, 167, 181n

Tate Gallery *see also* Rothenstein, Sir John
S.S.'s works and exhibitions 90, 249,
411, 467, 480; bombed 418; Trustees
514, 519
Tea Party, The (Lamb) 219
Tea in the Ward (S.S. 1932) 97
Template, The (S.S. 1942) 421, 423, 433
Temptation of St Anthony, The (S.S. 1945)
447–50, 449, 456
Thomas, Hilda *see* Spencer, Hilda
Tidying (S.S. 1945) 445, 452, 466–7
Tiger Rug, The (S.S. 1939) 408, 408–9,
412
Times, The 352–3, 490, 492, 527
Todd, Major 182
Todorova 145, 146
Tolstoy, Leo 41
Tonks, Henry 13, 17, 18, 26, 108, 178,
190, 517, 524
Tooth (Arthur) & Sons 276, 398, 503–4,
520, 523
Tooth, Dudley 276
promotion of S.S.'s work 276, 284, 340,
341, 357–8, 405, 411–12, 423, 447;
protests and defences 67n, 306, 341,
358–9, 412, 444; sale of landscapes
286, 358, 383, 400; financial help for
Spencers 362, 370, 392, 393, 421,
431, 435–6; management of S.S.'s
affairs 357–8, 396, 406, 416, 422,
433, 434–6, 467, 478, 519; advice on
autobiography xi, xii, 398
*Travoys Arriving with Wounded Soldiers
at a Dressing Station at Smol,
Macedonia* (S.S. 1919) 183, 184,
186–90, 192, 269, 458, 493
Trivick, Henry 478
Turkish Window, The (S.S. 1934) 347

Tweseldown 119–22
Two Girls and a Beehive (S.S. 1910) 24, 46

Ulysses (Joyce) 75
University College, London: S.S. painting 41
Unveiling Cookham War Memorial (S.S. 1922) 208, 273, 321

Vale of Health Hotel studio 45–6, 184, 209, 221, 226, 251, 520
van Gogh, Vincent 44
Vardar Hills 129, *130*, 132, 144–5, 153, 156, 162, 165–7, 188, 205
 depicted in panels 205, 219, 253, 269
Vaughan Williams, Ralph 146, 525
Venice Biennale (1938) 383
Vickery, Dolly 261
Vickery, Sgt. Sam 98, 260, 261, 262, 264, 516
View from Cockmarsh Hill (S.S. 1934–5) *134*, *135*, *331*
View from Cookham Bridge (S.S. 1936) 328n
Village in Heaven, A (S.S. 1937) 372–3, 373–7, 380, 498
Village Life, Gloucestershire (*Village Gossips*: S.S. 1940) 405, 409–10
Visitation, The (S.S. 1912–13) 398
vorticism 80

Wadsworth, Edward 15, 52, 80, 276, 517
Waking Up (S.S. 1945) 445, 450, 467
War Artists Advisory Committee:
 1st WW 161, 176, 178, 182; 2nd WW 411–14, 415, 417, 419–20, 444
War Artists Exhibition (1940) 415
Warren, Fiske 344n

Washing Lockers (S.S. 1929) 96, 258, 258–9, 268, 286
Washing Peter's Feet (S.S. 1922) 216
Waste Land, The (Eliot) 75
Waugh, Evelyn 514
Welders (S.S. 1941) 416–18
Westropp, Revd Michael and Rachel 499, 500, 504, 512
Wheeler, Sir Charles 512
White, Miss (writer) 19, 20
Whiteford, Mrs (landlady) 428, 441, 484
Widbrook Common 3, 25–6, 28n
Wilenski, R. H. 43, 45n, 467, 468, 527
Wind in the Willows (Grahame) 383, 481, 504
Wise Men, The (S.S. 1940) 412
Wistaria Cottage 5, 48–9, 75, 83
Witchell, Jack 115, *116*, 116, *117*, 117, 195, 389, 516–17, 524
Wood, James (Jas) 124, 292
 friendship with S.S. 123–4, 157, 236, 263, 282, 351, 362, 363, 514, 524; admirer of Hilda Carline 203, 233, 236; Second WW 398; depicted 236
Wool Shop, The (S.S. 1939) 407–8
Woolf, Virginia 325
Wooster, Dorothy (*later* Remington *qv*) and Emily 19, 38, 280
Workmen in the House (S.S. 1935) 315–18, *317*, 338–9, 344, 375, 389, 507
World War I: historical text 126–8, 142, 144–6, 161–2
World War II: historical text 415–16, 421

Yockney, Alfred 160, 182

Zacharias and Elizabeth (S.S. 1913–14) 49, 71n, 273
Zwemmer, Anton 369–70, 470n, 519